A. FLVVIVS

# PRAGUE

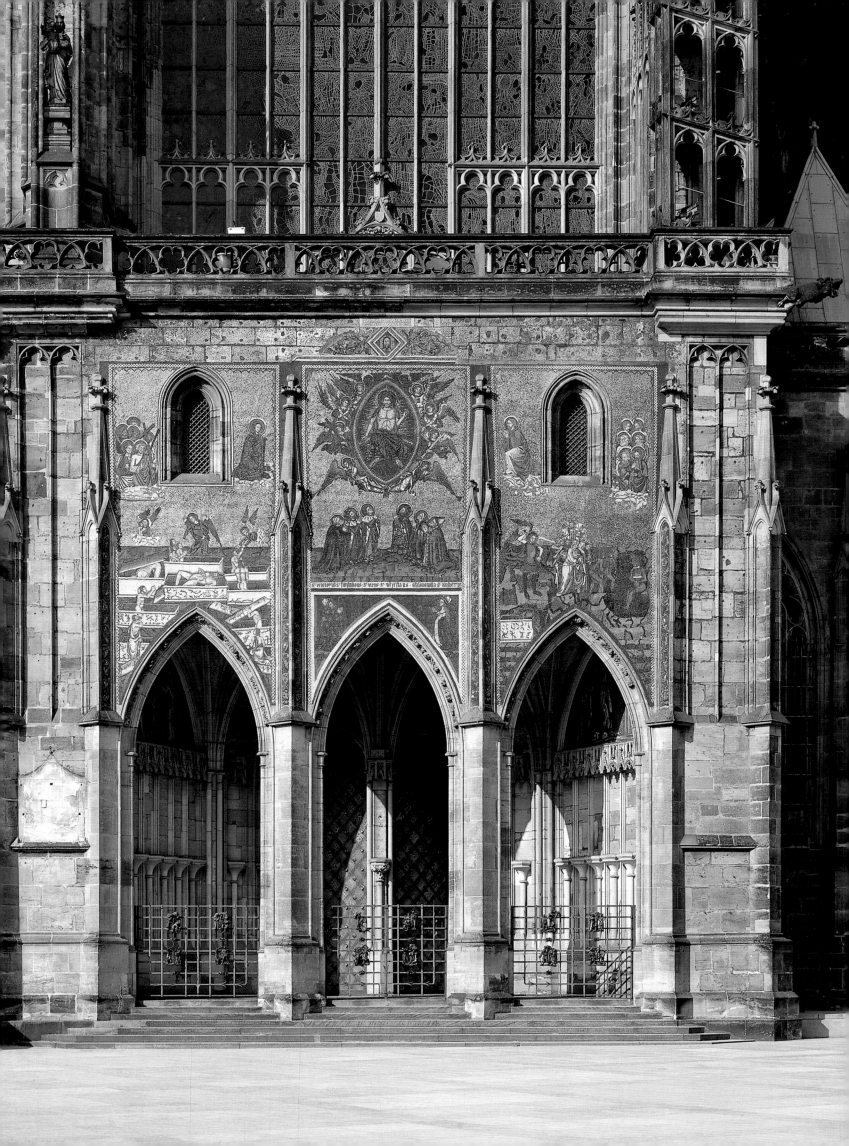

# PRAGUE

## THE CROWN OF BOHEMIA

### 1347–1437

Edited by Barbara Drake Boehm and Jiří Fajt

The Metropolitan Museum of Art, New York

Yale University Press, New Haven and London

This publication is issued in conjunction with the exhibition "Prague, The Crown of Bohemia, 1347–1437," held at The Metropolitan Museum of Art, New York, from September 20, 2005, through January 3, 2006, and continuing as "Karel IV. – Císař z Boží milosti. Kultura a umění za vlády posledních Lucemburků. 1347–1437" at Prague Castle from February 16 through May 21, 2006.

The exhibition is made possible in part by Carl B. and Ludmila Schwarzenberg Hess; Agnes Gund and Daniel Shapiro; and the William Randolph Hearst Foundation.

Additional support has been provided by the National Endowment for the Arts.

The exhibition catalogue is made possible by the Andrew W. Mellon Foundation and the Samuel I. Newhouse Foundation, Inc.

The exhibition was organized by The Metropolitan Museum of Art, New York, and Prague Castle Administration.

The exhibition is supported by an indemnity from the Federal Council on the Arts and the Humanities.

Published by The Metropolitan Museum of Art, New York

John P. O'Neill, Editor in Chief
Gwen Roginsky, Associate General Manager of Publications
Margaret Rennolds Chace, Managing Editor
Sue Potter and Margaret Donovan, Editors
Bruce Campbell, Designer
Gwen Roginsky and Paula Torres, Production
Jane S. Tai, Publication Project Coordinator
Robert Weisberg, Desktop Publishing
Jean Wagner, Bibliographer

Translations from Czech by Keith Jones, Alexandra Suda, Elizabeth Monti, and Suzana Halsey; from German by Dietlinde Hamburger and Russell M. Stockman; from Latin by Eric Ramírez-Weaver and Xavier Seubert, O.F.M.; and from Polish by Ewa Goodman.

Typeset in Bembo and Aureus Uncial
Separations by Professional Graphics, Inc., Rockford, Illinois
Printed and bound by Arnoldo Mondadori Editore S.p.A., Verona, Italy

Jacket/cover illustrations. Front: Saint Luke (cat. 33), attributed to Master Theodoric; paint and gold on panel, Prague, 1360–64; Národní Památkový Ústav, Územní Odborné Pracoviště Středních Čech, Prague (KA 3.676). Back: Tabernacle (cat. 45); gilded iron, Prague, ca. 1375; Metropolitní Kapitula u Sv. Víta, Prague (HS 04270a, b [V 00325a, b], Svatovítský fond). Frontispiece: The Last Judgment; mosaic, 1371; South Portal, Saint Vitus's Cathedral, Prague. Endpapers and half titles: Sadler's Panorama of Prague, 1606 (fig. 5.3, details); The Metropolitan Museum of Art, New York, Harris Brisbane Dick Fund, 1953 (53.601.10)

Cataloging-in-Publication Data is available from the Library of Congress.

ISBN 1-58839-161-2 (hc: The Metropolitan Museum of Art)
ISBN 1-58839-162-0 (pb: The Metropolitan Museum of Art)
ISBN 0-300-11138-x (Yale University Press)

# CONTENTS

# Director's Foreword

From the mid-fourteenth century to the dawn of the twentieth, chroniclers and poets from Petrarch to Guillaume Apollinaire have lauded the city of Prague. The Gothic jewel of the kingdom of Bohemia, capital of today's Czech Republic, Prague has been called the most picturesque city in the world, a city that "teems with wonders," "the dream of delirious architects" whose "magic needs no wand." Yet for much of the twentieth century our view of the city has been obscured. Abandoned by its allies to the Nazis and then isolated by a Communist regime, the city of Prague and its rich artistic heritage were often neglected by both scholars and the general public.

Since the Velvet Revolution, not only chroniclers and poets but throngs of tourists again flock to Prague, to see its imposing castle, its soaring cathedral and mighty bridge. Still, many do not realize how much of the city's fairytale skyline and how many of its treasures were created after Charles IV established his new European capital on the banks of the Vltava (Moldau). This exhibition focuses on that endeavor, and on the extraordinary works of art that came into being as a result. Charles's reign drew artists to Prague from across Europe. Working in media as distinct as paint and gems, stone and gold, sometimes collaborating in unique and inventive ways, they produced works of art of exceptional quality. Despite the political and religious turmoil that marked their reigns, Charles's sons Wenceslas IV and Sigismund witnessed the apogee of Gothic art in the lands of the Bohemian Crown, the "Beautiful Style."

For The Metropolitan Museum of Art to be able to present "Prague, The Crown of Bohemia, 1347–1437," an extraordinary level of international cooperation was essential. We acknowledge our lenders and colleagues for their enthusiasm for this project and their willingness to share their treasures. Our greatest debt is to our co-organizer, Prague Castle Administration. The exhibition, conceived with the support of former President Václav Havel, was embraced by President Václav Klaus and his administration. We thank them for their vision and promotion of culture. We especially appreciate the work of Jiří Weigl, Chancellor of the Office of the President, and the support of Pavel Dostál, Minister of Culture of the Czech Republic. For her tireless devotion to the myriad administrative requirements of organizing the loans from the Czech Republic, we are most grateful to Duňa Panenková, Project Manager of the Exhibitions Office, Prague Castle Administration. For his vision and his invaluable collaboration on the catalogue and the exhibition, we are indebted to the project's co-curator, Jiří Fajt of the Geisteswissenschaftliches Zentrum Geschichte und Kultur Ostmitteleuropas an der Universität Leipzig and the Technische Universität Berlin.

Among the loans from the Czech Republic, those from the Church are of capital importance. Many of these truly marvelous works of art are not usually exhibited publicly. For making these loans possible we are indebted to His Eminence Miloslav Cardinal Vlk, Archbishop of Prague, and to Jan Matějka, Dean of the Metropolitan Chapter of the Cathedral of Saint Vitus.

At the Metropolitan Museum, I wish to thank especially Mahrukh Tarapor, Associate Director for Exhibitions, who forged a new and exceptional rapport with our Czech colleagues and our other European partners to ensure the realization of the project. The Museum's Trustee Placido Arango was instrumental in securing key loans that have significantly enhanced the richness of the exhibition. Barbara Drake Boehm, Curator, Department of Medieval Art and The Cloisters, created its intellectual framework in partnership with Jiří Fajt, and she contributed substantially to the creation of the catalogue. I wish to acknowledge the Office of the Associate Director for Exhibitions, the Registrar, the Editorial Department, the Office of the Secretary and Counsel, the Conservation Departments, the Design Department, and the Department of Medieval Art and The Cloisters. I commend them for their commitment to the Metropolitan and for their collegiality and professionalism.

I wish to express both my personal and our institutional gratitude to those who have supported this project financially. First, to the individuals who have committed their resources to this exhibition, we extend our profound thanks. Carl and Ludmila Schwarzenberg Hess, stirred both by a tradition of support for the Metropolitan and a special knowledge of the cultural richness of Prague, where Ludmila was born, were the first to pledge their support. Through their generosity, the masterpieces of goldsmiths' work from the Czech Republic, including works from the Treasury of Saint Vitus's Cathedral, which are not on view in Prague even today, have been brought to New York. At critical junctures, Agnes Gund and Daniel Shapiro responded beneficently to an acute need for support. Without the understanding born of the finely attuned aesthetic sensibilities of these individuals and their willingness to contribute so generously, this project would not have been realized. We also acknowledge the National Endowment for the Arts for their critical support of this exhibition. In addition, the Federal Council on the Arts and the Humanities has granted an indemnity for this project through an exceptional program which enables us to present exhibitions that are international in scope, and thus vital to our mission as an institution. Of course, the lasting legacy of the exhibition will be this catalogue, which would not have been possible without the vital endowment support of the Andrew W. Mellon Foundation and the Samuel I. Newhouse Foundation, Inc.

Philippe de Montebello
*Director, The Metropolitan Museum of Art*

# acknowledgments

The organization of an international exhibition brings both the extraordinary possibility to present great works of art and the attendant benefit of forging contacts with colleagues at institutions worldwide. The level of cooperation that we received was truly remarkable, transcending all expectation. Among those whom we now thank we are proud to count many new friends.

We extend our profound thanks to Václav Klaus, President of the Czech Republic, and his administration for its endorsement and abiding support of this project. We are grateful to Václav Havel for his vision at its inception. We thank Jiří Weigl, Chancellor of the Office of the President, for his office's tireless work, diplomacy, and generous welcome to the Metropolitan staff during our visits to Prague, and Pavel Dostál, Minister of Culture of the Czech Republic, for the Ministry's efforts on behalf of the exhibition. At Prague Castle Administration, we thank in particular Jiří Franc, Duňa Panenková, Ivana Kyzourová, Katarína Hobzová, and Šárka Stehlíková for their collegiality.

To His Eminence Miloslav Cardinal Vlk, Archbishop of Prague, we offer our heartfelt gratitude for his blessing of the project and his unequivocal support. We thank Jan Matějka, Dean of the Metropolitní Kapitula u Sv. Víta, Prague, for his efforts in connection with the loans from the Cathedral.

For loans from the Czech Republic, we are deeply indebted to the staff of the following institutions: in Bečov, Římskokatolická farnost Bečov u Mostu; in Brno, Moravská Galerie; in Broumov, Římskokatolická farnost–Děkanství Broumov; in České Budějovice, Biskupství Českobudějovické and Národní Památkový Ústav; in Domažlice, Římskokatolický farní Úřad Stanětice; in Hluboká nad Vltavou, Alšova Jihočeská Galerie; in Hradec Králové, Biskupství Královehradecké; in Kutná Hora–Sedlec, Římskokatolická farnost Kutná Hora–Sedlec; in Litoměřice, Biskupství Litoměřické; in Mělník, Římskokatolická–Proboštství Mělník; in Milín, Římskokatolický farní Úřad Slivice-Milín; in Most, Římskokatolická farnost–Děkanství Most; in Nelahozeves, Lobkowicz Collections, o.p.s.; in Nová Říše, Kanonie Premonstrátů; in Olomouc, Arcibiskupství Olomoucké and Vědecká Knihovna; in Pilsen, Biskupství Plzeňské; in Prague, Arcibiskupství Pražské, Benediktinské Arciopatství Sv. Vojtěcha a Sv. Markéty v Praze-Břevnově, Knihovna Akademie věd České Republiky, Královská Kanonie Premonstrátů na Strahově, Magistrát Hlavního Města Prahy, Metropolitní Kapitula u Sv. Víta, Muzeum Hlavního Města Prahy, Národní Galerie, Národní Knihovna České Republiky, Národní Muzeum, Národní Památkový Ústav, Provincie Kapucínů v České Republice, Římskokatolická farnost u Kostela Matky Boží před Týnem, Římskokatolická farnost u Sv. Jakuba Staršího Praha-Zbraslav, Správa Pražského Hradu, Uměleckoprůmyslové Museum, and Židovské Muzeum; in Rokycany, Římskokatolická farnost Rokycany; in Stará Boleslav, Kolegiátní Kapitula Sv. Kosmy a Damiána; in Šternberk, Římskokatolická farnost Šternberk.

We express our thanks to Jaromír Kubů, Státní Hrad Karlštejn. In Prague it has been our pleasure to collaborate with Eliška Fučíková; Marika Gálová; Vladimír Kellnar, Arcibiskupství Pražské; Ivo Koukol; Petr Gandalovic; Jiří Krump; Kaliopi Chamonikalasová; Ladislav Kesner Jr.; Daniel Sobotka; Zdenek Synáček; Vít Vlnas, Národní Galerie; and Radovan Boček. In New York we thank Aleš Pospišil, Eva Raisinger, and Monika Koblerova.

Fully half the works of art in the exhibition come from European collections outside the Czech Republic that generously lent their rare and fine works of Bohemian provenance.

In Austria we thank, in Admont, at the Museum Admont Monastery, Michael Braunsteiner for his gracious welcome to that vibrant community of faith; in Innsbruck, at the Tiroler Landesmuseum Ferdinandeum, Gert Ammann and Ruth Zimmermann; in Klosterneuburg, at the Stift Klosterneuburg, Propst Bernhard Backovsky, Floridus Röhrig, and Wolfgang Huber; in Salzburg, at the Universitätsbibliothek Salzburg, Anton Breitfuss and Beatrix Koll, for her collegial encouragement; in Vienna, at the Akademie der bildenden Künste, Monika Knofler, who introduced us to her collection; at the Kunsthistorisches Museum, Wilfried Seipel, Helmut Trnek, and Franz Kirchweger, whom we were pleased to have welcomed as a fellow at the Metropolitan Museum, Rudolf Distelberger, for his generous counsel, Christian Beaufort-Spontin, Matthias Pfaffenbichler, and Ilse Jung; and at the Österreichische Nationalbibliothek, Andreas Fingernagel. We especially acknowledge the guidance of Gerhard Schmidt.

In Belgium we are grateful for the extraordinary efforts of our colleagues in Antwerp at the Museum Plantin-Moretus, which does not customarily make loans from its collection, especially Francine de Nave, Dirk Imhof, Patricia Kolsteeg, and also Karen Bowen.

In France, in Paris, at the Bibliothèque Nationale de France, we thank Jean-Noël Jeanneney, Agnès Saal, Jacqueline Sanson, Thierry Grillet, Monique Cohen, Nathalie Leman, and François Avril. We acknowledge the scholarship of Michel Garel. At the Musée du Louvre, we thank Henri Loyrette, Marc Bascou, and our dear colleagues Danielle Gaborit, Jannic Durand, Elisabeth Delahaye, and Daniel Alcouffe. We are grateful to Claude Billaud of the Bibliothèque Historique de la Ville de Paris, and especially for the collaboration of Florian Meunier, first as a *stagiaire* in the Department of Medieval Art and The Cloisters and then at the Musée Carnavalet. At the Musée National du Moyen Âge, Thermes et Hôtel de Cluny, we thank Alain Decouche. We especially remember the friendship and support of Viviane Huchard, with whom we were honored to work and whose memory we cherish.

In Germany we are grateful to the following institutions and individuals: in Aachen, at the Parish Church of Saint John the Baptist, Volker Spülbeck; in Berlin, at the Humbolt-Universität, Angelika Keune and Antonia Weisse for their enthusiasm and diligence; and at the Staatliche Museen zu Berlin, Peter-Klaus Schuster and especially Bernd Wolfgang Lindemann, Rainald Grosshans, Erich Schleier, Hartmut Krohm, Hiltrud Jehle, and Michael Klühs; in Bonn, at the Rheinisches Landesmuseum, Frank Günter

Zehnder, Ingeborg Krueger, and Hans-Georg Hartke. In Brandenburg, at the Domstift, we owe a special debt of gratitude to Helmut Reilen for his advocacy of international cultural exchange and to Gerda Arndt, Rüdiger von Schnurbein, Birgizt Malter, and Werner Ziems; in Cologne, at the Metropolitankapitel der Hohen Domkirche, we commend Barbara Schock-Werner and Rolf Lauer for their exceptional collegiality; and at the Museum Schnütgen, we thank Hiltrud Westermann-Angerhausen for her generosity as a lender and for assisting with loans from neighboring institutions, as well as Manuela Beer and Niklas Gliesmann. We thank, in Dresden, at the Staatliche Kunstsammlungen, Martin Roth, Dirk Syndram, Jutta Kappel, and Katrin Bäsig; in Düsseldorf, at the Stiftung Museum Kunst Palast, Jean-Hubert Martin and Barbara Til; in Erlangen, at the Graphische Sammlung der Universität, Hans-Otto Keunecke, Christina Hofmann-Randall, and Sigrid Kohlmann; in Frankfurt am Main, at the Städtische Galerie im Städelschen Kunstinstitut, Herbert Beck, Bodo Brinkmann, Katja Hilbig, and Ute Wenzel-Förster; in Görlitz, at the Kulturhistorisches Museum, Annerose Klammt and Marius Winzeler; in Göttingen, at the Niedersächsische Staats- und Universitätsbibliothek, an institution that since the time of J. Pierpont Morgan has had important links to New York, Elmar Mittler and Helmut Rohlfing; in Hamburg, at the Staats- und Universitätsbibliothek, Hans-Walter Stork, Eva Horváth, and Madeleine Schulz; in Herrieden, at the Katholisches Pfarramt, Pfarrer Georg Härteis; in Munich, at the Bayerisches National-museum, its indefatigable director, Renate Eikelmann, and Matthias Weniger, Astrid Scherp, and Martina Holzmann; in Nuremberg, at the Germanisches Nationalmuseum, G. Ulrich Grossmann, as well as Ralf Schürer, Birgit Schuebel, Karin Tebbe, Anja Löchner, and Frank Matthias Kammel; in Panschwitz-Kuckau, at the Zisterzienserinnen-Abtei Sankt Marienstern, Sister Thaddäa Selnack, who welcomed us to her convent; in Pommersfelden, at the Kunstsammlungen Graf von Schönborn, Paul Graf von Schönborn, Dorothee Feldmann, and Nicole Bertschy; in Würzburg, at the Museum am Dom, Karl Hillenbrand, Jürgen Lenssen, and Michael Koller.

Also in Germany we are indebted to, in Bamberg, Thomas Bachmann and Ulrich Bauer-Bornemann; in Berlin, at the Monumenta Germaniae Historica, Michael Lindner and Olaf B. Rader; in Cottbus, Peter Berger; in Leipzig, at the Geisteswissenschaftliches Zentrum Geschichte und Kultur Ostmitteleuropas at the University of Leipzig, Winfried Eberhard and Tomasz Torbus; in Marburg, at the Elisabethkirche, Ralf Hartmann and Bernhard Dietrich; in Munich, Gertrud Rudigier, Alexander Rudigier, and Elke Kollöchter; in Nuremberg, Matthias Exner; in Würzburg, Georg Pracher.

In Hungary we express our thanks to, in Budapest, at the Budapesti Történeti Múzeum, Sándor Bodó and András Vegh; at the Magyar Nemzeti Múzeum, Tibor Kovács and Etele Kiss; and at the Szépművészeti Múzeum, László Baán, Miklós Mojzer, Imre Takács, Zsombor Jékely, and Andrea Czére; in Esztergom, at the Keresztény Múzeum, Pál Cséfalvay and Dora Sallay; at the Főszékesegyházi Kincstár, György Horváth and Alajos Eck.

Our special thanks go to His Eminence Dr. Peter Erdő, Archbishop of Esztergom-Budapest. Moreover, we owe a particular debt to Barnabas G. Kiss, O.F.M., Holy Cross Hungarian Church, Detroit.

For their generosity, we thank our colleagues in Italy: in Florence, at the Museo degli Argenti, Marilena Mosco, Antonio Paolucci, and Ilaria Bartocci; and at the Museo Nazionale del Bargello, Beatrice Paolozzi Strozzi, Maria Grazia Vaccari, and Antonio Paolucci; in Trent, at the Museo Diocesano Tridentino, Monsignor Iginio Rogger and Domenica Primerano; and in Turin, the private collectors willing to share their precious painting. To our friend Michelangelo Lupo we extend our special thanks equally for his cordiality, graciousness, counsel, and efficacy.

Our thanks go to a number of colleagues in Poland: in Gdańsk, at the Archiwum Państwowe, Piotr Wierzbicki; in Malbork, at the Muzeum Zamkowe, Janusz Trupinda, Magdalena Skotnicka, and Jacek Spychała; in Warsaw, Kinga Szczepkowska-Nalijwajek, and at the Muzeum Narodowe, Ferdynand B. Ruszczyc and especially Małgorzata Kochanowska-Reiche; in Frombork, Henryk Szkop. For the generosity of the Church we are particularly grateful and express our thanks to the Most Reverend Edmund Piszcz, Archbishop of Warmia, and to the Most Reverend Jacek Jezierski, Bishop of Warmia.

In Slovakia we thank, in Bratislava, at the Mestské Múzeum, Peter Hyross and Zuzana Francová, and at the Slovenská Národná Galéria, our colleague Dušan Buran.

In Spain, in Madrid, we thank Carmen Calvo Poyato, Minister of Culture; Blanca Sánchez Velasco, Asesora de la Ministra; and, at the Biblioteca Nacional, Rosa Regás and María Luisa Cuenca. We are also very grateful for the efforts of Leopoldo Rodés and Margarita Mejía of his office in Barcelona. As we have so often in the past, we convey our utmost gratitude to Placido Arango, Trustee of the Metropolitan Museum, for all that he has done to help us.

In Sweden we received a generous welcome and unqualified cooperation. Accordingly, we are indebted to, in Stockholm, at the Nationalmuseum, Hans Henrik Brummer, Torsten Gunnarsson, Lillie Johansson, and Gunilla Vogt; at the Royal Collections, Agnete Lundström and Ursula Sjöberg; at the Royal Library, National Library of Sweden, Thomas Lidman, Charlotte Ahlgren, and Camilla Stomberg.

In Switzerland we have depended on the generosity of Ulrich Niederer and Peter Kamber at the Zentral- und Hochschul-bibliothek in Lucerne and Stephan Kemperdick at the Kunst-museum in Basel. We thank especially Gaudenz Freuler for alerting us to important works.

In the United Kingdom we met with gratifying collegial response. We express our thanks to, in London, at the British Library, Gregory Buzwell, Pamela J. Porter, and Barbara O'Connor; in Oxford, at Pembroke College, Christopher Melchert, Ellena Pike, Lucie Walker, and Jane Richmond; in Edinburgh, at the University Library, John Scally; and in Preston, Francis Marshall. In England, we also extend our gratitude to Martin Kauffmann, Marian Campbell, and Nigel Ramsay.

In the United States, colleagues at sister institutions were unsparing in their generosity: in Baltimore, at the Walters Art Museum, Gary Vikan and Barbara Fegley; in Bloomington, at the Lilly Library, Indiana University, Breon Mitchell, Sandra Taylor, and Anthony Tedeschi; in Boston, at the Museum of Fine Arts, Malcolm Rogers, Ronni Baer, Rhona MacBeth, and Kim Pashko; in Cleveland, at the Cleveland Museum of Art, Katherine Lee Reid, Charles L. Venable, Stephen Fliegel, Holger Klein, Mary E. Suzor, Lynn Cameron, Diane De Grazia, and Monica Wolf; in Los Angeles, at the J. Paul Getty Museum, Deborah Gribbon, Thomas Kren, Elizabeth Morrison, and Nancy Turner; in New York, at the Pierpont Morgan Library, Charles E. Pierce, William Voelkle, Roger S. Wieck, Margaret Holben Ellis, Rhoda Eitel-Porter, and Lucy R. Eldridge; at the Yeshiva University Library, Pearl Berger;

and at the Institute of Fine Arts, New York University, Jonathan J. G. Alexander; in Washington, D.C., at the National Gallery of Art, Earl A. Powell III, Andrew Robison, Margaret Morgan Grasselli, and Stephanie Belt. We extend our special thanks to His Eminence Edward Cardinal Egan, Archbishop of New York.

For loans from the Vatican, we are indebted to His Eminence Angelo Cardinal Sodano, Don Raffaele Farina, and Giovanni Morello. We also thank Patricia Lurati.

We express our appreciation to the anonymous lenders who agreed to share works from their collections with us, allowing them to be seen in the fuller context of Bohemian art.

At the Metropolitan Museum we are grateful for the leadership of Philippe de Montebello. Thanks to his own appreciation of Bohemian Gothic art and the atmosphere of creativity and professionalism that he fosters, work on this exhibition has been an unmitigated pleasure. We thank colleagues at the Metropolitan for their abiding generosity of spirit and their extraordinary collegiality. In the Department of Medieval Art and The Cloisters, we are especially grateful to Peter Barnet, Charles T. Little, Helen C. Evans, Julien Chapuis, Melanie Holcomb, Timothy Husband, Christine E. Brennan, Robert Theo Margelony, Thomas C. Vinton, and Sarah Brooks. Moreover, we owe a special debt to William D. Wixom, who enthusiastically supported this exhibition at its inception. We wish to acknowledge Dorothea Arnold, George Goldner, Nadine Orenstein, Stuart Pyhrr, Dirk Breiding, Keith Christiansen, Maryan Ainsworth, Laurence Kanter, Pia Palladino, Stefano Carboni, James Draper, and Wolfram Koeppe. We thank the Metropolitan's conservators, especially Kathrin Colburn, George Bisacca, Marjorie Shelley, Margaret Lawson, Rachel Mustalish, Yana van Dyke, Larry Becker, Pete Dandridge, Jack Soultanian, and Lucretia Kargère.

For the realization of the catalogue, the professionalism, diligence, and patience of the Editorial Department, headed by John P. O'Neill, have been unmatched. We thank especially our sterling editors, Sue Potter and Margaret Donovan, who were assisted by Margaret Aspinwall, Elizabeth Powers, and Elizabeth Allen. Gwen Roginsky, Margaret Rennolds Chace, Rob Weisberg, Paula Torres, Jane Tai, Kamu Romero, Jean Wagner, Tina Henderson, Mary Gladue, Cathy Dorsey, and Anandaroop Roy all made essential contributions to the production of the catalogue, which owes its beautiful design to Bruce Campbell. Furthermore, we acknowledge the work of Barbara Bridgers, Joseph Coscia Jr., and Wallace Lewis in the Photograph Studio for the catalogue.

We very much appreciate the efforts of Emily K. Rafferty and of Nina McN. Diefenbach, Christine Scornavacca, Rosayn Anderson, and Claire Gylphé of the Development Office. Vital to the complex administration of the loans were Doralynn Pines, Herbert M. Moskowitz, Sharon H. Cott, Rebecca Noonan Murray, Amanda Thompson, and, in the Office of the Associate Director for Exhibitions, Martha Deese, Heather Woodworth, and Penelope Taylor.

The installation relied upon the creative expertise of Linda M. Sylling, Michael Batista, Sophia Geronimus, Franz Schmidt, Emil Micha, Constance Norkin, and an unrivaled team of installers and artisans. Security was coordinated by the office of John Barelli.

Harold Holzer, Elyse Topalian, Egle Žygas, and Diana Pitt oversaw publicity for the exhibition. Educational programs were organized, under the direction of Kent Lydecker, by Teresa Russo, Stella Paul, Mara Gerstein, Elizabeth Hammer, Nancy Wu, Hilde Limondjian, and Craig Feder.

The Merchandising Department developed a remarkable array of products inspired by the exhibition. We extend our thanks especially to Sally Pearson, Valerie Troyansky, Joanne Lyman, Sheila Bernstein, Marlene Reiss, Maureen McDonald, and Sarah Kirtland, and to Marilyn Jensen and Helen Garfield.

We are indebted to Ken Soehner, Linda Seckelson, Robin Fleming, and Katherine Yvinskas of the Watson Library. An extraordinary international team of graduate students and interns contributed their scholarly insights and linguistic and diplomatic skills to this project. These colleagues and friends are to be thanked for their boundless energy and effort: Eric Ramírez-Weaver, Alexandra Suda, Monika Abbott, Xavier Seubert, Xiomara Murray, Elizabeth Monti, Alison Langmead, Patricia Kiernan, Tara Kelly, Amy Brabender, Tiffany Sprague, Geoffrey Shamos, Lisa Skogh, Sarah Thein, Miriam Kriss, Melanie Brussat, Rosina Buckland, Lyle Humphrey Johnson, Ilka Seer, Shayna McConville, Heidi Gearhart, and, especially, Christine McDermott, for her enduring commitment.

We also thank the following for assistance: Thomas Abbott, Jolana Blau, Anthony Blumka, William J. Brennan, Sandra F. Brennan, Gerald Beasley, Marian Burleigh-Motley, Lisa Ciresi, Markus Cruse, Christopher de Hamel, Richard Field, Sam Fogg, Nicholas Hall, Suzana Halsey, Paul Harcourt, Don Jensen, Thomas daCosta Kaufmann, Robert Bruce Livie III, Christina Nielsen, Barry Roberts, Mary B. Shepard, Kay Sutton, Leslie Tait, Florentine Mütherich, Willibald Sauerländer, Lothar Schmidt, George Waldes, and John Weber.

For critical logistical support we thank Orion W. Davis, Jane and Jeffrey Sestilio, Alexandra Pope, Jamie Chase, Kathleen and Steven McCarthy, Joanne Murphy, John Weisel, Brian and Valerie Lynch, Thanassis and Helen Mazarakis, Hank and Angela Uberoi, Joel Chatfield, Kathryn Richards, Anne Wilson, Anne and Carol Mackinnon, Charles Nurse, Jana, Elisabeth, and Nicholas Fajt, and Michael, Alexander, and David Porcelli.

To all those involved, we extend our deep appreciation.

Mahrukh Tarapor
*Associate Director for Exhibitions, The Metropolitan Museum of Art*

Barbara Drake Boehm
*Curator, Department of Medieval Art and The Cloisters,*
*The Metropolitan Museum of Art*

Jiří Fajt
*Project Director, Geisteswissenschaftliches Zentrum Geschichte*
*und Kultur Ostmitteleuropas an der Universität Leipzig,*
*and Guest Professor, Department of Art History,*
*Technische Universität Berlin*

# Lenders to the exhibition

**Austria**
Akademie der bildenden Künste, Vienna, Kupferstichkabinett
  46, 47
Kunsthistorisches Museum, Vienna, Kunstkammer 36, 117
Museum Admont Monastery 42
Salzburg University Library 2, 84
Stiftsbibliothek Klosterneuburg 44
Tiroler Landesmuseum Ferdinandeum, Innsbruck 120

**Belgium**
Museum Plantin-Moretus, Antwerp 85

**Czech Republic**
Alšova Jihočeská Galerie, Hluboká nad Vltavou 108
Arcibiskupství Pražské, Prague 125
Benediktinské Arciopatství Sv. Vojtěcha a Sv. Markéty v Praze-
  Břevnově, Prague 128, 129
Biskupství Českobudějovické, České Budějovice 81
Kanonie Premonstrátů, Nová Říše 124
Knihovna Akademie věd České Republiky, Prague 135
Kolegiátní Kapitula Sv. Kosmy a Damiána, Stará Boleslav 11, 14
Královská Kanonie Premonstrátů na Strahově, Prague 37, 41
Lobkowicz Collections, o.p.s., Zámek Nelahozeves 3
Magistrát Hlavního Města Prahy, Prague 152
Metropolitní Kapitula u Sv. Víta, Prague 6, 8, 28, 31, 45, 50, 51,
  52, 53, 55, 56, 57, 91, 149, 150
Moravská Galerie, Brno 54, 119, 153, 154, 158
Muzeum Hlavního Města Prahy, Prague 70
Národní Galerie, Prague 9, 30, 91, 154
Národní Knihovna České Republiky, Prague 134, 148
Národní Muzeum, Prague 12, 39, 60, 62, 63, 69, 83
Národní Památkový Ústav, Územní Odborné Pracoviště, České
  Budějovice 97
Národní Památkový Ústav, Územní Odborné Pracoviště
  Středních Čech, Prague 33
Provincie Kapucínů v České Republice, Prague 147
Římskokatolická farnost–Děkanství Most 19, 27
Římskokatolická farnost Kutná Hora–Sedlec 123
Římskokatolická farnost Milavče, Domažlice 29
Římskokatolická farnost–Proboštství Mělník 48
Římskokatolická farnost Rokycany 40
Římskokatolická farnost Šternberk 106
Římskokatolická farnost u Sv. Jakuba Staršího Praha-Zbraslav,
  Prague 5
Římskokatolický farní Úřad Slivice-Milín 115
Správa Pražského Hradu, Prague 49, 67
Uměleckoprůmyslové Museum, Prague 21, 65, 66, 68, 114, 130
Vědecká Knihovna, Olomouc 133
Židovské Muzeum, Prague 77

**France**
Bibliothèque Nationale de France, Paris, Département des
  Manuscrits Orientaux 78
Musée du Louvre, Paris, Département des Objets d'Art 36,
  93, 121
Musée National du Moyen Âge, Thermes et Hôtel de Cluny,
  Paris 16

**Germany**
Bayerisches Nationalmuseum, Munich 64, 113, 144
Domstift Brandenburg 43
Germanisches Nationalmuseum, Nuremberg 71, 74
Graphische Sammlung der Universität, Erlangen 35
Humboldt-Universität zu Berlin 72
Katholisches Pfarramt Herrieden 23
Kulturhistorisches Museum Görlitz 140
Metropolitankapitel der Hohen Domkirche, Cologne 59
Museum am Dom Würzburg 151
Museum Schnütgen, Cologne 58
Niedersächsische Staats- und Universitätsbibliothek
  Göttingen 89
Parish Church of Saint John the Baptist, formerly Abbey,
  Aachen 24
Rheinisches Landesmuseum Bonn 107
Collection Graf von Schönborn, Pommersfelden 103
Staatliche Kunstsammlungen Dresden, Grünes Gewölbe 36
Staatliche Museen zu Berlin, Gemäldegalerie 1, 92, 95
Staatliche Museen zu Berlin, Skulpturensammlung und
  Museum für Byzantinische Kunst 100, 110
Staats- und Universitätsbibliothek Hamburg 76
Städtische Galerie im Städelschen Kunstinstitut, Frankfurt am
  Main 17
Stiftung Museum Kunst Palast, Düsseldorf 108
Zisterzienserinnen-Abtei Sankt Marienstern, Panschwitz-
  Kuckau 15

**Hungary**
Budapesti Történeti Múzeum, Budapest 145
Főszékesegyházi Kincstár, Esztergom 142
Keresztény Múzeum, Esztergom 146
Magyar Nemzeti Múzeum, Budapest 141
Szépművészeti Múzeum Budapest 124

**Italy**
Museo degli Argenti, Palazzo Pitti, Florence 36
Museo Diocesano Tridentino, Trent 102
Museo Nazionale del Bargello, Florence 122
Private collection, Turin 38

**Poland**
Archidiecezji Warmińskiej, Olsztyn 138
Archiwum Państwowe, Gdańsk 139
Muzeum Zamkowe, Malbork 109

**Slovakia**
Mestské Múzeum, Bratislava 143

**Spain**
Biblioteca Nacional, Madrid 87, 155

**Sweden**
Nationalmuseum, Stockholm 116
Royal Collections, Stockholm 36
Royal Library, National Library of Sweden,
    Stockholm 13

**Switzerland**
Zentral- und Hochschulbibliothek, Lucerne, Sondersammlung
    Handschriften und Alte Drucke 104

**United Kingdom**
British Library, London 88
Pembroke College, Oxford 82

**United States of America**
Jonathan J. G. Alexander 131
Cleveland Museum of Art 20, 116
J. Paul Getty Museum, Los Angeles 7, 116
Lilly Library, Indiana University, Bloomington 116
The Metropolitan Museum of Art, New York 4, 34, 36, 61, 75,
    90, 94, 112, 156, 157
Museum of Fine Arts, Boston 18, 22, 26
National Gallery of Art, Washington, D.C. 105, 116, 124, 126
Pierpont Morgan Library, New York 25, 80, 116
Walters Art Museum, Baltimore 10
Yeshiva University, New York 79

**Vatican City**
Biblioteca Apostolica Vaticana 96

Private collection 98, 99, 101, 118, 127, 137

# CONTRIBUTORS TO THE CATALOGUE

PB    Peter Barnet, Michel David-Weill Curator in Charge, Department of Medieval Art and The Cloisters, The Metropolitan Museum of Art, New York

MB    Milena Bartlová, Department of Art History, Filozofická Fakulta, Masarykova Univerzita, Brno

BDB    Barbara Drake Boehm, Curator, Department of Medieval Art and The Cloisters, The Metropolitan Museum of Art, New York

HJB    Hans J. Böker, Professor, Department of Art History, McGill University, Montreal

DHB    Dirk H. Breiding, Assistant Curator, Department of Arms and Armor, The Metropolitan Museum of Art, New York

CEB    Christine E. Brennan, Collections Manager, Department of Medieval Art and The Cloisters, The Metropolitan Museum of Art, New York

VB    Vladimír Brych, Vice Director, Národní Muzeum, Prague

DB    Dušan Buran, Curator, Department of Gothic Art, Slovenská Národná Galéria, Bratislava

JC    Julien Chapuis, Associate Curator, Department of Medieval Art and The Cloisters, The Metropolitan Museum of Art, New York

PC    Petr Chotěbor, Office of the Chancellor of the President of the Republic, Pražský Hrad, Prague

PCr    Paul Crossley, Professor of the History of Art, Courtauld Institute of Art, London University

HCE    Helen C. Evans, Curator, Department of Medieval Art and The Cloisters, The Metropolitan Museum of Art, New York

JF    Jiří Fajt, Project Director, Geisteswissenschaftliches Zentrum Geschichte und Kultur Ostmitteleuropas an der Universität Leipzig; Guest Professor, Department of Art History, Technische Universität Berlin

WF    Wilfried Franzen, Independent Scholar, Berlin

JFr    Jan Frolik, Institute of Archaeology, Akademie věd České Republiky, Prague

HH    Hana Hlaváčková, Department of Art History, Filozofická Fakulta, Univerzita Karlova, Prague

MH    Markus Hörsch, Geisteswissenschaftliches Zentrum Geschichte und Kultur Ostmitteleuropas an der Universität Leipzig

FKi    Franz Kirchweger, Kustos der Kunstkammer, Weltliche und Geistliche Schatzkammer, Kunsthistorisches Museum, Vienna

HK    Helena Koenigsmarková, Director, Uměleckoprůmyslové Museum, Prague

FK    Fritz Koreny, Institut für Kunstgeschichte, Universität Wien

ASL    Adam S. Labuda, Professor of Art History, Humboldt-Universität zu Berlin

RL    Rolf Lauer, Dombauverwaltung Köln

CTL    Charles T. Little, Curator, Department of Medieval Art and The Cloisters, The Metropolitan Museum of Art, New York

VBM    Vivian B. Mann, Morris and Eva Feld Chair, The Jewish Museum, New York; Advisor to the Master's Program in Jewish Art, Jewish Theological Seminary, New York

RTM    Robert Theo Margelony, Departmental Coordinator, Department of Medieval Art and The Cloisters, The Metropolitan Museum of Art, New York

EM    Ernő Marosi, Institute of Art History, Magyar Tudományos Akadémia, Budapest

XMM    Xiomara M. Murray, Curatorial Intern, Department of Medieval Art and The Cloisters, The Metropolitan Museum of Art, New York

ZO    Zoë Opačić, Courtauld Institute of Art, London University

KO    Karel Otavský, Institute of Christian Art History, Katolická Teologická Fakulta, Univerzita Karlova, Prague

ERW    Eric Ramírez-Weaver, Research Assistant, Department of Medieval Art and The Cloisters, The Metropolitan Museum of Art, New York

MR    Martin Roland, Austrian Academy of Sciences, Commission of Paleography, Otto Pächt-Archiv, Vienna

JR    Jan Royt, Department of Art History, Filozofická Fakulta, Univerzita Karlova, Prague

GS    Gerhard Schmidt, Institut für Kunstgeschichte, Universität Wien

DS    Dana Stehlíková, Curator of Collections of Precious Metals and Lapidarium, Národní Muzeum, Prague

MS    Milada Studničková, Institute of Art History, Akademie věd České Republiky, Prague

RS    Robert Suckale, Professoren im Ruhestand, Berlin

AS    Alexandra Suda, Research Assistant, Department of Medieval Art and The Cloisters, The Metropolitan Museum of Art, New York

AT    Achim Timmermann, Assistant Professor, Department of History of Art, University of Michigan, Ann Arbor

EW    Evelin Wetter, Geisteswissenschaftliches Zentrum Geschichte und Kultur Ostmitteleuropas an der Universität Leipzig

MW    Marius Winzeler, Curator, Kulturhistorisches Museum Görlitz

# MAPS AND GENEALOGY

# Lands of the Bohemian Crown under Charles IV, 1378

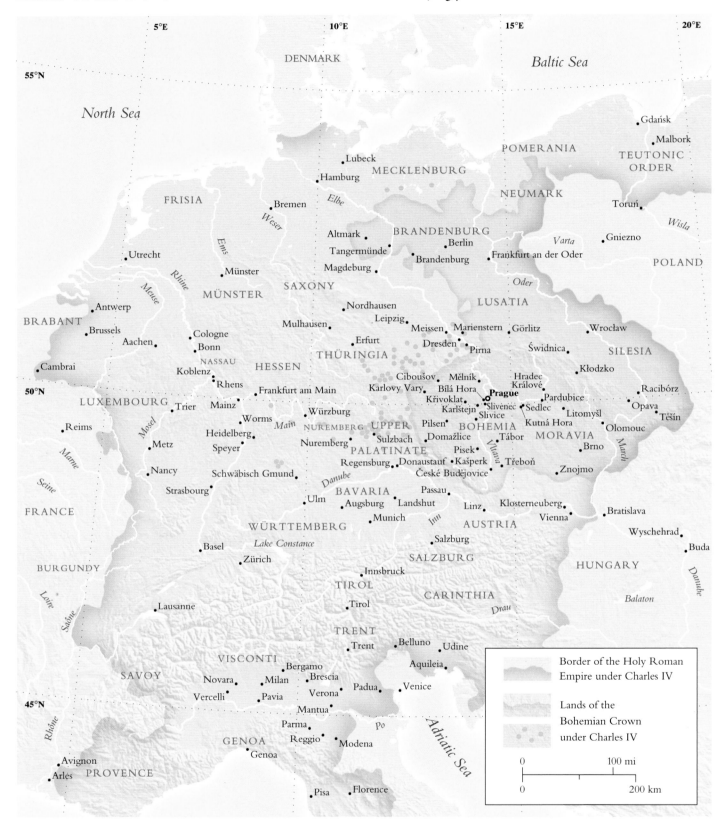

Border of the Holy Roman
Empire under Charles IV

Lands of the
Bohemian Crown
under Charles IV

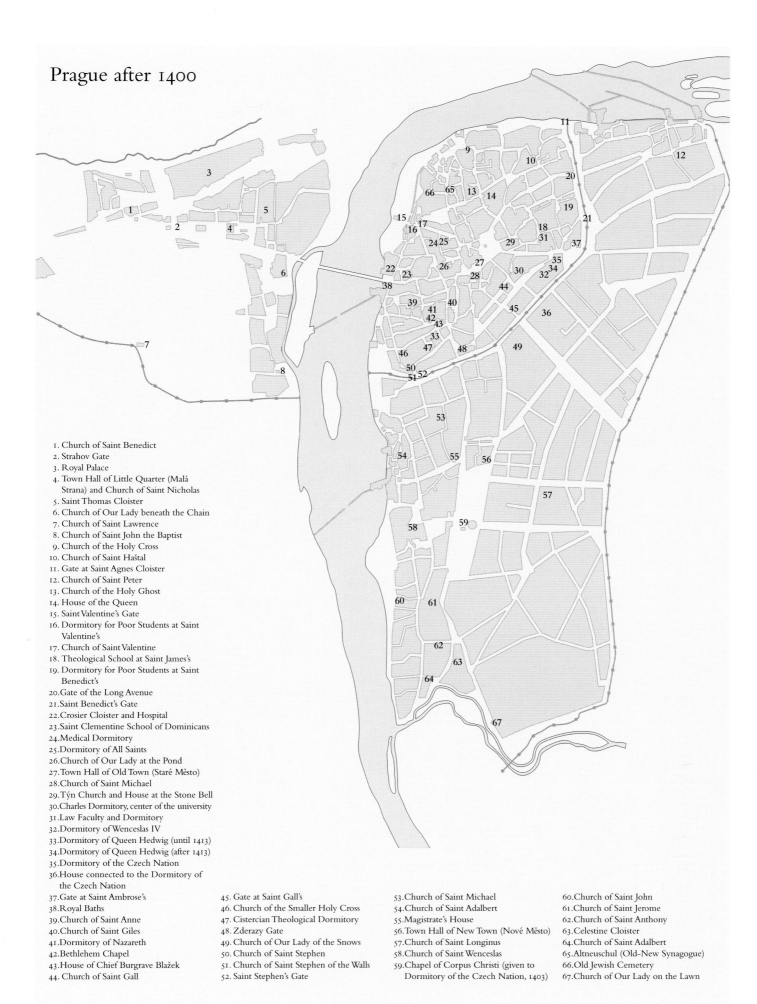

# Prague after 1400

1. Church of Saint Benedict
2. Strahov Gate
3. Royal Palace
4. Town Hall of Little Quarter (Malá Strana) and Church of Saint Nicholas
5. Saint Thomas Cloister
6. Church of Our Lady beneath the Chain
7. Church of Saint Lawrence
8. Church of Saint John the Baptist
9. Church of the Holy Cross
10. Church of Saint Haštal
11. Gate at Saint Agnes Cloister
12. Church of Saint Peter
13. Church of the Holy Ghost
14. House of the Queen
15. Saint Valentine's Gate
16. Dormitory for Poor Students at Saint Valentine's
17. Church of Saint Valentine
18. Theological School at Saint James's
19. Dormitory for Poor Students at Saint Benedict's
20. Gate of the Long Avenue
21. Saint Benedict's Gate
22. Crosier Cloister and Hospital
23. Saint Clementine School of Dominicans
24. Medical Dormitory
25. Dormitory of All Saints
26. Church of Our Lady at the Pond
27. Town Hall of Old Town (Staré Město)
28. Church of Saint Michael
29. Týn Church and House at the Stone Bell
30. Charles Dormitory, center of the university
31. Law Faculty and Dormitory
32. Dormitory of Wenceslas IV
33. Dormitory of Queen Hedwig (until 1413)
34. Dormitory of Queen Hedwig (after 1413)
35. Dormitory of the Czech Nation
36. House connected to the Dormitory of the Czech Nation
37. Gate at Saint Ambrose's
38. Royal Baths
39. Church of Saint Anne
40. Church of Saint Giles
41. Dormitory of Nazareth
42. Bethlehem Chapel
43. House of Chief Burgrave Blažek
44. Church of Saint Gall

45. Gate at Saint Gall's
46. Church of the Smaller Holy Cross
47. Cistercian Theological Dormitory
48. Zderazy Gate
49. Church of Our Lady of the Snows
50. Church of Saint Stephen
51. Church of Saint Stephen of the Walls
52. Saint Stephen's Gate

53. Church of Saint Michael
54. Church of Saint Adalbert
55. Magistrate's House
56. Town Hall of New Town (Nové Město)
57. Church of Saint Longinus
58. Church of Saint Wenceslas
59. Chapel of Corpus Christi (given to Dormitory of the Czech Nation, 1403)

60. Church of Saint John
61. Church of Saint Jerome
62. Church of Saint Anthony
63. Celestine Cloister
64. Church of Saint Adalbert
65. Altneuschul (Old-New Synagogue)
66. Old Jewish Cemetery
67. Church of Our Lady on the Lawn

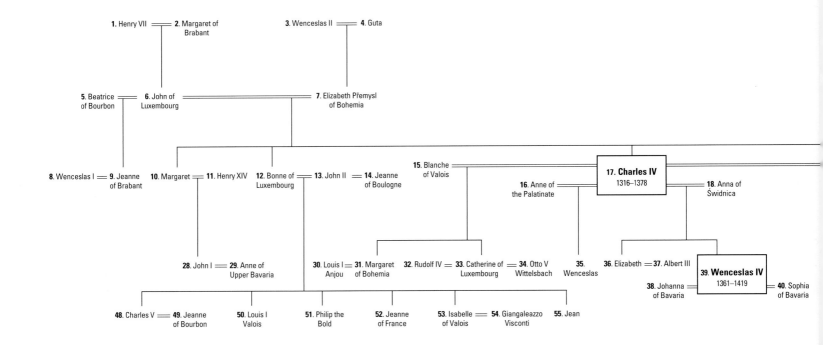

**1. Henry VII** (1275–1313)
Count of Luxembourg 1288–1310
King of the Romans 1308
King of Bohemia 1310
Holy Roman Emperor 1312

**2. Margaret of Brabant** (1276–1311)
m. 1292

**3. Wenceslas II** (1271–1305)
(son of Otakar Přemysl II, king of Bohemia)
King of Bohemia 1283
King of Poland 1300

**4. Guta** (1271–1297)
(daughter of Rudolf I, Holy Roman Emperor)
m. 1287

**5. Beatrice of Bourbon** (before 1324–1383)
m. 1334

**6. John of Luxembourg (the Blind)** (1296–1346)
Count of Luxembourg 1309
King of Bohemia 1310

**7. Elizabeth Přemysl of Bohemia** (1292–1330)
m. 1310

**8. Wenceslas I** (1337–1383)
Duke of Luxembourg 1354

**9. Jeanne of Brabant** (1322–1406)
m. 1352

**10. Margaret** (1313–1341)
m. 1328

**11. Henry XIV** (1304–1339)
Duke of Lower Bavaria 1310

**12. Bonne of Luxembourg** (1315–1349)
m. 1332

**13. John II** (1319–1364)
Duke of Normandy
King of France 1350

**14. Jeanne of Boulogne** (1326–1361)
m. 1350
Countess of Auvergne and Boulogne

**15. Blanche of Valois** (1317–1348)
m. 1329

**16. Anne of the Palatinate** (1329–1353)
m. 1349

**17. Charles IV** (1316–1378)
King of the Romans 1346
King of Bohemia 1347
Holy Roman Emperor 1355

**18. Anna of Świdnica** (1339–1362)
m. 1353

**19. Elizabeth of Pomerania** (1347–1393)
m. 1363

**20. Otakar** (1318–1320)

**21. Margaret of Kärnten-Tirol** (1318–1369)
m. 1330

**22. Margaret of Opava** (1330–ca.1360)
m. 1350

**23. John Henry** (1322–1375)
Count of Tirol 1335–1341
Margrave of Moravia 1349

**24. Margaret of Austria** (1346–1366)
m. 1364

**25. Anne** (1323–1338)
m. 1335

**26. Otto** (1301–1339)
Duke of Austria

**27. Elizabeth** (1323–1324)

**28. John I** (1329–1340)
Duke of Lower Bavaria 1339

**29. Anne of Upper Bavaria** (ca. 1326–1361)
m. 1339

**30. Louis I Anjou** (the Great) (1326–1382)
King of Hungary 1342
King of Poland 1370

**31. Margaret of Bohemia** (1335–1349)
m. 1346

**32. Rudolf IV** (1339–1365)
Duke of Austria 1358

**33. Catherine of Luxembourg** (1342–1386)
m. Rudolf 1357, Otto 1366

**34. Otto V Wittelsbach** (ca. 1341–1379)
Margrave of Brandenburg 1353–73

**35. Wenceslas** (1350–1351)

**36. Elizabeth** (1358–1373)
m. 1366

**37. Albert III** (1348–1395)
Duke of Austria 1365

**38. Johanna of Bavaria** (1356–1386)
m. 1370

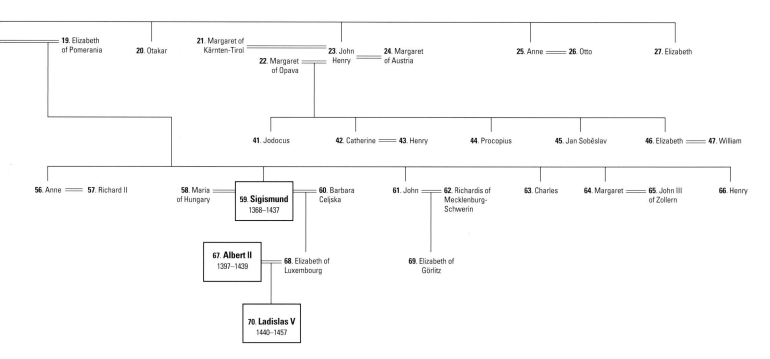

19. Elizabeth of Pomerania   20. Otakar   21. Margaret of Kärnten-Tirol   22. Margaret of Opava   23. John Henry   24. Margaret of Austria   25. Anne   26. Otto   27. Elizabeth

41. Jodocus   42. Catherine   43. Henry   44. Procopius   45. Jan Soběslav   46. Elizabeth   47. William

56. Anne   57. Richard II   58. Maria of Hungary   59. Sigismund 1368–1437   60. Barbara Celjska   61. John   62. Richardis of Mecklenburg-Schwerin   63. Charles   64. Margaret   65. John III of Zollern   66. Henry

67. Albert II 1397–1439   68. Elizabeth of Luxembourg   69. Elizabeth of Görlitz

70. Ladislas V 1440–1457

---

**39. Wenceslas IV** (1361–1419)
King of Bohemia 1363
King of the Romans 1376–1400
Duke of Luxembourg 1383

**40. Sophia (Euphemia-Sophie) of Bavaria** (1376–1425)
m. 1389

**41. Jodocus** (1351–1411)
Margrave of Moravia 1375
Margrave of Brandenburg 1388
King of the Romans 1410

**42. Catherine** (1353–1378)
m. 1372

**43. Henry** (d. 1382)
Duke of Falkenberg

**44. Procopius** (1355–1405)
Margrave of Moravia 1375

**45. Jan Soběslav** (ca. 1355–1394)
Bishop of Litomyšl 1380/81
Bishop of Olomouc 1387
Patriarch of Aquileia 1388

**46. Elizabeth** (d. 1400)
m. 1366

**47. William** (1343–1406)
Margrave of Meissen

**48. Charles V** (1337–1380)
King of France 1364

**49. Jeanne of Bourbon** (1338–1378)
m. 1350

**50. Louis I Valois** (1339–1384)
Duke of Anjou 1360
King of Naples 1382
King of Provence 1382

**51. Philip the Bold** (1344–1404)
Duke of Burgundy 1363
Count of Flanders 1369
Count of Artois 1383

**52. Jeanne of France** (1343–1373)
m. 1360

**53. Isabelle of Valois** (1348–1372)
m. 1360

**54. Giangaleazzo Visconti** (1351–1402)
Duke of Milan 1395
Count of Pavia 1396

**55. Jean** (1340–1416)
Duke of Berry 1360

**56. Anne** (1366–1394)
m. 1382

**57. Richard II** (1367–1400)
King of England 1377–99

**58. Maria of Hungary** (1371–1395)
m. 1385

**59. Sigismund** (1368–1437)
Margrave of Brandenburg 1378
King of Hungary 1387
King of the Romans 1410
King of Bohemia 1419
King of the Lombards 1431
Holy Roman Emperor 1433

**60. Barbara Celjska** (ca. 1393–1451)
m. 1408

**61. John** (1370–1396)
Duke of Görlitz 1378

**62. Richardis of Mecklenburg-Schwerin** (ca. 1372–1444)
m. 1388

**63. Charles** (1372–1373)

**64. Margaret** (1373–1410)
m. 1381

**65. John III of Zollern** (ca. 1369–1420)
Burgrave of Nuremberg 1398

**66. Henry** (1377–1378)

**67. Albert II** (1397–1439)
Duke of Austria 1404 (as Albert V)
Duke of Luxembourg 1421
King of Bohemia 1438
King of Hungary 1438
King of the Romans 1438

**68. Elizabeth of Luxembourg** (1409–1442)
m. 1421

**69. Elizabeth of Görlitz** (1390–1451)
Heiress of Luxembourg 1441

**70. Ladislas V Posthumous** (1440–1457)
King of Hungary 1440
King of Bohemia 1453

PRAGA

MVLTAVI

# PRAGUE

## THE CROWN OF BOHEMIA
### 1347–1437

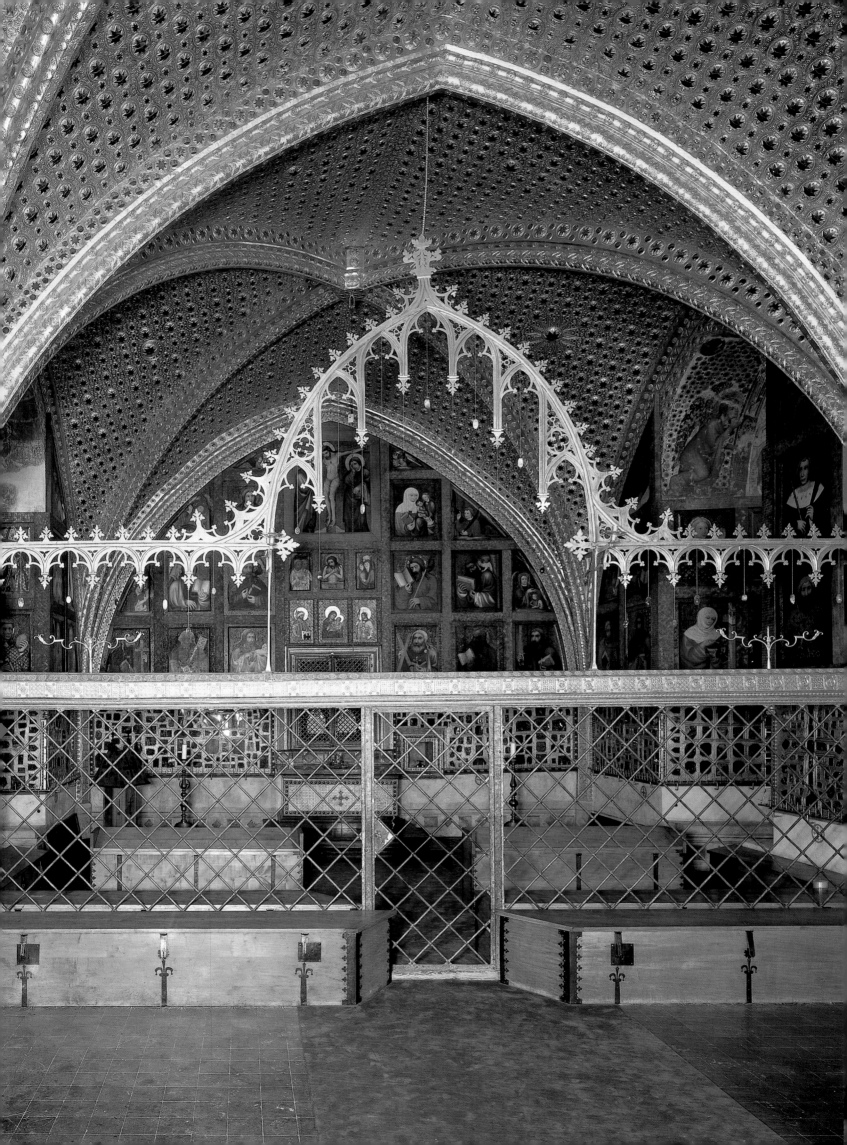

# chARLes iv: TowARd A New iMpeRiAL styLe

*Charles IV, Roman Emperor and King of Bohemia, founded the new Prague Church, an expensive work, as is apparent, and at this expense, his own, did this; . . . a university in Prague was instituted by him, and the building of a new bridge across the Vltava was ordered by him. Excellent lover of Divine Worship and of the clergy, he died in Prague in the year of Our Lord 1378. —Inscription at Saint Vitus's Cathedral[1]*

Jiří Fajt

Born in Prague in 1316, Charles IV was the son of King John of Bohemia and grandson of Henry VII, the first Holy Roman Emperor from the house of Luxembourg. His mother, Elizabeth, was from the Bohemian royal house of Přemyslid. Czechs venerated Charles as the father of their country, but for Germans he was the "stepfather" of the Holy Roman Empire.[2] All agree, however, that he was a deeply religious, cultured, and pragmatic ruler who was also one of medieval Europe's great art patrons. A look at how he presented himself in art, including his own writings, suggests something of his intellectual bent and aesthetic intentions. Charles knew full well how art might enhance a sovereign's prestige. His maternal grandfather, the Bohemian king Wenceslas II, composed minnelieder praised by Ulrich von Eschenbach, and the splendor of his Prague court was widely celebrated.[3] Charles's mother was said to be both a patron of the arts and an accomplished embroiderer.[4] According to the Parisian poet and composer Guillaume de Machaut, John of Luxembourg had decorated his castle in Durbuy with oriental splendor and liked to have passages from the story of Troy read to him there.[5]

Like the emperors Frederick II and Louis IV the Bavarian before him, Charles IV consistently used art to immortalize and exalt his deeds. Much as royal authority was based on divine right, so was sensual beauty considered, in Augustinian theology, to be a reflection of God's ideal beauty, and works of art were thus thought to approach the divine. The art of Charles's court was part of a comprehensive program glorifying the Luxembourg dynasty and the empire. His donations combined two aspects, the public and the private, and thus represented both his "theological politics" and his "political theology." Today it is difficult to appreciate their wealth of spiritual, historical, and political connotations, but to the people of his time, at least the ruling class, they were perfectly comprehensible.[6] They share a

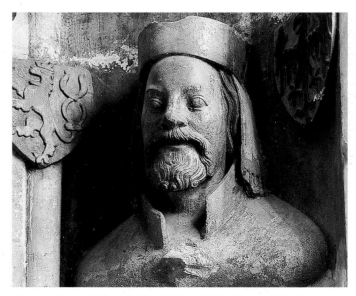

Fig. 1.2 Bust of Charles IV. Triforium, Saint Vitus's Cathedral, Prague. Sandstone, 1375–78

Fig. 1.1 Holy Cross Chapel, Karlštejn Castle

3

common artistic idiom, one that, regardless of subject, displays a universally recognizable style.

## FORMATIVE ENCOUNTERS WITH ART: PARIS AND NORTHERN ITALY

In 1323, at the age of seven, Charles was sent by his father to the French court,[7] where he was reared in an atmosphere of ceremonial piety. In the same year, he was married to Blanche of Valois, sister of the future King Philip VI. An important early influence was the court priest and tutor Pierre de Rosières, later to become Pope Clement VI: "The beauty and eloquence of the abbot's sermon pleased me so much that hearing and seeing him, I found myself in contemplation, and kept wondering, 'What is it about this man that causes so much grace to flow over me?'"[8] Charles took part in the ceremonial events at the Sainte-Chapelle in Paris that focused on adoration of the Passion relics. He must also have been greatly affected by the French royal burial place at Saint-Denis. Perhaps its famous treasury awakened his interest in the classical and Byzantine past, which may help explain the antiquarian aspect of his donations. Just as he legitimized his rule through early chronicles and fictive genealogies, he sometimes made deliberate use of materials and forms that evoked imperial Rome and the venerable rulers of Christendom, even incorporating older works into new contexts (see, for example, cats. 24, 36, 50).

In 1330 John dispatched his son Charles to northern Italy to protect Luxembourg holdings there.[9] Dramatic events during the two years he spent in Italy affected the maturing prince. In the Augustinian monastery at Padua, he survived an assassination attempt, and on Saint Catherine's Day (November 25) in 1332 he won a seemingly hopeless battle near the castle of San Felice. Most significant was a dream he had in August 1333, in Terenzo, near Parma, in which an angel admonished him to end his sinful way of life.[10] Twenty-six years later, he founded on the site a collegiate church which he endowed so that masses would be said for his soul.[11] The only new structure built during his first stay in Italy was the Monte Carlo fortress,[12] which he erected as the lord of Lucca for the protection of the city.[13]

Charles apparently brought from France some holdings of books and art, presumably including the alabaster Virgin and Child at Karlštejn[14] and the ivory Virgin and Child in the treasury of Saint Vitus's Cathedral (cat. 8). Yet it was in Italy that he first became acquainted with flourishing urban cultures[15] and with the art of its northern regions, which would leave its stamp on court painting in Prague during Charles's reign. Essential features of this style were a new depth to the picture space, achieved through perspectival foreshortening of architectural motifs; broad expanses of landscape peopled with stocky figures in a wide range of poses and gestures; modeling with light and shadow that emphasized volumes; dark flesh tones reminiscent of Byzantine icons; subtle color gradations of a diversity previously unknown, achieved in part with glazes on silver or gold foil; and the ornamentation of pictures with engraving, punching, and three-dimensional applications, such as pastiglia, known in Italy. Italian subjects, including the Madonna dell'Umiltà, the *vera icon* (see cats. 137, 148, 149), and the Volto Santo (after the clothed crucified Christ in the Cathedral of Saint Martin, Lucca),[16] were also adopted by the Prague court. Not only were Italian artists called to Bohemia from the very beginning of Charles's reign, but Italian artworks were imported as well.[17]

## VARIETY AND IMITATION IN THE EARLY YEARS OF CHARLES'S REIGN

In 1333 Charles made his way to Bohemia with a retinue of family members and Italian followers, led by Chancellor Nicholas Eberhard from Brno.[18] His first act upon arriving was to visit his mother's tomb in the Cistercian Church of Aula Regia in Zbraslav, near Prague (see cat. 5).[19] His reminiscences suggest the awkwardness he felt: "And thus when we arrived in Bohemia we found neither father nor mother nor brother nor sisters nor anyone else we knew. In addition, we had completely forgotten the Czech language, which we have since relearned, so that we speak it and understand it like any other Bohemian."[20] Since Charles's father had devoted himself more to his western European fortunes than to his kingdom, the sole representative of central authority was the bishop of Prague, Jan IV of Dražice (r. 1310–43). In 1334 Charles was granted the title margrave of Moravia, which strengthened his political position and made possible the consolidation of governmental institutions and personnel. He placed the government in the hands of the Bohemian nobility, restoring Petr Rožmberk, for example, to the office of high chamberlain.

Although they shared similar notions of central government, Bishop Jan sought to turn Prague into an episcopal center, whereas Charles, bent on restoring royal authority, pictured a city that might vie with Paris. Their less than cordial relationship is reflected in the religious realm: the bishop strengthened the cult of Saint Adalbert, the canonized bishop of Prague, while Charles championed the veneration of Saint Wenceslas, the holy Přemyslid. Prague's cathedral became an outward manifestation of their rivalry.

The ultimate choice to build a new Gothic cathedral reflected Charles's preference over Dražice's.[21] This rivalry strengthened the position of the bishop of Olomouc, Jan Volek (r. 1334–51; see cat. 10), a stepbrother of Elizabeth Přemysl and provost of Vyšehrad, who spent more time in Prague than in his own see. Charles had to stay at first in the burgrave's house at Prague Castle and at burghers' houses in the Old Town. Soon he managed to buy back a number of royal castles[22] and constructed "a royal residence worthy of admiration, such as no one had previously seen in this kingdom. He built it at great expense after the pattern of the residence of the French king."[23] The way the older chapel was linked to the new palace, and certainly the placement of the collegiate chapter next to the All Saints Chapel in 1339, recalled the example of the Sainte-Chapelle.[24]

French inspiration can be seen in Prague even earlier. The decoration of John of Luxembourg's city palace in the Old Town, later known as the House at the Stone Bell, recalls the sort of display favored by King Philip the Fair,[25] which is understandable given that John frequently spent time in Paris.[26] Moreover, the last Přemyslid rulers, especially Wenceslas II, had already patterned their court art after that of western Europe, as, for example, in the tombs of the royal family, including that of Bonne, Wenceslas's daughter, dating to 1294–97, and in seals executed in Prague by Parisian artists. John of Luxembourg did not break with the Přemyslid era; he not only retained Wenceslas's adviser Peter of Aspelt, later archbishop of Mainz, but also utilized the services of the court goldsmith Johannes de Grecius (John the Greek). The artist who illuminated the Passional of the abbess Cunigunde (fig. 1.3), which evokes the style associated with the Parisian Master Honoré, was still indebted to the atmosphere of the Přemyslid court in the second decade of the fourteenth century.[27] Imported works of art also served as models for local artists. Bishop Jan IV had his palace in the Little Quarter (Malá Strana) painted with designs he brought back to Prague in 1329, after an unwilling sojourn at the Papal Curia in Avignon.[28]

Among the works in this Přemyslid-Luxembourgian tradition is the Crucifixion from the Kaufmann Collection (cat. 1), originally part of a Passion diptych whose second panel probably depicted a Marian scene. Many influences are evident in this remarkable work. One is the French-inspired Prague painting represented by the Cunigunde Passional, as seen in the drapery of the two Marys at the foot of the cross, and even more obviously in the physiognomy of the crucified Jesus and in his loincloth with its three cascading lines of folds (fol. 8v; fig. 1.3).[29] A striking, somewhat puzzling figure is the centurion on horseback

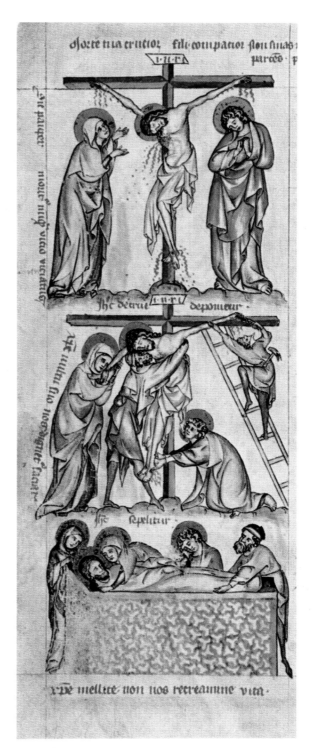

Fig. 1.3 The Crucifixion, Deposition, and Entombment. Passional of Abbess Cunigunde, fol. 8v (detail). Tempera on parchment; Prague, 1313–21. Národní Knihovna, Prague (XIV A 17)

who gazes at something outside the picture. With the curly blond hair and short beard of the ideal knight and ruler, he could be identified as John of Luxembourg.[30] If that is correct, manuscripts from the ecclesiastical institutions at Prague Castle seem to point to Bishop Jan IV of Dražice as the patron of the diptych. As one of the few high-ranking dignitaries in the kingdom, Jan IV maintained an alliance with John. The

original location of the diptych could have been the luxurious episcopal palace in the Little Quarter.[31] The apparent numerous quotations from the Kaufmann Crucifixion panel throughout central Europe suggest an unusually keen interest excited by the work.

Although there had been conflicts between John and his ambitious son, the family quarrel did not continue long. At the national assembly in June 1341 John, having become blind, proclaimed Charles heir to the throne, and in the following year he transferred sovereignty to him. In 1344 Charles's tutor, now the pope, elevated Prague to the seat of an archbishopric. Finally, after John died at the side of the French king in the Battle of Crécy, Charles was crowned King of the Romans in Bonn on November 26, 1346.[32]

Prague's new cathedral, designed by the French architect Matthias of Arras, expresses both the greater autonomy of Bohemia and Charles's increased stature on the European stage. Charles's adherence to the art of western Europe as an aesthetic standard, succeeding earlier achievements like a carved statue for the tomb altar of Saint Benigna in the Augustinian Hermitage of Zaječov (ca. 1327),[33] is mirrored in the work of the anonymous sculptor called the Master of the Michle Madonna. Traditionally thought to have had his workshop in Brno, this artist is more likely to have settled, in the mid-1330s at the earliest, in Prague, Charles's primary residence even as margrave (the title for heirs to the Bohemian throne).[34] His work shows an affinity with that of artistic circles in the Rhineland, for example Oberwesel, a link related to Charles's great-uncle Baldwin, archbishop of Trier, under whose authority the city lay.[35] With his elegant, elongated figures, calligraphic versatility, and more refined carving, this master ennobled the earlier tradition of Bohemian sculpture.[36]

Charles favored Marian subjects, especially those presenting the Virgin as chosen by God to be the mother of Jesus and with attributes suggesting the messianic calling of her child. Among these were the Woman of the Apocalypse clothed in the sun and the Madonna on Lions, a picture type probably created at Charles's court.[37] The king appears to have delighted in the ambiguity of this subject: the lion could represent the Lion of Judah, emblematic of the biblical King David, or serve as a symbol of triumph over evil, or be the heraldic device of Bohemia. Prague's archbishop, Arnošt of Pardubice, had once compared Charles to King Solomon,[38] whose golden throne was guarded by fourteen lions.[39] The Master of the Michle Madonna could have depicted this subject, as did other court artists, creating such examples as the French-influenced statue from Łuków (Muzeum Narodowe, Poznań)[40] and the many echoes of Charles's donations.[41]

The transformation of the image of the Virgin, begun in France, culminated in Bohemia and was probably spurred by Arnošt's support for the veneration of Mary. New pictorial types were developed that were suitable for both royal display and private devotions.[42] Deliberately borrowing from Byzantine-Italian prototypes, especially that of the Dexiokratusa (Gr., "Holding [the Child] on Her Right Arm"), Bohemian artists settled on the type of the Virgin supporting the Infant Jesus on her right side. The earliest Bohemian panel paintings of the Virgin, dating to the 1340s, are half-figure variants on the Queen of Heaven (Regina Coeli) type, based on the Eleusa (Gr., Glykophilusa, "Compassionate"), in which the Virgin and Child are gracefully touching each other in a wide range of gestures and positions. These are accordingly called "graceful Mary images" (milostná madona) in Bohemia. Although little is known of their origin, at least an indirect link to Charles's court in Prague seems highly probable. The Madonna from Zbraslav (cat. 5) was the treasured icon of the Virgin at that Cistercian monastery, which was particularly important to Charles as the burial place of the last Přemyslids; he may possibly have presented the image to the church himself. This same type is repeated in the Virgin in the Strahov Monastery (cat. 37), executed close to the king's or archbishop's courts in the workshop of the Master of the Kłodzko Madonna, and in a painting of the Virgin in the Národní Galerie, Prague (cat. 9). Such small precious works, presumably intended for private devotions, would have been made for the high prelates at Charles's court. The Virgin from Veveří could have been a donation from the burgrave of this royal castle near Brno to the Cistercian convent at Oslavany, or it may also have been originally destined for the castle chapel.[43]

The original Byzantine-Italian type was enriched in Prague by the addition of French motifs, including the Virgin's diadem and crown of lilies, which distinguish her as simultaneously Queen of Heaven and Bride of Christ. Paris court inventories indicate, for example, that the dowry of Charles's aunt Marie of Luxembourg included several crowns.[44] Marie purchased a wedding crown in 1323, ultimately passed down to Blanche of Valois, and ordered two expensive circuli from the court goldsmith Simon of Lille.[45] In Bohemian representations, small gold crowns are often combined with magnificent circlets (cats. 5, 9, 37). Crowns and circlets were also produced as sets, such as the one made for the wedding of Charles and Blanche.[46] Her luxurious trousseau in the French fashion, which was admired by the abbot of the Zbraslav monastery, Peter of Zittau,[47] could also have inspired court painters.

The popularity of Byzantine-Italian images of the Virgin stems from several different factors. First, there is a legendary one, for the chronicler called Dalimil reported that the Czechs' original homeland lay on the shores of the Mediterranean in Byzantine territory.[48] A religious aspect was also involved: hoping that the Great Schism could be resolved, Charles foresaw a decisive role for the Slavs as mediators between Orthodoxy and Catholicism. Finally, from a political point of view, he exalted Bohemia, located between East and West, as the new center of his imperial world.

One artist involved in the rapid distribution of panels with the "graceful Mary image"[49] was the Master of the Vyšší Brod Cycle, whose iconlike, ceremonious austerity and glowing colors were unparalleled in Europe. His workshop in Prague produced the Virgin from Veveří[50] as well as the eponymous cycle of nine panels from the Cistercian church at Vyšší Brod, which were commissioned by Petr Rožmberk, the king's high chamberlain and judge. In the Nativity (fig. 3.2), Rožmberk had himself portrayed as the abbey's *secundus fundator* (second founder), holding a model of the church. Obviously tailored to courtly expectations, the refined images are filled with allusions to Cistercian texts, especially Bernard of Clairvaux's commentary on the Song of Songs. The absence of compositional accents in the narrative flow of the Christian account of Salvation, with the Crucifixion at the center, suggests that the panels were originally placed in sequence on a choir screen.[51] A French calligraphic elegance combines with an Italian sense of volume and color to make the Master of Vyšší Brod an outstanding representative of an aesthetic strain prevalent in central Europe in the second quarter of the fourteenth century, one that was dominant in Prague until the mid-fourteenth century.[52]

Following the tradition of the French kings, Charles focused on building campaigns like his royal palace with its two-story chapel, the cathedral, which he enriched as the locus of coronations and royal burials, and his castle outside the city. He embellished them (as in France) with stained glass and stone sculpture, more and more tending away from religious and liturgical subjects and toward royal and courtly themes. He endowed the treasuries of his newly erected churches and chapels with splendid liturgical objects. Due to the almost complete loss of the relevant structures, it is no longer possible to determine how important wall painting was at the Paris court in the fourteenth century, but it seems to have been increasingly replaced by textile hangings. To Charles, however, it still had tremendous worth, and panel painting at the Prague court took on a new monumentality as well.

Until Charles was crowned Holy Roman Emperor in 1355, there was no distinct, uniform style in the art of the Prague court. Initially, he apparently imported and imitated the art of the Parisian court, of papal Avignon or cities in northern Italy, and of the ancestral Luxembourg possessions. Ideologically and artistically, he also drew upon the earlier Přemyslid-Luxembourgian tradition. His seal as margrave of Moravia (1334–46), for instance, was doubtless executed by a French goldsmith from his father's court.[53] An interest in Venetian and Tuscan trends[54] marks the so-called Košátky Dormition (cat. 26), a panel painting executed about 1345–50 for an unknown ecclesiastic by a painter trained in the circle of Paolo Veneziano.[55] That it was no exception is confirmed by the panel depicting the Madonna dell'Umiltà formerly in the Asscher and Welker collection, now lost,[56] and the somewhat later picture of the same subject called the Madonna of Vyšehrad.[57] The court's embrace of the most varied styles, combined with an insistence on luxurious execution, set new aesthetic standards in Prague, creating a rich foundation for future developments.

## THE PATH TO THE IMPERIAL STYLE

After his coronation as king of Bohemia on September 2, 1347, Charles IV took steps to solidify Bohemia's position within the empire. His policy decisions were often linked to his increased activity as a patron, which was concentrated on transforming Prague into a splendid imperial capital. With gifts of numerous relics, he strengthened the position of Saint Vitus's Cathedral as a spiritual center to which the faithful flocked on pilgrimage.[58] In 1348 he founded the New Town (Nové Město), whose walls, some three kilometers long, were completed in a mere two years.[59] With forty thousand inhabitants and a total area of fifty hectares, Prague became one of the largest cities in Europe. All urban development for the next five hundred years found space within its walls.

Charles's imperial policies were at first constrained by conflict with the excommunicated emperor Louis IV the Bavarian, who died in 1347. He resolved any succession issues by marrying Anna, the daughter of one of Louis's relatives, Wittelsbach Count Palatine Rudolf II. On June 24, 1349, Charles was crowned King of the Romans in a ceremony above Charlemagne's tomb in Aachen. For the occasion he commissioned a crown of lilies with antique cameos and gemstones that was later placed on the reliquary bust of Charlemagne (fig. 2.7).[60] Charles's coronation as Holy Roman Emperor was delayed until 1355. On December 15, 1354, during his journey to Rome, he met Francesco Petrarch whose appreciation for the Western

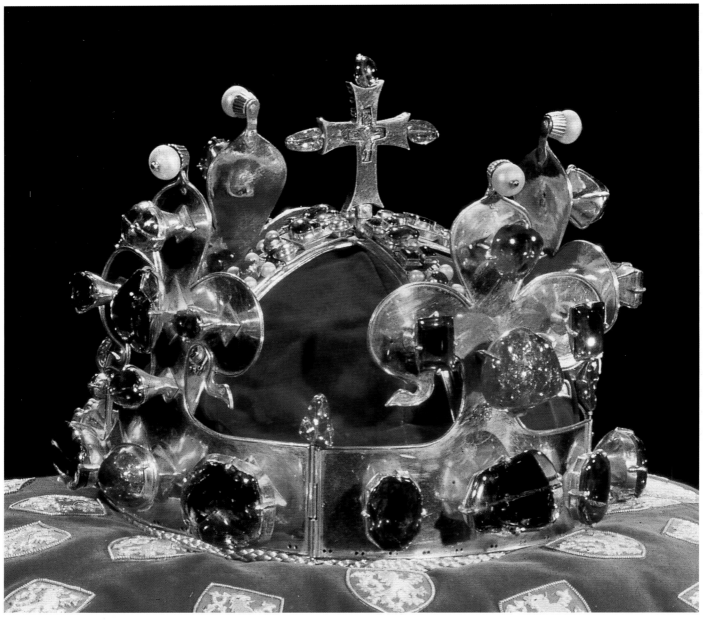

Fig. 1.4 The royal crown of Bohemia. Gold with sapphires, spinels, pearls, emeralds, and rubies; 1346. Treasury of Saint Vitus's Cathedral, Prague

imperial tradition, which he traced back to pagan antiquity, must surely have pleased Charles. The poet wrote: "I gave him a few gold and silver coins with the portraits of our rulers, which were inscribed with tiny and ancient letters. . . . It would seem that he had never received any gift with greater delight."[61] In return, Petrarch was presented with "a portrait of Caesar of antique workmanship."[62]

On January 6, 1355, Charles was crowned with the iron crown of Lombardy in Sant'Ambrogio in Milan. On Good Friday of that year, after viewing "the sacred visage of Christ on Veronica's veil," the *vera icon,* he set out on a pilgrimage to the relics of Jesus in Rome.[63] He visited San Giovanni in Laterano (where the table from the Last Supper was enshrined), Santa Maria Maggiore (with its relics of the Nativity), Santa Prassede (where the column from Jesus'

flagellation was believed to be), and the shrine to Saint John the Baptist in San Silvestro in Capite. It is quite probable that the wall painting above the altar of Saint Wenceslas in Old Saint Peter's was executed at this time. Known only from seventeenth-century drawings, it showed Bohemia's patron saint flanked by the Benedictine Saint Procopius and Adalbert, the patron of the Prague bishopric. Next to Procopius was an adoring donor figure of Charles IV, and next to Adalbert an unidentified prelate. Since the iconography and composition were not typically Italian, Charles himself may very well have commissioned the work from a painter active north of the Alps, perhaps in Prague and perhaps a member of his own retinue.[64] Charles brought back from Rome gold, jewels, pearls, and "other noble things,"[65] probably including copies of the *vera icon* (see cats. 137, 149)[66]

and the miracle-working image from Santa Maria in Ara Coeli on the Capitol (cat. 28).

Between 1347 and 1355 Charles changed his focus from the intellectual and literary interests of his youth to a fixation on politics.[67] Whereas his *Moralitates* (*Moralities,* early 1340s) had still featured reflections on the conduct expected of the Christian ruler, his autobiography, begun in 1346, was conceived by a prince with a clear political agenda. His *Ordo ad coronandum regem Boemorum* (1347) codified the ceremony for the king's coronation. His own talent for ceremonial drama was demonstrated at his coronation in Prague as king of Bohemia, for which he commissioned the Wenceslas crown (fig. 1.4) patterned after those of both the Přemyslid rulers of Bohemia and French royalty. Its sacred symbolism was suggested in the coronation ceremony: "Bless and consecrate this crown. Just as it is set with a variety of gems, so shall its servant be . . . filled with a multiple gift of noble virtues."[68] The historicizing features of the crown, its simple monumentality and economy of ornament—deliberately contrasting with the elaborate decoration of earlier examples of goldsmithing—are emblematic of Charles's mode of royal ostentation.

Charles regularly imbued works of art with political meaning. His first royal donation was the Carmelite Monastery of Our Lady of the Snows, founded in Prague only two days after his coronation. A monumental stone relief depicting the Coronation of the Virgin with the Trinity and Charles and Blanche as donors commemorates the event, linking it allegorically to the coronation of the Virgin in heaven. The relief was commissioned from a sculptor associated with the milieu of Friedrich of Hohenlohe, bishop of Bamberg and an ally of Charles.[69]

## JAN OF STŘEDA'S CONTRIBUTION TO THE IMPERIAL STYLE

The change in political style had organizational and personal consequences. One of these was that, after 1350, Nurembergers were given leading positions in Charles's chancellery.[70] Another was that the chancellery itself was directed by a close associate of Charles, Jan of Středa, from 1353/54 to 1364 and briefly again from 1371 to 1374.[71] A noted champion of literary culture and a friend of numerous Italian humanists, Jan became an influential adviser in artistic matters. In one of his letters he calls the emperor's attention to an unnamed painter he was sending to him with a picture in which an angel was escorting the emperor and the pope into heaven.[72] Jan changed the format of imperial documents, adding more quotations in Latin from classical authors and the Church Fathers.[73] He also gave new direction to the book illuminators' workshops. The dark Venetian colors and French calligraphic elegance of earlier miniatures gave way to a lighter palette and monumental figures with velvety soft drapery. The Master of the *Liber viaticus* (Library, Národní Muzeum, Prague; see fig. 3.6) imparted a knowledge of Italian art, commanding the technical and artistic resources of Sienese painting, particularly of the Lorenzetti brothers and Simone Martini. But the qualities that made him the one artist who most changed the style of court art in Prague in the third quarter of the fourteenth century were his innovative modeling and his dynamic, individualized figures reminiscent of the works of Vitale da Bologna[74] and Niccolò di Giacomo da Bologna.[75]

The norm in Bohemian manuscripts until the early fifteenth century remained the decorative format devised by the Master of the *Liber viaticus,* with its rich Lombard vine ornaments, monochrome painting in the figural initials reminiscent of the Parisian miniaturist Jean Pucelle, and narrative scenes in the bas-de-page, also derived from Paris. The Master's draperies create a rhythmic contrast between supple, sweeping shell-shaped curves and severely vertical parallel folds, while they are almost dissolved in their raised sections by an inner glow. But this style relaxed over time, becoming increasingly inventive, as younger painters expanded the Master's limited stylistic range.[76] Their statuelike figures and stiff ornament gave way to freer, more imaginative lines and more voluptuous foliate shapes. These distinguish the later works of this group, especially the archiepiscopal *Orationale Arnesti* (before 1364), the Missal of Jan of Středa (shortly after 1364; see fig. 3.1),[77] and most notably the Gospel of Jan of Opava (1368).[78]

The change in style in Jan of Středa's painting workshop and scriptorium coincides with his appointment as bishop of Olomouc in 1364. There, Jan encountered two new collaborators familiar with the workshop of the Master of the *Liber viaticus:* the painter of the miniatures in his own missal, who also ornamented the *Orationale Arnesti* for Archbishop Arnošt of Pardubice and collaborated on the Vienna Gospel Book, and the court scribe and illuminator Jan of Opava.[79] Their painterly approach reflects the evolution of Prague painting brought about after 1360 by the imperial painter Theodoric.

Clearly working under the influence of the Master of the *Liber viaticus* was a painter who about 1360 illuminated a selection of lessons on the Virgin and a collection of prayers by the Carthusian Konrad of Haimburg, executed for the bishop-elect of Trent, Meinhart of Hradec, who was fervently devoted to Mary. It is not known who commissioned the illuminations for the *Laus Mariae* (cat. 39), but

two full-page miniatures, conceived as small panel paintings, are quite close to the Virgin and Child in Boston (cat. 18). A number of identical signature details even suggest the same hand. The crowning achievement of this court painter is the Morgan Library diptych (cat. 25).

In this period Charles's court was a meeting place for artists from all over Europe. Pictorial stimuli from the most varied sources converged about 1355 into a uniform aesthetic that was consistently employed in the service of imperial authority and dynastic policy. The intensity of this process of integration is particularly evident in the Virgin and Child from the Old Town Hall (fig. 4.5), presumably commissioned from the sculpture atelier of Prague Cathedral, which translates a French prototype into a new idiom marked by striking breadth, corporeality, and contrasting drapery motifs. The strong resemblance of the tear shape in the drapery above the left knee to the softly modeled twists in the figures of the Master of the *Liber viaticus* leads one to regard this Virgin as the counterpart in stone to his miniatures. Her author must have had a great impact as well on wood sculpture produced in the milieu of Charles's imperial court in Prague, as reflected in works like the standing Virgin and Child from Zahražany (cat. 19), a seated figure of the same iconography from Hrádec near Benešov, and three sculptures from the high altarpiece in the former main Parish Church of Saint John in the imperial city of Cheb.[80]

KARLŠTEJN CASTLE AND NICHOLAS WURMSER OF STRASBOURG

Charles IV's largest artistic undertaking after his return from Rome was the rebuilding of Karlštejn Castle (fig. 1.5). Although the origins of the cliffside castle set amid the royal forest are unknown,[81] it was probably a Luxembourg country seat, a day's ride from the palace in Prague, similar to the Valois Castle in Vincennes, outside Paris. The sacral character of Karlštejn is underscored by its five chapels.[82] The Holy Cross Chapel in the Great Tower (fig. 1.1), created by remodeling a secular hall,[83] was meant to hold the imperial treasure. It was entrusted to the canons of the Karlštejn chapter, who used the Church of Our Lady, once a residential area in the Small Tower, for its services. Next to it was a chapel containing relics of the Passion, known since the sixteenth century as the Saint Catherine Chapel. At the lowest level stood the imperial residence, with its Chapel of Saint Nicholas and also probably an oratory consecrated to Saint Wenceslas, which was part of the imperial couple's private apartments.

The walls of the castle hall were painted in 1356–57 with portraits of Charles's Luxembourg and Brabantine ancestors, as well as his putative progenitors from Noah to the Trojans to Charlemagne.[84] Today these can be judged only by copies from the second half of the sixteenth century (see figs. 4.2, 4.3).[85] Although the perspective foreshortening and radically new modeling with light were North Italian inventions, the corporeality of the figures, their lifelike gestures, and their individualized faces betray the painter's western European origin. This master may have shaped his style in Paris after the middle of the fourteenth century,[86] or he may have come from the court of Charles IV's half brother, Duke Wenceslas, in Louvain or Brussels, which would account for his works' numerous Italian innovations, not then known in Paris.[87]

In either case, the Master of the Luxembourg Genealogy brought to the Prague region the kind of Franco-Flemish nature study without which the further development of painting at the imperial court and the birth of the portrait in central Europe are unthinkable. Charles had exceptional judgment in assigning this prestigious commission to such a sophisticated painter. Countless responses to the master's work in contemporary Prague court painting attest to his far-reaching influence. Some twenty years later, in 1378–79, for example, the Karlštejn rulers reappear in the initials of the rhymed chronicle of Ernst von Kirchberg, commissioned by Duke Albert II of Mecklenburg,[88] and in stained glass of the Chapel of Saint Bartholomew in Saint Stephan's Cathedral in Vienna.[89]

The Master of the Luxembourg Genealogy has been sporadically identified as Charles's first painter to the king.[90] Initially documented in 1357,[91] Nicholas Wurmser, a citizen of Strasbourg, probably worked at Karlštejn Castle from that year until 1360. He was rewarded on December 13, 1360, with an unencumbered farm in the village of Mořina, near Karlštejn, "in view of his numerous genuine merits as well as the faithful and deserving services with which our beloved Master Nicholas, painter, our courtier, has always sought to oblige us."[92] Since Charles presented the same farm seven years later to Theodoric, the most important painter at Karlštejn, for his "profound and masterly" work on the Holy Cross Chapel,[93] Wurmser's contribution to the decoration of the castle must have been greater than generally assumed.[94] He has been credited, for example, with the rather bland Crucifixion above the altar of the Saint Catherine Chapel and the Apocalypse cycle in the Chapel of Our Lady. Yet the eloquent gestures of his stocky figures, with short necks, sharp features, and lush, full beards, and the soft modeling of the drapery, with S-shaped loops at the hem, do plausibly mimic the style of the Luxembourg Genealogy.[95] The Master of the Genealogy must therefore

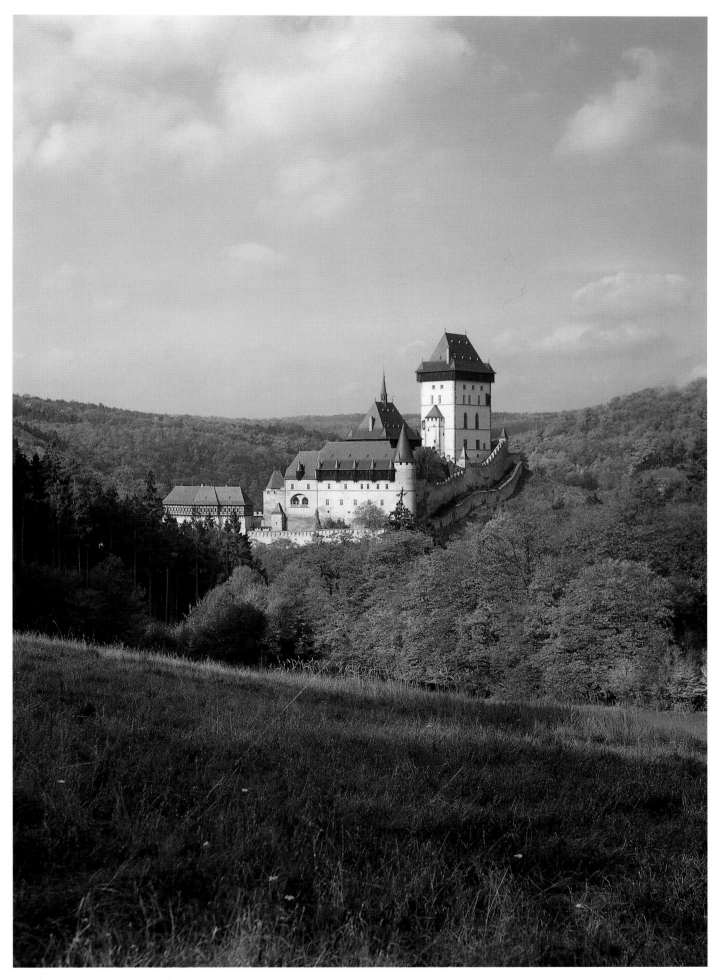

Fig. 1.5 Karlštejn Castle, view from the west

Fig. 1.6 Nicholas Wurmser of Strasbourg. Charles IV and Anna of Świdnica. Mural above the entrance portal, Oratory of Charles IV, Karlštejn Castle

have led a larger atelier of painters, who did much of the work following his guidelines, but whose results, despite similarities in composition and figural type, could not equal his in elegance of execution. These painters were clearly familiar with Strasbourg and Franco-Flemish art from the second half of the 1350s.[96] If the Apocalypse cycle at Karlštejn, painted most probably by his workshop, recalls the Dormition of the Virgin from an Alsatian manuscript (dated 1362) of Jacobus de Voragine's *Golden Legend*,[97] with its stylized faces of the apostles, the extraordinary relic scenes on the south wall display parallels with the Adoration of the Magi from the stained glass cycle in the episcopal chapel in Saverne, north of Strasbourg (commissioned by Charles's ally Bishop Johann of Lichtenberg [r. 1354–65]), which could have been created only by the painter of the Luxembourg Genealogy himself.[98]

The artistic threads linking the Master of the Luxembourg Genealogy with Strasbourg would tend to identify him as Nicholas Wurmser. Arriving at Charles's court in the mid-1350s, he undertook the painting of the Genealogy, along with his assistants, while Charles commissioned a painter more familiar with Italian trends to decorate the Saint Catherine Chapel.[99] That artist adorned all the walls, which were partially faced with semiprecious stones, with half-figures of the apostles and patron saints of Bohemia; he also executed the votive scene of the imperial couple before the Virgin in the altar niche. After being named court painter in 1357,[100] Wurmser continued his work at Karlštejn by painting the Chapel of Our Lady with a pictorial program he probably drafted himself. But he confined himself to the most important sections, such as the relic scenes, which included a portrait of the emperor (figs. 2.1, 2.5),[101] and the depiction of the Woman of the Apocalypse on the west wall.[102]

Shortly after 1357 Charles also had the small oratory repainted, most probably to accommodate a cross holding relics of the Passion that was kept there after December 1357. All but the votive scene in the niche was sheathed with slabs of polished Bohemian jasper. Wurmser's collaborators decorated the altar with a Crucifixion,[103] while the master painted the tympanum above the portal with the earliest official portrait of Charles IV and his third wife, Anna of Świdnica (fig. 1.6).[104] When Wurmser was granted the fief in December 1360, it was expected that he would continue to "work so often in future"[105]—which fits nicely with the presumed completion of the painting in the Chapel of Our Lady in 1362–63.[106]

## MASTER THEODORIC AND A COLOGNE ACCENT IN THE IMPERIAL STYLE

The rebuilding of Karlštejn Castle culminated about 1360 with the decoration of the Holy Cross Chapel, of which

Charles's chronicler, Beneš Krabice of Weitmile, wrote: "In the whole wide world there is no other castle and chapel as richly decorated," adding that the walls were covered with "pure gold and semiprecious stones."[107] Holy Cross belongs to the tradition of lavishly decorated reliquary chapels that includes the one in the palace of the Byzantine emperor in Constantinople, the papal chapel of the Sancta Sanctorum in the Lateran Palace, Rome, and Louis IX's Sainte-Chapelle in Paris. Its precious materials are intended to suggest the vision of the Heavenly Jerusalem (Apoc. 21). Strikingly evocative of the Holy Cross Chapel is the description of a heavenly palace in the Czech-language *Legend of Saint Catherine* from the third quarter of the fourteenth century. The saint's mystic marriage to Christ takes place in a magnificent hall from whose vaults "the sun, moon, and stars" look down "as symbols of the [heavenly] host." The floor was made of "beryl, the walls of diamonds set in gold, in [the walls were] many tiny windows made of emeralds and sapphires, in which gleamed precious stones instead of glass: hyacinths and rubies, turquoise, sardonyx, ballas rubies in ivory, jasper, chalcedony, chrysolite, amethyst, pearls, [all] exquisitely worked."[108]

The depiction of saints in the Holy Cross Chapel was directly linked to the veneration of their relics, placed in the niche in the monumental altar wall, in the frames of most of the 130 panel paintings, and even beneath the plaster.[109] The presence of relics of the Passion perhaps served to guarantee that on his return Christ would descend to the chapel. Thus, the sanctity of this spot, of the entire kingdom, and of the empire itself appeared to be assured—not to mention special treatment of its founder, Charles IV, on Judgment Day. But this eschatological aspect is only part of the complex meaning of the decorative program of the Holy Cross Chapel, which links the evangelists' apocalyptic visions to Christ's miraculous appearances, the heavenly host to the secular hierarchies of Pseudo-Dionysius the Areopagite, and veneration of Charlemagne to the glorification of the Holy Cross.[110] The Holy Cross Chapel also equated the idea of empire with the church triumphant, the kingdom of God reserved only for saints. It was a monument to the house of Luxembourg, legitimizing its sway within the empire and celebrating the apotheosis of Charles IV as a wise and pious sovereign[111]—a dynastic, courtly counterpart of the Allegory of Good Government in Siena's Palazzo Pubblico.[112]

Charles entrusted the entire decoration of the Great Tower to his court painter Theodoric,[113] who is first documented as owning a house next to Prague Castle in 1359. He was still living there nine years later, and it was presumably there that he had his workshop.[114] Theodoric took over

coordination of the work at Karlštejn from Nicholas Wurmser. The precise circumstances are unknown, but the collision of their divergent concepts can be seen even from the preliminary charcoal drawings of saints on the plaster of the chapel's walls. In their sharp facial features, most recall the rulers from Wurmser's Luxembourg Genealogy. These graceful half-figures, each carefully centered in its frame on the wall, seem somewhat fragile. One exception is the apostle Andrew (fig. 1.7): here the visual weight is shifted to the upper edge of the picture space, completely filled with the saint's robust body, which even extends beyond the frame. This drawing, with its wholly different composition and monumental effect, is the first evidence of the hand of Master Theodoric, who was here probably demonstrating his conception to the emperor in situ. Instead of traditional wall painting, he envisioned a mosaic of individually framed panels hung side by side over the chapel walls in three tiers. Are these drawings the traces of competition between the two court painters? It seems very likely that they are. Theodoric's winning solution was original and more compositionally balanced. Above all, it promised to deepen religious feeling in this dramatic chapel, where flickering candlelight reflected off gilded relief ornaments on panel paintings, semiprecious stones on the walls, and glass stars on the gold ceiling.[115]

Fig. 1.7 Master Theodoric. Saint Andrew. Charcoal drawing, Holy Cross Chapel, Karlštejn Castle

Theodoric presumably devised the concept for the entire chapel about 1360, establishing the composition and palette of all the paintings. With his workshop he prepared the wood panels and executed the underdrawings. He reserved the execution in paint of approximately thirty—the most important ones—for himself, including the central Crucifixion, the evangelists, most of the apostles, patron saints of Bohemia, and Charlemagne (cat. 33). The rest were divided among at least three other Prague painters. Theodoric's hand is also recognizable in the broad monochrome figures painted directly on the vaults of the window niches. The only works exhibiting Nicholas Wurmser's characteristic features are the moving depictions of the twenty-four elders, which can thus be considered the oldest paintings in the chapel. One of the largest pictorial programs of the fourteenth century was completed in three, or at most four, years, the finished pictures being delivered to Karlštejn in the fall of 1364, in order to have the chapel completed before its consecration on February 9, 1365.

The painting of the new staircase leading to the chapel must have been completed in the same year.[116] Its outside wall is covered with scenes from the Wenceslas cycle, reading from bottom to top. These were taken not only from Charles's own account of the saint's legend but also from its older version, *As the Sun Was Already in the East (Oriente iam sole)*. The scenes from the life of Saint Ludmila are ordered, by contrast, from top to bottom. The layout of opposing directions may have been based on Jacob's Dream[117] and the ladder to heaven with its "angels also of God ascending and descending by it" (Gen. 28:12). The place where Jacob slept became known as Heaven's Gate.[118] The staircase to the Holy Cross Chapel thus gives access to the heavenly Jerusalem, through the intercession of Wenceslas and Ludmila. The biblical messengers of God found their place as serenading angels on the stairwell ceiling. Charles himself played the role of the pious pilgrim. He is shown among other members of the imperial family as though taking part in the ceremonial consecration of the chapel in 1365.[119] Holding a consecration capsule with the relics, he is accompanied by the Prague archbishop Jan Očko of Vlašim and two other mitered prelates.

Two painters likely worked on the staircase, each assigned one of the saint's cycles. That their techniques and ornamentation (the stenciling, for example) match those of the Holy Cross Chapel indicates their close association with Master Theodoric. The painter of the Ludmila cycle, presumably the older of the two, was fully rooted in this tradition. The other, despite a few traces of Theodoric's influence, foreshadows the change in Prague court painting in the 1370s. This is apparent in his renewed idealization of slender figures, his rather novel realism in the rendering of their physiques, and his diagonally structured architectural and landscape elements. The deep mountain landscapes of the Wenceslas cycle, with their isolated trees and vistas of meandering rivers, can be thought of as transalpine equivalents of the Sienese "landscape portrait."

This raises the question of the artistic sources of Theodoric's monumental style. His corporeal figures, with troubled expressions and soft drapery modeled with light, the men wearing long, thick beards, point to the art of Bruges or, more generally, Franco-Flemish art.[120] After the middle of the century this style was also represented on the Upper Rhine by Nicholas Wurmser. It predominated as well in the Rhineland, in proximity to Charles's ancestral Luxembourg territories, between Aachen and Cologne, where he frequently sojourned.[121] Cologne Cathedral served as an important model in the design of Prague's Gothic cathedral. And it is surely no coincidence that the father of Peter Parler, Heinrich, was from Cologne, where he worked as a *parlier* (master of works) on the building of the cathedral.[122]

The "best painter in German lands," the legendary Master Wilhelm, was virtually synonymous with Cologne painting after the mid-fourteenth century. Praised in a chronicle of 1380 for his lifelike figures,[123] this artist could not have escaped the notice of Charles IV, who was constantly searching out the best talent.[124] Comparison of works recently associated with Wilhelm[125] with those by Theodoric suggests a network of artistic connections that cannot be explained simply as exemplifying the style of the period, but only by closer ties between their workshops. Both painters emphasize the human figure, but are less concerned with the problems of constructing space. Crowded onto the picture surface, figures are frequently cut off by the frame or even extend onto it. The artists shared the European fascination with luxurious oriental textiles, and their drapery clings close to the body and is modeled with light.[126] The similarity of facial types, gestures, and poses suggests a common heritage, perhaps pattern books from a single workshop.[127] It seems that Theodoric spent time in a workshop in Cologne, arguably that of Wilhelm. Cologne was, moreover, one center where painted altarpieces housed framed relics in compartments,[128] as was the case later with Theodoric's paintings for Karlštejn. When Charles summoned Theodoric to Prague, sometime between 1355 and 1359,[129] his figures took on volume and breadth, and his palette became lighter and more delicate owing to the influence of Italian painting.

Theodoric's example was followed by other painters, among them artists working in Saint Vitus's Cathedral. The only one documented by name is Master Oswald, most likely from a German-speaking territory, who according to the first accounts, of 1372–73, executed decorative architectural elements with his workshop assistants along with more demanding paintings such as a Martyrdom of Saint Wenceslas located "ad hostium minus" (at the lesser door).[130] The "discretus vir Osvaldus pictor Caroli" (distinguished gentleman Oswald, Charles's painter), as he was called on his tomb,[131] presumably died in 1383.[132] In the years mentioned he was the only painter paid from the construction budget of Saint Vitus's, but this does not suffice to allow the attribution of specific paintings there. The most interesting of those paintings is in the chapel with altars to Saints Erhard and Ottilia (consecrated 1368)[133] showing the bishop of Regensburg baptizing the Alsatian duke's blind daughter, who miraculously gains her sight. This scene, set in front of a Gothic church, embellishes upon the baptism of Saint Ludmila portrayed in the staircase of the Great Tower at Karlštejn. The two paintings are also linked by their painterly execution and decorative forms, specifically the stenciling combined with three-dimensional ornaments.[134]

The example of Karlštejn also resonates in the work of the painter who executed the Adoration of the Kings in the Saint Dorothy Chapel (1369) and the Virgin with Saints Mary Magdalen, James, and Bartholomew along with two kneeling canons in the Chapel of Mary Magdalen (1368). It can be seen as well in the votive picture commissioned by Jan Očko of Vlašim about 1370 for the Chapel of Our Lady at his archiepiscopal castle in Roudnice (fig. 8.4). This extraordinary historical document reflects the sacred and secular hierarchy during the reign of Charles IV. In the lower half, Saint Adalbert confers episcopal office on Jan Očko (shown in strict profile),[135] with the support of the cathedral's patron, Saint Vitus, assisted by the Moravian monk Procopius and the Přemyslid princess Ludmila. In a place of honor above the archbishop and closer to Christ in upper part of the picture, the emperor kneels before the Virgin and Child, presented by Saint Sigismund, king of Burgundy, whom Charles had elevated to patron saint of Bohemia. Across from Charles is his heir to the throne, Wenceslas IV, with his patron and namesake, the Bohemian duke Wenceslas.

Ever since Charles's coronation as Holy Roman Emperor in 1355, official portraits had presented him as a wise ruler. Convinced he was chosen by God, Charles saw himself as the successor of such biblical figures as Solomon, David, and the Three Magi. A number of likenesses bear his characteristic features, described in 1355 by the Florentine chronicler Matteo Villani: "[He] was of medium height, but small for a German, slightly bent, thrusting his head and neck forward, but not excessively; with black hair, his face rather broad, protruding eyes and full cheeks, his beard black, with a bald head."[136] The first painted portrait of the emperor was either the one in the Luxembourg Genealogy, from 1356–57 or the double portrait in the Chapel of Saint Catherine from the late 1350s (fig. 1.6), both most probably by Wurmser, who thus greatly influenced the development of this type of image of Charles. Jan Očko's votive picture combines Charles's actual features with an idealized face expressing the virtues then associated, in both literature and art, with the wise and just ruler.[137] And Charles's features are sometimes imposed on one of the kings in scenes of the Adoration of the Magi (cat. 98).

## SEBALD WEINSCHRÖTER: IMPERIAL COURT PAINTER IN CHARLES'S NUREMBERG

The fame of Theodoric's decoration of Karlštejn Castle extended far beyond Prague and the borders of the kingdom. The Nuremberg painter Sebald Weinschröter, for instance, soon became a member of the court retinue.[138] On December 30, 1360, roughly at the same time Wurmser was granted his fief, Charles rewarded Weinschröter with a tithe from the Röthenbach farm, near Nuremberg. The two proclamations, issued in Nuremberg, are similar in the way the painters are addressed and in the enumeration of their services. It is not so much the boilerplate text that astonishes, but rather the fact that Charles maintained a second administrative center in Nuremberg, which had all the accoutrements of a court. As the emperor's second most important residence, Nuremberg served as a link between western Europe and imperial Prague.

Weinschröter first visited Prague in 1348–49, after Charles had banished him from Nuremberg for participating in the anti-Luxembourg revolt of the city's guilds. The painter, who was likely trained in the Franco-Flemish manner, became acquainted with works by the Master of Vyšší Brod, whose influence is apparent in various details of his pictures. In 1357, at the latest, Weinschröter returned to Nuremberg, undoubtedly through the intervention of Charles himself. In the early 1360s he went again to Prague, where he met Theodoric.

As imperial painter in Nuremberg, Weinschröter enjoyed considerable stature and his work was greatly influential there in the second half of the fourteenth century. Presumably at the behest of Charles IV, he celebrated the birth in 1361 of the heir to the throne, Wenceslas, in a wall painting at

the Church of Saint Moritz, near Saint Sebaldus's Church (fig. 8.2). This attribution confirms his execution of a small altarpiece (cat. 17) produced for the Nuremberg Convent of the Poor Clares immediately after his first sojourn in Prague. A few years later there followed the unusually large retable for the Teutonic Order's Church of Saint James. The painterly praxis and wide range of activities of his workshop are revealed in fragments of a pattern book (fig. 1.8) and a number of stained glass panels for the Hospital Church of Saint Martha, whose patrons included members of families close to the emperor.[139] One of these—possibly Friedrich Stromer, who worked for a time in the imperial chancellery in Prague—could have recommended Weinschröter to the emperor.

## THE IMPERIAL STYLE AS BASIS OF THE BEAUTIFUL STYLE

The second half of the 1350s saw major changes in Prague. Artists from Charles's early years had reached their creative peak in the late 1330s and the 1340s; as they aged, it seems they were less able to fulfill his expectations. As a result, Charles imported artists from abroad, who rapidly assimilated the milieu of his court but also forged a new imperial style. Their expressive, robust figures had bodies that were visible through softly modeled, close-fitting drapery. Women's faces typically had an oval outline, a prominent forehead, and thin lips, while men's were sharper and schematic, with long straight noses, heavy beards, and introverted expressions. Light played a radically new role, bringing out volumes and charging forms with dramatic contrast, in painting and sculpture as well as architecture.

Developed in Prague about 1360, this imperial style prevailed for the remainder of Charles IV's reign. From Prague it was exported through the systematically built network of the emperor's allies to almost every part of the empire and its allied lands, from Frombork and Toruń in central eastern Europe via Brandenburg (see cat. 43) or Rathenow to the Rhineland on the western border of the empire, from Falsterbo in Sweden on the north via Hanseatic Hamburg or Doberan in Pomerania to the Alpine Tirol in the south.[140] At the end of the 1370s, it gave way to the "cult of beautiful form," which had been anticipated by the youngest generation of artists even in Charles's time, but which triumphed only under his son Wenceslas IV. Thus, Charles's imperial art—for all its intrinsic wonders—also inspired the Beautiful Style, the powerful trend that would unify central Europe at the turn of the century.

1. The complete text in Latin is inscribed adjacent to the bust of Charles IV (fig. 1.2) in the triforium of the cathedral (quoted and translated in Benešovská and Hlobil 1999, pp. 154–55): "Karolus IIII. imperator Romanorum et / Boemie rex hic fundavit novam Pragensem ecclesiam / de sumptuoso opere ut ap[p]aret ac sumptibus / propriis laboravit hic eciam impetravit a sede / apostolica ecclesiam Pragensem erigi in metropolitanam / per Clementem papam VI., et archiepiscopum legatum apostolice / sedis fieri procuravit per dominum Urbanum papam / Vtum, collegium omnium sanctorum in castro, / et mansionarios in ecclesia Pragensi / instituit et dotavit, studium Pragense / instituit, pontem novum per Multauiam laborare / precepit. Amator cultus divini et cleri precipuus. / Moritur Prage anno domini M°CCC°LXXVIII° die / penultima novembris etatis sue anno LXIIII" (Charles IV, Roman Emperor and King of Bohemia, founded the new Prague Church, an expensive work, as is apparent, and at this expense, his own, did this, and achieved from the apostolic see the raising of Prague Church to a metropolitan one, through the good offices of Pope Clement VI, and had the archbishop made apostolic legate, appointed through the good offices of Pope Urban V, and the collegiate church of All Saints at the Castle and a choir of mansionaries in Prague Church was instituted and endowed by him; a university in Prague was instituted by him, and the building of a new bridge across the Vltava was ordered by him. Excellent lover of Divine Worship and of the clergy, he died in Prague in the year of Our Lord 1378 on the penultimate day of the month of November at the age of 64).

2. Frey 1978.

3. See, for example, Seibt 1978b, pp. 61–67, and most recently Vaníček 2002, pp. 414–97, 552–74.

4. Zbraslav Chronicle, FRB 1884, chap. 92, pp. 128–31.

5. Hoepffer 1908–21, vol. 1, pp. 112–13, v. 1468–87: "en moult grant joie / Estoit assis sur un tapis de soie / Et ot un clerc que nommer ne saroie / Qui li lisoit la bataille de Troie" (with much great joy, was seated on a carpet of silk, and there was a cleric whom I would not be able to name who was reading to him of the battle of Troy).

6. See the writings of Paul Crossley, Jaromír Homolka, Josef Krása, Albert Kutal, Jaroslav Pešina, Iva Rosario, Gerhard Schmidt, Karel Stejskal, Robert Suckale, and others.

7. Klein 1926; Mezník 1969, pp. 291–95. Marie of Luxembourg, Charles's aunt, was the second wife of the French king Charles IV; his brother-in-law would later become King Philip VI; and his second sister, Bonne, was to marry the Dauphin, subsequently King John the Good.

8. Charles IV, Autobiography 2001, chap. 3, p. 29: "Placuit autem michi predicti abbatis facundia seu eloquencia in eodem sermone, ut tantam contemplacionem haberem in devocione ipsum audiens et intuens, quod intra me cepi cogitare dicens: Quid est, quod tanta gracia michi infunditur ex homine isto?"

9. Among these were Bergamo, Como, Pavia, and Vercelli (Lombardy), Parma, Mantua, Modena, and Reggio (Emilia), Lucca (Tuscany), and Piacenza and Bologna (Papal States). After negotiations with Emperor Louis IV the Bavarian in Regensburg, Charles was officially awarded Brescia as an imperial fief. Milan, Bergamo, Padua, Novara, Cremona, Parma, Modena, Reggio, and Bobbio he assumed as imperial pledges, Lucca as a hereditary signoria.

10. Dinzelbacher 1989, pp. 161–71; Seibt 1994, pp. 124–26.

11. RI, no. 2983 (June 13, 1359); Hledíková 1982, pp. 5–55, esp. pp. 12–13.

12. The coat of arms with a two-tailed lion above the entry gate recalled Charles's alliance with the Bohemian Crown. Charles's later foundations (Karlštejn, Karlskrone, Karlsberg, and so on) also frequently bore his name. See Machilek 2002–3, pp. 113–45, esp. pp. 128–29.

13. RI VIII, no. 4 (August 8, 1333). Charles later demonstrated his affection for Lucca by founding its university and liberating it from Pisan rule. See most recently Bobková 2003, p. 125.

14. Note its general resemblance to the statue that Jeanne d'Evreux may have donated to the Cistercian convent at Pont-aux-Dames. See Paris 1981–82, pp. 91–92, no. 36.

15. In April 1337 Charles journeyed to Italy by way of Ofen, Dalmatia, to the episcopal see of Senj on the Adriatic coast, recommending as bishop his chaplain and adviser Jan Protiva from Dlouhá Ves. He then proceeded to Aquileia, where later Nicholas of Luxembourg, an illegitimate son of John of Luxembourg and thus his half brother, became patriarch (r. 1350–58).

16. Charles bowed down before this cult image for the first time in 1333, in the presence of his father, and then a second time as emperor during his visit in 1369. In 1372 a silk tapestry was made for him depicting the venerated sculpture. The importance of this cult for Charles is suggested by a depiction of the Volto Santo in the castle chapel at Bečov nad Teplou, which belonged to the emperor's close allies the lords of Riesenburg. Boreš of Riesenburg became one of Charles IV's most important diplomats and court officers and was also his longtime representative in the Upper Palatinate. In 1354 Charles awarded the lords of Riesenburg the privilege of mining gold and silver. They subsequently enlarged their castle and added a chapel, commissioning painters from Charles's court to decorate it. The chapel also contains a scene of the Adoration of the Magi, a subject especially favored by Charles and by court circles. Works in even more remote places copied this clearly Caroline iconography, including a Volto Santo in Weissenburg, Bavaria (Schädler-Saub 2000, pp. 87–89, fig. 20 on p. 88) and another in Poniky, Slovakia (Buran 2002b, pp. 149–51, esp. p. 150n139).

17. The abbot of Břevnov, Bavor of Nečtiny, for instance, purchased patterns for his workshops in Venice and Rome (see Poche in Chadraba 1984, vol. 1, pt. 2, pp. 440–96, esp. pp. 448–49.

18. Nicholas served John of Luxembourg and Charles as chancellor in Italy, as margraval chancellor (1334–38), and finally as bishop of Trent (r. 1338–47). See Spěváček 1968.

19. Founded on April 20, 1292, by King Wenceslas II. For his gifts, see František of Prague, FRB 1997, p. 66. The Přemyslid princess Elizabeth, Charles's mother, donated nine altars to the church in 1329.

20. Charles IV, Autobiography 2001, chap. 8, pp. 67–69: "Et sic, cum venissemus in Boemiam, non invenimus nec patrem nec matrem nec fratrem nec sorores nec aliquem notum. Idioma quoque Boemicum ex toto oblivioni tradideramus, quod post redidicimus, ita ut loqueremur et intelligeremus ut alter Boemus."

21. Hledíková 1991, p. 165.

22. Charles IV, Autobiography 2001, chap. 8, p. 69: "Quod regnum invenimus ita desolatum, quod nec unum castrum invenimus liberum, quod non esset obligatum cum omnibus bonis regalibus, ita quod non habebamus ubi manere, nisi in domibus civitatum sicut alter civis" (We found the kingdom so forsaken that there was not one castle which was free and not mortgaged together with all its royal property, so that we did not have anywhere to stay except in houses in the cities just like any other citizen). The castles Charles bought included those in Křivoklát, Týřov, Lichtenburk, Litice, Hradec Králové, Písek, Nečtiny, Zbiroh, Tachov, and Trutnov (Bohemia); Lukov, Telč, Veveří (Moravia); and at Olomouc, Brno, and Znojmo.

23. František of Prague, FRB 1884, book 3, chap. 1B, pp. 413–14: "Et in brevi tempore domum regiam construxit numquam prius in hoc regno talem visam, ad instar domus regis Francie cum maximis sumptibus edificavit, et non tantum hic, verum eciam in aliis locis idem fuit factum ex sibus, dehinc ad castrum Pragense se transtulit, in quo cum sua curia morabatur."

24. See Homolka 2004, pp. 135–39.

25. Benešovská 1998, esp. pp. 125–27.

26. John owned a palace near the Louvre, the Hôtel de Bohème, which Philip had given him after John's marriage to Beatrice of Bourbon (1334), great-granddaughter of Saint Louis.

27. On the Passional, see Toussaint 2003.

28. František of Prague, FRB 1884, book 1, chap. 16, p. 368: "Capellam pulcherrimis picturis depingi procuravit, in qua ymagines omnium episcoporum Pragensium secundum ordinem sunt situate. Palacium vero sive cenaculum scripturis et picturis extat repletum, multi quidem versus doctrinales et morales sunt ibi notati, et multi clipei

principum, baronum ac regni nobilium sunt decenter depicti. Speciale vero commodum suum variis ymaginibus fuit decoratum et simbolum prophetarum et apostolorum cum suis propriis figuris et scripturis exstat signatum in optima proporcione, quod de curia cum prefatis versibus attulit roman" (He had the chapel painted with glorious paintings. There, one next to the other, are portraits of all of Prague's bishops. The hall, or refectory, is filled with drawings and inscriptions, all of them immortalizing instructive and edifying verses, and numerous splendidly painted coats of arms of princes, lords, and nobles of the kingdom. His bedroom especially was then decorated with various pictures. Here, in the finest proportions, are depicted the symbols of the prophets and apostles along with their likenesses and texts, which he brought from the Roman curia with the above-mentioned verses).

29. The Passional was commissioned by Cunigunde, abbess of the Benedictine Convent of Saint George in Prague Castle. The abbess contributed to the revival of the cult of Saint Ludmila, who was buried in her convent and was also honored by John of Luxembourg. Jan IV dedicated a church to Ludmila in his hometown of Dražice and secured episcopal and curial indulgences for a chapel consecrated to her in Tetín; in 1336, when he compiled the first list of feasts for the Prague diocese, Ludmila was the only saint to be celebrated not only on the day of her martyrdom but also on the day of the translation of her relics from Tetín, where she was martyred, to Saint George's. She thus became the most important female patron of Bohemia. See Hledíková 1991, pp. 155–56. In this connection, it is possible that the episcopal painter of the Kaufmann Crucifixion could have come to know the manuscript in the library of the Saint George Convent. For other French precedents, like the wall painting in Strakonice Castle, see Schmidt 1993; on a statue of Virgin and Child from Křtiny near Brno, which was commissioned by the highest marshal of Bohemia, Jindřich of Lipá, in 1321, see Vlček 1999, p. 269.

30. Although John is praised in the works of French poets, the Czechs considered him the "king from abroad," as Peter of Zittau put it (see Bobková 2003, pp. 210–12).

31. This hypothesis is supported by close parallels with the crucified Jesus in the northern side chapel of the Augustinian Hermitage Church of Saint Thomas, close to the former bishop's palace. The so-called Roudnice Predella (ca. 1340) from the Augustinian canonry founded by Jan IV, also points to a link to the episcopal court. Its French flavor is not altogether remote from that of the Kaufmann Crucifixion.

32. Charles IV, *Autobiography* 2001, chap. 14, p. 145.

33. It also copies French precedents, presumably mediated by such works as the apostles in the Cologne Cathedral choir, which it echoes with its oval face, clinging, stylized hair, and abundant drapery.

34. It remains a possibility that he had formerly worked at the court of Elizabeth Ryksa in Brno and moved to Prague only after her death in 1335.

35. Some sculpted figures from the Liebfrauenkirche in Oberwesel (for example, from its high altarpiece from 1331, the so-called Gold Altar) could be named as possible links, which points to one stylistic source for the Michle Master. Also important from this point of view is the figural tombstone of Saint Goar in the Parish Church of Saint Goar. On the altarpiece, see Ronig in Frank et al. 1985, pp. 489–558, esp. pp. 502–4, 506.

36. To appreciate this, one need only compare the Saint Benigna with the Michle Madonna. Works in a similar style are scattered among Moravia, Bohemia, Lusatia, lesser Poland, and upper Austria. This distribution gives little indication of where the sculptor settled—especially since it is accidental, depending on condition. The Madonna in Znojmo, for example, a royal city that always allied itself with the sovereign, could certainly have made its way there from Prague. The same can be assumed of the Madonna in Velké Meziříčí, again a royal city whose precincts were named after the pattern of those in Prague, some as early as the second half of

the fourteenth century. "This Greater Mezeříč was, however, once called Young Prague" (Štingl 2004, p. 36). In Bohemia as well, works survive that are associated with this master and his workshop, for example, in the region around Pilsen and in Broumov and Prague (see Bartlová 1998 and Hlobil 1998). Yet attributions to this artist are questionable because of the wide variations in artistry and level of execution among the works assigned to him.

37. On this subject, see Suckale 2002.

38. Patze 1978, pp. 1–37; Kelly 2003.

39. Suckale 2003b, pp. 119–50.

40. The composition of the small Łuków statue anticipates that of the Virgin from the Old Town Hall, Prague (fig. 4.5), and both follow a type favored in Paris court circles.

41. The relief in Prague's Church of Our Lady of the Snows, for example, in which the Virgin is enthroned atop a lion, which assumes a heraldic role as well (Fajt, Hlaváčková, and Royt 1993–94).

42. Suckale 2002, pp. 123–71, esp. pp. 150–53.

43. The former possibility seems suspect owing to the absence of typical Cistercian motifs such as the ring that, according to the medieval interpretation of the Song of Solomon, identifies Mary as the Bride of Christ. A clue to the location of the workshop of the painter of the Veveří Madonna, and especially to its dating, is the way Mary's hair falls in spiral curls similar to those of the Michle Madonna (Hlobil 1998, p. 219).

44. Viard 1917, nos. 3999, 5465, 2171, and others.

45. Ibid., nos. 3946ff.; Otavský 1992, pp. 132–45.

46. Viard 1917, no. 3354.

47. Zbraslav Chronicle, FRB 1884, book 3, chap. 2, p. 320: "Specie quidem et pulchritudine sua in oculis omnium hec placuit et spero, quod virtutibus plus placebit; habitum muliebrem secundum sue gentis conswetudinem secum attulit et apparatum secundum dignitatis sue statum, quem domus regia exigit, non modicum apportavit" (With her charming figure and beauty, all eyes took a fancy to her, and I hope that her virtues will also find favor; she brought with her a dress in the style of her people, and carried with her a dowry appropriate to a royal house).

48. See *Dalimili Bohemiae Chronicon,* FRB, vol. 3 (1882). A recently acquired richly illustrated fragment of its Latin translation (Národní Knihovna, Prague, Sign. XII.E.17) could have been decorated for Charles IV himself about 1340 by painters who were especially familiar with contemporary painting in Bologna.

49. Responses to these images appear at Prague's cathedral chapter and that of the city's bishops and archbishops; similar motifs—a little bird in the hand of the infant Jesus, for example—are also found in wall paintings from about 1343 in Holubice and in Dražice, the family seat of Bishop Jan IV (see Všetečková 1999). Very probably it was Arnošt of Pardubice who participated in the development of this type of Marian image.

50. Matějček and Pešina 1950, p. 45, fig. 26.

51. Regarding the provenance of the cycle, see Kalina 1996 and also Hlaváčková 1998, esp. p. 251n33.

52. Typical of this style is the altarpiece of the Virgin with Saints Catherine and Margaret (Alšova Jihočeská Galerie, Hluboká nad Vltavou, N 1.12), executed in the 1350s in Prague and presumably from the royal Cistercian monastery of Zlatá Koruna in southern Bohemia, whose church was completed in this period. See Matějček and Pešina 1950, no. 18, where the panel is dated to about 1360.

53. Krása 1982.

54. Suckale 1993b, pp. 124–31.

55. The painter's connection to Charles's court circles is attested by fact that the composition recurs in the Morgan diptych (cat. 25) and in a stained glass painting in Saint Bartholomew's, Kolín. The picture space is divided in the manner of Sienese painting, with columns in the foreground that partially support the coffered ceiling of a narthex and permit a view into the three-vaulted nave of a church interior (see, for example, Ambrogio Lorenzetti's Saint Crescentius Altar, Siena [1342], and see also Schmidt 1969b, pp. 174–75).

56. Zeri in Lavin and Plummer 1977, vol. 1, pp. 462–63, vol. 2, pl. 1, p. 161. I am grateful to Stefan Kemperdick for this reference.

57. Matějček and Pešina 1950, pp. 50–51, no. 23, pls. 49, 50. This subject was especially favored at the Anjou court in Naples.

58. According to inventories from 1354 to 1378, the cathedral treasury owned more than 300 imported textiles and 150 pieces of gold-smiths' work and jewelry, including 13 silver reliquary statuettes and 27 gold and silver reliquary busts. In 1422 Sigismund transported all of Charles IV's personal treasures out of Bohemia, including a sword studded with pearls that he had been given at the diet in Metz in 1355–56, as well as those of the cathedral; the five hundred wagons containing these were captured by the Hussites near Německý Brod (Stejskal 1970, pp. 31–60, esp. p. 37).

59. Beneš Krabice of Weitmile, FRB 1884, p. 516.

60. The probability that Charles used the Aachen crown for the cere-mony is supported by its dimensions, which conform to those of his skull (see Vlček 1984, pp. 471–93, esp. p. 482). It is highly probable that Sigismund was also crowned with it in 1414. Where it was made is unknown, though the stones are set in a manner reminis-cent of the Wenceslas crown in Prague (fig. 1.4). See Grimme 1972, pp. 88–90, no. 69; Otavský 1980; and Minkenberg in Aachen 2000, pp. 59–68, esp. pp. 63–64.

61. Petrarch, letter to his friend Laelius (Fracassetti 1890, vol. 2, p. 520, letter XIX.3, quoted in Salač and Hrdina 1933, p. 236): "Sumpta igitur de verbis occasione, aliquot sibi aureas argenteasque nostro-rum principium effigies, minutissimis ac veteribus litteris inscriptas, quas in deliciis habebam, dono dedi, in quibus et Augusti Caesaris vultus erat pene spirans: et ecce, inquam, Caesar, quibus successisti, ecce quos imitari studeas et mirari, ad quorum formam atque imaginem te componas, quos praeter te unum, nulli hominum daturus eram: tua me movit auctoritas. Licet enim horum ego mores et nomina et res gestas norim, tuum est non modo nosse sed sequi: tibi itaque debebantur."

62. Petrarch, letter to his friend Laelius of June 1355 (Fracassetti 1890, vol. 4, p. 201, letter XIX.12, quoted in Salač and Hrdina 1933, p. 236n5): "Caesaream effigiem pervetusti operis . . ." In another letter dated March 21, 1362, Petrarch thanks Charles for an "extremely valuable chalice of pure gold with engraved decora-tion" (Petrarca 1974, p. 263).

63. Porta 1913, pp. 77–80.

64. Claussen 1980.

65. Jan of Středa, letter to the chancellery in Prague(?), written in Italy 1354/55(?) (Piur 1937, pp. 128–29, no. 84): "Hic enim in tanti auri copiosis deliciis constitutus, cum Joue in deitate sompnians, mensas[?] celestium nunc contemplor, et quidquid diues imperra-trix Fortuna prisco tempore lippiente quodam oculo inspexit, nunc serenissima facie scintillantibus aureis[?] letissime perillustrat. Et deo vt meorum sitis participes gaudiorum, ecce a Domino factum est istud et est delectabile in mentibus amicorum. Quapropter sup-plico, quantenus ad deducendum gemmas, margaritas et alias res nobilissimas camelos, spandones et dromedarios aliquos transmit-tatis. Nam quilibet[?] aurum rapit iuxta arbitrium voluntatis."

66. One of the earliest depictions in Prague manuscripts, from the Breviary of the Grand Master Lev (1356), shows the *vera icon* in a frame with half-figures of saints in medallions that anticipates the type of the Bohemian Marian image with a painted frame. See Krása 1990, p. 123, fig. 64.

67. Vidmanová 2000.

68. Cibulka 1934, pp. 76–98, esp. chap. 14g, p. 137. It was given an aura of sanctity by a thorn from the crown placed on Jesus' head during the Passion, which was inserted in the cross above the junction of the hoops fashioned from the ornamented wedding belt of Blanche of Valois. See Otavský 1992, esp. pp. 26–47.

69. Flachenecker in Gatz 2001, pp. 48–49. The sculptor may have been recommended to the Prague court by another member of the same family, namely Kraft von Hohenlohe, who was resident in Prague at this time.

70. These included Heinrich Schatz, protonotary under Charles's father, and presumably Friedrich Stromer (Schöffel 1934). For figures from the circle of Archbishop Baldwin of Trier, see Moraw 1985, pp. 32–34.

71. Bishop of Naumburg (1352–53), Litomyšl (1353–64), Olomouc (1364–80), and finally bishop-elect of Wrocław (1380), Jan received the title *regalis capellae Bohemiae comes* (member of the royal chapel of Bohemia) in 1356, which entitled him to crown Bohemian kings in the absence of the archbishop of Prague. He founded the Augustinian hermitage in Litomyšl in 1356, the one in Jevíčko somewhat later, and also confirmed one for Šternberk.

72. Jan of Středa, letter to Charles IV, 1364–66(?) (Piur 1937, pp. 56–57, no. 32): "Presentis pictoris industria artis sue suffragio rite depinxit ambas potestates, regiam videlicet dignitatem et auctoritatem pontificiam, ab vno dependere principio, dum celestis paranym-phus, sicut in pictura prospicitis, diuine prouisionis clemencia coro-nat vtrumque, Cesarem videlicet vt caput orbis et Romanorum pontificem, cui ligandi et soluendi potestas ab alto conceditur, et vterque ipsorum in regnum celorum prouehitur, sicut superior pic-ture declarat facies, si tamen vterque ipsorum bene administrauerit christiane caritatis officio, quod de raro . . . censeo reperiri."

73. Tadra 1886a; Tadra 1886b, pp. 85–101, 76–197.

74. It is particularly instructive to compare works by the Master of the *Liber viaticus* with Vitale's Crucifixion panel of about 1340 (Museo Thyssen-Bornemisza, Madrid; Benati 1985, vol. 1, p. 220, fig. 337). Vitale's heir was Simone dei Crocifissi (ca. 1330–ca. 1400), whose figural compositions influenced the artist who created the designs for the niello scenes on the Reliquary Cross of Pope Urban V (fig. 8.5) as well as related gold reliquaries in the treasury of the Hofburg in Vienna (Otavský in Fajt and Hörsch 2005, pp. 55–75).

75. See, for instance, Officium of 1348 (Monastery in Kremsmünster), Decretalien of 1352 (Biblioteca Apostolica Vaticana, Lat. 1456), or Decretalien of 1354 (Saint Peter Monastery, Salzburg, cod. XII 10 A). The popularity of Bolognese painting in Prague may have resulted from personal contacts with the university there, among them Arnošt of Pardubice. Also, as early as 1353, one of Charles's *familiares* was the Franciscan Giovanni dei Marignolli, professor at the University of Bologna, whom he appointed chaplain (Harrison 1950, pp. 10ff.).

76. This change can be seen in the missal commissioned about 1357 from the imperial chancellery workshop by Charles's protonotary Nicholas of Kroměříž (Archiv Města, Brno, Sign. MA 10/1).

77. Metropolitan Chapter of Saint Vitus's Cathedral, Prague, Library, Sign. XII C 12.

78. Österreichische Nationalbibliothek, Vienna, Cod. 1182.

79. Since the Gospel Book of Jan of Opava for Duke Albert III of Mecklenburg was intended for ceremonial use, the painter gave it a traditional look by adapting the pictorial decor of Carolingian and Ottonian manuscripts. See Schmidt 1967 and also Jenni and Theissen 2004b, pp. 65–87, no. 6.

80. Fajt 2004; Fajt 2005. On the statues from Cheb, see Ševčíková 1974, pp. 44–46, nos. 3–5, figs. 4–7.

81. Fajt 2003a, pp. 504–15.

82. Two recent studies on the artistic adornments of Karlštejn Castle are Homolka 1997 and Fajt and Royt 1997.

83. For structural changes to Karlštejn Castle, see Chudárek 2003.

84. Neuwirth 1897b, p. 2n15; Homolka 1997, pp. 99–108, quotation with commentary, p. 99n16. Charles had Johann de Klerk (d. 1351) create a genealogy of his dynasty, which became the basis for the painted version in Karlštejn.

85. Codex Heidelbergensis, Národní Galerie, Prague, Archives (AA 2015); Österreichische Nationalbibliothek, Vienna.

86. Dvořák 1899, pp. 238–48.

87. Krofta 1958, pp. 2–30; Krofta 1975, pp. 63–66; Sterling 1987, pp. 176ff., 197ff. Especially for the present discussions, a reexamination of the role of papal Avignon as a mediator between Italian and transalpine art is sorely needed.

88. Mecklenburgisches Landeshauptarchiv, Schwerin, Bestand 1198, PS-no. 22. One might also compare the figure of John of Luxembourg from Karlštejn in the Codex Heidelbergensis (see note 85 above); the movement scheme influenced that of King Gottschalk on folio 21 of the Kirchberg Chronicle.

89. Compare the figure of Duke Rudolf IV from the 1380s (Museum der Stadt, Vienna) with the one of Charles the Bald from Österreichische Nationalbibliothek, Vienna, Cod. 8330, fol. 38r (Schmidt in Brucher 2000, pp. 476–77, figs. 17, 18).

90. Homolka 1997, p. 106.

91. For the most important documents relating to him, see Fajt 1998, pp. 101–2.

92. Ibid., p. 101: "Notum facimus, quod nos consideratis multiplicibus meritis probitatis necnon fidelibus gratisque obsequiis, quibus dilectus nobis magister Nicolaus pictor, familiaris noster, nobis actenus complacere studuit et volet et poterit amplius in futurum."

93. Ibid., p. 102: "Notum facimus tenore presencium universes, quod advertentes artificiosam picturam et solemnem regalis nostre capelle in Karlstein, qua fidelis nobis dilectus magister Theodoricus, pictor noster et familiaris, ad honorem omnipotentis dei et inclytam laudem nostre dignitatis regie predictam capellam tam ingeniose et artificialiter decoravit, et innate fidelitatis constanciam et obsequiorum aliorum puritatem continuam."

94. Also attesting to Wurmser's importance is the privilege of absolution from January 25, 1360, issued by the Papal See in Avignon (Fajt 1998, p. 101).

95. The precarious pose of the right-hand prophet on the east wall of the Church of Our Lady repeats that of the Trojan king Priam from the Luxembourg Genealogy, and once again there are analogous faces with sharply drawn brows, beaklike noses, and long, thick beards.

96. Schmidt (1969b, pp. 195–96) has seen a close connection to Strasbourg in both the Master of the Luxembourg Genealogy and the painter of the Crucifixion in the Saint Catherine Chapel, in both cases leaving open a possible identification with Wurmser. Recht (1980, pp. 106–17, esp. pp. 108, 109, figs. 9–11) pointed out the similarity between the Luxembourg Genealogy and stained glass paintings from 1355–60 in the Church of Saint Florent, Niederhaslach, Alsace. Not only do the facial types compare favorably, but so do the specific movements of the seated figures, for example, the king in the bottom pane of the North Window III in Niederhaslach, whose right hand is braced against his thigh with an unnatural twist. This telling motif is frequently seen in the rulers of the Luxembourg Genealogy (for example Cylepricus, Charles the Bald, and Charles IV himself).

97. Bayerische Staatsbibliothek, Munich, Cod. germ. 6, fol. 140v. Stylistically, this manuscript is related to the famous colored design drawing for the bell story of the facade of Strasbourg Cathedral (Musée de l'Oeuvre Notre-Dame, Strasbourg, 5; see Recht in Cologne 1978–79, vol. 1, p. 280), the construction of which in this period had already become the responsibility of the city, while the bishop had moved his residence to Saverne.

98. Especially comparable are the green-robed figure that appears to be the Byzantine emperor John V Palaiologos (r. 1341–91) in the second relic scene in Karlštejn and the last of the Saverne kings in the scene of Adoration of the Magi (see Recht in Cologne 1978–79, vol. 4, pp. 106–17, fig. 27).

99. These frescoes are underpainted in red, and the three-dimensional gilded glorioles were executed in the classic Italian pastiglia technique. Stylistically, these works resemble those of painters who worked for Jan of Středa and used northern Italian models in varying degrees.

100. An official letter from Žatec from 1357 (cited in Fajt 1998, p. 100), in which the mayor and city council confirm Wurmser's right to receive interest on a loan he had made to a citizen of that town, reads: "Viro Nicolao, serenissimi principis domini Karoli Romanorum imperatoris semper augusti et Bohemie regis pictori, civi in Strazburk."

101. A wall painting by Matteo Giovanetti in the palace of Pope Clement VI in Avignon, dating to 1342–43, pictured the French dauphin John II the Good presenting a painted diptych to the pope. This kind of work forms the background for the political and documentary aspect of Charles's self-projection in art, especially as represented in the Karlštejn relic scenes and later in Nuremberg. The Avignon painting is known only from a seventeenth-century drawing (Bibliothèque Nationale de France, Paris, Collection Gaignières, Est. Oa 11, fols. 85–88).

102. The key to the dating of the relic scenes is provided by an identification in the second one. If the green-robed ruler is indeed meant to be Emperor John V Palaiologos (see note 98 above), the scene could document a fictitious meeting between Charles and the "Greek" ruler at which Charles was presented with a piece of the sponge raised up to Jesus on the cross. This relic was part of a major gift sent by John at the end of 1359 and received by Charles early in the following year (Otavský 2003, pp. 135–36). The relic scenes were therefore probably executed at the end of the 1350s, in anticipation of that gift, or in 1360, as documentation of it.

103. The altar itself was also reworked, for the lower part of the earlier wall painting depicting the imperial pair before an enthroned Virgin is now partially hidden behind the altar slab.

104. Plans for two stained glass windows, most likely installed in connection with the redesign of the Saint Catherine Chapel, must also have been executed in the workshop of Nicholas Wurmser (Stejskal 1978b, p. 111, pl. 88).

105. See note 92 above.

106. This is confirmed by inscriptions under the ceiling referring to a lost pictorial frieze. Above the relic scenes Blanche of Valois was pictured with Charles worshiping before the Trinity as the Throne of God; in the corresponding position on the west wall were apostles with Charles's two subsequent wives, Anna of the Palatinate and Anna of Świdnica (d. 1362). Since Charles married his fourth wife, Elizabeth of Pomerania, in 1363, the paintings must have been completed before that. For the inscriptions, see Friedl 1950, p. 14.

107. Fajt 1998, pp. 33–34: "Construxerat enim imperator castrum hoc de miro opera et firmissimis muris, prout hactenus cernitur, et fecit in superiori turri unam magnam capellam, cuius parietes circumdedit auro puro et gemmis preciosis et decoravit illam tam reliquiis sanctorum."

108. Ibid., p. 257: "Na téj biechu divné divy / zdělány z bohatéj měny: / dno z byryl, z adamantuov stěny / spojovány biechu v zlatě / v nich mnoho okének bohatě //(975) z smaragduov i z safieróv biechu, / v nichžto miesto stkla sě stkviechu / drahých kamenuov činové: / jochanti i rubínové, / turkat, sardin, palejs v sloni, //(980) jaspisové, kalcidoni, / topas, granát, kryzoliti, / amantisky, margariti, / zpósobení přieliš lepě. / Tudiež na téj sieni sklepě //(985) slunce, měsíc, při tom hvězdy / podobenstvím týmiž jiezdy / stviechu, jakož Boží mocí / dú na nebi dnem i nocí, / časujíce všecky chvíle."

109. The Libri Carolini, the late-eighth-century Carolingian treatise on the role of images, explains that while pictures will be burned at the Last Judgment, the saints will be resurrected from their relics. Libri Carolini III, 24, in Patrologia Latina 98, pp. 153ff.

110. For a detailed description of the iconography of the chapel, see Fajt and Royt in Fajt 1997, pp. 156–254.

111. Fajt 2000.

112. See Norman 1999, esp. pp. 1–17, 45–65, figs. 12–16.

113. The first artist to be permanently employed at the imperial court was the Sienese goldsmith Lando under Henry VII in the second decade of the fourteenth century, even though the title "artist to the court" had been common in Italy, England, and France as early as the first half of the thirteenth century. The crisis within the Holy Roman Empire due to the power vacuum after the death of Frederick II prevented the rise of a stable court with the attributes of sovereign splendor already traditional elsewhere. And Henry VII died prematurely. Louis IV the Bavarian adopted the French-Italian model of courtly manifestation, with a homogeneous style. Often, rather large workshops were involved, as in the instance of the pictor pape Matteo Giovannetti of Siena, who by 1346 employed six Italians, seven

Frenchmen, a Scot, and a Dutchman for the decoration of the new palace of Pope Clement VI in Avignon. See Warnke 1985, p. 26.

114. Fajt 1998, p. 102.

115. Ibid., pp. 226–77.

116. In the scene of the dedication of the Holy Cross Chapel at the end of the stairs, Charles's fourth wife, Elizabeth of Pomerania, is depicted as queen of Bohemia. She did not attain the rank of empress until her coronation in Rome on November 1, 1368, and consequently the painting must date before that, as proved also through technological analyses made during the recent restoration by Petr Brodský and Jiří Bareš.

117. See Studničková 2004.

118. A depiction of this subject appears in connection with Charles in a stained glass window at Saint Martha's, Nuremberg, donated by Conrad Waldstromer I, the steward of the imperial forests and drafted by the Nuremberg painter to the emperor, Sebald Weinschröter.

119. Fajt and Hlaváčková 2003.

120. The same qualities are evident in a portable altar in the cathedral at Susa executed in Bruges in 1355, and in the first part of the Paris Bible of Jean de Sy (1355–57), illuminated by a painter from the circle of Jean Bondol.

121. Eberhard 1978, pp. 104–5.

122. In addition to stylistic and motivic connections between the cathedrals in Cologne and Prague, a network of personal connections link the two cities (see, for example, cats. 58, 59). For a brief summary of the Parler family links, see Benešovská 1999b and Hlobil 1999. On the present state of Parler scholarship, see Strobel and Siefert 2004.

123. Wyss (1883) 1973, p. 75: "1380. In diser zit was ein meler zu Collen, der hiss Wilhelm. Der war der beste meler in Duschen landen, al ser wart geachtet von den meistern, want er malte einen iglichen menschen von aller gestalt, als hette ez gelebt" (1380. In this time there was a painter in Cologne called Wilhelm. He was the best painter in German lands, as he was esteemed by the masters, for he painted all sorts of people of every form as if they were alive). On the painter Wilhelm, see Thieme and Becker 1907–50, vol. 35, pp. 575–76, and Suckale 2004b.

124. As one can see from the other artists, for example, Peter Parler, Nicholas Wurmser (Master of Luxembourg Genealogy), and Theodoric, who were invited by Charles IV to come to Prague and are counted by contemporary art historians among the best artistic personalities of their era.

125. German historians had developed the notion that there was no painting of high quality in Cologne during the second half of the fourteenth century. Suckale (2004b, pp. 45–72, esp. pp. 50–56) then advanced a revised chronology of painting in the city during that period, redating some of works and attributing them to Wilhelm. Among these were the reliquary triptych of the Enthroned Virgin with Saints Cyriac and Pancras (Hamburger Kunsthalle); the triptych with the Adoration of the Magi with Saints Philip, James, Severin, and Walburga (Detroit Institute of Arts, 26.106); and the Crucifixion with Saints and a Canon (Suermondt-Ludwig-Museum, Aachen).

126. Suckale (ibid., pp. 55–56) pointed out the similarity between the grieving Mary of the Crucifixion in the Emmaus Monastery, from the circle of Master Theodoric (ca. 1365), and the corresponding figure in the Aachen Crucifixion.

127. The oval face of the Virgin in the Detroit Institute of Arts triptych (see note 125 above) is repeated, for example, in the Karlštejn Saint Catherine (KA 3751) by Master Theodoric; the Saint Pancras on the Hamburg triptych (see note 125 above) and a sainted sovereign at Karlštejn (KA 3780) have identical facial structures. The evocative

gesture of the right hand of Saint Walburga in the Detroit triptych is repeated in Theodoric's Saint Helena at Karlštejn (KA 3746), and the strictly frontal depictions of Saint Severin from the same altarpiece and Saint Nicholas at Karlštejn (KA 3701) are clearly related. These comparisons by no means exhaust the myriad connections between the work of Wilhelm and Theodoric.

128. See the reliquary-triptych with a seated Virgin and Child in the middle and Saints Cyriac and Pancras on its wings in the Hamburger Kunsthalle (Suckale 2004b, fig. 5).

129. This confirms Suckale's (ibid., n. 120) early dating (1360–70) of the paintings he attributes to Master Wilhelm; indeed, it would even permit a reassignment closer to 1350s. This leads to the conclusion that there had to have been a similar production by Master Wilhelm as early as the mid-1350s.

130. Chytil 1891, pp. 25–30.

131. Hejnic 1959, no. 6; Fajt and Sršeň 1993, no. 165.

132. An insolvent debtor of Oswald's is mentioned as late as February 7, 1383 (Stejskal 1984, p. 338n27, citing Tadra 1893, pp. 33, 223).

133. Charles IV acquired the relic of Saint Ottilia for Prague Cathedral in 1365. See Tomáš Jan Pešina of Čechorodu, Swatych tel ostatkůw Reliquigi (Jan Dlouhoveský), 1673, p. 16, cited in Vítovský 1976, n. 34; Všetečková 1994, pp. 114–17. The wall painting must thus have been finished sometime between 1365 and 1368, when the altar was consecrated. See Tomek 1872 (ground plan of Saint Vitus's Cathedral showing the altars as they were in 1419), reproduced in Benešovská and Hlobil 1999, p. 140.

134. Ten years later a large painting on the west wall of the Vlašim Chapel was created that showed Christ on a cross formed like the Tree of Life and the Beheading of Saint Catherine. The worshiping Jan Očko of Vlašim already wears the vestments of a cardinal, a dignity he attained on September 17, 1378, or shortly before the emperor's death. An earlier parallel to this depiction is found on the former high altar of Brandenburg Cathedral from 1375.

135. One of the reasons for deciding on this type of depiction was surely the fact that the archbishop was blind in one eye. Hence the epithet "Očko" (little eye).

136. Istorie di Matteo Villani, cittadino fiorentino, che continua quelle di Giovanni suo fratello, cited by Vlček 1984, p. 472: "la sua persona era di mezzana statura, ma piccolo secondo gli Alamanni, gobbetto, premendo il collo e'l viso innanzi non disordinatamente, di pelo nero, il viso lerghatto gli occhi grossi, e le gote rilevate in colmo, la barba nera, e'l calvo dinanzi. Vestiva panni honesti e chiusi continuovamente, senza niuno adornamento, ma corti appreso al ginocchio."

137. For the origins of this concept of the official portrait of Charles IV, see most recently Suckale 2003c. Additional forms of the visual representation of the emperor are found in Rosario 2000. See the review by Fajt (2003b).

138. For the painter and his family, see Gümbel 1923–24a, and see also Gümbel 1923–24b.

139. The first attempt to reconstruct the Weinschröter oeuvre on the basis of stylistic and formal analysis was made in my paper "Karlstein und die Nürnberger Malerei des dritten Viertels des 14. Jahrhunderts," read at the meeting in Prague's Emmaus Monastery in May 2004. My full monograph on this artist's work is in preparation.

140. See the altarpieces in Rathenow (Wolf 2002, figs. 112–17), Schotten (ibid., figs. 133–38, 186–87), Falsterbo (Tångeberg 1989, ill. p. 317), and from Saint Peter's Church in Hamburg (Hamburg 1999, pp. 101–11, no. 1, ills. pp. 104–7), and also the altarpiece of the Holy Cross in Doberan (Erdmann 1995, ill. pp. 59–65) and the altarpiece from Tirol Castle (Trattner in Brucher 2000, no. 279, p. 540, ill. pp. 166–67).

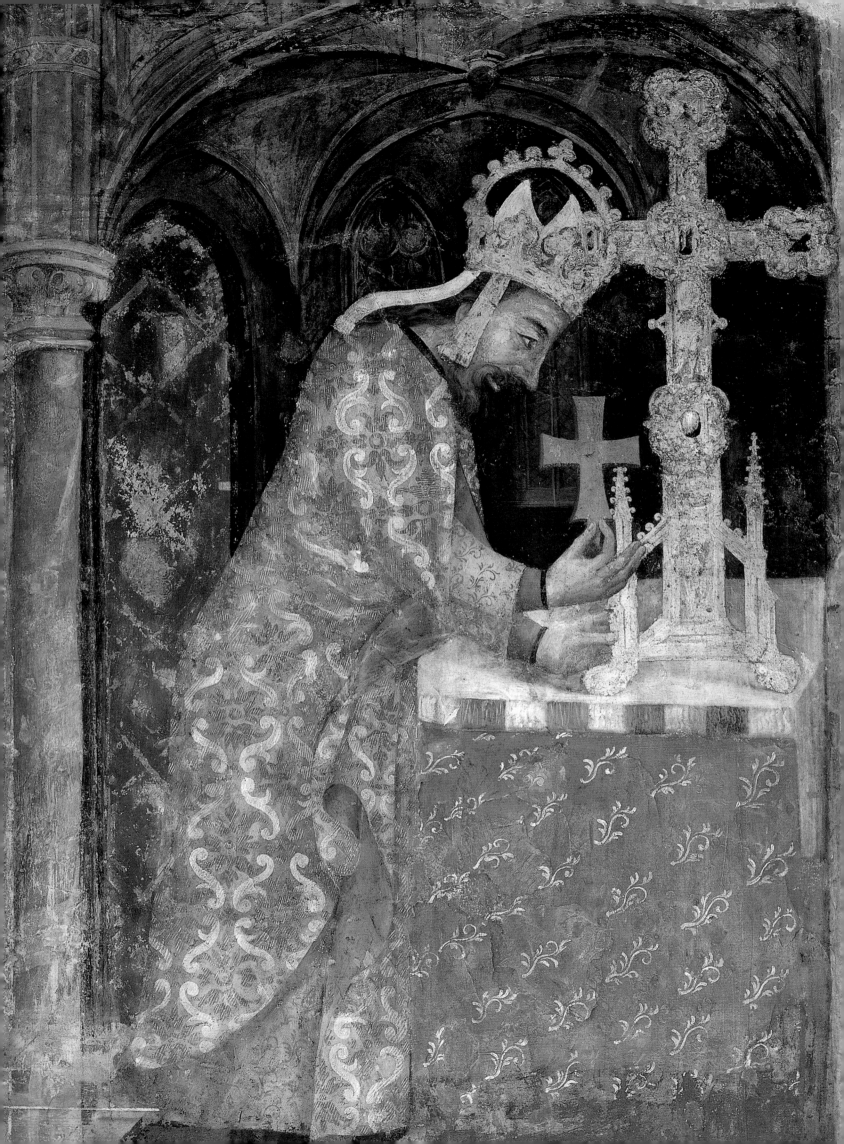

# Charles IV
# The Realm of Faith

---

*And I shall not conceal the grace poured into me by God.*
—*Charles IV*[1]

---

Barbara Drake Boehm

The modern visitor to Prague quickly perceives the fundamental political motivations underlying Charles IV's choices of monumental works of art in the city. Set high on a hill, Prague Castle and the massive bridge spanning the Vltava unequivocally signify the one-time presence of a powerful ruler. Nor has the enduring visual impact of such monuments been ignored by modern propagandists; the exquisite backdrop of the city of Prague was co-opted in the twentieth century by both the Nazis and the Communists. Indeed, perhaps for this reason, modern literature has frequently focused on the monuments as witnesses of a calculated political agenda. No less than the castle, the Cathedral of Saint Vitus was the beneficiary of Charles IV's patronage. Enfolded within the castle precinct and protected by its moat, the cathedral is inextricably linked to the castle, like a vast royal chapel for the king and people of Bohemia. In much the same way, politics and faith have been considered perfectly fused in the person of Charles IV.[2] Charles's chronicler Beneš Krabice of Weitmile, canon of the cathedral, frequently juxtaposed Charles's political and spiritual activities.[3] Nonetheless, it is possible to discern particular aspects of his personal praxis and to assess the impact of his faith on works of art created during his reign.

Charles's own compositions and the writings of contemporary chroniclers, both domestic and foreign, present telling evidence about his beliefs and his practice of Christianity. The emperor's autobiography, which recounts his travels and youthful military campaigns, offers some of the earliest glimpses of his faith and its formation. In 1323, when Charles was seven years old, his father sent him to the court of Paris.[4] That year he was confirmed at the Royal Abbey of Saint-Denis[5] and given the name Charles, in honor of his sponsor, Charles IV of France, in place of his baptismal name, Wenceslas.[6] In the same year he was married to Blanche of Valois.[7] Charles IV's chaplain served as his teacher,[8] and the king's account books confirm regular payments for the care and education of the prince of Bohemia.[9]

Charles expressed appreciation for having been taught to read the hours, the cycle of prayers adopted as a daily regimen by the faithful in imitation of monastic tradition.[10] He followed this prayer ritual throughout his life. The emperor did more than attend the recitation of the Divine Office. In his eulogy for Charles, Jan Očko of Vlašim, archbishop of Prague (r. 1364–80), credited him with saying his own Canonical Hours, just as a priest would.[11] These practices were recognized attributes of holy kings.[12] It is not surprising that during his final visit to Paris in 1378 the emperor asked his nephew Charles V for the gift of one of the king's own books of hours. The king sent two, one large and one small, and Charles IV elected to keep both.[13] A psalter and book of hours made at the French court for Charles's sister Bonne (see fig. 2.2) exemplifies the manuscripts Charles knew during his boyhood years in France. Slightly later manuscripts from the reign of Wenceslas IV, like the Czech Hours of the Virgin (cat. 83) and the Hours of Wenceslas IV (cat. 82), attest not only to the practice of

Fig. 2.1 Nicholas Wurmser of Strasbourg(?). Charles IV Places the Passion Relics into the Bohemian Reliquary Cross. Wall painting, 1357–58. Chapel of Our Lady, Karlštejn Castle

Fig. 2.2 Probably Jean Le Noir, his daughter, and his workshop, Paris. Crucifixion with Donors. Psalter and Hours of Bonne of Luxembourg, fols. 328v–329r. Tempera and gold on parchment; Paris, before 1349. The Metropolitan Museum of Art, The Cloisters Collection, 1969 (69.86)

reciting hours at the court of Prague but also to the creation of such luxury manuscripts in Bohemia.

Despite the emperor's interest in intellectual pursuits, the emphasis he placed on education in his empire, and his self-conscious role as a wise ruler, virtually no trace survives of a personal book collection, sacred or secular. Unlike his nephew and contemporary Charles V of France, Charles IV left no inventory of his books and no evidence that they were preserved in a special library.[14] No coat of arms on preserved manuscripts betrays the ruler's former ownership. Nor does any chronicle speak of his commissioning books in the way that Arnošt of Pardubice, the first archbishop of Prague, ordered them.[15]

The inventory of Saint Vitus's Cathedral, replete with Charles IV's gifts of liturgical objects and reliquaries, contains only four references to manuscripts associated with him.[16] According to the inventory of 1354,[17] the sovereign presented the cathedral with a copy of the *Scivias* (*Know the Way*) by the twelfth-century nun and mystic Hildegard of Bingen, whose renown grew after a campaign for her canonization was advanced during the papacies of Clement V (r. 1305–14) and John XXII (r. 1316–34).[18] A second copy of the same text, which Charles had given to Arnošt of Pardubice, came to the cathedral the following year.[19] Charles may have been drawn to the story of Hildegard because of her many religious visions. "And it came to pass," she recounted, "when I was forty-two years and seven months old, Heaven was opened and a fiery light of exceeding brilliance came and permeated my whole brain and inflamed my whole heart and my whole breast."[20] This, she believed, allowed her to know the meaning of the Scripture. Charles wrote at length in his autobiography of his own spiritual visions, which he considered a divine gift that allowed him "to write down something for you to help you understand the gospel."[21]

In the listing of the cathedral's great choir books is a note of 1368 indicating that the chaplain Bartholomew (*Bartholomeus capellaniae*) gave one of the old antiphonaries in the treasury to the emperor.[22] Charles may have planned to use it as a model for a new set of choir books, perhaps in honor of one of the important events that occurred that year, such as the birth of his son Sigismund or the coronation of the queen, Elizabeth of Pomerania, as empress in Rome.[23]

The fourth mention in the cathedral's records of a manuscript associated with Charles IV is a listing in the inventory of 1355 of a fragment of the gospel of Saint Mark that Charles had acquired in Aquileia.[24] Important not just as a text but also as a relic of the evangelist himself, the gospel was believed to have "been written with his own hand," as Charles IV attested in his own royal hand at the beginning of the manuscript.[25] Charles's written instructions that the gospel's arrival in Prague be greeted by deacons in their liturgical garb establish unequivocally the link in his mind between its acquisition and the role of the deacon.[26] The Church in the fourteenth century conferred the liturgical status of deacons on kings by anointing them with sacred oil during the coronation ceremony.[27] Consequently, the liturgical reading of sacred text was part of Charles's royal prerogative, which he took pride in exercising.[28] On the road to France in 1378, for example, he remained in Cambrai for Christmas so that he might serve as lector for the seventh lesson at matins, a practice permissible in the Holy Roman Empire (fig. 2.3).[29]

Devotion to saints and their relics was the most demonstrable aspect of Charles's spirituality. A contemporary biography of Pope Innocent VI (r. 1352–62) describes Charles IV as "exceedingly diligent and solicitous in gathering relics from all parts, which he then treated with great veneration and adorned magnificently, placing them in the churches and monasteries of the city of Prague."[30] As a consequence, Prague's reputation as a repository for relics was surpassed only by Rome and remained so for centuries.[31] Giovanni dei Marignolli, the Florentine Franciscan chronicler in Charles's service, told of Charles's cutting off a piece of the finger of Saint Nicholas at the residence of the Poor Clares in Prague to have for his own, only to discover that it bled. After conferring with his archbishop, Arnošt of Pardubice, he returned the fragment and restored it to its original place.[32] He then immediately demanded that his miraculous experience be depicted in a wall painting.[33] Beneš Krabice of Weitmile spoke of Charles's zeal in acquiring relics for Saint Vitus's Cathedral: "In the same year [1354] Lord Charles, King of the Romans and in Bohemia, was marvelously set ablaze with feelings of devotion, in different churches, in different cathedrals, in houses governed by the Rule, in monasteries, and in other pious places in parts of Gaul and Germany obtained different relics of many saints, and seven bodies of saints, and heads and many arms of saints energetically, and decorated those with gold, with silver, and with precious stones, beyond that which is able to be expressed, and gave to the church of Prague."[34]

Fig. 2.3 Emperor Charles IV Reading the Epistle on Christmas Day. *Grandes chroniques de France,* fol. 467v. Tempera and gold on parchment; Paris, ca. 1378–79. Bibliothèque Nationale de France, Paris (Fr. 2813)

The day-by-day descriptions of Charles's visit to Paris in 1378 in the *Grandes chroniques de France* (see fig. 2.3) provide vivid testimony of his veneration of relics. At the Royal Abbey of Saint-Denis the ailing emperor was so adamant about seeing the relics that he was carried to the treasury on a litter.[35] He remained a long time, "and took very great pleasure, as was evident from his face, according to those who were close by."[36] Two days later, on Monday, January 4, the emperor returned to the church early in the morning and "kissed the relics, the head [of Saint-Denis], the nail and the crown of saint Louis." On January 6 Charles determined to climb up to the Grande Chasse in the Sainte-Chapelle to see the relics preserved there, notably those linked to the Passion, including the crown of thorns. The access being difficult and narrow, he could not be carried in his litter and had to be lifted bodily by his arms and legs up the twisting stair and down again, enduring "great pain, effort and heaviness of his body." Reaching the top, he removed his head covering, joined his hands, and "as in tears made his prayer a long time, and in great devotion" before kissing the relics.[37] Charles made this extraordinary display of devotion on Epiphany, the feast commemorating the visit of the Three Kings to the infant Jesus. He and his secular royal contemporaries saw themselves as quite literally the living heirs of this regal tradition and paid homage, as earthly kings, to the infant Jesus, as

Fig. 2.4 Master Theodoric. Adoration of the Magi (detail). Wall painting, Holy Cross Chapel, Karlštejn Castle

the King of Kings. Indeed, Charles's own features seem to have been imposed on one of the Three Kings in the Morgan Diptych (cat. 25) and on figures in other works created during his reign, such as the wall painting of the Adoration of the Magi in the Holy Cross Chapel at Karlštejn Castle (fig. 2.4).[38]

Charles's acquisition of relics of Christ's Passion for the Bohemian Crown required the generosity of his French cousins. The inventory of Saint Vitus's for 1355 describes the emperor's gift of a double-arm cross containing "ligno Domini" (wood or cross of the Lord), from the "monasterio Parisiensi," presumably the Abbey of Saint-Denis,[39] along with other relics of the Passion Wall paintings in the Chapel of Our Lady at Karlštejn commemorate the dauphin of France's presentation of relics from the crown of thorns to Charles IV in 1356 at Metz with an attention to accuracy suggested by the precision of period costume detail and the individualized appearance of the figures[40] (see figs. 2.1, 2.5). Charles is placed at center stage in such depictions. After the pope's official establishment of the Feast of the Holy Lance and Nails on February 13, 1354, Charles himself

expounded on it, either in writing or, given his diaconal role, by preaching, in partnership with theologians.[41] On the pilgrim's badge associated with the feast (cat. 70), Charles is shown raising the image of the lance.

A generation before, Charles's mother, Elizabeth, had acquired a relic of the crown of thorns from Charles IV of France in 1326.[42] The following year Elizabeth sent relics in a rectangular gem-encrusted gold reliquary to the pope.[43] She argued for the canonization of Agnes of Bohemia and wrote to the pope in support of the cause of the saintly princess and follower of Saint Clare.[44] Her role in fostering her son's interest in relics is suggested by a relic of Saint Ignatius that she had obtained from the Cistercian Monastery of Osek and presented to her son; he, in turn, donated it to Saint Vitus's.[45] Elizabeth was also Charles's source for a relic of Saint Lucy and one of Saint Clare enshrined in a monstrance.[46] Elizabeth's influence most likely underlay Charles's early devotion to Saint Ludmila, his ancestor on his maternal side. While in Paris he wrote a poem in honor of Ludmila.[47] As Charles related in his legend of Saint Wenceslas, it was Wenceslas who transported the body of Saint Ludmila "with great veneration and devotion, to the Church of Saint George in the Castle of Prague."[48] The inventory of Saint Vitus's includes a relic of Saint Ludmila in a *manus* (hand), or arm-shaped reliquary,[49] a form usually reserved for male saints. It may have been the young Charles who presented the fourteenth-century head reliquary of Saint Ludmila (cat. 6) to the neighboring Convent of Saint George, where his mother had once been resident.

Not only in the case of relics of the Passion did Charles's tutelage at the court of France inform his devotion to holy relics. A relic of the tooth of Saint Martin of Tours was set in a container in the form of an angel that was a gift from Charles V of France,[50] and in 1377 the king gave Charles IV a relic of the tooth of Saint Scholastica, as well as part of a rib and other minor relics.[51] Charles's devotion to Saint Denis had apparently endured since his youth, evidenced by the relics he provided to Saint Vitus's. The 1354 inventory includes part of the head of the saint.[52] In 1355 the cathedral also obtained part of his arm.[53] A seventeenth-century engraving of a bust of the saint (fig. 2.6) that Charles gave to the Benedictine Abbey of Saints Ulrich and Afra at Augsburg in 1354 also evokes this pattern of patronage.[54] The engraving shows this saint, so closely linked to France, nonetheless wearing medallions representing the lion of Bohemia and a miter with the single-headed eagle of Saint Wenceslas emblematic of the King of the Romans.[55]

Charles IV attributed his success in battle at San Felice, in defense of Modena, on November 25, 1332, to Saint

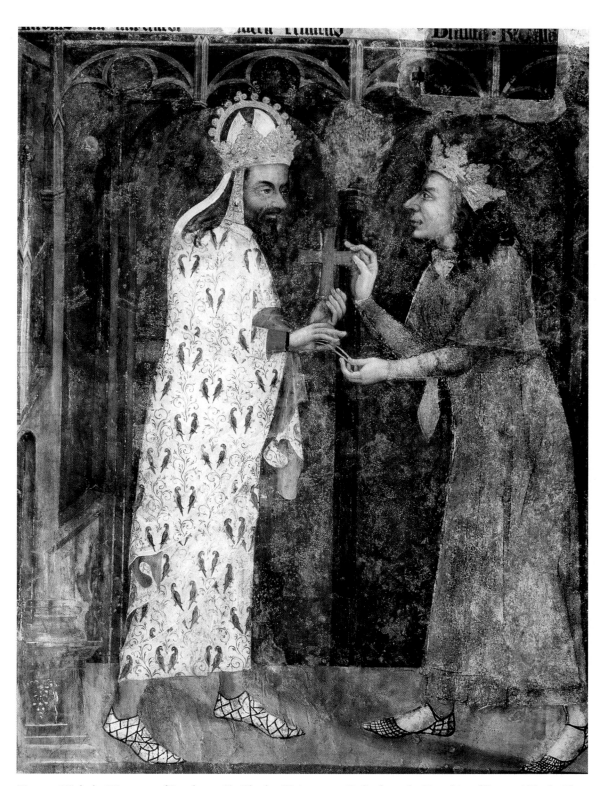

Fig. 2.5  Nicholas Wurmser of Strasbourg(?). *Charles IV Accepts a Relic from the Dauphin of France (Charles V).*
Wall painting, 1357–58. Chapel of Our Lady, Karlštejn Castle

Catherine, whose feast day it was.[56] This personal link is often cited as yet another motivating influence on the emperor. In 1342 his second daughter was christened Catherine. In his private oratory chapel at Karlštejn, Saint Catherine's image was painted on the right face of the stone altar, and he established a new Augustinian nunnery dedicated to Saint Catherine in Prague.[57] In the second half of the fourteenth century two legends of the life and martyr-

dom of Saint Catherine were written in Czech, perhaps at the order of Charles or a Prague ecclesiastic.[58] Yet this evidence and Charles's pivotal victory on the field of battle on Saint Catherine's day notwithstanding, his devotion to the saint, at least insofar as it is reflected in works of art, seems to have been no more fervent than that of other contemporary European nobility. Saint Catherine was much favored in French royal circles; the *Belles heures* of Jean, duke of

(caption below)

PARS SECVNDA.    7I

IV.

S DYONISIVS M EPS ET PATRONVS AVG

CAROLVS Quartus Romanorum Imp. adfectum suum erga *D. Dionysium* primum Vrbis Augustanæ Episcopum o-stendere volens, hanc ipsius imaginê argenteam inauratam Pra-gâ Augustam dono misit Anno MCCCLIV. cui *Caput Diui* huius inclusum fuit atq; etiam hodie est, insculptis ad oram Imaginis his etsi rudibus ad morem illius seculi, plenis tamen pietate ver-sibus.

Anno

Fig. 2.6  Bust of Saint Denis. Given by Charles IV to the Abbey of Saints Ulrich and Afra, Augsburg, 1354. Engraving, 1627

Berry, for example, include a profusely illustrated cycle of prayers devoted to Saint Catherine. She was also patron of the philosophy faculty of the Sorbonne,[59] an honor that does not seem to have transferred to the university the emperor founded in Prague. A gilded silver reliquary of Saint Catherine in the treasury of Saint Vitus's Cathedral (cat. 56) has no apparent links to Charles IV and was probably created after his death. It was first recorded at Karlštejn in 1420.[60]

Like the princes of France, Charles venerated the canon-ized French monarch Louis IX. In the summer of 1324, soon after the arrival of the Luxembourg prince in Paris, a new Chapel of Saint Louis was dedicated in the north nave aisle at the Royal Abbey of Saint-Denis.[61] Louis's saintly example was widely presented: in stained glass, in illuminated man-uscripts, and in precious images.[62] In the 1320s Clemence of Hungary, Mahaut d'Artois, and Jeanne d'Evreux (who was queen during Charles IV's stay in Paris), all owned reliquary

statuettes of Saint Louis. By 1354 Charles IV had presented a gilded silver image of Saint Louis holding a piece of Jesus' crown of thorns to the Cathedral of Saint Vitus.

Also in 1324, just prior to his death, the French king Charles IV presented the head reliquary of Saint Bartholo-mew to the Premonstratensian abbey of the saint at Joyenval, near Versailles.[63] A creation of the goldsmith Simon of Lille, the reliquary's significance is suggested by the royal accounts and by its depiction in manuscript illuminations.[64] The first inventory of Saint Vitus's Cathedral prepared during Charles IV's reign, in 1354, includes a royal gift of a gilded silver image of Bartholomew holding the mandibulum—with three teeth—from the saint's own skull.[65]

The inventories of Prague Cathedral evince a demon-strable predilection for the skulls of saints on Charles's part. According to long-established medieval tradition, the most significant relic of any saint is the head—unique and dis-tinctive in form, with particularly strong associations as the locus of the soul.[66] The head reliquaries of Saint Louis, the holy ancestor of the kings of France, and Saint Denis, the first bishop of Paris, were particularly sacred in France at the time. The 1354 inventory of Saint Vitus's lists five head reliquaries. First is the reliquary of Wenceslas, Charles's own canonized ancestor, which was then the only head reliquary in the cathedral that was made of gold, like the head of Saint Louis at the Sainte-Chapelle.[67] Following it in the inventory is the crown of Bohemia (fig. 1.4),[68] which Charles had made at the time of his coronation to be used by his successors in perpetuity but then presented as a gift to the cathedral to honor the head of Saint Wenceslas. A head reli-quary of Saint Adalbert, venerated as the first Czech bishop of Prague, is named in the inventory, as is the gilded silver reliquary for the head of Saint Ignatius, which Charles obtained from his mother. Also in the inventory are the skulls of a Saint Sapientia and Saint Chrisogon, likewise encased in gilded silver busts.[69]

Within a year, a significant number of head reliquaries had entered the cathedral treasury, many as imperial gifts. The head reliquary of Saint Vitus, patron of the cathedral, appears in the inventory for the first time in 1355.[70] Also included that year are heads of apostles (Bartholomew, Mark, and Luke), holy martyrs (Pope Urban, Saint Purchard, a bishop, and Saint Stephen, the first Christian martyr), con-fessor saints (among them Othmar, abbot of Saint Gall), and holy virgins, widows, and other chaste saints, or *viduarum* (such as Leodegarius, bishop of Autun, and Sigismund, king of Burgundy). The head of Saint Victor was acquired through Charles's illegitimate brother in Aquileia. Charles presumably acquired the head of Saint Malozil, one of the

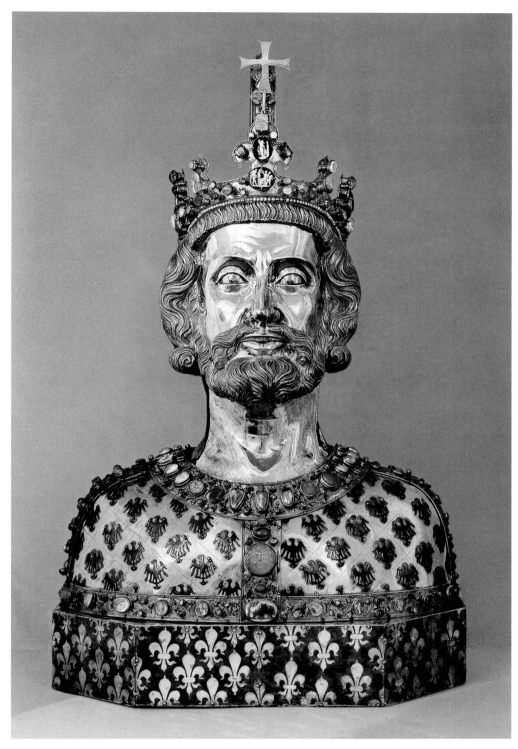

Fig. 2.7 Reliquary Bust of Charlemagne. Beaten silver, partly gilded, cameos, gemstones; probably 1376. Treasury of Aachen Cathedral

Theban martyrs, at Saint-Maurice d'Agaune. None of the head reliquaries Charles gave to Prague Cathedral has survived, but the bust of Charlemagne he presented to the cathedral at Aachen (fig. 2.7) and the bust of John the Baptist preserved at the former monastic church of that saint at Aachen (cat. 24) testify to their scale and richness.

A number of the relics and reliquaries Charles obtained for the cathedral were unusual in type and form. Manna that miraculously nourished the Israelites in the desert and the rod of Moses, kept in a crystal container with gilded silver mounts ("canula parva cristallina argento circumdata et deaurata") are mentioned in the 1354 inventory.[71] Relics of Abraham, Isaac, and Jacob set in a gold and silver reliquary in tablet form were received from imperial Constantinople.[72] There was also a coral tree intended to decorate the tomb of Saint Wenceslas. A remarkable little crystal ship

of Saint Peter, with golden figures of the apostles and even fish in the water,[73] combined precious stones and precious metals to create a miniature stage set, the kind of object more commonly associated with Renaissance and Baroque art.[74] Among the most prized relics at Saint Vitus's is the Tablecloth of the Last Supper (cat. 51). A gift from the king of Hungary, the cloth was housed in a crystal ewer that was probably manufactured in Paris for secular use and adapted at Charles's order by goldsmiths in Prague.[75] An indulgence of one year and forty days was granted to those who came to the cathedral on Holy Thursday to see the tablecloth.[76] The inventory describes the pectoral containing part of the finger of Stephen of Hungary as having "Greek letters," suggesting that it was a relic of Byzantine origin whose original precious-metal inscription was preserved as a testament to its rarity and authenticity.

Charles prided himself on the distinguished provenance of the relics at Saint Vitus's Cathedral: "The zeal of devotion and love with which we are consumed for the holy church of Prague, our venerable mother, and for the blessed martyr Vitus, Wenceslas, and Adalbert, our glorious patron saints, stirs our passion, so that when we by our devout generosity acquire something outstanding, an extraordinary jewel from among the treasures of the holy relics somewhere in the holy empire, in our royal benevolence we use it to adorn that church."[77] Clearly Charles's gifts of relics were a function of his strong personal sense of vocation as a ruler. In this, he emulated both Saint Louis, patron of the Sainte-Chapelle in Paris, and Wenceslas of Bohemia. According to Charles's account of the saint's life, it was Wenceslas who obtained the arm of Saint Vitus and brought it to Prague to be interred,[78] and he had the body of his holy grandmother, Ludmila, translated to the Convent of Saint George in Prague.[79] In a letter to Pope Innocent VI Charles further emphasized his rightful inheritance of the many sacred objects that he appropriated, since they had been "donated to these churches and places by our predecessors, the kings of the Romans of blessed memory."[80]

Although Pope Clement VI had been the childhood tutor of Charles IV in Paris, comparing the objects and relics at Saint Vitus's in Prague with those at Avignon during Clement's papacy reveals nothing that might suggest the pope's influence on Charles's piety. There is, however, direct evidence that the pope contributed to Charles's collection of precious objects by presenting him with a gilded silver coffret made by the Sienese goldsmith Giovanni di Bartolo.[81] And Clement VI actively encouraged the young Charles IV to follow the example of Charlemagne in his generosity as a patron of the church,[82] "for who had ever been more devoted to the Church, and more munificent than Charlemagne?"[83] The strain was picked up by Charles's chancellor Jan of Středa, who referred to Charles as the "living image" of Charlemagne,[84] and the chronicler Giovanni dei Marignolli, who called Charles "a new Charlemagne."[85]

Charles's veneration of Charlemagne, both his namesake and his sacred imperial ancestor, was manifest in his career through a number of highly visible public gifts, from the foundation of the Collegiate Church of Charlemagne at Prague, to his gifts to the city and cathedral treasury at Aachen, to the probable donation of the Reliquary Bust of John the Baptist (cat. 24). At Karlštejn, Charlemagne is one of the holy rulers depicted in the paintings of Master Theodoric (cat. 33b).[86] When Emperor Charles IV visited Paris in 1378, Charles V presented him with a gold goblet representing Saint James directing Charlemagne's path in Spain.[87]

Fourteenth-century rulers assiduously venerated their saintly royal ancestors,[88] and Charles's veneration of both Charlemagne and Saint Wenceslas conformed to an established tradition. But Charles's advocacy of Wenceslas, beginning with his writing a new life of the saint, surpassed the example of his contemporaries. Like Wenceslas, he "devoted himself to acts of charity and generosity";[89] his presentation of a chalice intended for the use of the infirm (cat. 50) to Saint Vitus's Cathedral is but one example. Wenceslas followed a rigorous prayer ritual. "One morning he was late to arrive because he had spent the night in vigil and prayer and was exhausted from his labors,"[90] which could also describe Charles's behavior during his visit to Paris. According to his legend, Wenceslas "longed for knowledge of books; he mastered the book of Psalms and the remainder of the other books, and retained them firmly within his memory."[91] Charles IV was eulogized for his ability to discuss the psalms and gospels with theologians.[92] Wenceslas would often kneel for the prayers of the Divine Office, and he secreted small handwritten books on his person beneath his clothes,[93] a biographic detail that calls to mind Charles's request to Charles V of France for books of hours. Charles shared with Wenceslas a particular reverence for the sacrament of the Eucharist. Accordingly, Charles obtained permission to use a portable altar when traveling. Charles's dynastic and very personal devotion to Wenceslas also found expression in the creation of works of art in the saint's honor.

While Charles's veneration of Saint Wenceslas endured from his childhood in France until his old age, his devotion to other saints clearly evolved over time. For example, he first acquired a relic of the skull of Saint Sigismund in 1354,

and it was enshrined in a gilded reliquary in 1355.[94] It was not until 1365, however, after he had been crowned king of Burgundy at Arles and had brought the saint's body to Prague, that his reverence for Sigismund began to take shape.[95] In 1367 he baptized his son Sigismund and made gifts to the saint's altar at the cathedral.[96] When Charles became seriously ill in 1371, his wife Elizabeth went by foot from Karlštejn to Prague to the tomb of Saint Sigismund and made an offering of pure gold worth 1,670 gold pieces. The emperor recovered and credited his healing to the saint.[97] He donated an image of Saint Sigismund to Saint Vitus's that was registered as a new acquisition in the inventory of 1374.[98] By 1387 the head of Saint Sigismund, like the head of Saint Wenceslas in the chapel opposite it at the crossing of the cathedral, was enshrined in pure gold.

Twice in his chronicle of Charles IV's reign Beneš Krabice of Weitmile spoke poignantly of the emperor's humble profession of his faith, summoning an image of him that is distinct from that of the proud and propagandistic imperial office. Beneš recounted that before Charles's coronation as Holy Roman Emperor in 1355, "with humility and on foot and even though the Romans prepared to welcome him with great ceremonial splendor, he, in contempt of worldly glory, entered the Holy City in secret and in three days he crossed all the holy thresholds in concealment and with great piety, and his own people did not know him."[99] When he was in Rome again in 1368, Charles stepped down from his horse and traveled on foot to Saint Peter's.[100] For Jan Očko of Vlašim, offering the eulogy at Charles's funeral, there were seven reasons the emperor could be considered saintly: the fact that he was an anointed king; the dignity of his character; the miraculous events surrounding his life, including his visions; the emotion he displayed in the presence of the sacrament of the Eucharist; his ability to recite the Divine Office and embellish it; and his reception of all seven sacraments.

From Charles's piety sprang his vocation as a collector of sacred objects. His motivation may have been distinct from that of later patrons of works of art, whether of the Renaissance or the present, but the heartfelt intensity of the collector, as recounted by his eulogist, sounds a common chord: "This one was in all sacred affairs a diligent researcher . . . , for whenever he was aware of shrines and bodies of saints he was accruing them and was overlaying with shiny gold and precious stones, and with all his heart he was selecting them, just like a second Constantine."[101]

1. Charles IV, *Autobiography* 2001, chap. 3.
2. See, for example, Spěváček 1982, p. 167.
3. Describing the emperor's activities in 1358, for example, Beneš Krabice of Weitmile (FRB 1884, pp. 526–27) recounted that "in the year of the Lord 1358, the Lord emperor came to Bohemia and established many fortified towns in different places, in which he placed his burgraves, in order that they might administer the peace and expel the nefarious. In the same year, the Lord emperor, possessing a special devotion for Saint Wenceslas, his special guardian and assistant, covered the head of that saint with pure gold, and fabricated a tomb from pure gold and adorned it with the most precious gemstones and the most exquisite stones and decorated it to such a degree, that such a tomb in these parts of the world is not known. In addition, in the tombs of other saints in fact he decorated heads, arms, and relics of diverse saints with gold, silver, and the most attractive gemstones and he gave [them] to the church of Prague" (Anno Domini MCCCLVIII dominus imperator venit Boehmiam et multa edificavit in diversis locis castra. In quibus posuit purgravios suos, ut pacem procurarent et maleficos exterminarent. / Eodem anno dominus imperator specialem habens devocionem ad sanctum Wenczeslaum, protectorem et adiutorem suum precipuum, caput ipsius sancti circumdedit auro puro, et fabricavit ei tumbam de auro puro et preciosissimis gemmis atque lapidibus exquisitis adornavit et decoravit adeo, quod talis tumba in mundi partibus non reperitur. Insuper tumbas aliorum sanctorum nec non capita, brachia et reliquias diversorum sanctorum auro, argento et gemmis venustissimis decoravit et ecclesie Pragensi donavit).
4. Kalista (1971, pp. 20–36) points to the importance of Charles's childhood to his spirituality.
5. According to Machilek (1978, p. 88), the confirmation and name change took place in early summer 1323. French royal documents first refer to him as Charles on November 8, 1323. See Mezník 1969, pp. 291–93.
6. Charles IV, *Autobiography* 2001, p. 23.
7. For expenses associated with the marriage, see Mezník 1969, pp. 291–92.
8. Charles IV, *Autobiography* 2001, p. 25.
9. Mezník 1969.
10. Charles IV, *Autobiography* 2001, p. 25.
11. See FRB, vol. 3 (1882), p. 429, cited in Rosario 2000, p. 97n70: "nam horas eciam suas canonicas, sicut unus sacerdos dicebat." The Roman Breviary is a book containing the yearly cycle of prayers and readings that the clergy are bound to recite on a daily basis. The Divine Office, as it is also called, consists of psalms, seasonal prayers, and readings from the Bible and the lives of the saints. It is also referred to as the Liturgy of Hours or Canonical Hours because the prayers and readings for any day are divided and grouped to correspond to certain hours of the day. Only the clergy were obliged to recite the Divine Office, but laity, seeking spiritual perfection, also took on this obligation.
12. Ibid., pp. 429–30: "divinum officium libenter audiebat et eciam augmentabat." In the case of Louis of Anjou, for example, see Kelly 2003, p. 125.
13. Delachenal 1910–20, p. 264. Charles was not the only ruler who looked to Paris for luxury objects. A similar phenomenon in the case of goldsmiths' work is suggested by the history of the translucent enamel shrine of Elizabeth of Hungary, a luxury object but not a special commission that was apparently purchased in Paris for export to Hungary (see Gaborit-Chopin 1992).

14. Kavka (1978, p. 152) refers to Charles's ownership of a French translation of Livy, without citing the source. Charles possessed an astronomical manuscript from the collection of his father preserved at Cues Hospital (cod. 207). See Krása 1971, p. 48. On Charles V's library, see the still classic exhibition catalogue, *La librairie de Charles V* (Paris 1968).

15. Beneš Krabice of Weitmile (FRB 1884, p. 530) spoke of Arnošt's commissions.

16. The chapter library of Saint Vitus's Cathedral would not have been the appropriate place for books of personal prayer from the king's collection to have been presented as gifts or preserved.

17. Podlaha and Šittler 1903a, p. XI, no. 101. The gift was noted by Hledíková 1984, p. 149nn100–101. Klaes (1993, p. 183) suggests that the information is incorrect. However, both texts were mentioned by Pertz 1847, esp. p. 476. I am grateful to Dr. Michael Embach of the University of Trier for this information.

18. *The Catholic Encyclopedia,* www.newadvent.org/cathen/07351a.htm

19. Podlaha and Šittler 1903a, p. XXV, no. 179.

20. Hildegard of Bingen 1990, p. 59.

21. Charles IV, *Autobiography* 2001, p. 107. On Charles's visions, see Dinzelbacher 2002, pp. 76–77.

22. Podlaha and Šittler 1903a, p. XXIIIn2.

23. Spěváček 1979, p. 257. Could Charles have intended to use the antiphonary as an exemplar for a new liturgy on which he may have been collaborating, as he may have done for the Feast of the Exposition of the Relics at Prague? See Rosario 2000, p. 97. Or could this have been in connection with a royal chapel founded by Charles? There are several instances throughout his career, including the Chapter of All Saints in 1339, Karlštejn in 1357, and Tangermünde in 1377. See Fajt 1998, p. 20.

24. See Podlaha and Šittler 1903a, p. XV, no. 119.

25. "Ego Karolus quartus dei gracia Romanarum Rex semper augustus et Boemie Rex vidi librum evangeliorum sancti marci de sua propria manu scriptum integrum ab uncio usque ad finem in septem quaternis in potestate patriarche et eclesie Aquilegiensis qui liber in dicta ecclesia fuit cernatus a beato hermatova et ab ecclesia Aquilegiensi predicta usque in hodiernum diem qui videlicet beatus hermatoras de manu beati marci eundem librum accepit set a beato petro per resignacionem et intercessionem sancti marci recepit prefultrum predicte Aquilegiensis eclesie de quo libro petitione mea apud patriarcham et capitulum dicte Aquilegiensis eclesie optinui istos duos quaternos ultimos libri predicti et alii quinque precedentes remanserunt in ecclesia supradicta. Et haec scripsi manu mea propria anno ab incarnato verbo millesimo trecentesimo quinquagesimo quinto in vigilia omnium sanctorum Regnorum meorum anno novo" (I, Charles IV, by the grace of God, King of the Romans, always Emperor and King of Bohemia, saw the book of the Gospels of Saint Mark completely written by his own hand from the anointing all the way to the end in seven quaternions in the control of the patriarch and church of Aquileia, where the book was received as an inheritance into the said church from blessed Hermagoras and from the aforementioned church of Aquileia all the way to this present time, where the blessed Hermagoras evidently received the same book from the hand of blessed Mark, but also from blessed Peter through the resignation and intercession of Saint Mark he received the leadership of the aforementioned church of Aquileia, concerning whose book, because of my request before the patriarch and the chapter of the said church of Aquileia, I obtained these two last quaternions from the aforementioned book and the other five preceding ones remained in the above-mentioned church. And, I wrote these things with my own hand in the year from the word made flesh 1355, in the vigil of All Saints, during the ninth year of my reign). I thank Eric Ramírez-Weaver, who transcribed and translated the text.

One of the other rare examples of Charles's autograph appears on a letter concerning the proper ceremony for receipt of relics at Prague (see Mengel 2003, p. 301).

26. For the details of the ceremony proposed by Charles, see Mengel 2003, p. 300.

27. Bloch 1973.

28. See Rosario 2000, p. 33, concerning a Christmas service at Nuremberg in 1355, for example.

29. Delachenal 1910–20, vol. 3, p. 199. For a cogent summary of Charles's role as a priestly monarch, including his reading of holy texts in the context of the liturgy, see Rosario 2000, pp. 96–102.

30. Cited in Mengel 2003, p. 268. First-class relics are generally some part of the bodily remains of a canonized saint. Second-class relics are objects that came into contact with the saint. A third-class relic is something that has touched a first-class relic, such as a piece of cloth that has touched the bone of a saint. The veneration of relics must be put in the context of the Last Judgment, at which time it was thought that the soul would be reunited with the body. The bodily remains of a saint, which had already been blessed by God's presence during the saint's life, would be reunited at the Last Judgment with the saint, who was already enjoying the glory of heaven. First-class relics, especially, were seen to be the locus of the past and future presence of the saint, and already involved in the final process of glorification. They were thus a way for those on earth to connect with that presence. The head, which was thought to be the locus of the soul, would have been especially important in this regard. It was thought that relics were an enormous blessing on the church that enshrined them, and the more relics that were accumulated in a place, the greater the connection between the earthly and the heavenly realms. I am grateful to Xavier Seubert, O.F.M., for this summary and the one in note 11 above.

31. Ibid.

32. Beneš Krabice of Weitmile, FRB 1884, p. 521a.

33. Machilek 1978, p. 93.

34. Beneš Krabice of Weitmile, FRB 1884, p. 522: "Eodem anno dominus Karolus, Romanorum et Boemie rex, mire devocionis affectibus successus, in diversis ecclesiis kathedralibus, regularibus, monasteries et aliis piis locis in partibus Gallie et Alemanie obtinuit multorum sanctorum diversas reliquias, et septem corpora sanctorum, et capita atque brachia sanctorum multa valde, et illas ornavit auro, argento et gemmis preciosis, ultra quam exprimi potest, et donavit ecclesie Pragensi."

35. The chronicler (see Delachenal 1910–20, vol. 3, p. 206) uses the verb "se dementer" to suggest the almost crazy determination.

36. Ibid.

37. Ibid., p. 233.

38. See Pujmanová 1997.

39. Podlaha and Šittler 1903a, p. XIII, no. 59.

40. See Fajt 1998, pp. 131, 143, fig. 85.

41. According to his chronicler Beneš Krabice of Weitmile (FRB 1884, p. 519). In Fajt 1998, p. 204n188, and earlier literature, such as Folz 1950, p. 462 and n. 146, the emperor's contribution is inferred to have been written, but Beneš's text can be interpreted to mean either a written or an oral exposition. Folz indicates that the pope granted Charles permission to choose the members of the committee who wrote the office. A fragment of a fourteenth-century Italian silk in the Metropolitan Museum (15.126.1; New York 1915–16, no. 80) representing angels holding the holy lance and nails may be linked to the creation of this new feast in Prague. Other fragments include one in Berlin (Falke 1913, vol. 2, pl. 464). I am grateful to Dr. Karel Otavský for this suggestion. On the holy lance, see also Kirchweger 2005.

42. František of Prague, FRB 1884, p. 399. Also noted by Mengel 2003, p. 278n35, citing Petr of Zittau (Zbraslav Chronicle, FRB 1884, p. 280). Louis IX had previously given a relic of the crown of thorns to Premysl Otakar II. See Otavský 1992, p. 34.

43. František of Prague, FRB 1884, p. 399.

44. Ibid., p. 403. Agnes of Bohemia was canonized on November 12, 1989 (*The Catholic Encyclopedia,* www.newadvent.org/cathen/01213b.htm/).

45. Podlaha and Šittler 1903b, p. 21.

46. Pešina of Čzechorod 1673, reprinted in Podlaha 1931, pp. 66 no. 8, 74 no. 13.

47. The *Legend* is edited by Wŏdke 1897, cited in Klaniczay 1990, p. 238.

48. Charles IV, *Legend* 2001, p. 195.

49. The arm reliquary was the gift not of Charles but rather of Nicolas of Holubicz, who also gave an arm reliquary of Saint Margaret. These are listed as nos. 35 and 36 of the inventory of 1354. The rest of the body of Saint Ludmila was placed in a new tomb at Saint George's in 1371. See Prague Castle 2003, p. 135.

50. Pešina of Čzechorod 1673, reprinted in Podlaha 1931, p. 71, no. 11.

51. Ibid., p. 49 (Februarius 10).

52. This was an extraordinary acquisition, as possession of the skull of the saint was hotly disputed between Saint-Denis and Notre-Dame of Paris. At the end of the fourteenth century, Jean de Berry's request to the monks of Saint-Denis for part of the head was denied, after which he turned to the canons at Notre-Dame, which claimed to have part of the crown of the saint's head. See Delaborde 1884, pp. 299–302.

53. Podlaha and Šittler 1903a, pp. VIII no. 246, XIV no. 88.

54. Hertsfelder 1627, p. 71, pl. 4, cited by Otavský 1992, p. 22.

55. I am grateful to Robert Theo Margelony for identifying these from the engraving of Wolfgang Kilian.

56. Charles IV, *Autobiography* 2001, pp. 43–44.

57. See Hledíková 1984, p. 145 (with bibl.). Mengel (2003, p. 77) properly notes that Charles's interest in the Augustinian Order needs to be seen against the broader backdrop of institutions and orders introduced by the emperor.

58. *Dvě Legendy* 1959, p. 93.

59. See ibid., p. 112.

60. Cologne 1978–79, vol. 2, p. 708.

61. See Brown 1984.

62. See Boehm 2000, pp. 284–94.

63. *Journaux du trésor de Charles IV* 1917, no. 10311.

64. See Otavský 1992, p. 99, fig. 36.

65. Podlaha and Šittler 1903a, p. III, no. 9.

66. See Boehm 1990, pp. 37–41.

67. Beneš Krabice of Weitmile (FRB 1884, book 4, p. 527) speaks of the fabrication of the gold crown in 1347 to be placed on the head of Wenceslas. He refers to a newly embellished gold head and tomb of Saint Wenceslas in 1358. He also refers (ibid., p. 536) to additional embellishment of the chapel in 1367.

68. Sometimes said to have been modeled on the crown of Saint Louis at Saint-Denis, its form, with lily terminals, is consistent with the earlier Bohemian royal crown (see Otavský 1992, p. 34).

69. Probably the martyr of Aquileia, of which Charles's illegitimate brother was patriarch.

70. Three years later Charles presented a relic of Saint Vitus to Herrieden (Machilek 1978, p. 94). Such gifts to lands under Charles's authority are seen as a kind of territorial marking.

71. Podlaha and Šittler 1903a, p. III, no. 18.

72. Pešina of Čzechorod 1673, reprinted in Podlaha 1931, p. 69, no. 9.

73. Podlaha and Šittler 1903a, p. III, no. 16. The 1378 inventory (ibid., p. XXXII, no. 57) describes the object in more detail.

74. See, for example, the ship of Saint Ursula in the treasury of Reims Cathedral or the crystal ship in the Museo Civico d'Arte Antica e Palazzo Madama, Turin (Turin 2004, p. LXI).

75. The relic of the Tablecloth of the Last Supper seems to have been an isolated gift of the king of Hungary, but there was an influx of objects from Hungary in 1374. Chief among them were a gilded silver reliquary statuette of Saint Catherine and an image of Saint Sigismund, as well as an alb from the queen of Hungary and a red and white pall decorated with the arms of Hungary. If they were linked to Prince Sigismund's betrothal to Mary of Hungary, prior to their marriage in 1382, these acquisitions may well have reflected the political situation of the Bohemian kingdom. In fact, the inven-

tory of 1368, the year of Mary of Hungary's birth, records the gift of a chalice and "tabula" of the Virgin Mary.

76. Cited by Mengel 2003, p. 308.

77. Podlaha and Šittler 1903a, p. 36n3: "Zelus devotionis et amoris, quo circa sanctam Pragensem ecclesiam, venerandam matrem nostram, et beatissimos martyres Vitum, Wencezlaum et Adalbertum, gloriosos patronos nostros incessanter afficimur, animum nostrum sollicitat, ut dum de sacrarum reliquiarum thezauris per loca sacri imperii egregium aliquid et insigne clenodium devotorum nostrorum largitone consequamur, per illud eandem ecclesiam benignitate regia decoremus." For the English translation, see Mengel 2003, p. 271n17.

78. Charles IV, *Autobiography* 2001, p. 193.

79. Ibid., p. 195.

80. See Mengel 2003, p. 283.

81. Pujmanová 2001, p. 178n16.

82. See Folz 1973, pp. 423–25.

83. Cited in Klaniczay 2002, p. 329.

84. Folz 1973, p. 452.

85. Cited in "Beata stirps" (Klaniczay 2002); FRB vol. 3, fol. 2, pp. 425–26.

86. See Fajt 2000, esp. pp. 494–95.

87. Delachenal 1910–20, p. 269.

88. See recently, "Sacred by Blood: Beata stirps," in Kelly 2003, pp. 119–29.

89. Charles IV, *Legend* 2001, p. 195. Not surprisingly, there is remarkable correspondence between the legend of Saint Wenceslas and that of other royal saints, such as Louis IX of France.

90. Ibid., p. 191.

91. From the second Slavonic life of Wenceslas, cited in Kantor 1990, p. 72.

92. There are three surviving eulogies, conforming to a central European tradition of royal eulogies (Klaniczay 2002, pp. 346–47). The text of one eulogy, ascribed either to Jan Očko of Vlašim or to Jan of Jenštejn, is available online (http://www.clavmon.cz/ clavis/FRRB/chronica/Sermo%20Ocko.htm, p. 5): "Nam psalterium in aliquibus locis pulcherrime exposuit, similiter ewangelium et oraciones et alia magistralia similiter componebat, sepius cum magistric, doctoribus et aliis scientifics conferebat disputando."

93. Kantor 1990, p. 77 (from the second Slavonic life of Saint Wenceslas). For Charles IV, see note 13 above.

94. Mengel (2003, p. 351) notes that Charles also apparently gave a head reliquary of Sigismund's queen.

95. This is a central and compelling argument of the thesis of Mengel (ibid., pp. 325–72).

96. Beneš Krabice of Weitmile, FRB 1884, pp. 536–37.

97. Recounted by Beneš Krabice of Weitmile (ibid., pp. 543–44); see Tomek 1855–1901, vol. 2, p. 65, and Podlaha and Šittler 1903a, p. 60. A canon of Saint Vitus's Cathedral specifically credits the saint's body with healing powers (Mengel 2003, p. 263): "Oh, what a venerable, precious and indescribable gift, the aid for every infirmity, is the body of Saint Sigismund" (O venerandum, pretiosum et ineffabile donum, omne infirmitatis auxilium, sancti Sigismondi corpus). A number of earlier sources, including Gregory of Tours, credit Saint Sigismund with healing fever (Mengel 2003, p. 331).

98. Podlaha and Šittler 1903a, p. XXIX (second item).

99. Beneš Krabice of Weitmile, FRB 1884, p. 530; *Kronika pražského kostela* in Bláhová 1987, p. 229.

100. Beneš Krabice of Weitmile, FRB 1884, p. 539.

101. http://www.clavmon.cz/clavis/FRRB/chronica/SERMO%20 Ocko.htm: "Tercie ipse fuit in omnibus sanctis negociis diligens inquisitor: ubicunque enim sciebat sanctuaria et corpora sanctorum, acquirebat et auro fulso gemmisque preciosis obducebat et toto corde diligebat ea, sicut alter Constantinus. "Sermo factus per dominum johannem archiepiscopum pragensem post morten imperatoris caroli iv."

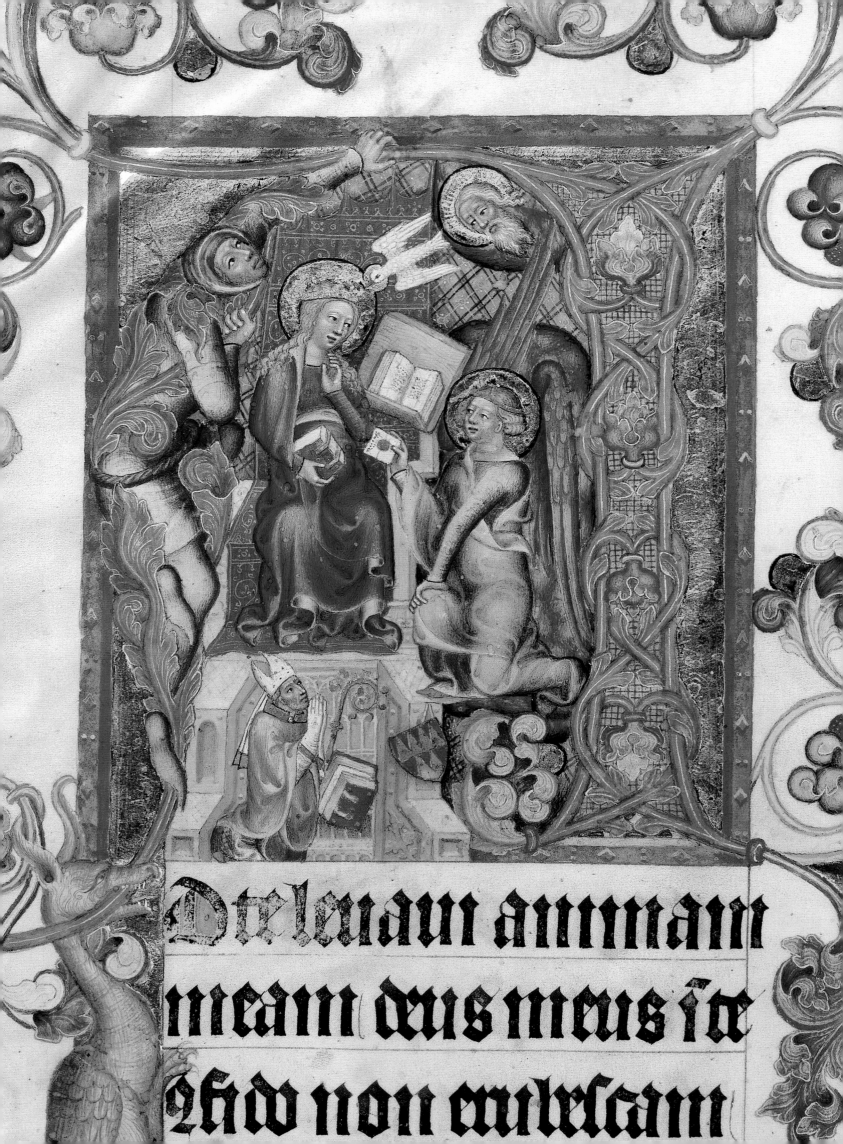

Delectani animam
meam deus meus in
q̄d non emtristam

# The Circle of Charles IV

*At the same time in the territory called Vogtland the emperor managed to procure for
the Crown of Bohemia well-fortified encampments facing Meissen and Thuringia, and he expanded
and forcefully increased the kingdom everywhere. —Beneš Krabice of Weitmile*[1]

Robert Suckale and Jiří Fajt

Anyone looking in a historical atlas at the domain of Charles IV would conclude that the emperor presided alone and unchallenged over a large, unified territory.[2] This would be a false inference. In the fourteenth century there were no states in the modern sense, with clear boundaries and well-defined sovereignty; there was only the dominion of rulers whose power was rooted in a tangle of complex rights, incomes, and rents born, above all else, of a network of personal relationships. To represent the realm of Charles in cartographic form one would need many maps set next to and superimposed on each other, in order to chart the places occupied by advisers, followers, and dependents of the emperor. Each map would resemble a patchwork quilt, but none of them could represent one essential feature of the politics of the period: their constant flux.[3] A successful ruler—and Charles IV was more successful than any other emperor of the later Middle Ages—constantly sought to increase his rights and to strengthen the network of those who depended on him, even if he could do so only gradually. Our conventional picture of history, which emphasizes actions of state, great leaders, and heroic deeds, remains a conglomerate of historical myths that attaches little value to small but significant acts. In this political context, we traditionally neglect the importance of the founding of churches and monasteries, as well as the commissioning of works of art.

One might assume that the emperor was the mightiest man in the empire. Unlike other princes, who inherited their power and in turn passed it on to their heirs, the emperor was chosen by seven prince-electors motivated by self-interest.[4] This compelled candidates to purchase votes, normally by handing over imperial rights and sources of income. Each election further weakened the central authority and accelerated the erosion of the emperor's power. Moreover, the process led to the fraction of the Holy Roman Empire into hundreds of separate sovereign states. Even within his own territories, the ruler had to share power with many other people and institutions. In Bohemia in the hundred years following the death of Charles IV, the position of the monarch deteriorated to such an extent that a prominent merchant commanded greater resources than he did, and some members of the higher aristocracy controlled more land than their official ruler.

The extent of royal power resulted largely from the success or failure of the politics of the period: power was not a given, and it varied from place to place according to the operative political constellation. A diplomatically astute strategist like Charles IV was able to more than double his realm without ever waging a major war,[5] but the authority he built up incrementally quickly dissipated during the reign of his erratic and hedonistic son Wenceslas IV.

A politician of the period needed qualifications altogether different from those required today. He had to understand the history, ambitions, and alliances of more than a thousand families who exercised power and influence within his realm. He had to know the character and qualities of a corresponding number of opponents, allies, and competitors. In addition, he had to be able to assess them all, an ability of particular importance when it came to choosing his advisers.

Fig. 3.1 The Annunciation in an Initial A. Missal of Jan of Středa, fol. 4v (detail). Tempera and gold on parchment; Prague, after 1364. Metropolitan Chapter of Saint Vitus's Cathedral, Prague, Library (Cim 6)

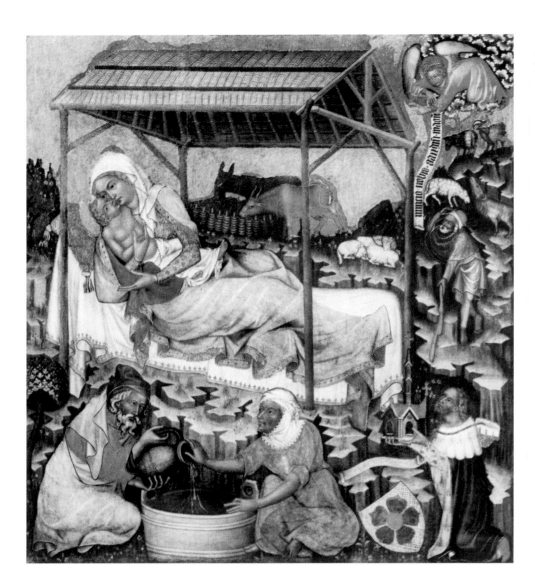

Fig. 3.2 The Nativity. Oil on canvas over maple, ca. 1347. From Vyšší Brod. Národní Galerie, Prague (06787)

Charles's beginnings were arduous. His father, John of Luxembourg, was the archetype of the dashing, knightly daredevil always ready to undertake new, spectacular adventures. A spendthrift, capricious in his politics, he was nonetheless a much-admired man who embodied the romantic ideals of his time. At the Battle of Crécy in 1346, despite having been blinded, he insisted on remaining with his French allies, and as defeat against the English became inevitable, he had himself led into the thick of the fighting to die. His son Charles, who also took part in the battle, ran for his life. Unlike his father, Charles did not at first enjoy favorable public opinion outside Bohemia. Many considered him a usurper against the legitimate emperor, Louis the Bavarian, and mocked him as "the priests' emperor," who served by grace of the pope, or as "the royal merchant," who only came to Italy on account of money.

Even at the time, there was a gulf between widely held ideals and reality. Having witnessed the downfall of his father and of other ambitious rulers, Charles remained a realist. His model was his great uncle Baldwin, the arch-bishop of Trier, the sober, rational brother of the reckless emperor Henry VII and a skillful strategist and negotiator.[6]

Precisely because John of Luxembourg was a celebrated knightly monarch, Charles had for the sake of appearances to maintain this masquerade, at least to a certain extent. Still, rather than imitate his father, he sought to cast himself in distinct roles: as the new Solomon and as other wise men.[7] (Nonetheless, there was considerable continuity in personnel: for example, the famous and powerful head of Charles's chancery, Jan of Středa, had previously served Charles's father.)[8] King John had shown only limited interest in the remote eastern territories of the Bohemian Crown and early on had left their governance to his son. There Charles effectively played his patriotic role as the sole heir, through his mother, of the mythical Czech royal dynasty of the Přemyslids. In the meantime, however, the nobility and patricians had grown accustomed to living without a ruler and had usurped many rights. Charles therefore sought to win back his kingdom. To do so, he enlisted the support of the Church and the populace.

The emperor exploited the political structure of fiefdoms to secure the fealty of as many influential persons as possible. Pragmatic and astute, he never lost sight of his long-term imperial goals. He skillfully organized sumptuous assemblies of princes, in Vienna in 1353 as well as in Metz in 1356 and in Nuremberg.[9] Through financial donations, personal persuasion, and the manipulation of his allies' vanity, he knitted together an extensive, intricate network of personal connections and dependencies. Above all, he isolated his enemies so well that in the end he achieved unrivaled political power, at least in central and eastern Europe. Had he been able to pursue his policies for another decade or two, he would have brought vast parts of the empire under the sway of the Crown of Bohemia.

Charles gathered around him a large number of assistants, courtiers, advisers, and followers.[10] There was hardly a member of the Bohemian aristocracy among them, however. Petr Rožmberk, whose family possessed huge territories in southern Bohemia, was an exception. He was the provost of the All Saints' Chapter in Prague and, together with his three brothers, Jodok, Ulrich, and Jan, founder of the community of Augustinian friars in Třeboň and donor of the famous cycle of paintings in Vyšší Brod (see fig. 3.2).[11] More willing and able to assist were the higher aristocracy not only in Silesia and the neighboring territories to the north but also in those regions supposedly close to the king: Franconia, Swabia, and the Middle Rhine.[12] The number and influence of counselors varied considerably during Charles's reign.[13] There were several advisory councils and a corresponding number of chanceries.[14] Charles was careful to avoid establishing or allowing to be established institutions that did not depend on him.

In the early phase of his reign Charles also employed foreign advisers. Some, like Matthias of Arras, the first architect of the cathedral in Prague, came to him from Avignon via the papal court.[15] Pope Clement VI (r. 1342–52), who was called the *grand seigneur* on the throne of Saint Peter, did more than his predecessors to adorn his residence and city. He distinguished himself not only with his luxurious lifestyle but also with his liberal support of artists and scholars. In light of Charles's ties to Avignon, he must have considered the pope's patronage a model to emulate.

At the outset Charles even took into his service advisers of his archenemy, Louis the Bavarian. One of them was Markwart von Randeck, a canon of Augsburg Cathedral who later became bishop of that see and then, at Charles's express wish, patriarch of Aquileia, no doubt because of his military prowess and bravery in battle.[16] The south portal of the choir of Augsburg Cathedral, of about 1355, reflects Charles's preference at the time for sculpture based on French models. Another follower of Charles, Albrecht von Hohenlohe, bishop of Würzburg, displayed a similar taste for a style oriented toward Paris.[17] Like many Nuremberg patricians, the burgraves from the house of Hohenzollern had been allies of Louis the Bavarian, who had endowed them with more privileges than any previous ruler. Nonetheless, the citizens of Nuremberg were the first, years before Louis's death, to side with his adversary, because they expected still more from the new ruler of Bohemia. They were proven correct.[18] It was in Charles's interest to promote them and their city more than any other imperial metropolis, and for several decades Nuremberg was second only to Prague as a center of Bohemian art (see cats. 17, 100, 137). At the same time, however, Charles sought to keep everything there tightly under his control. For example, the choir of canons (whose principal role was eternal prayer and who were therefore called *mansionarii*) that Charles founded at the Frauenkirche (Church of Our Lady) in Nuremberg remained subordinate to the corresponding chapter at the Cathedral of Saint Vitus in Prague.[19]

The stylistic and thematic diversity of the art created during the initial phase of Charles's reign could be said to mirror the multifaceted politics of the period, as well as the varied backgrounds of Charles's entourage. Moreover, Charles was always prepared to seize upon the ideas and models not only of his followers but also of his opponents, provided that they were convincing and enhanced the prestige of his line.[20] Based on its appearance alone, one would hardly regard the Velislav Bible of about 1340 (see fig. 3.3), for example, as representative of the court art of Charles IV. Yet its commissioner, Velislav, was Charles's *secretarius* and *protonotarius*.[21] Another example is the silver Man of Sorrows in the Walters Art Museum in Baltimore (cat. 10), a donation of Jan Volek, bishop of Olomouc from 1334 until his death in 1351, and therefore more or less securely dated. The monumentality of its conception and its compact proportions call to mind the paintings of Master Theodoric (see cat. 33, for instance). One cannot ignore this resemblance simply because it does not fit within received notions of the history of Bohemian art. Instead, might we not consider the work a unique witness to an artistic tendency adopted by the new court following the coronation of the emperor?[22] Bishop Volek was the illegitimate son of Wenceslas II and thus Charles's uncle, and as provost of Vyšehrad and Charles's chancellor he was one of the most influential men in Prague.[23]

From Pope Clement VI Charles had received the right of naming bishops far beyond the territories governed by the

Fig. 3.3 Scenes from the Life of Saint Joseph. Velislav Bible, fol. 41v. Ink on parchment; Prague, ca. 1340. Národní Knihovna, Prague (XIII C 124)

Crown of Bohemia, and he appointed many, filling virtually all positions in his immediate circle with allies. In other regions he met fierce resistance from the cathedral chapters, who were recruited from the local nobility and were unwilling to relinquish their right of election to either the pope or the emperor. Charles counted at least fifty bishops among his closest advisers.[24] Their participation in politics and culture was still greater: especially in the second half of Charles's reign, they set the tone of court and council. Charles's preference for high-ranking ecclesiastics can be explained in part by the fact that he understood his imperial office as a spiritual one uniquely granted to him by the grace of God. This did not, however, preclude his employing prelates as agents of his political agenda.

Charles had especially close ties to the Bohemian bishops. They were his most important paladins, for they counterbalanced the magnates' power. They also helped him achieve complete administrative control of the kingdom, right down to the very last village. Given that spiritual offices and possessions could not, by canon law, be inherited, their distribution did not diminish royal power. In this regard Charles resumed the policy of the Ottonian emperors, but simultaneously ensured that the prelates remained

sufficiently constrained that they could never emerge as autonomous prince-bishops within their own territories, as had happened throughout the empire. Just such a close alliance united Charles with Przeclaw of Pogorzela, bishop of Wrocław, who proved himself a most loyal follower.[25]

In 1344 Charles took advantage of the nomination of a follower of Louis the Bavarian to the archbishopric of Mainz to wrest the diocese of Prague from the jurisdiction of Mainz and, with the help of Pope Clement VI, to elevate Prague itself to an archdiocese. Concomitantly, the archbishop of Prague assumed the exclusive right to crown the king of Bohemia. A second step in the same direction would have been to extend the sphere of influence of the new archbishop to the neighboring German dioceses, to begin with, those of Bamberg, Regensburg, and Meissen. Only after tedious negotiations with the pope did Charles succeed, in 1365, in having the archbishop of Prague named *legatus natus,* that is, a legate with full papal authority, for these three dioceses, and then only for a few decades.[26] Charles's attempt to pry the bishopric of Wrocław from the archbishop of Gniezno failed in the face of stubborn resistance on the part of King Casimir III of Poland (r. 1333–70), although at the time Silesia belonged almost in its entirety to the territory of the Bohemian Crown and had only nominal ties to Poland. This case in particular demonstrates that vestigial rights were by no means abandoned, for there always remained the hope that they could be renewed through some change of circumstances. (Similarly, the Anjou dynasty never relinquished the title of "king of Jerusalem.") Charles was equally unsuccessful in his efforts to found a diocese in the region of Lusatia with its seat in Bautzen.[27] In spite of such setbacks, the institutionalization of connections to Prague had the effect of establishing in neighboring dioceses the cult of the national patron saint of Bohemia, Wenceslas, along with the statutes of the Prague synod of 1381 and, no later than 1392, the Feast of the Visitation, initiated by Jan of Jenštejn, archbishop of Prague.[28] The increased number of images of Saint Wenceslas, including the often overlooked relief in Litzendorf near Bamberg, reflects the extent to which all this was deliberate.[29]

In the first archbishop of Prague, Arnošt of Pardubice (1297?–1364), the emperor found the perfect ally. Arnošt was the son of the master of the royal palace of Kłodzko, that is, a member of the lower nobility. Following a conversion experience as a young man, he pursued an ecclesiastical career, studying theology and canon law in Padua and Bologna, where he earned the esteem of his contemporaries. He quickly made his career in the Prague Cathedral Chapter, being elected deacon in 1338, bishop at the

beginning of 1342, and archbishop of Prague in 1344. In that capacity Arnošt was the first chancellor of the University of Prague. Charles also made him his legate to Poland. In 1363 Arnošt was promoted to the post of cardinal. He reorganized his diocese, provided it with new statutes, conducted many visitations and synods, and improved the education and discipline of the clergy. He led an exemplary life, even as he remained at the disposal of the emperor for whatever service he might ask of him.[30]

The new archbishop oversaw a considerable number of artistic enterprises, which he considered integral to his efforts to promote piety and to renew the Church, an undertaking in keeping with the millenarian expectations of the emperor.[31] In his chronicle of Charles's reign, Beneš Krabice of Weitmile (d. 1375) suggested the range and extent of Arnošt's commissions, from beautiful choirbooks and other manuscripts to stained glass to the building of monasteries, hospitals, and episcopal palaces.[32] Relatively little has survived, but there is enough, certainly, to allow one to recognize the extent and direction of his artistic patronage. Among the surviving works probably the most important is the Virgin and Child in the Gemäldegalerie in Berlin (fig. 3.4) that was purchased in 1902 from the secondary school in Kłodzko. As his birthplace and the site of his conversion, Kłodzko was close to Arnošt's heart. He had the parish church renovated and richly decorated with works of art, of which a standing Virgin and Child in wood (fig. 3.5) survives.[33] As his burial place the archbishop chose this same church, not the Augustinian collegiate church he had founded nearby. The Marian panel in Berlin (fig. 3.4) probably also originally came from the parish church. In part because the faces of the Mother and Child in the panel from Kłodzko are modern restorations, its similarity to the Virgin and Child from Strahov (cat. 37) has been largely overlooked. The kinship is especially apparent if one compares the Strahov Virgin and Child to the well-preserved angels on the Berlin panel. One can thus conclude that the Strahov Virgin and Child was either donated by the archbishop or at least painted in the same workshop as the Berlin picture.[34] There is some evidence that the Kaufmann Crucifixion in the Gemäldegalerie in Berlin (cat. 1) was also in the possession of the first archbishop of Prague and perhaps even his predecessor as bishop of Prague, Jan IV of Dražice. And Arnošt may have brought from Bologna a Marian image that served as the point of departure for the type of the Beautiful Madonna from Krumlov (fig. 9.3).[35] His patronage of the arts, above all his donations of Marian images, was so extensive that it was rumored that he himself sculpted statues of the Virgin.[36]

The complex imagery of the Kłodzko Virgin and Child (fig. 3.4) suggests that the archbishop had some say in its formulation. He valued the theologically subtle and nuanced lyrics of the Carthusian Konrad of Haimburg (see cat. 39) and kept him in his service as his court poet.[37] The Marian panel from Kłodzko represents the first attempt, apparently at the archbishop's instigation, to translate into visual terms the Laurentian litany's poetic names for the Virgin Mary, which in turn are based on the orthodox Akathistos hymn to the Mother of God.[38] The admiration and reception of Byzantine piety and liturgy were part of

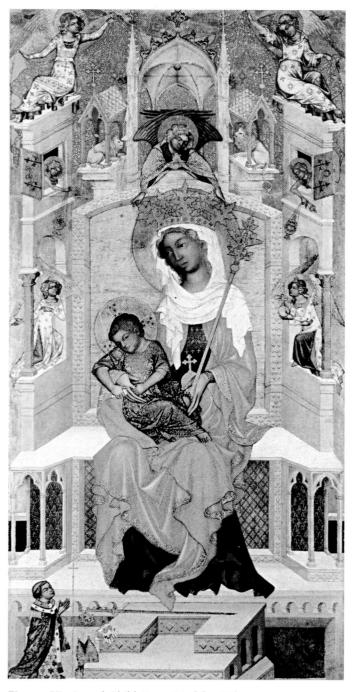

Fig. 3.4 Virgin and Child. From Kłodzko. Oil on canvas over wood, after 1350. Staatliche Museen zu Berlin, Gemäldegalerie (1624)

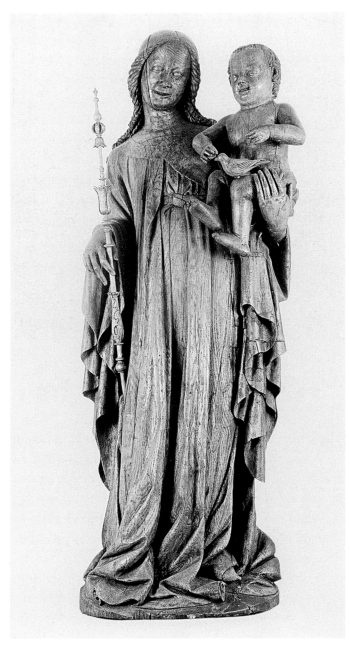

Fig. 3.5 Virgin and Child. Oak, originally painted; Prague, ca. 1350–60. Church of the Assumption, Kłodzko

the religious and political program of Charles IV and his spiritual supporters.[39] The Kłodzko Madonna does not stand at the absolute beginning of this movement, but it appears, along with other closely related Bohemian images, to have stimulated interest in the motif of the *hortus conclusus* (enclosed garden) and the related theme of the Virgin in the Rose Bower (for later examples, see cats. 120, 138). In this context it is worth noting the archbishop's patronage of an illuminated manuscript of the type known as a Marial with poems by Serrasancta, a little-known Italian Franciscan author of hymns.[40]

Arnošt of Pardubice had spent fourteen years in Italy and as a result knew it better than did the emperor. It is

probably thanks to him that the Bolognese component in Bohemian painting of the period is so strong. The works that he commissioned, however, are neither imports, the creation of itinerant Italian artists, nor copies. Each is an independent variation and an attempt to make of the heterogeneous models a new style, simultaneously imperial and Bohemian. Especially striking in the panel from Kłodzko is the hybrid architecture of the throne, which is inhabited by angels and lions. Such pictorial and ornamental architecture, which evokes space yet is unrealistic in comparison with actual buildings, is among the hallmarks of Italianate Bohemian painting. Wherever forms of this kind appear, one can speak of the impact and influence of Bohemian art, whether in the Franciscan church in Toruń or in the Throne of Solomon on the north wall of the transept of the Benedictine Abbey of Saint Lambrecht in Styria, Austria (and see also cats. 21, 156).[41]

In the wake of the reform of the Augustinian order decreed by Pope Benedict XII in 1339, Jan IV of Dražice, the last bishop of Prague, called to Bohemia canons following the stricter Italian Observance. Between 1340 and 1343 he founded for them and richly furnished the monastery at Roudnice nad Labem, located north of Prague at an important crossing of the Elbe (Labe). This laid the groundwork for the reform of related houses in neighboring regions. Jan's successor, Archbishop Arnošt, founded four additional monasteries, in Kłodzko, Sadská, Rokycany, and Jaroměř, all of them profusely decorated (see cat. 40).[42] The canons were the most important allies of the archbishop; they propagated his Marian piety and devoted themselves to preaching and the pastoral care and catechism of the laity. From their ranks emerged the first radical preacher of this period in Bohemia, Konrád Waldhauser. The innovative canons also cultivated new forms of personal piety that were closely related to the Netherlandish *devotio moderna*.[43] Charles IV contributed to the expansion of this congregation by founding, in 1350, a new church for the Augustinian canons in Prague that was dedicated to Our Lady and Saint Charlemagne (Karlov)[44] and, in 1354, a chapel with a chapter of four canons at the legendary birthplace of Charlemagne in Ingelheim, near Mainz. (The chapel was consecrated to Saint Wenceslas and to the imperial patron saint Charlemagne, both of them venerated by Charles IV.) He stipulated that Ingelheim's four canons be Czechs and thus act as Slavic ambassadors within the empire.[45]

The emperor took special care when it came to the filling of those dioceses that could assist in the expansion of his territories, above all those bordering Bohemia, such as Meissen, Naumburg, and Regensburg.[46] In Brandenburg,

Dietrich von der Schulenburg, bishop from 1365 to 1393 and an official adviser (*consiliarius*) to Charles IV, acted as the emperor's agent against the territorial lords of the house of Wittelsbach and thereby laid the groundwork for the takeover of the Mark by Charles in 1373.[47] Charles could be found interfering wherever it proved possible, however, whether in Brixen in South Tirol, in Verden, in Schleswig, or in Schwerin.[48]

On the grounds of *primae preces,* the custom that gave a newly elected king the right to have one wish fulfilled by every spiritual and worldly institution of the empire, Charles appointed quite a number of canons, abbots, and other ecclesiastical officials. As a result, he could call on a network of supporters throughout the empire who supplemented his chancery officials and courtiers.[49] Charles also secured the loyalty of religious institutions and followers by the granting and giving of gifts, especially precious reliquaries, sometimes in return for relics that he himself had received.[50]

Given that the emperor Charles IV was a great lover of the arts, it was to be expected that his favorites should seek to imitate him in such matters. In most instances we know nothing more than what a few isolated passages in the documents can tell us. For example, Jan of Jenštejn, bishop of Meissen and later archbishop of Prague (see cat. 96), donated an altar in Meissen Cathedral dedicated to Wenceslas with especially precious decoration.[51] Charles's followers knew what he expected of them. Thus in 1376 Prior Ulrich of the Praemonstratensians at Chotěšov wrote in his *Agenda seu breviarii ordinis praemonstratensium* that by renovating his monastery he had sought to avoid the displeasure of the emperor.[52]

At the royal court in Paris, Charles had witnessed the advantages of a capable administration. As soon as he assumed power he established an efficient chancery, which he filled primarily with clerics. Here he profited from his secure position as a favorite of the papacy, for the generosity of the Curia enabled him to place his advisers in prebendary and other ecclesiastical positions. The chancery stood at the head of his administration and formulated the better part of his policies.[53] Among the *cancellarii,* the chancellors played the dominant role. They were either already bishops, like Berthold von Hohenzollern of Eichstätt,[54] or they received a bishopric as a reward for their efforts: Jan of Středa, for example, was first bishop of Naumburg, then of Litomyšl, then of Olomouc;[55] Dietrich of Portitz, famous for reorganizing the finances of the Crown, succeeded one after the other to the bishoprics of Sarepta, Schleswig, and Minden, then served as provost of Vyšehrad before becoming archbishop of Magdeburg in 1361.[56] Both bishops appear

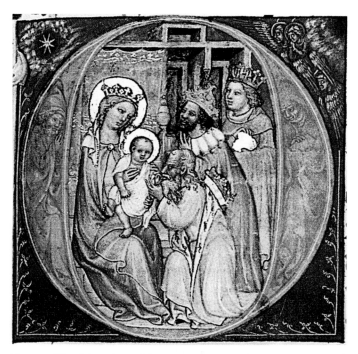

Fig. 3.6 The Adoration of the Magi in an Initial O. *Liber viaticus* of Jan of Středa, fol. 97v (detail). Tempera and gold on parchment; Prague, 1355–64. Národní Muzeum, Prague, Library (XIII A 12)

to have had considerable revenue at their disposal. Although the iconoclasts destroyed most of their treasures, some items of importance were saved, in part because their value was appreciated, and to a certain extent one can assume that what remains is representative of what has been lost.[57]

Jan of Středa and Dietrich of Portitz represented different religious and spiritual tendencies. Jan (ca. 1310–1380), a native of Silesia, was a master of rhetoric and literary form. A lover of the fine arts, he favored delightful formal compositions and sumptuous decoration. He thought in rhetorical terms and deemed himself worthy only of the "sublime style."[58] As a connoisseur he took a particular interest in Italian painting, but he also apparently valued the court art of France.[59] He eagerly appropriated new Italian subject matter, especially complex themes suited to private devotion, such as the pregnant Mary (*Maria gravida*) or the Sienese invention the Virgin in Glory.[60] At the Augustinian Hermits' Church of Saint Thomas in Prague, Jan inaugurated the cult of Saint Hedwig, the holy patron of Silesia. He also endowed the monastery with numerous books, among them a manuscript of Dante's works and yet another of Dante's poems, complete with commentary.[61] Jan wanted his books *decore pontificale,* or decorated in a manner befitting his episcopal office (see fig. 3.1).[62] In the *Liber viaticus,* the traveling breviary made for him in Prague between about 1355 and 1364, the coloration is exceptionally rich and varied, like a perfectly preserved panel painting (see fig. 3.6). The modeling of the figures is very soft and the handling of light highly

differentiated. The painter also introduced elaborate architectural settings and all manner of decorative elements on every folio, so that each one delights the eye in a different way.[63]

Dietrich of Portitz was not such an aesthete and lover of the arts.[64] Only the altarpiece in the small village church of Pechüle in Brandenburg can be firmly associated with him. On the altarpiece, which is related to the Vorau Antiphonary (see fig. 3.7), the Passion of Christ is recounted in two registers.[65] The cycle has no central axis and no clear narrative structure. Each of the pictorial fields is as wide as the event depicted requires. In all likelihood, however, the narrative scenes in the upper and lower registers were meant to relate to one another. The triumphal Entry into Jerusalem in the upper register corresponds to the humiliation of the Way to Calvary at the bottom, and the Offering of the Host in the Last Supper above corresponds to the Deposition below.[66] Only what is absolutely necessary for the viewer's understanding has been included. All anecdotal elements, whether in architecture or landscapes, have been omitted, and the only trace of decoration is the punchwork on the nimbi. The simple and limited colors lack the sensuous appeal of Jan of Středa's illuminated manuscripts, and they are applied in a flat manner that makes them appear even more strident. The patron and his painter were concerned above all with a clear message. Dietrich favored the humble style (*stilus humilis*), with a distinct reduction in ornament and an accentuation of subject matter drawn from the Passion.[67] He had begun his ecclesiastical career in the Cistercian monastery at Lehnin, in the Mark Brandenburg, and in the depth of his heart he remained a Cistercian, an adherent of the emotional Christocentric and Marian piety of Bernard of Clairvaux and his followers, who rejected all pomp. With his own money Dietrich founded the Cistercian monastery of Skalitz, and during his tenure as archbishop of Magdeburg (1361–67) he made numerous large donations to the houses of his former order.[68] It is a pity that not one of the many chapels endowed by this patron has been preserved.[69]

Typical of Dietrich's attitude was his pronouncement as archbishop of Magdeburg on the occasion of his donation of an unusually large red marble slab for the high altar of Magdeburg Cathedral (see fig. 3.8) in 1363: "It is to be known that no one should place painted or carved images on the high altar, other than a crucifix. Only ornamented Gospel books, sacramentaries, and the relics of the saints may be exhibited there. For images are shadowy things and do not contain the truth of what they represent. In contrast, the Gospels contain the teaching of salvation and the truth.... What is signified is worthier than what signifies. But the Passion of Christ is necessary to our salvation.... We must therefore always have it before the eyes of our body and of our soul, and especially as we celebrate Mass, for the Mass is nothing other than the commemoration of the suffering of Christ."[70] This attitude was clearly very different from Jan of Středa's delight in and desire for images, and that difference exemplifies the range of opinion found at Charles's court. Despite the many quarrels and struggles that marked his tenure in Magdeburg, Archbishop Dietrich left a powerful impression, borne out by the many tales still woven around his memory.[71] None of those who came after him achieved anything near his success.[72]

For a brief period Lambert of Brunn, later bishop of Bamberg, played an important role in the imperial chancery. The remnants of murals in his remodeled palace at Forchheim testify to his inclination toward Bohemian art.[73]

The emperor liberally granted titles like *cancellarius* in order to tie important people to him. He was especially good at heaping privileges on those institutions that tended to regard him with mistrust or were less than willing to bend to his wishes, and he also supported the reform of

Fig. 3.7 Prince Vratislav II. Vorau Antiphonary, frontispiece (detail). Tempera and gold on parchment; Prague, ca. 1365–70. Augustiner-Chorherrenstift, Vorau (Cod. 265 [259])

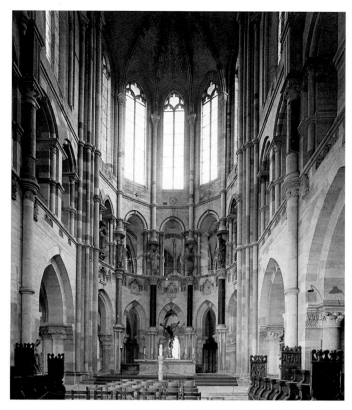

Fig. 3.8 Altar, Magdeburg Cathedral

hostile institutions. He was clever enough, for example, to patronize the Prague Cathedral chapter, a venerable and for the most part highly aristocratic body that was jealous of its rights and concerned with the preservation and expansion of its privileges.[74] In the end it was the chapter of the cathedral of Prague that bore the cost of erecting Saint Vitus's Cathedral. The canon who was in charge of the construction, Beneš Krabice of Weitmile, was a friend of Charles's since childhood and the principal chronicler of his reign. Through Beneš Krabice the emperor was able to act as the driving force behind the building. Charles also sponsored the venerable Vyšehrad monastic foundation. When he established, in 1339, the aristocratic collegiate chapter of the Royal Chapel of All Saints at Prague Castle on Hradčany hill, he created yet another institution in this sphere, whose first provost, Jan Očko of Vlašim (d. 1380), succeeded Arnošt of Pardubice as archbishop of Prague in 1364 (see fig. 8.1).

Whenever an adviser to the emperor can be identified as a donor of a work of art, then, it immediately becomes apparent that the work was either imported from Prague or made by artists from or trained in Bohemia. The same heuristic premise can be applied in reverse: whenever one encounters a work that is closely affiliated with Bohemian art, it is safe to assume that behind it stands a follower of Charles IV.[75]

1. Beneš Krabice of Weitmile, FRB 1884, p. 540 (regarding the year 1369): "Item eodem tempore emit imperator in terra advocatorum versus Misnam et Turingiam plura castra fortissima pro regno Boemie, et dilatatum est regnum et ampliatum ad omnes partes vehementer" (translation by Xavier Seubert).
2. See Putzger 1954, pl. 67; and Kinder and Hilgemann 1964, vol. 1, p. 194. The four maps in Stoob 1990 that chart Charles's itinerary and correspond to the four most important stages in his life represent enormous progress, however.
3. Newman (1937 and 1971) clarified this in an exemplary fashion using conditions in France.
4. From the time of their establishment the seven electors consisted of two groups: spiritual (the archbishops of Mainz, Cologne, and Trier) and secular (the king of Bohemia, the count of the Rhine Palatinate, the duke of Saxony, and the margrave of Brandenburg).
5. On territorial expansion, see Grotefend 1909; Reincke 1924; Hofmann 1963; Hohensee 1967; Kavka 1978; and Rader 1997.
6. Of Baldwin it was said, "All his life the hegemony of his family remained the measure of his actions" (Stengel 1937, esp. p. 12; and see also Haverkamp 1978 and Heyen et al. 1985). Baldwin's efficient and well-organized chancery was an example for Charles to emulate. One of Baldwin's most generous acts was to allow Charles to take into his service Rudolf Losse, a gifted jurist of middle-class background and one of his best notaries and chancery officials. Losse represented a class of competent professionals who seldom could be counted among the patrons of art and none of whom can be connected with significant commissions of works of art. See Stengel 1921–30.
7. Herkommer 1980, pp. 68–116; Kelly 2003, esp. pp. 287–305; Suckale 2003c.
8. Moraw 1985, esp. pp. 31–37.
9. See Hergemöller 1999 and, on the masterful diplomatic accomplishments of the meeting in Vienna, Stoob 1970, esp. pp. 171–214.
10. For a discussion of just how numerous and varied this court society was, see Patze 1978, pp. 1–37.
11. On the Rožmberk family foundation, see Claussen 1980, pp. 295–99. The brothers were also founding contributors to the Bohemian hospice in Rome, which Charles IV placed under the jurisdiction of the abbot of Třeboň (see Kadlec 2004, pp. 83–84).
12. See Moraw 1978 on the importance of the Silesian dukes in the Great Council (p. 288) and on the steward Burchhard, burgrave of Magdeburg, whose tomb monument in the Cathedral of Saint Vitus survives in a fragmentary state (p. 287). On Burchhard's administration of the court, see also Moraw 1987, esp. pp. 196ff.
13. Moraw (1978, p. 287) reckons that Charles IV had a total of 182 advisers and secretaries (secretarii). See also Hlaváček 1992 and Hlaváček 1987.
14. Moraw 1985, p. 36. On the separation of the so-called court chancery and the steward Burchhard of Magdeburg, see Hölscher 1985, pp. 43–44.
15. Baumgärtner 1993, col. 292. It is regrettable that after some scholarly forays in 1901 by Max Dvořák, who exaggerated the importance of the papal see for the formation of art under Charles IV, virtually no further research on this topic has been undertaken. See also Dostál 1922.
16. He proved himself to be a courageous soldier during the Italian campaign of 1355 (see Glasschröder 1888). On his artistic commissions in Augsburg, see Suckale 1993b, pp. 165ff., and Gatz 2001, pp. 20–23.
17. Fajt 2004, pp. 207–20.
18. Lehmann 1913; Schultheiss 1963–64; Suckale 1993b, pp. 156ff.
19. See Blohm 1990.
20. On the diversity of Charles's early commissions, see Suckale 1993b, pp. 165ff., and Schmidt in Benešovská 1998, p. 163.
21. On Velislav and his Bible, see most recently Schmidt 1998a, esp. p. 159.
22. Frind 1864–78, vol. 2, p. 170; Verdier 1973 (the most extensive analysis but incorrectly dated, corrected by Otavsky in Cologne 1978–79, vol. 2, pp. 702–3); Gatz 2001, p. 511.

23. Moraw 1985, p. 34.

24. Hölscher (1985, pp. 210ff.) provides a preliminary list.

25. Gatz 2001, pp. 111–12. On Wrocław and Preclav von Pogarell, see Hledíková 1972, p. 224. On Preclav von Pogarell, see also Marschal 1980, pp. 38–40.

26. Hledíková 1972; Veldtrup 1989, esp. p. 75. On the institution of *legatus natus,* see Schott 1778. In Germany, the archbishops of Trier, Cologne, Mainz, and Salzburg possessed this title. According to Hölscher (1985, p. 53), Charles sought to extend the power of the legates to the diocese of Brandenburg.

27. Pustejovsky 1975; Hledíková 1972, p. 222 (on Bautzen).

28. Hledíková 1972, pp. 242ff.

29. For an example of a representation of the Visitation that apparently was added to a manuscript from Regensburg on account of this decree, see Regensburg 1987, no. 63, pl. 57. See also Zimmermann 1964.

30. Balbín 1682; Miller 1690; Frind 1864–78, vol. 3, pp. 90ff.; Neuwirth 1893, pp. 66ff.; Chaloupecký 1946; Gatz 2001, pp. 587–89.

31. On Charles's millenarian conception of himself as Emperor of the Last Days, see Suckale 1993b, pp. 161ff.

32. Beneš Krabice of Weitmile, FRB 1884, p. 530. On Arnošt's commissions, see Suckale 1993–94, Royt 1998, and Suckale 2003b, esp. pp. 140ff. The painted cross that was added afterward cannot be interpreted as the insignia of the papal legate, insofar as this office was first conferred on the archbishop of Prague in 1365, that is, a year after Arnošt's death. Moreover, according to canon law the gilded processional cross was reserved for true metropolitan sees (i.e., archbishoprics). It therefore remains most plausible to interpret the cross as an archbishop's crozier and to date the picture to 1343–44.

33. Miller 1690; Schultes 1998, pp. 36ff.

34. Schmidt (1969b, p. 176) is the only scholar to have previously recognized this connection.

35. Suckale 2003b, p. 130; Hermann 1929, no. 87, pp. 162–67, pl. 66.

36. Neuwirth 1893, p. 158.

37. Frind 1864–78, vol. 2, p. 407; Dreves (1888) 1961; Suckale 2003b, pp. 124ff. The *Orationale Arnesti* (Národní Muzeum, Prague, Library, XIII c 12), commissioned by Arnošt, contains important poetic works by Konrad. The Carthusian also compiled texts for use in the liturgy of the Prague chapter of the Mansionarii, for example the *Laus Mariae,* also probably commissioned by Arnošt (Národní Muzeum, Prague, Library, XVI D 13; cat. 39).

38. Meersseman 1958–60; Suckale 1993b, pp. 265ff.

39. Suckale 2003b, pp. 103–50.

40. Österreichische Nationalbibliothek, Vienna, cod. 1389 (Hermann 1929, no. 85), which comes from the monastery of Augustinian Canons in Kłodzko and bears the coat of arms of the archbishop on the title page. On Serrasancta, see Möckshoff 1954.

41. The majority of examples most likely stem from the period of Charles IV.

42. See Frind 1864–78, vol. 3, pp. 97ff., Zibermayr 1929, pp. 333ff., and Zeschick 1969 on the new monasteries and affiliated houses founded subsequently outside Bohemia, for example Neunkirchen am Brand in the region of Bamberg, Langenzenn in the territory of the burgraves of Nuremberg, and Indersdorf in Bavaria.

43. Winter 1964, pp. 50ff.; Girke-Schreiber 1974, esp. pp. 84ff. One aspect of this different conception of monastic life was the elimination of the dormitory and its replacement by individual cells.

44. On the construction of the Karlov monastery on the model of the cathedral in Aachen, see Zibermayr 1929, pp. 328ff., and Kroupová and Kroupa 2003.

45. On Ingelheim, see Claussen 1980, pp. 291ff. (with bibl.). According to legend it was in Ingelheim that Charlemagne had received the sword with which he went into battle against the heathens (Hledíková 1982, pp. 23–27).

46. See Frind 1864–78, vol. 2, pp. 374ff. (on the bishops of Meissen), 390ff. (on the bishops Charles installed in Regensburg).

47. Gatz 2001, p. 76.

48. The low esteem in which such episcopal seats were held becomes apparent when one considers how often they served as stepping-stones on the way to more highly respected appointments, as, for example, in the case of Peter Jelito, who was archbishop of Magdeburg from 1371 to 1381 after having served as bishop of Chur from 1356 to 1368 and of Litomyšl from 1368 to 1371 (Gatz 2001, p. 514).

49. See Hölscher 1985, p. 46, on Charles's efforts to revive and turn to his own purposes the practice of *primae preces,* which was reviled by those subject to it, who sought to relieve themselves of their obligations through one-time payments.

50. The imperial Benedictine Abbey of Saints Ulrich and Afra in Augsburg received a bust of Saint Denis from Charles in 1350 (see fig. 2.6). On the reliquary shrine Charles donated to Saint-Maurice-d'Agaune in the Swiss Valais, see Reiners 1944.

51. Frind 1864–78, vol. 3, pp. 423ff., vol. 4, pp. 532ff. See also, among others, Claussen 1980, pp. 293ff.; Hölscher 1985, p. 49; Fajt 2000, pp. 489–500; and Suckale 2003b, p. 127. On Jan of Jenštejn, a nephew of Jan Očko of Vlašim and his successor as archbishop of Prague, see Neuwirth 1893, p. 75, and Weltsch 1968.

52. See Neuwirth 1893, pp. 81ff., 111, on Charles's influence on the artistic undertakings of his ecclesiastical appointees.

53. The other noteworthy innovation of the French court, the institution of the royal council, had a much more limited function.

54. Berthold, who was originally a Teutonic knight, was bishop of Eichstätt from 1351 to 1365, chancellor to Charles IV, and administrator of the bishopric of Regensburg for his brother Friedrich. His epitaph, with a legible inscription despite its having been overpainted in 1497 by Wolf Traut, survives in the Cistercian monastery of Heilsbronn in Middle Franconia. Suckale (1993b, pp. 151ff.) associates this bishop with the murals in Dollnstein, near Eichstätt.

55. Frind 1864–78, vol. 2, pp. 112ff.; Tadra 1879; Tadra 1886; Petersohn 1960; Klapper 1964; Rieckenberg 1975; Moraw 1978, pp. 291ff. In 1357 Jan of Středa founded the monastery of the Augustinian Hermits in Litomyšl and generously enlarged the church dedicated to the Raising of the Cross. According to Neuwirth (1893, p. 80), the Chapel of the Cross in the bishop's house in Prague was decorated in an especially rich fashion.

56. Frind 1864–78, vol. 2, pp. 171ff.; Nováček 1890; Sello 1890; Engel 1982, pp. 206ff.; Moraw 1982, p. 254; Hölscher 1985, p. 44.

57. Nonetheless, the fact that we do not have any of Charles's own luxury manuscripts represents an enormous loss.

58. On the application of the lessons of the *genera dicendi* in Bohemian court culture of the period, see Suckale 2003b, pp. 257–86, and also Burdach 1893–1937, vol. 1, pp. 73, 106.

59. Schmidt 1969b, esp. pp. 171–79. Krása (in Kotrba et al. 1971, pp. 396ff.) mentions the French illuminator Jean Pucelle (active ca. 1319–34), among others.

60. Krása in Kotrba et al. 1971, pp. 393ff.

61. Neuwirth 1893, p. 240.

62. Burdach 1893–1937, vol. 1, p. 79.

63. The genesis of the style of the Master of the *Liber viaticus* is often explained in terms of the emperor's trip to Rome for the imperial coronation in 1355 (see Schmidt 1969b, esp. pp. 180–81). The manuscript with Walafridus Strabo's glosses on the book of Job in the library of the Národní Muzeum, Prague (XVI A 15), which is dated 1354, shows that by then the style of the Vorau Antiphonary (see fig. 3.7) favored by Dietrich of Portitz was also fully developed. See Brodský 2000, no. 230, fig. 272.

64. Suckale 1996b.

65. The previously supposed connection between the Vorau Antiphonary and the Vyšehrad monastery and its provost, Dietrich of Portitz, can be further maintained, confirmed by a great conceptual similarity between the antiphonary and the Pechüle altarpiece.

66. Schultes (1987) has already eloquently expounded on the eucharistic character of the theme of the Deposition.

67. Suckale 1996b.

68. Frind 1864–78, vol. 2, p. 101.

69. See Neuwirth 1893, pp. 71 (on the Roudnice episcopal palace chapel, consecrated in 1370 and completed in 1371), 80 (on the chapel in the Prague residence of Jan of Středa), 163ff. (with a list of documented castle chapels).

70. Quoted in Sello 1890, pp. 37ff.; see also Kroos 1989, esp. p. 91. Attached to the reverse of the Pechüle altarpiece is a support that was probably intended to hold a cross. A Crucifixion would otherwise be a striking omission from the cycle. On the altarpiece, see Suckale 1996b and Suckale 2001a, pp. 247–65.

71. For these legends, see Sello 1890.

72. Between 1368 and 1372 Albert of Šternberk served as director of Charles's chancery in Magdeburg. His successor as chancellor there was Peter Jelito (r. 1372–80; see note 48 above). The beautiful Bohemian Pietà of marly limestone (Clasen 1974, figs. 378–80) probably came to the cathedral under Albrecht von Querfurt, the first archbishop of Magdeburg (r. 1382–1403) who was not from Bohemia. See the forthcoming monograph by Maria Deiters to be published by Deutscher Kunstverlag Berlin.

73. Frind 1864–78, vol. 2, p. 172. Following a period as provost of the Benedictine monastery of Gengenbach, Lambert became provost of Vyšehrad, before finally serving successively as bishop of Brixen, Speyer, Strasbourg, and Bamberg.

74. Frind 1864–78, vol. 2, pp. 165ff. Only in 1390 were they granted the privilege of wearing pontifical insignia—miter, gloves, cope, and so on—on certain high feasts (see ibid., vol. 3, p. 19).

75. The proposition also makes sense the other way around. Take, for example, Kuno von Falkenstein, archbishop of Trier (r. 1362–88), who demonstrated determination, even intelligence, in going his own way with the works of art he commissioned in order to maintain his distance from the Bohemian mainstream. It should not come as a surprise to learn that he was among the most stubborn and empassioned enemies of the emperor Charles IV.

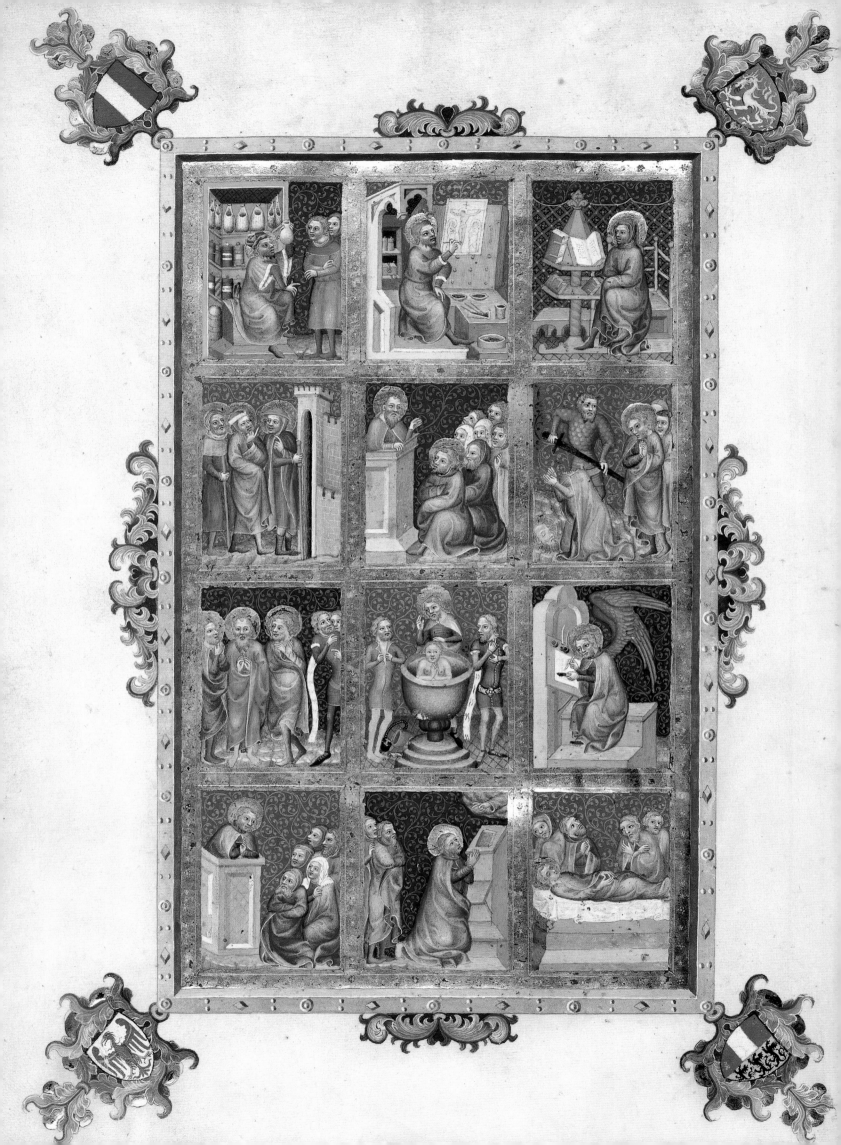

# The example of prague
# in europe

*He took himself to the German lands and likewise secured peace there between*
*imperial lords and the towns.* — Beneš Krabice of Weitmile[1]

Robert Suckale and Jiří Fajt

The complex web linking late medieval dynasties affected both contemporary politics and art, including the history of Charles IV and the Luxembourgs in central Europe. The archrivals of the Luxembourgs were the Habsburgs, partly because of similar family histories. While both belonged to the high aristocracy, they had originally been only minor counts. Ironically, this proved fortuitous, for the council of electors who chose the monarch did not want a powerful prince to be emperor. Like the Luxembourgs, the Habsburgs originated in the western territories of German-speaking lands but achieved success only farther east, where their lack of a venerable lineage was not a disadvantage. Instead, they created fictitious genealogies or falsified evidence: Charles's Luxembourg family tree included biblical patriarchs (fig. 4.2, and see also fig. 4.3) and Roman emperors, while the Habsburg Rudolf IV presented documents by Julius Caesar and Nero as proofs of privilege. In the east, it was easier for the two families to acquire large, contiguous territories, to sustain feudal relationships, and to centralize power.

As players in a complex chess match, every ruling house experienced rivalries and court intrigues, and the game was further complicated by the interference of royal neighbors. Although dynasties battled one another ferociously, they were also bound by close intermarriages, so that most unions required a papal dispensation. Each marriage alliance was an act of state, often planned for decades.[2] Shortly after birth, a royal would be espoused in a pro forma fashion. While still unconsummated, such marriages could be dis-

solved, especially if a better opportunity arose or political allegiances shifted. Children were often taken from their families to live in the court of their espoused, a policy that could produce tragic results.

The fate of Charles's oldest sister, Margaret (1313–1341),[3] is a case in point. Raised as a French princess, she was engaged at fourteen months to Duke Heinrich II of Lower Bavaria. When she was nine, the symbolic consummation took place, and seven years later she gave birth to her only child, John. About ten years later, after her husband and son had died in rapid succession, she was driven from her property by her husband's despised cousin, Emperor Louis the Bavarian, and returned to Charles in Prague. Her brother had long since secretly forged plans for Margaret to marry King Casimir the Great of Poland (r. 1333–70) and, with much urging, ultimately obtained her consent. Overjoyed, the gift-laden Casimir rushed to Prague, only to find his intended overcome with grief. According to the chronicler Matthew of Neuenburg: "From her first glance at this man from Kraków, who appeared to her like a heathen, this refined woman was so deeply shocked that, after a brief greeting, she turned to the wall without a word and died."[4] For his part, Charles was primarily disappointed that the alliance with Poland had suffered such a setback.

This failed marriage alliance perhaps sheds light on two sculptures in Polish collections that Casimir may have brought back from Prague. The first is the Madonna on Lions in Łuków.[5] Its subject identifies it as a product of the Prague court, but its quality surpasses that of any other extant example of its kind. Stylistically, it is apparently indebted to French courtly figures, such as the statuette of the Virgin and Child from the royal Dominican convent at Poissy, a

Fig. 4.1 Scenes of the Life of Saint Luke. Gospel Book of Jan of Opava, fol. 2r. Tempera on parchment, 1368. Österreichische Nationalbibliothek, Vienna (Cod. 1182)

47

Fig. 4.2 Noah. After the Luxembourg Genealogy painted on the walls of Karlštejn Castle (now lost). Codex Heidelbergensis, no. 1. Tempera on paper, 1571. Národní Galerie, Prague, Archives (AA 2015)

Fig. 4.3 John of Luxembourg. After the Luxembourg Genealogy painted on the walls of Karlštejn Castle (now lost). Codex Heidelbergensis, no. 53. Tempera on paper, 1571. Národní Galerie, Prague, Archives (AA 2015)

widely disseminated type.[6] A French-trained artist was responsible for the second sculpture in Poland, the important wood Virgin and Child in the Carmelite convent of Kraków "Na Wesołej."[7] The figure displays strong similarities to the elegant stone statue in the Louvre from the Church of La Celle-sur-Seine, which was carved about 1340.[8]

Although familial bonds tied the Luxembourgs to the Capetians in France, surprisingly few links to France are found in the visual arts of Bohemia. The single imported marble statue at Karlštejn is unexpectedly modest.[9] To it can be added the statues carved by western-trained sculptors in the Ursuline Cloister, Würzburg, and in nearby Nordheim (fig. 4.4) and on the south choir portal of Augsburg Cathedral; the Virgin and Child from the Old Town Hall in Prague (fig. 4.5); and the French ivory statuette in the treasury of Saint Vitus's Cathedral (cat. 8).

In many respects, Casimir modeled himself on Charles IV, although his dynastic ties to Hungary were in fact consider-

ably closer. The art he commissioned was chiefly indebted to Bohemian examples but did not slavishly imitate them.[10] That ecclesiastical patrons and institutions in Poland were also familiar with the court art of the Luxembourgs is attested to by the two Bibles in the library of the archiepiscopal court in Gniezno.[11] Striking similarities to architecture in Prague are apparent in churches from 1350 to 1400, including the Convent Church of Saint Catherine of the Augustinian Hermits in Kazimierz, whose cloister, moreover, was decorated about 1400 with murals in the Bohemian manner.[12] The same is true of the principal parish church of Kraków, the Marian Church, of which the city's bishop was the patron. Construction of its choir by Niklas Wirzing the Elder (d. 1360), a follower of Matthias of Arras, the master of Prague Cathedral, was financed by Casimir.[13] In 1365 his son commissioned a new high altarpiece for the choir, which from 1360 to 1400 was decorated with a cycle of stained glass most likely designed by painters from Prague.[14]

Poland's orientation toward Bohemia continued even after the Jagiellonian dynasty came to power in 1386. In 1390, for example, the Slavs' Benedictine convent was modeled after the Emmaus Convent in Prague. They also supported the construction of the nave in the Marian Church, Kraków, executed by another Prague architect, Niklas Wernher.[15] In addition, the Pietà in the Beautiful Style from about 1400 in the nearby Church of Saint Barbara was made in Prague.[16]

The clearest indication of dynastic ties between Poland and Prague is the coronation Ordo of the Polish kings, compiled by the bishop of Kraków, Zbigniew Oleśnicki. In most respects, this ritual book of directions for the ceremony translates a Bohemian model into a Polish context. The ceremonial procession to the tomb of the Polish national saint, Stanislas, in the Skałka Sanctuary beneath Wawel Castle mirrored the one to the palace of the legendary ruler Přemysl at Vyšehrad, close to Prague, during the coronation of the Bohemian monarch. Bishop Oleśnicki's source was a transcription of the Bohemian Ordo appended to Přibík Pulkava's *Chronica Bohemorum,*[17] which Charles had had prepared for his son Wenceslas (see fig. 8.3).[18]

Fig. 4.4 Virgin and Child. Sandstone; French sculptor, late 1340s. Private collection, Nordheim

Fig. 4.5 Virgin and Child. From the Old Town Hall, Prague. Sandstone; Prague, ca. 1356–57. Muzeum Hlavního Města, Prague (41 274)

Such close bonds between Poland and the Prague court explain why the Piast dynasty in Silesia, a former Polish territory, considered themselves vassals of the Bohemian ruler.[19] Duke Ludwig of Legnica and Brzeg, for instance, analogously emulated Prague's cult of Saint Wenceslas by promoting devotion to the Silesian Saint Hedwig. In her honor Ludwig founded several churches and chapels, ordered from a painter trained in Prague the magnificent manuscript of the saint's legend (cat. 7), and most likely commissioned the panel with the Throne of Mercy (Muzeum Narodowe, Wrocław) from an artist in the workshop that created the Vyšší Brod Altarpiece.[20]

As for the Habsburgs, they claimed superiority because two of their ancestors, Rudolf I (r. 1273–91) and Albert I (r. 1298–1308), had become kings. By contrast, the Wittelsbachs were regarded as inferior to both houses and were sought only as partners in alliances. Following the premature death of King Henry VII (the first Luxembourg Holy Roman Emperor) in 1313, however, and considering that their own candidate, John, was too young, the Luxembourgs needed a substitute candidate to put up against Frederick III, the Austrian pretender to the throne. Their hopes that Louis (r. 1314–47), the second-born in the Upper Bavarian line of the Wittelsbachs, would be a willing puppet were quickly dashed. The Bavarian proved to be not only long-lived but also skillful in pursuing his own interests. He expanded his power base, for example, by appropriating the reverted margravate of Brandenburg, which the Luxembourgs also had in their sights. For a time, Louis even entered into an alliance with the Habsburgs. His actions ultimately established the Wittelsbachs for centuries as the third power competing for the imperial crown.

The example of the Salzburg archdiocese demonstrates the power of these complex relationships. Because of considerable antipathy against the neighboring Habsburgs and Wittelsbachs, Luxembourg partisans were repeatedly elected to important ecclesiastical offices in the city. Charles IV also exploited the right given to him by Pope Clement VI to fill almost all episcopal positions, especially within the Wittelsbachs' sphere of influence, in order to encircle his rivals.[21] As a result, Bohemian works and Bohemian artists were strikingly visible in Salzburg. The Beautiful Madonna from Altenmarkt im Pongau may represent a donation of Archbishop Ubaldin, who was the papal nuncio in Prague from 1389 to 1394.[22] Another example is the Pietà from the Benedictine Abbey of Seeon, near Salzburg (fig. 4.6), which was certainly also imported from Prague.

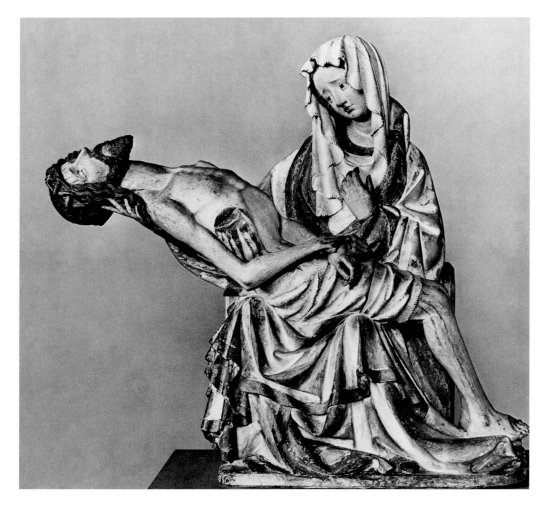

Fig. 4.6 Pietà. From the Benedictine Abbey of Seeon. Limestone with paint; Prague, ca. 1400. Bayerisches Nationalmuseum, Munich (MA 970)

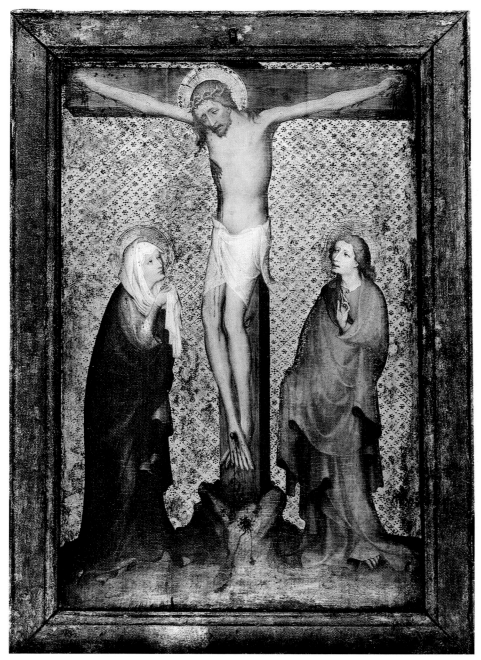

Fig. 4.7 Bavarian artist under Bohemian influence. The Crucifixion. From Pähl Castle. Tempera and gold on linen over wood, ca. 1400. Bayerisches Nationalmuseum, Munich (MA 2377)

After the death of Louis the Bavarian in 1347, Charles IV did not rush to make peace with his sons, but instead exploited differences between them. When, in 1373, he was able to purchase the Brandenburg margravate, which lacked any significant natural resources, he was willing to sacrifice the Upper Palatine and the "land bridge" to Frankfurt as part of the agreement. At least for a while, this exchange meant an end to his political ambitions in the western territories of the Holy Roman Empire, as he decided to concentrate on regions adjoining Bohemia. To further this process, he appointed an ally, Dietrich von der Schulenburg (r. 1365–93), as bishop of Brandenburg.[23] In the end, Charles won over the Wittelsbachs of the Rheinland-Pfalz line through his marriage in 1349 to Anna of the Palatinate (d. 1353), daughter of Rudolf II of that dynasty.[24] The allegiance between the two dynasties was reinforced when the heir to the throne, Wenceslas, married the Bavarian princess Johanna in 1370. Thus, only toward the end of the fourteenth century does Bavarian art begin to emulate Bohemian models (the retable from Pähl Castle is a case in point; fig. 4.7).[25]

In light of the antagonism between Louis the Bavarian and Charles IV, it is surprising that Charles borrowed extensively from Louis's imperial iconography. He both copied Louis's seal and adopted certain symbols of state from him, including innovations in the imperial dress such as the priest-

**Rudolfus Archidux Austrie tertu**

Fig. 4.8 Court painter, Prague. Rudolf IV. Paint and gold on panel, ca. 1370. Dom- und Diözesanmuseum, Vienna

like stole, the increased prominence of the miter within the crown, and the double-eagle insignium.[26] Like Louis, he turned from artistic models in the style of the French court to those provided by Italian painting,[27] although this was in keeping with the trend of the times. More difficult to explain is how Louis's court workshops came to Moravia.[28]

At the rulers' Diet in Vienna in 1353,[29] Charles arranged for the marriage of his daughter Catherine to Rudolf IV, the heir to the Habsburg throne. The ambitious Rudolf, envious of the splendor of Charles's court, assumed the title of archduke, invented new insignia, and encouraged the imitation of Prague models in Vienna. Like Charles, Rudolf was a passionate collector of relics. In seeking to raise the status of Saint Stephen's Church in Vienna to a bishopric, he transferred the cathedral chapter of the imperial palace to the church and established the *capella regia Austriaca,* or royal courtly chapel, there. He had the church decorated with a series of statues of past and contemporary rulers (see fig. 4.9)

and ordered a carved stone tomb for himself, complete with his portrait painted by an artist trained in the circle of Master Theodoric, Charles's court painter in Prague (fig. 4.8).[30] The statues he obtained for the Chapel of Saint Eligius are also based on examples from Prague; the Virgin and Child, for instance, imitates that in the Old Town Hall (fig. 4.5).[31]

Rudolf's emulation of his despised father-in-law's court is remarkable in that Vienna boasted art from the ducal workshops, especially those of the so-called Michael's Master, that was in all respects equal to Prague's.[32] Imitation can, of course, be an expression of grudging dependency as well as of admiration. Two lines of defense presented themselves, of which the first was to outdo the model. Thus, the spire of Saint Stephen's copies the forms of Prague Cathedral's but surpasses it both in size and in ornate decoration. The other means was to cite the model, but take it in another direction, as can be seen, for example, in the works of the Master of Grosslobming and the court workshop of Viennese painting.[33]

Rudolf's siblings and cousins were similarly ambivalent. His brother Albert III, also married to one of Charles's daughters, had a retable made for his castle residence at Tirol by a Bohemian court artist of the same generation as Master Theodoric.[34] In 1368 he also commissioned Jan of Opava in Prague to create perhaps the most unusual Gospel book of the period, in which borrowings from pre-Romanesque art are meant to assert the ancient ancestry of the Habsburg line (figs. 4.1, 4.10).[35] Other exceptional Bohemian works can be found in the regions controlled by the dukes of Styria, among them a retable with three Passion scenes from the Benedictine Monastery of Saint Lambrecht dated about 1366 (Landesmuseum Joanneum, Graz), whose middle panel varies the composition of the Kaufmann Crucifixion (cat. 1).[36]

In contrast, evidence of Bohemian models explainable by political or dynastic relationships is rare in the West Austrian territories ruled by the Habsburgs. That these regions looked mostly to Franco-Flemish court culture is in itself an indication that the Upper Rhine was no longer in the emperor's sphere of influence. This was even truer of Northwest German lands, although the duchy of Luxembourg was a near neighbor and had close family ties to the ruling dynasties there. In light of the superior power of the rulers of surrounding territories, Charles could not sustain imperial policy or intervene militarily in the regions ruled by the Rhenish electors. He nonetheless consciously behaved as the benevolent ruler, waiting for any sign that conditions were ripe for change.[37]

This absence of Prague-inspired works appears to be contradicted by the sculptures on the Saint Peter Portal at Cologne Cathedral (cat. 59). Although the archbishop of

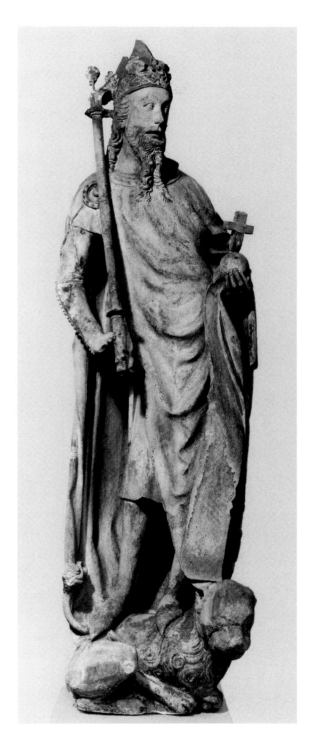
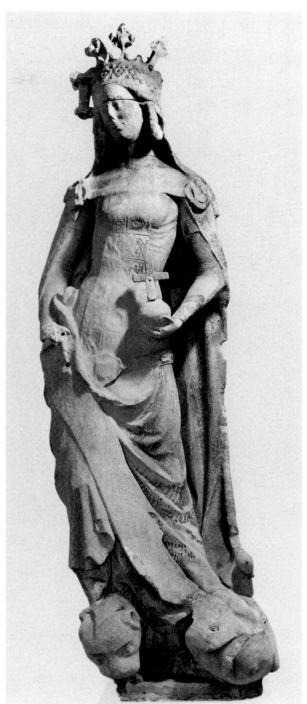

Fig. 4.9 Ducal workshop, Vienna. Charles IV and Blanche of Valois. From the Cathedral of Saint Stephen, Vienna. Sandstone, 1359–65. Historisches Museum der Stadt, Vienna (567, 579)

Cologne, Friedrich von Saarwerden, was an ally of the emperor, he had no say in this matter because he resided in Bonn. More important was the network that linked cathedral ateliers within the Holy Roman Empire, dominated by the family of master builders, the Parlers. When Charles brought Peter Parler to Prague from the Upper Rhineland, the center of this dynasty shifted to Saint Vitus's Cathedral (see, especially, cats. 45–47, 57).[38] In this context, the Parlers' presentation drawing for the belfry tower of Strasbourg Cathedral resulted

not from Charles's relative Johann von Luxembourg-Ligny's being the bishop of the city but rather from the Strasbourg workshop's being controlled by the Parlers.[39]

Similarly, as Prague emerged as a flourishing center of artistic production, it developed its own dynamic that no longer depended on the taste and commissions of the ruler. Many artists from various regions settled in the city, where they could study and hope that lucrative projects would come their way. The superiority of the new art from Prague

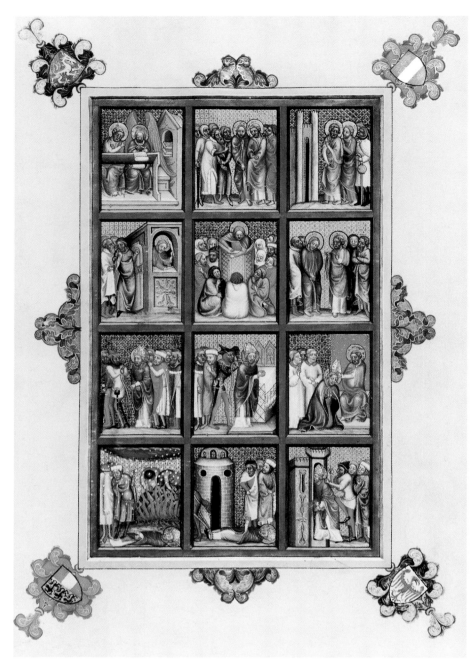

Fig. 4.10 Scenes of the Life of Saint Mark. Gospel Book of Jan of Opava, fol. 55v. Tempera on parchment, 1368. Österreichische Nationalbibliothek, Vienna (Cod. 1182)

quickly became widely known, guaranteeing commissions to artists who had mastered the new style, even in cities remote from the capital. Traces of Bohemian influence in western or north central Europe can almost always be attributed to traveling artists or to the exportation of Bohemian works. Especially favored about 1400, because of their surpassing quality and emotional power, were expensive images of the Pietà and the Virgin and Child, such as the Bohemian Pietàs in Marburg (cat. 111), Bern, Marienstatt, Preetz, and Düsseldorf.[40]

Of the other ruling houses that aspired to an elevation in rank, the most venerable were the Guelphs in Lower Saxony. Their territories, which lay far from the center of contemporary politics, were divided among several family lines. Probably well aware of their ambitions, Charles IV employed shrewd diplomacy to prevent the various Guelph lines from reconciling. He treated the Wettins in Saxony similarly, but they concerned him more because of their greater proximity and their status as imperial electors.[41] As such, the *Kurfürsten* had a rank unparalleled in Europe. Officially superior to all other German princes, they were able to profit disproportionately from their office.

The Prince's Chapel at Meissen Cathedral was built by the Wettins as a dynastic mausoleum. Its many traditional

features included sculptures that relied heavily on the posthumous tomb monuments of the Přemyslid rulers in the Cathedral of Saint Vitus. Although the thirteenth-century models for the Prague tombs are not known, those at the Prince's Chapel imitate statues carved for the choir of Meissen Cathedral made by the Naumburg workshop there. The enlarged choir screen at Meissen, decorated with sculpted consoles in the manner of the Parlers and with two coats of arms of the margravate of Moravia, reflects the formal world of Bohemian art. The patrons of the rebuilding of the cathedral were Wilhelm I, the margrave of Meissen; his spouse, Elizabeth of Moravia, Charles's niece; and Jan Jindřich, the margrave of Moravia, who probably expected to be interred under the vaults of the choir screen.

The members of another family, the Mecklenburgs, were longtime allies of Charles, as both had a common enemy, the margrave of Brandenburg of the Wittelsbach line. Duke Albert II of Mecklenburg was indispensable to the emperor's policy of extending his sphere of influence to the Baltic. It was he who commissioned a Bohemian artist to prepare the painted decoration of the official chronicle of the knight Ernst von Kirchberg, a project initiated in January 1378.[42]

It is more difficult to evaluate how dynastic relationships affected the painting workshops in the cities of the Hanseatic League between 1360 and 1400. The most relevant works are found between Hamburg and Rostock, and also in the Cistercian Abbey of Doberan, which served as the dynastic mausoleum of the Mecklenburgs. The badly damaged paintings of the Altar of the Holy Cross at Doberan have traditionally been attributed to Master Bertram of Minden (ca. 1345–1415), although the various works linked to his name actually reflect diverse aspects of an artistic current to which several artists contributed. An important, little-known example of this trend is the Altar of Saint Christopher in the former fishing village of Falsterbo in southern Sweden.[43] The style may have originated in Bohemia or in an artistic center in western Europe, perhaps Bruges. Any firm conclusion is complicated by the likelihood that Master Theodoric himself took paintings from Bruges or its immediate sphere of influence as his point of departure.[44] Statues on the previously mentioned altar at Doberan, however, have parallels to Franconian works in the Luxembourg manner; compare, for example, the reliefs from the western inner portal of the Frauenkirche in Nuremberg and the Virgin and Child on the eastern side of the cross with the Virgin from Bamberg in the museum at Coburg.[45]

The Abbey Church of Doberan underwent an extensive renovation under Albert II of Mecklenburg, who, after being named duke in 1348, also ruled Sweden for several years; the frontispiece to the Kirchberg Chronicle depicts him and his son Albert III on the Swedish throne.[46] To reflect this improvement in rank, the familial place of burial received a new tabernacle and an enlarged high altar during the 1350s. The process culminated toward 1360–70 with the creation of the double-sided Altar of the Holy Cross with its monumental Crucifixion. In 1390, after Albert's death, an artfully constructed clock was added that imitates those adorning the great churches along the Baltic shoreline and that, in its painted decoration, mirrors the Kirchberg Chronicle. This feverish artistic activity suggests that the Mecklenburg rulers took advantage of their close relationship with Charles IV. Further testimony comes from the cenotaph of Albert III and his first wife, Richardis (d. 1377), probably carved near the end of the fourteenth century, which has tomb figures much indebted to the Beautiful Style.[47]

Charles's desire to extend his political reach to the sea perhaps explains his efforts during his final years to improve his relationship with England. His close ties to France had originally made him an enemy, but after the definitive defeat of the French at the Battle of Poitiers in 1356, he increasingly sought to cultivate contacts with England. Thus, for example, the wall of rulers at the Holy Cross Chapel at Karlštejn devotes much space to King Arthur and other English monarchs (see cat. 33).[48] A similar intent may be seen in Charles's arranging for his daughter Anne to marry the English prince Richard II Plantagenet.

Still, the royal house of France remained the most important model for the Luxembourgs. Their admiration stemmed not only from having looked toward France for generations and having reared their children according to French customs. Most significant was the Luxembourgs' ambition to marry into the French royal family, as they did several times in the second quarter of the fourteenth century. Through Mary and Bonne of Luxembourg (see fig. 2.2), the ties between the two ruling houses had become still closer. Charles IV did not have a good relationship with the first Valois monarch, Philip VI. Close contacts remained, however, because Philip's son was married to Charles's sister Bonne. Among her children were the French king Charles V, Louis of Anjou, the duke of Berry, and Duke Philip the Bold of Burgundy, all of whom exchanged lavish gifts with their uncle. During Charles's last state visit to Paris in 1377–78, Charles V gave him two illuminated books of hours, and he came home with the relic of Saint Eligius (see cat. 62). Thus, it is quite understandable that, in the next generation, the French king Charles VI had a Prague-trained

illuminator illustrate his prestigious commission, the *Grandes chroniques de France*.[49]

Charles had undertaken the arduous journey to Paris partly to join with the Anjou dynasty in preventing the spread of French power in Italy and Hungary, which threatened to encircle Bohemian territories. The Anjou enlarged their territory under Louis I, who became king of Hungary in 1342 and of Poland in 1370. Now Bohemian lands seemed to be really surrounded in a fatal fashion. Yet, with his last move in the game of dynastic chess, Charles married his youngest son, Sigismund, to the princess destined to inherit the Hungarian throne, thus acquiring the crown for his family and driving out the French. As a result, Bohemian art became a major influence in Hungary. Although it never quite replaced the older taste for Italian art, the two mingled in a unique way, as can be seen in the Buda Castle sculptures (cat. 145) and in works from other Hungarian territories.[50]

1. Beneš Krabice of Weitmile, FRB 1884, p. 525: "Deinde transivit ad partes Alamanie et procuravit similiter ibidem pacem inter principes et civitates imperii."
2. Veldtrup 1988; Kavka 2002.
3. On the marriage politics of John of Luxembourg and Charles IV, see Veldtrup 1988, pp. 242–53.
4. Matthew of Neuenburg, SRG 1924–40, pp. 159–60: "De quo Cracovo quasi gentili illa probissima valde territa, cum eum salutasset, se vertens ad parietem nullo verbo dicto amplius expiravit."
5. Białłowicz-Krygierowa 1968; Veldtrup 1988, pp. 253ff.; Suckale 1999.
6. Didier 1970; Suckale 2002, pp. 148–64; Fajt 2004.
7. Olszewski in Kraków 2000, vol. 2, p. 105, no. ii/60.
8. Baron 1996, p. 134 (RF1398: *Virgin and Child*; sandstone, h. 157.8 cm [62⅛ in.]).
9. Stejskal (1978) 2003, p. 104, fig. 80; Suckale 1993b, p. 66, fig. 48.
10. Cologne 1978–79, vol. 3, pp. 479ff.
11. Handschriften Ms. 46a, 165.
12. A reference in 1414 to the so-called Hungarian Chapel at Saint Catherine's, founded by Stibor of Stibořice, a courtier of Sigismund of Luxembourg, indicates the continued sigificance of the convent. Stibor's tomb of red marble is preserved in the Church of Our Blessed Lady in Buda. Wenzel 1874, p. 163; Rajman 2002, p. 94.
13. Skubiszewski 1978, p. 477; Crossley 1985, pp. 100–135; Węcławowicz 1990, p. 234; Węcławowicz and Korczynska 1998.
14. Kalinowski 1991; Małkiewicz 1996–97, pp. 16–17.
15. Miłobędzki 1965, esp. p. 91; Crossley 1985, pp. 108–46.
16. Olszewski in Kraków 2000, vol. 2, pp. 115–16, no. II/70, fig. III/488.
17. Miodońska in Kraków 2000, vol. 1, pp. 50–51, no. I/16.
18. Crossley 2005.
19. Numerous members of Piast families were in Charles's service; see Karłowska-Kamzowa in Cologne 1979–80, vol. 4, pp. 160–63.
20. Pešina 1986; Kalina 1996; Hlaváčková 1998.
21. That there was a tradition in such matters is apparent when one considers that the bishop of Regensburg, Nikolaus von Ybbs (r. 1313–40), was installed in office by the Luxembourg Henry VII.
22. According to Kutal 1966b, pp. 438ff.
23. On Dietrich von der Schulenburg and the Bohemian altarpiece he commissioned (cat. 43a), see Sachs and Kunze 1987 and, recently, Wolf 2002, pp. 166–78, figs. 99–111. For his tombstone, see Fajt 2005.
24. Veldtrup 1988, pp. 257ff., 407ff.
25. See the panels of the high altar in the Augustinerkirche, Munich (Bayerisches Nationalmuseum, Munich); recently Preyss 2001. On the retable from Pähl Castle (fig. 4.7), see Suckale 2003b, pp. 103–18. See also the badly damaged Marian panel from Augsburg Cathedral and related works from Benediktbeuren (Alte Pinakothek, Munich).
26. Suckale 1993b.
27. Ibid., pp. 124–30. It is striking that the acanthus in Jan of Středa's manuscripts resembles that in the manuscripts of Louis the Bavarian; see, for example, ibid., pp. 37, 42–43.
28. Ibid., pp. 238–84 (the Premonstratensian cloister Rosa Coeli in Dolní Kounice, near Brno). Since sculpted heads of exceptional quality have been found in Hungary at the Cistercian Monastery of Pilis, a royal mausoleum, it is possible that the Moravian workshop came from Hungary, not from Bavaria; see Takács in Budapest 1994–95, pp. 30–33, 264–69. In Bohemia, the Virgin and Child in Osek is among those that could be claimed as a product of Louis's court workshops. On this work, see most recently, Fajt 1999.
29. On the conflicting plans of John of Bohemia and Charles IV, and the resulting cabals at the Diet, see Veldtrup 1988, pp. 275ff.
30. Oettinger 1952; Suckale 1993b, pp. 167ff.; Suckale 1996a; Fajt 1998, pp. 281–341, esp. p. 341.
31. Tietze 1931, pp. 212ff., 390ff. The Eligius chapel is the lower level of the double chapel in the southwest corner of the church, which Rudolf probably already planned to hold the insignia of the empire. This supposition has been confirmed not only by the cycle of stained-glass windows depicting the Habsburg rulers, emulating the models from Karlštejn's Luxembourg Genealogy (Schmidt in Brucher 2000, pp. 476–77, figs. 17, 18), but also by the discovery of a niche in the upper Chapel of Saint Bartholomew that is approximately the same size as the niche in the north wall at Karlštejn, where the imperial relics and insignia had been kept. Saliger 2003.
32. Schultes 1988; Suckale 2002, pp. 225–51.
33. Brucher 2000, esp. pp. 281ff., 311ff., 371ff., and Schmidt in ibid., pp. 476–77.
34. Oberhammer 1948; Fajt 1998, pp. 281–341, esp. p. 341; Schmidt and Trattner in Brucher 2000, pp. 476–77, and no. 279, respectively.
35. Schmidt 1967.
36. According to Wonisch (1951, pp. 110–11), the retable probably stood in front of the choir screen on the Altar of the Cross, which was painted by one Hans Wölffel von Neumarkt (d. 1382) and dedicated in 1366. This, however, remains nothing more than a hypothesis; for instance, see Stange 1934–61, vol. 11, p. 59.
37. Janssen 1978, pp. 240–41.
38. Family connection did in fact play a role insofar as Peter was married to a daughter of the master of the works in Cologne, Michael of Savoy. The Parler family had gotten its start in the mason's workshop of Cologne Cathedral.
39. Kletzl 1936. For a different view, see Stejskal (in Kotrba et al. 1971, esp. p. 376), who expresses the opinion that Bishop Johann von Luxembourg-Ligny (r. 1365–71), who was appointed by Charles IV and who spent 1355–58 in Prague, must have been the motivating force behind the drawing of the belfry, which displays the influence of Bohemian models.

40. Most easily available in Clasen 1974, a publication marked by numerous problematic theses; see the reviews by Suckale (1976) and Schmidt (1978). See also Salzburg 1965 and Salzburg 1970.

41. Lippert 1894; Ahrens 1895, pp. 10–11. According to Harnisch (1997, pp. 182–83), Frederick II Wettin was the son-in-law of Louis the Bavarian. Lindner (1997, esp. pp. 106ff.) states that the Wettins, who originally were cultivated by Charles, became his opponents in 1371 because of Bohemian expansion and had to be persuaded to return to his side in 1372 through negotiations and expensive compromises. Their electoral vote guaranteed them relative protection until the crown prince Wenceslas was elected king of the Germans.

42. The manuscript is in the Mecklenburgisches Landeshauptarchiv Schwerin, Bestand 1198, PS-Nr. 22; see Stoob 1970, pp. 163–64. See also Mohrmann 1978, p. 389. Another member of the Luxembourg dynasty, Jan, the duke of Görlitz (d. 1396), had married Richardis, a daughter of Duke Albert II of Mecklenburg and sister of Albert III, who became the king of Sweden (1364–1405).

43. Tångeberg 1989; see the index, p. 317.

44. Suckale 2004b.

45. Cologne 1978–79, vol. 1, p. 353 (Kunstsammlungen der Veste Coburg, pl. 141: linden wood, h. 172 cm [67¾ in.], Bamberg-Nuremburg(?), 1360–70).

46. Mecklenburgisches Landeshauptarchiv Schwerin, Bestand 1198, PS-Nr. 22, fol. 1v; Erdmann 1995, ill. p. 66.

47. For Doberan, see Erdmann 1995, pp. 50–77, and Laabs 2000.

48. Suckale 1998, pp. 157–59.

49. See Avril in Paris 2004, no. 168.

50. Cologne 1978–79, vol. 3, pp. 450ff.

# Prague as a New Capital

*And then Charles withdrew to Prague, which is now the seat of the Bohemian archbishopric,*
*and where now the seat of the Empire is, which once was in Rome, then Constantinople,*
*but now rests in Prague. —Heinrich Truchsess of Diessenhofen (1359)[1]*

Paul Crossley and Zoë Opačić

Thus did Heinrich Truchsess, canon of Constance Cathedral and chaplain of Pope John XXII, praise Prague as the center of a new empire—a new Rome and a new Constantinople befitting the emperor's dignity as the self-styled "ruler of the world" (*monarcha mundi*).[2] He was not alone in his admiration for "Golden Prague." Its university, the first of its kind east of the Rhine, made it a mecca for masters and students in the empire and far beyond.[3] Its relics attracted a mass cosmopolitan pilgrimage. Its colossal scale and ingenious planning had no rival in the fourteenth century outside central Italy. And it is to Charles IV of Luxembourg (r. 1346–78) that Heinrich attributes this shining example of *civitas,* a metropolis where intellectual, commercial, and devotional life went hand in hand with artistic and architectural splendor.

Charles IV's talent for self-publicity, his *sacro egoismo,*[4] has left a Prague still dominated by his vision. He began his architectural revival of Prague in the first year of his return to the city, in 1333, when he rebuilt the castle on the Hradčany, or castle hill, on the left bank of the river Vltava. He left Prague with a final commemoration of himself in the center of its most prominent monument, the Old Town Bridge Tower (fig. 5.1), where the aging king, flanked by his son Wenceslas IV, is posthumously commemorated as Roman emperor, as *pontifex* (bridge builder), as (in the words of Niccolo Beccari) Vespasian with Titus.[5] Such self-promotion tends to conceal the vital role played in fourteenth-century Bohemia by Charles's cultural and spiritual advisers—men of exceptional literary talent, such as his chancellor Jan of Středa (1353–74), or of administra-

tive skill and dependability, such as the first archbishop of Prague, Arnošt of Pardubice (r. 1344–64). Nor should one take at face value Charles's exaggerated picture of a ramshackle Prague waiting to be redeemed by his generous patronage. In his autobiography he describes his return to Bohemia as a journey into desolation:

> The kingdom we have found so destitute, that we could not find one free castle, which was not sold off together with all the royal goods. We did not have a place to live, but had to dwell in ordinary town houses like other townspeople. Prague castle was completely desolate, ruined and destroyed and from the time of King Otakar [II] leveled to the ground. In that place we had a large and beautiful palace built anew and equipped it with many and sumptuous goods, which can be seen today by all.[6]

Yet Prague under the early years of the reign of his father, John of Luxembourg (1310–1346), was neither provincial nor wholly neglected. Jan of Dražice, the last bishop of Prague (r. 1310–43), who had spent eleven years in Avignon, fostered new links between Bohemian building and advanced, French-inspired Rayonnant architecture. His (now lost) palace in the Little Quarter (Malá Strana) of Prague contained a sculptural cycle of the bishops of Prague that anticipated Charles IV's interest in the public display of lineage. The palace almost certainly incorporated the kind of sophisticated Rayonnant traceries and portals surviving in Jan's castles at Dražice and Litovice (both about 1335) and also in his Augustinian canons' foundation at Roudnice, part of which was designed by his French architect, William of Avignon. Jan was also a *pontifex,* commissioning William to build a bridge at Roudnice.[7]

John of Luxembourg may have neglected Bohemia and rightly earned the soubriquet of "foreign king" (*přislý kral*),[8]

Fig. 5.1 Old Town Bridge, Prague, east facade

but he did commission the rebuilding of a residence in the Old Town (Staré Město) in Prague "in the French manner" (*modo Gallico*)[9]—perhaps the House at the Stone Bell in the Old Town Square. Its imposing facade, looking out onto the main marketplace, is decorated with elegant tracery and was once filled with sculpted figures of the enthroned king and his queen, Elizabeth Přemysl, accompanied by two men-at-arms. The four empty niches above them probably contained the figures of Bohemian patron saints. The whole ensemble, which anticipates the rulership iconography of the Old Town Bridge Tower, shows interesting similarities to John's Parisian residence, the Hôtel de Bohême, and even to North Italian donjons, yet it also finds close parallels in the older Přemyslid iconography, especially that on royal seals.[10]

But it was Charles, with his characteristic mixture of pragmatism and ideology, who recognized the potential of Prague, and of Bohemia, as the dynastic power base from which to secure the fortunes of the Luxembourgs and launch his claim to the imperial throne. His boyhood in Paris had exposed him to the dynamism of a royal capital, where the machinery of government and the mythology and persona of the king were brought together in glamorous partnership. And his years as a young *condottiere* defending his father's interests in northern Italy had given him firsthand knowledge of city government and of the dangers of internecine city-state politics. By contrast, the Holy Roman Empire had no permanent capital: its main residence and administrative center changed with each new dynasty, if not with every ruler. A stable empire required a political base that could satisfy the increasing demands of written government and act as the symbolic focus of imperial kingship.

Charles's power was still predominantly itinerant (he was the most widely traveled emperor since Frederick Barbarossa and Henry IV),[11] and other towns, such as Nuremberg, suggested themselves as imperial capitals. But it was Prague, "the crown of Bohemia," that fulfilled Charles's vision of a national and imperial capital. Its new architecture, more publicly than any other art, was to bolster two of the principal aims of his Bohemian policy: first, the sacralization of his kingdom, in which the Luxembourg dynasty, as kings of Bohemia *ex dei gratia*, were joined to the previous Přemyslid dynasty with the blessing of their common protector, Saint Wenceslas; and second, the celebration of the power and prestige of the emperor as God's anointed *monarcha mundi*. These "two thrones," as Charles called them, were to be captured in the permanent visions of art.[12]

When Charles arrived back in Prague in 1333, the city already had a clearly configured layout (fig. 5.2). Its river, the

Vltava (Moldau) divided two castles and three towns: the Old Town on the right bank, with its Jewish ghetto tucked beneath the right-hand turn of the river; the Little Quarter (founded by Přemysl Otakar II and originally known as the New Town) on the left bank, below the castle; and the more recent Hradčany district on the castle hill. Prague's two castles were Vyšehrad, rising dramatically on a high rock above the right bank (fig. 5.2-25), and its rival, the Hrad, dominating the left bank (fig. 5.2-1). Vyšehrad was the Delphi of Prague, recognized by the mid-fourteenth century as the seat of Přemysl Oráč (the Ploughman), the legendary founder of the Přemyslid dynasty, and his wife, the prophetess Libuše, who foretold the rise of Prague.[13] From the second half of the eleventh century until 1135, it was the residence of the Přemyslid kings, and its Collegiate Church of Saints Peter and Paul, directly affiliated to Rome, on occasion served as a royal necropolis.

If Vyšehrad enshrined the myths of Prague's Slavonic origins, the city's second fortified hill, the Hrad, sheltered its effective center of government and its royal saints. Bořivoj I, the first Christian duke of the Bohemians, had set up his court there in the late ninth century. For some subsequent Bohemian chroniclers, such as Christian and Charles IV himself, this settling on the Hrad ranked with the other momentous events of Bořivoj's reign: Bohemia's conversion to Christianity, its formation as a state, and its *Translatio Imperii,* its transfer of power from the Great Moravian Empire of the ninth century to the future Přemyslid dynasty.[14] The oldest settlement in the city, the Hrad continued to be the residence of the Přemyslids up to the end of the thirteenth century, first as a wooden castle, then as its twelfth-century stone replacement.[15] But the compound damage of plague, famine, fire, and unstable government had reduced it to dilapidation when John of Luxembourg arrived in 1310 to be crowned as the successor to the defunct Přemyslids.

Charles recognized the ideological charisma of the Hrad and its usefulness as the administrative headquarters of royal government. His initial act of architectural patronage in Bohemia was therefore the remodeling of its ruinous palace. His motives may also have been personal, for his first wife, the Parisian princess Blanche of Valois, had settled with him in Prague in 1333 and needed a suitable residence. This may explain the chronicler František of Prague's cryptic description of the new palace as "constructed at great expense on the pattern of the royal palace of the French kings" (*ad instar domus regis Francie*)[16]—a reference not just to the advanced Rayonnant detailing of its portals and tracery-headed doorways and window profiles, but also to its general layout

Fig. 5.2  Plan of Fourteenth-century Prague
(hatched areas indicate the New Town)

1. Castle
2. Hunger Wall
3. Carthusian Gate
4. Carthusian Monastery
5. Church of Saint Adalbert
6. Charles Bridge
7. Saint Peter's Gate
8. Mountain Gate
9. Saint Procopius's Gate
10. Saint John's Gate
11. Church of Saint Peter
12. Church of Saint Ambrose
13. Church of Saints Henry and Cunigunde
14. Church of Our Lady of the Snows
15. Church of Saint Michael
16. Church of Saint Stephen
17. Chapel of Corpus Christi
18. Emmaus Monastery (Na Slovanech)
19. Church of Saint Catherine
20. Church of Saint Apollinaris
21. Church of Our Lady and Saint Charlemagne
22. Church of Our Lady on the Lawn
23. Church of Our Lady
24. Church of Saints Peter and Paul
25. Vyšehrad
26. Saint Pancras's Gate

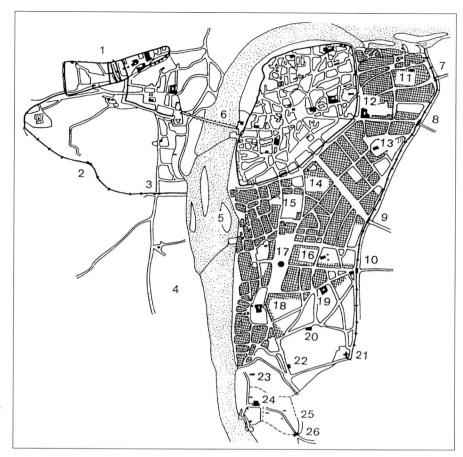

and spatial sequences. It combined an elaborate first-floor entrance portal, approached up a prominent staircase running at right angles to it and leading into an enlarged aula with generous windows and (from 1355) 120 panel paintings of Charles's imperial ancestors.[17] This arrangement echoes the sequence of additions made after 1299 by Philip the Fair to the Palais de la Cité in Paris, additions familiar to Charles: the great staircase (*grands degrez*) leading up to a large portal, through which the visitor moved to the first-floor Galerie Mercière and eventually to the Grand'salle, with its spectacular genealogy of the French kings.[18]

Parisian too, was Charles's refoundation of the court Chapel of All Saints in Prague Castle in 1339, combining, as did Louis IX's palace chapel, a new college of resident canons, a private space for court liturgy, and a setting for the preservation and display of its relic collection, distinguished by Charles's gift of a particle from the crown of thorns—a relic that related the chapel closely, though not officially, to the exclusive club of French "Saintes-Chapelles."[19] The chapter had to wait until the 1370s, however, before Charles founded for it a new Sainte-Chapellian chapel to give proper form to these Parisian resonances.[20]

The Hradčany, like the Palais de la Cité, embraced cult as well as power. The oldest, most sacred part of the city, it was the site of the Church of the Virgin, founded by Bořivoj in the 880s. It also housed the Benedictine Convent of Saint George, established in the early tenth century as a royal burial church and refounded as a convent in 973. At its episcopal center, Hradčany sheltered its most precious reminder of Bohemian royal sanctity: the small rotunda church, founded before 930 by the martyr-prince Wenceslas, the first saint of the Přemyslid dynasty, the *dux perpetuus*, the eternal protector and liberator of Bohemia. Interred at the rotunda were the saints who would become Bohemia's patrons: Vitus in its eastern apse, Adalbert (second bishop of Prague) in its western, and Wenceslas himself in its southern.[21] With a retrospective piety that prefigures Charles's own, their relative positions were carried over into the eleventh-century Romanesque basilica that replaced the church.

In her vision of a future Prague, Libuše had seen Wenceslas and Adalbert as "two golden olive trees" growing from the castle hill to the sky and illuminating the whole world.[22] Charles IV shared her aspirations for a *Bohemia sacra* emanating from the Hrad to Bohemia, the empire, and beyond.

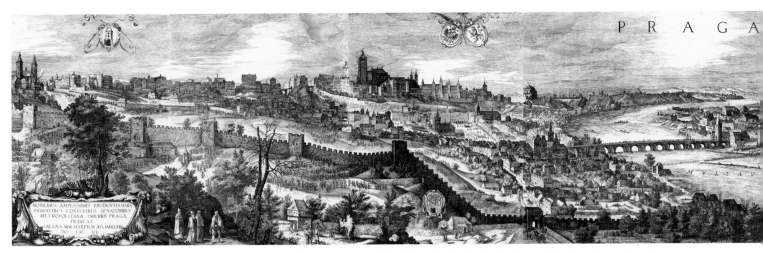

Fig. 5.3 Sadler's Panorama of Prague, 1606. The Metropolitan Museum of Art, New York, Harris Brisbane Dick Fund, 1953 (53.601.10)

Its starting point would be the creation of a new archbishopric, and with it the foundation of a new cathedral. Only then could Bohemia emerge as an independent national church, and its patron saints assume their proper places at the center of a new royal and ecclesiastical culture. Not surprisingly, the first donation charter for the prospective cathedral, dated October 23, 1341, and issued by John of Luxembourg, deals mainly with the embellishment of the tombs of Saints Adalbert and Wenceslas, and only secondarily with the fabric of the church.[23] Wenceslas, in particular, was recognized in all his *Lives,* including Charles's own biography, as the royal saint of exemplary Christ-like piety, as the *Alter Christus.*[24] He was to be the nucleus around which much of Charles's new cathedral would revolve.

The Gothic cathedral of Saint Vitus, built on the site of the Romanesque basilica and the Wenceslas rotunda, was founded as the celebration of Prague's elevation to an archbishopric. The promotion was granted in 1344 by Pope Clement VI, and the foundation stone was laid on November 21, 1344, the same day that Archbishop Arnošt of Pardubice, Charles's counselor and virtual alter ego, was vested with the pallium.[25] More eloquently than its predecessors, the new cathedral served both as the repository of Bohemian sacred history and as the royal church of the Luxembourgs, combining the functions of a shrine of national sainthood, a coronation church, and a mausoleum of the Přemyslid and Luxembourg dynasties. Although the administration of its works was the responsibility of the archbishop and chapter, the cathedral was the personal creation of Charles IV, who recruited its two architects and who, according to the inscription above his bust in the triforium, built it "at his own expense."

The cathedral was also the most prominent tribute to Charles's cultural Francophilia. Its architect, Matthias of Arras, was brought to Prague from Avignon by Charles himself, earlier in 1344,[26] probably at the recommendation of Clement VI, who had been bishop of Arras. Matthias's new choir was a close copy of the ground plan and general disposition of the choir of Narbonne Cathedral (completed 1332), at that time the most modern French version of what an archbishop's great church should look like.[27] Narbonne's polygonal chapels in the straight bays, its large three-light windows in the radiating chapels, its smooth continuity of graphically linear profiles running seamlessly from shafts into ribs, and its scant architectural ornament —all reappear, with fastidious refinement, in Prague. To this French paradigm, Matthias adds quirkier details that suggest a knowledge of the Rayonnant of the Upper Rhine, particularly his prow-shaped pinnacles decorating the chapel buttresses, their finials seeming to penetrate the setoffs, and his plan for star vaults (and perhaps pendant bosses) in the eastern bay of the sacristy, left unfinished at his death.[28]

Not surprisingly, Charles's coronation as king of Bohemia in 1347 had a French inflection, dominated by a new, French-style crown, and prosecuted with a distinctly Remois theatricality.[29] But the new "French" choir designed to accommodate such coronations was incomplete, and the ceremony had to take place in the Romanesque building. At Matthias's death in 1352, the choir was still only half finished, with the ambulatory and radiating chapels complete, together with the eastern chapels on the north and south sides, and the arcades of the apse and eastern choir bays. It was not until 1356 that Charles, and a new architect, Peter Parler, focused on the cathedral's realization. In the interim, Charles's energies were diverted to the building of Karlštejn Castle (fig. 1.5) and the creation of the New Town (Nové Město) on the right bank of the Vltava.

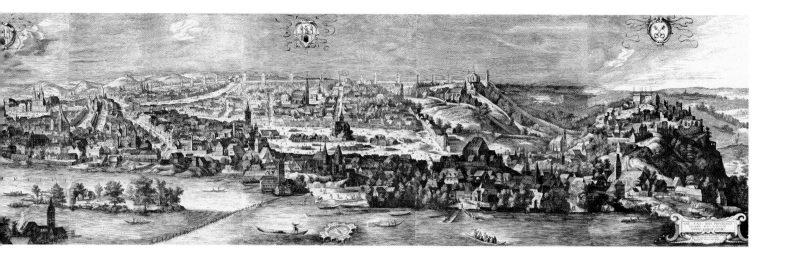

Charles's election as King of the Romans in 1346, and with it the prospect of an imperial coronation, gave new momentum to his artistic patronage, beyond the confines of the royal castle. In April 1348 the king set in motion a series of key initiatives: the codification of the powers and boundaries of the Bohemian kingdom at the general imperial parliament; the establishment of a university in Prague, the first such institution in central Europe; and the official foundation, on Saint Mark's Day (April 25), in the company of the princes and nobility of Bohemia and the Holy Roman Empire, of a vast new urban development on the southern and eastern flanks of the city—the New Town.[30] The concomitance of these measures clearly demonstrated that the political and intellectual identity of the kingdom was inextricably bound up with the physical and architectural definition of its capital.

The New Town gave to King John's old capital the scale and spiritual prestige of the metropolises of antiquity (figs. 5.2, 5.3). As an urban enterprise there was nothing comparable north of the Alps. The district was laid out on a heroic scale, occupying no less than 360 hectares (890 acres) of unurbanized land between the Old Town and Vyšehrad. Its villages and hamlets—though not its Romanesque churches and monasteries—had to make way for paved streets, brick houses, and large squares. With a three-and-a-half-kilometer (two-mile) circuit of walls, with monumental double-towered gates, with (where possible) a regular checkerboard street plan reminiscent of Roman or central Italian prototypes, and with almost forty churches, the New Town transformed the Bohemian regional capital into an imperial metropolis. In a spirit characteristic of Charles's newly acquired imperial decorum, Prague emerged as a prospective center of the world, a new Jerusalem and a new Rome.

Imposing fortifications and colossal squares, intended to accommodate markets, embodied the confidence and commercial potential of the New Town. But what really gave the district its character were its religious institutions, nine of which were founded at the emperor's specific request. They proclaimed the universality of his office and the progress of his personal history, interests, and devotions. The dedication, form, and layout of these "Carolinian" churches and monasteries consistently show a balance of national and universal concerns, a balance woven into the eclectic character of the New Town.

The first to be founded, on September 2, 1347, was the colossal Carmelite Church of Our Lady of the Snows, situated at the junction of the New Town's Wenceslas Square and the Old Town's Saint Gall market (fig. 5.2-14), where only the day before Charles and Blanche of Valois had celebrated their Bohemian coronation.[31] The church's commemoration of such a momentous event may have influenced the decision to abandon its original basilican plan with three parallel choirs in favor of a structure more openly indebted to French Rayonnant architecture—an apsed glasshouse choir about 34 meters (111 feet) high with corbels for standing apostles, reminiscent of the Parisian Sainte-Chapelle. The ceremonial portal on the north side incorporated a votive relief that sanctified the donors' own coronation: the Coronation of the Virgin with the Holy Trinity flanked by the kneeling figures of Blanche and Charles.[32]

The Parish Church of Saints Henry and Cunigunde was dedicated to the emperor-saint Henry II, but also recalled Charles's grandfather, Emperor Henry VII (fig. 5.2-13).[33] Such links to a sacral imperium were enhanced in 1350 (a year after Charles's coronation as German king in Aachen), with the foundation of the Augustinian canons' Monastery of the Assumption of Our Lady and Saint Charlemagne (now

Fig. 5.4  Church of Our Lady and Saint Charlemagne, Prague

Fig. 5.5  Emmaus Monastery (Na Slovanech)

referred to as Karlshof, or Karlov) on a hilly southeastern corner of the town (fig. 5.2-21, 5.4). Karlov formed the Bohemian center of Charles's carefully nurtured cult of Charlemagne, and its large octagonal nave was deliberately conceived as a "copy" of Charlemagne's Aachen minster.[34] The Augustinian nuns' Church of Saint Catherine (fig. 5.2-19) was founded in honor of the saint on whose feast day, in 1332, Charles won his first battle, at San Felice, near Modena.[35] The Benedictines in the Monastery of Saint Ambrose (since demolished) were brought to Prague in 1355 directly from Sant'Ambrogio in Milan (the church of Charles's coronation as king of Lombardy) with the privilege of maintaining their own Milanese liturgy.[36]

The most exotic of Charles's liturgical transplants, however, was the Benedictine Monastery of Our Lady and the Slavonic Patrons (later known as the Emmaus), founded in 1347 just before the New Town was officially inaugurated (figs. 5.2-18, 5.5). It was Charles's most open tribute to his Slavonic past, and to the close political and religious links between Bohemia and the Great Moravian Empire of the ninth and tenth centuries. He brought monks from Dalmatia, probably from the diocese of Senj, and obtained permission from Clement VI for the community to practice their Church Slavonic liturgy and to use the Glagolitic language, invented in the ninth century by Saints Cyril and Methodius.

The architecture of the monastery, with its *Reduktionsgotik* hall church and its traceried cloister, is conventionally Gothic, but its dedication in 1372 amounted to a roll call of Bohemia's Přemyslid and Byzantine saints: Procopius, Adalbert, Cyril, and Methodius. Pride of place, however, was given to Saint Jerome, credited since at least the thirteenth century with the translation of the Bible into Slavonic as well as Latin, thereby removing the Slav liturgy from the taint of heresy.[37] The New Town's eclectic array of churches was completed with the foundation in 1360 of the small Church of the Annunciation, also known as Our Lady on the Lawn (Na Travničku), with a Servite community that came from Florence (fig. 5.2-22). The second Augustinian church, dedicated to Saint Apollinaris, the first bishop of Ravenna, dominated the hill of Větrnik (fig. 5.2-20).

The positioning of the New Town churches provides critical insight into Charles's translation of symbolic association into scenic experience. Two "axes of meaning" can be isolated in the New Town, and both converge on Charles Square.[38] The first, running north from the steep Vyšehrad hill to the Emmaus Monastery and beyond, might be described as Slav. Vyšehrad Castle (fig. 5.2-25) was the locus of Bohemia's Slavonic past and its Přemyslid myth. Charles's mother, Elizabeth, had spent her last years on the Vyšehrad and had had the basilica's Romanesque choir extended by

a Sainte-Chapellian apsidal sanctuary.[39] After 1369, to underline his royal Bohemian pedigree, Charles added his own alterations, extending the nave with a series of side chapels stylistically typical of *Reduktionsgotik* in Prague in the 1370s.[40] A few years earlier (1348–50) he had refurbished the castle and fortified it independently of, but simultaneously with, the New Town.

The old Přemyslid settlement thus acted as a historical antechamber to the modern and cosmopolitan city below. It is no coincidence that Charles located Emmaus, with all its Slavonic associations, just north of Vyšehrad in the fishing settlement of Podskalí, owned by the Vyšehrad chapter and entirely populated by Czechs. Its parish church, given over immediately to the Emmaus community, was dedicated to Saints Cosmas and Damian, as were the Benedictine monastery on the Dalmatian island of Pašman (from which the monks may have come) and the church at Stará Boleslav, where Saint Wenceslas was martyred and first buried.[41] This rich nucleus of Slavonic association, at the southern entrance to the New Town and the whole city, became the starting, and finishing, point of royal processional liturgies.

The Emmaus also provides a link with the second "axis of meaning" in the New Town, one connected to the annual exposition in Charles Square of the Bohemian and imperial Passion relics. Originally known by the Latin *forum magnum* and the Czech *Dobytčí trh* (Cattle Market), this square, measuring 80,550 square meters (20 acres), was the largest in Europe. Its vast scale is explicable only in terms of its commercial and religious functions. When Charles first acquired the imperial relics in 1350, he clearly intended to make them the objects of international pilgrimage (see fig. 5.6). On its arrival in Prague from Munich on Easter, March 21, 1350, the treasure, consisting of the Passion relics and the imperial regalia, was first brought to Vyšehrad, then taken through the New Town and displayed there, almost certainly in Charles Square.

These expositions became annual (on the Friday after the octave of Easter Sunday), with their own feast—the Feast of the Holy Lance and Nail, held in honor of the relic of Longinus's lance; the office for this feast may have been initiated and cowritten by the emperor himself.[42] Until 1365 the relics were probably kept in the cathedral,[43] but the discovery in the eastern wing of the Emmaus Monastery of the original presence of wall paintings of the Passion, emphasizing the lance and other emblems of Christ's suffering, suggests that the relics may well have been taken there regularly for veneration in connection with the feast.[44] For the earliest displays of the relics, a wooden platform was set up in the center of Charles Square, probably not dissimilar to the *Heiltumsstuhl* erected in the fifteenth century in Nuremberg's Hauptmarkt for the same purpose. In 1382, after Charles's death, the New Town Brotherhood of the Hammer and Circle, closely connected with the court of Wenceslas IV, replaced the provisional structure with a tall rotunda dedicated to Corpus Christi (fig. 5.2-17, now demolished), from where the relics were shown to mass audiences.[45]

The Church of Corpus Christi thus marked the intersection of the two dominant axes. The first, a "secular" north-south one, was defined by a large basilican market hall, about 50 meters (164 feet) long, just to the north of the church, with the Town Hall beyond it, placed on the square's north side. The second, more sacred, developed east-west, directly in a line from the eastern apse of the church, along Ječná Street to Saint John's Gate on the eastern perimeter of the walls (fig. 5.2-10). Halfway down this broad vista, dominated by the climax of the Corpus Christi Church and its relics, were placed a number of related *memoriae*: the new Church of Saint Stephen (begun shortly after 1348; fig. 5.2-16), and to its east the Romanesque rotunda rededicated to Saint Longinus, which served as a burial chapel for pilgrims.[46] Just west of Charles Square was

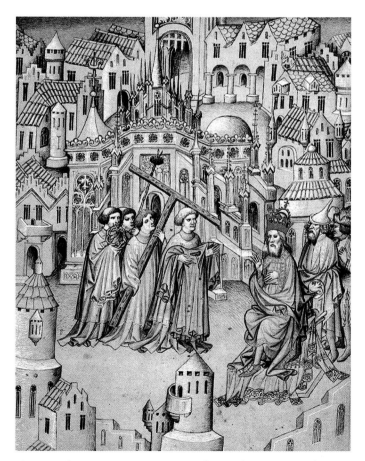

Fig. 5.6 The Byzantine Emperor Is Shown the Passion Relics. *The Travels of Sir John Mandeville* (cat. 88), fol. 11r. British Library, London (Add 24189)

the Church of Saints Peter and Paul (fig. 5.2-24), the home of the order of the Custodians of the Holy Sepulcher, which contained a replica of Christ's tomb.[47] These links between Jerusalem and Prague find a less obvious echo in the schematic parallels between the entire disposition of the east-west axis and contemporary maps of the Holy City; that is, in the sequence of gate and straight street (both encountering references to Saint Stephen) culminating in dominant, circular-planned buildings (in Jerusalem, the Temple of Christ).[48]

If distant and (by then) inaccessible Jerusalem was a diagrammatic template for one aspect of the New Town, Rome—the ideal alternative, and since the Jubilee of 1300, the most attractive pilgrimage goal in Christendom—was its living inspiration. Charles's journey to Rome in 1355 to receive the imperial crown marked a climax in his career. He entered the city incognito, dressed as a pilgrim intent on visiting its principal churches and venerating its relics; he left it as emperor, crowned in Saint Peter's by the papal legate Peter, the cardinal of Ostia.[49] Although nothing in the New Town literally copies the sacred topography of the Holy City,[50] the pilgrims' way through central Rome, from the Porta Maggiore to Santa Maria Maggiore, must have been known to Charles and his retinue. On the feast of the Assumption (August 15), a procession, carrying the Acheropita, an image of Christ thought to be painted by an angel, traversed some of the most prominent landmarks of papal and imperial Rome, many having associations with Charles and with the Prague New Town.

The Lateran Palace, for example, contained the papal chapel of the Sancta Sanctorum, a possible source for the iconography and decoration of the Holy Cross Chapel at Karlštejn (fig. 1.1).[51] The Church of San Clemente is the burial place not only of Saint Clement but also of Saint Cyril, the Apostle of the Bohemian Slavs, believed to have once been buried on Vyšehrad. The Colosseum and Arch of Constantine recall Charles's constant identification with the first Christian emperor, who moved his capital to an eastern city. The Church of SS. Cosma e Damiano brings to mind the dedication of Saint Wenceslas's first mausoleum at Stará Boleslav. And the goal of the procession, the Basilica of Santa Maria Maggiore, is dedicated to the same miraculous vision of the Virgin (in which Mary predicted snowfall in summer) as Our Lady of the Snows in Prague.[52] Charles's Roman experience of 1355 could not have influenced the initial planning of the New Town some ten years earlier, but it must have endorsed his vision and offered him the means to sanctify his city with Roman reminiscences.[53]

As works of architecture, the New Town churches expanded the vocabulary, and the artistic horizons, of Gothic in Prague. The first generation of buildings (Emmaus, Our Lady of the Snows, Saint Stephen's, Saint Henry's, and Karlov) consolidated local traditions of the first half of the fourteenth century and showed a debt to the architectural legacy of the last Přemyslids. Although their masons responded to the particular requirements of each foundation and drew from a variety of sources, each church offering different spatial and constructional solutions, there are strong reasons for regarding these structures as a homogeneous group, with a shared stylistic identity. Their ambitious scale—as, for example, in Our Lady of the Snows and Emmaus—captured the heroic vision of the entire project and created powerful architectural accents in the developing urban texture, comparable to the grandest churches in the Old Town.[54]

The "New Town style" is recognizable by its spacious, clearly legible interiors, its comparatively austere architectural ornament, and its preference for choirs with polygonal apses amply illuminated with long windows, which probably never contained colored glass.[55] Although the immediate impact of the Prague Cathedral workshop on these buildings was minimal (Our Lady of the Snows, Karlov, for instance), they demonstrated a close familiarity with the most up-to-date, *Reduktionsgotik* forms of Austrian mendicant architecture as well as the austere, expressive basilicas and hall churches of Silesia, since 1348 part of the kingdom of Bohemia. In the special case of the Emmaus Monastery, formal similarities with Clement VI's mausoleum at La Chaise-Dieu might be explained through the mediation of Matthias of Arras. As the principal architect of Charles IV, he would have been the obvious candidate to plan the New Town in its early stages.[56]

Charles's return to Prague late in 1356 coincided with a profound change in his political fortunes and artistic policy. His coronation as King of the Romans (Germans) at Aachen in 1349, as King of Lombardy in Milan in 1355, and as Holy Roman Emperor in Rome in the same year, elevated him into the "universal ruler" of the last thirty years of his life. The Golden Bull, promulgated in Nuremberg earlier in 1356, had confirmed his power as king of the Germans, and (he hoped) secured his Bohemian successors as the leading contenders to the imperial title. To the sacred center of the Bohemian state he now brought a Roman experience and a newly conscious German authority. His model for a royal church shifted from papal France to imperial Germany. Matthias of Arras's death paved the way for Charles's appointment in 1356 of the twenty-four-year-old Peter Parler, who belonged to a family of German masons originating in Cologne and working in

the milieu of Strasbourg Cathedral, the two preeminent centers of German Rayonnant architecture.

Dominating the largest city in the empire, the archiepiscopal Cathedral of Cologne, of whose chapter the emperor was an ex officio honorary member, offered a dazzling example of the most modern version of French-inspired Rayonnant architecture. Parler's knowledge of Rhenish Rayonnant was complemented by a set of outstandingly creative gifts: flexibility in responding to the demands of his patron and the legacy of Matthias of Arras; intelligence in adapting past precedents to new contexts; an exceptional decorative inventiveness; and an ability to employ a wide range of stylistic modalities in the service of symbolic meaning or functional decorum.[57] In completing the main body of Saint Vitus's choir (fig. 5.7), Parler chose an openly Cologne repertory—massive bundle piers with clusters of prominent vault shafts resting on broad, diamond-shaped plinths—thus forming a pointed contrast between his western bays and Matthias's delicately linear arcades farther east. Cologne-like too is the glass-house effect of the upper parts of Parler's choir, with a multilight clerestory above a glazed triforium, supported by double batteries of flying buttresses that owe their general composition to the technologically most ambitious cathedrals of Christendom, Cologne and Beauvais (cat. 47). As a crown for the exterior of the high choir, Parler installed a tall balustrade, an archaic termination consciously recalling the dwarf galleries of German Romanesque cathedrals and earlier archiepiscopal choirs such as twelfth-century Sens and thirteenth-century Reims and Magdeburg (the latter the last archbishopric before Prague's to be set up by a Holy Roman Emperor, Otto I). Prague was to be a new Reims but also a new kaiserdom.[58]

Into the self-consciously retrospective framework of his choir, Parler inserted a set of decorative and spatial novelties that mark a prodigious enlargement of the vocabulary of Continental Rayonnant architecture. His clerestory windows, with their unexpected elisions, inversions, and flexuous combinations, amount to the first consistent display of curvilinear tracery on the Continent.[59] His decorative vaults, which may take their cue from Matthias's plans, match *curiositas* with *varietas:* gravity-defying pendant bosses sprouting skeletal ribs (in the western sacristy bay; fig. 5.8); a fountain of flying ribs in the south transept porch; an Islamic-looking dome over the Wenceslas Chapel; and, most influentially, a net configuration over the high choir whose parallel tracks transform the conventional Gothic vault from a series of discrete canopies into a continuous, densely patterned ceiling. The bay-denying horizontality of the vault complements the longitudinal accents of the elevation below it—the promi-

nent triforium balustrade and the famous zigzagging projections and recessions of the triforium and clerestory, all of which undermine both the verticality and the flatness of the conventional Rayonnant elevation.

Informing these disruptive novelties are a dynamism, a plasticity, a delight in syncopation and layered complexity that have their closest precedents in English Decorated architecture of the first half of the fourteenth century (which Peter may have known firsthand),[60] although intimations of a similar inventiveness can also be found in Strasbourg and Regensburg cathedrals and their local affiliations.[61] Peter Parler's genius for virtuoso variations on a given theme must have been just as evident in the now much remodeled Chapel of All Saints in Prague Castle, begun about 1370 as Charles IV's homage to the Parisian Sainte-Chapelle and as the appropriate setting for a relic of the crown of thorns. Here, as in the contemporary high choir of the cathedral, Parler combines a Rayonnant glasshouse with an elevation structure conceived in layered depth. The colossal windows were pulled inward to the innermost plane of the wall, and the exterior framing arches

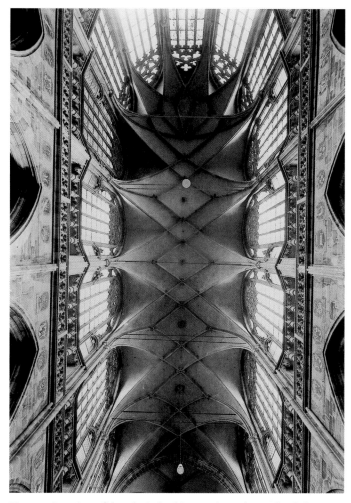

Fig. 5.7 Interior of the choir, looking up into the vaults, Saint Vitus's Cathedral, Prague

and their tracery curtains outward, to leave dark pockets of space framing each exterior bay.[62]

The cathedral's imagery found itself in creative partnership with the unorthodoxies of its architecture. In 1373 six posthumous tombs of Přemyslid kings were set up in the somber radiating chapels (fig. 5.9-32–37); a little later, busts of the Bohemian patron saints were placed around the exterior base of the luminous clerestory (fig. 5.9-22–31). Uniting these representatives of the Bohemian past and *Bohemia aeterna* is the famous series of portrait busts—of Charles IV, his family, his architects, and the cathedral's higher clergy—surmounting the entrances to the triforium passages (fig. 5.9-1–21).[63] These are the *familiares* of the royal household and, in some cases, the *fundatores,* sometimes placed above their respective tombs in the choir below. Their visibility is secured by Parler's unique device of setting the triforium grille back toward the outer plane of the high wall and framing each bust with the angled projections at the bay divisions. The equally angled aedicules above them, in the clerestory, suggest the presence of standing figures in stained glass, perhaps a cycle of Bohemian kings modeled on the great gallery of kings inserted into the base of the clerestory of Cologne's choir about 1300.[64]

Similar programmatic patterns, designed to place the Luxembourgs at the unifying center of Bohemian history, determine the sacred topography of the cathedral's altars, shrines, and installations. The relative positions of the shrines of the Bohemian patron saints in the tenth-century Wenceslas rotunda—Saint Vitus in the eastern apse, Saint Adalbert to the west, and Saint Wenceslas in the south—reappear, much extended, in the new choir (fig. 5.9-39, 42, 41, respectively), with the addition of the shrine of Saint Sigismund (fig. 5.9-40), the first Christian German king to suffer martyrdom, in the outer north choir aisle, adjoining the north transept.[65] At the center of the notional cross formed by the axes of these four tombs, Charles set his own tomb (fig. 5.9-38), and round it his family mausoleum. This occupied the *chorus minor,* the three self-contained western bays of the choir presided over by the altar of the Virgin (fig. 5.9-46), and staffed by a royal chantry, the college of priests that Charles had established in the Romanesque cathedral in 1343.[66] The emperor and his family lie literally at the crossroads of Bohemian sacred history, under the protection of the Virgin, whose relics (veil, robe, and drops of milk), donated to the cathedral by Charles, were treasured at the altar and formed the focus of a popular Marian cult.[67]

More than any other Bohemian patron, Saint Wenceslas dominated the rituals, the iconography, and the sacred topography of the cathedral. Wenceslas's cult articulated

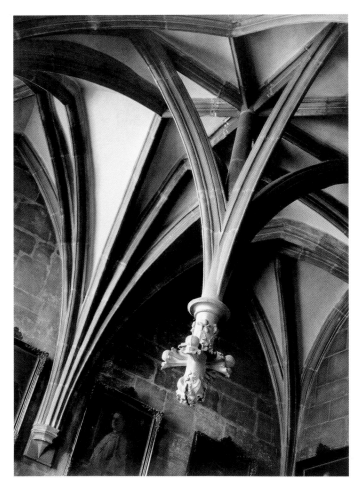

Fig. 5.8  Interior of the sacristy, Saint Vitus's Cathedral, Prague

the myths of Bohemian sacral kingship. Around his tomb (fig. 5.9-41), the ideological nucleus of the Bohemian state, Charles lavished his most generous patronage: statues of the Twelve Apostles around the old tomb (1333),[68] a shrine base (in 1348 or perhaps just before), a gem-incrusted feretory (1358), and, most expressively, a reliquary bust (before 1354), on which Charles's new crown (mid-1340s; fig. 1.4) was to be placed in perpetuum. The political abstraction of the *Corona Boemie* was thus inseparably wedded to the most potent image of the nation's sacred history.[69] The saint's new chapel in the cathedral, which Parler and the emperor planned in the spring and summer of 1356,[70] is unlike any Gothic building north of the Alps (fig. 6.1). Dark, mural, and introverted, girdled with a dado of semiprecious stones (an afterthought of 1370–71), its manner is at once neo-Romanesque and Early Christian, laced with a strong sense of Italo-Byzantine *Romanitas.* This consciously retrospective mode of design, contrasting pointedly with the bright, robust language of the high choir, amounts to an aesthetic rhetoric designed to recall the ancient character of Wenceslas's rotunda and the site of his grave, over which the new chapel was reverently and exactly constructed.[71]

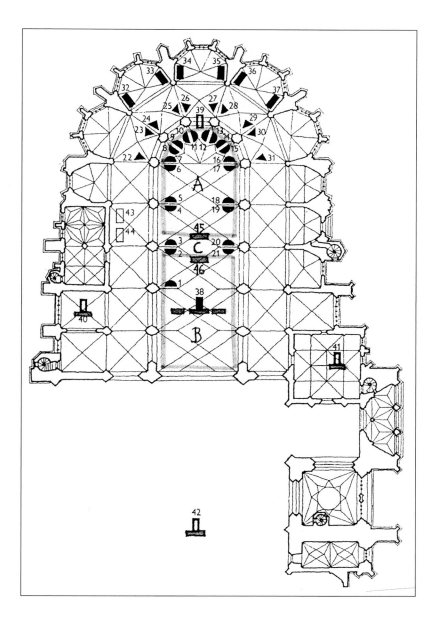

Fig. 5.9 Plan of Saint Vitus's Cathedral, Prague

A. canons' choir

B. choir of the Virgin

C. altar of Saint Catherine *intra choros*

1–21. busts in triforium

22–31. busts in exterior clerestory

32–37. Premyšlid tombs

38. tomb of Charles IV with the altars of Saint
Nicholas, Saint Louis, and the Holy Innocents

39. altar and tomb of Saint Vitus

40. altar and tomb of Saint Sigismund

41. altar and tomb of Saint Wenceslas

42. altar and tomb of Saint Adalbert

43, 44. tombs of Matthias of Arras and Peter Parler

45. altar of Saint Catherine

46. altar of the Virgin

Equally "rhetorical," in a spirit of decorum (the fitness of form to function), is the chapel's large, square plan, also a "copy" of the centrally planned rotunda, while its inflated size and boxy misalignment with the rest of the cathedral's layout emphasizes its status as a church within a church.[72] Such a loose agglomeration of discrete parts also characterizes the south transept facade, the principal entrance to the cathedral, flanked on its east side by the low Wenceslas Chapel and on its west side by a single gigantic steeple, the whole effect lopsided and irregular. For the first time on the Continent, integrated orthogonal planning, a notion at the heart of all Gothic Great Church architecture since its beginnings at Saint-Denis, was being openly challenged in favor of a looser sequence of *memoria*.[73]

The south transept facade is a showcase for Peter Parler's handling of contrasting modes of design, as well as an object lesson in the adaptability of a Rayonnant-trained architect to the eccentric Italianate taste of his patron. In its startling juxtaposition of boxy massing and traceries of filigree delicacy,

it had few parallels in fourteenth-century northern Europe.[74] The mural lower story is decorated with an exotic Venetian mosaic of the Last Judgment that consciously echoes Roman and central Italian facade mosaics (see frontispiece).[75] This contrasts bizarrely with a virtuoso display of northern Rayonnant decoration in the upper stories, notably a vast single window and its eastern buttress, the latter alarmingly perforated by the openwork cage of a spiral stairway, festooned with a fanfare of imperial and Bohemian heraldry. The openwork staircase was to become a leitmotif of the next generation of German Gothic architects.[76]

So, in a more structural sense, was the cathedral's massive (but incomplete) south tower, conceived and set out by Peter Parler as an integral part of the south transept facade yet acting as a beacon, not just for the cathedral but for the adjoining royal palace to its south and for the whole city of Prague beneath it. Two drawings of the lowest story of the tower, made at a planning stage in the 1370s or 1380s (Akademie der Künste, Vienna, 16817, 16817R; see cat. 47), register its

importance as both a "facade" and an integral part of the south transept and eastern bays of the nave.[77] The design of the tower's upper parts and of the adjoining upper gable of the transept belongs to the first two decades of the fifteenth century and may be the work of Peter Parler's son Johann or his successor, Master Petrlík. Their spiderweb application of tracery to towers and high masonry anticipated, and paralleled, the concentration on giant, tracery-clad steeples that was to absorb the creative imaginations of leading architects in South German lands in the first half of the fifteenth century.[78]

To acknowledge the legacy of Prague Cathedral to later works along the Danube and in South German lands is to admit its corollary: the muted impact of the cathedral in Prague itself. The west porch (about 1370) of the Church of Our Lady under the Chain in the Little Quarter is a simplified version of the cathedral's south entrance.[79] In the Old Town, the north aisle of Saint Castulus was extended after 1375 with a double-aisled hall arrangement, whose "green-man" capitals closely resemble those of the Wenceslas Chapel, but whose slender, capital-less columns and simple vaults owe far more to local architecture—for example, the sacristy of the nearby Franciscan Church of Saint James and the side aisle of Saint Peter na Poříčí (now demolished)—than to the Parlers.[80] It was largely in the selective and adaptable field of microarchitecture that the Parler workshop was most influential outside the Hrad. The metal tabernacle in the Wenceslas Chapel, dated to the third quarter of the fourteenth century and usually attributed to the Parler workshops (cat. 123), shows a narrow octagonal upper spire supported by flying buttresses clearly modeled on the choir's. Such slender octagons reappear in the plan for a steeple in the drawing of the cross section of the cathedral's choir, prepared about 1360 (cat. 47), a plan whose octagonal elements (perhaps staircases) show remarkable similarities to the ground plan of Peter Parler's sacrament house for Saint Bartholomew's at Kolín (before 1378).

The slender, octagonal cylinder at Kolín, resting on concave corbels, anticipates a type of microarchitectural structure popular in Prague and Nuremberg: the sometimes strikingly ornate polygonal oriel, or *Chörlein,* projecting from the facade of a house and often containing a chapel. The type appears in the chapel oriel in the east facade of the Old Town Hall in Prague (before 1381),[81] and, even more elaborately, in the ostentatious oriel of the Prague Carolinum (fig. 8.7), a college rebuilt in 1383–86 by Wenceslas IV for Prague University.[82] In both (very similar) oriels the polygonal core is overlaid with a network of Parlerian Rayonnant accents: microarchitectural niches, blind and hanging tracery, and openwork tracery cusps.

The only substantial incursion of Parlerian forms into the city of Prague occurred at the very center of the Old Town's spiritual and economic life, the Church of Our Lady before Týn, fronting the Old Town Square (see endpapers). Begun soon after 1350, already generously endowed by one of the greatest of Prague's burgher patricians, Konrad of Litoměřice, the new church presented the Old Town with the opportunity to respond to the scale and novelty of the cathedral, while offering a genuinely municipal alternative to it. Its three-apsidal choir looked back to the Emmaus, while its vertiginous height and basilican format owed something to contemporary Silesian town churches. The attenuated windows and austere, skinlike walls recall the expressive, monumental basilicas of Wrocław, one of Charles IV's alternative, and increasingly popular capitals. Only the details speak of the cathedral: Peter Parler's trademark of placing a respond on the axis of the main choir vessel; arcade moldings and tracery patterns echoing both Matthias's and Peter's cathedral. The ambitious round-arched north portal, with its curtains of cusped tracery and its complex microarchitecture, is clearly a late Parlerian cathedral import, and it may reflect Wenceslas IV's new residence nearby at the Horská Gate of the Old Town, begun in the late 1370s.[83]

The cathedral's impact on architectural style in Prague after the death of Charles IV may have been muted, but the inescapable presence of the Hrad—dominated by its cathedral and adjoining royal palace—was crucial to the life and layout of the city. Like a coulisse, the cathedral's south transept faced both the royal palace and the whole of Prague beneath it. Under the year 1370, Beneš Krabice of Weitmile, the chronicler of Prague Cathedral and a director of its building works, grouped together the "beautiful and very expensive" south transept mosaic, made "in the Greek manner," and the two towers of the royal palace, which Charles gilded "so that they might shine and reflect the sun over a great distance."[84] The brilliance of the one was to be echoed in the dazzle of the other, and both were to dominate the city beneath them. With the building of the Charles Bridge, beginning in 1357, perhaps to the design of the specialist bridge builder, Master Oto, the cathedral's visual complexity and symbolic resonance were extended into the lower parts of the city (figs. 5.1, 5.2-6).

The structure, a replacement for the old Judith Bridge destroyed by flood in 1342, acted as a ceremonial arch for a processional route beginning on the right bank of the Vltava with Vyšehrad Castle and the New and Old Towns and moving across the river to the Little Quarter and the Hradčany.[85] The pivotal point was the Old Town Tower

(begun about 1370), which was designed, decorated, and sculpted by the Cathedral workshop. Its east facade (fig. 5.1) shows the crowned and enthroned figures of Charles IV and his son Wenceslas IV, surmounting the arms of the provinces of the empire and flanking the central figure of Saint Vitus; above them stand figures of Saints Sigismund and Procopius (or possibly Adalbert), all saints singled out in the cathedral choir.[86] The whole composition—rising directly in front of the distant cathedral and partly framed in what resembles the cross section of a church—reads like a diagrammatic overture to the main symbolic themes of the cathedral choir, in particular its vertical sculptural program, proceeding from the Saint Vitus altar to the triforium busts of Charles and Wenceslas and to the Bohemian patron saints in the clerestory above them.[87] Nor is the cathedral's much-promoted cult of the Virgin neglected, for on the Bridge Tower's west facade, facing the cathedral, were once kneeling figures of Charles IV and Queen Elizabeth of Pomerania venerating a large standing figure of the Virgin and Child.[88]

The theocratic imagery of the Bridge Tower and its pivotal position between the right and left banks of the Vltava drew it into a processional liturgy that united Vyšehrad and the Old and New Towns with the Little Quarter and the Hrad: the pilgrimage of the king-elect to Vyšehrad on the evening before his coronation. From Charles's coronation ordinal, which he himself wrote soon after 1344,[89] and from the evidence of Přibík Pulkava's later fourteenth-century *Chronica Bohemorum,*[90] it is clear that the ritual began on the vigil of the coronation with the prince's procession on foot from the Hradčany to the Church of Saints Peter and Paul on the Vyšehrad, there to be shown the shoe of Přemysl the Poughman and to place his ancient satchel over his shoulder.[91] When these rustic reminders of the king's humble origins were completed, the royal procession moved back to the cathedral for vespers, on a route that the king must also have traversed in his ceremonial arrivals into Prague from the south. This "Royal Route" might be described as a *via triumphalis,* descending from Vyšehrad to the Emmaus Monastery and from there to Charles Square in the New Town. It then traversed the Old Town, passed under the Old Town Bridge Tower, and proceeded over the Charles Bridge to the Little Quarter and the Hradčany. The general meanings of this liturgical journey were diverse but clear: it was a rite of passage,[92] an exercise in retrospection and humility, and, above all, a literal progress from Přemyslid myth to Luxembourg triumph, a pilgrimage in which the whole city of Prague and its *memoria*—its churches, chapels, and squares—acted as a sacred theater.

Exactly the same journey, in reverse, marked the itinerary of Charles IV's funeral on December 11, 1378, when his body was taken for a night's vigil to Vyšehrad, before returning to the tomb prepared for it in the cathedral. The corpse of the crimson-robed emperor, framed by his Bohemian and imperial regalia, rested on a bier covered in a golden cloth and protected by a golden baldachin supported by twelve knights. The Empress Elizabeth headed the procession of noblewomen, filling some forty carriages draped in black. Behind them rode the standard-bearers from every quarter of the empire, with a single knight bringing up the rear who carried the emperor's helmet in its ermine cover and his sword pointing downward. Abbots, monks, and canons from all the monasteries of Prague, students, professors, and representatives of the trades (carrying candles and symbols of their guilds)—all dressed in black—moved in solemn procession, from the castle hill to the Charles Bridge, from the Old to the New Town, from the Emmaus to Vyšehrad, where the body lay for the night in the provost's palace, the same house that Charles's mother had died in forty-eight years before.[93]

Charles's posthumous pilgrimage encapsulated both a lifetime's journey and a compressed history of Bohemia. His reign began and ended with this enactment of Bohemian myth across the heroic spaces of a great city. Vyšehrad reflected both the rise and the demise of the Přemyslids; the Emmaus recalled the origins of Slavonic Christianity; the New Town spoke the language of imperial success and cosmopolitan exchange; the Old Town housed the new university; the Charles Bridge Tower acted as a mnemonic overture to the main symbolic themes of the cathedral choir; and finally—at the climactic point from which and to which this historical and topographical journey proceeded—the gilded modern palace on the Hrad and the dazzling cathedral of the new Luxembourg dynasty welcomed its royal resident.

The promise of renewal and continuity that lay behind this symbolic topography was short-lived. Charles IV's identification of religion with imperial ideology, his promotion of sacral Luxembourg kingship through art, architecture, and dynastic myth, collided with the reality of Bohemian nationalism and anticlericalism that fomented through the last quarter of the fourteenth century. The sacred crown of Saint Wenceslas, with all its hierarchical implications, proved no defense against charges of ecclesiastical corruption and royal weakness. Paradoxically, Charles's tolerant accommodation of diverse religious and ethnic cultures in Prague had paved the way for religious dissent, while his propagandist art had confused the boundaries between myth,

religion, personality, and politics. By opening up his New Town to an artisan and predominantly Czech population, he shifted the balance of power from the Germans in the Old Town to an increasingly populous Bohemian citizenry.[94] Political protest merged imperceptibly with iconoclasm.[95] When long-held dissatisfactions finally erupted in 1419 with the Hussite Revolution, Charles's public art, and with it the dream of "golden Prague," was the inevitable target of the political and religious reformers. The firebrand preaching of Konrád Waldhauser and Milíč of Kroměříž in the Týn Church in the 1370s had turned the parish church of the Old Town into the center of Prague dissent.

The architecture that embodies the Hussite critiques most vividly, however, was not the grandiose Týn but the simple Bethlehem Chapel (see fig. 10.3), also in the Old Town. Founded by no less a figure than Archbishop Jan of Jenštejn in 1391, it was Jan Hus's preaching church from 1402 to 1413. Built on a trapezoidal plan, adapted informally to the restrictions of the site, it opposed everything that the stylish and ritually lavish architecture of Luxembourg Prague—"the honoured, noble and respected" city foreseen by Libuše—stood for. Simple lancet windows lit a preaching auditorium whose wooden roof rested on wooden pillars. The radical Hussitism that this kind of architecture fostered and the iconoclasm which flowed from it effectively destroyed Prague as an architectural capital until the revival of a specifically "Carolinian" culture under King Vladislav II Jagiello in the last two decades of the fifteenth century.[96] The "Junker von Prag," the legendary builders of Prague Cathedral and the executants of the emperor's visions, had to rekindle their creativity outside Bohemia, along the Danube and in the Upper Rhine.[97]

1. Heinrich Truchsess of Diessenhofen, FRG 1868, p. 116: "Et inde [Karolus] Pragam secessit, que nunc metropolis regni Bohemie existit, ubi nunc sedes imperii existit, que olim Rome, tandem Constantinopolim, nunc vero Prage degit."
2. For the use of the phrase in the Bohemian chancellery in the 1350s, see Seibt 1978a, p. 24.
3. Chaloupecký 1948; Kavka and Petráň 1995.
4. Pirchan 1953, pp. 64–67.
5. Stejskal 1978a, p. 144. For Charles's "identities" in the form of constructed "portraits," see Suckale 2003c.
6. Charles IV, *Vita* 1978, p. 70: "Quod regnum invenimus ita desolatum, quod nec unum castrum invenimus liberum, quod non esset obligatum cum omnibus bonis regalibus, ita quod non habebamus ubi manere, nisi in domibus civitatum sicut alter civis. Castrum vero Pragense ita desolatum, destructam ac comminutum, quod a tempore Ottokari regis totum prostratum fuit usque ad terram. Ubi de novo palacium magnum et pulchrum cum magnis sumptibus edificari procuravimus, prout hodierna die apparet intuentibus."
7. Fischerová 1974; Menclová 1972, vol. 2, pp. 34–42.
8. Spěváček 1976, p. 16.
9. Zbraslav Chronicle, FRB 1884, p. 331.
10. Benešovská 1998; Benešovská 2003a.
11. Eberhardt 1978; Widder 1993.
12. Charles IV, *Vita* 1978, chap. I, p. 10: "Secundis sedentibus in thronis meis binis" (To my successor on my double throne). See also Ormrod 1997.
13. See, conveniently, Státníková et al. n.d., and also, Hrdlička and Nechvátal 2001; Opačić 2003, pp. 71–73.
14. For Christian's late-tenth-century *Life and Martyrdom of Saint Wenceslas and His Grandmother, Saint Ludmila,* the so-called *Legenda Christiani,* see Kantor 1990, pp. 165–66; and for Charles's "Life of Saint Wenceslas," see Blaschka 1934, esp. pp. 22–25. For the most up-to-date interpretation of the concept of *Translatio Imperii,* see Vavřínek 2000.
15. For the early history of the castle in English, see entries by Frolík, Benešovská, and Chotěbor in Prague Castle 2003; and also Frolík 2000.
16. Prague Castle 2003, pp. 158–65: "ad instar domus regis Francie cum maximus sumptibus."
17. Menclová 1972, vol. 2, pp. 43–48.
18. Bennert 1992; Whiteley 1989; Crossley 2000, pp. 113–20.
19. Grass 1965, pp. 166–68; Billot 1998.
20. Sokol 1969; Homolka 2004.
21. The most useful guide to the rotunda and the Romanesque cathedral is Merhautová 1994, pp. 13–24. For the Romanesque Hrad and Saint George, see entries by Benešovská et al. in the "Romanesque" section of Prague Castle 2003, pp. 88–149, and see also Frolík 2000.
22. Cosmas of Prague, FRB 1874, pp. 15–16.
23. Haussherr 1971, pp. 22–23; Benešovská 2003b.
24. Charles IV, "Život svatého Václava" (Vita sancti Wenceslai), VI–VII, see Blaschka 1934; Kavka 1993, part 1, pp. 108, 113ff.; Ormrod 1997; Rosario 2000, pp. 54–63.
25. František of Prague, FRB 1884, p. 438; Beneš Krabice of Weitmile, FRB 1884, p. 495.
26. For the inscription and Matthias's work, see Benešovská and Hlobil 1999.
27. Mencl 1971, pp. 217–54; Freigang 1992, pp. 19–112; Benešovská 1994; Freigang 1998, pp. 69–74.
28. Benešovská and Hlobíl 1999; Schurr 2003, pp. 53–57.
29. Otavsky 1992; Crossley 1999; Crossley 2000, pp. 111, 156–72.
30. Lorenc 1973, p. 45; Beneš Krabice of Weitmile, FRB 1884, p. 516. The new district was probably in the planning stages as early as 1344–45, and almost certainly from 1346.
31. Beneš Krabice of Weitmile, FRB 1884, p. 515.
32. Fajt, Hlaváčková, and Royt 1993–94.
33. Benešovská 1995.
34. Fajt 2000; Baťková 1998, pp. 137–41; Kroupová and Kroupa 2003, pp. 142–55.
35. Beneš Krabice of Weitmile, FRB 1884, p. 524; Kalista 2004, pp. 149, 196–97. John of Luxembourg was a member of a chivalric confraternity of Saint Catherine. See Hilger 1978, p. 352.
36. Lorenc 1973, p. 121.
37. Benešovská 1996; Petr and Šabouk 1975. For the fullest account of the foundation and the monastery, see Opačić 2003.
38. Crossley 2000, pp. 128ff.
39. Benešovská 1991; Benešovská 2001b.
40. Benešovská 1991.
41. Opačić 2003, p. 90.
42. Bühler 1963; Adelson 1966; Opačić 2003, p. 145.
43. Beneš Krabice of Weitmile's testimony that the relics were initially kept there has been questioned. See Beneš Krabice of Weitmile, FRB 1884, p. 519; and Opačić 2003, pp. 136, 274–75.
44. Opačić 2003; Opačić 2005a; Benešovská 1996; Všetečková 1996.
45. Grüns 1843; Bachmann 1969, pp. 92–97; Polívka 1983; Baťková 1998, pp. 87–88.
46. Lorenc 1973, p. 108; Crossley 2000, p. 131n71; Opačić 2003, pp. 123–24, 151n160.
47. Kotrba 1975, p. 60; Opačić 2003, p. 121.
48. Crossley 2000, pp. 131–32.

49. Beneš Krabice of Weitmile, FRB 1884, p. 524; Hilsch 1978.
50. The Roman references in Karlštejn Castle—its Passion relics and its spatial dispositions—are, however, too insistent to be ignored. See Möseneder 1981, pp. 64–69, for similarities between the chapels in the Small Tower at Karlštejn and Santa Croce in Gerusalemme in Rome; and Homolka 1998, p. 65, for the influence of the San Zeno Chapel in Santa Prassede in Rome on Karlštejn.
51. Möseneder 1981.
52. For the cult of the Acheropita, see Belting 1994, pp. 63–73, 311–29. For the hypothetical route of the Acheropita procession, see Kessler and Zacharias 2000.
53. As a direct result of his Rome journey, Charles commissioned a copy of the *vera icon* from the original kept in Saint Peter's (cat. 137) and entrusted it to Saint Vitus's sacristy, where its image appears in the central section of the south portal's Last Judgment mosaic (see frontispiece). See Podlaha and Šittler 1903a, p. 115.
54. For example, the Franciscan Church of Saint James (ca. 1308) and Saint Gilles (1311).
55. See Benešovská 1995 for a discussion of the "New Town style." Also Líbal 1983; Opačić 2003, pp. 187–207; and Opačić 2005b.
56. Lorenc 1973, pp. 56–57; Opačić 2003, p. 207.
57. An incisive analysis of Peter Parler's creative processes can be found in Schurr 2003. Note also the perceptive insights in Benešovská 1999a and Benešovská and Hlobil 1999. See also Baumüller 1994.
58. Kurmann 2001; Schurr 2003, p. 108.
59. Bony 1979, pp. 66–67, and Schurr 2003, pp. 120–25.
60. Crossley 1981; Crossley 2005.
61. Schurr 2003, pp. 97–126.
62. See note 20 above.
63. Benešovská 1994; Schwarz 1992; Freigang 2002; Schwarz 2004.
64. Brinkmann and Lauer 1998.
65. Schurr 2003, pp. 86–88, with earlier literature.
66. For the importance of the *chorus minor* and its tombs, see most recently Benešovská 2004. The strange placing of a Virgin altar in the western bays of a choir primarily follows the old double-ended system of the Romanesque church, but it may also reflect its identical position in the new choir at Aachen Minster, begun under Charles's auspices in 1355. See Crossley 2000, pp. 162–64, and Benešovská 2003b.
67. Podlaha and Šittler 1903a, pp. 21ff.
68. Kotrba 1960, p. 353n27; Ormrod 1997; Crossley 2000, p. 111.
69. For the crown, see Otavsky 1992. The notion of *Corona Boemie* is discussed in Seibt 1978b, pp. 169–70; and also fully in Ormrod 1997, pp. 217–40.
70. Kotrba 1960; Kotrba 1971.
71. Suckale 1980. Charles, of course, could not have known the original rotunda since it had been demolished in the eleventh century; but a surviving fragment of its southern apse and other extant Bohemian and Moravian rotundas may have given him an idea of its general shape.

72. Benešovská 1994.
73. But note Schurr's (2003, pp. 67–69) suggestion that Peter Parler had planned a short nave with a western apse and a corresponding transept tower on the north side, thus reestablishing an east-west symmetry with the choir and transepts and expressing both the double-ender plan of the eleventh-century basilica and of imperial *Kaiserdome*. See also Benešovská 2001a.
74. The closest parallels might be the architecture of Michael of Canterbury and its followers. See Wilson 1990, pp. 192–204.
75. Puppi 1982; Všetečková 1994, pp. 94–102.
76. Nussbaum 2000, pp. 133, 143–51; Schurr 2004.
77. Bork (2003, pp. 166–67) calls attention to evidence of erasures in the drawings, which suggest that Peter Parler originally foresaw in this position a lightweight single-story chapel, balancing Saint Wenceslas's, instead of a massive tower.
78. Benešovská 2001a; Chotěbor 2001; Bork 2003, pp. 162–218; Schurr 2004.
79. Mencl 1948, p. 96; Bachmann 1969; Líbal 1983, pp. 279–83.
80. Mencl 1948; Líbal 1983, p. 301; Benešovská in Prague 2001a, p. 76.
81. Vlček 1996, p. 137.
82. Ibid., p. 360. Both oriels are discussed in Timmermann 1999, pp. 403–5.
83. Líbal 1983, pp. 286–94; Outrata 1986; Benešovská 2001b, pp. 94–95; Kalina 2004. For the Wrocław and Silesian background, see Kutzner 1998.
84. Beneš Krabice of Weitmile, FRB 1884, p. 541: "pulchro et multum sumptuoso . . . de opere vitreo more greco . . . lucerent et resplenderent tempore sereno ad longam valde distanciam."
85. Chadraba 1974; Pesek and Zilynskyj 1988, pp. 18–19; Crossley 2000, p. 107.
86. Chadraba 1974; Sauerländer 1994, pp. 197–201; Vítkovský 1994.
87. Crossley 1999, pp. 361–63.
88. Vítkovský 1994.
89. The *Ordo ad Coronandum Regem Boemorum;* see Cibulka 1934, p. 76; Crossley 1999, p. 363; and Crossley 2000, pp. 129–30.
90. Pulkava, FRB 1893, p. 7.
91. Opačić 2003, pp. 70ff.
92. For the related meanings of a similar penitential and triumphant pilgrimage on the eve of coronation, in the fifteenth-century ordinal for the kings of Poland in Kraków, see Węcławowicz 2002.
93. For the funeral, see Šmahel 1993 and Opačić 2003, pp. 130–33.
94. Brosche 1978, p. 249.
95. For the thesis that the Hussite Revolution had its roots in the policies of Charles IV, as early as the 1350s, see the contributions in Seibt 1997.
96. For the Bethlehem Chapel, see Benešovská in Prague 2001a, pp. 102–3, and Vlček 1996, pp. 58–61.
97. Schurr 2004.

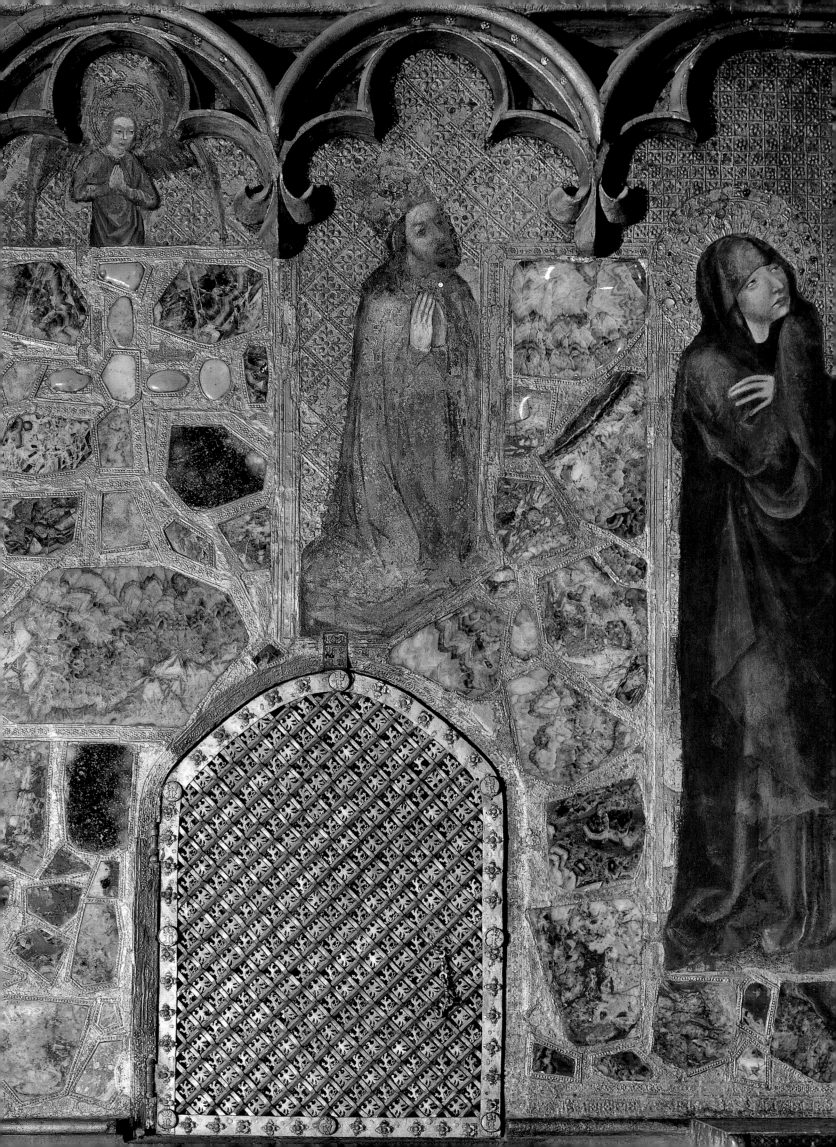

# CALLED TO CREATE

## LUXURY ARTISTS AT WORK IN PRAGUE

*Our Lord the Emperor wanted to demonstrate the magnificence*
*of the glory of his kingdom of Bohemia.*
*—Beneš Krabice of Weitmile[1]*

Barbara Drake Boehm

From as early as the tenth century, Prague was a town at a crossroads frequented by international merchants. An envoy of the caliph of Córdoba described Prague as becoming rich through trade: "Russians and Slavs go there with goods from the city of Kraków. And Muslims, Jews, and Turks go there from the lands of the Turks, also with goods and currency, and they export from them slaves, tin, and [various] kinds of furs."[2] Romanesque manuscripts from Czech monastic libraries and works of art such as an eleventh-century oliphant in the treasury of Saint Vitus's Cathedral (fig. 6.2) offer tangible evidence both of artistic dialogue between Bohemia and the rest of Europe and of the importation of works of art from the eleventh to the thirteenth century.[3] Nevertheless, with the arrival in 1333 of the future emperor Charles IV, international commercial and artistic contacts were newly invigorated and personally fostered by the well-traveled and cosmopolitan prince.

Charles was a passionate collector. The *Grandes chroniques de France,* for example, record in some detail the emperor's abiding eagerness to acquire works of art during his last visit to Paris in 1378, the year of his death. This official history of the French monarchy recounts how the merchants and aldermen of Paris presented Charles with a gilded silver *nef* (boat-shaped vessel) and two large enameled and gilded ewers, while his son Wenceslas was given a silver fountain.[4] In addition to the holy relics given him by his nephew King Charles V of France, the emperor received a jasper coffret, golden goblets, hanaps, ewers, and pots, includ-

ing some objects identified as "the type that can be made in Paris."[5] Charles IV was more than a passive recipient, however. He asked to examine a crown that the French king had commissioned and met the goldsmith, Hennequin, responsible for its creation.[6] The emperor also requested a book of hours from his nephew's collection; when Charles V gave him the choice of a large or small one, he unabashedly chose both.[7] There is little indication of what Charles IV offered his French cousins,[8] but his eagerness to acquire works in France clearly did not stem from a lack of artists in his own new capital. In 1333 he had ordered the initial renovations of Prague Castle, wanting "to demonstrate the magnificence of the glory of his kingdom of Bohemia, since princes, administrators, and nobles were pouring in to visit him from all parts of the world. He had the two royal towers of the Prague Castle . . . covered with lead and with gold on top, so that [they] might powerfully shine and gleam at a far distance in fair weather."[9] And, like his castle towers, Charles's patronage served as a beacon as well to artists across Europe.

Fig. 6.1  Charles IV at Prayer. Wall painting with jasper, amethyst, and gold revetement; 1372–76. Saint Wenceslas Chapel, Saint Vitus's Cathedral, Prague

Fig. 6.2  Oliphant. Ivory, late 11th century. Treasury of Saint Vitus's Cathedral

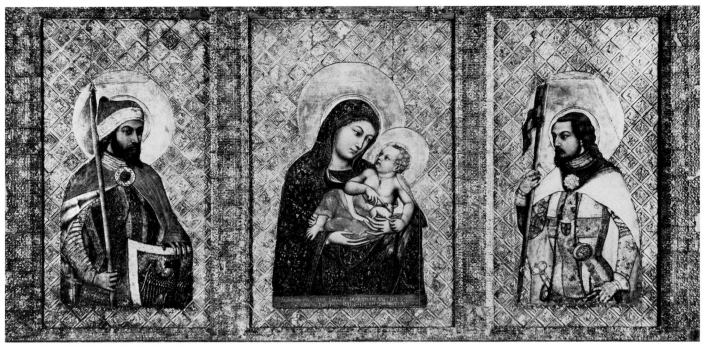

Fig. 6.3 Tomaso da Modena (1325/26–1379). Triptych with the Virgin and Child. Tempera and gold on panel, before 1365. Holy Cross Chapel, Karlštejn Castle

## PAINTERS

Within a year of Charles's coronation as king of Bohemia in 1346, the painters of Prague established the Brotherhood of Saint Luke. Its members in the Old Town (Staré Město) were affiliated with the Church of Our Lady of the Lake, where they maintained an altar dedicated to their patron saint;[10] a parallel group was later formed in the New Town.[11] The book of records of the Old Town brotherhood, one of the rare documents of its kind to survive, provides a wealth of information concerning the regulation and membership of the group.[12] Its lists of members reveal the year that each painter enrolled, how much each individual was assessed, and the relative status of members. Some are named as "magister" (master); others, such as a certain Panicz Waczlaw, as "panici" (bachelors). Several names are officially designated as those of royal painters: Master Osvald, for example, is mentioned in connection with painted decoration of architectural elements at Saint Vitus's Cathedral.[13] The best documented royal painter is Master Theodoric (Magister Theodoricus) (see cat. 33).[14] Theodoric is named as "primus magister" (first master, in the sense of most important) in the brotherhood and as "malerius imperatoris" (painter to the emperor) from 1359 to 1368.[15] Moreover, he is recorded as the owner of a house comfortably situated at Hradčany, adjacent to Prague Castle.[16] On April 28, 1367, Theodoric is referred to in an imperial document as "pictor noster et familiaris" (our painter and inti-

mate), implying a level of affiliation between royal patron and artist traditionally considered to be a hallmark of the Renaissance.[17] Recognized by the emperor as the artist who had worked "skillfully and ingeniously" on the Holy Cross Chapel at Karlštejn Castle (fig. 1.1), he was granted a nearby estate at Mořina in 1367 that was exempt from taxation except for a gift of thirty pounds of wax annually to the chapel.[18] Theodoric was the second painter at Karlštejn to be presented with this free estate; the first, Nicholas Wurmser, a native of Strasbourg, was named in royal documents in 1357 and received the property in 1360.[19]

Although the name Tomaso da Modena does not appear in court documents, the presence of his signature on a triptych with the Virgin and Child (fig. 6.3) embedded into the wall of the Holy Cross Chapel at Karlštejn and on a diptych preserved at the castle offers additional evidence that the emperor brought paintings from outside Bohemia to his court.[20] The book of records also reveals the international origins of some painters active in Prague. A Frenchman, "Monsier Johannes Galicus," figures on the list of about 1375.[21] Henslinus from Augsburg is listed in 1370 as having been admitted as a burgher without any payment.[22] Johannes Rogel from Halberstadt paid thirty groschen as an admission fee in 1379, while Henricus from Passau is listed in 1383.[23] Nicholas of Erfurt, a town near the imperial city of Nuremberg, is named in the records of 1391, which note his admission as a burgher without payment

"because he is a painter." Pertoldus, from the same town, appears on a list of about 1405.[24]

At the same time, the records indicate that other guild members were of local origin. A Czech form of the name Mauritius (Mořic) identifies the painter listed as "Petrus Merschico." Nycolaus is named about 1405 as a "pictor de Chotyeborz," painter from Chotyeborz, southeast of Prague, or from Chotěbuz (Cottbus) in Lusatia, part of Bohemian lands.[25] The appellation "Magister Stephanus Bohemus," listed about 1400, signifies a master painter from Bohemia.[26] A "Mistr Kuncz" is indicated as a "Kraluow malerz" (king's painter), either in the service of King Wenceslas IV or King Sigismund, as late as 1436–37, at the time of the Sigismund's patronage initiatives in Prague.

Freedom from tax assessment was only one aspect of the relatively privileged lifestyle of Prague's painters. Through what seems a surprisingly progressive policy, painters, "because of their art," were exempt from military service.[27] Instead, each was asked to make for the city of Prague three shields or large military cloaks, to paint municipal banners, and to provide for nine soldiers-in-arms serving in his stead.[28] The painters' records for about 1365 mention an armorer named Vndersik living in the New Town (Nové Město) who was presumably part of the company named in an imperial document as producing pieces for "a complete set of armor for the tilt, a saddle, a shaffron, a leather breastplate, and a shield."[29]

Originally the Brotherhood of Saint Luke was intended to comprise only painters, including those who worked on shields; about 1410 it was officially expanded to admit a wider range of artists. But its record book, from the very first entries, mentions members working in other media, including glaziers, sculptors, illuminators, parchment makers, bookbinders, and mirror makers.

## ILLUMINATORS AND SCRIBES

There is some documentation linking the names of a number of ecclesiastics to the manuscripts they produced. Brother Jacob of Prague, for instance, is identified by inscription and shown in the margin of the Gradual of Master Wenceslas (fig. 6.4) working at his desk with pen, black and red ink, and a scraper for correction, in accordance with the long-established medieval convention for representing scribes. In most instances, however, it is not possible to match a documented illuminator with a surviving work. Brother Ondrej (Andrew) of the Monastery of

Fig. 6.4 Initial A with Brother Jacob of Prague in the margin at the left. Gradual of Master Wenceslas, fol. 2v (detail). Tempera and gold on parchment; Prague, ca. 1410. Archive of Charles University, Prague (VII 1/5)

Břevnov is recorded as an illuminator in 1337; Gottzwin, from the Cistercian monastery of Pomuk, served as the illuminator of a gradual in 1385; and Jan of Opava, a priest in the town of Lanškroun, is also named as an illuminator.[30] In 1403 Matěj, a cleric from Prague, began to study the art of illumination with Master Štěpán.[31]

The names of secular illuminators also appear in documents. "Štěpánek illumator," or "Stephanus de Praga," for example, is named in the records of the painters' guild.[32] Indeed, by the time that Wenceslas IV became king, following his father's death in 1378, only Paris could boast of a greater number of illuminators than Prague.[33] As with painters, certain illuminators were recognized employees of the king. Among these was the "konigliche Illuminator František" (royal illuminator Francis), recorded in the service of Wenceslas as of 1397, who repeatedly penned his nickname, "Frana," in the book of Numbers of the Wenceslas Bible, the king's most luxurious commission.[34] František was a property owner, but he lived in the Old Town, not adjacent to the castle, as Theodoric the painter did. His house and tower there were formerly the property of a Jewish resident named Pinkas.[35] František's relative affluence is further indicated by his ownership of a second residence in the Old Town,[36] acquired sometime before his death about 1414–16.[37] The name of another illuminator, "N. Kuthner," also appears in the Wenceslas Bible, in volumes 2 and 3.[38] This name, which has not been identified in other contemporary documents, may denote the artist's place of origin—Kutná Hora, the site of the royal silver mines—rather than his family.[39]

As the namesake of the patron saint of Bohemia, the illuminator "Wácslaw" must certainly have been of Bohemian origin.[40] Although he purchased a house in the Little Quarter (Malá Strana) below the castle,[41] most of the craftsmen involved in manuscript production appear to have been residents of the New Town. A "scriptor regius" (scribe of the king) documented in 1419 lived near the Town Hall (Na Karlove Náměstí).[42] A binder of manuscripts named Wenzel resided nearby at W Prwni Řeznická ulice,[43] while his neighbor "Matthias colorator" (Matthias the colorist) may have been a painter or illuminator.[44]

Still, the historian Wácslaw Wladiwoj Tomek has identified only ten illuminators from archival records dating up to 1419.[45] The ambitious production to which the surviving luxury manuscripts bear witness—more than fifty published by Josef Krása alone for the period 1355–1410—apparently represents the work of a quite restricted group of professionals.[46] Consider, for example, the number of recorded illuminators in light of the more than three hundred people engaged in the contemporary brewing industry in Prague.[47]

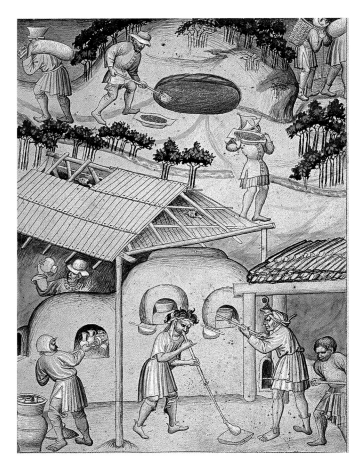

Fig. 6.5 A late medieval glassmaker's atelier in Bohemia. *The Travels of Sir John Mandeville* (cat. 88), fol. 16r. Tempera and gold on parchment; Prague, ca. 1410–20. British Library, London (Add 24189)

## GLASS PAINTERS

While stained glass is known from documentary sources to have decorated the Romanesque Cathedral of Saint Vitus in Prague, there is a paucity of information concerning the Gothic glazing of the cathedral.[48] The only recorded commission pertains to glazing for the Chapel of John the Baptist at Saint Vitus's, ordered by Archbishop Arnošt of Pardubice in 1364.[49] Tomek identified twenty individuals described as "sklenarz" (glazier) in documentary sources between 1348 and 1419.[50] These have been assumed to have been simply installers of windows, since glass was more easily produced in a rural environment with access to wood for the furnaces, as in the illumination from *The Travels of Sir John Mandeville* (fig. 6.5). Nonetheless, the affiliation of glaziers with painters in the Brotherhood of Saint Luke suggests that stained-glass artists were resident in Prague. "Martinus vitreator" is first named in 1365 in the guild's records,[51] and about 1413 a glazier named Claus is listed as one of its leaders.[52] In the same list, three women also number among such artists, two designated as widows and the

third named Margaretha.[53] Rarely is a glazier's nationality discernible. Wenczlaw is named as a master glazier from 1400 to 1410; about 1413 his widow is designated in his stead, but her name does not appear again.[54] Peter Czech is designated as a "sklennarz" in the 1440s.[55] A 1407 document naming Henry the Glazier of the New Town of Prague shows him also to have been the owner of a house in Opatovice, in Moravia.[56]

## EMBROIDERERS

The 1355 inventory of Saint Vitus's Cathedral includes a "vexilla" (banner) "described as a work made by Saint Ludmila."[57] Elizabeth Přemysl, Charles IV's mother, was celebrated for having fabricated her own wedding gown and for embroidering with pearls and jewels.[58] The pearl-encrusted vestments from Saint Vitus's Cathedral are lost, but a chasuble from Saint Marienstern (cat. 15), a flourishing nunnery within the crown lands of Bohemia, attests to the practice of embroidering with tiny freshwater pearls. It is possible that the nuns at Marienstern produced the embroidery themselves, but given the wealth of this community, the abbess could also have commissioned it from Prague. Needlework was traditionally considered an occupation of virtuous women, yet there are no female names among the

Fig. 6.6 Bohemian artist in Paris. Saint Eligius Supervising the Building of a Church, in an Initial Q. *The Life and Office of Saint Eligius,* fol. 23 (detail). Tempera and gold on parchment; ca. 1390. Bibliothèque Historique de la Ville de Paris (Ms reserve 104)

embroiderers known to have been active in Prague during the reigns of Charles IV, Wenceslas IV, and Sigismund. Embroiderers are recorded in both the Old and the New Town. One, named Kunc, is identified as an embroiderer for Charles IV.[59] Twenty-one distinct references to embroiderers have been found between the years 1362 and 1440, with specific addresses given for fully half of them.[60] Among them, one "Thomas" is identified in the New Town in 1389 as coming from the Old Town ("antiqua civitate Pragensi"), while "Georius" is cited in 1404–17 as being from Hungary.[61]

## GOLDSMITHS

In the second half of the fourteenth century, goldsmiths were active in about two hundred European cities and numbered in the thousands.[62] Paris, a city of some two hundred thousand people, boasted six hundred goldsmiths during the reign of Charles VI (1380–1422),[63] while Cologne had about one hundred.[64] For Prague, Tomek identified seventy-one who acquired or registered property between 1348 and 1419, the year of Wenceslas IV's death;[65] fifty were established as new citizens between 1334 and 1393.[66] The goldsmiths of Prague first set governing ordinances in 1324. Their relative prominence in society is suggested by the mention in Saint Vitus's 1354 inventory of the gift of a "chortina" (belt) by Nicholas, goldsmith of Prague, which is paired with a second given by the sister of Jan, bishop of Olomouc.[67] "Hanuš z Kolina" (Hans of Kolín nad Labem, on the Elbe), named as an imperial goldsmith, purchased property in 1371 at Castle Square, where court painters and builders lived.[68] Others resided on Goldsmiths' Street in the Old Town.[69] A Greek goldsmith known as "Wácslaw Řek" living in the Old Town at 156 Velká Jezuitská may have been a son of Jan Řek, a court goldsmith who worked for Wenceslas II and John of Luxembourg.[70]

In 1371, goldsmiths by the names of Jindřich, Jiří, and Kubin were employed for the adaptation of a reliquary of Saint Vitus.[71] Gerhard of Dortmund was a native German speaker active in Prague. Gerhard returned to Dortmund in 1373 with a letter from Charles IV, in which the emperor expressed satisfaction with his work.[72] A "Magister Heinrich goltsmid" is named about 1414.[73]

In 1378 Charles IV acquired the miter of Saint Eligius, patron of goldsmiths, in Paris. He brought the precious relic back to Prague and presented it to the goldsmiths of Prague, who enshrined it in a miter-shaped reliquary that bears an inscription proudly acknowledging the emperor's gift (cat. 62). Because of their close relationship to the miniatures in

the Codex of Jan of Jenštejn (cat. 96), the Bohemian illuminations of the *Life and Office of Saint Eligius* (fig. 6.6) are too late in style for the manuscript to have been a gift to France from the emperor in exchange, as has been suggested in the literature. Whether it belonged to the community of goldsmiths in Prague, or whether it was a commission by a French client from a Bohemian illuminator resident in Paris remains an open question. The manuscript first appeared on the art market in France in the nineteenth century, but its earlier history is not known.

LAPIDARY POLISHERS

Artists working with semiprecious stones were established and recognized in cities such as Paris and Venice by the thirteenth century, long before they are recorded in Prague. But nowhere else in Europe did stone polishers have an assignment quite like the one they received from Charles IV for the sacred spaces of Karlštejn Castle, for the Wenceslas Chapel at Saint Vitus's Cathedral (fig. 6.1), and for Charles's castle at Tangermünde. They were to transform each chapel into a space that resembled heaven itself by sheathing the walls with stones. More than a thousand slabs of jasper, amethyst, chalcedony, carnelian, and chrysoprase, each measuring up to two feet high and about 7 to 14 millimeters thick, adorn the Wenceslas Chapel.[74] The craftsmen who performed this work were designated as *pulierer imperatoris* (imperial polisher) or *pollitor lepidum* (polisher of stones). Johannes, listed as *pullierer imperatoris* in 1353, owned a house in the new market (*novo foro*),[75] an area that was home to other stonecutters: James, Symon, and another John. Among the stone polishers named in archival sources without being given imperial designation were Pesco (1377, 1405) and Jacob (1379–97).[76] It is noteworthy that Jacob was succeeded by his widow, Elisabeth, in 1381,[77] as was sometimes the case with Prague glaziers, as well as with illuminators and goldsmiths in Paris, for example. Not surprisingly, teams of brothers sometimes worked together—Symon, Johannes, Petrus, and Leonhardus are recorded along with Katharine, the widow of their brother Waczlaus, in 1381.[78]

Were the same stone polishers also creators of hard-stone vessels? The established tradition of crystal carvers in Venice and Paris and the similarities between a work such as the Reliquary for the Tablecloth of the Last Supper (cat. 51) in the Saint Vitus treasury and Parisian examples point to the importation of some precious vessels.[79] At the same time, however, there are clear signs of Bohemian production. The golden mounts on a jasper bowl in the Kunsthistorisches Museum, Vienna (cat. 36j) and on a small cup in the Metropolitan Museum (cat. 36g) are manifestly central European in origin. Moreover, the distinctive jasper of these vessels, with its large inclusions of crystal and amethyst, is the same stone used in the cathedral and imperial chapels and derives uniquely from Bohemian mines, the medieval exploitation of which has recently been confirmed by examination of the site at Ciboušov.[80]

Whether in the domain of lapidary arts, or in painting, sculpture, and other precious arts, Prague became a center for the creation of works of art. Beginning in the mid-fourteenth century, artists across Europe flocked to the city to make it a place that "might powerfully shine and gleam."[81] When Charles IV died, artists and guild members dressed in black and lined the bridge to honor the emperor as the funeral cortege passed.[82] The monuments that dominate Prague today and the objects gathered in the present exhibition testify both to the enduring debt owed to the legacy of Charles IV and to the success of their creative work.

1. See note 9 below for the full quotation and source.
2. Abu Ubajda Abdallah al-Bakri, cited in Prague Castle 2003, p. 68.
3. For Bohemian manuscripts and their relation to other European art centers, see Swarzenski 1959; for the oliphant, see Podlaha and Šittler 1903b, p. 7, nos. 1, 2, and Prague Castle 2003, pp. 20–21, ill.
4. Delachenal 1910–20, vol. 2, p. 227.
5. Especially notable among the "joyaux telz que on savoit faire à Paris" are a historiated enamel cup with zodiacal signs and planets and stars, as well as two flagons with raised images illustrating how Saint James guided Charlemagne in Spain; ibid., pp. 268–69.
6. Ibid., p. 267.
7. Ibid., pp. 249, 264.
8. Ibid., p. 271.
9. Beneš Krabice of Weitmile, quoted in Tomek 1855–1901, vol. 2 (1871), p. 63n20 (translated by Xavier Seubert): "quoniam ad ipsum confluebant principes et procur[atores] ac nobiles de omnibus partibus mundi, volens ostendere magnificentiam gloriae regni sui Bohemiae, fecit cooperiri duas turres regales in cas[tell]o Pragensi . . . cum plumbo et auro desuper, ita ut eaedem turres lucerent et resplenderent tempore sereno ad longam valde distantiam."
10. Pangerl 1878, p. 15.
11. Ibid., p. 14.
12. To suggest its rarity, Matthias Pangerl (ibid., p. 13) mentions two other, later examples, one from Augsburg (1471), the other from Strasbourg (1456). The document is divided into four sections: the statutes of the confraternity, its enrollment, its members, and its acts.
13. Both are mentioned in Kutal 1971, p. 64.
14. See Fajt 1998.
15. Earlier scholars raised the possibility that he is the same as the "Theodoric Zelo" mentioned in the Hradčany municipal records, October 3, 1359. See ibid., pp. 228–29, for arguments against this, including the dating of this part of the register to after 1365.
16. Ibid.
17. Ibid., p. 102.
18. Transcribed in ibid., p. 102. In 1381 the estate was sold to Nikolaus Mendil of Jílové and Johann Wacenser, a goldsmith; ibid., p. 103.
19. Ibid., pp. 100–101.
20. Gibbs 1989, pp. 176–202. See also Pangerl 1878, pp. 37–38.
21. Pangerl 1878, p. 86. The editor's footnotes indicate some uncertainty in the transcription of the title "Monsier" as opposed to "Magister."
22. Winter 1906, p. 162. On the use of geographic place names to denote a person's origin, see Kedar 1973.
23. Ibid.
24. Pangerl 1878, p. 86.
25. I thank Jiří Fajt for this suggestion.
26. Pangerl 1878, p. 86.
27. The exemption of artisans from "compulsory public services" was originally a feature of the fifth-century Theodosian Code and was intended to enable them to better learn their skills and to teach their children. See Theodosian Code 1952, pp. 390–91. I am grateful to Dr. Melanie Holcomb for bringing this to my attention.
28. Winter 1906, p. 161. I am not aware of similar provisions elsewhere in Europe. In Siena, by contrast, Duccio was fined for not being present for military muster. See Satkowski 2000, p. 66, no. 35. I am grateful to Dr. Carl Strehlke for bringing the example of Duccio to my attention.
29. Pangerl 1878, p. 85n207: "einen ganzen Stechgezeuge, einen sattel, einen roskopf, ein prustleder und einen schilt."
30. Winter 1906, p. 164.
31. Ibid.

32. Pangerl 1878, p. 87; Chytil 1906, pp. 39, 104.
33. Krása 1971, p. 73.
34. Ibid., p. 158.
35. Ibid.
36. Ibid.
37. Ibid.
38. Ibid., p. 192.
39. Ibid.
40. Tomek 1855–1901, vol. 5 (1881), p. 49.
41. Patze 1978, p. 747.
42. Ibid.
43. Ibid.
44. Ibid.
45. Tomek 1855–1901, vol. 2 (1871), p. 382.
46. See Krása 1971.
47. Tomek 1855–1901, vol. 2 (1871), p. 380.
48. Matouš 1975, p. 10.
49. FRB, vol. 1 (1873), p. 385, cited in Matouš 1975, p. 10.
50. Tomek 1855–1901, vol. 2 (1871), p. 382, no. 186.
51. Pangerl 1878, p. 85.
52. Matouš 1975, p. 18n19.
53. Pangerl 1878, p. 87.
54. Ibid., pp. 86–87.
55. Ibid., p. 88.
56. Mareš 1893, p. 1.
57. Podlaha and Šittler 1903a, p. XXI, no. 357.
58. According to the Zbraslav Chronicle (1976, p. 175), written by two fourteenth-century Cistercian monks at Zbraslav and covering the period 1278–1338.
59. Wetter 2001, p. 116.
60. All those named are men. Wetter (ibid., p. 117) suggests that perhaps women who were active in this field were not named because they lacked legal status. However, this is not the case of women glaziers. See above.
61. Ibid., pp. 116–18, esp. p. 208, fig. 79.
62. Fritz 1978, p. 180.
63. Philippe Henwood in Paris 2004, p. 183.
64. Fritz 1978, p. 164.
65. Tomek 1855–1901, vol. 2 (1871), p. 382.
66. Fritz 1982, p. 335.
67. Podlaha and Šittler 1903a, p. VII, no. 224.
68. Krása 1978, pp. 16–17.
69. Tomek 1855–1901, vol. 2 (1871), p. 169.
70. Ibid., vol. 2, p. 426, vol. 5, p. 60; Krása 1978, p. 17.
71. Poche 1983, p. 671.
72. Ibid.
73. Pangerl 1878, p. 87. Thought to be Heinrich Umfarer, also given as "Heinczlinus goltslaher" living in the New Town at Baarfusser or Mariengasse with his wife "auripercustrix Katherina." See ibid., p. 120n211.
74. Hahnloser and Brugger-Koch 1985, pp. 28–29.
75. Legner in Cologne 1978–79, vol. 3, p. 180.
76. Ibid.
77. Ibid.
78. Ibid.
79. See Paris 1981, pp. 214–15, no. 173.
80. The medieval mine shafts are still preserved. See Kudrnáč 1985; Marek 1985.
81. See note 9 above for the full quotation and source.
82. Kavka 1989, p. 122.

prechende · Sweiget wen
ne es ist ein hailiger tak ·
vnd nicht lasset euch laide
sein · Vnd also gink hin al

les volk so das es truncke

# The artistic Culture
# of Prague Jewry

*And as the Jewes have a peculyar Citty at Prage, so they had freedome throughout all the kingdome.*
*—Fynes Moryson (1592)[1]*

*In Prague, men of low character gathered on . . . the day after Passover 5249 [18 April 1389],*
*and attacked the Jews with swords and woodcutter's axes, killing them in the streets and burning their houses.*
*They even removed corpses from their graves. —David Gans (1592)[2]*

Vivian B. Mann

Customs documents of 903, the first records of a regular Jewish presence in Bohemia and Moravia, imply that Jews traded in the region by the eighth century.[3] Between 961 and 965, during the reign of Boleslav I (929–67), the Jewish traveler Ibrāhīm ibn Yaʿqūb of Tortosa reported that Jewish merchants were active in Prague, but it is uncertain if they resided there. Boleslav's Jewish subjects also performed diplomatic services for him: a Joseph and a Saul from Prague, for example, represented him at the caliphal court in Córdoba.[4] The number of Jewish residents in Prague increased during the Late Middle Ages, owing in part to an influx of German Jews during the thirteenth century.[5] Jews lived in four areas of the city, together with Christians, until the middle of the fourteenth century.[6] Late in that century, the largest settlement (the Judenstadt) was located around the synagogue known as the Altneuschul (Old-New Synagogue), now the oldest extant synagogue in Europe (figs. 7.2, 7.3). The Altneuschul may be the synagogue depicted in a seventeenth-century drawing by the Flemish artist Roelandt Savery (fig. 7.4). The Jewish quarter was bounded by six gates (the *portae Judaeorum*), built perhaps as protection for the community rather than as the

result of enforced segregation.[7] Despite these physical boundaries, Jews and Christians continued to live together at the edges of the quarter and occasionally within it.

Four synagogues are known to have been built in Prague during the Middle Ages. The earliest, dating to the eleventh century and situated in the Little Quarter (Malá Strana), was probably a wooden structure; it was destroyed by fire in 1142 during a siege of the city.[8] A cemetery was also acquired when the synagogue was built. The gravestones of another, which existed from the thirteenth century until 1477 in the area called the Jewish Garden (Židovská Zahrada, or Hortus Judaeorum),[9] were first recovered in 1866 (cat. 77). In the eleventh century, Jews in the Old Town (Staré Město) built a second synagogue, which came to be called the Altschul (Old Synagogue) following the construction of the Neuschul (New Synagogue) about 1260. When the Old Synagogue burned during the pogrom of 1389, the site was later used by emigrés from the Iberian expulsions of 1492 and 1497 to establish a synagogue following the Sephardi liturgy.

Only one of these synagogues survives, the Neuschul, which was renamed the Altneuschul after another house of worship with its original name was erected in the seventeenth century. Its five-ribbed vaulting bays resemble those of Gothic chapels and chapter-houses built in Bohemia during the same period.[10] Two large columns supporting the vaults divide the space lengthwise into two naves. One liturgical focus—the ark, in which the Torah scrolls are

Fig. 7.1 Jews Eating in a Sukkah on the Feast of Tabernacles. The Wenceslas Bible. Tempera and gold on parchment; Prague, ca. 1390–95 and late 1390s. Österreichische Nationalbibliothek, Vienna (Cod. 2759–64)

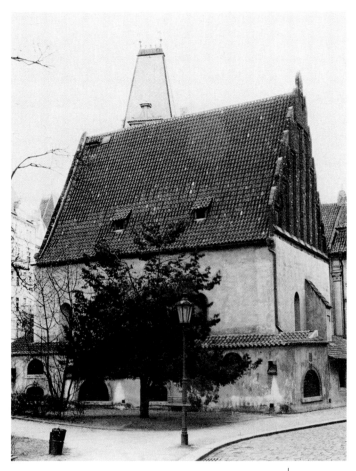

Fig. 7.2 The Altneuschul, Prague

affirmed their right to self-government. In fact, his *Statuta judeorum* may have encouraged the community to erect the Altneuschul, an expensive masonry house of worship expressing a sense of permanence, in place of the vulnerable wooden synagogues built earlier. Otakar's decree refers to the Jews as *servi camerae* (servants of the royal chamber), forbidding violence against them as damage to royal property. In return, the Jewish community was required to pay high annual taxes and special subventions.

The situation of the community changed radically under John of Luxembourg (r. 1310–46). Contemporary chroniclers relate how Jewish property was confiscated: "In the same year [1336] the king had the earth dug up in the synagogue of the Jews of Prague and discovered several thousand marks."[13] At the same time, and to the astonishment of his contemporaries, John also seized riches from the cathedral of Prague.[14] The chronicler František of Prague indicates, "After this, he [John] ordered the Jews throughout all his kingdom to be captured and from these ones, he extorted a great deal of money."[15] In a deliberate reversal of his father's policy, Charles IV (r. 1347–78) reaffirmed Otakar's charter, declaring again that Jews were "servants of the royal chamber" who could form their own communities and were equal to Christians before the law.[16] In 1357 Charles awarded the Jewish community its own flag as an acknowledgment of service to the crown.[17]

During the reign of Wenceslas IV (1378–1419), the Jews of Prague were not immune to devastating attacks similar to those that decimated communities in the Rhineland and northern France. At Easter 1389 three thousand members of the community died at the hands of local citizens, victims of the common superstition that they had desecrated the Host. To escape retribution, some survivors killed their children or had themselves baptized. An elegy by Avigdor Kara (d. 1439) movingly records the pogrom and the concomitant loss of life, art, and books.[18] In 1422 and 1448 (and later in 1483), in the midst of political uprisings, Jews were again attacked, because of their different ethnic identity and faith and because many supported themselves by lending at high rates of interest.[19] The effect of such persecution was the loss of much of the artistic culture of Prague Jewry. Given the large Jewish population in Prague during the fourteenth and fifteenth centuries in comparison with those of other cities, the number of extant works of art attributable to Jewish ownership is infinitesimal.[20]

Only four illuminated manuscripts written and decorated in Prague survive from this period.[21] The earliest, dated 1396, bears scribal ornamentation consisting of decorative arrangements of texts and highlighting of chapter headings

stored—is centered along a short side and denotes the direction of prayer. The other—the raised desk on which the Torah scroll is read (the *bimah*)—is surrounded by a Late Gothic iron grille, emphasizing the importance of the Torah reading within the service. Because the *bimah* is centered between the columns, those standing on it or seated near it cannot see the ark. This placement, however, does fulfill the dictum of Maimonides (1135–1204) that the reader's desk be situated at the center of the synagogue so that all can hear the recitation of the Torah.[11] Thus, the two liturgical foci, separated architecturally, do not reinforce one another visually. Although in its plan and style the Altneuschul resembles contemporaneous Christian buildings, it lacks the figurative sculpture that commonly adorns the latter. Instead, the tympana of the entry door and the ark are filled with vegetal and tree forms, perhaps alluding to the Tree of Life in the Garden of Eden; the capitals are also decorated with foliage.

The Altneuschul was built about 1260, shortly after King Přemysl Otakar II (r. 1253–78) regularized the legal position of Bohemian Jews in 1254.[12] In addition to guaranteeing their right to engage in pawnbroking, the king promised to protect them, their synagogues, and cemeteries. He also

with red-and-white frames (cat. 76). This manuscript is a copy of Maimonides's *Guide for the Perplexed* (*Moreh Nevukhim*), a central work of Jewish philosophy, in the Hebrew translation of Samuel ibn Tibbon (ca. 1160–ca. 1230). Before beginning his translation, Samuel wrote to Maimonides and received in return a paper on translation, including the specific difficulties of translating the *Guide* from Arabic to Hebrew. In his introduction (included in the Prague codex), Samuel sets forth his methodology, thereby creating a model for later translators. He also composed an alphabetized glossary of difficult Hebrew words and added his own discussion of the original text. According to the colophon inscribed by the owner on folio 145: "This book was written for me by Isaac ben Joseph from Warsaw in the city of Prague in the year 156 [1396], according to the small counting, Simon."[22] Written beneath is a tribute to the patron: "Simon . . . the great rabbi, the godly philosopher, the true man helped by God."

Two manuscripts from the second half of the fourteenth century show the influence of earlier Hebrew manuscripts from Germany, probably as the result of the large Jewish immigration during the previous century. One is a copy of the great work by Isaac Alfasi (1013–1103), *The Book of Jewish Laws* (*Sefer ha-Halakhot*), dating to about 1380–1400, a compendium of the still practiced talmudic laws (see fig. 7.5). Its page layout is similar to that of a complete Talmud: the main text appears in square Ashkenazi script at the center, with the commentary by Solomon ben Isaac (known as Rashi), in cursive along the sides. Sections of the commentary fill geometric designs and symbols, forming calligrams, an art form known from the Carolingian period but unusual for Hebrew manuscripts.[23] Other pages are adorned with griffins and grotesques, including half-human, half-animal creatures playing instruments. The court costumes that clothe the upper, human half of their bodies contrast with the bestial characteristics of the lower half. These animated forms differ from the geometric designs in their three-dimensionality, achieved through manipulation of line and modeling. Similar half-human, half-animal figures appear in the Duke of Sussex Pentateuch, a Hebrew Bible from southern Germany dated about 1320, but these earlier figures are not engaged in specific activities.[24] In a related

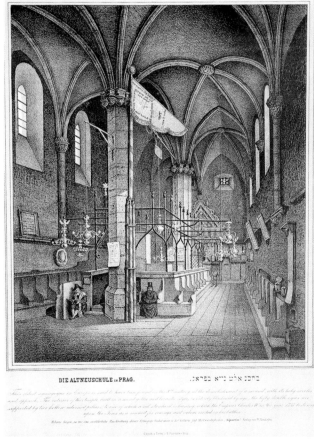

Fig. 7.3 František Šír (1804–1865), after Joseph Mánes (1820–1871). Interior of the Altneuschul, Prague. Lithograph; Prague, ca. 1840. Library of the Jewish Theological Seminary, New York (43.123 [Friedenberg])

Fig. 7.4 Roelandt Savery (1576–1639). Jews in the Altneuschul(?). Pen and brown ink over pencil, 1612–16. P. and N. de Boer Foundation, Amsterdam

Fig. 7.5 *The Book of Jewish Laws (Sefer ha-Halakhot)* by Isaac Alfasi, Abraham and Samuel, scribes, fol. 90. Ink on parchment; Prague, ca. 1380–1400. Bibliothèque Nationale de France, Paris (Ms. hébreu 311)

Fig. 7.6 Lupus. Atlas of the Constellations. Tempera and gold on parchment, mid-14th century. Strahov Library, Prague (DA II 13)

manuscript of the same date, the Tripartite Festival Prayer Book, animals are musicians.[25] The two motifs may have first been combined in Prague, perhaps under the influence of an astronomical manuscript such as the atlas in the Strahov Library, Prague (fig. 7.6), in which two zodiac signs appear as centaurs with human, clothed upper bodies.[26] Signs of the zodiac regularly occur in medieval Hebrew festival prayer books accompanying the Prayer for Dew, creating a bridge between the Strahov Atlas and the images in the *Book of Jewish Laws*.[27]

The second manuscript, *The Row, The Path of Life (Tur, Oraḥ Ḥayyim*; cat. 78), dating to about 1350, with later additions, is a section of the law code written in Toledo by Jacob ben Asher (1270?–1340). Its decoration is similar to that of Hebrew manuscripts from Germany in that the incipits are highlighted as word panels filled with both floral and animal forms.[28] The Bohemian Bible dated before 1300 now in the Library, Národní Muzeum, Prague, also has similar panel motifs.[29] Thirteenth-century Hebrew books were the first to contain written examples of the Czech language

(see, for example, folio 89 of *The Row*).[30] Conversely, the Wenceslas Bible (figs. 84.2–84.7) has Hebrew inscriptions within some illustrations,[31] while the Bohemian Bible of Andreas of Austria in the Pierpont Morgan Library, New York (cat. 80; fig. 7.7) contains terms transliterated from Hebrew. These suggest a high degree of cultural interaction between religious groups in Bohemia during the Late Middle Ages.

The most lavishly illuminated Hebrew manuscript produced in Prague is a three-volume Bible copied in 1489 (cat. 79). Word panels, gold bars, and foliate scrollwork (variable in color and sometimes inhabited by animals) constitute the principal decoration, which appears on eighty-four leaves. These elements resemble the ornamentation of the Wenceslas Bible and are similarly executed with expensive materials—gold letters on a gouache panel framed in lapis lazuli.[32] The thin leaves branching out from some word panels are also seen in Tomáš of Štítné's *Six Booklets on General Christian Matters* (cat. 73).[33] Only two human forms appear in the Hebrew Bible: a hand emerging from the first

word panel in the book of Joshua and a green mask in the border of the word panel that begins Samuel I (see cat. 79).

Biblical, philosophical, or legal in nature, all four surviving Hebrew manuscripts lack narrative illuminations revealing aspects of Jewish life in Prague during the period. Several contemporaneous Latin manuscripts, however, include scenes of Jewish subjects that reflect some familiarity with customs, but not an accurate, intimate knowledge of the life of the community. A scene in the Wenceslas Bible depicting the reading of the Torah in a synagogue, for example, shows the reader at a special desk, but the artist did not know that the Torah must be read from a scroll, not a codex, during the synagogue service.[34] More successful is the Bible's portrayal of Jews eating in a sukkah on the Feast of Tabernacles, a practice that recalls their forty years of wandering in the Wilderness (fig. 7.1).[35] The unusually large number of subjects from the Hebrew Bible in Gothic manuscripts from Prague may be accounted for by the presence of Hebrew manuscripts in the royal collection.[36]

Unfortunately, no scene of Jewish life in Bibles from Prague includes the distinctive objects depicted in the illustrated German haggadoth (service books for Passover), used at the Seder (festive meal), held on the first and second nights of the holiday.[37] Discovered in both German lands and Bohemia, some of these objets de luxe had been buried during times of persecution and survived; others had passed into Christian ownership.[38] One type of ceremonial object specifically associated with Jewish usage is a ring having a bezel in the shape of a small building, inscribed "mazal tov" (Hebrew, good luck).[39] The shape signifies that this was a marriage ring, since marriage had been associated with the establishment of a home as early as the time of the Mishnah, the law code redacted before the end of the second century.

A set of nested beakers made in Prague between 1310 and 1335 was hidden in a house in Kutná Hora, perhaps during the same period in which the marriage rings were buried (cat. 74). The five silver beakers provide an example of the Jewish appropriation of an existing work for ceremonial use. Their faceted form is a stylistic feature of metalwork dated to the first half of the fourteenth century,[40] but a more precise date may be deduced from the enameled coats of arms at the base of three of the cups. These identify the owner as Elizabeth Ryksa (1288–1335), wife of Wenceslas II of Bohemia and later of Rudolf III of Austria. Sometime after her death in 1335, the beakers were acquired by a Jew named Ze'ev (Wolfe), who wrote his Hebrew name inside one, an unthinkable mutilation unless he intended to use them for the ceremony of kiddush (sancti-

Fig. 7.7 Judah and Simeon Leaving to Do Battle against the Canaanites, in an Initial P. Bohemian Bible of Andreas of Austria (cat. 80), fol. 80 (detail). Tempera and gold on parchment; Prague, ca. 1391. Pierpont Morgan Library, New York, Belle da Costa Greene Fund (M.833)

fication). Kiddush, the blessing over wine, is performed often in Jewish life—on Sabbaths and festivals and at life-cycle events.

Double cups became especially popular in German lands during the thirteenth century because of their association with *Minnetrinken,* special toasts offered on ceremonial occasions. For Jews, the form not only expressed the joining of a bride and groom in marriage, but also signified the merging, in the previous century, of the two parts of the Jewish wedding ceremony, each with its blessing over wine. As Jewish weddings increasingly became public events in imitation of Christian marriages, Jews embraced the Germanic form in order to signal their practice of ceremonial toasts and their acceptance of ritual display.

A double cup, now in the Gräfliche Rentkammer, Erbach, passed from Isaac ben Zekhariah to Dietrich Schenk zu Erbach, archbishop of Mainz (1434–59), who placed his own coats of arms over the original enamel plaques, one of which had a Hebrew inscription.[41] A glance through haggadoth illuminated in German territories or by German

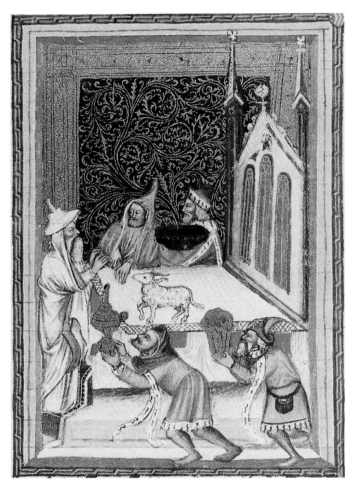

Fig. 7.8 The Bringing of Gifts to the Temple. The Wenceslas Bible. Tempera and gold on parchment; Prague, ca. 1390–95 and late 1390s. Österreichische Nationalbibliothek, Vienna (Cod. 2759–64)

scribes working in northern Italy reveals numerous examples of double cups being used at the Passover Seder.[42] In addition, a Bohemian manuscript depicts a man offering a double cup to the ancient Temple in Jerusalem (fig. 7.8). Obviously, the same social class capable of commissioning illuminated manuscripts could own such an expensive object. Two other double cups with decoration incorporating both Jewish and Christian elements may have served as gifts from Jews to their patrons (cat. 75).[43]

The impact of persecutions on the artistic culture of Prague Jews was two-sided. Much was lost to the attackers, who saw only the material value of synagogue furnishings and manuscripts painted with gold. But they also awakened an instinct for preservation in some medieval Jews, who buried or hid their treasures, thus saving them for posterity.

While many cities of the German lands expelled their Jewish communities in the fifteenth century, the Jews of Prague were not disturbed.[44] After 1500, prominent rabbis came to serve the city's Jews, among them Judah Löw, known as the Maharal (ca. 1525–1609).[45] Mordecai Meisel (1528–1601), financier to Rudolf II, used his enormous wealth to sponsor synagogues, study halls, a hospital, and institutions of learning in the Jewish Quarter. He also recruited scholars from other cities. As a result, the Jewish community was well able to participate in the Renaissance culture of Prague, as evidenced by the precious amulet it commissioned about 1600 as a gift to Rudolf (fig. 7.9).

Fig. 7.9 Amulet (*hoshen*) presented by the Jews of Prague to Rudolf II. Emerald, brown amethyst, ruby, sapphire, coral, onyx and black onyx, heliotrope, hyacinth, amethyst, agate, turquoise, carnelian, gold; enameled; Prague, ca. 1600. Kunsthistorisches Museum, Vienna (12.383)

1. Hughes 1967, p. 275, quoted in Spicer 1996, p. 218.
2. This translation is from David 1993, p. 86.
3. "Judaei et ceteri mercatores, udecunque venerint, de ista patria vel aliis patri (ut Baemanis vel Moravis) justum theoloneum solvant tam de mancipis, quam de aliis rebus, sicut semper in prioribus" (Jews and other merchants, from wherever they have come, whether they come from this or other countries [such as Bohemia and Moravia], let them pay the proper toll both for slaves and other things, as was the case in earlier times); quoted in Stein 1904, p. 1.
4. Putík and Sixtová 2002, p. 15.
5. Vilímková 2000, p. 16.
6. Haverkamp 1995, p. 22. In the same period, Jews and Christians in other cities also lived in the same neighborhoods, as, for instance, in Cologne (Toth 2001, p. 12).
7. Haverkamp 1995, p. 22.
8. Vilímková 2000, p. 14. Vilímková discounts most of the sources cited by previous writers on the early history of the Jews in Prague, relying instead on the sixteenth-century chronicle of Václav Hájek and on royal decrees.
9. Pařík and Hamáčkova 2003, p. 17; Vilímková 2000, p. 16.
10. For a comprehensive study of the architecture, see Munzer 1928. Many features of the Altneuschul appeared earlier in the Worms Synagogue of 1180, which was destroyed on Kristallnacht, 1938. See Krautheimer 1927, pp. 151–80, 199–213.
11. Maimonides, *Mishneh Torah, Hilkhot Tefillah,* 11:3.
12. On Otakar's decree, see Zachová 1978, pp. 71–74.
13. "Eodem anno ipse rex fecit fodi in synagoga Iudeorum Pragensium et invenit plura milia marcarum" (Beneš Krabice of Weitmile, FRB 1884, p. 488). I wish to thank Barbara Boehm and Eric Ramírez-Weaver for this citation and those in notes 14 and 15 below.
14. "But he was led by bad advice, especially from the men of the Rhine, who allied themselves with him. . . . He carried off and took away the likenesses of the twelve apostles, which had been placed before the tomb of Saint Wenceslas by his son Charles, and which had been made from the offerings of the faithful" (sed malo ductus consilio, et precipue per suos Reynenses, qui sibi adherebant. . . . imagines XII apostolorum, que pro sepulchro sancti Wenceslai fuerant per filium suum Karolum et de fidelium elemosina fabricate, abstulit et asportavit) (Beneš Krabice of Weitmile, FRB 1884, p. 488). This is also recounted by František of Prague (FRB 1884, chap. IX[b], p. 423).
15. František of Prague, FRB 1884, chap. IX(b), p. 423: "Post hoc Judeos mandavit per totum regnum suum captivari et ab ipsis maximam peccuniam extorsit."
16. Vilímková 2000, p. 16; Stein 1904, p. 16.
17. Abrahams 1896, p. 63.
18. "Rushing they entered the new and old synagogues, / I cried in a faint voice / as they mocked, burnt and shredded holy books, / The Torah given by Moses as our inheritance. / Shout, hasten, rush, rob, loot, / grab their silver, steal gold and all that you can find. / They are free for the taking and their property and belongings, too. / All those who find them may devour them and be deemed guiltless. / Unto us the fallen are too numerous to name, / The infant with the elder, youths and maids" (Kara, "All the Afflictions," translated in Rubin 2004, p. 198).
19. František 1999, pp. 31–34.
20. According to Vilímková (2000, p. 19), 143 houses in Prague were inhabited by Jews at a time when the Jewish quarter of Frankfurt consisted of 20 houses.
21. Among the papers found in the Cairo Genizah was a record of forty-five *diwans* (collections of poetry) belonging to one owner and four books belonging to a coppersmith who lived in the eleventh century (Goitein 1999, p. 425). There are similar records from other Jewish communities.
22. "According to the small counting" is a standard phrase denoting that the millennium number was omitted from the Hebrew date. This quotation and that which follows are from Róth and Striedel 1984, no. 119.
23. On folio 158, four calligrams that are heraldic motifs—a Jewish star and three blazons—may allude to the flag granted the community by Charles IV in 1357 (Paris 1991–92a, p. 147). A Carolingian calligram can be found in the Harley Aratus (British Library, London, Harley Ms. 647).
24. Narkiss 1970, pl. 32.
25. Ibid., pl. 33.
26. Strahov Library, Prague, DA II 13; Bohatec 1970, ills. 122, 123. The Strahov Atlas originated in northern Italy but was already in Prague by the reign of Charles IV. The half-human, half-animal motif also appears in other astrological manuscripts; see, for example, the Vienna Astrological Anthology, fol. 10r (Österreichische Nationalbibliothek, Ms. 2352).
27. For examples, see Sed-Rajna 1983, figs. 72–83.
28. For comparisons, see Narkiss 1970, pls. 27, 30, 35.
29. Cologne 1978–79, vol. 2, p. 743–44.
30. Šedinová 1981, pp. 73–89.
31. Hlaváčková in Prague 1995b, p. 137.
32. For a similar page, see Cologne 1978–79, vol. 2, pl. 24, after p. 730.
33. Urbánková n.d.
34. Pařík and Štecha 1992, p. 4.
35. Berger 1990, fig. 5.
36. When Wenzelstein, Wenceslas's castle, was plundered after his death in 1419, Hebrew books were among those pilfered (Krása 1971, pp. 17–18). I thank Barbara Boehm for this reference.
37. One Seder is celebrated in Israel, two in the Diaspora because of past uncertainty regarding the calendar.
38. For an overview of medieval Judaica, see Mann 1988, pp. 13–24; the new discoveries in Toledo 2002–3; and note 39 below.
39. For fourteenth-century rings, see Speyer 2004–5, pp. 194–95, 198–99, 222.
40. Schiedlausky 1975, pp. 300ff.
41. On the Erbach double cup, see Mann 1988, pp. 18–20.
42. For examples, see Narkiss 1970, pls. 38, 41. A set of nested beakers also appears in plate 41.
43. A second example in Basel also seems to have been a gift from the Jewish patron to its recipient; see Mann 1988, p. 18.
44. Twenty-five cities of the German-speaking lands expelled their Jewish communities in the fifteenth century; Prague was one of four cities that did not (Haverkamp 1995, p. 17).
45. "In his benevolence, our master, the renowned luminary Emperor Rudolf, may he be exalted, sent for our teacher Rabbi Loew ben Bezalel, greeting him graciously, and speaking with him 'face to face' [Exod. 33:11] as one man speaks to another. Their conversation dealt with esoteric subjects. This took place here, in Prague, on Sunday, the 3rd of Adar [February 16, 1592]" (David Gans, *Zemah David [Offspring of David],* 1592, translated by L. J. Weinberger and D. Ordan in David 1993, p. 90).

# WENCESLAS IV

*"Rejoice, beloved subjects, we have a son." —Charles IV (1361)*[1]

Barbara Drake Boehm and Jiří Fajt

ven before his coronation as king of Bohemia, Charles IV had begun to strengthen and enrich his new capital at Prague, starting with the renovation of the castle and cathedral. That complex remains today his most visible legacy. But Charles's dynastic legacy was less easy to secure: by 1360, at age forty-four, he still had no living male heir. At the birth of a prince on February 26, 1361, Charles expressed great relief: "Relinquish all anxiety of seeing our royal line wither and the realm brought to ruin. . . . In him our Bohemian kingdom is to be firmly founded as if on an impregnable rock."[2] With an image of the ruined castle he had inherited etched indelibly on his mind, Charles recognized that his kingdom was in jeopardy without a strong ruler.[3]

Charles's confidence at the birth of his son notwithstanding, the career of King Wenceslas IV was surely not what his father would have intended. He was never crowned Holy Roman Emperor; he left no son to succeed him. Political and religious unrest dominated Wenceslas's forty-one-year reign. During his peripatetic kingship he eschewed Prague Castle and Charles's beloved Karlštejn. He was twice imprisoned, once in Prague itself, at the hands of his subjects and his own brother. His volatile personality and alcoholism were notorious, both in Bohemia and abroad.[4] With no official chroniclers to celebrate his achievements and a paucity of information concerning his possessions, there is little to mitigate the impression of a failed reign. Yet the artistic heritage of Wenceslas's time is not in question. Indeed, the years of his kingship witnessed the apogee of the celebrated Beautiful Style in a number of media, including architecture, painting, sculpture, manuscript illumination, and embroidery.

Fig. 8.1 Astronomical Clock on Old Town Hall, Prague

From the time of Wenceslas's birth in the imperial city of Nuremberg, works of art played an integral role in Charles IV's campaign to ensure the prince's succession and the security of the Luxembourg dynasty. For the extraordinary celebrations that accompanied the prince's baptism on April 11, 1361, Charles ordered the imperial regalia to be transported to Nuremberg and displayed from the balcony of the Frauenkirche. In thanks for the prince's birth, Charles also made an offering of gold equivalent to the boy's weight to the church at Aachen.[5]

The emperor commissioned commemorative wall paintings (see fig. 8.2) for the Church of Saint Moritz, near the Nuremberg Parish Church of Saint Sebaldus, where the

Fig. 8.2 Sebald Weinschröter. Announcing the Birth of Wenceslas; The Baptism of Wenceslas IV. Wall painting, ca. 1365. Formerly Church of Saint Moritz, Nuremberg

Fig. 8.3 A Young King in an Initial A. *Chronica Bohemorum* of Přibík of Radenín, called Pulkava, fol. 1r (detail). Tempera and gold on parchment, Prague, 1373. Muzeum Narodowe, Kraków, Czartoryski Library (Ms. Czart. 1414)

actual baptism took place.[6] Murals commemorating historic events, such as Charles's acquisition of the relics of the Passion, and legends of saints such as Ludmila and Wenceslas had been part of the decorative program at Karlštejn, but the Nuremberg paintings blended historical documentation with allegory. The upper portion presents a variation of the Annunciation: A pregnant woman recognizable as Empress Anna of Świdnica stands in an enclosed garden as an eagle, representing the Holy Roman Empire (over which she reigned with Charles IV), hovers over her head. A page hands her a sealed letter, while Charles, wearing a crown and robe, stands at the left. The allegory is based on the tradition of courtly poetry. The grass represents the lovers' bed; the enclosed garden with figs, apple trees, and grape vines symbolizes the bride. Charles considered his new son the savior of the family and the protector of the realm, thus the compositional parallels to scenes from the lives of Jesus and the saints. At the left of the lower section Charles appears at the bedside of the empress, just as Saint Joseph attended the birth of Jesus. The central scene, depicting the baptism of Wenceslas with the emperor and Archbishop Arnošt of Pardubice looking on, recalls Jesus' Presentation in the Temple. The scene of the education of

Wenceslas, at the right, conforms to legends of the childhood of Jesus and to similar scenes from the lives of the royal saints Louis of France and Wenceslas of Bohemia.[7] Such an elaborate commission was surely the work of a court artist, and the only feasible candidate is Sebald Weinschröter (see also fig. 1.8), who had returned to his native Nuremberg after a longer absence in 1357.[8]

At the age of two Wenceslas already bore a number of titles: margrave of Lusatia, duke of Luxembourg and Silesia, and count in Sulzbach. (In 1373 he was also given the title of margrave of Brandenburg.) On the feast of Saint Vitus in 1363, soon after the death of Wenceslas's mother, Anna, and before the coronation of the new queen, Elizabeth of Pomerania, Charles had the two-year-old boy crowned king of Bohemia, despite the protests of the archbishop of Prague (see fig. 1.4, the crown).[9] The coronation order written by Přibík of Radenín, called Pulkava, at the behest of Charles IV for his son Wenceslas evokes the occasion.[10] On its opening page the manuscript portrays a youthful enthroned king and the arms of the Bohemian kingdom (fig. 8.3). Given the age of the prince, the coronation ceremony was not what the emperor might have otherwise envisioned. In the eyes of the participants the modest event disparaged not only the solemnity of the event but also the dignity of the Bohemian king.

Conscious of his responsibility as a royal parent, Charles IV asserted that it was "fitting for a king to teach his son the art with which he should preserve his kingdom."[11] In 1378 the ailing Charles IV took Wenceslas, then seventeen, with him to France to afford the prince an opportunity to see the precious holy treasures of French churches and to ensure that he would remain loyal to his French cousins, and they to him. Not only the emperor but also Wenceslas, as the "roi de Bohême," received gifts from the king of France, his brothers, and representatives of the city of Paris.

At Charles IV's funeral later that year, the archbishop of Prague proclaimed that "although our father has died, our most serene sovereign, Charles, . . . it is as if 'he were not dead: for he hath left one behind him that is like himself'" (Ecclus. 30:4).[12] The first images of Wenceslas emphasize this continuity, portraying him in his father's company as his heir. Wenceslas, with his patron saint, kneels opposite Charles IV and Saint Sigismund before the Virgin and Child on the upper part of the panel (fig. 8.4) Jan Očko of Vlašim gave to the chapel in the archbishop's residence at Roudnice nad Labem in 1371, probably to commemorate its consecration. Wenceslas appears as a crowned king opposite his father on the Reliquary Cross of Urban V (fig. 8.5). And the youthful Wenceslas is immortalized in stone, along with his immediate

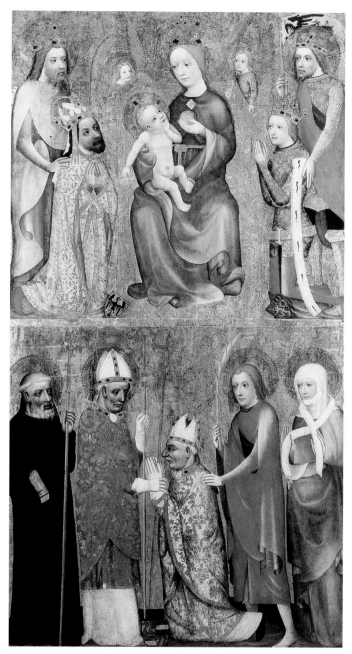

Fig. 8.4 The Votive Picture of Jan Očko of Vlašim. From the chapel in the archbishop's residence, Roudnice nad Labem. Tempera on lime wood, gesso ground; Prague, ca. 1371. Národní Galerie, Prague (O 84)

family and his wife, in a lifesize portrait bust (fig. 8.6) on the triforium level in the apse of Saint Vitus's Cathedral that dates to about 1374.[13] The sacred setting notwithstanding, the bust offers a glimpse of a vital and energetic secular prince.

Before Charles IV's death the electors unanimously named Wenceslas King of the Romans. The coronation took place in Aachen on July 6, 1376. Wenceslas did not wait for the pope to confirm his election; he immediately started using the title "Wenceslaus dei gracia Romanorum rex semper augustus et Boemie rex," adopting his father's heraldic device as it is shown on his seals.[14] Accordingly, Wenceslas initially supported the Roman Urban VI as the

legitimate pope, proclaiming himself the follower of his father in matters of Church policy.[15] The first disagreement between the followers of Urban and the Avignon antipope Clement VII, who was supported by the French court, arose during the 1370 assembly in Frankfurt am Main. Their common position toward the Roman pope brought Wenceslas closer to the spiritual electorates and to the English royal court, and the wedding of Wenceslas's sister Anne of Bohemia and Richard II of England in 1382 confirmed the links between Prague and London. Artistic exchanges between royal residences may account for the Bohemian characteristics in the official portrait of the Richard II from Westminster Abbey,[16] or arguably in the illuminations of the *Liber regalis* (Westminster Abbey, Ms. 38), containing the coronation *ordo* of English kings.[17] The English court's fascination with art from Prague is attested by additional information from Derby, where Henry of Lancaster, later King Henry IV (r. 1399–1413), ordered the consecration of paintings he bought in Prague in 1392.[18]

As time went on, Wenceslas's defense of the pope in Rome disintegrated. The desire of French delegates to bring the two monarchs closer culminated in Wenceslas's trip to Reims. Wenceslas negotiated the engagement of his niece Elizabeth to Louis, duke of Orleans, and even though the wedding was never realized, the agreement opened a dialogue with the Parisian court. On March 23, 1398, Charles VI welcomed his cousin the king of Bohemia in an atmosphere of celebration. It is no coincidence that the French king entrusted a Prague illuminator with his prestigious commission of the *Grandes chroniques de France* (Bibliothèque Nationale de France, Paris, Fr. 2608),[19] and that about 1400 Prague witnessed a new wave of Parisian artistic inspiration, as exemplified by the Bible of Konrad of Vechta (cat. 85) and the Gerona Martyrology (cat. 86).

At the beginning of Wenceslas's reign his patronage of artistic monuments conformed to his father's example. The situation at the court of Prague changed quickly, however,[20] with a significant influx of artists. Many had to seek new patrons, for Wenceslas favored the manuscript illuminators, as the registers of the Confraternity of Saint Luke attest; aside from the court illuminators, they mention only one painter who went by the title "pictor Regis Romanorum et Boemiae" in the years 1382–92: one Johannes, who owned the house at no. 175 on Hradčany Hill. The affluent and respected "Bohunko pictor" might also have worked for the royal court. First resident in Hradčany, of which he became a town councillor in 1382–83, in 1386 he bought a house on Spálená Street in the New Town, where from 1387 to 1390 he served as a councilman.[21]

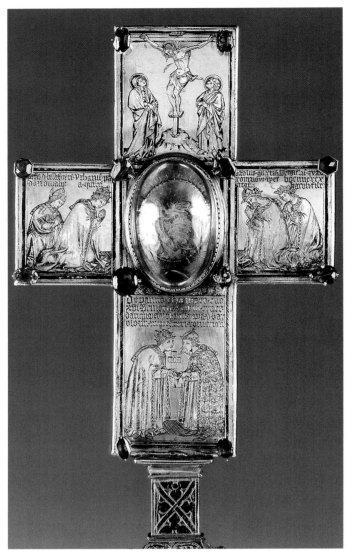

Fig. 8.5 Reliquary Cross of Urban V. Gold, niello, and precious gems, after 1368. Treasury of Saint Vitus's Cathedral, Prague

astonishingly pictorial vision of 1388, which he had illustrated on the wall of the bishop's residences in Prague and Roudnice (or was he already referring to those paintings in his vision?). These qualities characterize the paintings of the Třeboň Master, as shown in the facial expression of the resurrected Christ in the altarpiece from the Augustinian Church of Saint Giles in Třeboň.

The Třeboň Master had most probably been reared in the aesthetic environment of the court of Prague. Accordingly, he could have been the author of the Crucifixion in Vyšší Brod,[22] which changes the otherwise classical composition by adding Mary's blood-stained veil, a motif favored at the Prague court.[23] The intense emotions of the secondary figures and the imposing expression of the crucified Christ find their closest analogies in Parisian, or Franco-Flemish, art from the 1370s and suggest a similar date. The Master of the Třeboň Altar perpetuated the western European orientation of Prague painting that was already evident in the early 1370s.[24] Innovations in the palette and the role of light and technological advances (red undercolor in painting, black bole under gilding instead of red) that were not common in central Europe suggest that the painter visited western Europe. The earlier Italianate style of painters at Karlštejn (as in the staircase cycle of Saint Wenceslas) and the cloister Na Slovanech was superseded.

It was probably Petr II Rožmberk, provost in the king's Chapel of All Saints in Prague, who hired the painter to complete the retable for the main altar of the Augustinian canonry in Třeboň, which he founded in 1367, together with his three brothers.[25] Petr bequeathed funds to complete the church in 1380.[26] Accordingly, sometime around 1380 the Prague painter must have completed the retable for the main altar. It is impossible to dismiss the possibility that the Crucifixion and the Nativity (cat. 97) also came from this church, an indication of the appreciation of the painter's work among the Augustinians.[27] Shortly afterward, the Master of the Třeboň Altar received more commissions at the parent monastery in Roudnice, recommended either by Petr II Rožmberk or by the patron of the Augustinian canonry, Prague Archbishop Jan of Jenštejn,[28] in whom he found a new benefactor.[29]

The change in the artistic situation at Prague Castle was evident at the Cathedral of Saint Vitus, where construction continued under the direction of Peter Parler and the supervision of the cathedral's clerk of works, Ondřej Kotlík (d. 1380), and Václav of Radeč (d. ca. 1418). The cathedral chapter, not the king, bore responsibility for the project. Even Wenceslas's ceremonial participation was compromised by his disputes with Archbishop Jan of Jenštejn, who was

Unfortunately it is impossible to identify reliably this artist with the painter associated with the highest level of European painting during the fourteenth century: the Master of the Třeboň Altar (see cat. 97). The use of a light and brightly colored palette to illuminate shape and enhance modeling, the choice of the diagonal in compositions to intensify the emotional component, the depiction of crude malefactors rather than lyrical spiritual witnesses, are all elements of the painter's religious vision. These basic paradigms of medieval art eventually became the theme of the Prague synods of 1389 and 1392, which Prague's archbishop Jan of Jenštejn (1349–1400) used to defend the function of miracle-working paintings against the iconoclastic views of Mathias of Janov. He invoked the supranatural sensual beauty that according to Augustinian aesthetics is a means of access to Christ's "unspeakable beauty, very aristocratic character, happy and more pleasant features," as were described in his

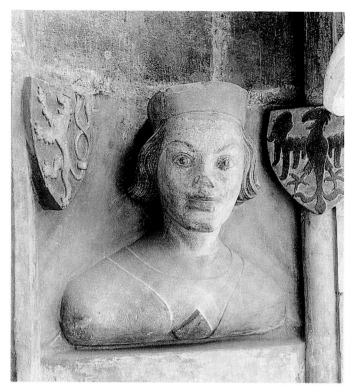

Fig. 8.6 Bust of Wenceslas IV. Sandstone, 1375–78. Triforium, Saint Vitus's Cathedral, Prague

chancellor until 1384. When Jan of Jenštejn hosted a feast to celebrate the completion of the vaulting of the choir and its consecration in 1385, Wenceslas refused to attend. Seven years later, on Pentecost, Wenceslas and his younger brother John, margrave of Brandenburg, laid the cornerstone for the nave of the cathedral.[30] The archbishop again hosted the celebration in his residence in the Little Quarter (Malá Strana); on this occasion the king was in attendance with his second wife, Sophia of Bavaria (probably because only the archbishop could crown her queen).[31] Wenceslas issued a proclamation that any suitable stone found within three miles of Prague could be quarried from private properties for use on the cathedral.[32] While this decree suggests an official exercise of royal purview rather than the king's personal involvement in the project, there is direct evidence of his participation in other building campaigns in Prague.[33]

Below the castle, on the banks of the Vltava, work continued on the sculptural program of the Tower Bridge (see cat. 60) that had begun during the 1370s, late in the reign of Charles IV.[34] The project was conceived with the idea of building a monument on the Old Town riverbank to celebrate the political victories of Charles IV, the end of conflict with the Wittelsbachs of Austria, the acquisition of Brandenburg, and above all the election of the adolescent Wenceslas as Holy Roman Emperor. On the bridge gate, Charles and Wenceslas appear side by side as guardians of

the realm, Charles pictured in an alb with a stole crossed over his chest in the manner of a deacon of the Church, Wenceslas in knightly mail with a royal cloak. Wenceslas embellished the monument with the personal motifs also found in his manuscripts: kingfishers and love knots in stone on the exterior and painted images of bath maidens set within the arched ceiling of the gate.[35] They injected decorative, playful accents into the triumphal, dynastic imagery.

Across the bridge at the university, Wenceslas relocated the Carolinum (fig. 8.7), the college his father had founded, near the Old Town Hall, giving it a new, more magnificent home in a residence purchased from Jan Rotlev, master of the mint at Kutná Hora.[36] The center of university life, the Carolinum had a great hall, lecture halls named for Aristotle and Plato, a chapel with a richly decorated stone oriel, and administrative rooms. Before 1381 Wenceslas also established a new college bearing his own name opposite the Carolinum on the Fruit Market.[37] In a move that seems remarkably precocious but which was in fact consistent with contemporary

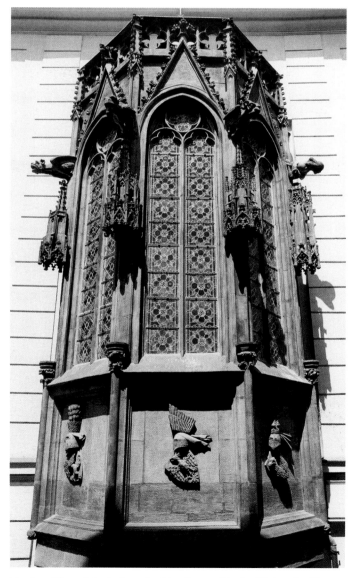

Fig. 8.7 The oriel window, the Carolinum, Charles University, Prague

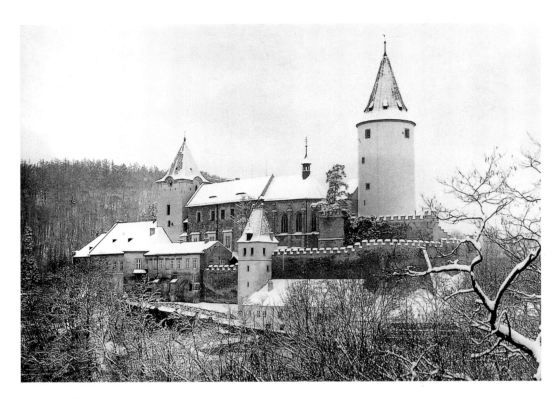

Fig. 8.8 Křivoklát Castle, near Prague

practice in both Paris and Bologna, financial support and lodging were provided for a number of indigent students.[38] In January 1409 Wenceslas IV again directed the course of Prague University by issuing the edict of Kutná Hora, which gave preferential treatement to Bohemian masters. The subsequent exodus of German professors weakened the Prague campus intellectually and, conversely, strengthened the foundation of other European universities, such as Leipzig or Erlangen, which apparently received a pair of scepters created for the university in Prague (cat. 72).

The first of Wenceslas's royal town residences was the so-called royal court at Saint Benedict, which had two courtyards and a palace with a significant tower spanning the then Old Town gate and Celetná Street.[39] This residence was likely finished in 1385, when Wenceslas IV moved there from Prague Castle, where his mother-in-law and half brothers Sigismund and Jan lived. Perhaps the well-known family quarrels, or his disagreements with the clergy, or the better lifestyle afforded by the town palace motivated the king. With the new royal seat in the Old Town he could better communicate with the clergy of the nearby Church of Our Lady before Týn, which served the court. In the north choir it still bears stone likenesses of King Wenceslas IV and his first wife, Johanna of Bavaria.[40] Presumably it was not until the late 1390s that Wenceslas started building another castle in town, behind the cloister of the Order of the Holy Sepulcher at Zderaz, in the New Town, thus creating a balanced alliance with the two Prague districts.[41] His characteristically luxurious palace with its tall tower

became an essential part of the New Town panorama. Wenceslas even had the Church of Saint Wenceslas built nearby and its presbytery painted with symbolic renderings of the Immaculate Conception of the Virgin and the Tree of Life.[42]

Outside Prague, Wenceslas renovated Křivoklát (fig. 8.8) and Točník Castles, both set in the royal forest, where he liked to hunt. The castle at Točník included a great hall measuring 34 by 9 meters, the largest in a royal castle. Apparently built to Wenceslas's specifications,[43] the castle walls were painted with images of his royal ancestors.[44] The king's dislike of Karlštejn might be interpreted as a rejection of that intensely spiritual site. It should not, however, be construed as evidence that he neglected the spiritual component of his residences. The king's new castle at Točník included a private chapel,[45] and when he rebuilt the existing castle at Křivoklát, he had the old single-naved chapel renovated. Although its appearance today is connected with the reign of Vladislav II Jagiello (1471–1516), the stonework decoration of the chapel evokes the classical stylistic repertory of the late fourteenth century: shallow spiral pillars set along the sides of the chapel, spandrel consoles decorated with vegetal motifs and painted face masks, and solid baldachins, their mass broken up by simple gables with crabs and violets.[46] Wenceslas stayed at Křivoklát in the first decade of his independent reign,[47] at which time he must have rebuilt the castle sanctuary.

In the imperial city of Nuremberg, the new king continued royal patronage in the tradition of his father. The central stained glass at the Parish Church of Saint Sebaldus was

Wenceslas's gift after the completion in 1379 of the eastern choir initiated by Charles IV; the neighboring north window was commissioned by the bishop of Bamberg and the southern window by the burgrave of Nuremberg, a member of the Hohenzollern family. The new choir thus was dominated by the presence of the most important men of the land. The altar of Saint Peter was originally located under the king's window, and directly connected to it were two extensive wall paintings narrating the legends of Saint Peter and Saint Paul. The lively gesticulating figures with their twisted, caricature-like expressions depend on examples from the court at Prague, like Karlštejn and the Benedictine Monastery Na Slovanech in the New Town. Despite the extensive damage, the paintings are among the best-preserved works in Francony of the time of the last reigning Luxembourgs.[48] The idea that the atelier working for the king was the same as the one in Forchheim, the residence of the Bamberg bishop, is supported not only by visual similarities,[49] but also by the personality of Lambert of Brunn, bishop of Strasbourg (r. 1371–74), who was named bishop of Bamberg in 1374. Lambert helped Charles IV negotiate Wenceslas's election as King of the Romans. Wenceslas then named him a temporary chancellor of empire in 1384.[50] In honor of his son, Charles IV commissioned the glazing at Hersbruck in Oberpfalz, near Nuremberg, which includes, besides the rich Easter cycle, the emperor's beloved motif of the Virgin clad in the sun and a heraldic roundel with the lion of Bohemia.[51] Planning for Nuremberg's Beautiful Fountain (see fig. 100.1) had also begun under Charles IV, and it was built during Wenceslas's reign, from 1385 to 1396. But the fountain was commissioned by the city itself,[52] and as was the case with the Cathedral of Saint Vitus in Prague, its realization did not depend on the new king's initiative or involvement.

Charles IV famously supported the churches of his realm, and particularly the Cathedral of Saint Vitus in Prague, with gifts of saints' relics and precious reliquaries to house them. He endeavored to instill in Wenceslas a similar devotion to the saints, obliging the prince to participate in venerating the holy shrines of France. But Wenceslas IV did not share his father's indefatigable obsession. It is perhaps not surprising that the young prince should have preferred a trip to see the lions kept by King Charles V to the veneration of relics.[53] But if that choice can be attributed to adolescent taste, Wenceslas in his maturity never embraced the cult of the saints the way his father did. A story from April 1370 best highlights Wenceslas's disregard for relics and for family tradition. At that time Wenceslas was residing in Nuremberg at the home of a burgher named Nicholas

Muffelo whose wife, Barbara Kolerina, regularly washed the Bohemian king's hair. In return for her services, she could request whatever she wanted. When she asked for a piece of the Holy Cross that Wenceslas had tied around his neck in a gold pouch to remind him of his grandfather John, he told his chaplain to bring a goldsmith, who then cut a piece of the cross and set it in a silver case that he presented to Barbara.[54] Tellingly, the inventories of Saint Vitus's Cathedral record only two gifts from Wenceslas IV, a crystal monstrance "with images of the emperor and empress," first mentioned in 1387, and a ceremonial belt recorded in 1396, after the death of his first wife, Johanna of Bavaria.[55]

The Březnice Madonna (cat. 81), a copy of a Byzantine icon, is the only devotional painting commissioned by Wenceslas, in 1396. In the context of contemporary faith, the icon serves as a reminder that early advocates of Church reform in Bohemia were not iconoclasts but rather embraced traditional devotional images. Jan Hus drew an explicit analogy that conforms to Wenceslas's example, proclaiming, "It is as bad to destroy an image as it is a book."[56]

In 1396 in Rome, Prague's Archbishop Jan of Jenštejn stepped down. But the king also had strained relationships with other metropolitan chapter members. As Wenceslas's own interest in the splendor of his crown diminished, the high clergy assumed this role. Jan of Jenštejn's successor was his cultured nephew Olbram of Škvorece (r. 1396–1402), who translated the relics of Saint Adalbert and the Five Brother Martyrs (see cat. 11) to the newly built nave at the Cathedral of Saint Vitus, where he also brought the relics of Jan Nepomuk, murdered by the king's henchmen in 1396. He presented liturgical vestments, a reliquary cross, and rare books to the church.[57] His successor, Zbyněk Zajíc of Hazmburk (r. 1403–11), was not a major patron, even though his 1409 missal (see fig. 9.1) is one of the most beautifully decorated books from the era. In honor of his memory, Oldřich, the brother of the late archbishop and the king's courtier, commissioned the altar of Saints John the Evangelist and John the Baptist in the lower level of Prague Cathedral's southern tower in 1415. The prestigious and often copied painting of the Virgin and Child (cat. 91), with its richly carved frame, might also have been created in this context. Zbyněk of Hazmburk argued against clerical reform with the faculty at Prague University and with the king, in the face of whose anger he—like Jan of Jenštejn—retreated to Roudnice with the entire chapter. He announced a ban on Prague, and in retaliation Wenceslas had the entire Saint Vitus treasury moved to Karlštejn in 1410.[58] Archbishop Albík of Uničov (ca. 1358–1427), renowned as the doctor of Wenceslas and Sigismund,[59] dedicated two independent

chapels in the Cistercian Monastery of Saints Cosmas and Damian, the patrons of medicine, in Sedlec; and in the Old Town Church of the Virgin on the Lawn, he commissioned an ornately sculpted tombstone. As provost of Vyšehrad, he commissioned the busts of the apostles Peter and Paul (cat. 125), patrons of the Vyšehrad chapter.

As provost of Vyšehrad Albík replaced one of the most powerful figures of pre-Hussite Bohemia, Wenceslas Králík of Buřenice (d. 1416). Presumably the illegitimate son of a Luxembourg, he was a lifelong adviser to King Wenceslas, becoming dean and later provost of the Vyšehrad chapter (1397–1412) and also chancellor (1394–1409).[60] He became famous as a patron of art, especially at Vyšehrad, but few fragments of his commissions survive today. Among them was a gilded shroud (with the imperial eagle and the Bohemian lion) for the Virgin of Humility, venerated for its relic of the Virgin's gown, for which the pope had granted indulgences in 1396. Wenceslas Králík also obtained for Vyšehrad the finger of Saint Anna from Perugia and, in 1410 the body of Saint Longinus.[61] In 1404 he founded a chapter there, for which he commissioned a Chapel of the Resurrected Christ in the newly built Gothic Church of Saints Peter and Paul and had it decorated with, among other things, an altarpiece. He probably also initiated the decoration of the high altar in the Vyšehrad Church in the early fifteenth century.[62] He helped found the Brotherhood of Corpus Christi at the Church of Saints Philip and James at the gate of the Cistercian monastery in Sedlec near Kutná Hora and most likely was the patron of the Gerona Martyrology (cat. 86). The elegant taste and princely lifestyle of Wenceslas Králík of Buřenice suffuses even heraldic tiles from Melice Castle, where the Olomouc bishop resided between 1412 and 1416.[63]

The significance of Vyšehrad for the king and his closest supporters resulted in a great number of commissions. In the first chapel on the south side of the provost church is a fragment of a wall painting of the Virgin with Saint George and Saint Adalbert on which the letters a and p (abbatissae pragensis) are intertwined with love knots, a royal emblem relating to bathhouses, and the coat of arms of the donor, Abbess Cunigunde from Kolovraty (1386–1401), who in fact sat next to Queen Sophia during her coronation in 1400.[64] After the royal wedding in 1389 in Cheb, the thirteen-year-old second wife of Wenceslas IV, Sophia of Bavaria (1376–1428), was probably put in the care of Cunigunde, the abbess of the Saint George Convent, which traditionally played a key role in the lives of Bohemian queens. The prominent members of the court would then have redecorated Vyšehrad Chapel for the queen's corona-

tion on the feast of Saint Longinus in 1400. Already as a young woman, Queen Sophia had decided that she would commission churches in the towns of Chrudim and Dvůr Králové. She supported the foundation of other orders, such as the Church of the Poor Clares in Panetský Týnec and the Augustinian canonry in Jaroměř.[65] Shortly after Wenceslas's death she had to abandon the Hussite Bohemians and until her death lived in Bratislava, where in the Church of Saint Martin she had an oratory and funerary chapel built.[66] A lamp with an amber sculpture (cat. 143) survives from the decoration of this chapel. The inventory of the chapter also includes an alabaster statue of the Virgin, a panel painting attributed to Saint Luke, a painting of Saint Catherine and Saint Barbara, other altarpieces with a Marian theme, a religious text in Czech, a chalice, numerous reliquaries, and a crown.[67]

Wenceslas's last big building project was the luxuriously outfitted, towered castle at Kunratice, not far from Prague,[68] into which he moved, with his renowned library, only a year after construction began in 1411. While virtually nothing is known about Charles IV's books,[69] that is not the case with Wenceslas IV. The contrast is particularly marked given Charles's reputation as a scholar whose reign ended peacefully and Wenceslas's as a dandy and a wastrel whose reign ended in chaos. No inventory of Wenceslas's books survives, and no contemporary spoke, even in passing, of his manuscripts. But two years after his death wagonfuls of books were carted away from his castle, Nový Hrad, called Wenzelstein: "Wagons were brought before the castle for the purpose of transporting both the enemy goods and themselves. And when Fulssteyn [Burgrave Herbort von Feulstein] started to load the wagon granted to him with many manuscripts along with other things belonging not to him but to the king, the populace of the place rushed furiously into the castle and stole as much of the goods in the wagon as each was able to lay hold of. . . . They came to a vault of books, which they plundered, and they went about taking anything useful which [the castle inhabitants] were not able [to take with them]. They sold these in Prague for a small price."[70] Another source indicates that the king's manuscripts included both Christian and Hebrew texts.[71] A letter written by Ladislas Posthumous in 1455 refers to books from Wenceslas's library that had come into his possession, noting in particular a large and beautiful Bible in German and Latin, holy writings, and texts about the "black arts"[72] and about natural phenomena.[73] Seven manuscripts that certainly belonged to Wenceslas IV have been identified.[74] Two are translations from Latin to German of sacred text; three pertain to astronomy; one, the Golden Bull,

is political in nature;[75] and one is purely secular. One of the seven, a psalter in German and Latin (cat. 84) features in the exhibition. Five other manuscripts that may be associated with the king by virtue of their decoration or their history are showcased as well: the Pembroke Hours of Wenceslas IV, Madrid's William of Conches manuscript, *The Travels of Sir John Mandeville,* and the *Bellifortis,* or treatise on the art of war, by Konrad Kyeser (cats. 82, 87–89).

Most famous of Wenceslas IV's manuscripts is a multi-volume illuminated Bible in German (see figs. 84.2–7). With this project of unmatched ambition Wenceslas apparently endeavored to establish himself as a patron on a level that rivaled, but was distinct from and arguably even at odds with, his father's example. Translations of the Bible from Latin into the everyday language of people were expressly forbidden as heresy by Charles IV by 1369.[76] About 1375, before Charles's death, Jan Rotlev, whose property became the new home of the Carolinum, had sponsored this German translation by an anonymous scholar. An inscription in the Bible confirms Wenceslas's own patronage, along with his second wife, Sophia, of this spectacular edition, in direct contravention of his father's order.[77]

Wenceslas IV also owned a psalter in German (cat. 84) and, it appears, a German edition of selected writings of Saint Paul corresponding to the readings to be used in church services beginning in Advent.[78] These texts testify to the king's involvement in contemporary reform issues in Bohemia. Adopting a position championed by John Wycliffe in England, liberal churchmen in Prague, including Jan Hus, the leader of the reform movement there, advocated the edification of the faithful in their own spoken language rather than in Latin, in which only the most educated men were conversant.[79] Wenceslas IV wrote to the antipope John XXIII and the College of Cardinals to express his opposition to the ban on Wycliffe's books in Bohemia. His queen, Sophia, seconded the protest.[80] To appreciate how radical the king and queen's position was at the time it is sufficient to remember that they confronted the Church hierarchy a century before Martin Luther touched off the Protestant Reformation, espousing the use of vernacular language as part of his cause.

Only one manuscript from the royal collection relates to private prayer. The Hours of Wenceslas IV (cat. 82) refers to the ruler as "W" in three separate prayers and calls him he "whom God has placed on the throne of royal honor."[81]

At the intersection of the sacred and secular in the Middle Ages are three astronomical manuscripts from Wenceslas IV's collection. These filled a practical need at the court; the study of the stars allowed for prognostication, providing the means

for choosing favorable dates for political or military action or even for undertaking important projects like the building of the Charles Bridge.[82] The Madrid manuscript of William of Conches (cat. 87) may bear the arms of the king of Bohemia, obscured by the superimposed later arms of Matthias Corvinus, the bibliophile king of Hungary. The manuscript, along with the codices in Vienna and Munich (see figs. 84.8, 84.9, 87.1), was probably intended for one of Wenceslas IV's astronomers. The contents of the Munich text, drawing on diverse traditions—Hebrew, Arabic, and Christian—suggest a degree of intellectual tolerance at the court of Prague that rivals any subsequent academic traditions anywhere, in any era. Wenceslas's interest in astronomy is also evidenced in the creation of Prague's famous Astronomical Clock (fig. 8.1), which was created by Master Iohannes Šindel, physician to Wenceslas IV in 1409 and rector of the university in 1410, in collaboration with Nicholas of Kadaň.[83] Wenceslas's links to the new university in Prague, already apparent in the endowment of colleges and the commissioning of translations of scripture, are equally noteworthy in connection with his role as a patron of astronomers.

The appeal of natural science for Wenceslas, suggested by Ladislas Posthumous's mid-fifteenth-century reference to the contents of his library, is manifest in an encyclopedia of science, the *Historia plantarum,* that was purportedly given to Wenceslas IV by Gian Galeazzo Visconti.[84] The luxurious manuscript presents Wenceslas, enthroned and flanked by courtiers, on its frontispiece. Again, the arms of Matthias Corvinus obscure those of Wenceslas, which originally decorated the bottom of the page.[85]

Two manuscripts associated with Wenceslas IV exemplify the rich tradition of European secular literature at the court of Bohemia. The illuminations from *The Travels of Sir John Mandeville* (cat. 88) come from a fantastic travelogue that captured the imagination of princes of the day. Another version belonged to the library of Charles V of France, Wenceslas's cousin; a third was given to Charles's brother and fellow bibliophile, Jean, duke of Berry.[86] The Czech version, on which the British Library's illuminations depend, was the work of Vavřinec of Březová, who became a priest after studying at the University of Prague and later composed a chronicle of the Hussite Revolution.[87] The patron of the manuscript is not known, but Vavřinec identifies himself as a servant of the Holy Roman Emperor and king of Bohemia.[88]

An explicit, or note at the conclusion of the *Willehalm* manuscript (see fig. 84.1) gives the date of its completion as 1387 and indicates that it was illustrated through the generosity of Wenceslas IV.[89] The text, composed in the early thirteenth century by Wolfram von Eschenbach, author

Fig. 8.9 A Bathhouse. *The Bellifortis* of Konrad Kyeser (cat. 89), fol. 114v (detail). Tempera and ink on parchment; Prague, completed 1405. Niedersächsische Staats- und Universitätsbibliothek, Göttingen (2° cod. ms. philos. 63 Cim.)

of *Parzival,* addresses the conflict between Christian and Muslim cultures through the fictional account of a warrior saint named Willehalm and his wife Gyburc, a convert from Islam. Exceptionally for its time, the text considers issues of religious and cultural tolerance and questions the justification for the Crusades.[90]

Despite the ubiquity of bath imagery in Wenceslas's manuscripts, it is still perhaps surprising to discover that the virtues of bathing, public and private, were the subject of conflicting contemporary opinions. Bodily cleanliness was a means to spiritual rebirth: "Always cleanse yourself happily in the bath, enjoy yourself in the warm bath, and put everything else aside. Your life should be like this at all times, maintain the cleanliness of your body, so that it is not rendered black from debauchery."[91] About 1393 Vyšehrad had its own bathhouses.[92] Court and spiritual environments met in the Vyšehrad frescoes. Albík of Uničov counseled Wenceslas at length about the personal consequences of bathing: "Public baths are poisonous for someone suffering from rheumatism." On the other hand, he believed that "steam and sweating baths are beneficial."[93] The reality of

men and women crowded into baths warmed by great pot-belly stoves is evoked in an illumination from Konrad Kyeser's *Bellifortis* (fig. 8.9). Clearly a draft for a royal manuscript, the *Bellifortis* text is interpreted by wonderfully fresh images that draw on contemporary costume, situations, and surroundings. The illustration of the bright orange tent decorated with the king's devices (see cat. 89) makes clear that it was intended for Wenceslas IV, before he was denied the imperial throne. The book is replete with images of military devices, including a catapult and a prototype of a diving suit for underwater battle. Blending the experimental with the conventional, this manuscript of the "art of war" presages the inventive drawings for military use by Leonardo da Vinci. From a numbing historical distance of several centuries, it becomes possible to respond on an aesthetic level to a potent mix of science and art that was the purview of royal commanders in chief and the military elite.

A bone saddle from Prague evokes the amorous dalliance of life in the courts of Europe about 1400. If the attribution to Wenceslas's court at Prague is correct, the saddle does not represent a new aesthetic at the court. Already during

Charles IV's lifetime a box decorated with bone plaques carved with secular subjects (cat. 55) was adapted as a reliquary of Saint Sigismund and immured in the chapel dedicated to him in Saint Vitus's Cathedral. The erotic nature of some of the scenes did not, surprisingly, preclude its use or its official sealing by Wenceslas and Jan of Jenštejn, archbishop of Prague. Secular and sacred seem to have coexisted in a delicate balance, the rules of which are difficult now to discern. Nubile bath maidens are a leitmotif of Wenceslas's reform-minded Bible, but erotic scenes decorating private houses in the New Town provoked the wrath of Jan Hus.[94]

Only isolated references link Wenceslas to other secular objects.[95] For example, the king presented a gold cup to one of his favorites, Sulek of Riesenberg and Skála.[96] But such a generic, unique record cannot be thought to represent the king's taste. On the other hand, according to the French chronicler of Wenceslas IV's visit to Charles VI in 1398, the Bohemian king's appreciation for the woolen tapestries and silk wall hangings embroidered with lives of ancient kings was so intense that Charles VI presented the entire suite as a gift to his Bohemian cousin. With Wenceslas's commissions and acquisitions, a sense of the secular culture of Bohemia emerges, sometimes intersecting with Christian thought, sometimes taking flight from it.[97]

In the era of Charles IV the imperial and spiritual face of Prague had predominated, whether in the emperor's own commissions or in those of ecclesiastics and the nobility at his court. In Wenceslas's time, ecclesiastical commissions begun under his father continued. At the same time, the king supported new kinds of projects that seem especially to have grown out of the university environment. Although Charles IV had worried about his dynastic legacy, art in Prague, at least, depended not only on the person of the king but also on the efforts of the Church, the court, and the city. Together they contributed to the city's permanent status as a cultural capital of Europe.

1. Quoted in Rosario 2000, p. 125, citing Spěváček 1986, pp. 29–33.
2. Ibid. Perhaps not surprisingly, given Charles's sense of the divine nature of kingship, the quotation recalls the biblical text describing Christ as the "sure foundation" and Peter as "the rock" upon which the Church is built.
3. As a child at the court of France, Charles had witnessed firsthand the disruption caused by the lack of male heirs to the Capetian dynasty.
4. When the dukes of Berry and Bourbon went to pick up Wenceslas for a celebratory dinner in his honor during his visit to Paris in 1397, they found him sound asleep in his bed, reeking of wine. Responding to their surprise at this crass behavior, Wenceslas's retinue laughed and said it was his custom. The dinner had to be rescheduled (Bellaguet 1994, p. 569). I am grateful to Elisabeth Taburet-Delahaye for this reference.
5. Bresslau 1922, pp. 117–18.
6. The Church of Saint Moritz was destroyed in the Second World War; see Kehrer 1912, pp. 65–67, and Mulzer 1992.
7. Boehm 2000, pp. 267–310.
8. For archival research connecting these paintings for the first time with Weinschröter, Charles IV's court painter, see Fajt 2004a.
9. Beneš Krabice of Weitmile, FRB 1884, p. 528.
10. Czartoryski Library, Kraków, Czart. 1414 (Cologne 1978–79, vol. 2, p. 740; Miodońska in Kraków 2000, pp. 50–51, no. 1/16).
11. Quoted in Rosario 2000, p. 126.
12. FRB, vol. 3 (1882), p. 430, translated in Rosario 2000, p. 129.
13. Benešovská and Hlobil 1999, pp. 94–96.
14. See, for instance, the majestic seal of King Wenceslas IV on a document of November 21, 1383 (State Archives, Prague, LIV-1279).
15. Weltsch 1968, pp. 14–15.
16. The frontality and drapery recall sculpture contemporary with the portrayal of the Luxembourg monarch from the Old Town Bridge Tower (cat. 60) or the royal husband in the illumination of the Wenceslas Bible (vol. 1, fol. 2; for the Bible, see figs. 84.2–84.7). See Binski 1995, pp. 202–5.
17. Binski 1997, pp. 233–46.
18. Kutal 1966b, p. 456n12.
19. Avril in Paris 2004, pp. 272–73, no. 168.
20. Hlaváček in Moraw 2002, pp. 105–36; Hlaváček 2003.
21. Chytil 1906, p. 39n1.
22. The Crucifixion was traditionally attributed to the circle of the Třeboň Master and dated to about 1390. See, for example, Chlíbec et al. 1992, pp. 28–29, no. 11.
23. Veneration of Mary's cloak, which is kept in Saint Vitus's Cathedral, was brought to life by the Czech translation of Pseudo-Anslem's *Dialogus beatae Mariae et Anslemi de passione domini* and other literary works. This can be seen in the Cathedral Missal of Heinrich Thessauri (Národní Muzeum, Prague, Library, XVI B 12, fol. 42), long a high administrator on the Luxembourg court and trustee of the archbishop's office (Pujmanová in Benešovská 1998, pp. 256–59).
24. The Vyšší Brod Mary was adopted for the Crucifixion from Saint Barbara from the late 1370s by the Třeboň Master; they share similar profiles that turn to Saint John.
25. Kadlec 2004, p. 30n115.
26. He donated 360 groschen payable in three yearly payments; books were to be purchased with any leftover money (Kadlec 2004, p. 58). A document from April 4, 1380, mentions the main altar and the Altar of the Virgin, and also in 1380 there was news of another Altar of Saint Mary Magdalen and Saint Augustine, which stood on the choir (ibid. pp. 3, 5, 78).
27. Petr II thus followed the example of his father, who had commissioned a Passion cycle from the Prague court painter, in the 1340s, this time for the mother house of the Cistercian church in Vyšší Brod (see fig. 3.2).
28. At the Augustinian cloister in Kazimir, near Kraków, the last monastery established from Roudnice, there are interesting wall frescoes from about 1410 that show strong Bohemian influences. On Jenštejn, see, for instance, Bartoš 1940 and Weltsch 1968, esp. p. 59.
29. The cultivated expression of the Master of the Třeboň Altar was often duplicated and paraphrased, even in distant Magdeburg, where even at the end of the era of Czech archbishops the cultural orientation of the local artistic milieu was toward Prague and the Bohemian lands, as is indicated by the panel from a private collection with the beheading of a saint (cat. 99). Archbishop Albrecht Edler von Querfurt (r. 1382–1403) may have been responsible for that; he not only studied law in Prague but also became engaged in the politics of the empire under Wenceslas IV, serving as the king's chancellor in

1395–96 (Scholz in Gatz 2001, pp. 392–93. On Magdeburg, see Deiters 2005.

30. Benešovská and Hlobil 1999, p. 151.

31. Weltsch 1968, p. 64.

32. Benešovská and Hlobil 1999, p. 162, citing Tomek 1871, vol. 4, p. 111.

33. Neuwirth 1893, vol. I, p. 60.

34. Rosario 2000, p. 79.

35. Kutal 1971, p. 111.

36. Spěváček 1986, p. 371.

37. Novotný (1923, p. 13) provided a summary of the discussion; see also Kavka and Petráň 2001, vol. 1, p. 51.

38. Mulin 1991, pp. 59–63.

39. The house of Těma of Koldice, the king's favorite land commissioner from Wrocław, and the house at the Black Eagle behind the Týn Church in the direction of Dlouhá Street were integrated into the royal district. From 1360 the latter had belonged to the bishop of Wrocław, the provost of Wrocław, and the notable diplomat from Charles's court, Przeclaw of Pogorzela, and to the provost of Wrocław. It was the residence of the Bohemian king until 1484, when Vladislav II Jagiello moved to the renovated castle. The king also owned the house at Saint Apollinaris in New Town (Hlaváček 1991, p. 58; on architectural aspects, see Durdík 1986, pp. 24–43, esp. pp. 25–30).

40. After Wenceslas's brother Sigismund returned to Prague he took over the minor Old Town Church of Saint James the Less, where the Luxembourg emperor had seven altars consecrated in 1436. The painted panels of the Saint James retable (cat. 153) may be linked to this. For the castles, see Durdík 1986, pp. 30–34; for the wall paintings, see Všetečková 1979, pp. 215–28.

41. On the order, see Tomek 1855–1901, vol. 3, pp. 202–4.

42. On the castles, see Durdík 1986, pp. 30–34; on the wall paintings, see Všetečková 1979, pp. 215–28.

43. Durdík 2000, p. 554.

44. Neuwirth 1893, p. 60.

45. Durdík 2000, p. 554; Prague 2001a, vol. 2, p. 239.

46. During the Jagiellonian era only the wooden parts of the chapel were added.

47. Beginning in 1389 Žebrák Castle began appearing on Wenceslas IV's itinerary. Then between 1401 and 1405 Točník Castle, built on the opposite hill, became the king's seat (Hlaváček 1991, pp. 63, 65).

48. Schädler-Saub 2000, pp. 81–87, 166–67. Another fragment with Saint Martin under the third and fourth windows in the choir of Saint Sebaldus's Church that is similar to many of the scenes from the life of Saint Paul suggests that originally the entire area under the windows of the new choir could have been decorated with saints' legends.

49. See the exalted gesticulation of the Nuremberg emperor Nero and the figure of King David at Forchheim (Kehrer 1912, vol. 26, pt. 3).

50. Lambert of Brunn followed the example of the Luxembourgs in Bohemia. The design of Altenburg, the castle he rebuilt for the bishop near Bamberg, was most likely based on Karlštejn (see von Pfeil 1986 and Hörsch and Schmidt in Bamberg 2002, pp. 94–95). Lambert remained one of Wenceslas's most influential advisers, and he was a strong proponent of a pro-Roman resolution of the schism in the Western Church (Machilek 2001, pp. 185–225).

51. Scholz 2002, p. 219.

52. New York–Nuremberg 1986, pp. 132–35, no. 14.

53. Delachenal 1910–20, p. 261.

54. This event is noted in *Historia de notabili particular s. Crucis ad s. Aegidium Nurembergae* (Andreas Felix Oefele: *Rerum Boicarum scriptores I.*, p. 353; see Spěváček 1986, p. 66, and also Machilek 1986, pp. 57–66).

55. Podlaha and Šittler 1903a, pp. XXXIV, no. 132, XLIIIn2. Krása (1983a, p. 24) stated, without supplying documentation, that Jean, duke of Berry, sent Wenceslas a relic of Christ in the form of a stone mounted in gold.

56. Hus 1930, p. 98.

57. Buben 2000, pp. 339–41.

58. The archbishop died suddenly while traveling to visit Sigismund in Bratislava in 1411. His body was transferred to Prague in 1436. His monumental tomb in the basement of the south cathedral tower was repaired, and the altar of Saints John the Evangelist and John the Baptist was "newly elevated" as well (see Bartlová 2001b, p. 166).

59. Albík's health regimen for Wenceslas tells of the king's uncontrolled love for wine and his frustration at not having a son (Říhová 2001, vol. 2, pp. 154–92).

60. Vyšehrad provosts were appointed by Bohemian kings, and starting in 1226 they also served as chancellors (Čumlivski in *Královský Vyšehrad* 2001, vol. 1, p. 155; Hledíková in *Královský Vyšehrad* 2001, vol. 2, pp. 74–89).

61. Tomek 1855–1901, vol. 2, pp. 258–62. A Roman sarcophagus survives at Vyšehrad; Saint Longinus's body was once kept in it.

62. Kořán 1987, pp. 540–47.

63. Michna 1976.

64. Krása 1971, pp. 59–103. For a new interpretation of the paintings at Vyšehrad and identification of their patrons, see Všetečková 2001, pp. 133–53.

65. Mencl 1948, pp. 158–60. See also Všetečková 2001, p. 138.

66. Žáry 1990.

67. Vítovský 1991.

68. Durdík 1984.

69. See Krasá 1971, pp. 10–11.

70. Given in Old German in Krása 1971, p. 18. We are grateful to Xavier Seubert, O.F.M., for providing the translation. A list of the books in the possession of Wenceslas's widow, Sophia, at the time of her death survives, but there is no reason to infer that these belonged to her husband. They included three "Bohemian" books written on paper, a "Bohemian" book on parchment, a German text on paper, a psalter bound in red leather, a Bible, a book about the Ten Commandments, a book about the Seven Joys of the Virgin Mary, and parts of the gospel of Saint Matthew and the life of Alexander.

71. Krása 1971, p. 18. Not even Sigismund, who visited Wenceslas's new castle immediately after the secret coronation in June 1420, removed the entire load: "9 'three heaps' full, pressed, piled with different goods with gems, money and clothes, boxes with various books, Jewish and Christian of which there were plenty there."

72. A reference to books on necromancy in the collection of Emperor Maximilian I may refer to these books from Wenceslas IV's collection (Krása 1971, p. 20).

73. Ibid., p. 18.

74. A French-Latin dictionary made for Wenceslas and his brothers John and Sigismund that was in the collection of Emperor Maximilian I in 1507 has not survived (ibid., p. 20).

75. Österreichische Nationalbibliothek, Vienna, Cod. 338. On folio 46v is the explicit "Explicit bulla aurea constitucionum imperialium atque legume seuillarumque ad electionem romanorum pertinent sive Regis ordinacionum. De mandato serenissimi principis domini Wenceslai Romanorum et Boemie Regis anno domini milesimo quadringentesimo." See Krása 1971, p. 256n78.

76. Hlaváčková 1993, pp. 371–82; Hlaváčková in Gordon, Monnas, and Elam 1997, pp. 223–31; Heger et al. 1998; Fingernagel 2003, p. 118.

77. Krása 1971, p. 29.

78. Ibid., pp. 37–38. That Wenceslas owned this manuscript is not universally accepted.

79. A "Bohemian Bible" with a luxury binding recorded in the collection of Emperor Maximilian I may have come from Wenceslas IV's collection as well (Krása 1971, p. 20).

80. Urbánek in Stloukal 1940, p. 152, cited in Thomas 1998, p. 46.

81. Alexander in Lavin and Plummer 1977, vol. 1, p. 28.

82. See Chadraba 1971.

83. Spěváček 1986, p. 382. Tycho Brahe, the famous astronomer at Rudolf II's court, was aware of the work of Šindel, finding the earlier astronomer's measurements more exact than his own. See Hadravová and Hadrava 2002, pp. 237ff.

84. Krása 1983a, p. 40. Krása also noted that a copy of the *Tacuina sanitatis* (Bibliothèque Nationale, Paris, nouv. Acq. Lat. 1673), a health handbook, contains notes in Czech. For information on the relationship between Wenceslas IV and Gian Galeazzo Visconti, see Hlaváček 2000, pp. 203–26.

85. Wenceslas had sold the hereditary title of duke of Milan to Gian Galeazzo Visconti in 1395, and the title of duke of Lombardy in 1396.

86. Krása 1983a, p. 13.

87. Vavřinec of Březová 1954.

88. Krása 1983a, p. 12.

89. Krása 1971, p. 59: "Anno dominimillesimo trecentesimo octoagesimo septimo finitur et completes liber iste, videlicet marchio Willehalmus. Illustrissimo principi et domino domino Wenceslao, Romanorum regi simper augusto et Boemie regi domino suo generosissimo."

90. See the Literary Encyclopedia entry by Gibbs: http://www. litencyc.com/php/sworks.php?rec=true&UID=14452.

91. Daňhelka 1950, p. 66. See also Všetečková 2001, p.149, fig. 55.

92. Tomek 1855–1901, vol. 2, p.187, cited in Všetečková 2001, p. 149: "[Wenceslaus rex] balneum situm sub castro nostro et ecclesia Wischegradensi, quod olim Chwalo ibidem pro tunc burggravius pro castro nostro Wissegradensi praedicto comparasse dinoscitur . . . Girae et Valentino balneatoribus de Clumina . . . pro 25 sxg. gr . . . vendidimus."

93. Říhová 1999, pp. 98–117.

94. Jan Hus criticized paintings depicting "orgiastic dancing of madwomen and dishonest nudists" (quoted by Stejskal in Poche 1983, p. 40).

95. According to Krása (1983a, p. 40), Wenceslas apparently purchased objects through Italian merchants, especially Pietro Picorani of Venice.

96. Neuwirth 1893, p. 60.

97. Jan Hus's explanation of the Ten Commandments critiques the secular themes that Prague's wealthy citizens had painted on the walls of their homes.

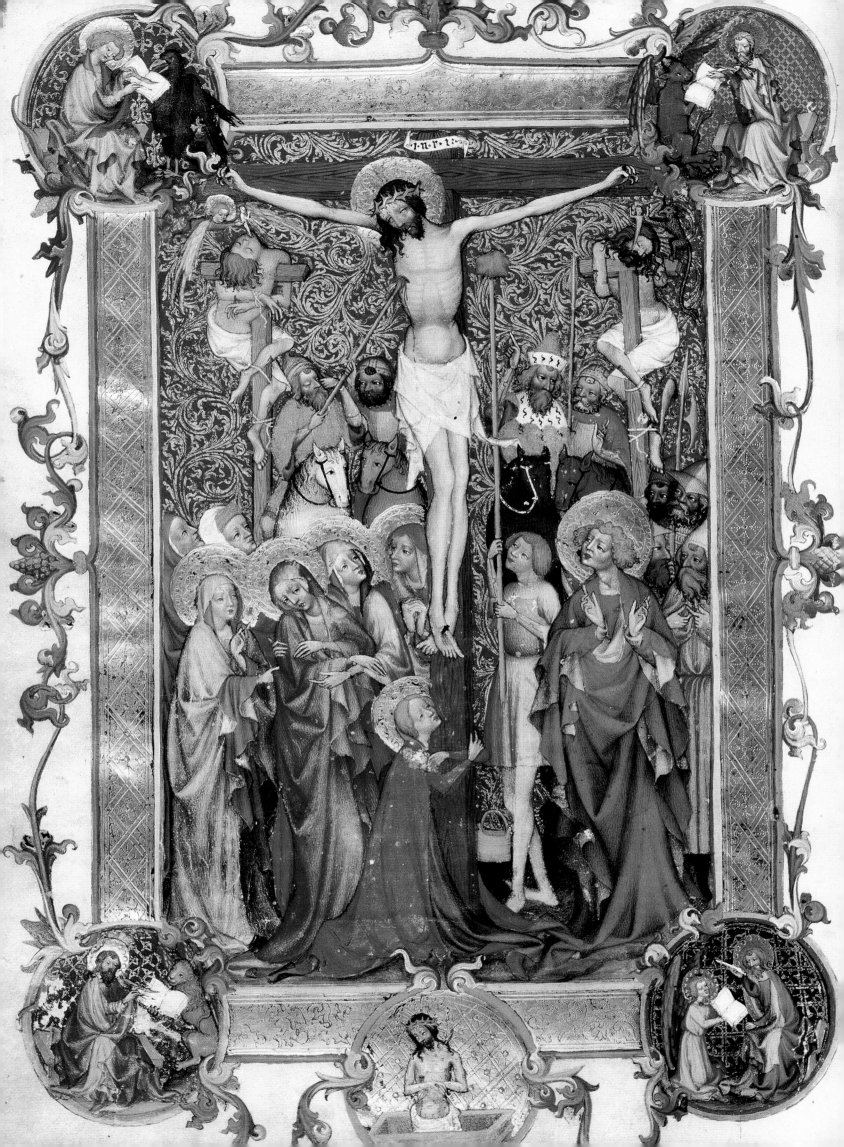

# The Beautiful Style

The unprecedented uniformity of the European art idiom at the turn of the fifteenth century did not
result from the triumph of one superior artistic system, which might have assured hegemony to a
single country; it was rather the fruit of a multisided exchange of ideas of diverse origin, the
astonishingly homogeneous end result of a decades-long dialogue in which now
the one, now the other, interlocutor was the giver. —Otto Pächt (1962)[1]

Gerhard Schmidt

More than forty years ago, Otto Pächt thus aptly described the emergence of the artistic phenomenon now generally referred to as the "International Style" or "International Gothic." Around 1400, art throughout Europe was distinguished from the altogether less refined, but more expressive, art of the preceding decades by a new gracefulness in its human figures, by the unreal, almost fairy-tale atmosphere in which these figures moved, by a drapery style that combined sculptural fullness with sinuous elegance, and by a distinct fondness for ornament and decorative effects.

Nevertheless, European art in the International Gothic style did not achieve complete uniformity. Deviations in regional styles are generally sufficiently apparent to permit experts to classify a given work from the period as either French, Italian, German, or Bohemian. Added to this are discrepancies that arose because artists in various locations faced differing tasks, new art techniques were introduced here and there, and the traditional themes of Christian iconography were being reformulated.[2] Bohemia appears to have been especially creative with respect to iconography. It produced the prototypes of the sculptures known in art history as the Beautiful Madonnas (Schönen Madonnen), characterized by lavishly draped cloaks and naked, thrashing infants, as well as the Pietàs in the Beautiful Style (Schönen Pietàs; see cats. 110–12), expressing Mary's sorrow over the

death of her son in a moving yet dignified manner.[3] Another regional specialty were half-figure paintings of the Virgin set in wide frames adorned with smaller-scale depictions of saints (cat. 91).[4]

Formal nuances from one region to another explain why the art of the period around 1400 was first described by different terms in the various European countries. In German-speaking lands, in a nod to what was perceived to be its chief characteristic, namely sumptuous drapery with voluminous folds, the designation "Weicher Stil" (Soft Style) was long in use, while in France the term "Style Courtois" (Courtly Style) emphasized the sociological aspect by identifying the principal patrons of such art. Only in Italy did the term "Gotico Internazionale" come to be accepted early on. In Bohemia, which experienced its greatest artistic flowering of the medieval period in the years around 1400, the prevalent term was "Krásný sloh" (Beautiful Style).[5] In this essay I hope to show that the last designation—quaint though it may seem—adequately distinguishes a specifically Bohemian variant of the International Gothic.

It is important to note that, just as the International Style was not as universal as its name suggests, Bohemia's Beautiful Style was anything but homogeneous. Among painters and sculptors in Prague alone, there was no such thing as a uniform artistic expression. This is most strikingly apparent in the divergent styles of the many illuminators employed there in the decoration of particularly opulent manuscripts (see especially cat. 85).[6] Their miniatures indicate that some had absorbed influences from western Europe, others German or Italian ones, all blending these with local traditions. From

Fig. 9.1 Hazmburk Master. Canon page. Missal of Zbyněk of Hazmburk, fol. 149v (detail). Tempera on parchment; Prague, 1409. Österreichische Nationalbibliothek, Vienna (Cod. 1844)

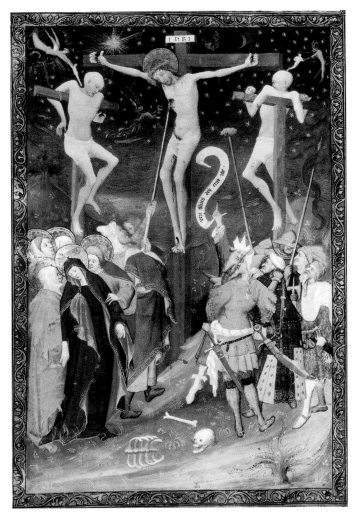

Fig. 9.2 Bedford Master. Canon page. Missal for the Church of Saint-Magloire, fol. 213A. Tempera on parchment; Paris, 1412. Bibliothèque de l'Arsenal, Paris (Ms. 623)

their works we can see how cross-fertilization between imported and native stylistic trends gradually brought about that variant of International Gothic that now strikes us as typically Bohemian and whose most exquisite products can quite rightly be identified as documents of a "beautiful" style. Anyone attempting to ascertain what is unique about this style is well advised to compare specific examples with characteristic works of art from other parts of Europe. For this purpose, I have selected four outstanding monuments of Bohemian art: a miniature, two sculptures, and a drawing.

At the beginning of the fifteenth century, an unusually large number of excellent illuminators were working in Prague, but none is thoroughly documented. Two stand out above the rest of their colleagues: the Joshua Master of the Konrad of Vechta Bible and the Master of the Hazmburk Missal.[7] While the former worked in a cosmopolitan style enriched by Italian and French influences, the latter held to an essentially local tradition, which had already attained the level of the Beautiful Style in many panel paintings of

the late fourteenth century such as the late work of the Master of Třeboň (cat. 97) and the Master of the Jeřen Epitaph. The greatest and most important miniature by the Hazmburk Master is the canon page for a missal created in 1409 for Prague's archbishop, Zbyněk of Hazmburk (fig. 9.1). It thus falls in the artist's middle period, for his surviving works appear to have been produced between roughly 1403 and 1415.

Most canon pages painted in Bohemia at that time depict the crucified Christ flanked by the sorrowing figures of Mary and John, but this miniature by the Hazmburk Master also draws upon an iconographic type featuring a crowd assembled on Calvary, which was first developed in panel painting over the course of the fourteenth century. The illuminator made certain obvious borrowings from that type: some of his figures (the two thieves with their contorted limbs and Mary Magdalen embracing the foot of the cross) must have been copied from a panel painting similar to the Kaufmann Crucifixion (cat. 1).[8] Such quotations are limited to only a few figural motifs, however; in its formal idiom the miniature is a typical example of Bohemia's Beautiful Style. It is therefore instructive to compare it to the canon page from a French missal executed in 1412 and convincingly attributed to the Master of the Bedford Book of Hours (fig. 9.2).[9]

In both pictures Jesus' cross is flanked by two groups of figures, the crosses of the two thieves rising above them. With the exception of minor details, the members of these groups—dominated on the left by the friends of Jesus, and on the right by his persecutors—are equally distributed. In the French page Mary Magdalen does not kneel at the foot of the cross, and in the Bohemian one John, who in the French work supports the swooning Virgin, stands apart from her. As in earlier three-figure crucifixions, he appears alone and prominently on the right.

A much more important difference between the two miniatures is the treatment of the picture space. In the French manuscript the viewer's eye is led step by step into the distance—from a diagonal climbing path and strip of grass in the foregound to the crosses and figural groupings in a middle space, and from there to the line of hills on the horizon, above which arches a starry sky. By contrast, the only indication of the Hazmburk Master's interest in rendering a third dimension is that the two groups of horsemen flanking the cross are depicted in a distinctly smaller scale than the foreground figures, who are lined up parallel to the picture plane and stand on the very bottom edge of the frame. There is no trace of landscape or sky, the firmament being replaced by a tapestry design of entwined golden vines.

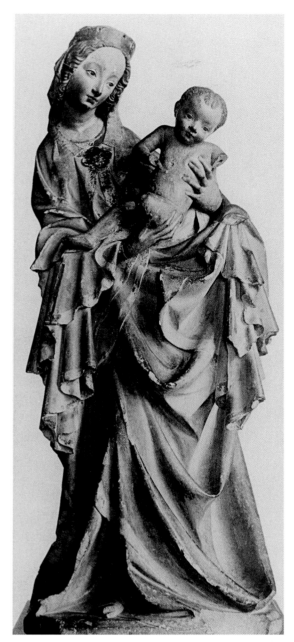

Fig. 9.3 Virgin and Child. From Krumlov. Limestone, ca. 1400. Kunsthistorisches Museum, Vienna

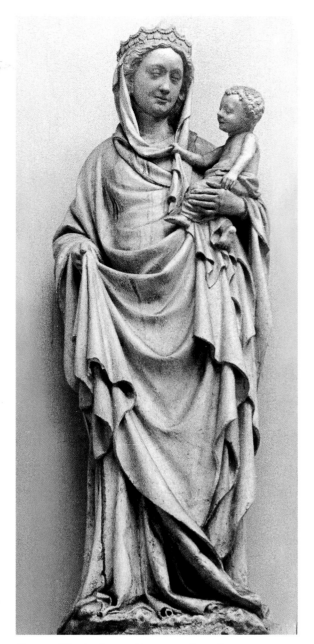

Fig. 9.4 Virgin. Stone; France, early 15th century. Sainte-Chapelle, Châteaudun, France

That the Bohemian illuminator was unconcerned about more precise spatial relationships is equally evident in the poses of his figures and their relation to the viewer. The chief figures—Jesus, Mary, and John—present themselves en face, the secondary ones at most in half-profile. The poses of the Bedford Master's figures, by contrast, are much more varied. A number are seen from the side, and some even from the back. Accordingly, his composition is considerably more dramatic than the Hazmburk Master's, which seems more solemn and ceremonial. This difference is also evident in details—Mary's swoon, for example, is much more convincingly depicted in the Paris version, and the gestures of the Prague John suggest pious transport rather than sorrow.

Another, by no means unimportant, difference between the two canon pages relates to palette. In the Bedford Master's miniature, the only bright accent is found in the group around the swooning Mary, where dark blue, vermilion, and a bit of green play off each other. Elsewhere the tones are muted and often appear faded. The Hazmburk Master, on the other hand, uses jewel-like, glowing colors throughout: ultramarine, carmine red, vermilion, and a radiant emerald green. Along with the abundant gold leaf, these give his miniature, for all its unreality, an uncommon richness.

Finally, the Hazmburk Master's fondness for decorative effect is further manifested in the luxurious and complex drapery with which he hides the bodies of his most

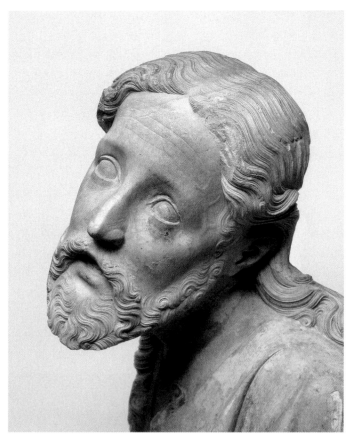

Fig. 9.5 Bohemian artist. Christ on the Mount of Olives (detail of cat. 109). Limestone; Toruń, ca. 1400. Malbork Castle Museum (MZM/RZ/19)

Fig. 9.6 Angel of the Annunciation (detail). Marble; Florence, 1397. Museo dell'Opera del Duomo, Florence

prominent figures. In each case the viewer is presented with a cascade of sumptuous V-shaped folds flanked by clusters of vertical ones, across which fall the sinuous lines of hems. This system of drapery is a prime characteristic of works in the Beautiful Style. We encounter it in identical, or only slightly divergent, form not only in the majority of paintings produced in Bohemia around 1400 but also in the best works of sculpture (see, for example, cat. 106). The Beautiful Madonna from Krumlov serves as a prime example (fig. 9.3). A comparison of that statue with the roughly contemporary Virgin and Child in the Sainte-Chapelle at Châteaudun (fig. 9.4) reveals certain similarities that can be identified as features of the period style—above all the very similar draping of the Virgins' mantles.[10] But the differences are far more striking.

As in my comparison of the two Crucifixion miniatures, the French work here strikes me as being closer to nature, the Bohemian more artful and sophisticated. In the Châteaudun Virgin it is possible to discern the volumes and curves of the body; the folds of her cloak are arranged more logically and sparingly than those of her Bohemian sister. The latter hang like a curtain, beneath which one can sense the graceful curve of Mary's body but cannot fully comprehend its

volumes. The expressivity of the two Virgins differs just as clearly as their forms. The French one is radiant in her serene maternity, while the Bohemian appears to be captured in a transient movement. Her extremely lively, naked infant is pulling away from her, and she compensates with a graceful bend of her torso to the other side. It is this anecdotal motif that occasions the figure's unusually expressive outline, which combines with the dynamic flow of her drapery and its delicately rippling hems to result in a polyphonic interplay of lines and volumes. Yet, although the statue has a definite depth, from the front we perceive it as a mere relief, more ornamental than descriptive of a figure.

This same ornamental quality, deriving from the subtle interplay of linear and plastic elements, can also be seen in a technical detail of Bohemian sculptures in the Beautiful Style, namely, the carving of hair and beards. The compact mass of hair on the head of the magnificent Christ on the Mount of Olives in Malbork is structured with wavy, curving lines (fig. 9.5);[11] below it the shorter hair on the temples and cheeks curls into a snail-shaped, distinctly graphic ornament. In the beard the strands of hair once again become thicker, but again they follow this ornamental pattern.[12]

Fig. 9.7 Claus Sluter (ca. 1350–1406). Crucifixion from the Moses Fountain, Dijon (detail). Stone, 1399. Musée Archéologique, Dijon

Fig. 9.8 Angel of the Annunciation. Silverpoint; Bohemia, ca. 1400. Harvard University Art Museums, Cambridge, Massachusetts (1947.80)

It is instructive to compare this head of Jesus with contemporary ones in Italian and French sculpture. The hair of a Florentine Angel of the Annunciation (fig. 9.6)[13] consists of numerous loosely undulating strands; although relatively thin, these have a material density that in no way corresponds to the quality of human hair. The Italian artist was primarily concerned with translating the natural phenomenon of "curly hair" into a sculptural formula. The Netherlandish sculptor Claus Sluter, working in Burgundy, solved the same artistic challenge in a wholly different way (fig. 9.7).[14] The hair and beard of his crucified Christ are perceived as a soft mass modeled only on the surface and suggesting, above all, the tactile quality of real hair. Each of the three artists thus perceived a different aspect of the same material as artistically relevant, and it is doubtless no coincidence that the representative of Bohemia's Beautiful Style primarily recognized the hair's ornamental potential and chose to emphasize it in his work.

Bohemian drawings from the period about 1400 reveal the same priority. The lovely head of an Angel of the Annunciation at Harvard (fig. 9.8) shows that its creator was also fascinated by the possibility of turning curly hair into ornament. A fruitful comparison is provided by the roughly

contemporary drawings from a French sketchbook in the Pierpont Morgan Library (M.346).[15] The contrast between them and this angel is much like that between Sluter's crucified Christ and the Bohemian Christ on the Mount of Olives. In the French drawing the most delicate of strokes characterize the dense hair of a wild man (fig. 9.9) as a gossamer substance; once again the artist has appealed more to the viewer's sense of touch than to his or her eye. At the same time, this head is so convincingly modeled by means of soft but dark shadows that the head of the Bohemian angel strikes one as flat and insubstantial by comparison. It is significant that in the latter the strongest shadows are found precisely in those spots that most clearly caught the draftsman's interest, namely, the clumps of hair transformed into ornament at the base of the angel's neck.

From these few examples I have attempted to extract three essential qualities of Bohemia's Beautiful Style. First, a preference for surface decoration over spatial definition. This is evident both in painting (fig. 9.1) and in the frontal views of sculptures (fig. 9.3). Second, a high degree of autonomy in linear design elements, the result being that natural phenomena such as human hair or the draping of fabric are subjected to a quasi-calligraphic metamorphosis,

Fig. 9.9 Jacquemart de Hesdin (active 1384–1409). Wild man from a sketchbook. Silverpoint on boxwood; France, late 14th century. Pierpont Morgan Library, New York (M.346, fol. 3v)

and in this way brought closer to ornament (figs. 9.5, 9.8). Ornament as such plays a particularly important role in the art of the Beautiful Style, especially in illumination (fig. 9.1). Whether as complex scrollwork filling the margins of manuscript pages, as filigree patterns in the backgrounds of pictures, or as engraved and punched designs on gilded surfaces, it gives miniatures an aura of extraordinary splendor. The last essential quality of the style is a perceptible restraint in the depiction of dramatic situations or strong emotions. Expressive gestures are softened or avoided: pain and despair are transformed into quiet grief or humble subjection to the will of God (fig. 9.5). To that end, even gruesome scenes are seen to take place in a surprisingly peaceful and relaxed atmosphere.

The four works considered here do not represent the entire spectrum of artistic production in Bohemia in the years around 1400, but they at least represent dominant trends. There are countless other works one might analyze to reach quite similar conclusions. Instead of the Beautiful Madonna from Krumlov, we could have studied her sisters in Pilsen (Saint Bartholomew's Church), Šternberk (cat. 106), and Vimperk (Saint George's Church) or the Saint Catherine in Jihlava (Saint James's Church), and stylistic principles matching those of the Hazmburk Master can be observed just as well in the work of the Joshua Master of the Vechta Bible. In the illustrations that the Joshua Master contributed to the Gerona Martyrology (cat. 86) about 1410 the torturing of saints is depicted with almost dancelike movements, which fit nicely into the roundels of his small, relatively flat compositions (fig. 9.10).

In short, Bohemia's Beautiful Style proves to be an art that translates earthly reality into uncommonly refined and idealized forms. The primary subjects of medieval art,

including the Passion of Christ and the exemplary lives of the Virgin and saints, are always—even in their bleakest or most tragic moments—suffused with a human light. Well suited to that end was a formal vocabulary intended more to delight the eye than to stir the emotions. It would nevertheless be incorrect to accuse the representatives of the Beautiful Style of superficiality, to imply that they were lacking in religious fervor. Indeed, to the present-day viewer, they may appear to be imbued with a piety that is as naive and full of trust in God's grace as the bedtime prayer of a child.

To the historian mindful of the political and religious situation in Bohemia at the close of the fourteenth century, the ingenuous charm of the Beautiful Style cannot but seem puzzling. King Wenceslas IV (r. 1378–1419) was a luckless ruler of whose character the sources paint an unfavorable picture. The authority of the Church had been weakened by the Great Schism (1378–1417) and was being even further questioned by the reformist ideas of Jan Hus, who lectured at the University of Prague from 1398. Such religious controversies, heightened by social ills and by tensions between Czechs and Germans, ultimately led to the Hussite Revolution (1419–36).

Against such a background one might have expected the development of a pessimistic art that reflected the issues and crises of the era. This sort of art appeared in Bohemia only later—beginning roughly in the 1420s, by which time the International Gothic had ceased to dominate in the rest of Europe as well. But at the beginning of the century, Bohemian artists and their patrons appear to have considered Christ's sacrifice and the suffering of the martyrs primarily as guarantees of humanity's salvation. That belief in turn engendered not only pious compassion but also joyous

confidence. Just as the Beautiful Madonnas exhibit both charm and dignity, contemporary paintings present even dramatic episodes in a serene tonality. It seems as if works in the Beautiful Style, precisely because of their gracefulness and harmony, were perceived as remedies against the widespread spiritual unrest of the era.

1. Pächt in Vienna 1962, p. 53: "Die beispiellose Vereinheitlichung der europäischen Kunstsprache an der Wende vom 14. zum 15. Jahrhundert war nicht das Ergebnis des Triumphes eines überlegenen künstlerischen Systems, das einem einzigen Land die Hegemonie gesichert hätte; sie war die Frucht eines vielseitigen Austausches künstlerischer Ideen verschiedenen Ursprungs, das überraschend homogene Endresultat eines viele Jahrzehnte währenden Wechselgesprächs, in dem bald der eine, bald der andere Partner der gebende Teil war."

2. In Tuscany, for example, bronze casting was revived about 1400, while Paris became famous for its small sculptures *en or émaillé* (in enameled gold). Also in France a new iconographic formula for the depiction of the Trinity was created with the *Pitié de Notre Seigneur* (Compassion of Our Lord), which showed God the Father holding his dead son in his arms.

3. See Kutal 1972 and Schmidt 1977a.

4. For examples, see Matějček and Pešina 1950, pls. 120 (Ara Coeli Madonna), 149 (Budějovice Madonna).

5. This usage was presumably suggested by Wilhelm Pinder's use of the term "Beautiful Madonnas" (1923) for a statue type widespread in Europe about 1400. In Czech scholarly literature the term "Beautiful Style" may have been introduced by Pečírka (1933, p. 32). Since the exhibition "Die Parler und der Schöne Stil" (Cologne 1978–79), it has also become accepted in German-speaking countries.

6. For the Wenceslas Bible, see figs. 84.2–84.7.

7. For these two artists, see Schmidt 1977, pp. 65–68.

8. See Matějček and Pešina 1950, pls. 33–36. This panel was painted as early as the 1340s; its place of origin (Bohemia or Austria) is now disputed.

9. Bibliothèque de l'Arsenal, Paris, Ms. 623. The manuscript was destined for the Church of Saint-Magloire, Paris. See Paris 2004, no. 182.

10. For French statues that can in many respects be considered counterparts to the Beautiful Madonnas of Bohemia, see Didier and Recht 1980 and Paris 2004, pp. 324–25, nos. 129, 208–12; for the Châteaudun Madonna, see ibid., no. 215.

11. Schmidt 1992, pp. 282–87.

12. The hair and beard of the deceased Jesus are stylized very similarly in many of the "Beautiful Pietàs." See especially cat. 110.

13. The Annunciation group was intended for the Porta della Mandorla of the Cathedral of Santa Maria del Fiore and was presumably executed about 1397. Who the sculptor was is a matter of debate: Jacopo della Quercia and Giovanni d'Ambrogio have both been suggested, along with various other artists.

14. The fragment comes from the so-called Moses Fountain in the Great Cloister of the Charterhouse at Champmol. The crucifix was completed in 1399; see Morand 1991, pp. 335–36.

15. The drawings are convincingly attributed to Jacquemart de Hesdin, a painter in the service of the duke of Berry. See Pächt 1956, pp. 144–60.

Fig. 9.10 Joshua Master. Martyrdom of Saint Dula. Gerona Martyrology (cat. 86), fol. 34v (detail). Tempera, gold, and silver on parchment; Prague, ca. 1410. Museo Diocesano de Gerona, Spain (M.D. 273)

Dauid pobil osm set muziuo[r]
sedmem napadem

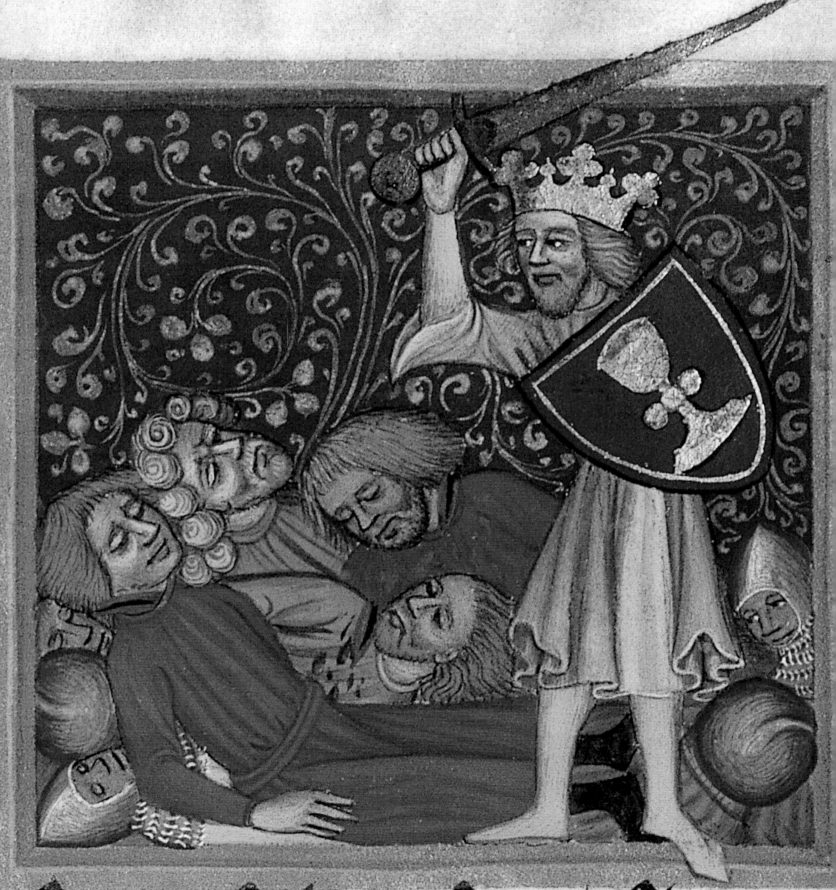

oknuwe ßadrnako mekda na

# The Hussite Revolution and Sacred Art

*Images of our Savior and of his sayings, . . . the ringing of bells, and various customs long observed in the Holy church that comply with God's law should not in Christian law be forsaken, but should be suffered and observed.* —Charles University Decree (January 25, 1417)[1]

Jan Royt

The rule of the Luxembourg dynasty in the kingdom of Bohemia created optimal conditions for the flourishing of the visual arts. As early as the final years of Charles IV's reign, however, the first symptoms appeared of the political and religious turmoil that would fully unfold during the reign of his son Wenceslas IV, who would gradually lose his political standing both within the Holy Roman Empire and in the kingdom of Bohemia. Wenceslas's position was undermined by quarrels with the nobility and with the archbishop of Prague, Jan of Jenštejn, as well as by crises within the papacy. In the universities, voices emerged professing the need for change. Early reformers such as Konrád Waldhauser and Jan Milíč of Kroměříž were critical of the fiscal policy of the Papal Curia and also appealed for a deeper spirituality. Eschatological tendencies gained strength, as some warned of the coming of the Antichrist. Also much criticized were the lavish decoration of churches, the portrayal of abstruse religious subjects, and even the very presence of art in sacred spaces.

One of the first to express strong reservations toward painting was the Prague reformer Matěj of Janov. He stated his views in his treatise *Rules of the Old and New Testament* (*Regulae Veteris et Novi Testamenti*), probably written as early as 1388,[2] as well as in his Czech-language sermons in the Church of Saint Nicholas.[3] According to Matěj, paintings were "dead and lifeless"[4] things, and people should not be made to believe that God performed miracles through them. He considered the cult of painting to be a "human invention,"[5] if not perhaps even a creation of the Antichrist himself, and in appeals of 1389 and 1392 advocated the removal of images toward which undue respect was shown.[6] On the other hand, Matěj favored the "reasonable use of images in churches"[7] for the edification of the laity.

The role of visual images during the reign of Wenceslas IV, the Hussite Revolution, and the brief rule of Sigismund of Luxembourg—roughly the period 1378–1437—has been written about extensively.[8] Nevertheless, recent research suggests the need for an assessment of the actual function of such images, as well as of contemporary opinion about them. The surviving art makes clear that iconoclasm was not predominant in the society at large, even though Wenceslas IV was much criticized at the Council of Constance in 1416 for not punishing "the destroyers of holy images, but rather agreeing with them."[9] During the Hussite Revolution, in spite of the loss of contact with major artistic centers, artistic production was not altogether disrupted. In Prague especially, moderate Hussites were patrons of art; extant works from the southern Bohemian estates of the lords of Jindřichův Hradec and the Rožmberks (for instance, the Madonnas of Hroby and Choustnik) also testify to the same phenomenon. Although many artists left Prague, incomplete sources indicate that twenty-eight painters and eight illuminators worked there during the critical years 1422–43. They not only decorated shields and signboards[10] but also created a number of altars, images of the Virgin Mary, and illuminated manuscripts. In those parts

Fig. 10.1 David and Goliath. Krumlov Anthology, fol. 18v (detail). Tempera and gold on parchment; Prague, 1420. Národní Muzeum, Prague, Library (III B 10)

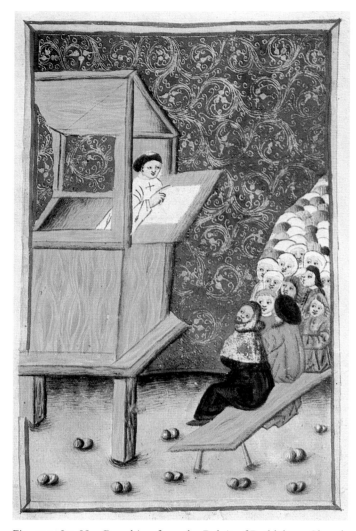

Fig. 10.2 Jan Hus Preaching from the Pulpit of Bethlehem Chapel. Jena Codex, fol. 37v. Tempera and gold on parchment, Bohemia, ca. 1500. Národní Muzeum, Prague, Library (IV B 24)

of the Bohemian lands that remained loyal to Sigismund, such as Moravia and Silesia, hardly any instances of iconoclasm can be found; on the contrary, certain forms of pictorial anti-Hussite propaganda evolved, particularly in Silesia.[11]

Opinions about the role of visual imagery differed among reformist Hussites. As in any revolutionary movement, mobs and soldiers engaged in looting and vandalism without regard for ideology but out of social envy or greed. During the pillaging and destruction of the Cistercian monastery in Zbraslav, a mob even desecrated the recently buried body of Wenceslas IV. This essay is principally concerned, however, with the intellectual sources of iconoclasm and the nature of their critique. One can scarcely view as iconoclasts reformers who objected to certain subject matter deemed unsuitable for holy places, to the popular faith in the miraculous power of images, or to inappropriate "worldly" forms of art (a criticism of the Beautiful Style). These objections are quite close to those of Saint Bernard

of Clairvaux, the twelfth-century founder of the Cistercian order, who was quoted by many of the critics, including Jan Hus, the Prague cleric who emerged as the standard-bearer of the eponymous reform movement in Bohemia. The same critics accepted the long-standing notion that paintings served to instruct the laity, as had the English reformer John Wycliffe.[12] This view was also held by Prague University lecturers Master Stanislav of Znojmo, Štěpán of Páleč, and Křišťan of Prachatice, and in particular by Hus. In the University Decree of January 25, 1417, there is this defense of the use of images: "Images of our Savior and of his sayings . . . that comply with God's law should not in Christian law be forsaken, but should be suffered and observed."[13]

Moderates from Prague and from Tábor (in southern Bohemia), the two rival urban centers of reform, met in the capital on December 10, 1420, in an attempt to settle their differences. The Praguers voiced their concern that, out of a misguided love of God, the Taborites abided by the Jewish custom of rejecting images. In his treatise *Antihus* of 1414, Štěpán of Páleč entered into the iconoclastic controversy, arguing that churches, statues, and paintings were essential.[14] Furthermore, about 1436, an adherent of the Prague University faculty most probably commissioned a Latin anthology of treatises[15] citing Wycliffe and others on the necessity of images. Those who disagreed with the iconoclasts were aware of the consequences and therefore hid valuable paintings, manuscripts, and holy relics, either in secure castles (such as Karlštejn or Rábí) or abroad (for instance, the Augustinians of Roudnice sent objects to Kraków). The Old Chronicles of Czech Lands relates that paintings and sculptures were returned to the altars in 1436, immediately after the end of the Hussite Revolution.[16]

Hus published his fundamental views on art in his treatise *Exposition of the Faith, the Decalogue, and the "Our Father"* (*Výklad viery, desatera božieho přikázanie a modlitby Páně*, 1412).[17] To support his sympathetic attitude regarding art within sacred spaces, he evoked Saint Gregory the Great: "For paintings are in churches, so that those who do not know writing could at least look and read on the wall what they cannot read in books."[18] The Bethlehem Chapel in Prague, where Hus preached from 1402 to 1412, was decorated with biblical and typological subjects (figs. 10.2, 10.3).[19] Warning against the worship of images, Hus stressed that neither should "paintings be condemned" or destroyed for this reason: "It is a pity to destroy a painting, just as it is to destroy a valuable book."[20] Yet, he feared the influence of art on the viewer: "and so should we diligently keep simple and bovine folk away from images and the playing of the organ . . . as a simple man thus wastes all his time in church,

and moreover upon coming home continues for the entire day to speak only of this, and nothing of God."[21] Similar to Bernard of Clairvaux in the *Apologia to the Abbot William* (*Apologia ad Guillelmum abbatem,* 1124),[22] Hus focused his criticism on the improper subject matter that was, in his opinion, to be found in the art of the court of Wenceslas IV: "But alas! Instead of the Martyrdom of Christ they now paint the Battle of Troy! And instead of the apostles they paint merely soldiers, and instead of communion with Christ they paint the life of Najthart, and instead of the martyrdom of holy virgins they paint the frolicking of foolish maidens and unchaste nudes, and men of strange and unnatural constitution."[23] Apart from testifying to Hus's attentiveness to contemporary art, these words attest to the existence of certain themes that have not survived in Prague but have in other locations in central Europe. His mention, for instance, of the "life of Najthart" proves that there were frescoes in Prague inspired by the work of the great medieval minnesinger Neidhart von Reuenthal.[24] An idea of their appearance can be obtained from a mural from about 1400 in the festival hall of a house in Tuchlauben Street in Vienna.[25] Hus and Jakoubek of Stříbro frequently criticized depictions of the Virgin Mary and holy virgins with pretty features, sensuous poses, and fashionable attire that accentuated their curves (see, for example, cat. 121), Jakoubek having written that "images of beautiful virgins arouse lust in men."[26]

Matěj of Janov, and then Jakub Matěj of Kaplice, espoused similar and even more radical iconoclastic positions, placing reverence for the Eucharist before the veneration of images, as indicated in a document of Pope Boniface IX dated December 13, 1390.[27] Jakoubek delivered a crucial sermon promoting iconoclasm on January 31, 1417.[28] He preached that artistic images (*imago artificialis*) occupied the lowest stage within the genre of all images (*infinum genus*) and were merely a religious custom, not derived from Holy Scripture. Appealing first to the king and then to the people to remove such images from churches if they obscured reverence for the Eucharist, Jakoubek also argued that a stone tabernacle be substituted for a painted altar to better ensure the safekeeping of the consecrated Host.

Still, even Jakoubek was not a consistent iconoclast, allowing a limited number of images in churches to serve for the edification of the laity. He did not question the authenticity of the *vera icon,* or true image of the face of Jesus (see, for instance, cats. 137, 149), but considered implausible the legend that the original image of the Virgin was painted from life by Saint Luke.[29] Jakoubek's remark that "today both whoremongers and hooded monks will play at

Fig. 10.3  Bethlehem Chapel, Prague

puppets and pegs"[30] probably referred to theatrical performances in churches, as when statues of Jesus mounted on a donkey were towed into the church on Palm Sunday as a reference to the Entrance into Jerusalem.

Unlike Jakoubek, the Englishman Peter Payne, a follower of Wycliffe who came to Prague in the Hussite era,[31] and the more Waldensian Nikolaus of Dresden condemned all images on principle. Nikolaus summed up his radical views in the treatise *On Images* (*De ymaginibus*),[32] but even he took advantage of their propagandist function. At his urging, in 1412–14, students in Prague carried painted panels contrasting Jesus' austerity with the profligacy of the Church hierarchy, particularly the pope, who was identified as a veritable Antichrist.[33] Similar cycles adorned the walls of the houses of Prague burghers (for instance, the house "U černé růže" at Na Příkopě). Illuminations in the so-called Jena Codex (see fig. 10.2)[34] and the Göttingen Codex[35] provide some idea of the appearance of such works. Among other Prague radicals was the preacher at the Church of Our Lady

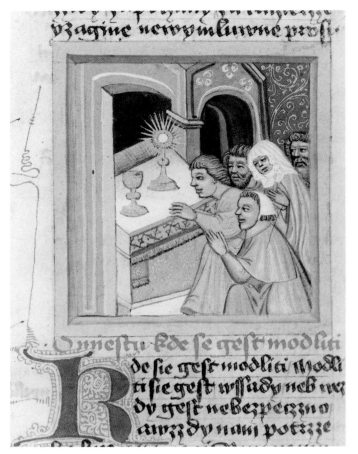

Fig. 10.4 The Faithful at the Altar. Krumlov Anthology, fol. 164 (detail). Tempera and gold on parchment; Prague, 1420. Národní Muzeum, Prague, Library (III B 10)

of the Snows, Jan Želivský; it was probably he who, on July 21, 1421, urged the citizens of Prague to destroy the furnishings of Saint Vitus.[36] In the so-called Controversies between Prague and Kutná Hora (1420),[37] these radical iconoclasts from Prague argued with representatives of Kutná Hora that God himself had forbidden the worship of images in the Old Testament, that this form of worship had no basis in Scripture, and that it was better to destroy images made for money than people, the living images of God. Among their arguments were that Charles IV had had gold removed from the paintings in Karlštejn and that Sigismund had taken reliquaries from the treasury of Saint Vitus. A more ambiguous view was held by Jeroným of Prague. Although accused of having desecrated a crucifix in Prague, he admitted during his interrogation in Constance[38] that his house in Prague contained frescoed portraits of "doctors of philosophy," including Wycliffe.

Hussite priests in Tábor were the most strident iconoclasts, as can be seen from their demand on August 5, 1420, that the citizens of Prague "tear down and uproot heretical monasteries, unnecessary churches, and altar paintings, as well as those paintings secretly hidden."[39] Radical elements in the city, heeding their call, replaced a number of their

paintings and statues with stone tabernacles for the Eucharist.[40] (These were later destroyed as symbols of the Hussite movement by Sigismund's troops.) On the other hand, some Tábor priests and captains commissioned luxury manuscripts of the Scriptures. The priest Václav Koranda attests that he owned an illuminated Bible that "cost many a threescore."[41] Another splendid one (Österreichische Nationalbibliothek, Vienna, Cod. 1175) was obtained by the radical Hussite captain Filip of Paděřov.[42] In these manuscripts, traditional subjects appear alongside Hussite themes, primarily veneration of the Eucharist and references to Holy Communion under both species (*sub utraque specie*), which moderate Hussites, known as Utraquists, advocated should be given to the faithful, not just to priests, as was then the custom.

The eucharistic chalice became the most recognized symbol of Hussitism;[43] more rare was the emblem of the goose (from the Czech *husa,* and thus a symbol of Jan Hus) found on the banners of Hussite armies.[44] A more complex motif appears in an illumination in the so-called Krumlov Anthology (fig. 10.4),[45] in which worshipers adore a chalice containing the Blood of the Lord and a sun-shaped monstrance within a tabernacle. According to literary sources, many of the small devotional images of the suffering Jesus referred to the sacrament of the Eucharist as practiced in pre-Hussite and Hussite Bohemia.[46] This motif cannot be connected only with the Utraquists of the Hussite movement, since it also commonly appears in historical contexts unfavorable to the Hussites. The theme of Hussite warriors miraculously victorious with the help of God was symbolized by certain Old Testament stories, especially that of King David. In one illumination in the Krumlov Anthology (fig. 10.1), the shield of David bears the image of a large chalice. An illustration in a manuscript of the Old Testament in Czech (Národní Knihovna, Prague, XVII A 34, fol. 115r) alludes to the struggle between the Hussites and the Crusaders.[47]

Soon after his burning at the stake in Constance in 1415, Hus came to be regarded as a holy martyr throughout Bohemia. Anticipating this, his judges had ordered the destruction of anything that could be construed as a relic. Petr of Mladoňovice recounts in his *Report (Zpráva)*[48] that Hus's shoes and clothes were thrown into the fire; his ashes were dropped in the Rhone, according to the chronicle of Ulrich von Richenthal (ca. 1420; fig. 10.5), a contemporary eyewitness.[49] Yet the Czech disciples of Hus, as Eneas Silvio Piccolomini writes in his *Czech History (Historie česká)* of 1458,[50] took soil from the site of execution and carried it back to their home. The cult of Hus emerged soon after

the news of his death reached Bohemia. According to Štěpán, the prior of Dolany prison,[51] funeral services commemorating him as a holy martyr were held in Prague's celebrated Bethlehem Chapel (fig. 10.3). (Given his strongly negative attitude toward the Hussites, Štěpán's report has to be viewed with some reservation.)

After the burning at the stake of Jeroným of Prague in 1416, Jakoubek of Stříbro delivered a sermon in the Bethlehem Chapel about the "seven martyrs": Hus; Jeroným; three youths killed in Prague during the 1412 riots against the promulgation of indulgences;[52] and two disciples of Hus executed at Olomouc in 1415.[53] Jakoubek called Hus "the Knight of Christ," and probably for the first time hymns for the "holiday of the Czech martyrs" were sung during the Mass. The affidavit of the Olomouc Chapter[54] to the Council of Constance states that Hus and Jeroným had been compared to Saint Lawrence and placed above Saint Peter and other saints. This depiction of Hus as a martyr is a prominent feature of fifteenth-century Czech iconography. That he was portrayed as such in churches under the care of Hussite priests soon after his death is known from the complaint of the Council of Constance to Sigismund, stating that the Czechs represented Hus and Jeroným by "painting them within chapels as though beatified."[55] Those who commissioned such paintings followed the convention of depicting a cycle of episodes from the saint's miracles and martyrdom.

The oldest portrayal of Hus's martyrdom occurs in the so-called Martinice Bible (cat. 135), dating from about 1430.[56] Hus, at the stake, is being adored as a martyr by a male figure holding a book and dressed as a university master. This is most probably the commissioner of the manuscript, Petr of Mladoňovice, who witnessed Hus's death and whose Report was, according to Veleslavín's *Historical Calendar* (*Kalendář hystorický*) of 1590, "being read each year in the churches"[57] as late as the end of the sixteenth century. Of a rather more illustrative nature are the drawings found in all six surviving manuscripts of Richenthal's Chronicle.[58] Probably the oldest, the so-called Aulendorf Manuscript of about 1423 shows some of the stages of Hus's execution (fols. 135–139). In the first illustration, Hus, clad in monastic garb, is defrocked by two bishops. In the second,

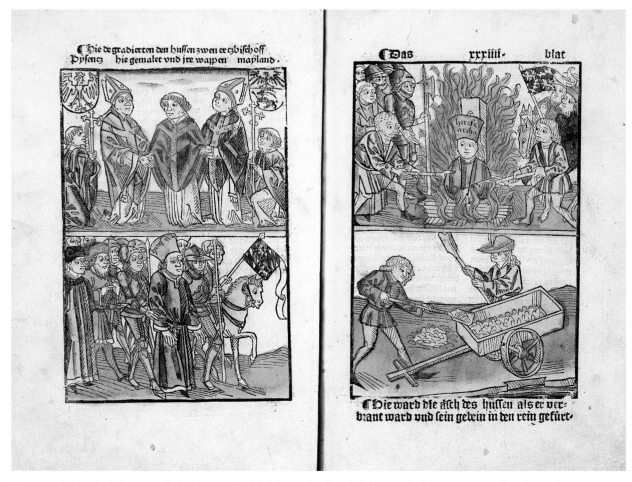

Fig. 10.5 *Chronicle of the Council of Constance,* by Ulrich von Richenthal (ca. 1420), fols. 33v–34r. Colored woodcut on paper, 1465. University of Kansas, Lawrence, Kenneth Spencer Research Library (Incun. 1483.R5)

he is dressed in black and wears a heretic's crown adorned with two devils as he is led to the stake by the bailiffs.[59] The third illustration portrays Hus walking toward the place of execution; in the fourth he is already tied to the stake. The fifth depicts two men loading the remains of the stake onto a cart. Similar illustrated motifs are encountered in other manuscripts and in later printed versions of Richenthal's Chronicle (fig. 10.5).

The cult of Hus remained strong throughout the mid-fifteenth century. At the Council of Basel on August 11, 1433, the Hussite spokesman Martin Lupáč reported on the popular reverence for Hus in Bohemia, which the legates of the council had personally witnessed on July 6 in Prague.[60] Gradually, to commemorate his martyrdom, texts were created both for the Mass and the Daily Office.[61] It is not clear whether Jan Rokycan, the elected but unordained archbishop of Prague, celebrated Hus's feast day during his term in Prague. It appears that pressure from Emperor Sigismund and the legates of the Council prevented him from doing so and that he observed the feast day only after his flight to Hradec Králové.[62] The veneration of Hus and Jeroným as martyrs, or "men of sacred memory," who were to the Bohemians "no less than Peter and Paul are to the Romans," is referred to in Piccolomini's account.[63] Its Czech translation

by Mikuláš Konáč of Hodíštkov, who revised some anti-Hussite passages, included a woodcut portraying the execution of Hus. At the beginning of his Chronicle, Mikuláš Biskupec of Pelhřimov also refers to Hus as a man of "sacred memory."[64] After the mid-fifteenth century there are, among the Utraquists, altarpieces showing Hus as a martyr, the oldest being a wing of the Roudník Altar (1460–70; now in the collection of the Bishopric of Litoměřice). Hus's death is there likened to the martyrdom of Saint Sebastian, ordered by Emperor Diocletian, a ruthless persecutor of Christians; the allusion is clearly to Emperor Sigisimund, considered by Hussites and later by Utraquists as an enemy of the "true faith."

The Hussite Revolution partially disrupted artistic links between Bohemia (and, to a lesser degree, Silesia and Moravia) and the important European artistic centers, in which Franco-Flemish painting flourished. Artistic production slowly declined, and the Beautiful Style began to stagnate. While iconoclasm was a feature of the Hussite movement, images nonetheless often served as a medium for reformist thought, and in the midst of the iconoclastic tendency, a new Utraquist iconography also emerged, which included symbols of Hussitism and the portrayal of Master Jan Hus as a martyr.

1. *Archiv Český* 6 (1872), p. 36: "Obrazové Spasitele našeho a jeho svatých . . . zvonění, míru líbání a všelijací obyčejové od dávna v cérkvi svatej zachovávaní, kteříž se s božím zákonem sjednávají, že v zákonu křesťanském nemají zatraceni býti, ale že mají být trpěni a držení."
2. Národní Knihovna, Prague, III A 10, fol. 123v. See Kybal (1905) 2002, pp. 19–20, 39, 118, 131–36, 193, 195, 201–3, 253, 261.
3. Národní Knihovna, Prague, XIII E 7, fol. 188v.
4. Kybal (1905) 2002, p. 132: "mrtvé a bez života."
5. Ibid., p. 131: "nálezek lidský."
6. "Let it be said first of all that the images of Christ and the Saints do not cause and do not give opportunity for idolatry, nor if for any reason I am absent should they be burnt or destroyed" (Dico primo, quod ymagines Christi et sanctorum non dant causam nec occasionem ydolatrie nec quod propter cuiuscunque abusum debent comburi vel destrui); Höfler 1863, p. 37.
7. Kybal (1905) 2002, p. 133: "rozumné užívání obrazů v kostele."
8. Nejedlý 1913; Pekař 1927–33; Kropáček 1946; Campenhausen 1957, p. 96; Stejskal 1959; Nechutová 1964; Krása 1974b; Nejedlý 1974; Bredekamp 1975; Rejchrtová 1984; Chlíbec 1985; Nechutová 1985; Šmahel 1985; Stejskal 1985; Spunar 1987; Šmahel 1988; Feld 1990; Krása 1990; Belting 1991, pp. 599–601; Thümmel 1991; Bartlová 1992, p. 276; Debický 1992; Stejskal 1992; Fudge 1993; Šmahel 1994; Suckale 1994; Kalina 1995; Royt 1995; Fudge 1996; Schnitzler 1996; Fudge 1998; Bartlová 2001b; Halama 2002. Oddly enough, an article on Hussite iconoclasm was omitted from the publication *Iconoclasme: Vie et mort de l'image médiévale* (Bern–Strasbourg 2001).
9. Palacký 1896, p. 640: "ničitele svatých obrazů a křížů, ale spíše s nimi souhlasí."
10. Kropáček 1946, p. 15.
11. Kostowski 1999.
12. Workman 1926, vol. 2, p. 18.
13. See note 1 above.
14. Pekař 1927–33, vol. 1, p. 15.
15. Stejskal and Voit 1991, pp. 59–60.
16. *Staří letopisové čeští od roku 1378 do 1527* (Old Chronicles of Czech Lands, from 1378 to 1527), in Palacký 1829, p. 98.
17. Hus 1930, p. 98.
18. Ibid.: "Neb proto malování v kostele, aby kteříž písma neumějí, aspoň na stěnách vidouce čtli, kteříž na knihách číst nemohou."
19. Chytil 1918, pp. 142–45.
20. Hus 1930, p. 98: "Je škoda obraz zničit jako drahou knihu."
21. Ibid.: "též i my máme pilně lid hloupý a hovadný vystříhati; vidění v dívání obrazů a varhan . . . a tak člověk sprostý veškeren čas v kostele zmaří, a ještě příjda domů celý den bude mluviti o tom i o Bohu nic."
22. *Patrologia latina* 1844–55, pl. 182, col. 895.
23. Hus 1930, p. 98: "Ale pohřichu! Již lidé místo Kristova umučení malují Trojánské bojování! a místo apoštolů namaží kolcův, a místo obcování Krista malují život Najtharta a místo svatých panen umučení malují bláznivých panen frejování a naháčův nepoctivých a mužů divně a potvorně způsobilých."
24. See Haupt 1858 and Simon 1968. See also Šmahel 1999b.
25. Lanc 1983, pp. 32–40.
26. Nejedlý 1913, pp. 75–76: "Obrazy krásných panen u mužů žádostivost vzbuzují."
27. Krofta 1900, p. 278.
28. Postils in Národní Knihovna, Prague, III G 28, fols. 194–203; see also Nejedlý 1913, pp. 68–82.
29. Nejedlý 1913, p. 74.
30. Ibid., p. 78: "dnes kubenáři i kuklíkové v lútky a v špalky budou hráti."
31. On Peter Payne, see Molnar 1953, Cook 1971, Bělohlávková 1987, Kalina 1995, and Šmahel 2004.

32. Nechutová 1964.

33. Šmahel 1992b; Fudge 1993.

34. Chytil 1918, pp. 153–72; Vlk 1963; Drobná 1970; Brodský 1984; Šmahel 1985; Stejskal and Voit 1991, pp. 67–68; Brodský 2000, pp. 49–54.

35. Svec 1994.

36. Vavřinec of Brežnová, FRB 1893, p. 494.

37. Pekař 1927–33, vol. 1, p. 73.

38. Stejskal 1994, pp. 369–80.

39. Pekař 1927–33, vol. 2, p. 181: "strhli a vyvrátili kláštery kacířské, nepotřebné kostely, oltáře, obrazy, i obrazy tajně ukyté."

40. Vavřinec of Březová, FRB 1893, p. 411.

41. Stejskal and Voit 1991, p. 29: "bieše za mnoho kop drahá."

42. Ibid., pp. 55–56.

43. Bartlová 2001a.

44. Šmahel 1992a.

45. Stejskal and Voit 1991, pp. 51–52.

46. Všetečková 2002a.

47. Stejskal and Voit 1991, p. 60.

48. Petr of Mladoňovice 1981, p. 159; "Relatio," "Pašije Mistra Jana Husi," and "Hus a Jeroným v Kostnici," in *Fontes rerum Bohemicarum* 8 (1932), pp. 111–20, 120–49, 151–67. The *Report* of Petr of Mladoňovice is analyzed by Fiala 1965, pp. 9–30.

49. See also Herkommer 1984, pp. 114–45.

50. Piccolomini (1458) 1998, p. 101.

51. Štěpán of Dolany, *Epistolae ad Hussitas I Pez. Thesaur. Anecd. IV. P. II. co 521*, sig. CO 224, Capitular Library in Olomouc. Štěpán of Dolany engaged in a number of polemics with the Hussites, which survive in the Kapitulní Knihovna, Olomouc, under the title *Listy husitům* (CO 224, CO 345), and *Antiviklef* (sig. CO 224, CO 284).

52. Bartoš 1947, pp. 356–57, with references for further reading, esp. Novotný 1921.

53. Regarding reverence for Master Jan Hus, see Adámek 1873; Kraus 1917–24; Bartoš 1924; *Fontes rerum Bohemicarum* 8 (1932), pp. 368–484; Holeton 1985; Rejchrtová 1985; Čornej 1995, pp. 247–48; and Holeton 1995.

54. *Archiv für österreichische Geschichte* 82 (1985), pp. 386–91.

55. Palacký 1869, p. 447: "malují v chrámech jako blahoslavené."

56. Stejskal and Voit 1991, p. 53.

57. Veleslavín 1590, p. 369: "každého roku v kostelích čítá."

58. See also Štech 1915, pp. 85–86n10, figs. 26–32.

59. Richenthal's Chronicle mentions two devils on a heretical headdress made of paper worn by Hus, depicted also in the relevant illustrations. Petr of Mladoňovice speaks in his *Report* (1981) of three devils fighting for his soul and, moreover, of a sign reading, "This one is an archheretic." For further reference, see Kubíková 1985.

60. Proclamation "Hos articulos," in *Monumenta Conciliorum saec. XV*, 1 (1857), pp. 444–45. See also Bartoš 1966, p. 156.

61. Holeton 1995, p. 157.

62. Ibid.

63. Piccolomini (1458) 1998, p. 101: "mužů svaté paměti"; "ne menší než sv. Petr a sv. Pavel u Římanů."

64. Mikuláš Biskupec of Pelhřimov 1981, p. 293: "svaté paměti."

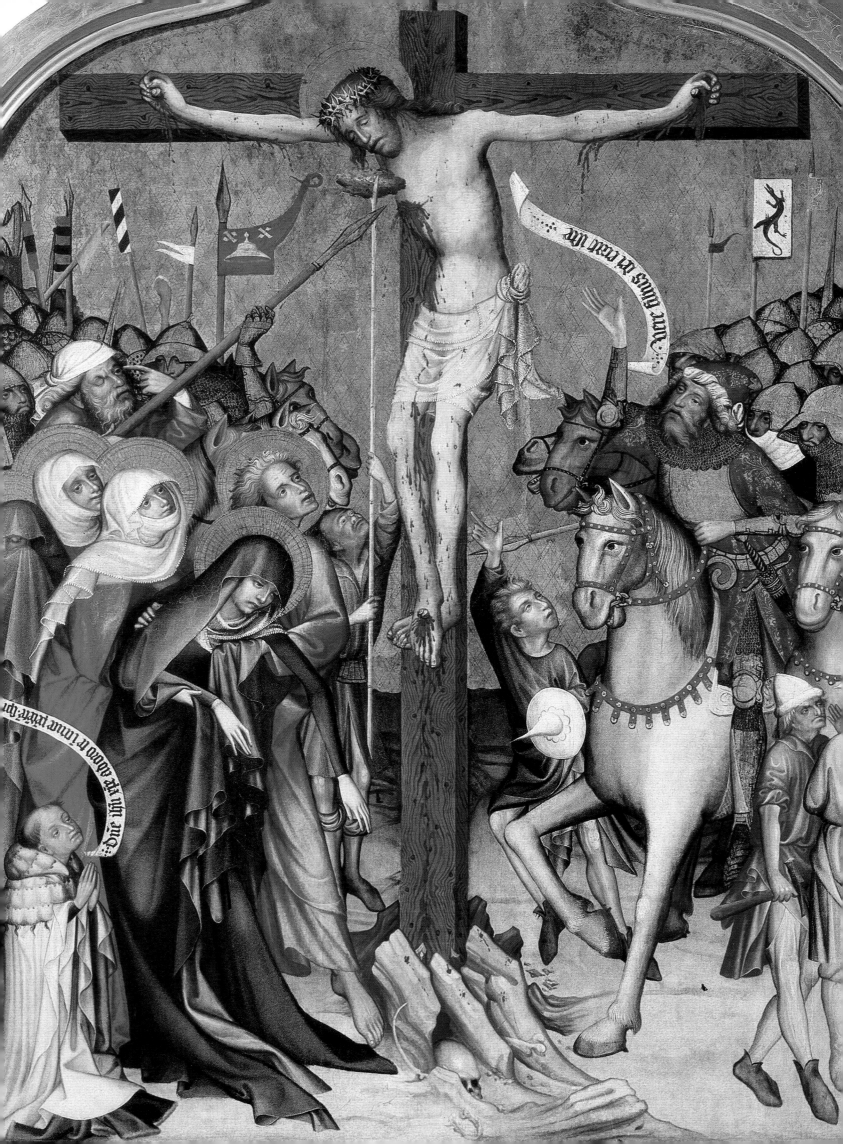

# SIGISMUND, THE LAST LUXEMBOURG

*Prague from "práh"—a threshold, / Gets her name, /
For whoso in Bohemia will enjoy royal Fame / Must cross into Prague.
—Unnamed citizen of Prague (1419)[1]*

Ernő Marosi

igismund, the last ruler of the Luxembourg dynasty, lived in such tumultuous times that, although he became king of Hungary by marriage (1387) and later Holy Roman Emperor (1433), he occupied the throne of Bohemia for only two brief periods (1419–20, 1436–37). He has been the subject of much historical, ethical, and religious debate, and his policies, particularly in regard to religion, are still controversial.[2] Only in recent historical literature have criteria been introduced for a proper judgment of his role as a predecessor of the modern-day politician.[3] This essay focuses on Sigismund's place in art history, while keeping in mind the question of whether the historical significance of a personage has any relationship to the works of art produced during his or her lifetime. This methodological dilemma lies at the heart of the aesthetic approach to history, as expressed in Jakob Burckhardt's discussion of "the state as a work of art" and similar concepts concerning the history of ideas proposed by Johan Huizinga.[4]

In his early years as a ruler, Sigismund gave no indication that he intended to continue the Luxembourg tradition of art patronage. Neither in the margravate of Brandenburg, where he acted as elector, nor in Kraków, where he spent many years in hopes of succeeding to the Polish crown, did he leave any evidence of an interest in art. The only surviving memento of this period—a seal with a superb image of a rider (fig. 11.2), evidently made in Prague for a five-year-old child[5]—reveals that Sigismund often used attributes of his rank not in an artistic context but as conventional insignia of power.

The same lack of interest in art most likely characterizes the period between Sigismund's coronation as king of Hungary and his election as king of the Romans in 1410. The only sign that the tradition of the late Angevin royal Hungarian house continued is provided by the first seals produced during his reign.[6] Sigismund's double majesty seal, in use from 1387 to 1405, apparently adheres in shape and style to that of his queen, Mary, which was made after the death of her father, King Louis I, in 1382. This seal and a few others demonstrate that a Late Angevin workshop was still active in the first decade of the fifteenth century;

Fig. 11.1 Tamás of Koloszvár. The Crucifixion. Tempera and gold on panel, 1427. Keresztény Múzeum, Esztergom, Hungary (54.3)

Fig. 11.2 Sigismund's seal as elector of Brandenburg, 1374

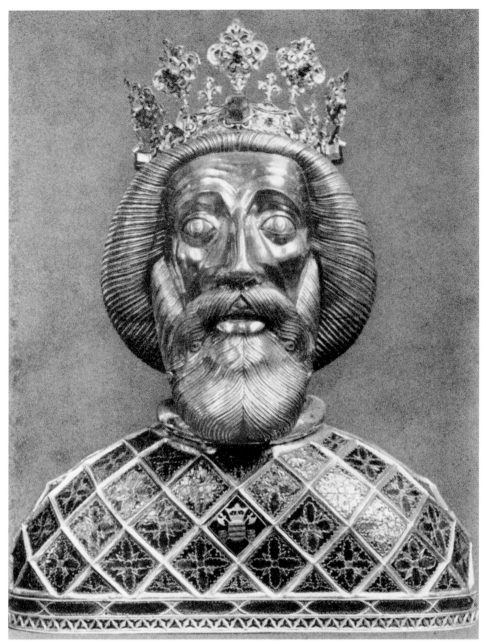

Fig. 11.3 Reliquary Bust of Saint Ladislas. From Várad Cathedral. Gilded silver, gems, and enamel; Hungary, ca. 1406. Treasury of Győr Cathedral

among its productions were the seal of the lords of the nation ("of the Holy Crown of Hungary," according to the inscription), made when these noblemen held Sigismund captive in 1401, and his second double royal seal, in use from 1405 to 1433.

A noteworthy example of the goldsmith's art can perhaps also be dated to the early years of Sigismund's reign. The interior of the reliquary containing the skull of Saint Ladislas (fig. 11.3) is engraved with scenes of Christ in Majesty and the Four Evangelists that seem to relate stylistically to the previously mentioned seals.[7] The silver container may have been donated by the king to Várad Cathedral after a fire in its sacristy, which he mentions in a document

of 1406.[8] The political significance of the work becomes clear in light of the fact that, in 1403, those who supported the king of Naples in the conspiracy against Sigismund had sworn their oath upon the head of Saint Ladislas.[9]

The few major works to survive from the Late Angevin period share a set of distinctive characteristics. Artistic relationships with Prague are evident; for instance, a fragmentary statue of the Nursing Virgin that was perhaps owned by the dowager queen of Hungary Elizabeth Piast—and therefore dating to before 1380—is of the same type as the Virgin from Konopiště (cat. 30).[10] Attempts to imitate the art of the French court can be observed as well. Thus, the composition of a seal showing King Charles V as dauphin was

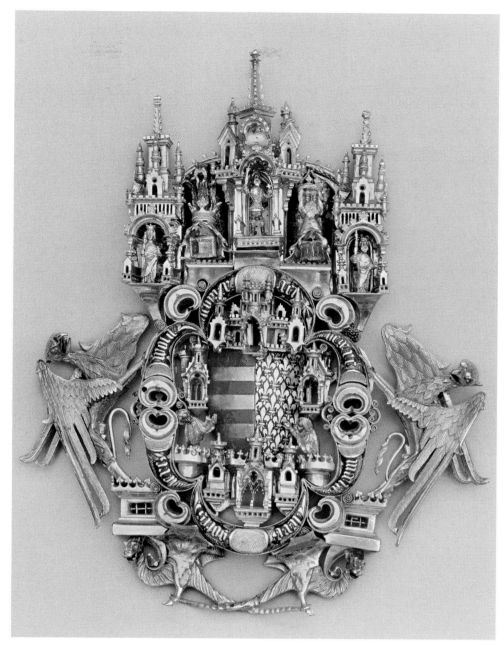

Fig. 11.4 Great mantle clasp from the Hungarian Chapel. Gilded silver and enamel, before 1381. Treasury of Aachen Cathedral

chosen for the reverse of Queen Mary's double seal. The influence of Charles's seal is also evident in the mantle clasps in the treasury of Aachen Cathedral (see fig. 11.4), made before 1381, and the golden buckle from Curtea de Arge, Romania.[11]

Nevertheless, French models rarely had such a direct impact on the International Style in the late fourteenth century. The reliquary bust from Trenčín of an unknown saint (cat. 141) has parallels with that of Saint Cassian (Kunsthistorisches Museum, Vienna), a work surely produced in South German territories.[12] Surviving fragments of stone sculptures, such as those of the retable from the Chapel of Our Lady in Pécs (1370–80)[13] and the red marble

gravestones in the Benedictine Abbey in Pannonhalma,[14] suggest the influence of the Austrian court style, as seen in the Church of Maria am Gestade and the nave portals of Saint Stephen's, both in Vienna.[15] Executed after 1370 of Hungarian red marble, the tomb of King Casimir the Great in Kraków was commissioned by Louis I and may well have been the work of a sculptor born in Brabant who also practiced in Rheims. Such interrelationships are also discernible in Hungarian artworks.[16] An unfinished gravestone for Palatine Nicholas Garai (d. 1385), recently discovered in Siklós, indicates the presence in Hungary of both the style and the figure type found in sculptures from the Austrian ducal workshop (fig. 11.5).[17]

Fig. 11.5 Gravestone of Nicholas Garai. Red marble, before 1385. Former Augustinian priory, Siklós

Architecture offers the best evidence of the continuity of the Late Angevin tradition into the first decades of the fifteenth century. New studies concerning the construction of the Royal Palace in Visegrád have revealed that the core of the Late Gothic building, which incorporated the former palace of Louis I (r. 1342–82), was built in the late fourteenth century.[18] This structure had previously been assigned an earlier date on the basis of the Angevin Ostrich device found on the baldachin slab of one of its fountains. The design of the castle, with its regular shape, square court containing a well, and four towers, goes back to the time of King Louis and reflects the influence of Italian and French innovations.[19] The same building type is well represented in several castles built from the late 1300s to the 1430s: at Diósgyőr (1370s), Zólyom (Zvolen; 1370–80), Végles (Vígľaš; late fourteenth century), Ónod (end of the fourteenth century), Tata (early fifteenth century), Ozora (Eisenstadt/Kismarton; 1416–23), and Pozsony (Pressburg/Bratislava; 1420s–?1434). This Angevin design became the most fashionable one for a seigneurial palace during the first half of Sigismund's rule in Hungary. The influence of the central European architectural tradition, consisting mainly of

Bohemian examples, remains unclear in these modestly articulated buildings, for richer carved decoration was apparently reserved for ceremonial halls and chapels.

The castle in Buda was not used as a royal seat until 1408, as the Angevin kings preferred to locate their court at Visegrád, a fairly modest mid-fourteenth-century structure consisting of a palace and a belfry. The first time Buda Castle was enlarged, about 1400—with the addition of an irregularly shaped courtyard enclosed by palace wings and a chapel—the Visegrád layout was apparently closely followed. The original assignment of an earlier date for the renovation was based on only one source (a 1366 supplication for a papal indulgence for the Chapel of Our Lady), but this has been proved to actually relate to the Visegrád palace.[20] Thus, Sigismund's initial building activities at Buda can be clearly linked by this dating with his political aims to encourage urban development.[21] Since the primary supporters of his urbanization policy were Nuremberg merchants,[22] rather than the Italian financiers of the Angevin period, architectural trends from South German territories and Franconia dominated the design of the rest of the royal castle,[23] as they did private and religious constructions in the town. The subsequent radical enlargement of Buda Castle was perhaps motivated by Sigismund's election as king of the Romans, and ultimately by his imperial ambitions. Some scholars have regarded the new construction as a result of his attendance at the Council of Constance in 1419 (see below).[24] Several parts of the new complex, which was perhaps never finished, were already in use in 1424 for a series of important diplomatic events related to the Holy Roman Empire.[25]

Sigismund's complex is today known only from written sources and from excavated remains, including walls and carved stone fragments (cat. 145). Yet, these elements attest to his aim of building a palace that would accord with the highest artistic principles of his time. There was a great hall (perhaps timber-vaulted, since the Portuguese ambassador Pedro Tafur compared it in 1438 with the Salone in Padua);[26] a tower decorated with coats of arms; a huge donjon, never completed; and a gateway (perhaps a tower on a bridge leading to the palace area) topped with a statue of Sigismund. Saint Sigismund's Collegiate Church, founded by the king about 1410 and completed by 1424, was a hall church with a longitudinal choir and square nave. In type and location similar to the Frauenkirche in Nuremberg, it was situated on the town square opposite the emperor's new priory of the Royal Chapel.[27]

Sigismund's personal involvement in the ambitious plans for his residence reveals one significant characteristic of his

activities as a patron. While his predecessors and some of his contemporaries exhibited the refinement born of an exquisite aesthetic culture, Sigismund himself had a particular fondness for heraldic devices, a fashionable aspect of court art that was to some extent an expression of rivalry among sovereigns. One of his creations was the badge of the Order of the Dragon (cat. 144), which, although finalized by the foundation in 1408,[28] ultimately harks back to earlier times, possibly even to the Crusades. Sources mention the luxurious attire of the Burgundian knights who came to Hungary in 1395 before the Battle of Nicopolis, as well as their ornate shields hanging in the Dominican Church in Buda.[29]

The final form of the badge employs a complex symbolism, based perhaps on the slain dragon as an attribute of Saint George, although a relationship between the Angevin Order of Saint George (established in 1326) and Sigismund's foundation cannot be proved. The dragon's body, curved in a ring with its tail wrapped around its neck, ultimately refers to the dragon as an emblem of eternity. The apocalyptic character of this beast is confirmed both by the donation charter of 1429 to Duke Witold of Lithuania, in which it is identified as the Leviathan, the common enemy of humanity, and by the appellation *Draco Rufus* (Red Dragon), used by the Hussites to identify Sigismund as the Antichrist.[30] For Sigismund, the badge in its simple form seems to have been meant to express a sense of his mission as both a knight and a Christian king.

In its larger form this emblem was combined with a radiating cross bearing the inscription "O QUAM MISERICORS EST DEUS IUSTUS AC PIUS" (Oh, how merciful is God to the just and holy), an allusion to the vision of the Roman emperor Constantine that led him to convert to Christianity and to his motto "In hoc signo vinces" (In this sign thou shalt conquer), as well as to the cross as a traditional symbol of the Crusader. This emblem may actually be Sigismund's first, for both its form and its reference to divine mercy suggest a dating to 1395–96, the years leading up to the Battle of Nicopolis. The two devices did not, as a rule, have to be combined: they appear both separately and together when used by Sigismund, members of the order, and foreign princes, who received them as diplomatic gifts. The impulse behind the creation of the order's emblem can best be explained by the rivalry among rulers, for its holders were employed with other ensigns abroad and also in Hungary, often worn together with the Bohemian Order of the Scarf and with the Aragonese Order of the Jar.

Curiously enough, the complete ensign of the Order of the Dragon also appears on the obverse of Sigismund's first imperial seal.[31] Here the cross and the dragon are separate, but the basic purpose of the composition is still to indicate the emperor's missionary calling. The reverse bears the image of a haloed double-headed eagle and an inscription that invokes both the eagle of Ezechiel (Ezech. 17)—"sent to the bride from heaven," according to the inscription— and that from the Apocalypse (Apoc. 8:13). The eagle in flight symbolizes imperial power and, according to a tradition in German-speaking lands that dates back to Emperor Louis the Bavarian (r. 1314–47), Alexander the Great's ascension to heaven.

This powerful monument to Sigismund's imperial ambitions did not come into use until 1433, and the date of its creation remains an open question. How serious and politically realistic the king's expectations were is also an issue, for the seal must have been created in hopes of his coronation as emperor in the near future. As early as 1417, the seal is described in a royal charter to Arnold Boemel, a goldsmith from 's Hertogenbosch who worked in Paris. The dating accords with the apparent age of the king on this first real individual likeness in sigillography, as well as with its possible Parisian inspiration. The well-known medals in the Kunsthistorisches Museum, Vienna, depicting the emperors Constantine and Heraclius may well have served as models for Sigismund's seal, both in its style and its symbolism of the missionary role of a Christian king. The appearance of the title "King of Bohemia" among others is, however, an argument for execution after 1419.[32]

The earlier dating of the seal is supported mainly by writings of the clerk Winand von Steeg.[33] Winand finished his allegorical treatise *Adamas colluctantium aquilarum,* on the interpretation of the symbolism of the double-headed eagle in 1419, during his stay in Hungary at the Esztergom court of Archbishop Georg Hohenlohe of Passau. He was in Sigismund's service from 1417, during the last phase of the Council of Constance, and came to Hungary in 1419 with the bishop. However, his ties to Hungary could be dated even earlier. The knight Lawrence Tari, who traveled throughout Europe in 1411–12,[34] visited Winand in his Nuremberg study as early as 1412 and ordered another allegorical treatise on the various meanings of the number seven.[35] While Tari's travels were partly to carry out a diplomatic mission, they also involved espionage on behalf of the king. Winand's longer association with Sigismund is therefore a distinct possibility.

Winand not only wrote sophisticated allegories but also illustrated them himself with pen drawings. It has been observed that Sigismund was far less interested in illuminated manuscripts than either his bookish contemporaries

Fig. 11.6 Saint Sigismund. Wall painting, 1417. Augustinian Church, Constance

Winand's treatises belong to another category,[37] for their phantasmagoria and utopian prophecies made them accessible to more than the intellectual elite. One such work, the *Book of the Holy Trinity (Buch der Heiligen Dreifaltigkeit)*, perhaps written in Constance by the Franciscan friar Ulmann, was dedicated in 1419 to Sigismund.[38] The author, who may have been in the service of Burgrave Friedrich of Nuremberg, described a future in which the entire empire would be at peace. These promised lands—or at least the emperor's propaganda promoting them—were echoed about 1439, soon after Sigismund's death, in the pamphlet *Reformation of Sigismund (Reformatio Sigismundi)*.[39] This new literary genre, the so-called folk book, marked the beginnings of a break with courtly literature and a turning toward more popular written communication. At the same time, the image of the emperor was disseminated more widely among the public.[40] Sigismund's features became well known to them from the imperial seal and a fresco at the Augustinian Church, Constance (fig. 11.6).[41] More realistic depictions of his appearance, including signs of aging, as shown, for example, in drawings by Pisanello (fig. 11.7), seem to have been reserved for a more private audience.[42] Some sense of how he looked to contemporaries may be gleaned from the report of the chronicler Johannes of Thuroz: "Sigismund was a very capable man, judging by the excellence of his manner and by his robust figure, endowed by the Creator with a pleasant face, crisp blond hair, and an earnest expression. He used to wear a long beard in imitation of the Hungarian style."[43]

Immediately after his return to Hungary in 1419, after his attendance at the Council of Constance, Sigismund was confronted with the beginnings of the Hussite Revolution in Bohemia. As an opponent to these reforms, Sigismund is presented in a contemporary drawing as the triumphant warrior trampling the heretic underfoot (fig. 11.8). Although he was not yet able to assume the throne of Bohemia in Hussite Prague, this period was significant for the realization of Sigismund's plans to build a new, strongly fortified imperial residence in Buda. The few available facts concerning his personal participation attest to Sigismund's extraordinary engagement in the project. He twice conducted a search for pictorial representations, perhaps even plans, of famous buildings. During his stay in northern Italy in 1414, he asked the city of Siena for a picture of the Santa Maria della Scala hospital;[44] in 1416 a representation of the papal palace at Avignon was created for him by the painter Bertrand de la Barre and the mason Jean Laurent.[45] One common denominator marks both buildings: large timber-vaulted halls, which could have served as possible models for

or even his half brother, Wenceslas IV.[36] If few such luxurious works on parchment were to be found in Sigismund's library, their lack was evidently balanced by popular books written on paper and illustrated with pen drawings. Books for reading, these anticipated the invention of printing in that numerous copies of them were made. Their subjects would appeal to the intellectual reader: there are illustrated chronicles such as Ulrich von Richenthal's on the Council of Constance (see fig. 10.5) and Bendicht Tschachtlan's on the city of Bern; the biography of King Sigismund by Eberhard Windecke; treatises on military technique, many, including Konrad Kyeser's *Bellifortis* (see cat. 89), dealing with artillery, but also the Sienese Taccola's *De ingeneis ac edifitiis non usitatis*, dedicated to Sigismund in 1433.

Fig. 11.7 Antonio Pisanello (by 1395–ca. 1455). Emperor Sigismund of Luxembourg. Charcoal and brown ink on paper, ca. 1433. Musée du Louvre, Paris, Département des Arts Graphiques (2339, recto)

his stay in Paris, Sigismund recruited a group of French masons and goldsmiths into his service and dispatched them to Hungary.[48] Perhaps Dietrich and his companions were intended to work on his buildings, while the French joined with silk weavers from their country in introducing various fashionable luxury industries to Sigismund's capital. In fact, in 1433 the Burgundian ambassador to Hungary, Bertrandon de la Brocquière, met French masons (already jobless) in Pest as well as the tapestry merchant Claus Davion from Arras in Buda.[49]

Most of Sigismund's workmen came from German-speaking lands, including the pipe maker Hartmann from Nuremberg, who arrived before 1416, and Heinrich, a master builder of fountains from Augsburg, recorded in 1418. Their activities are hard to determine because, as metalworkers, they might just as likely have been making cannons as water conduits (the new palace had a modern hydraulic system). The king's return from Constance occasioned the recruiting of more builders: the master mason Stephen Holl of Stuttgart; the master mason Georg of Tübingen, with sixteen companions; and the Augsburg carpenters Erhard and Leonhard Vingerlin with six companions.[50] Also among these craftsmen from South German territories was the

the Royal Palace in Buda, the essential part of Sigismund's construction. In political terms, such a building would advance the concept of an assembly of states, serving not only as a parliament for Hungary but also as a meeting place for the electors and vassals of the imperial realm.

Although the sources are incomplete, it seems that a great number of foreign artists were recruited by the king on his journeys abroad. One Petrus Kytel, a sculptor in court service, is documented as early as 1409; his widow, Catherine, is given in 1422 as the wife of the royal mason Aegidius.[46] On December 16, 1414, Dietrich (of Cologne?), "Mason of the Roman King of Hungary," was freed from captivity in Regensburg. He had been traveling as the leader of a company of workmen, among them a second master and four other masons, two carpenters, and a maker of lead roofs—a complete workshop.[47] At the same time, the king was preparing for his coronation in Aachen. In 1416, during

Fig. 11.8 Sigismund on Horseback. Ink on paper; Bohemia (Prague?), ca. 1420–30. Kunstsammlungen der Vest Coburg (z 240-k2)

master builder of Bratislava Castle, Konrad of Erling, documented in the early 1430s in the accounts of the masons' workshop.[51]

At present, no works can be confidently attributed to these names. Stylistic analysis of the architectonic and ornamental fragments of the Buda castles suggests, however, the heritage of the post-Parlerian generation of architects in South German lands.[52] Significant in this respect is the recorded presence in Bratislava in 1423 of Konrad Felber, one of the masters of Saint George's Church, Nördlingen; his former colleague Konrad Stenglin was also there in 1439.[53] Construction in Buda was apparently halted in the mid-1420s, and perhaps because of the exigencies of the Hussite Revolution, a new residence was begun in Bratislava. The Bratislava castle could have been nearly completed by 1433–34, the years documented in surviving accounts.[54] An early example of the Late Gothic style, it has parallels with certain features of Saint Martin's Church in Bratislava (mainly the west chapels)[55] as well as with the funerary chapel of the Garai family (before 1433; destroyed at the end of the nineteenth century), located on the north side of the choir of the Church of Our Lady in Buda.[56]

Stylistic comparisons reveal more about the origins of the art at both castles. The characteristic "Parlerian" masks, once regarded as signs of Prague's direct influence by the end of the fourteenth century,[57] are now thought to have been transmitted through Vienna or perhaps areas of Croatia (for example, through masters working on the Cathedral of Zagreb, where the last member of Peter Parler's family, Johann, still lived in the 1330s and 1340s).[58] To clarify the influence of the Parler style in Buda, it is necessary to consider the sculptures of Sigismund's time, especially those found in 1974 at Buda Castle (cat. 145).[59] Research has revealed that various fragments from the Buda find belonged to the same group as others already discovered in earlier excavations at Buda.[60] Subsequently, there have been other important finds, most significantly in excavations of Saint Sigismund's Collegiate Church.[61]

The Buda Castle sculptures provide valuable insights into the mechanism of courtly production. They demonstrate both the impact of Sigismund's experience at the French court during the early 1400s[62] and the manner in which French artistic ideals were adapted in other locales. It seems that, in Buda, the principles of sculpture (and perhaps also of architecture) were dictated by the Master of Grosslobming from the workshop of Saint Stephen's in Vienna. This atelier, rooted in a continuous tradition of French-influenced sculpture since the last third of the fourteenth century, was regarded in Buda as ideal for the implementation of new ideas. The close working relationship advances arguments for the later dating—mainly on the basis of analogous sculptures dating to about 1410 in the Austrian towns of Gödnach and Wilhering— and for the collective character of this style.[63]

The predominantly heraldic, portraitlike character of the Buda sculptures led to the belief that they all belonged to the same cycle, the so-called Apostle series, consisting of statues of saints and secular figures. It appeared that the most likely purpose of such a large series would be the decoration of the Royal Palace. Today, at least one figure, a praying Virgin of the same size as the statues in the series, has been proved to have been made for the palace chapel. Fragments from the Saint Sigismund Chapel also indicate that the same workshop was quite active throughout the castle complex in the early 1420s. A local style seems to have emerged from the Viennese artists' work, although executed in different degrees of competence.[64]

Aside from this relationship of central Europeans, other stylistic influences can be seen in the extraordinarily fine figures of the Buda saints. While they are evidently based on types developed by the Netherlandish artist André Beauneveu (ca. 1335–1401/3), their direct roots seem to be in Brabant sculpture from about 1400. The work of the Saarwerden Master, both in Cologne and on the Aachen choir piers, confirms this theory,[65] as does the Regensburg source concerning Master Dietrich. Finally, this style can be compared with that of the young Hans Multscher (ca. 1400–1467), who perhaps was also involved in the decoration of the Aachen choir and whose works about 1430 in Ulm show the influence of Early Netherlandish art.

Some of the Buda sculptures—those characterized by cubical heads and voluminous forms—clearly belong to a younger generation. The sculptor of these works can probably be identified with a master mason who, in the early 1430s, produced a series of figural red marble gravestones. The Master of the Stibor Gravestones, named after two tomb plates he executed in the early 1430s, later carved similar gravestones for Sigismund's Bosnian vassals.[66] (Two characteristic social phenomena can be observed here: the dissemination of courtly art among the aristocracy and the decision of a sculptor to specialize as an independent image maker after a career in a court workshop.) Fragments of figural tomb slabs of King Tvrtko II, found in the Bosnian Monastery of Bobovac (now in the Sarajevo Museum), can be attributed to the master's workshop and attest to the immediate impact in central Europe of the new artistic standards introduced during the second period of Sigismund's reign.

From the time of the Council of Constance, the king had sought ways to produce luxury goods. Early pieces of filigree enamel can be attributed to goldsmiths coming from France. The sword of the electors of Saxony is firmly dated, because it was given to Duke Friedrich the Belligerent, who was promoted to elector in 1425 in Buda; the reliquary bust of Saint Ladislas, made for Várad Cathedral (fig. 11.3), may date to the same time.[67] Despite earlier attempts by scholars to locate enamel workshops in the diocese of Várad or in Transylvania, the close relationship between the Várad head and the Buda sculptures seems to point to the court milieu.[68] Therefore, the Várad reliquary bust can be linked to the politically tinged cult of Saint Ladislas, which also motivated Sigismund's choice of Várad as his burial place. The capital was also influential in the spread of another kind of gold work, engraved figural decoration. One of the key monuments of this technique, the Chalice of Torna, was identified by its coats of arms as a donation by Pál Ezdegei Beseny, a knight of the Hungarian court and member of the Order of the Dragon, thus signaling Buda as the most probable place of origin.[69] In an excavation in Buda, among other tools of a goldsmith's workshop, two engraved copper plates were found with models of ornamental letters and foliated ornaments apparently made for the workshop.[70]

The least-known aspect of art under Sigismund's rule is painting, of which no monument in the strictest sense survives. If the Hronský Beňadik Altarpiece of the Crucifixion, a signed work of 1427 by the painter Tamás of Koloszvár (fig. 11.1, and see also cat. 146) can be considered typical of the prevalent taste at court, Bohemian painting was a dominant influence. That the commissioner of the altarpiece was a cantor of the royal chapel argues for the work being a production of the court.[71] Supporting the link between painting in Bohemia and Hungary is the widespread collaboration between the two kingdoms in producing illuminated manuscripts of the highest quality. With his stylistic connections to the Master of the Gerona Martyrology (cat. 86) and to the Vienna Model Book (cat. 117), Master Tomáš seems to be representative of the last Prague generation of artists during the pre-Hussite period.

The influence of Italian art on Sigismund's court can be deduced only through written tradition. Sigismund's presence in Italy attracted such artists as Pisanello and Filarete; Masolino's journey to Hungary is also well known, although nothing of his work survives there. Pier Paolo Vergerio, one of the greatest Italian art theorists, followed Sigismund back from Constance and lived in Hungary, but no record of his impact on artistic culture there is known.[72] Perhaps the fact that the antiquarian Ciriaco d'Ancona served as cicerone during Sigismund's coronation stay in Rome indicates he was more interested in the tradition of International Gothic than in the radical tendencies of early quattrocento art.

Oddly enough, one clue to Sigismund's aesthetic attitude may be found in how he arranged his burial. In 1437, having forcibly pacified Prague but aware that he was dying, he first ordered the arrest of his wife, Barbara Celjska, in order to forestall the opposition to his appointed heir, his son-in-law Albert II Habsburg. Then, before his corpse was transported to Várad, where he would be buried at the feet of his venerated knightly exemplar, Saint Ladislas, his will stipulated that it was to be placed on the throne, dressed in full imperial attire. With this act, Sigismund was both imitating Charlemagne and meeting his own extravagant need for attention.

Johannes of Thuroz speaks poignantly of the emperor's effort to reach Hungary before dying: "Leaving the city of Prague, he could not enter into his homeland as he wished, but died in the Moravian city of Znojmo on December 8, 1437 at the age of seventy, in the fifty-first year of his rule as a king of Hungary, in the twenty-seventh as a Roman king, in the seventeenth as a Bohemian king and in the fifth year as an emperor."[73]

1. *Historica* 17 (1969), p. 106: "Prahat jméno má ot práhu, / Neb ktož královské chce slávu / Mieti v Čechách, mát po Praze / Vjíti jakožto po práze / Dobrý pastýř do ovčince."
2. Aschbach 1838–45; Mályusz 1984; Baum 1993.
3. See Macek, Marosi, and Seibt 1994, especially the first essay by Seibt.
4. The first account in Hungarian of Sigismund's period is Horváth 1937, a cultural history.
5. Kéry 1972, p. 125, fig. 87.
6. Ibid., pp. 125–27, see also Budapest 1987, pp. 13–21, no. Zs.4-9.
7. Marosi 1987, p. 644; compare to Deér 1966, pp. 251ff.
8. Mályusz 1951– , vol. 2 (1956), p. 636, no. 5066, quoted in Balogh 1982, vol. 2, pp. 42–43.
9. Mályusz 1951– , vol. 2 (1956), p. 611, no. 4899, quoted in Balogh 1982, vol. 2, p. 42.
10. Budapest 1994–95, pp. 488–90, no. X-3; Marosi 1997.
11. Marosi 1982.
12. Székesfehérvár 1982, p. 309, no. 164; Budapest 2000, p. 126, no. I-1; see also Müller 1935, p. 52.
13. Budapest 1994–95, pp. 270–73, no. IV-42-46; Marosi 1998, pp. 99–101; Sándor et al. 1999, pp. 61ff.
14. Székesfehérvár 1982, p. 271, no. 138; Pannonhalma 1996, vol. 1, pp. 310–14, no. II.25–26.
15. "Zu einigen Stifterdarstellungen des 14. Jahrhunderts in Frankreich," 1981, reprinted in Schmidt 1992, p. 129; Saliger in Vienna 1994, pp. 46ff.
16. "Bemerkungen zur Königsgalerie der Kathedrale von Reims," reprinted in Schmidt 1992, pp. 18–19.
17. Budapest 1994–95, pp. 276–78, no. IV-49; Jékely 1998.
18. For the earlier theory of the construction history, see Marosi 1987, pp. 389–92. For the revised chronology of the Visegrád royal palace, see Buzás 1990, pp. 22ff.; Buzás 1994, pp. 115ff.; and Buzás 1995, pp. 10ff. See also Marosi 1998, pp. 106–8.
19. Balogh 1981. For an overview of the monuments, see Feld 1993.
20. This location is proposed by Kumorovitz 1963, p. 136, based on a fragmentary text corrected by Érszegi 1992. The earlier chronology was elaborated by Gerevich 1966. See also Gerevich 1971.
21. For influential hypotheses concerning contemporary central European relationships, see Gerevich 1954 and Gerevich 1958.
22. Mollay 1959.
23. Buzás 1997.
24. Windecke 1893, p. 109; Schmidt and Heimpel 1977, p. 18.
25. Windecke 1893, pp. 172–74.
26. See Balogh 1952, pp. 30ff., and Nagy 1955; see also Marosi 1984, pp. 20–21.
27. See Feld 1999.
28. Baranyai 1925–26; Kovács 1987; Kovács in Marosi 1987, pp. 217–20; Lővei 1987.
29. Thuróczy 1985–88, sec. 203, p. 214/10–13.
30. Kovács in Budapest 1987, vol. 1, p. 135.
31. Budapest 1987, vol. 1, no. Zs.17, vol. 2, p. 24; Kéry 1972, pp. 128–29, figs. 97, 98.
32. Flor 1992, p. 400; Pferschy-Maleczek 1996; see also Marosi 1995, p. 128.
33. A. Schmidt 1967, pp. 363–72; Schmidt and Heimpel 1977; Graf 1992, pp. 344–51.
34. Delehaye 1908.
35. Completed in 1414, this was entitled *Paries septenariorum*. A. Schmidt 1967, pp. 367–68 and n. 19.
36. Schmidt 1987, p. 509. In fact, Sigismund's library was dissolved in the early 1440s. In 1455 his grandson, King Ladislas V Posthumous, asked Emperor Frederick III to return the books that had once belonged to Wenceslas, which had passed by inheritance from Sigismund to King Albert and were kept in the gate tower of the Vienna castle. Manuscripts with Wenceslas's coats of arms, later obscured by those of King Matthias Corvinus, can be identified as fragments from this library (Marosi 1987, p. 103; for Ladislas V's books, see Csapodi 1973, p. 36).
37. Obrist 1983; Graf 1992.
38. Flor 1992; Pferschy-Maleczek 1996, pp. 451–57.
39. Beer 1951; Dohna 1960; Koller 1964.
40. Kéry 1972; Künstler 1976; Knauer 1977; Végh 1987, pp. 93ff.; Végh 1992.
41. Schramm and Fillitz 1978, no. 78; Kéry 1972, pp. 44–46, figs. 23, 24.
42. For an essay distinguishing between public and private portraiture, following the example of Sherman 1969, see Marosi 1993.
43. Thuróczy 1985–88, part 1 (1985), chap. 219, p. 231: "Fuit imperator Sigismundus homo in sui vultus qualitate et persone quantitate satis idoneus, pulcra facie, crinibus crispis et glaucis ac sereno intuitu a summo rerum conditore adornatus. Hic in favorem Hungarorum quondam longas barbas deferentium prolixam barbam deferebat."
44. Gaye 1839, p. 92, no. 26.
45. See Marosi 1984, pp. 12–14.
46. Takács 1989, p. 54.
47. Liedke 1975.
48. See the letter sent by Stephen Rozgonyi from Paris in 1416, published by Áldásy 1902, p. 576. See also Csernus 1995, p. 116.
49. La Brocquière 1892, p. 235.
50. On foreign masters in Sigismund's service, see Horváth 1937, pp. 108–9; Gerevich 1966, pp. 284ff.; and Marosi 1987, pp. 104, 175, 179, 565.
51. Sűcs 1958.
52. Marosi 1987, pp. 563–70; Buzás 1997.
53. Klemm 1882, pp. 75–76.
54. Sűcs 1958; Marosi 1987, pp. 571–74; Simkovič and Bóna in Pozsony 2003, pp. 199ff.
55. Žáry in Pozsony 2003, pp. 226–30, 637, no. I.3.20.
56. Csemegi 1955, pp. 33–34, 102–3, 135ff.; compare with Budapest 1987, pp. 183–85, no. É.31.
57. Gerevich 1954.
58. Horvat 1959; Buntak 1963.
59. Zolnay and Marosi 1989, pp. 116–18.
60. See Budapest 1987, p. 258, no. Sz.13, and Marosi 1999, pp. 98–99.
61. See Feld 1999, especially the paper by Végh (1999).
62. See, primarily, Heinrichs-Schreiber 1994, esp. pp. 25–26.
63. Marosi 1994. Fundamental for the dating of Buda sculpture is Schultes 1986.
64. See Marosi 1999, pp. 98–99. For other influences in Hungary, see Budapest 1987, vol. 2, pp. 266–70, nos. Sz.26–Sz.30.
65. Zolnay and Marosi 1989, pp. 94–95.
66. Lővei 1999.
67. See Kovács in Marosi 1987, pp. 233–35, and Kovács 2004, pp. 269–70. For a major work relevant to this context, the chalice of the Bratislava Treasury, see Pozsony 2003, pp. 194–95, 808–9, no. 7.9, and, for comparison, no. 7.14 (by Wetter).
68. Kovács in Budapest 1987, pp. 405–7, no. Ö.1.
69. Lővei 1991, pp. 49–50.
70. Budapest 1987, pp. 417–18, no. ö.10. See also Marosi 1987, pp. 650–52.
71. See Végh in Marosi 1987, pp. 619–23; and, more recently, Takács in Pannonhalma 2001, pp. 175–80.
72. Huszti 1955; Marosi 1995, pp. 130–31.
73. Thuróczy 1985–88, part 1 (1985), chap. 219, p. 231: "Egressus igitur Pragensi de civitate optatam venire ad patriam nequivit, sed in Znoiima, civitatem Morauie delatus domini millesimo quadringentesimo tricesimo septimo anno in festo conceptionis gloriosissime virginis Mariae, etatis sue septuagesimo, regnorum autem suorum Hungarie quinquagesimo primo, Romanorum septimo et vigesimo, Bohemie decimo septimo, imperii vero anno quinto diem obiit."

## 1. The Crucifixion

*Prague, ca. 1340*
*Paint and gold on canvas transferred from panel,*
*67 x 29.5 cm (26⅜ x 11⅝ in.)*
*Provenance: Richard von Kaufmann, Berlin, sold*
*1917; acquired by Gemäldegalerie as gift of P. Cassirer*
*and F. W. Lippmann, 1918.*
*Staatliche Museen zu Berlin, Gemäldegalerie (1833)*

The number and quality of artistic parallels to this Crucifixion suggest that it was probably the best-known painting of the fourteenth century in Prague. Nowhere was it imitated so much as in Prague itself: in the Kłodzko Virgin and Child (fig. 3.4), dated 1343 and commissioned by the first archbishop of Prague, Arnošt of Pardubice, for example,[1] and in the wall paintings of the Church of Saint Thomas and the missal made in 1409 for Zbyněk of Hazmburk, fifth archbishop of Prague (fig. 84.3). The cycle of paintings from the southern Bohemian Cistercian Monastery of Vyšší Brod (see fig. 3.2) and the panel of the Virgin from Veveří in Moravia, which reflect this painting's style, were also painted in Prague.[2] Partial echoes are in Dolní Bukovsko in southern Bohemia,[3] Pulgarn in Upper Austria,[4] the Monastery of Saint Lambrecht in Styria,[5] and Saint Sebaldus's Church in Nuremberg.[6] The arguments for the Crucifixion having been painted in Vienna or Salzburg are not convincing, especially insofar as they are based exclusively on Austrian examples.[7] The relationship of the crucified Christ with that in the Passional of the Abbess Cunigunde (Národní Knihovna, Prague, XIVA 17; see fig. 1.3) also speaks for the Crucifixion's having originated in Prague.[8]

Given that the picture was quoted already in 1343 and that the double paraphrase of the female figure at the left edge in a missal in Wrocław (University Library, Ms. 1151) can be dated still earlier,[9] the Crucifixion could conceivably have been commissioned by Bishop Jan of Dražice (d. 1343), who spent eleven years at the Papal Curia in Avignon. There are additional arguments for an early date, the old-fashioned helm of the rider to the right among them. The long cuffs on the soldier dressed in light gray indicate a date after 1330, whereas his pointed hat and the alms purse on his belt suggest one closer to 1340.[10] The strong repoussoir motif at the right and the mediating role of the woman at the left suggest that the panel may once have formed half of a diptych.[11]

The picture is the first convincing reformulation of a pictorial type of Italian origin known as the "crowded Crucifixion."[12] In the richness of the palette, but also in many individual motifs such as the group around Mary at the foot of the cross, the artist looked to the

1

*Maestà* by the Sienese master Duccio.[13] The dice players and other dynamic motifs recall Bolognese painting.[14] The scene, traditionally presented in a static fashion, is dramatized here as if it were unfolding in space. No Italian, however, would ever have represented the thieves pressed together in so flat a manner and with such unnaturally angled limbs. The artist heightened and polarized the figural types: Christ's companions are especially passionate, and the centurion especially noble; the executioners, in contrast, are grotesque caricatures.

The artist modulated the colors, applying them in thin layers to achieve a transparency and lustrous surface that can be found earlier only in the work of Simone Martini. The punchmarks and tooling are also subtly differentiated.[15] The figures' clothing serves as a means of expression as well: Christ's robe, over which the soldiers struggle, is held dramatically high, whereas the Virgin's mantle seems to express devotion and grief. The woman dressed in green looking out of the image at the left, the good centurion, and the old man with a dark complexion near John the Evangelist offer a variety of visual interactions with the viewer.

RS, JF

1. The angel at the upper left in the panel from Kłodzko cites the dice thrower seated on the ground in this Crucifixion.
2. Matějček and Pešina 1950, p. 47, no. 12, fig. 26. Krása (in Kotrba 1971, p. 396) refers to the missal from Chotěšov as further evidence for a localization in Prague, but only the Virgin's pose is related.
3. Pešina 1980.
4. Schultes 2002, pp. 68–69.
5. Biedermann et al. 1982, pp. 63–65.
6. Frenzel 1962.
7. Fritzsche 1983, pp. 144–55; Trattner 1998; Suckale 2003b, pp. 136–43; Schmidt 2005, pp. 229–58.
8. Langer-Ottersböck 1972, p. 174.
9. Kloss 1942, pp. 48–51, 218, fig. 51. Codex R165 of the same library might well be based on the Hazmburk Missal.
10. The long cuffs are an aspect of Italian fashion found in central Europe following Louis the Bavarian's first trip to Italy in the late 1320s (Suckale 1993b, p. 57). For the pointed hat, see the man in the lower margin on folio 170r of Österreichische Nationalbibliothek, Vienna, Cod. 1419, dated 1337.
11. The diptych divided between the Foundation Emil G. Bührle Collection in Zurich and the Gemäldegalerie in Berlin speaks in favor of the second panel having been a Nativity (Suckale 1993b, pp. 124–31); the diptych by the Master of Saint Lambrecht in Vienna (Österreichische Galerie Belvedere) speaks in favor of its having been a Way to Calvary.
12. Roth 1967, pp. 67–69.

13. Duccio's *Maestà* (Museo dell'Opera del Duomo, Siena), completed in 1311, is the model for the craggy, ascending terrain of Golgotha, for the woman at the left edge, and for the group around the Virgin Mary. The black sandals of the man seated on the ground are a quotation from Duccio's representation of the Washing of the Feet.
14. See Schmidt 1969b, pp. 174, 176, 180; Trattner 1998, p. 14; and Suckale 2003b, p. 137. On *scorzi*, a method to heighten the expressive character of a painting, see Rathe (1938) 1968.
15. The tooling in Christ's halo, originally the most elaborate, has been distorted by subsequent overpainting. The pattern of the interior frame has also been poorly restored.

LITERATURE: Friedländer 1917, vol. 2; Matějček and Pešina 1950, p. 48, no. 15, pls. 33–36; Pešina 1980; Fritzsche 1983, pp. 144–55; Hlaváčková 1987; Schmidt 1995; Gemäldegalerie 1996–98, p. 19, no. 1833, fig. 33; Trattner 1998; Brucher 2000, no. 277, color ill.; Suckale 2003, esp. pp. 136–40; Schmidt 2005, pp. 229–58.

## 2. The Radeck Missal

*Salzburg, mid-14th century*
*Tempera on parchment, 438 fols., 37 x 25.6 cm*
*(14⅝ x 10⅛ in.)*
*Provenance: Itzling-Fischach-Zaisberg-Bergheim-Radeck family, Salzburg; Salzburg Cathedral (rebound by Urich Schreider with the cathedral library owner's mark sometime after 1477); acquired by the Universitätsbibliothek, 1807.*
*Salzburg University Library (M III 48)*

The style of the decoration of this missal from Salzburg combines local and Bohemian traditions with elements from Upper Austria and Passau. This missal has been robbed of its most important decoration, except for a few historiated initials and a masterful image of the Crucifixion, which would have been kissed by the priest at the beginning of the Canon of the Mass. A miniature of the pregnant Virgin Mary (*Maria gravida*) that is glued into an orationale from Nonnberg Abbey comes from the same workshop.[1]

The territory of the archbishops of Salzburg was wedged between the power bases of the Wittelsbach dynasty in Bavaria and the Habsburgs in Austria. They therefore gladly sought protection from the more remote and largely neutral kings of Bohemia. That Charles IV's sister Margaret was married to Duke Henry of Lower Bavaria, Salzburg's immediate neighbor to the north, also enhanced the relationship between Prague and Salzburg.

Little is known about the patron other than that he was probably a member of the

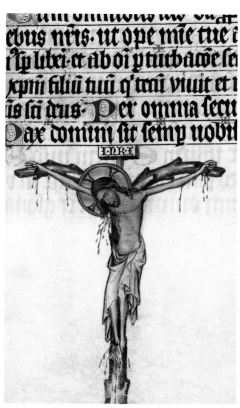

2, fol. 106v (detail), The Crucifixion

Itzling-Fischach-Zaisberg-Bergheim-Radeck family of Salzburg nobility.[2] The date of the commission as well as its circumstances also remains uncertain.

RS, JF

1. Bayerische Staatsbibliothek, Munich (Clm. 15902); see Schmidt 1962, p. 151; Lechner 1981; and Krása in Kotrba 1971, pp. 397–98. The theme of the pregnant Mary, which enjoyed enormous popularity in Bohemian art of the period, was apparently imported from Italy by Charles IV.
2. Rüdiger von Bergheim (Radeck), for example, bishop of Passau from 1233 to 1250, was a scion of this family. It is unclear how closely related this family was to the Bohemian Radeč family, one of whose most important members was Václav of Radeč (d. 1418), who was canon in Regensburg and Prague, secretary to Prague Archbishop Jan of Jenštejn, dean of the Church of Saint Apollinaris, custodian of Prague Cathedral, and the fifth overseer of the cathedral workshop. See Schmid in Gatz 2001, p. 553.

LITERATURE: Frisch 1949, pp. 47–52; Schmidt in Vienna 1979, pp. 460–61, no. 256; Roland in Brucher 2000, pp. 514–15, no. 253.

## 3. Reliquary Bust of a Female Saint

*Prague, ca. 1340*
*Gilded copper and silver, h. 28 cm (11 in.)*
*Provenance: Found in theater of Lobkowicz Castle,*
*Jezeří, 1930s; Lobkowicz family, Roudnice Castle;*
*Národní Galerie, Prague, 1945; restituted to*
*Lobkowicz Collections, 1990s.*
*Lobkowicz Collections, o.p.s., Zámek Nelahozeves,*
*Czech Republic (LJ 390)*

With its gently curling locks, high cheek-bones, and aquiline nose, this bust of a female saint, whose beauty was originally enhanced by a jeweled neckline and a circlet in her hair, is the very image of a holy princess, such as Saint Ludmila (cat. 6) or Saint Hedwig (cat. 7). Whether she represents a saint particularly venerated in Bohemian lands or one of the eleven thousand companions of Saint Ursula celebrated throughout Europe is unknown. The relic of a skull and any identifying label have been lost, along with her metal crown, which was once secured by hinges.

Stylistically, the bust is the goldsmith's counterpart of the celebrated Michle Madonna in the Národní Galerie, Prague,[1] and thus represents the Bohemian sculptural tradition at the time of Charles IV's return to Prague in 1333. Moreover, like the Bust of Saint Ludmila (cat. 6), the Lobkowicz bust represents that rarest form of Bohemian sculpture—reliquary images that, because of the inherent worth of the metal, often fell victim not only to iconoclasm but also to changing taste, financial necessity, and unbridled greed. These female busts hint at the sumptuousness of the contemporary images of the Twelve Apostles commissioned by Charles for the Saint Wenceslas Chapel at Saint Vitus's Cathedral, which were melted down by his father, John of Luxembourg, in 1336.[2]     BDB

1. Bachmann 1977, fig. 37.
2. Beneš Krabice of Weitmile, FRB 1884, book 3, p. 488.

LITERATURE: Kutal 1962, pp. 14, 127; Prague 1970, p. 336, no. 422; Poche 1983, pp. 660–62.

## 4. Enthroned Virgin and Child

*Moravia (Brno?), ca. 1350*
*Linden wood with original paint, h. 75.3 cm (29⅝ in.)*
*Condition: Carved in the round, back of throne*
*hollowed out. Abraded paint original. Crown's finials*
*replaced except for two at back; Virgin's left little finger*
*and right index and middle fingers and Child's right*
*little finger replaced; cross missing from orb.*
*Provenance: Said to come from the Convent of Saint*
*Ursula, Vienna; Hermann Schwartz, Mönchengladbach-*
*Hardt, until 1965.*
*The Metropolitan Museum of Art, New York,*
*The Cloisters Collection, 1965 (65.215.1)*

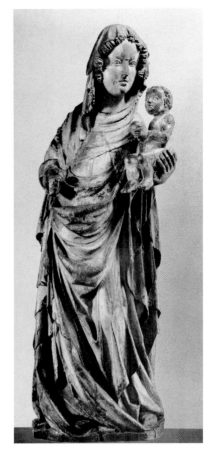

Fig. 4.1a Virgin and Child. From the Church of Saint James, Brno. Wood, ca. 1370. Moravská Galerie, Brno (E73)

The clockwise torsion of both the Virgin and the Child implies that this group was originally part of a larger ensemble, probably an Adoration of the Magi. The subject was traditionally taken to symbolize the subjection of the earth and its rulers to Christ, celebrating him as King of Kings (Rev. 17:14), to which the orb in his left hand refers. The throne, the large crown, and the scepter Mary originally held in her left hand would have underscored her regal nature.

Although carved from a relatively shallow piece of linden wood, the sculpture is remarkably three-dimensional. It invites the mobility of the beholder, and every vantage point reveals a fully resolved composition. This suggests that the Adoration ensemble was originally installed neither in a niche nor in the shrine of a retable, which would have hidden its sides.

Two sculptures of the Virgin and an apostle originally from the Church of Saint James in Brno and now on loan to the Moravská Galerie there (see fig. 4.1a) offer direct stylistic parallels to the Cloisters group. Both Virgins have fleshy cheeks, narrow mouths, pointed chins, thin noses, and high foreheads. In both cases curly tresses frame her face. The draperies follow the same principles: the vigorous oblique folds of

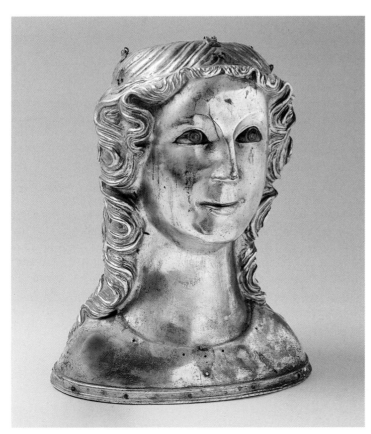

3

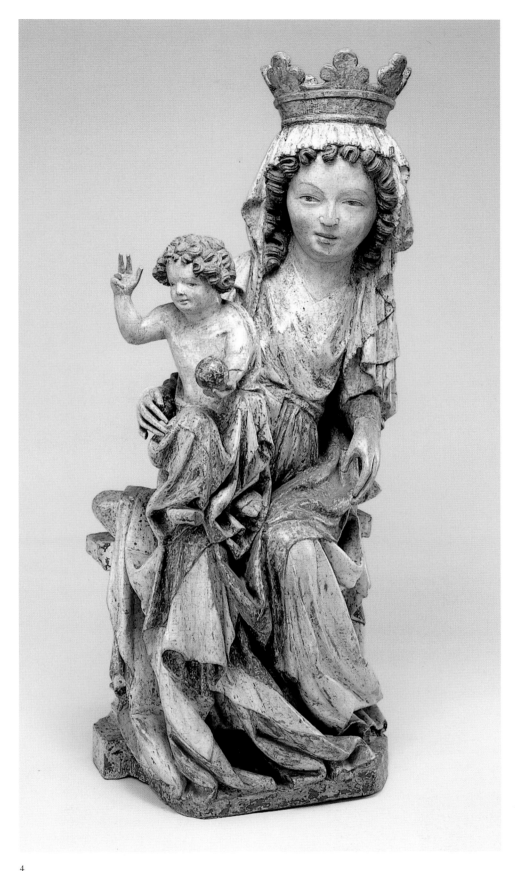

4

## 5. Virgin and Child

*Prague, 1345–50*
*Tempera and gold on panel, 89 x 59.5 cm (35 x 23⅜ in.)*
*Provenance: Cistercian Monastery of Saint James the Great, Zbraslav, by 1646.[1]*
*Římskokatolická farnost u Sv. Jakuba Staršího Praha-Zbraslav, Prague*

This panel translates several hymns in honor of Mary, the mother of Jesus, into a vision at once regal and heavenly. The golden stars on Mary's mantle refer to the oldest of Marian hymns, "Ave maris stella / Dei mater alma" (Hail, star of the sea, loving mother of God), which was so celebrated that it provided the basis for an exegetical poem that commented on each word.[2] The poem was written by Konrad of Haimburg (see cat. 39), who for a while lived at the court of Arnošt of Pardubice, archbishop of Prague.[3] The artist apparently endeavored to depict many of the ideas expressed in the hymn, for example that Mary is the new Eve but more beautiful than Eve and that she is especially "kind and mild." Konrad also wrote poems on Mary's ring and brooch, which explains the size and elaboration of the brooch pinned to her mantle. With the cruciform shape of the brooch the artist was referring to the Passion of Christ, already symbolized by the goldfinch in the infant Jesus' hand.

Following Tuscan models, the figure of the Virgin is enlarged beyond the half-length format.[4] In keeping with Western models and the French origins of the Cistercian Order, Mary wears a white veil that barely covers her flowing locks, rather than the Byzantine *maphorion* of many Bohemian Marian panels. She holds her child on her right, a motif that derives from a Byzantine type. Her left hand draws attention to the baby Jesus, who places his hand in hers in a gesture that could be described as one of taking possession.[5] Mary wears a double crown: a diadem-like circlet that like her ring designates her as a bride and a royal crown that refers to her title as Queen of Heaven. The calligraphic elaboration of the style of the 1340s, which was established by the painter of the Kłodzko Virgin and Child (fig. 3.4), suggests a date of about 1345–50.

This panel is without doubt the most precious and most representative of all the half-length Marian panels to have survived from Bohemia. The artist painted the image in a labor-intensive technique (see cat. 9). For the blue mantle, the most expensive pigment, ground lapis lazuli, was employed. Both the background and the frame are richly gilded, incised, and punched, and the Virgin wears a golden garment beneath her mantle. The painter also applied gold to the hems of

the mantle clarify the articulation of figure, while the diaphanous head veil allows a more graceful definition of volume. The relatively well preserved medieval paint gives a sense of the original magnificence of the ensemble.

JC

LITERATURE: Bachmann 1943, pp. 34–37, 53; Schmoll 1961, p. 180; Suermondt Museum 1961, no. 22; Grimme 1962, p. 79, fig. 3; Grimme 1966, no. 12, p. 103, ill.; *Metropolitan Museum of Art Bulletin*, n.s. 25 (1966), pp. 88–89, ill.; Metropolitan Museum 1975, p. 149.

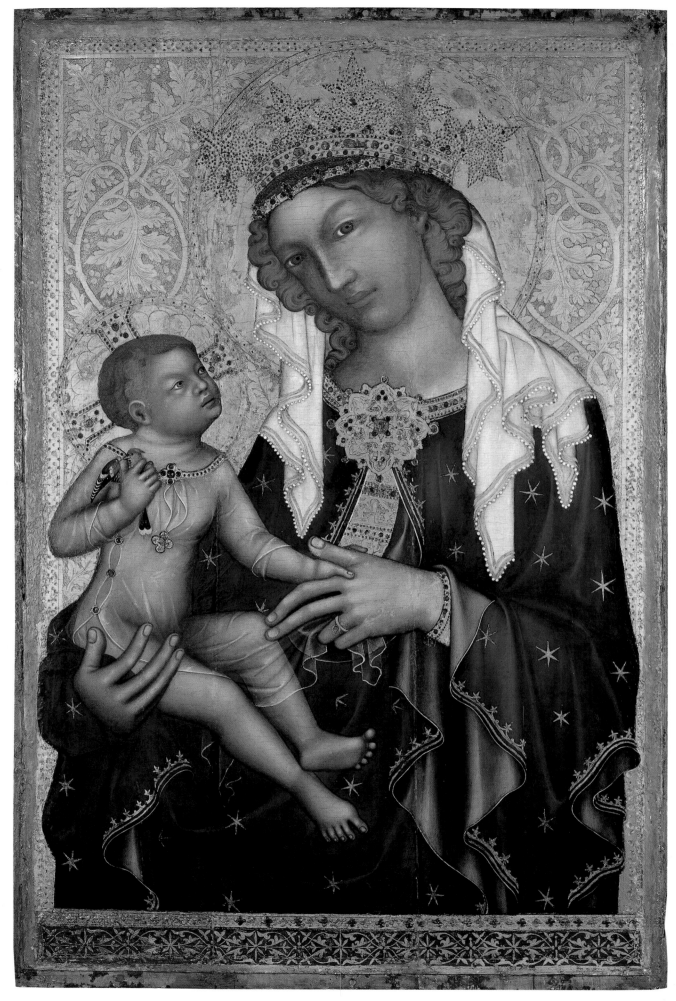

the veil and mantle and the chemise of the infant Jesus.[6]

Zbraslav (Aula Regia, or Königssaal) was the favorite burial place of the ruling house of Bohemia, who like other kings and nobles of east-central Europe preferred to be interred in Cistercian communities. Charles IV's mother, Elizabeth, was buried there. This much-copied image from Zbraslav, which carried the honorific title Mother of the Monastery (Mater domus), could well have been a gift from Charles IV to the necropolis of his Přemyslid ancestors. RS, JF

1. Matějček and Pešina 1950, pp. 58–61.
2. The hymn is by an unknown Carolingian author.
3. On the Carthusian Konrad of Haimburg, see Worstbrock 1985. His poems are published in Dreves (1888) 1961.
4. See, for example, the Virgin by Maso di Banco in the Gemäldegalerie, Berlin (Boskovits 1988, no. 41, pl. 163, and see also pl. 125, 130).
5. Prov. 8:22: "Dominus possedit me in initio viarum suarum" (The Lord possessed me in the beginning of his ways).
6. The decoration of the image with numerous donations of pearls and precious stones began in 1661, when the damaged Marian panel was miraculously "restored" by the Virgin herself (see Matějček and Pešina 1950, p. 49).

LITERATURE: Matějček and Pešina 1950, pp. 49–50, no. 19, pl. 45; Drobná 1956, pp. 34–35; Hamsík 1967, p. 323, fig. 2; Schmidt 1969b, pp. 206–7, fig. 159; Prague 1970, no. 295, fig. 65; Kutal 1971, p. 57; Pešina 1977; Pešina 1984, p. 364.

## 6. Reliquary Bust of Saint Ludmila

*Prague, ca. 1350*
*Gilded silver, rock crystal, and gems, h. 34 cm (13⅜ in.)*
*Inscribed in Latin on roundel at top of reliquary: Caput S. Ludmile M. (The head of Saint Ludmila, M[artyr]).*
*Provenance: Benedictine Convent of Saint George, Prague; acquired by Saint Vitus's Cathedral after secularization of convent, 1783.*
*Metropolitní Kapitula u Sv. Víta, Prague (HS 03342 [K18])*

In his *Legend of Saint Wenceslas,* Charles IV called Ludmila, the grandmother of Saint Wenceslas, "the first pearl" of the Bohemians and noted that she was renowned for having "imbued her grandson with the Christian faith and with holy writings and the words of the gospels."[1] This bust reliquary of Saint Ludmila, with softly flowing veil, delicate features, and golden countenance, is both holy and regal. Following

well-established tradition in the creation of bust reliquaries, the pupils of the eyes are colored to animate the face, while gold is employed to suggest a heavenly vision of the saint. The bust has been considered the counterpart in precious metal of Bohemian wood sculptures of about 1340, such as the celebrated Michle Madonna in the Národní Galerie, Prague,[2] but a more compelling visual comparison would be with the image of Saint Hedwig in a 1353 illuminated manuscript of her life (cat. 7).

The body of Saint Ludmila was enshrined at the Convent of Saint George, located within the Prague Castle precinct. The community had very close connections to the queens of Bohemia; Charles IV's mother, for instance, once resided there. During the tenure of Abbess Sophia of Pětichvost (1328–45), a chapel in the church was consecrated to Saint Ludmila. This bust was likely made at that time to enshrine the skull, which was the saint's principal relic. BDB

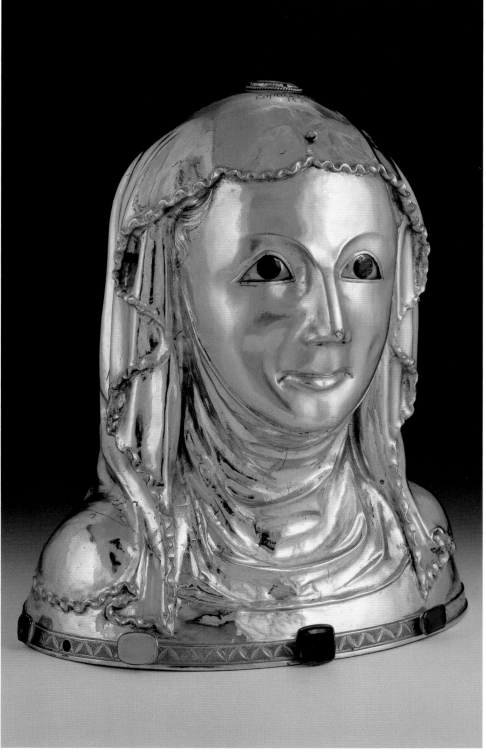

6

1. Charles IV, *Legend* 2001, p. 187.
2. Chlíbec et al. 1992, pp. 60–61, no. 29.

LITERATURE: Podlaha and Šittler 1903b, pp. 21–23, no. 13; Fritz 1982, p. 228, no. 285; Cologne 1985, p. 150, no. 52 (with earlier literature).

## 7. The Life of Blessed Hedwig (Vita beatae Hedwigis)

*Bohemian Lands, 1353*
*Tempera and ink on parchment, 204 fols., 34.1 x 24.8 cm (13⅜ x 9¾ in.)*
*Provenance: Duke Ludwig I of Legnica and Brzeg, 1364–98; Convent of Saint Hedwig, Brzeg, 1398; J. Breuner, 1630; Duke Julius Heinrich von Sachsen Lauenburg, Schlackenwerth Castle, near Karlsbad, mid-17th century; his daughter, Maria Benigna, 1665; Piarist monastery, Schlackenwerth, 1701; Municipal Library, Schlackenwerth, 1876; Gilhofer and Ranschburg, Vienna, purchase, 1910; Ritter von Guttmann, Vienna; confiscated 1938; Österreichische Nationalbibliothek, Vienna, and Altaussee, during World War II; Ritter von Guttmann, Royal Oak, Canada, restituted 1947; H. P. Kraus, New York, purchase 1964; Ludwig collection, Cologne; Getty Museum, purchase 1983.*
*J. Paul Getty Museum, Los Angeles (Ms. Ludwig XI 7; 83.MN. 126)*

7, fol. 12v (detail)

Canonized in 1267, the Silesian duchess Hedwig (1174–1243) was the holy ancestor of Duke Ludwig of Legnica and Brzeg, who commissioned this manuscript. A vassal of Charles IV and grandson of Wenceslas II of Bohemia, Ludwig was a patron of the arts and of the Church. He and his wife, Agnes, appear on the verso of folio 12 as small figures kneeling on either side of an exquisite image of Blessed Hedwig.[1] In a sense Hedwig's image conforms to a medieval tradition of portraying holy women busy at work as a function of their devotion. The Virgin Mary, for example, is often shown in the midst of contemplative reading when the angel Gabriel arrives to announce that she will bear the child Jesus (see cats. 39, 124), or she may be spinning yarn in preparation for the arrival of her child (see cat. 95).

Here, the depiction of the holy woman has even greater intensity. The comely Hedwig, mother of seven, is gracefully unencumbered by all that she juggles in her arms: a rosary hanging from her bodice and caught beneath her palm; a prayer book in her hand, with her fingers holding her place; shoes draped over her arm to allow her to walk humbly with bare feet, as was her custom; and, above all, a statuette of the Virgin and Child clutched to her chest. This last object represents an ivory image (similar in type to cat. 8) celebrated in the saint's legend for its power to heal; Hedwig had it clutched in her hand when she died, and it was interred with her.[2]

Hedwig, like Ludmila, was the female equivalent of a royal saint such as Louis of France. She resembled Louis in that she was renowned for her self-denial, her good deeds, including the care of prisoners and the sick, and her charitable foundations, among them a leper hospital. As such, she was an exemplar to her successors and a wellspring of royal authority. In advancing Hedwig's cult, Duke Ludwig asserted his heritage and his piety, much as Charles IV did with his Bohemian ancestral saints, Ludmila and Wenceslas.

Silesia had become one of the Crown Lands of Bohemia under John of Luxembourg, and Duke Ludwig's cultural links to the court at Prague are manifest throughout the manuscript. Its scribe, Nicholas, was notary to Bishop Przeclaw of Pogorzela (r. 1341–76), an associate of Charles IV.[3] It has been suggested that the image of Hedwig derives from a wall painting in the Church of Saint Thomas in Prague.[4] Although the rather ponderous, fanciful architectural backdrop is a common device in Bohemian art (see cats. 17, 21, 26, 95), the dialogue with Prague is more persuasively evidenced by Hedwig's particular kind of beauty. With her curls gently falling at either side of her face, her elegant nose descending from the gentle arc of her brows, her tiny rosebud mouth, and her long neck, she is the counterpart in manuscript painting of the reliquary busts of Saint Ludmila (cat. 6) and another female saint (cat. 3) as well as of the Virgin and Child in the Národní Galerie, Prague (cat. 9), and images of the Virgin from the Vyšší Brod cycle (fig. 3.2).[5]          BDB

1. Gottschalk 1964.
2. Cologne 1978–79, vol. 3, p. 234.
3. Drobná (n.d., p. 33) transcribes the scribal note as "per manus Nicolai Pruzie foris civitatem Lubyn" (by the hand of Nicholas of Prussia outside the city of Lubyn).
4. Euw in Cologne 1978–79, vol. 2, p. 508.

5. The comparison with the Annunciate Virgin is particularly apt. See Pešina 1982. The links were noted by Karłowska-Kamzowa (1980, p. 160).

LITERATURE: Wolfskron 1846; Braunfels 1972; Euw and Plotzek 1979–85, vol. 3 (1982), pp. 74–81, no. XI 7 (with extensive bibl.); Kren et al. 1997, pp. 58–59, no. 23; Essen–Bonn 2005, no. 249.

## 8. Virgin and Child

*Paris(?), beginning of 14th century*
*Ivory on gilded base with rock crystal aperture,*
*h. 18 cm (7 in.), with base 25.5 cm (10 in.)*
*Condition: Child's head and arm, two crowns, and*
*base replaced.*[1]
*Metropolitní Kapitula u Sv. Víta, Prague (HS 3339*
*[K15])*

Although it is apparently not listed in the early inventories of Saint Vitus's Cathedral treasury, this statuette is typical of the French images of the Virgin and Child that were available to Bohemian sculptors. The principal vantage point from which to view this Virgin and Child is from the front, so that the Child is seen almost entirely from behind. The sculptor appears to have exploited the curvature of the elephant tusk, which gives so many figures of about 1300 a swinging motion to the side. Here, Mary leans away from the Child. As a result, and unlike most statuettes of the early fourteenth century, this figure can be viewed from multiple vantage points. Only when the Virgin is seen from the left, for example, does one see the Child's face, the orb, and especially the hand she lays on the Child's breast, a gesture laden with meaning that has its origins in the Virgin on the trumeau of the north transept of Notre-Dame in Paris.[2]

One of the striking features of this group is the Virgin's billowing mantle, with its deeply carved, voluminous folds. The handling of the pose and drapery is astonishingly similar in a diptych leaf depicting the Virgin and Child between adoring angels and standing upon a dragon that was carved in Paris in the early fourteenth century.[3]

Much of the art of the Prague court about 1300 emulated the aesthetic of Paris under the saintly King Louis (1214–1270). One might therefore speculate that this ivory statue, which was probably carved in Paris, the internationally esteemed and well-documented center for ivory carving, was acquired by Charles IV, one of his royal Bohemian ancestors, or a prelate in Prague at an early date.[4]

JF

8

1. The relic behind the rock crystal window in the base remains unidentified.
2. Sauerländer 1970, pl. 188.
3. See Gaborit-Chopin 2004.
4. The cathedral treasury includes, for example, Parisian niello work of the time of Philip the Fair of France. See Podlaha and Šittler 1903, pp. 88–89, no. 68.

LITERATURE: Podlaha and Šittler 1903b, pp. 20–21, fig. 55; Koechlin 1924, vol. 2, p. 235; Paris 1998, pp. 89–93, 103–5, 132–33.

## 9. Virgin and Child

*Prague, ca. 1350–55*
*Tempera, oil, and gold on canvas-covered beech panel;*
*21 x 16.5 cm (8¼ x 6½ in.)*
*Provenance: Private collection, Rome; sold to Národní*
*Galerie, 1927.*[1]
*Národní Galerie, Prague (O 1439)*

This panel was once part of a diptych, although one would hardly know that from the composition. Contrary to tradition, the

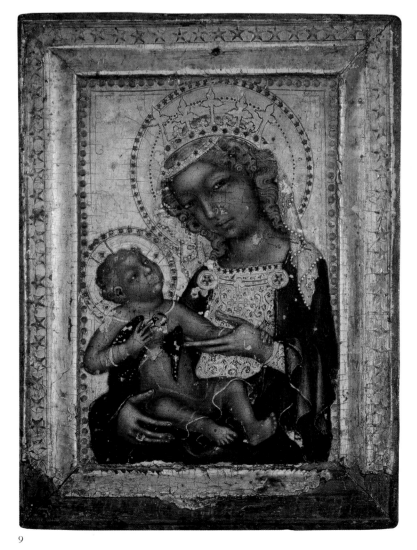

9

second wing, probably with a Man of Sorrows, was placed to the left of the Virgin, as in the diptych in the Kunstmuseum Basel.[2] The panel is a diminutive, arguably private version of the Zbraslav Virgin and Child (cat. 5). The Virgin's facial characteristics are somewhat childlike but also very sensual. The Child appears to be sitting on the frame as if on a parapet,[3] which allowed the artist to interpret the gesture of the Virgin's right hand not as holding but rather as embracing and sheltering. In a motif reminiscent of Duccio's Franciscan Madonna (Pinacoteca Nazionale, Siena), the Virgin wraps her mantle around the Child, a gesture related to her role as protectress (the Madonna of Mercy).[4] The painter chose a very old-fashioned type of mantle, the tassel or wheel mantle first introduced under the French king Philip Augustus in the early thirteenth century. Secured at the shoulders but open in front, it allows the richly ornamented golden gown to be seen. The golden cross hanging from the mantle's clasp foreshadows the Passion of Christ, as does the goldfinch that is actually biting the little boy on his middle finger. The ring on the Virgin's finger refers to her mystical marriage with Christ.

The pigments employed here were less costly and the punchmarks and tooling are simpler than those in the Zbraslav panel. But the amount of technical labor required in the process of painting was almost as great. As in the prototype, many layers of thin glazes were laid over a network of the thinnest possible lines incised in the chalk ground. The result is a luminous, shimmering surface. This refined aesthetic has been marred by the discoloration of the lead white, which makes the Child's chemise appear more transparent and lends an overall brownish tonality to the painting. The Virgin's fingers are thinner and more elegant here than in the Zbraslav painting. Her circlet and her crown, with its slender, elongated lilies, reflect a form that was current about 1350–55, when this painting was produced.[5]

RS, JF

1. Claussen 1980, p. 297.
2. Camille 1996, pp. 115–17; Suckale 2003b, pp. 103–18.
3. The motif also appears on folio 18v of the model book in the Herzog Anton Ulrich-Museum, Braunschweig (Cologne 1978–79, vol. 3, pp. 137, 139, 142–43, ill.; Scheller 1995, no. 18, figs. 94–97, 99–101; and see also fig. 99.1).
4. Belting-Ihm 1976.
5. For the type of crown, see also a drawing of three kings in the Herzog Anton Ulrich-Museum, Braunschweig (z 53; Nuremberg 1978, no. 26, ill.).

LITERATURE: Matějček and Pešina 1950, no. 22, fig. 48; Schmidt 1969b, p. 206; Pešina 1977, pp. 142–43.

## 10. Reliquary Statuette of the Man of Sorrows

*Prague(?), 1347*
*Gilded silver; h. 31 cm (12¼ in.), base 21 x 11.5 cm (8¼ x 4½ in.)*
*Inscribed on the base: HANC MONSTRANCIAM CUM SPINA CHORONE DOMINI DNS IOHANNES OLOMUCZENSIS EPISCOPUS PREPARARI FECIT (This monstrance with the thorn from the Crown of Our Lord was commissioned by Master Jan, the Bishop of Olomouc).*
*Provenance: [Jacques Seligmann, Paris]; Henry Walters, acquired 1903.[1]*
*Walters Art Museum, Baltimore (57.700)*

The reliquary statuette was commissioned by the bishop of Olomouc, Jan VII, called Volek (r. 1334–51), whose coat of arms is fastened to the rear left corner of the rectangular base.[2] One of the highest Church officials at the court of John of Luxembourg, Volek strongly supported the young Charles IV from his return to Bohemia in 1333 until his accession to the Bohemian and imperial thrones. At the beginning of his career, starting in 1319, as provost of the Vyšehrad Chapter he simulta-

neously held the post of chancellor of the kingdom of Bohemia; later, he also served as a diplomat in the service of the Luxembourgs. In 1350 he was entrusted with the receipt of the imperial treasure and its delivery to Prague. The close relationship between Charles IV and the bishop doubtless sprang as well from their being related by blood: as an illegitimate son of King Wenceslas II, Volek was also a half-brother of the emperor's mother, Elizabeth Přemysl, and the last living member of the ancient Přemyslid dynasty, the historical tradition of which Charles regarded highly.

The coats of arms on the base bearing the imperial eagle, the two-tailed lion of Bohemia, and the Moravian eagle are obviously references to Charles, therefore establishing the date of manufacture as between August 1346 and December 1349, for Charles's reign as Holy Roman Emperor began with his election in Rhense on July 11, 1346. He became king of Bohemia upon his father's death at the Battle at Crécy on August 26 of the same year, and he remained the margrave of Moravia until December 26, 1349.

Moreover, these coats of arms indicate that the king and the bishop were both associated

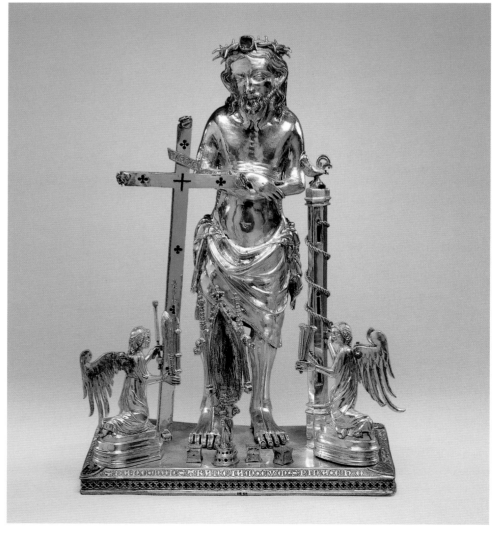

with the Baltimore reliquary statuette, most likely through a relic of the crown of thorns. This sacred item almost certainly came from the estate of Elizabeth Přemysl, who received it in 1326 from the French king Charles IV the Handsome.[3] After Elizabeth died in Volek's house in 1330, he may have kept the thorn.[4] Alternately, Charles IV also could have claimed the relic, so that Volek would have needed the king's consent when, toward the end of his life, he decided to donate it, probably to the Benedictine convent in Pustiměř, Moravia, which he had founded in 1340 for the salvation of the souls of Elizabeth and her parents.[5] While the bishop repeatedly lavished gifts of vestments, chalices, and holy relics on the convent,[6] Charles had also participated in its foundation through the gift of lands and the granting of privileges in 1341 and 1342, while he was still margrave of Moravia.[7] This is perhaps why the base of the reliquary includes Charles's arms as margrave, even though as king he no longer used this title in official documents. At the outset of the Hussite Revolution, the Pustiměř Benedictines entrusted their treasury to their fellow sisters at the Convent of Saint Dorothy in Vienna, where its presence was recorded only until 1469.[8] Whether it was returned to the original convent, which ceased to exist at the end of the sixteenth century, is unknown.

This remarkable example of the medieval goldsmith's art marries the function of a reliquary with that of a devotional image as a means to help the viewer experience the mystery of Jesus' sacrifice. Clad only in a loincloth, with a crown of thorns on his head and his arms folded on his chest as if in a tomb, this Man of Sorrows is surrounded by the instruments and symbols of his martyrdom (arma Christi). At his sides are the cross and the pillar to which he was tied while being scourged, as well as angels bearing cudgel, scourge, and hammer on the left and three nails on the right. Other emblems of the Passion shown here are the rope with which Jesus was tied to the pillar, the cock that crowed after Saint Peter denied knowing him, and the dice the soldiers used to cast lots for his tunic. The thorn from the crown of thorns mentioned in the inscription was obviously kept in the monstrance held by the tiny angel kneeling at the center of the group.

The Baltimore reliquary is a particular representation of the Man of Sorrows, an iconographic motif, which was inspired by the late medieval reverence for the Passion. The so-called Passional of the Abbess Cunigunde (see fig. 1.3), compiled by a Dominican named Kolda, a contemporary of Master Eckhardt, testifies that by the second decade of the fourteenth century this form

of religiosity was intensely cultivated.[9] Its chief proponents in the capital were apparently the surviving members of the Přemyslid dynasty, such as Cunigunde, the abbess of Saint George's Convent in Prague (1302–21), who was the daughter of Přemysl Otakar II; her great-niece, Queen Elizabeth, Charles's mother; and Bishop Volek. To this group unquestionably also belonged Volek's sister Elizabeth. Originally a Cistercian nun in Pohled, she entered the Benedictine Convent of Saint George in 1332 and became the first abbess of Pustiměř in 1340.[10]

The Baltimore statuette of the Man of Sorrows is the only surviving example of this kind of Bohemian goldsmithing work. It was most assuredly created in proximity to the royal court, where Bishop Volek primarily resided and where other reliquaries were being produced during this period.[11]               KO

1. Two restamped hallmarks on the front side of the base, probably from Brno, attest that the object belongs to the church silver confiscated between 1806 and 1809 by the Austrian state and earmarked to be melted down (Stehlíková 2001, p. 194).
2. The identity of the Jan, bishop of Olomouc, named in the inscription was at first unclear. Berliner (1955, pp. 63, 129n299) believed him to be Jan X Soběslav (r. 1387), while Verdier (1973, p. 329) took him for Jan IX of Středa (r. 1364–80). In 1977, on the basis of sphragistical data, Zelenka ascribed this coat of arms to Jan Volek; see Zelenka 1979, p. 197, and Cologne 1978–79, vol. 2, p. 703. Volek's seal of 1340, bearing his own coat of arms and that of the bishopric, is reproduced in Spěváček 1979, ill. 33. For further reading see Hlobil 1987.
3. Zbraslav Chronicle, FRB 1884, p. 280.
4. Stehlíková 2001, p. 194.
5. Codex diplomaticus et epistolaris Moraviae, vol. 7 (1858–68), p. 209.
6. Granum catalogi praesulum Moraviae (Loserth 1892, p. 87): "Hic monasterium . . . ornamentis nobilibus, calicibus et sanctorum reliquiis . . . magnifice et multipliciter decoravit" (He [Volek] magnificently and repeatedly embellished this monastery by means of splendid ecclesiastical utensils, chalices, and relics).
7. Regesta diplomatica nec non epistolaria Bohemiae et Moraviae, vol. 4 (1892), pp. 393–94 (no. 989), 429 (no. 1062), 438 (no. 1081). His charters and those of his father to the Pustiměř convent were confirmed by Charles IV on August 28–30, 1348. Regesta diplomatica nec non epistolaria Bohemiae et Moraviae, vol. 5 (1958–60), pp. 231–36 (nos. 455, 457, 458).
8. Stehlíková 2001, p. 196.
9. Národní Knihovna, Prague, UK XIV A 17, fols. 3r (the emblem arma Christi), 6r–8v (illustrated description of the Sorrows of Christ with special emphasis on the previously mentioned instruments and symbols), 10r (instruments and symbols of Christ's Passion); see Urbánková and Stejskal 1975, pp. 11–16.

10. Codex diplomaticus et epistolaris Moraviae, vol. 7 (1858–68), p. 209; Hledíková 2001, pp. 83, 88n73. Also relevant in this respect is the fragment of a fresco showing the Man of Sorrows surrounded with symbols of the Passion in the lower chapel of the House at the Stone Bell, Prague, which in the first half of the fourteenth century probably served as a royal residence (Benešovská 1998, p. 129, fig. 9).
11. Among these were five reliquary statuettes portraying the apostles that Charles bestowed in 1350 to the treasury of Saint Vitus's Cathedral.

LITERATURE: Berliner 1955, pp. 63, 129n299; Verdier 1973; Schiedlausky in Nuremberg 1978, no. 92; Otavsky in Cologne 1978–79, vol. 2, pp. 702–3; Zelenka 1979, pp. 196–98; Fritz 1982, p. 223, fig. 264; Stehlíková 2001, pp. 194–96.

## 11. Reliquary of the Five Brother Martyrs

*Reliquary: Prague, late 13th century–1315; case: before 1901*
*Gilded silver and translucent enamel strips in later wood and glass case, 35 x 29 x 7.5 cm (13¾ x 11⅜ x 3 in.)*
*Condition: Silver sheet and enamels reaffixed at some point; case restored about 1975.*
*Kolegiátní Kapitula Sv. Kosmy a Damiána, Stará Boleslav (A 112)*

In about 1001–2 two missionary monks of the Camaldolese Order left Pereo, near Ravenna, and traveled via Prague to the Polish borderland, where they founded a monastery. They were eventually joined by two Polish monks, Matthew and Isaac, and a cook named Christian and his brother Barnabas. In 1004, five of the six were murdered during a raid on the monastery. (Only Barnabas, who was away at the time, escaped.) The bodies of the martyrs were carried to the cathedral in Gniezno, and in 1008 the Five Brother Martyrs were declared patron saints of Poland.[1]

When he invaded Gniezno in 1039 the Bohemian duke Břetislav took from the cathedral not only the bodies of the five monks but also the relics of Saint Vitus and Saint Gaudentius. As penance, Pope Benedict IX (r. 1032–45) assigned to Břetislav and the bishop of Prague, Šebíř (r. 1030–67), the task of building and furnishing a chapter church. Stará Boleslav, just northeast of Prague, was chosen as the appropriate place. With its early Přemyslid settlement lying on an ancient road leading from Prague to Zittau, the town was already famous as the residence of the Bohemian duke Boleslav I (r. 929–67) and as the place where Boleslav's brother, King Wenceslas, was martyred

11

in 935. The new structure, which incorporated the existing Church of Saints Cosmas and Damian, was consecrated to Saint Wenceslas in 1046, and in 1052 Břetislav had the bodies of the Five Brother Martyrs transferred there.[2] Sometime between 1126 and 1150 Jindřich Zdík, bishop of Olomouc, took Christian's body from Stará Boleslav to Olomouc. His relics remain in the treasury of Prague Cathedral to this day in a gold panel reliquary dating to about 1215, when the brothers were declared patron saints of Bohemia. Legends continued to link their fates to that of Saint Adalbert; as a result, other venerated relics were in the treasuries of the Benedictine monastery in Břevnov and the Benedictines of the Convent of Saint George in Prague Castle[3] and in a silver panel at the Premonstratensian monastery in Teplá, near Mariánské Lázně, which was melted down in a mint in 1806. The martyrs are depicted on one of the panels by Master Theodoric in the Holy Cross Chapel in Karlštejn Castle.[4]

This reliquary panel from the church at Stará Boleslav holds arm bones of the other four martyrs. The bones are embedded in a wood panel covered with gilded silver sheets decorated with pierced tracery motifs. According to an inscription that was still on the panel in 1677, the reliquary was commissioned, or perhaps merely remodeled, in 1315 to celebrate the centennial of the canonization of the Five Brother Martyrs.[5] (It is evident that the repoussé silver sheet and enamels have been reaffixed at some point.) The donor could have been Jan IV of Dražice, bishop of Prague (r. 1301–43), an adherent of the cult of the Bohemian saints and benefactor of the Stará Boleslav church chapter, or perhaps the knight Janda of Hlavno (d. 1337),

who presented an altar dedicated to the Five Brother Martyrs to the Basilica of Saint Wenceslas in Stará Boleslav.[6]

The medallions decorating the frame depict four different scenes of vintners at work that evoke both the Garden of Earthly Delights and the parable of the laborers in the vineyard (Matt. 20:1–6). Medieval illuminators, stonecutters, and goldsmiths all used such scenes, sometimes in cycles illustrating the seasons of the year. These detailed and descriptive compositions are typical of others that can be dated to about 1300, and the figures' tunics are characteristic of the same period.[7]  DS

1. Nový, Sláma, and Zachová 1997, pp. 427–28.
2. Transcript of twelfth-century foundation letter cited in Friedrich 1904–7, vol. 1, p. 362, no. 382.
3. Raymund 1782, p. 247.
4. Fajt 1998, p. 450.
5. The panel was recorded in the church inventory of the chapter of 1564 (Ryneš 1962, p. 300). In 1677 (p. 43) Balbín recorded the inscription engraved on the panel's side: "A.D. 1315 inclusa sunt ista brachia ss. Quinque Fratrum ad honorem Dei nostri Jesu Christi et ipsorum gloriam sempiternam et ad consolationem" (A.D. 1315 these arms from the Five Holy Brothers were enclosed for the honor of our God Jesus Christ and his everlasting glory and consolation). The panel was altered again in 1901, and after that the inscription was no longer present (see Podlaha and Šittler 1901, pp. 52–53). Without performing a dendrochronological analysis, it is impossible to determine the age of the wood panel.
6. Emler 1892, p. 159. Poche (1972, p. 239) misread the Saint Vitus inventories and mistakenly proposed that this panel was created in the Břevnov Monastery workshop and that it was intended originally for the treasury of Prague Cathedral (see also Týž 1984, vol. 1, pt. 2, p. 450). Fillitz (1977, p. 254) placed the origin of the reliquary in Venice.
7. Unlike the tiny figures on the frame of the portal depicting the legend of Saint Adalbert in

Gniezno Cathedral, who are either shown climbing in the branches or who represent biblical figures like Joshua and Aaron, these wine growers are carrying out concrete chores.

LITERATURE: Balbín 1677, p. 43; Podlaha and Šittler 1901, pp. 52–53; Fillitz 1977, p. 254; Poche 1972, p. 239; Stehlíková in Prague 1997, no. 10.

## 12. Reliquary Tablet

*Probably Prague, second half of 14th century*
*Gilded silver and glass, silk, parchment, and paper;*
*17.8 x 17.8 x 2.1 cm (7 x 7 x ¾ in.)*
*Engraved in Latin on frame: It[em] ★ relikvi[a]e ★ s[an]c[t]a[e] ★ dorothe[a]e ★ bartholomei ★ margareth[a]e ★ mat[h]ei. ap[osto]li / agath[a]e .v´[irginis] . andre[a]e ★ ap[osto]li ★ blasii ★ m[ar]t[yri]s . georgiy ★ m[a]r[tyr]is ★ priste + v[irginis] ★ stepha / ni m[a]r[tyri]s + katherin[a]e + v[irginis] + ypolidus + liber. + de[x]tra ★ incon[is] + xpi [for christiani]+ i[n]ve[n]tu[m]+ / s[ancti] ★ we[n]czeslavi . mar[t]yri[s] ★ iacobi ★ ap[osto]li ★ maioris ★ mauricii . ex locoru[m] . cristofori / ludmill[a]e . m[a]r[tyr]is + agnietis . v[irginis] . de ligno + domi[ni] + tuni[c]a[e] Xpi + erasmi m[a]r[tyr]is / margareth[a]e . v[irginis] . decem mil[l]ia m[ar]t[y]rum [thebaeorum] . ad[a]lberti. m[a]r[tyris] . xi . mil[l]ia + v[irginum] . septem fr[atrum] m[artyrorum] / sixti pap[a]e et m[a]r[tyris] / oleu[m] sa[n]cti . nicolai / oleu[m] [sanctae] katherin[a]e ★ / procopi a[bba]tte / wale[n]tini m[a]r[tyris] . felic[i]s . / et adaucti m[a]r[tyrorum] . t[h]om[a]e (relics of Saints Dorothy, Bartholomew, Margaret, apostle Matthew, Agatha virgin, Andrew apostle, Blaise martyr, George martyr, Pris virgin, Stephen martyr, Catherine virgin, Hippolytus, free bone of right hand of unknown Christian, Saint Wenceslas martyr, James the Great apostle, Mauricius,*

12

from places of Christopher, Ludmila martyr, Agnes virgin, of the wood of God and Tunic of Christ; Erasmus martyr, Margaret virgin, ten thousand Theban martyrs, Adalbert martyr; eleven thousand virgins, seven martyr brothers, Sixtus pope and martyr, oil of Saint Nicholas, oil of Saint Catherine, Procopius abbot, Valentine martyr, Felicius and Adaucti martyrs, Thomas). Inscribed on labels on relics, from left to right, in top row: procopii m[ar]t[yris], Sancti procopii; Sancti venceslai; pars tunicae S[an]cti petri; in center row: s[anc]ti clementis; Sanctu viti m[a]r[tyri]s; s[an]ct[orum] q[u]inq[uorum] fr[a]tr[um]; in bottom row: sancti sygysmundi; ludmill[a]e; undecim mil[l]ia virginum (Procopius martyr, Saint Procopius; Saint Wenceslas; part of the tunic of Saint Peter; Saint Clement; Saint Vitus martyr; Five Holy Brothers; Saint Sigismund; Saint Ludmila; eleven thousand virgins). Painted on back of bottom panel: 171 (some losses of gilding).
Provenance: Goldsmiths' Guild, Prague; lent to Národní Muzeum by Association of Prague Goldsmiths, Silversmiths and Jewelers, 1876; acquired by Národní Muzeum, 1946.
Národní Muzeum, Prague (H2-60.706)

Bundled in colored silks and carefully labeled, the relics of saints are framed like jewels behind windows of glass that probably replaced panes of rock crystal. Among the packets are relics of Saints Ludmila, Vitus, Wenceslas, Procopius, and Sigismund, all considered patrons of Bohemia. The names of Saint Adalbert and the Seven Holy Brothers, also particularly venerated in Bohemia, appear among the many apostles and martyrs named in the inscriptions framing the relics. The form of the reliquary is conservative; examples of similar form dating from the mid-thirteenth century were contained within the Grande Chasse of the Sainte-Chapelle in Paris.[1]

This reliquary belonged to the guild of Prague goldsmiths and appears in the guild's inventory of 1680.[2] Given the history of its ownership, it was most likely of Bohemian manufacture, like the reliquary of the miter of Saint Eligius (cat. 62) that the guild made after receiving the relic from Charles IV. Guild records document the practice of displaying relics in the Chapel of Saint Eligius (the patron saint of goldsmiths) on Platnéřská Street in the Old Town (Staré Město) on the saint's feast day, June 25, for the benefit of all citizens.

DS

1. Durand in Paris 2001a, esp. p. 121, ill. p. 131.
2. Beckovský 1879, vol. 1, p. 650; Teige 1915, vol. 2, p. 387.

LITERATURE: Beckovský 1879, vol. 1, pp. 596–601; Teige 1915, vol. 2, pp. 387–88.

## 13. Virgin and Child with Saint Wenceslas

Prague(?), 1360–65
Ink and colored washes on parchment, 26.5 x 19.5 cm (10⅜ x 7⅝ in.)
Provenance: Possibly Queen Christina, 1625; Swedish royal collection by descent.
Royal Library, National Library of Sweden, Stockholm (A 173)

The history of this drawing, set into a later prayer book of Bohemian origin that includes texts by Archbishop Jan of Jenštejn, is difficult to deduce. Yet its artistic links to the court of Charles IV are indisputable. Saint Wenceslas, portrayed as usual as a young duke, hovers near the Virgin Mary, who sits on a sketchily rendered throne holding the infant Jesus. The

saint's legs are truncated, seemingly as a result of the artist's attempt to suggest his placement in space above and behind the Virgin's throne. The disposition of the figures and also the Virgin's drapery recall the Votive Picture of Jan Očko of Vlašim of 1371 (fig. 8.4). The Child's distinctive head as he turns to look at his mother is remarkably close to that of the Child on the Karlsruhe Diptych,[1] though the overall pose is less contorted. The exceptionally modish representation of Saint Wenceslas, with his small waist, leather lentner, and mail shirt with high collar and protruding hem,[2] is common to images of the 1360s, whether the wall paintings of the Luxembourg Genealogy at Karlštejn[3] or the monumental figure of Rudolf IV, son-in-law of Charles IV, on the Singertor of the Cathedral of Saint Stephen in Vienna.[4] The swayed-back stance of the figure of Rudolf, his arm akimbo as he grasps the

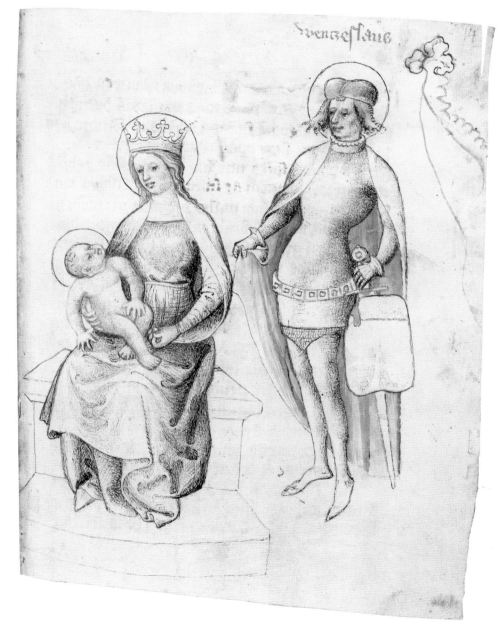

13

sword at his belt, echoes the pose of Saint Wenceslas in the drawing. JF

1. Cologne 1978–79, vol. 2, p. 764.
2. With thanks to Dirk Breiding for these observations.
3. Kutal 1971, fig. 83.
4. Brucher 2000, no. 97, ill. p. 77.

LITERATURE: Drobná 1956, p. 43, pls. 62, 63; Stejskal 1978b, pp. 121, 125, fig. 101.

## 14. Glove of Saint Adalbert

*Embroidery: Prague, 1370–90*
*Silk thread and pearls, 29.5 x 16.5 cm (11⅝ x 6½ in.)*
*Provenance: First recorded in inventory of Church of the Assumption, Stará Boleslav, 1564.*
*Kolegiátní Kapitula Sv. Kosmy a Damiána, Stará Boleslav (B 026)*

Bust-length images of Saints Peter and Paul flank the blessing Christ on the cuff of this single glove legendarily associated with Adalbert, the first Czech bishop of Prague, who was canonized in 999. Both the glove and the embroidery have been variously attributed in earlier literature. With its patterned gold ground, tiny pearls, and skillful figural embroidery, the cuff typifies the accomplished needlework of Prague during the reigns of Charles IV and Wenceslas IV.

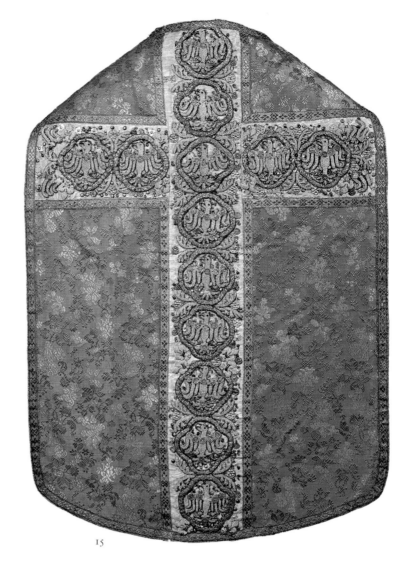

15

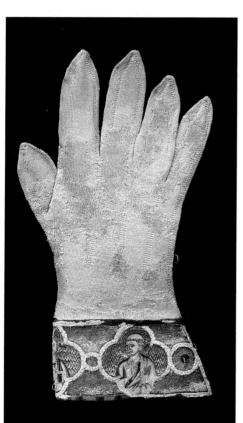

14

From the time of the apostles, bishops have been consecrated in a ceremony during which each incumbent in attendance lays his hands on the head of the individual being installed. This ceremony links the new prelate to his predecessors in a continuous line that traces back to Jesus' disciples. The hands of a bishop are therefore imbued with spiritual power. Thus, it is not surprising that only bishops and cardinals are unequivocally entitled to glove their hands and that putting gloves on the new bishop was part of the consecration liturgy.[1] The representation of Peter and Paul serves here as a patently visible reminder to the wearer of his mission. This particular emblem of episcopal office is also an important relic of a patron saint of Bohemia. BDB

1. *Catholic Encyclopedia* (http://www.newadvent.org).

LITERATURE: Podlaha and Šittler 1901, pp. 47–49; Prague 1997, p. 80, no. 12 (with bibl.); Stehlíková 2005.

## 15. Chasuble with Eagles

*Embroidery: Prague, 1350–1400; chasuble: Lyon, ca. 1700*
*Chasuble: silk; embroidery: silk and metal threads, laid and couched work on linen ground, river pearls, coral, gilded brass, and silver sequins; dorsal 107 x 74 cm (42⅛ x 29⅛ in.), pectoral 76 x 65 cm (29⅞ x 25⅝ in.)*
*Inscribed: O.H.A.M. [monogram], 1701 (reference to Abbess Ottilia Hentschel and the date of remounting).*
*Provenance: Convent of Saint Marienstern, since 18th century.*
*Zisterzienserinnen-Abtei Sankt Marienstern, Panschwitz-Kuckau, Germany*

Embroidered orphreys, the bands that decorate the chasuble worn by the priest during the celebration of the Mass, were often precious enough to warrant reuse on new liturgical vestments centuries after their creation. Such is the case with this eighteenth-century chasuble of Lyon silk preserved in the Convent of Saint Marienstern. The tiny freshwater pearls, thickly clustered to form single-headed

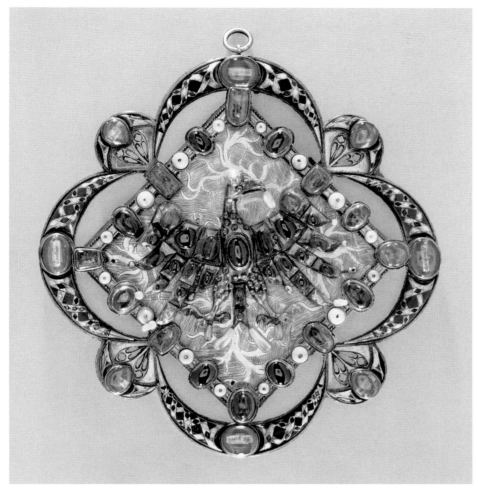

16

The settings of the stones decorating the perimeter of the central square relate to examples distributed throughout Europe between about 1325 and 1350 but found primarily in France and in German-speaking lands. The geometric or lozenge-shaped mounts that form the bird's wings have been associated with Venetian goldsmiths' work, such as the fourteenth-century embellishments to the Pala d'Oro (Basilica of Saint Mark, Venice).[4] However, a reliquary of Jesus' manger attributed to Prague sometime after 1368, when Pope Urban V gave the relic to Charles IV, is decorated with gems mounted in a similar manner.[5]

Fig. 16.1 Henry IV Parler, painted by Master Oswald. Saint Wenceslas. Saint Wenceslas Chapel, Saint Vitus's Cathedral, Prague. Marly limestone with paint; Prague, 1373. Metropolitan Chapter of Saint Vitus's Cathedral, Prague

eagles, are a rare surviving testament to the use of this material not merely to provide decorative accent but also to execute images in relief. In the 1355 inventory of Saint Vitus's Cathedral, which lists new chasubles given by the emperor and empress, other members of the court, and the Church hierarchy, only those from Charles IV and his wife, Anna, are described as rich with pearls in the manner of the Marienstern embroideries. Charles's chasuble was decorated with lions and eagles, heraldic devices of Bohemia and the Holy Roman Empire; that of the empress with two large fish made of pearls.[1] The single-headed eagles on the Marienstern chasuble are apparently emblematic of Saint Wenceslas, and thus of the lands of the Bohemian Crown, in which the prosperous Cistercian convent lay. This embroidery might have been realized by the nuns themselves or ordered in Prague, where a number of works were painted for the convent at that time.

BDB

1. Podlaha and Šittler 1903a, p. XIX, nos. 244, 245.

LITERATURE: Wetter in Panschwitz-Kuckau 1998, pp. 184–85, no. 2.125 (with bibl.).

## 16. Reliquary with the Eagle of Saint Wenceslas

*Bohemia, ca. 1350–75*
*Gilded, engraved, pierced, and enameled silver (red and black opaque and green translucent enamel) with rubies, sapphires, amethysts, garnets, rock crystal, glass, and pearls;[1] modern suspension ring; h. 18.5 cm (7¼ in.), l. 18.5 cm (7¼ in.), h. with ring 20 cm (7⅞ in.)*
*Provenance: Louis-Fidel Debruge-Duménil, Paris (sale, Hôtel Drouot, Paris, 1850, lot 981); Prince Petr Soltykoff, Paris, 1850–61 (sale, Hôtel Drouot, Paris, April 1861, lot 211, to Edmond du Sommerard for Musée National du Moyen Âge).*
*Musée National du Moyen Âge, Thermes et Hôtel de Cluny, Paris (Cl. 3292)*

Decorated with a profusion of pearls and precious and semiprecious stones, this magnificent reliquary represents a unique type in medieval Bohemian goldsmiths' work. Relics were originally set in the glass-covered mounts that decorate the eight lobes framing the eagle.[2] Parchment strips still proclaim the names of saints.[3] The back of the reliquary has two large bars that would have allowed for its attachment.

The single-headed eagle was the ancient arms of Bohemia and the particular attribute of Saint Wenceslas, protector of that kingdom.[6] Representations of this heraldic motif, also against a flame-pattern background, are found on the Bohemian Mühlhausen Altarpiece in Stuttgart, the tomb of Břetislav I in Saint Vitus's Cathedral, Prague, and the shield held by the sculpture of Saint Wenceslas in the saint's chapel in Saint Vitus's (fig. 16.1).[7]

Throughout its history, this celebrated work has been described as a reliquary brooch that would likely have been worn at the chest or neck to hold a cloak or tunic. It could also have been created as a plaque to decorate a belt, like the eagle that serves as a buckle on the figure of Saint Wenceslas at Saint Vitus's. Charles IV used the single-headed eagle after his coronation as king of Bohemia in 1347 and until his imperial coronation in 1355; his son Wenceslas IV took it as his insignia in 1363.[8] The combination of the single-headed eagle emblematic of the Bohemian king with holy relics and precious materials suggests a possible link either to Charles IV himself or to his son.

CEB

1. For a detailed description of the gems, see Taburet-Delahaye 1989, p. 248.
2. Taburet-Delahaye (ibid., pp. 248–50) has compared the enameled lobes to those on a brooch in the Treasury of Aachen Cathedral given by Louis I of Hungary probably between 1367 and 1381 (Lightbown 1992, pl. 103). The four small fan-shaped lobes on the Cluny reliquary have pierced Gothic tracery. Similar piercing appears on cat. 66. I thank Barbara Boehm for calling my attention to these works.
3. According to Taburet-Delahaye (1989, p. 248): Martin, Andrew, Margaret, Nicholas, Peter, Hippolytus, Constantine, and Lawrence.
4. Kraft 1971, p. 105; Munich–Nuremberg 1978, no. 96; Taburet-Delahaye 1989, p. 250; Taburet-Delahaye 1994, pp. 151, 158.
5. See Cologne 1978–79, vol. 2, p. 706. Venetian-type mounts were also used on the Klosterneuberg chalice, dated to 1337 and thought to be by a Viennese goldsmith (Fritz 1982, no. 244), and the reliquary bust of Saint Ermagore in the Cathedral of Gorizia, given to the Basilica of Aquileia by Patriarch Bertrand in 1340 (Rossi 1956, p. 20, fig. 6). Charles IV's half brother Nicholas of Luxembourg succeeded Bertrand as patriarch of Aquileia in 1350 (see www. hostkingdom.net/noritaly.html).
6. Kraft 1971, p. 105; Seibt 1978a, p. 312.
7. Fajt 1998, p. 272, fig. 217; Benešovská and Hlobil 1999, fig. 4, p. 87.
8. On the use of the single-headed eagle on coats of arms by kings without imperial authority, see Leonhard 1978, p. 195.

LITERATURE: Shaw 1843, pl. 88; Du Sommerard 1838–46, vol. 5, pp. 277, 406, album, pl. 24; Labarte 1847, no. 981, ill.; Jacob 1848–51, vol. 3, orfèvrerie f. 14, ill.; Labarte 1864–66, vol. 1, pl. 54, no. 4, vol. 2, pp. 381–2; Corblet 1868, p. 500; Viollet-le-Duc 1871–75, vol. 3, p. 14; Champeaux 1889–98, vol. 2, pl. 131; Evans 1953, p. 66, pl. 22; Kraft 1971, pp. 102–13, pl. 6; Munich–Nuremberg 1978, no. 96; Seibt 1978a, fig. 112; Taburet-Delahaye 1987; Taburet-Delahaye 1989, pp. 248–51, ill. 131; Lightbown 1992, pp. 227–28, fig. 122; Taburet-Delahaye 1994, pp. 29, 158, fig. 84.

## 17. The Coronation of the Virgin and The Way to Calvary

*Attributed to Sebald Weinschröter, Nuremberg, ca. 1355*
*Tempera and gold on oak panel, 35.2 x 25.1 cm*
*(13⅞ x 9⅞ in.)*
*Inscribed in Latin in the banderoles: Veni electa mea [et ponam in te thronum meum] / Dileldus meus ame[?] Loquidur.*
*Provenance: Convent of the Poor Clares, Nuremberg; Johann Peter Weyer, Cologne, by 1852; acquired by Städelsches Kunstinstitut, 1928.*
*Städtische Galerie im Städelschen Kunstinstitut, Frankfurt am Main (SG 443)*

This Coronation of the Virgin with a fragmentary image of the Way to Calvary on its reverse once formed part of the right-hand side of an altarpiece, probably about 150 centimeters high, with a sculpted image of the Virgin and Child at the center protected by hinged panels. The ensemble, only parts of which survive in Frankfurt am Main (this example), Berlin (Deutsches Historisches Museum; Staatliche Museen zu Berlin, Gemäldegalerie), and a private collection in the United Kingdom,[1] juxtaposed scenes from the lives of Christ and the Virgin with scenes from the lives of Saint Francis and Saint Clare. The altarpiece was probably made for the Convent of the Poor Clares in Nuremberg about 1355.

The painting of the altarpiece is of extraordinarily high quality, with punched gold grounds, elaborate fictive architecture,

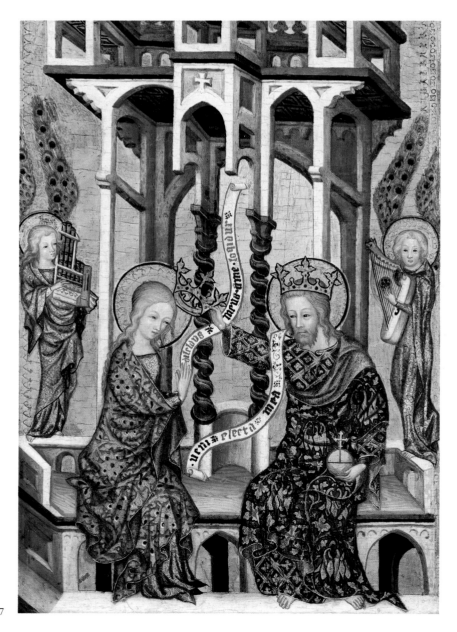

17

and figures dressed in beautiful vestments with painted, punched, and metallic details simulating costly fabric. The compositions contain echoes of Bohemian works created by artists in the immediate circle of Charles IV,[2] for whom the imperial city of Nuremberg was an important administrative, religious, and mercantile center. Given the ambitious nature of this altarpiece, the sophistication of its iconography, and the high price it must have commanded, it is logically attributable to Sebald Weinschröter, the Nuremberg painter who was in the service of Charles IV and who was probably the author of two drawings in the Germanisches Nationalmuseum, Nuremberg (fig. 1.8).[3]

The Coronation of the Virgin is a metaphor of the union between the Church and Christ. Seated on the heavenly throne, with music-making angels in attendance, Christ prepares to place a crown on the head of the Virgin Mary, his mother. Words corresponding to a well-known medieval hymn based on the Song of Songs appear on the banderole by his shoulder: "Come my chosen one [and I will place you on my throne]." Mary responds, in rather irregular Latin: "My beloved calls me." Beneath this scene would have been one of the Coronation of Saint Clare.                                        JF

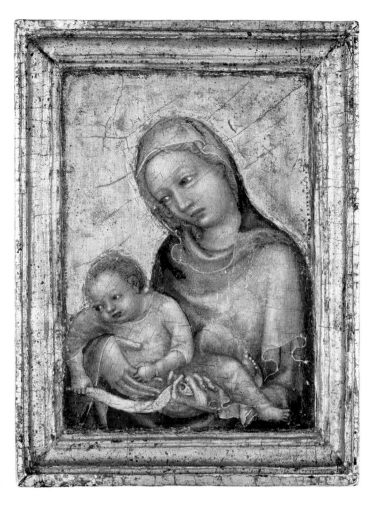

18

1. See Frankfurt am Main 2002 and Essen–Bonn 2005, no. 459.
2. The pose of Saint Joseph in the companion panel in Berlin, for example, bears some similarity to the image of Henry VII in the Luxembourg Genealogy that was painted on the walls of Karlštejn Castle (now lost but recorded in the Codex Heidelbergensis; see Fajt 1998, fig. 73).

17, reverse (top half of Way to Calvary)

3. My monograph about Sebald Weinschröter is in preparation.

LITERATURE: Stange 1934–61, vol. 1, pp. 116–18, fig. 115; Schmidt 1975, pp. 49–53; Brinkmann and Kemperdick 2002, pp. 33–54; Frankfurt am Main 2002; Fajt 2004; Essen–Bonn 2005, no. 45.

## 18. Virgin and Child

*Prague, ca. 1355–60*
*Tempera and gold on panel, 7.8 x 5.4 cm (3⅛ x 2⅛ in.)*
*Provenance: [Paul Bottenwieser, Berlin], by 1931–at least 1932; Frederick Locker, England; [Seligman, Rey and Co., New York], by 1934; Museum of Fine Arts, acquired 1934.*
*Museum of Fine Arts, Boston, Maria Antoinette Evans Fund (34.1459)*

At once tender and solemn, this image of the Virgin and Child is small enough to hold while praying. The panel retains its original frame. The traces of hinges, not demonstrably original, might indicate that it was part of a diptych. Both Mary and Jesus look to the left, as if to a companion panel. The baby Jesus

squeezes Mary's index finger in a gesture as typical of infants as it is charming. At the same time, he clasps the end of a cloth that the solemn-faced Virgin has allowed to slip between her fingers. As such images sometimes contain subtle references to Jesus' eventual death, this may allude to the winding cloth in which his body would be wrapped after the Crucifixion.[1]

Once attributed to Avignon and to Burgundy, this panel displays unmistakable links to Bohemia, especially to the image of the Virgin in the Adoration of the Magi panel of the Morgan Diptych (cat. 25). The similarities between the Virgin's face and images in the *Laus Mariae* (cat. 39) and the *Liber viaticus* of Jan of Středa (fig. 3.6) are particularly acute, providing unequivocal evidence of the perils of trying to distinguish between the works of panel painters and manuscript illuminators of this period.

BDB, JF

1. This is not, however, the substantial bolt of cloth evoking the shroud in Sienese painting. See Corrie 1990–91, p. 62.

LITERATURE: London 1932, no. 1; Vienna 1962, no. 6; Edgell 1935, pp. 33–36, fig. 2; Matějček and Pešina 1950, p. 51, no. 24, pl. 51; Fajt 1998, p. 258, fig. 196.

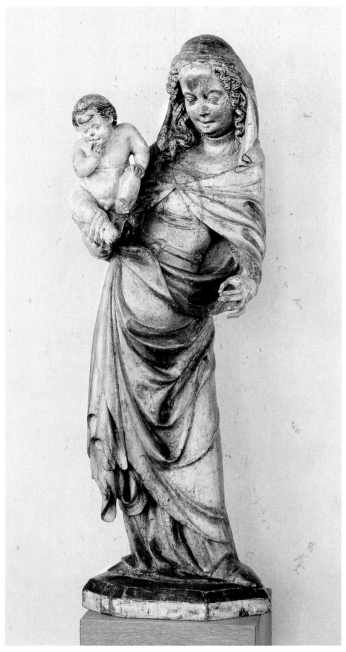

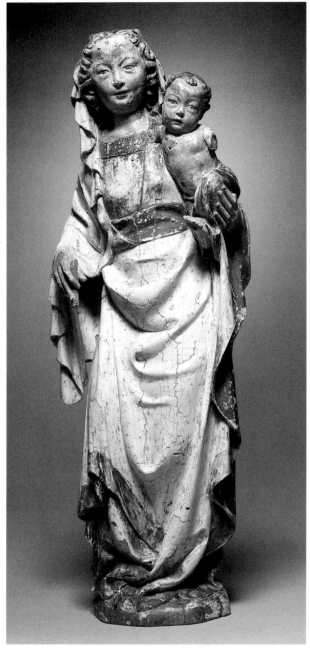

19

20

## 19. Virgin and Child

*Prague, ca. 1355–60*
*Linden wood with remnants of paint, h. 84 cm*
*(33⅛ in.)*
*Condition: Back hollowed out. Virgin's crown and*
*scepter, probably made separately, missing; her left little*
*finger a replacement. Paint on Child probably not orig-*
*inal. Conserved by J. Tesař, Národní Galerie, 1962.*
*Provenance: Possibly from the Convent of Saint Mary*
*Magdalen, in Zahražany, near Most.*[1]
*Římskokatolická farnost–Děkanství Most (VP 177)*

Kneeling in front of the sculpture, medieval
viewers would have been greeted by the
Virgin and Child looking down at them with
benevolence. In a literal illustration of the
dogma of the Incarnation, the belief that Christ
is God made man, Jesus is represented as a
bemused, chubby child, sucking on his right
index finger. Originally more regal with her
crown and scepter, Mary seems to direct
her loving gaze more at the viewers than at
her son. Her upper body is arched toward the
right and toward the back. The figure describes
an inverted S-shape not only when seen
frontally but also in profile. The effect is that
the robust Child, perched on her hip, appears
closer to the viewer than she is. Mary thus
facilitates the encounter between worshipers
and her son.

This serene image is carved with a refine-
ment that one would expect more in a work
in ivory than in a relatively large wood sculp-
ture. The superlative quality is evident in such
details as the gracefulness of Mary's left hand,
which originally held her scepter with only
three fingers; the diaphanous drapery of her
tunic, creasing in horizontal folds under her
breasts; and her curly hair arranged in parallel
tresses. At the same time, the spatial concep-
tion seems to prefigure that of the larger
Beautiful Madonnas of a few decades later
(see fig. 9.3). The engaged left leg functions
as an axis around which the volumes of the
body are distributed, more for an overall aes-
thetic effect than for an organic rendering of
the anatomy. Like the nearly contemporary
Nursing Virgin from Konopiště (cat. 30), this
sculpture exploits voids contrasting with mass,
and it invites the mobility of the beholder.
Each vantage point is rewarded by new dis-
coveries: the frontal view emphasizes Mary's
eye contact with the worshipers, while the
three-quarter view from the right shows the
Child to be almost separate from his mother,
already in the viewer's space. Only a superior

intellect could conceive of vision as such a
privilege.                                    JC

1. Fajt 2004, p. 213. Fajt also argues for the early dat-
   ing of the sculpture that has been adopted here.

LITERATURE: Kutal in Brussels 1966, no. 2; Kutal
1972, p. 57; Schmidt-Dengler in Bachmann 1977,
p. 28; Homolka in Cologne 1978–79, vol. 2,
p. 665; Fajt 2004, pp. 213–14, 219n34.

## 20. Virgin and Child

*Bohemia, 1365–70*
*Linden wood with paint, h. 51.5 cm (20¼ in.)*
*Condition: Much original paint; right hand of Virgin*
*restored.*
*Provenance: Kurt Rossacher, Salzburg, before 1962.*
*Cleveland Museum of Art, John L. Severance Fund*
*(1962.207)*

Devotional figures like this, and this specific
style of carving, became ubiquitous during
the third quarter of the fourteenth century
throughout Bohemia and the Holy Roman
Empire. They reflect the wide geographic
range of the Beautiful Style. This type of small
Virgin and Child, apparently created for pri-
vate devotion, has been related to sculptures
from the region of the Danube stretching
from Regensburg to Vienna, especially a
standing Virgin from Frauental now in the
Landesmuseum Joanneum, Graz.[1] The style
of the sculpture produced by the Parler work-
shop for the cathedral in Prague, as translated
for example in the Virgin and Child of
Konopiště (cat. 30) or the Virgin and Child of
Zahražany (cat. 19), was diffused over a large
area.[2] Whether these sculptures were created
locally or emanated from the Bohemian capi-
tal at Prague is uncertain. There is evidence of
the widespread imitation of certain types, but
with variations and different physiognomies.
The Cleveland statuette brings to mind, for
example, the impish child and youthful, even
girlish mother of the slightly later Beautiful
Madonna in the Franciscan monastery in
Salzburg.[3] Similar figures were made else-
where, some of them linked to the influence
of an Austrian sculptor known as the Master
of Grosslobming.[4]                            CTL

1. Erhesmann in Gillerman 2001, no. 210. See also
   Pujmanová in Seidel 2000, pp. 129–41, fig. 15.
2. See Homolka 1990, pp. 178ff., and also Fajt 2004,
   p. 212, fig. 7.
3. Clasen 1974, figs. 307, 308, 310. See also the criti-
   cal assessment by Schmidt (1992, pp. 229–68).
4. See Vienna 1994.

LITERATURE: Cleveland 1963, no. 5; Gillerman
2001, no. 210; Fajt 2004, p. 219n34.

21

## 21. Saint John the Baptist

*Bohemia, ca. 1355–60*
*Pot metal glass and vitreous paint, 64.5 x 39.5 cm*
*(25⅜ x 15½ in.)*
*Condition: Modern leading; replacement red glass on*
*right arm.*
*Provenance: Cistercian Church of the Baptist, Osek;*
*transferred to Uměleckoprůmyslové Museum, 1950.*
*Uměleckoprůmyslové Museum, Prague (65386)*

This panel was discovered in the abbot's
chapel of the Cistercian monastery in Osek in
northwestern Bohemia in 1950. It is the only
piece of the monastery's glazing that survives.
Founded in the late twelfth century, the
monastery gained royal recognition under the
leadership of its first abbot, Heřman, and it
thrived until the Hussite Revolution in the
early fifteenth century.[1] The community's
links to the crown may account for the choice
of richly colored glass, for Cistercians would
more customarily have employed grisaille.

The figure can be easily identified as
John the Baptist by the inscription in his halo,
"S. Johannes ba," and the Agnus Dei, or Lamb
of God, that he holds in his left hand and
points to with his right index finger, evoking
his role as foreteller of Jesus' earthly incarna-
tion. Scholars have dated this panel to the
mid-fourteenth century based on the similarity
of Saint John's head and hair to those of the
figures in the cycle of wall painting of about
1360 at the Emmaus Monastery.[2] The figure's

physiognomy, at once monumental and elegant, is also similar. The somewhat ponderous masonry of the simulated architectural framing is also found in contemporary Bohemian panel painting (see cat. 95). The brilliantly colored oak-leaf rinceaux of the background, found in contemporary stained glass from Nuremburg and its vicinity, provide added evidence for the mid-fourteenth-century date.[3]

In contemporary German and Austrian church glazing Saint John the Baptist is often pictured opposite a patron saint or apostle as part of a larger stained glass program of standing saints.[4]

AS

1. Cologne 1978–79, vol. 2, p. 716.
2. Matouš 1975, p. 80.
3. Scholz 2002, p. 12, fig. X, 12.
4. See, for example, Cologne 1998, p. 248, figs. 54.1, 54.2; Bacher 1979, vol. 3, pt. 1, p. 124, fig. 371; and Rode 1974, p. 47, colorpl. 4.

LITERATURE: London 1965, pl. 1; Stejskal 1974; Matouš 1975, pp. 80–81; Stejskal 1978a, p. 55, fig. 36; Cologne 1978–79, vol. 2, p. 716; Benda et al. 1999, p. 109, ill. p. 98; Prague 2001a, pp. 113–14; Hamburger 2002, fig. 19.

## 22. Golden Bull of Charles IV

---

*Prague, ca. 1355*
*Gold, diam. 6.1 cm (2⅜ in.), d. .4 cm (⅛ in.)*
*Inscribed in Latin around edge on obverse:*
*KAROLUS.QUARTUS. DIVINA.*
*FAVENTE.CLEMENCIA.ROMANOR[UM].*
*IMPERATOR.SEMP[ER].AUGUSTUS.ET.*
*BOEMIE.REX. (Charles IV, inclined toward divine*
*mercy, Emperor of the Romans, forever Augustus, and*
*King of Bohemia); around edge on reverse: ROMA.*
*CAPVT.MVNDI.REGIT.ORGIS.FRENA.*
*ROTVNDI. (Rome, capital of the world, governs the*
*bridle of the round world); on reverse: AUR/EA.*
*R/OMA (Golden Rome).*
*Provenance: Münzen und Medaillen A.G., Basel.*
*Museum of Fine Arts, Boston, Theodora Wilbour*
*Fund in Memory of Zoë Wilbour (57.663)*

Gold seals imparted unassailable authority to Charles IV's proclamations. Because Boston's "Golden Bull" has been separated from its original document, its context is unknown, but it may have been issued anywhere throughout the vast European territories comprising the Holy Roman Empire.

Charles's imperial vestments are very specific here. The scepter and orb are recognizable as those preserved in the imperial treasury in Vienna. Within his crown, the point of a miter is visible, and under his mantle he wears the

22, obverse and reverse

crossed stole of a deacon of the Church. Because the ruler had the status of a deacon by virtue of his having been anointed during the coronation ceremony, he was entitled to wear this ecclesiastical garb connoting his God-given authority. To his left is the lion of Bohemia; to his right, the eagle of Saint Wenceslas. The towers on the reverse represent Rome, where all Holy Roman Emperors since Charlemagne had been crowned. This traditional image of Rome conforms to that seen on gold bulls of Emperor Frederick II (1194–1250), one of Charles's most illustrious predecessors.[1]

BDB

1. Netzer 1991, pp. 105–7, no. 29.

LITERATURE: Netzer 1991, pp. 105–7, no. 29.

## 23. Reliquary of Saint Vitus

---

*Prague, 1358*
*Gilded silver, basse-taille and champlevé enamel, and*
*rock crystal; h. 42 cm (16½ in.)*
*Condition: Enameling of three silver plaques on foot*
*restored in 1978.*
*Inscribed in Latin on base: KAROLUS*
*ROMANORUM IMPERATOR ET REX*
*BOHEMIE DONAVIT ISTAM*
*MONSTRA(N)CIAM (Charles, Roman Emperor*

*and King of Bohemia, has donated this monstrance).*
*Katholisches Pfarramt Herrieden, Germany*

In a letter from Pisa dated January 22, 1355, Charles IV informed the archbishop of Prague, Arnošt of Pardubice, and the Prague Chapter that he had acquired relics of the body and head of Saint Vitus from the main altar of the Church of San Marino in Pavia.[1] The news of the Pavia relics, which Charles had learned about during his short stay in Milan at the beginning of 1355, excited his great interest. It contradicted the widespread belief that the saint's body was in Corvey in Saxony, where most of this saint's relics in central Europe came from, including the arm in Prague, given to Saint Wenceslas by the German King Henry I in 929.[2] Surely, Charles knew of the often contradictory local traditions regarding relics and thus did not hesitate to take this surprising piece of information seriously. Besides, the claim that the relics in Pavia were deposited by the Lombard king Aistulf concurred with some historical facts. This must have intrigued Charles especially because, by accepting the iron crown of the Lombards on January 6, 1355, he had become one of Aistulf's successors to the Italian throne. The favorable impression left in Lombardy by Charles's coronation in Milan allowed his negotiators in Pavia to acquire the relics, which then helped him make Prague Cathedral a focal point for the revived cult of Saint Vitus.

Whether Charles had actually visited Herrieden, an important local center of this saint, in connection with this gift, cannot be established.[3] During his three-month stay in Franconia in the summer of 1358, Charles certainly met members of the Herrieden Chapter, and in August of that year took them under his special protection.[4] He returned to Bohemia at the very beginning of September, and by the 23 (or 30) of the same month, he issued a letter to accompany the precious gift.[5] As for the authenticity of the relic, the emperor merely attests that he acquired it from a reliable source.

Even though the donation of the relic must have been arranged beforehand, no more than a few weeks were left for the creation of the reliquary. An ornate reliquary statuette, which the relic surely merited, could not have been realized by the deadline. Instead, a small figure was cast that portrays the martyr from Diocletian's Rome as a young fourteenth-century prince in a close-fitting doublet and a fashionable knee-length skirt with a low belt. The finely wrought face and the posture, which combines the holding of a relatively large object with an elegant contrapposto, betray that the model was the work of an experienced sculptor.

This unique tiny masterpiece is enclosed in a crystal vessel, which, by contrast, belongs to a standard type of ostensorium used for the display of a variety of relics.[6] In addition, it bears the signs of hasty work: the enamel plaques with the *vera icon,* the imperial eagle, and the lion of Bohemia were attached by rivets, under oval openings in the top surface of the foot, instead of fastening them to it by means of inconspicuous frames; in the inscription, the forms of the capital letters are rough and the hatching summary. Finally, there is an odd combination of three- and four-sided components. While the profile of the stem corresponds to the ground plan of the foot, an intersection of a triangle and a trefoil, four-sided elements such as the pyramidal spire and the capital of the stem support the crystal cylinder, which is held in position by four bands shaped like pillars. In addition, the knop bears four projections with the letters AVEM (Ave Maria) on small quatrefoil plaques.

Individually, these elements are quite ornate and finely done: the foot with its complex ground plan determining the peculiar profile of the stem, which has a socle in the form of a circular architectural structure with three supporting pillars and six semicircular windows; pairs of free vaulting ribs adorning the capital of the stem; the knop with four rotating Flamboyant window traceries; the pinnacles of the pillars holding the crystal cylinder; and finally the miniature goldsmith work of the crucifix on the top of the high spire. This indicates that the ostensorium had to be finished in a short period of time. The goldsmith was able to create the tiny statue of the saint, but he was obliged to use available components in order to execute the vessel on time.

KO

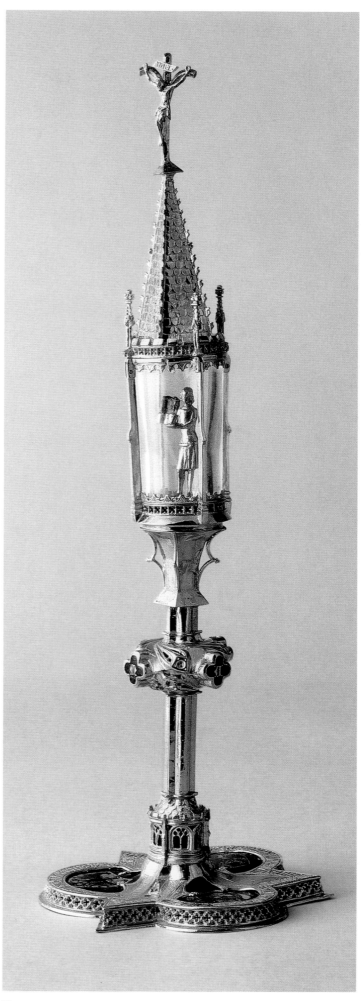

23, detail of base

23

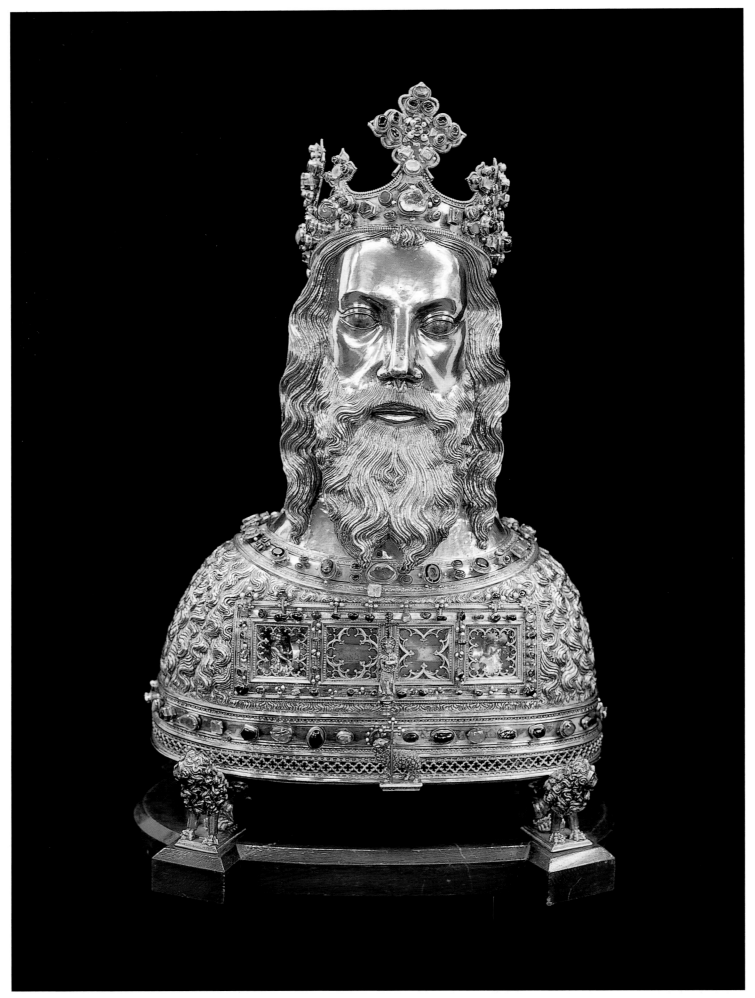

152   PRAGUE, THE CROWN OF BOHEMIA

1. Podlaha and Šittler 1903a, pp. 44, 45n3.
2. According to the ninth-century *Translatio sancti Viti martyris*, the saint's body venerated in Corvey in Saxony was transported there from Saint-Denis in 836 with the permission of Emperor Louis the Pious (Schmale-Ott 1979, pp. 32–63). The same source relates that the body came to Saint-Denis from Rome and was in the possession of an unnamed relative of Abbot Fulrad, a high Church official at the court of Pipin III and Charlemagne (Schmale-Ott 1979, pp. 33, 34).
3. Rüger and Stafski 1959, pp. 54–63.
4. Böhmer 1877, p. 231 (2823).
5. Suttner published a text of the letter, dated September 23 ("non. Kalend.Octobris"), 1358, from an unknown copy, in 1860, p. 100. However, two transcripts surviving among documents concerning the history of the Herrieden Chapter, collected by canon Joseph Coelestin Haltmayer (1754–1830) in the diocesan Archive Eichstätt (Diözesanarchiv Eichstätt, Akt p 152, vol. 7, fol. 64), give as the date September 30 ("II. Kalend."), 1358. The author thanks Dr. Bruno Lengenfelder, Diözesanarchiv Eichstätt, for kindly supplying this information. See Rüger and Stafski 1959, pp. 54–63, 65; and Otavsky in Cologne 1978–79, vol. 1, pp. 373, 374.
6. Fritz (1982, p. 223) with justice calls the ostensorium "nicht übermässig sorgfältig gearbeitet" (not worked with particular care).

LITERATURE: Rüger and Stafski 1959, pp. 54, 65–68; Kohlhaussen 1968, p. 510; Chadraba 1971, pp. 2, 13; Schramm and Fillitz 1978, pp. 61, no. 40; Schiedlausky in Nuremberg 1978, pp. 92, 93; Otavsky in Cologne 1978–79, vol. 1, pp. 373, 374; Fritz 1982, p. 223, fig. 261.

## 24. Reliquary Bust for the Arm of Saint John the Baptist

*Probably Aachen, after 1355*
*Gilded silver, silver, precious stones, cameos, intaglios, pearls, and rock crystal; h. 77 cm (30¼ in.), w. 50 cm (19⅝ in.)*
*Condition: Front terminal of crown replaced.*
*Provenance: Cistercian Convent of the Virgin Mary and Saint John the Baptist, Aachen-Burtscheid. Parish Church of Saint John the Baptist, formerly Abbey, Aachen, Germany*

John the Baptist, the desert ascetic who announced the coming of Jesus as the Messiah, appears here as an imposing, regal figure, readily identifiable to medieval faithful by the characteristic camel hair cloaking his shoulders, evoked by the patterns worked in the silver. His jeweled crown, seemingly inappropriate for this abstemious man, denotes his saintly status and conforms to his description in the medieval hymn of praise sung on his feast, as well as to other medieval reliquary busts

depicting him, including that at the Sainte-Chapelle in Paris.[1] At the center of the base stands a statuette of a lamb, emblematic of Christ. A miniature figure of the Baptist carrying a lamb (perhaps a later addition) is set before the aperture in the middle of the bust. Within, small kneeling angels hold the ends of a relic that is identified by inscription as an arm bone of the saint. Similar diminutive angels appear on other works in the treasury at Aachen,[2] to which Charles IV made generous gifts.

In the mid-fourteenth century, the Cistercian convent at Aachen-Burtscheid began a massive campaign of renovation that included the building of a new church.[3] The financing was helped by a papal indulgence granted in 1335 to those who supported the work. Still, the construction was not yet complete in 1352, when the nuns received a subvention from the imperial city of Aachen. Charles IV's reign coincides neatly with this time of straitened circumstances and high ambition for the city, which the emperor visited repeatedly.[4] There was an established precedent of imperial patronage for the community at Aachen-Burtscheid. Prior to Charles's imperial succession, it had enjoyed the support of his rival Louis of Bavaria. Charles, in his zeal to follow the tradition of his predecessors and to trump Louis's example, is the most likely patron of this reliquary. John the Baptist was a patron saint of Emperor Charlemagne, whom Charles IV, as his namesake and successor, particularly sought to emulate.[5] Indeed, another patron of sufficient status to commission such a work is difficult to imagine, given the significant relic it contains and the profusion not only of precious stones but also of classical cameos and intaglios.

The crown is of particular significance in this regard. Clearly an earlier piece of goldsmith's work, it was adapted to this context by trimming the edge to allow a snug fit around the saint's forelock. On two other occasions, Charles arranged the marriage of a royal crown with a saintly bust reliquary: the bust of Saint Wenceslas in the treasury of Saint Vitus's in Prague held the royal crown of Bohemia from Charles's coronation there in 1347 (fig. 1.4)[6] and the bust of Charlemagne at Aachen bears the crown with which Charles IV was crowned there in 1349 (fig. 2.7).[7] The crown on the Aachen-Burtscheid reliquary may have an analogous history.

BDB

1. First remarked by Arndt and Kroos 1969, p. 252.
2. Cologne 1978–79, vol. 2, pp. 127–28.
3. Clemen 1922.
4. Folz 1973, pp. 448–49.
5. Ibid., pp. 423–65; Fajt 2000, pp. 489–500.
6. Schwarzenberg 1960.
7. L. Schmidt 1978. The tradition of donating princely crowns to reliquary busts of saints was perpetuated in Prague in 1387, when Charles's daughter presented two crowns to the bust of Saint Sigismund. See Podlaha and Šittler 1903a, p. XXXI, no. 21.

LITERATURE: Clemen 1922, p. 266; Cologne 1978–79, vol. 1, pp. 127–28 (with bibl.); L. Schmidt 1978, pp. 148ff.

## 25. The Adoration of the Magi and The Dormition of the Virgin

*Prague, ca. 1355–60*
*Tempera and gold on linen-covered panel,*
*Adoration panel 30.8 x 19.7 cm (12⅛ x 7¾ in.),*
*Dormition panel 30.8 x 20.3 cm (12⅛ x 8 in.)*
*Provenance: [Dowdeswell and Dowdeswell, London], until 1903; Dr. Friedrich Lippmann, Berlin (d. 1903); his wife, until 1931; J. Pierpont Morgan, New York; Pierpont Morgan Library, by 1932.*
*Pierpont Morgan Library, New York (AZ022.1, AZ022.2)*

Judging by the luxurious and ornate decoration and the sophisticated use of color, these two small figural scenes were probably originally parts of a diptych commissioned by a demanding client of high social rank. The Adoration of the Magi and the Crucifixion are usually paired as eucharistic themes, but here the Dormition of the Virgin has replaced the Crucifixion. Was there a contemporary reason? The second king has Charles IV's features, and his mantle is decorated with the imperial eagle. In the Dormition scene Saint Peter wears the papal tiara. The theme of the diptych is thus the fragile balance between the power of the Holy Roman Empire and the Church, between *imperium* (imperial) and *sacerdotium* (sacred).[1] Without the accord of the pope, Charles would not have received the imperial crown; without the emperor's support, Pope Innocent VI (r. 1352–62) could not have pursued his plans for returning the papacy to Rome.[2] Allegories like this were common at Charles's court. It must have been Charles himself who commissioned the Morgan Diptych, either for his own devotion or as a diplomatic gift, probably for Pope Innocent VI.

The many visual links between these panels and the work of illuminators from the circle of Charles IV's chancellor Jan of Středa indicate that their author worked at the court in Prague.[3] The monumental scenes (always with a human figure as the focal point) in the *Laus Mariae* manuscript (cat. 39), for example,

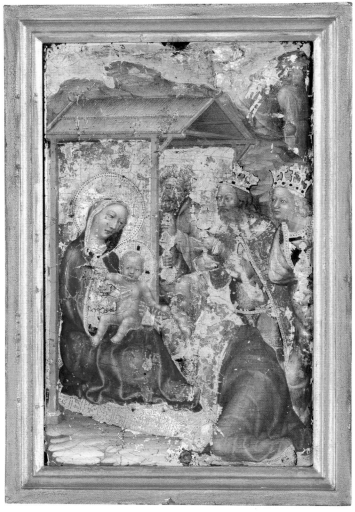

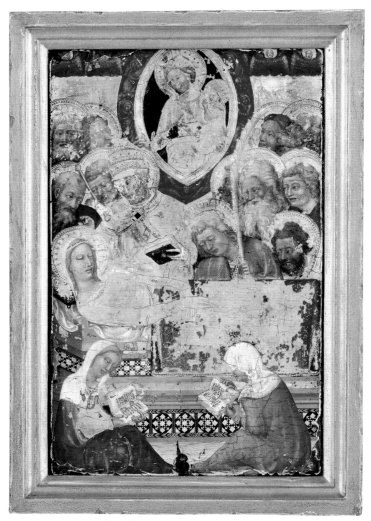

25, The Adoration of the Magi

25, The Dormition of the Virgin

are so similar to the Morgan panels that it is possible to consider that they are by the same artist. This painter would have been one of the most distinctive artists who contributed to the formation of the imperial style that asserted itself at the Luxembourg court about 1360, an unmistakable result of Charles IV's attempts at self-presentation through art.

In many ways the Morgan panels foreshadow the era of the later court painter Master Theodoric (see cat. 33), for whom these and similar paintings (see cat. 18) apparently became an important source of inspiration.                                     JF

1. Stejskal 1967; Pešina 1978.
2. The good relationship between the emperor and the pope did not even suffer from the one-sided proclamation of the Golden Bull in Nuremberg in 1356, which limited the role of the papacy in determining the imperial succession.
3. For the woman at Mary's bedside, see the Košátky panel in Boston (cat. 26).

LITERATURE: Fry 1903; Paris 1904, nos. 5, 6; Van Marle 1930, p. 186; Labande 1932, pls. 17, 18; Sterling 1941, rep. B, p. 14, no. 11; Matějček and Pešina 1950, p. 51, nos. 25, 26, fig. 52; Swarzenski 1952, p. 65, fig. 2; Frinta 1965, pp. 262, 263, figs. 37, 41; Stejskal 1967, p. 22; Pešina 1978; Bachmann 1969, pp. 47–48, fig. 106; Swoboda 1969, pp. 193, 203, 234, fig. 106; Kutal 1971, pp. 66, 105; Voelkle in Cologne 1978–79, vol. 2, p. 763; Fajt 1998, pp. 80–84, 201, 220, 223–24, 258–60, 263, 265, 318–27, color ills. pp. 198, 201; Rosario 2000, pp. 33–34, 110–11, 116, colorpls. 44, 45.

## 26. The Dormition of the Virgin

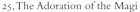

*Prague, ca. 1340–45*
*Tempera and gold on linen-covered oak panel, 100 x 71 cm (39⅜ x 28 in.)*
*Condition: Panel cut down at top by ca. 1–3 cm, on left by ca. 3 cm, on right slightly, on bottom by at least 10 cm. Color badly abraded in places, revealing incised drawing beneath.*
*Provenance: Possibly Weitmile family, Košátky Castle, near Mladá Boleslav, by 1420; counts of Kolowrat, Košátky Castle, by the late 15th century; discovered in the chapel at the castle, 1922; by descent to Henry Kolowrat (on loan to Národní Galerie, Prague [OP2110], 1934–39); Henry Pearlman, New York, purchase 1950;*

*E. and A. Silberman Galleries, New York, purchase 1950; Museum of Fine Arts, purchase 1950. Museum of Fine Arts, Boston; William Francis Warden Fund; Seth K. Sweetser Fund, The Henry C. and Martha B. Angell Collection, Juliana Cheney Edwards Collection, Gift of Martin Brimmer, and the Gift of Reverend and Mrs. Frederick Frothingham; by exchange (50.2716)*

The panel depicts the end of the earthly life of the Virgin, as it was visualized in the fourteenth century. Christ presides at his mother's bedside, cradling her soul, rendered as a doll-like figure, on his arm. To the left is Peter, with a censer, to the right the youthful Saint John. The other apostles, some of them only partially visible, gather around the bed in varying attitudes. The iconography is based on a Venetian interpretation of a Byzantine model.[1] The two veiled women sitting reading in front of Mary's bed conform to types also seen in fourteenth-century French ivories of this subject and should probably be identified as professional mourners. At the right a Benedictine or Augustinian monk kneels in prayer.

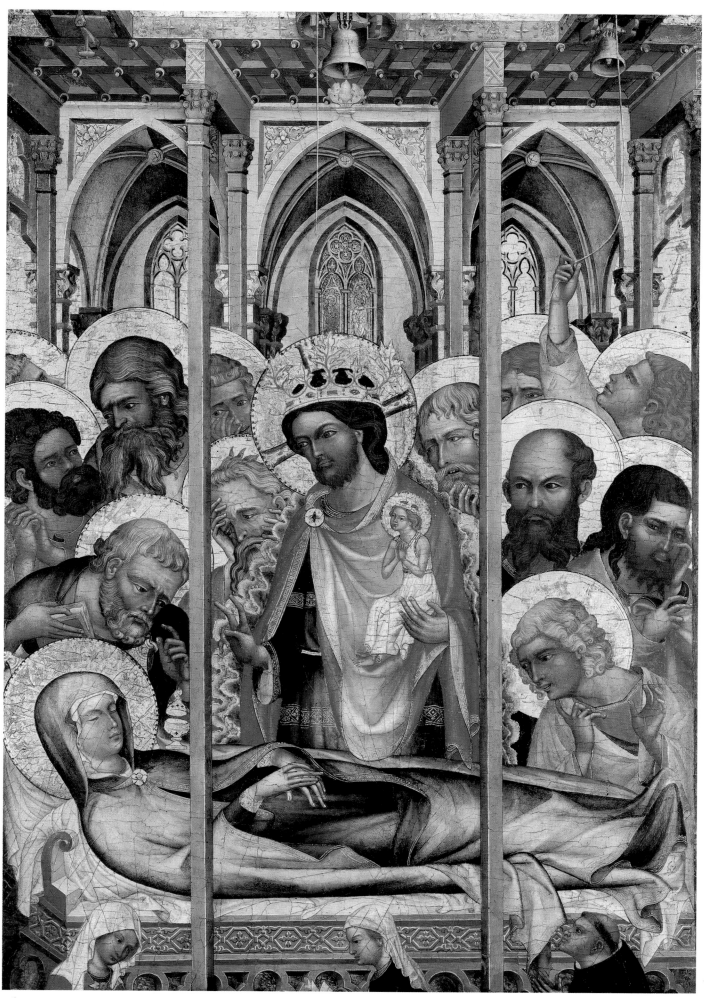

The panel is remarkable for its sumptuous decoration. The halos are alternately incised and punched, in keeping with the relative importance of the figures; those of Christ and Mary are elaborated with foliate ornament. Patterns in gold decorate the hems of all the garments, as well as other details. Especially rich are Christ's crown and the brooches. The generous use of lustrous glazes enhances the overall effect. Mary's bed and the tripartite architecture of the chapel are not so much accurate reproductions of reality as they are part of the pictorial decoration and a means of organizing its structure. The elegant columns of green marble and their antique capitals recall Duccio's *Maestà*.[2] Three chapels with vaulted ceilings and tracery windows filled with stained glass enliven the background. In Bohemian art of the decade 1340–50 the painter of this panel represents a trend that influenced the painter of the altarpiece of Saint Clare from Nuremberg, among others (see cat. 17).[3]

The castle of Košátky, near Mladá Boleslav, where this panel was discovered in 1922, belonged to the Weitmile family from about 1420, but in the second half of the fifteenth century it passed by marriage to the Kolowrat family, in whose possession it remained until the twentieth century. The most famous member of the Weitmile family was Beneš Krabice (d. 1375), author of a chronicle of Charles IV, a canon of the chapter of Saint Vitus's Cathedral, and the overseer of the building campaign at the cathedral. This panel could have been in the possession of his family.[4]

RS, JF

1. Schmidt 1969b, pp. 174–75.
2. Popp 1996.
3. See Kemperdick in Frankfurt am Main 2002.
4. Kuchyňka 1923, pp. 148–49.

LITERATURE: Kuchyňka 1923, pp. 148–49; Matějček and Pešina 1950, pp. 48–49, figs. 38–41; Schmidt 1969b, pp. 174–75; Stejskal 1978a, fig. 28, p. 222; Pešina 1984, pp. 355–56.

## 27. The Madonna of Most

*Bohemia, mid-14th century*
*Tempera and gold on canvas on panel,[1] 53 x 40 cm (20⅞ x 15¾ in.)*
*Inscribed in center of crossbars of painted window on reverse: M.[2]*
*Condition: Cut down at top; late restorations to image now removed.[3]*
*Provenance: Church of the Assumption of the Virgin, Most, after 1578; Capuchin Monastery, Most, after 1779. Římskokatolická farnost–Děkanství Most (VO 362)*

The Virgin gazes at the viewer while holding her left hand as if to present the Child, who reclines in her arms. This image, possibly the earliest of its type in Bohemia, has traditionally been attributed to Byzantine and Italian influence.[4] Other Bohemian images of the mid-fourteenth century are related to it through the pose of the Virgin, the twisting motion of the Child, and the goldfinch in his hand.[5] All of these are probably variants of the Kykkotissa (Gr., Compassionate), one of the most widely venerated miracle-working Byzantine icons. Housed on Cyprus, the Kykkotissa shows the Virgin holding the Child in an intimate pose as he turns in her arms; it is traditionally thought to have been painted from life by Saint Luke the Evangelist.[6]

The Madonna of Most is the most Byzantine of the Bohemian images—in the skin tones of the figures, their poses, and the Virgin's serrated head covering and *maphorion* with elaborate gold fringe. Specifically Italian motifs appear, however, in the Child's intricately patterned robe, in the luminous hues of the Virgin's dress, and especially in the presence of the goldfinch.[7] The Child's Byzantine pose is present on an Italian panel from the early 1300s that is associated with Cyprus, the Monastery of Saint Catherine at Sinai, and the Franciscans, one of the mendicant orders then active.[8] Wordplay in Italian may have been responsible for the goldfinch's replacing the scroll held by the Child in the Byzantine image (both are symbols of salvation).[9] The window painted on the back of the image, an allusion to the Virgin, is also Italian in inspiration.[10]

Hans Belting has shown that the Luxembourgs, including Charles IV, gave miracle-working images attributed to the Christian East to religious sites in Bohemia as a way of establishing the family's dominance there.[11] The popularity of this Lukan icon type in the region suggests that it may have been part of that tradition.[12] Charles IV's interest in Eastern images may also have been inspired by his desire to emulate Emperor Constantine, founder of the Christian state that was still called the "Empire of the Romans" in the fourteenth century and is today known as Byzantium.[13]

HCE

1. Stejskal (1978a, p. 222) identifies the panel as linden wood; Matějček (in Matějček and Pešina 1950, p. 45) considered it to be poplar.
2. Hlaváčková and Seifertová 1985, p. 60.
3. Matějček (in Matějček and Pešina 1950, p. 45) describes it as cut down in the "baroque" style at the top. He notes that the painted restorations of the seventeenth and eighteenth centuries were removed in 1937–38. Pešina (in Prague 1970, pp. 211–12) identifies a second restoration in 1963.
4. Matějček and Pešina 1950, p. 45; Stejskal 1978a, pp. 53–54; Hlaváčková and Seifertová 1985, p. 60; Frinta 1995, p. 107n14.
5. Most important of these are the Strahov Madonna (cat. 37) and that of Veveří (Matějček and Pešina 1950, nos. 26, 27, ill.); Frinta (1995, p. 107) associates the Strahov image as well as the Virgin of Březnice (cat. 81) with the Kykkotissa type.
6. The Kykkotissa image in which the Child's pose is closest to that in the present work is one associated with Cyprus that is now at the Monastery of Saint Catherine, Sinai, Egypt (Folda in New York 2004, no. 214, color ill.). Frinta (1995, pls. 39a,b, 40a,b, 42b) shows other variants of the image.
7. Stejskal 1978a, pp. 53–54.
8. Evans in New York 2004, no. 291; Pujmanová (1980) demonstrates the presence of another mendicant order at the court of Charles IV, the Dominicans; Hlaváčková (in Hlaváčková and Seifertová 1985, p. 63) addresses the importance of the Franciscans; Hlaváčková and Seifertová 1986, p. 57; Derbes and Neff (in New York 2004) discuss the role of the mendicants in artistic exchanges between Byzantium, Cyprus, and Italy.
9. In advancing this theory, Friedmann (1946, pp. 7–8, 22) pointed out the similarity between the Italian *cartellino* (scroll) and *cardellino* (goldfinch).
10. Hlaváčková and Seifertová (1985, pp. 60–61) relate the window, which covers the entire back of the icon, to the Virgin as mediator between heaven and earth (see also Hlaváčková and Seifertová 1986, pp. 56–57).
11. Belting 1994, pp. 333–35.
12. Ainsworth (in New York 2004, no. 349) discusses an Italian copy of a Byzantine Virgin and Child that was later identified as Byzantine when it became a famous miracle-working icon at Cambrai, France.
13. Rosario 2000, pp. 9–10, 40–46; Evans 2004, p. 5.

LITERATURE: Matějček and Pešina 1950, p. 45, no. 2, pl. 3; Pešina in Prague 1970, pp. 211–12, no. 291; Stejskal 1978a, pp. 53–54, 222, fig. 33; Hlaváčková and Seifertová 1985, pp. 59–65; Hlaváčková and Seifertová 1986; Prague 1988, p. 65, no. 6; Frinta 1995, pp. 104–13, pls. 39–43.

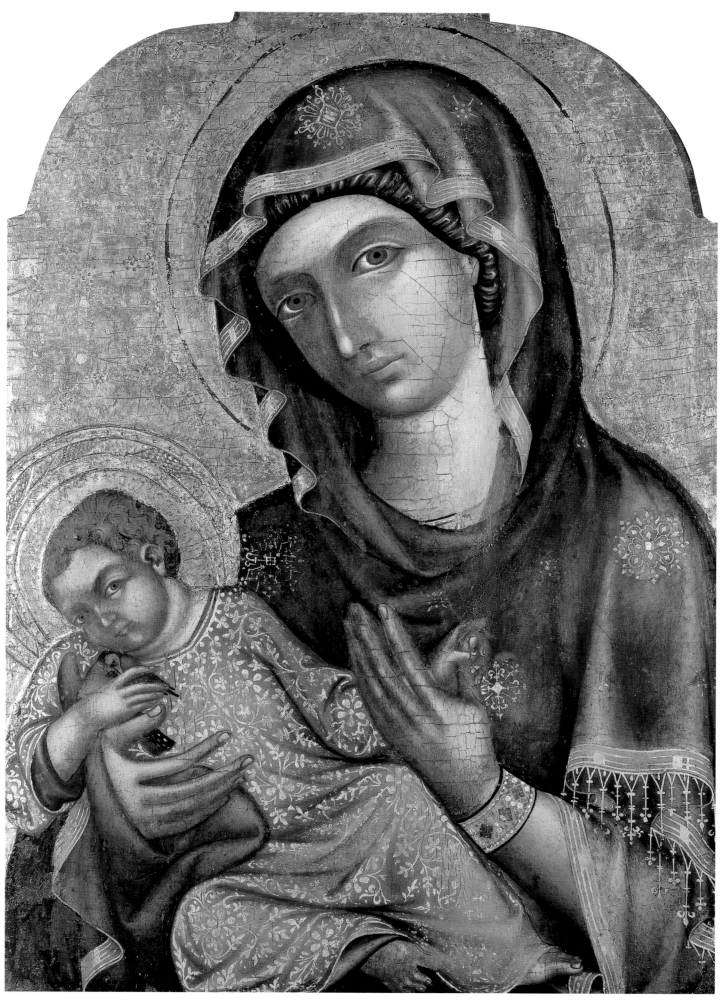

27

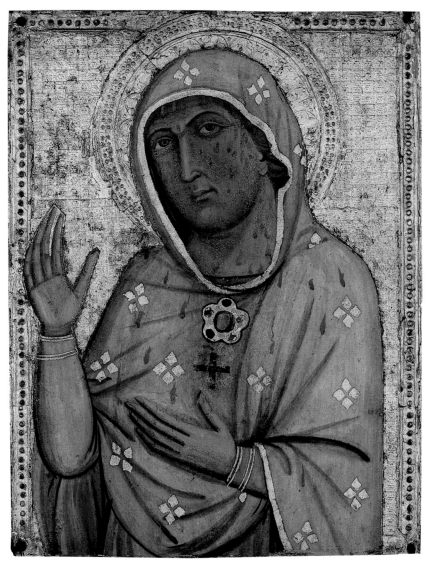

28

## 29. Saint Cunigunde

*Prague, ca. 1365–70*
*Linden wood with extensive traces of ancient paint,*
*h. 123.5 cm (48⅝ in.)*
*Condition: Hollowed out in back. Forearms, originally*
*carved separately, missing; crown and possible cathedral*
*model missing. Losses in drapery, especially along base.*
*Conserved in 1957–58 by J. Tesař and in 1994–95 by*
*T. Beranov.*
*Provenance: From the Church of Saint Cunigunde,*
*Stanětice; on loan from the bishopric of Pilsen to the*
*Národní Galerie, Prague, since 1994.*
*Římskokatolická farnost Milavče, Domažlice (VP 1.816)*

This sculpture probably represents Cunigunde
(d. 1033), the patron saint of the church at
Stanětice, near Domažlice in southern
Bohemia, from which it comes.[1] The wife
of Emperor Henry II, Cunigunde was
cofounder of Bamberg Cathedral, where she
was buried. Canonized in 1200, she was the
object of devout veneration not only in
Bamberg and surrounding Franconia (itself
near the diocese of Pilsen) but in much of the
Holy Roman Empire. Medieval imagination
recognized Marian qualities in her. Like the
Virgin and Joseph, she and Henry had main-
tained a chaste marriage. And as an empress
she was represented with a crown, as was
Mary when venerated as Queen of Heaven.
The rectangular slots on top of this figure's
head once accommodated a crown, probably
made of metal. If she is indeed Cunigunde,
one of her attributes would have been a
model of Bamberg Cathedral. Cunigunde was
often depicted, as here, with her head and
chin covered, a sign of her modesty.[2]

At once monumental and delicate, the
figure would have been an appropriate focus
for the prayers of the faithful. The open arms
and smiling face, with dimpled cheeks, wide-
open eyes, and raised eyebrows, make a partic-
ularly welcoming impression. The saint's body
is arranged along a grand S curve, with her
weight resting on her left leg and her head
tilted toward her left shoulder. The thin drap-
ery clings to the body, creating an effect both
calligraphic and three-dimensional. The artic-
ulation of the body, which engages the sur-
rounding space, calls to mind such a seminal
work as the stone Virgin and Child from the
Old Town Hall in Prague (fig. 4.5).

JC

## 28. Ara Coeli Madonna

*Bohemia, ca. 1355*
*Tempera on paper on punched and gilded panel,*
*29 x 22 cm (11⅜ x 8⅝ in.)*
*Provenance: Treasury of Saint Vitus's Cathedral, since*
*the Middle Ages.*
*Metropolitní Kapitula u Sv. Víta, Prague (HS 3422a,b*
*[K98])*

After Pope Urban V hosted Emperor Charles IV
in Rome in 1368–69, several miraculous paint-
ings came to Saint Vitus's Cathedral, among
them a *vera icon* and an Ara Coeli Madonna
(Madonna of the Altar of the Heavens), of
which this is one of three versions in Prague.
According to legend the image of the Virgin
on the altar of the Church of Santa Maria in
Ara Coeli in Rome was painted by Saint Luke.
It became famous when it was processed
through the streets of the city in 1348 to ward
off the plague. Like other Bohemian rendi-
tions of the celebrated image, which were
some of the earliest to be produced outside

Italy, this painting is distinguished by the
drops of Christ's blood that stain the brilliant
blue of the Virgin's mantle, in accordance with
contemporary Bohemian beliefs. Even so,
scholars have debated whether it was made in
Prague or Italy. What is particularly remarkable
about the image, however, is that it was painted
on paper and then cut out (the slicing marks are
most visible between the fingers of the Virgin's
right hand) and applied to the punched and
gilded ground of the panel, much as figures
painted by Tomaso da Modena were attached
to a patterned Bohemian gold ground in the
Holy Cross Chapel at Karlštejn Castle.[1]

BDB, JF

1. On the use of paper in Bohemia in the four-
   teenth century, see Pujmanová 1992, p. 261n10.

LITERATURE: Pujmanová 1992.

1. Fajt (in Prague 1995b, pp. 643–45) was the first
   to identify the figure as Cunigunde.
2. The statue of about 1290 on the facade of Basel
   Cathedral is but one example.

LITERATURE: Bachmann 1943, pp. 23–26; Fajt in
Prague 1995b, pp. 643–45.

## 30. Enthroned Virgin and Child

*Bohemia, probably Prague, ca. 1360–70*
*Pearwood with ancient paint and gilding, h. 45 cm*
*(17¾ in.)*
*Provenance: Church of Saint James, Chvojno, near*
*Benešov and Konopiště; Národní Galerie, since 1939.*
*Národní Galerie, Prague (P 5474)*

This tender statue from the Church of Saint James in Chvojno, near Konopiště, was conceived as a nurturing image of the Virgin offering her breast to the Child, who is partially wrapped in her mantle. In the Middle Ages the devotional theme of the *Maria lactans,* or Nursing Virgin, which emphasized Christ's humanity, generated a wide range of pietistic reports of lactation miracles, healings, and blessings.

Although the Virgin's pose and the way she enfolds the Child are close to both French and Italian sculptures, the plasticity of this group and its engaging composition, which sets off volumes against voids, relate it to the technically accomplished sculptures the Parler workshop created for Saint Vitus's Cathedral in Prague.[1] The carver fully realized the expressive potential of the wood, establishing this Virgin as a gracious model to be imitated. Indeed, it seems to have directly influenced a series of dynamic seated figures from Salzburg (Museum Carolino Augusteum, 178/32) in which the S-curve composition is equally emphatic.[2]                                    CTL

1. The facial type of the Virgin and her slender proportions have been related to the carvings of Adam and Eve on the consoles in the cathedral choir, which date to after 1385 (see Homolka in Cologne 1978–79, vol. 2, p. 665, and, for an illustration of the carvings, Benešovská and Hlobil 1999, fig. 10).
2. See Salzburg 1976, no. 14, fig. 19.

LITERATURE: Paris 1957, no. 175; Kutal 1962, p. 25, pls. 27, 29, VII; Brussels 1966, no. 3; Homolka and Pešina in Prague 1970, p. 133, no. 159, fig. 17; Kutal 1971, p. 79, fig. 55; Bachmann 1977, fig. 50; Cologne 1978–79, vol. 2, p. 665, ill.; Fajt 2004, p. 219n34.

29

30

## 31. Arm Reliquary

*Prague, first quarter of 14th century*
*Gilded silver, gems, mostly replaced by semiprecious*
*stones and glass imitations; h. 56.4 cm (22¼ in.)*
*Inscribed on back in 17th-century script: Brachiu[m]*
*S. Georgij M[artyris] (Arm of Saint George Martyr).*
*Provenance: Benedictine Convent of Saint George,*
*Prague; purchased by Chapter of Saint Vitus's*
*Cathedral after dissolution of convent in 1782.*
*Metropolitní Kapitula u Sv. Víta, Prague (HS 03343*
*[K19])*

This reliquary in the form of an arm comes from the remarkable treasury of the Convent of Saint George in Prague, which is associated with the second oldest church in the extensive premises of the Přemyslid princes of Bohemia, founded by Prince Vratislav I about 920. The cult of the martyr Saint George, an aristocrat from Cappadocia, spread rapidly from Byzantium and its sphere, including Venice, to Rome and western Europe. An important center of his cult in central Europe was the Roman stronghold Castra Regina (Regensburg), later the seat of the Bavarian princes and of the eastern Franconian Carolingian dynasty. It was probably the ancient Church of Saint George in Regensburg that Vratislav took as a model for his church in Prague. Its patronage, which was borrowed from Regensburg, suggests that a relic of the saint may also have been given to Vratislav by the Bavarian duke Arnulf (907–937) to retain the prince of Bohemia as an ally against the Hungarians and the increasing power of the Ottonian dynasty.[1] Vratislav probably intended his church as a future bishopric. Not only did he found a collegiate chapter at Saint George's, but he also had the body of his mother, Saint Ludmila, interred there.

When the Church of Saint Vitus, the site of the tomb of Saint Wenceslas, became Prague's cathedral in 973, Saint George's emerged simultaneously as the foremost Benedictine convent in Bohemia, closely related to the court by virtue of both its physical location and its residents.[2] Saint George's Basilica was probably much larger than the rotunda founded by Wenceslas, and in 1004 it hosted the ceremonial homage to Prince Jaromir, performed in the presence of his ally and protector Henry II, duke of Bavaria and king of Germany.[3]

After Wenceslas's rotunda was replaced by the Romanesque basilica consecrated in 1096, the Convent of Saint George remained significant primarily as the final resting place of Saint Ludmila and several members of the ruling dynasty. Indirectly, it also became a center of the veneration of Saint Adalbert after 1216, when the abbess Agnes had the bodies of his assassinated brothers transferred there

31

from Liblice. The members of the Saint George Chapter attended to the year-round liturgy, the high points of which were the feast of Saint George and the commemoration of the death and the translation of Saint Ludmila, as well as the anniversary of the consecration of the church, for which Pope Innocent IV granted special indulgences in 1251.[4] The maintenance of an appropriate setting for the solemn ceremonies necessitated campaigns of building, sculpture, and painting, particularly after a fire in 1142. The nuns themselves were renowned for the production of liturgical vestments like a set that Jindřich Zdík, bishop of Olomouc (r. 1126–50), bequeathed to his friend Pope Eugene III, as is documented in the pope's letter of condolence to the abbess and the nuns after the

bishop's death.[5] Manuscripts created in the Saint George scriptorium attest to the spiritual life within the convent. Among them is the well-known Passional of Abbess Cunigunde (see fig. 1.3), a fascinating testimony of a personal, mystical spirituality.[6] A handful of extant items from the old treasure of Saint George's testifies to the important role that the relics in their precious settings played in the liturgical and spiritual life of the convent.[7]

In the present case the reliquary reflects the form of the relic it enshrines: a part of the right arm of the eponymous saint of the convent church. This relic might conceivably be identical with the relic supposedly given to Vratislav by the duke of Bavaria about 920. It might have been removed from the original main altar and incorporated in the new treasure when the new choir was erected after the devastating fire of 1142. The reliquary is much more complex in structure than the arm reliquary of Saint Ludmila that also formed part of the convent treasury.[8] The relic of Saint George—a part of the right humerus—is sheathed in precious armor, the lacing of which is simulated on the front by an openwork trellis through which the package with the arm bone is visible. This vambrace (armor for the forearm) is rimmed with high-set stones, originally gems that were mostly replaced with imitations in the seventeenth or eighteenth century. The elegant decoration sets off the cylindrical relic case as the main part of the reliquary.[9] The arm rests on a base in the form of a four-sided edifice. Set within a little portal there are on each side bas-reliefs that depict Saint George in Byzantine-style armor holding a shield and banner, an enthroned Christ blessing, an enthroned Virgin and Child, and a standing Saint Ludmila. The surrounding gems evoke the Heavenly Jerusalem.

The reliquary can be dated roughly to the first quarter of the fourteenth century, as is the case with the reliquary bust of Saint Ludmila (cat. 6) and two reliquaries now belonging to the Strahov Monastery that also originate from the treasury of Saint George's Convent.[10] Some common features link the bas-relief figures on the base with royal and other official seals from the second half of the thirteenth century,[11] which also testifies to an unbroken tradition of artistic workshops from the time of the last Přemyslids until the early Luxembourg period.                    KO

1. Prinz 1988, pp. 332, 333nn35, 36; Třeštík 1997, pp. 355–64.
2. The founder, Mlada (973–994), was the daughter of Boleslav I, Abbess Agnes (1186–1227) was the daughter of Vladislav II, and Abbess Cunigunde (1302–1321) was the daughter of Přemysl Otakar II.

3. For the same reason, while the cathedral was being prepared to receive them, the basilica temporarily housed the relics of Saints Adalbert and Gaudentius and the Five Brother Martyrs that Břetislav I brought as spoils of war from Gniezno in 1039 (see cat. 11 and Raymund 1782, p. 246).

4. Ibid., p. 147.

5. Bishop Zdík was a great patron of Saint George's Convent before the 1142 fire and afterward. See ibid., pp. 304, 305.

6. Urbánková and Stejskal 1975, p. 14.

7. Podlaha and Šittler 1903a, p. 153.

8. Podlaha and Šittler 1903b, pp. 95, 96, no. 78.

9. The markedly richer decoration of the reliquary case led most authors to the conclusion that this part must be later than the base; see Fritz 1982, p. 193; Homolka 1982, pp. 153–55; Poche 1984, p. 454; Urešová in Cologne 1985, no. 51; Stehlíková 2004, p. 40.

10. Cologne 1985, nos. 48, 49.

11. Homolka 1982, p. 155; Stehlíková 2004, p. 40.

LITERATURE: Podlaha and Šittler 1903b, pp. 91–93; Poche 1972, p. 233; Fritz 1982, p. 193, figs. 69, 71; Homolka 1982, pp. 153–55; Poche 1984, p. 454, fig. 73; Cologne 1985, no. 51; Stehlíková 2004, p. 40.

## 32. Saint George Slaying the Dragon

*Márton and György of Koloszvár, 1373*
*Bronze, h. 196 cm (77⅛ in.)*
*Provenance: Third Courtyard, Prague Castle, by 1541–1966; Národní Galerie, Prague, 1966–2003; Prague Castle, since 2003.*
*Správa Pražského Hradu, Prague (VP 372)*
*Prague only*

32

Saint George's shield (now missing) proclaimed the history of this monumental bronze: "A.D. 1373 this work image of Saint George was fabricated by Márton and Győrgy of Koloszvár."[1] The stellate leather saddle and details of the knight's armor, including the mail, breastplate, and reinforced shoulders, are consistent with a late-fourteenth-century date.[2] Emblematic of Prague Castle, where it was first documented in 1541, when it already served as a fountain, this extraordinary work of art is the most important European bronze created outside Italy since the Roman Empire.

Devotion to Saint George in Prague can be traced to the tenth century, when the convent dedicated to him was founded within the precinct of Prague Castle. Because of the convent's close links to the Přemyslid dynasty, devotion to Saint George's relics intensified during the reign of Charles IV. The Arm Reliquary of Saint George (cat. 31) was apparently enshrined at Saint George's Convent early in the fourteenth century. It was even said that a relic of the dragon George slew was at Karlštejn Castle in 1355.[3] Each year the holy warrior's banner, which Charles presented to Saint Vitus's Cathedral in 1355,[4] was exhibited along with the Passion relics in the Cattle Market.[5] In 1371 Archbishop Jan Očko of Vlašim dedicated a new altar in the choir of the convent to Saints George and Ludmila.[6] In this context, the bronze's traditional association with Charles IV is not surprising, though that it survived the Hussite Revolution in Prague is extraordinary.

Creating an equestrian bronze to honor the saint would represent a Christian adaptation of an abiding imperial tradition. Charles IV would have been familiar with the figure Marcus Aurelius installed at the Lateran, as well as the Byzantine bronze horses that were set on the facade of the Basilica of Saint Mark in Venice after 1204. The Hungarian bronze casters of the Saint George are known to have created freestanding figures of royal Saints Stephen, Imre, and László for the Cathedral of Nagyvárad in Hungary in 1360.[7] Perpetuating the tradition, the authors of the Prague Saint George also made an equestrian figure of Saint Ladislas, now known only through drawings and engravings, that was commissioned in 1390 by King Sigismund and his Hungarian queen, Mary, who were married in 1382.[8] The inventories of the Cathedral of Saint Vitus evince the lively artistic dialogue that took place between Hungary and Bohemia in the second half of the fourteenth century. The relic of the Tablecloth of the Last Supper (cat. 51), for example, was a gift of King Louis of Hungary, and other members of the Hungarian royal family made equally important donations to the cathedral. A substantial group of gifts from Hungary entered the

cathedral treasury between 1368 and 1374, coincident with the planned engagement of Sigismund and Mary and with the creation of the bronze Saint George.[9]                    BDB

1. The inscription was transcribed on the shield in 1749: "A.D. MCCCLX[X?]III hoc opus imagines S. Georgii per Martinum et Georgium de Clussenberch conflatum est."
2. I thank Stuart Pyhrr and Dirk Breiding, Arms and Armor Department, Metropolitan Museum, for this information.
3. Pujmanová 1980, p. 321n21.
4. Podlaha and Šittler 1903a, p. XVIII, no. 211.
5. Pujmanová 1980, p. 321n21.
6. Beneš Krabice of Weitmile, FRB 1884, p. 544.
7. Pogány-Balás 1975.
8. Ibid., fig. 15.
9. Podlaha and Šittler 1903a, pp. XXIX–XXX.

LITERATURE: Kutal 1962, pp. 66–70, pls. 112–15; Kotrba 1969; Prague 1970, pp. 135–37, no. 166; Kutal 1971, p. 135, fig. 110; Bachmann 1977, fig. 58; Pogány-Balás 1975; Cologne 1978–79, vol. 2, p. 663, ill.; Marosi 1999a, fig. 3.

## 33. Saint Luke and Saint Charlemagne

*Attributed to Master Theodoric, Prague, 1360–64*
*Paint and gold on panel; Saint Luke panel 115 x 94 cm (45¼ x 37 in.), Saint Charlemagne panel 116 x 87.2 cm (45⅝ x 34⅜ in.)*
*Provenance: Holy Cross Chapel, Karlštejn Castle. Národní Památkový Ústav, Územní Odborné Pracoviště Středních Čech, Prague (KA 3.676, KA 3.694)*

Beneš Krabice of Weitmile, the chief chronicler of the reign of Charles IV, proclaimed that "in all the world no castle or chapel is so precious and meritorious a work [as the Holy Cross Chapel at Karlštejn], for there [the emperor] has deposited the imperial insignia and the treasure of all his kingdom."[1] Slabs of jasper, amethyst, and gold set in the shape of crosses sheathe the chapel's lower walls, while overhead wall paintings and commanding images of Christian saints stand as witnesses to the Crucifixion panel behind the altar (see fig. 1.1). The entire ensemble was realized in a period of about four years.

In his foundation charter for the Karlštejn chapter Charles invoked the gathering of saints, the "cloud of witnesses," in the Holy Cross Chapel: "We have founded this place in the name of Christ the Saviour for the praise and glory of the Holy Trinity and especially our most gracious Redeemer . . . and for the reverence of the whole Heavenly Host."[2] Of all the 130 saints that populate the chapel, this half-length image of Saint Luke is arguably

the most compelling. Affixed to the north wall, to the left of the altar, Luke appears in the company of the other authors of the gospels, apostles, and angels. The basic composition is set out in a detailed underdrawing. Luke holds the open text of his gospel, while an ox, his traditional symbol, floats in on a cloud to whisper divine inspiration in his ear. Seemingly aware of the voice, the saint looks directly at the viewer, the only figure in the chapel to do so. Accordingly, it has been proposed that this image of Luke, patron saint of painters, is a self-portrait of Master Theodoric, court painter to Emperor Charles IV and head of the Brotherhood of Saint Luke in Prague. Typical of Master Theodoric's panels, this sturdy, dignified figure, with his large head and hands, fairly bursts from his frame, the sleeve of his garment and the edge of his book spilling over onto its angled edge. Characteristic of the Karlštejn ensemble too are the compartment for a relic at the bottom edge and the patterned gold ground that gives the work such exceptional textural richness that it is perceptible even at a distance. Charles IV proclaimed the work "ingeniously and masterfully" done and granted property in the nearby village of Mořina to Master Theodoric.[3]

On the west wall of the nave of the Holy Cross Chapel the assembled saints are holy bishops and abbots, like Adalbert and Benedict, and holy rulers, including Henry II and Charlemagne, both Holy Roman Emperors whom Charles IV proudly claimed as his ancestors. He particularly honored Charlemagne, his namesake, who was celebrated not just for his piety but also for his political savvy, his patronage of the arts, and his wisdom. In this painting Charlemagne holds the imperial insignia: the golden scepter used by Charles IV that is preserved in the imperial treasury in Vienna, an orb, and a golden shield with the double-headed eagle of the empire. The shield was carved separately (as was Charlemagne's crown, now lost) and affixed to the panel at an angle and overlapping the frame. Traces of the circular metallic appliqués that once covered and enlivened the panel's gold ground are still visible. The strong, sure lines of the underdrawing are clearly visible in the robe of the saint and in the beard and hair, whose fullness is characteristic of Master Theodoric's work.

                                                     BDB, JF

1. Quoted in Fajt 1998, p. 25.
2. Ibid., pp. 174–75.
3. Ibid., p. 226.

LITERATURE: Fajt 1998, pp. 51, 126, 132, 135, 189, 198, 214, 242–44, 246, 324, 519, 528, 530–32, figs. 179, 239 (with extensive bibl.); Fait 2003, pp. 504–15.

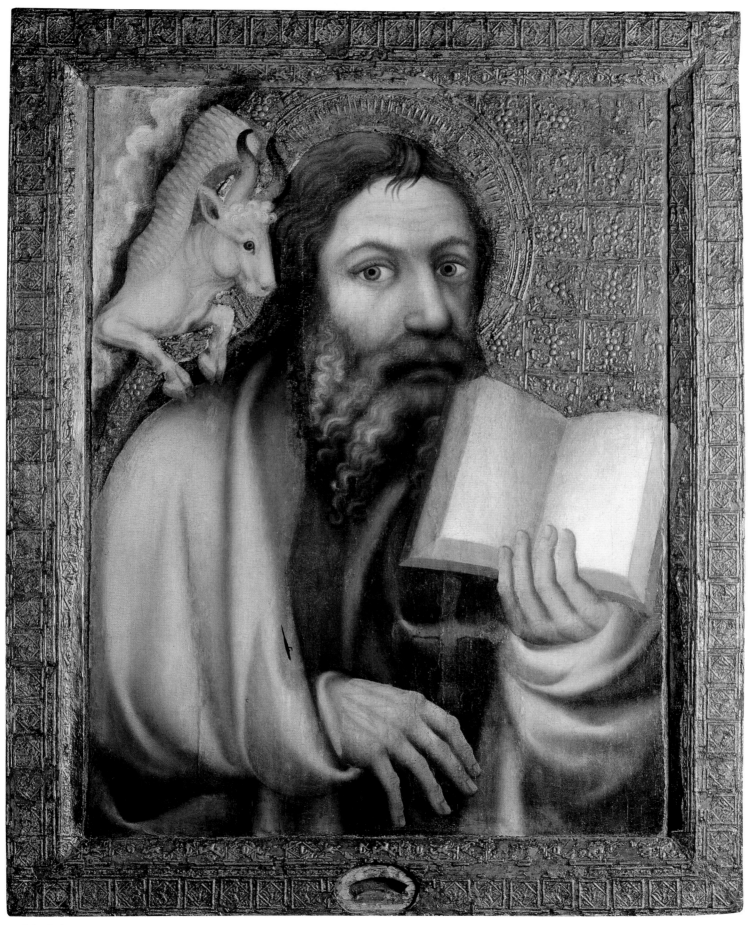

33, Saint Luke

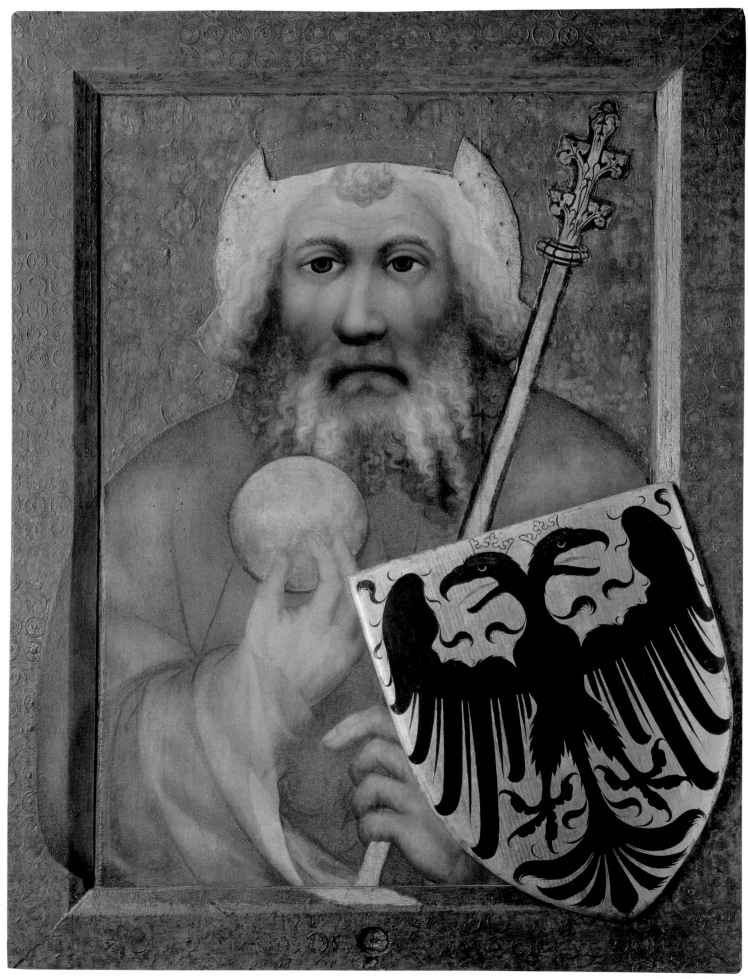

33, Saint Charlemagne

34

## 34. Head of a Prophet or an Apostle

———

*Bohemia, ca. 1360–80*
*Pen and gray-brown ink, brush with gray-black and*
*brown wash, traces of white gouache highlights on*
*paper; 11.3 x 8.5 cm (4½ x 3⅜ in.)*
*Provenance: Baron Adalbert von Lanna, Prague*
*(1836–1909; Lugt 2773 on verso); F. Kieslinger,*
*Vienna.*
*The Metropolitan Museum of Art, New York,*
*Purchase, Gift of Dr. Mortimer D. Sackler, Theresa*
*Sackler and Family, 2003 (2003.29)*

The solemn, ponderous expression along with
the hairstyle and wild beard conform to repre-
sentations of prophets and apostles in Bohemian
art of the mid-fourteenth century. The artist
deftly exploited each medium to his advantage.

Pen and ink define facial features, and brush-
strokes of wash subtly build detail. He even
manipulated the untreated paper support—less
porous and more easily worked with the cho-
sen media than parchment—so that the broad
cheekbones emerge from the blank page. The
linear vocabulary is varied: short, parallel lines
create shadow as well as establish the contours
of the shoulders; wavy, calligraphic lines define
individual strands of hair in the beard; and
small, arc-shaped brushstrokes form the soft
shape of the head.

Scholars have traditionally dated the sheet to
about 1410–30,[1] presumably on the basis of the
superior draftsmanship, high degree of finish,
and use of a paper support. But the greater
sophistication may simply indicate a mature
artist and not a late date. This head is closer to
the monumental heads in Master Theodoric's
works of the 1360s (see cat. 33) than to the
refined images in the Vienna Model Book
of about 1410–20 (cat. 117). It has the same
sense of mass and weight as Theodoric's
drawing of Saint Andrew in the Holy Cross
Chapel in Karlštejn Castle (fig. 1.7). The con-
temporary drawings of elders and prophets in
the Graphische Sammlung der Universität,
Erlangen (cat. 35), although less complex than
this one, provide another comparison.

The paucity of early independent drawings
complicates efforts to confirm a fourteenth-
century date for this sheet or to determine its
function. The great detail and monumentality
of the work suggest that it may have been a
preparatory design for a panel painting.

XMM

1. Vienna 1962, p. 248; Krása 1974b, p. 35.

LITERATURE: Vienna 1962, no. 246; Krása 1974b,
p. 49, fig. 16.

## 35. Two Leaves from a Model Book

———

*a: Cicero(?) and Ptolemy; b: a prophet, a young man,*
*and Noah(?)*
*Circle of Master Theodoric, Prague, ca. 1355–65*
*Ink and wash on parchment, a: 13.7 x 13.5 cm*
*(5⅜ x 5¼ in.), b: 12.7 x 17.2 cm (5 x 6¾ in.)*
*Provenance: Willibald Imhof the Elder (d. 1580),*
*Nuremberg, according to inventory of 1573–74;*
*acquired by the present owner before 1929.*
*Graphische Sammlung der Universität, Erlangen*
*(B 1, 2)*

The figure with a quadrant at the right on
the first of these two sheets is very likely
Ptolemy, the most famous astronomer of
antiquity. He was probably copied from a cycle
of the Seven Liberal Arts, and if this is so,
then the figure next to him holding a scroll
could be either Cicero, representing Rhetoric,
or possibly a grammarian like Donatus or
Priscian.[1] On the second leaf the figure at the
left is most likely a prophet. In the middle is
an unidentified man with a banderole. The
figure on the right can only be Noah, as he is
a copy of the Noah figure in the family tree
of the Luxembourg dynasty painted on the
walls at Karlštejn Castle in 1356–57 (and now
known only through late-sixteenth-century
copies; see fig. 4.2). These drawings also relate
stylistically to the paintings in the vaults of the
Holy Cross Chapel at Karlštejn, which were
completed shortly after 1360. Judging from
the modeling, which uses the fine pointillistic
technique developed for luxury manuscripts
of the period, these two leaves are fragments
of an illuminator's model book. A drawing of
a young standing saint in the Anhaltische
Landesbücherei in Dessau is from the same

35, Cicero(?) and Ptolemy

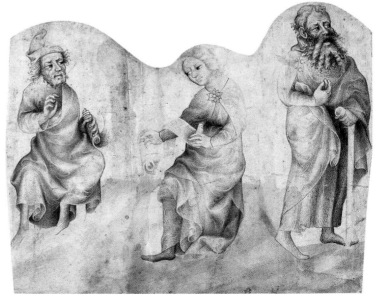

35, A prophet, a young man, and Noah(?)

book.[2] It was customary for model books of the period to combine two or three figures on a page.[3] A single leaf with four secular figures now in the Kupferstichkabinett in Berlin suggests that the practice of using such books came from western Europe.[4]

"Juncker von Brag gemacht" (made by squires of Prague) is written across the top of the leaf with Ptolemy (and on the sheet in Dessau) in a late-sixteenth-century hand in a Franconian dialect. This was probably an attempt to associate the drawings with legendary architects and sculptors in Prague who apparently were elevated to noble rank, notably the sons of Peter Parler, who because of his position as Charles IV's court architect and the architect of Prague Cathedral was most likely to have been granted aristocratic status.[5] Nevertheless, the "squires" could hardly have had anything to do with manuscript illumination.[6]

RS, JF

1. Seibert in *Lexikon der christlichen Ikonographie*, vol. 2, cols. 703–13, esp. 707.
2. Cologne 1978–79, vol. 3, p. 144.
3. See Scheller 1995. Other drawings that had previously been considered autonomous are in fact fragments of similar model books; see a sheet in the Herzog Anton Ulrich-Museum, Braunschweig (z 53; Nuremberg 1978, no. 26, ill.).
4. Avril 1978, p. 24; Müller 1996, p. 54.
5. Warnke 1985.
6. Kletzl 1936; Schmitt 1926; Kutal 1958, pp. 213–14; Kutal 1971, p. 123. According to Kutal, a late-fifteenth-century inventory of Saint Vitus's in Prague indicates that the "squire" also painted the *Virgin and Child* panel from the cathedral (cat. 91).

LITERATURE: Neuwirth 1895, pp. 71–75; Friedländer 1914, no. 1; Bock 1929, nos. 1, 2, figs. 1, 2; Drobná 1956, pp. 40–41, pls. 60, 61; Schmidt 1969b, p. 239; Kuhrmann in Cologne 1978–79, vol. 2, pp. 143–44, ill. (with bibl.); Fajt 1998, pp. 238–40, figs. 175, 177.

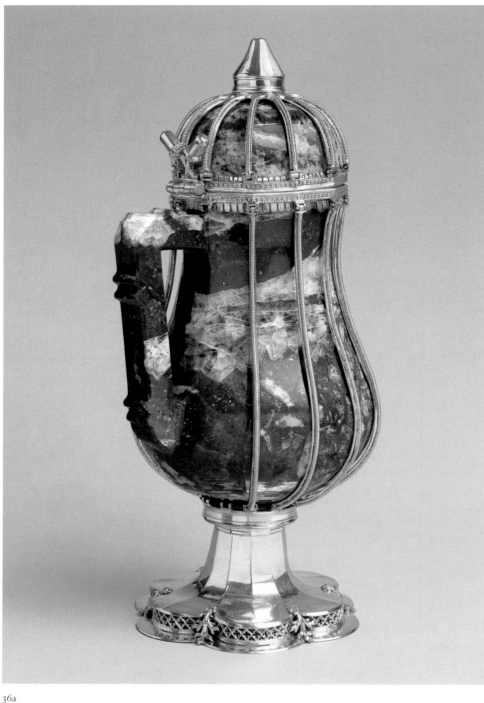

36a

## 36. Bohemian Jasper Vessels

### a. Ewer

*Prague, 1350–75; mounts, late 14th–early 15th century*
*Jasper with gilded silver mounts, h. 35 cm (13¾ in.)*
*Provenance: Parish church, Reinkenhagen, Germany (Mecklenburg-Vorpommern), 1876; J. Pierpont Morgan, London and New York, before 1916.*
*The Metropolitan Museum of Art, New York, Gift of J. Pierpont Morgan, 1917 (17.190.610)*

### b. Quatrefoil Bowl

*Prague, 1350–75*
*Amethyst, h. 11.5 cm (4½ in.), diam. 9.5 cm (3¾ in.)*

*Provenance: Imperial Treasury, Vienna; transferred to Kunsthistorisches Museum, 19th century.*
*Kunsthistorisches Museum, Vienna, Kunstkammer (KK 1900)*

### c. Bowl

*Prague, 1350–75*
*Jasper, h. 10.5 cm (4⅛ in.), w. 27.5 cm (10⅞ in.)*
*Provenance: Medici Collection, by 1492.*
*Museo degli Argenti, Palazzo Pitti, Florence (Gemme 1921 n. 789)*

### d. Bowl with Enameled Handles

*Prague, 1350–75; mounts, 17th century*
*Jasper with gold mounts set with amethysts, rubies, and*

enamel; h. 9.2 cm (3⅝ in.), diam. 21.5 cm (8½ in.)
*Provenance: Queen Hedvig Eleonora, Ulriksdal.*
*Royal Collections, Stockholm (HGK SS 39)*

### e. Footed Bowl

*Prague, 1350–75*
*Jasper with gilded silver mounts, h. 18.6 cm (7⅜ in.), diam. 27 cm (10⅝ in.)*
*Provenance: Archduke Ferdinand II, Castle Ambras, Innsbruck, by 1595; Emperor Rudolf II, after 1595; Imperial Collection, Vienna, during reign of Emperor Leopold I, 1658–1705; Kunsthistorisches Museum, by 1891.*
*Kunsthistorisches Museum, Vienna, Kunstkammer (KK 6699)*

### f. Goblet

*Prague, 1350–75*
*Amethyst, h. 11.5 cm (4½ in.), diam. 9.5 cm (3¾ in.)*
*Provenance: Purchased by Louis XIV from the merchant Alvarez, 1683.*
*Musée du Louvre, Paris, Département des Objets d'Art (OA 2042)*

### g. Cup with Trefoil Handle

*Prague, 1350–75*
*Jasper with gilded silver mount and foot, h. 10.5 cm (4⅛ in.), diam. 11.5 cm (4½ in.)*
*Provenance: Thurn und Taxis Collection, Bavaria, sold 1999.*
*The Metropolitan Museum of Art, New York, Purchase, Mrs. Charles Wrightsman Gift, in honor of Annette de la Renta, 2000 (2000.504)*

### h. Cup

*Prague, 1350–75; mounts, Burgundy, late 15th century*
*Jasper with gilded silver mounts, h. 14 cm (5½ in.)*
*Provenance: Grünes Gewölbe, founded 1560.*
*Staatliche Kunstsammlungen Dresden, Grünes Gewölbe (IV 343)*

### i. Bowl

*Prague, 1350–75*
*Jasper, h. 5.6 cm (2¼ in.), diam. 15.9 cm (6¼ in.)*
*Provenance: Inventory of the Imperial Treasury, Vienna, 1750; transferred to the Kunsthistorisches Museum, 1890.*
*Kunsthistorisches Museum, Vienna, Kunstkammer (KK 1638)*

### j. Fluted Cup with Pierced Handle

*Prague, 1350–75; mounts, 17th century*
*Jasper with gilded copper alloy and enamel, h. 8 cm (3⅛ in.), diam. 21.7 cm (8½ in.)*
*Provenance: Imperial Treasury, Vienna; transferred to Kunsthistorisches Museum, 19th century.*
*Kunsthistorisches Museum, Vienna, Kunstkammer (KK 2030)*

### k. Footed Bowl

*Prague, 1350–75; mounts, Florence, ca. 1785*
*Jasper with gilded silver mounts, h. 10.5 cm (4⅛ in.), diam. 17.4 cm (6⅞ in.)*
*Provenance: Medici Collection, by 1492.*
*Museo degli Argenti, Palazzo Pitti, Florence (Gemme 1921 n. 473)*

Carved vessels of semiprecious stone, often considered typical of the refined taste of ancient Rome or the Renaissance, were particularly favored at the imperial court of Charles IV. These jasper pieces, with characteristic amethyst and rock crystal inclusions, were carved from distinctive stone mined only in the foothills of the Ore Mountains

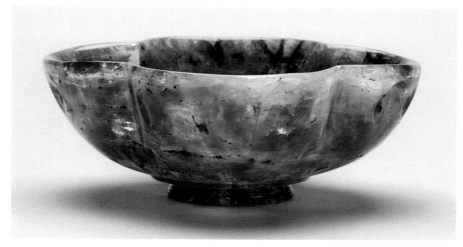

36b

(Krušnéhory), northwest of Prague. In recent years, geologists have found traces of the abandoned medieval mine shafts tucked into the mountains near Ciboušov.[1] Thousands of sheets of Bohemian jasper, many measuring more than a meter high, still sheathe chapel walls in Prague's Saint Vitus's Cathedral (fig. 6.1) and at Karlštejn Castle.

In such sacred contexts, the symbolism of the material motivated its choice. Christian thought considered semiprecious stones the building blocks of the Heavenly Jerusalem, described in the Apocalypse of Saint John (21:18–21). The same association applies to sacred vessels (see cat. 50). With the exception of the ewer (cat. 36a),[2] the bowl from Trier

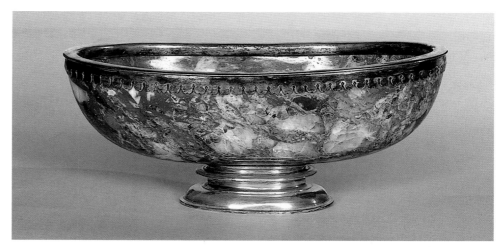

36c

36d

36e

in form is the twelve-sided faceted ewer (cat. 36a). The lid has an exquisite crystal inclusion probably expressly chosen for its translucence, which would be perceived each time the vessel was opened or closed. Its roughly contemporary gilded silver mounts fortify the vessel, which shows evidence of impact fracture.

Charles IV embellished the walls of the Chapel of Saint Wenceslas at Saint Vitus's with jasper by 1367 (fig. 6.1), the Chapel of Saint Catherine at Karlštejn about 1365, and the Chapel of the Virgin at Tangermünde about 1377.[5] There is no evidence that the taste for jasper—whether as a wall covering or for the carving of precious vessels—passed to either of Charles's sons after his death in 1378. Nonetheless, Bohemian jasper vessels were prized throughout Europe, no doubt because of the preciousness of the material and the artistic virtuosity required to create the various three-dimensional shapes. The inventories of the popes in Avignon[6] and of renowned princely collectors such as Charles V of France[7] and his brother Jean, duke of Berry,[8] describe similar pieces in detail. The New York ewer, which could originally have served either at a princely table or the altar of a church, was preserved in a church treasury in Germany until its sale in the nineteenth century.[9] Several bowls bear the engraved initials of Lorenzo de Medici (see cat. 36k). Later owners adapted the vessels to their taste by the addition of enameled gold mounts, as in the case of the bowl in the Royal Collection, Stockholm (cat. 36d).

Such subsequent changes, and even legend, have sometimes obscured the Bohemian medieval origin of a number of works. The bowl in Trier (fig. 36.1), probably the gift of

(fig. 36.1), and possibly the footed bowl from Vienna (cat. 36e), however, Bohemian jasper vessels were apparently used originally in a secular context. Thus, while the purple-red material may have been appropriate for its royal connotations,[3] pure visual richness was surely the inspiration underlying its choice.

Most surviving jasper vessels are carved in the form of shallow bowls, consistent with the shape of contemporary silver examples from France,[4] though these *hanaps* (the term used in medieval inventories) do not have the thin lip achievable in silver. The weight of the material, its rich coloration, and its occasional areas of translucence make these pieces unique among surviving medieval vessels. Some are enhanced with trefoil-shaped handles, for ease of gripping between thumb and forefinger. The Louvre goblet (cat. 36f) has exceptionally high walls and facets. The most accomplished

36f

36g

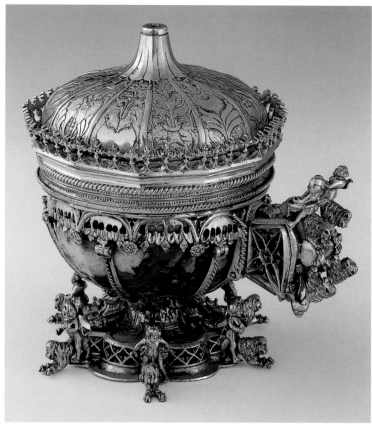

36h

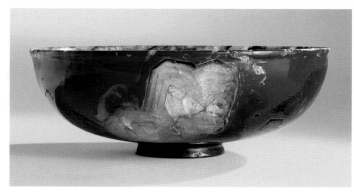

36i

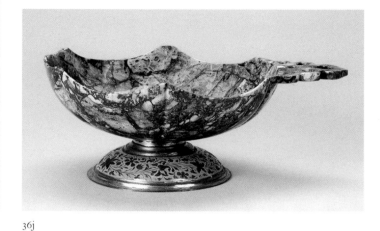

36j

Charles IV, became linked with the name of the Byzantine empress Saint Helena, as later officials at the church attempted to draw pilgrims to see a relic from the Early Christian period.[10] The original gilded silver mounts of the Trier bowl survive in part; remarkably, those of the footed bowl in Vienna (cat. 36e) and the cup in the Metropolitan Museum (cat. 36g) are intact. In their decoration, these three objects bear comparison to those in the treasury of Saint Vitus, especially the sardonyx chalice (cat. 50). This concurrence suggests collaboration between lapidary artists and goldsmiths resident in, and working for, the court in Prague.

BDB

1. Kudrnáč 1985; Marek 1985.
2. Recorded in the nineteenth century in a church in Pomerania, homeland of Charles IV's fourth wife, Elizabeth.
3. See Šedinová 1997 and Šedinová 1999, pp. 85–86.
4. See Toulouse 1992, pp. 227–46.
5. See Skřivánek 1985, esp. pp. 583, 588, 590.
6. Hoberg 1944 (the index of jasper objects is on p. 592). The descriptions often specify the red, or red and white, color of the jasper.
7. The inventory of the dauphin Charles V of France includes, for example, a jasper bowl with an "ear" without any metal mount, like one of the bowls from the Medici collection, now in the Museo di Mineralogia, Florence. For the description, see Gaborit-Chopin 1996,

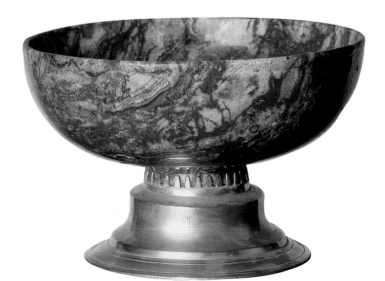

36k

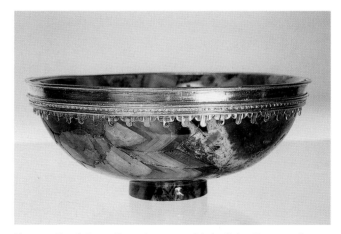

Fig. 36.1 Bowl. Jasper; Prague, 1350–75. Bischöfliches Dom- und Diözesanmuseum, Trier, Germany

p. 61, no. 419; for the bowl, see Hahnloser and Brugger-Koch 1985, no. 414, pl. 351.

8. See index in Guiffrey 1894–96, vol. 2, p. 407.

9. Fritz (2004) suggests that it might have been her gift to the treasury of Cammen.

10. Jopek 1988.

LITERATURE: Legner in Cologne 1978–79, vol. 3, pp. 169–82; Hahnloser and Brugger-Koch 1985, pp. 28–29, nos. 424 (Florence), 425 (Vienna), 426 (Florence), 475 (New York); Paris 2001, pp. 129–30, no. 36; Vienna 2002–3, nos. 12–14, 54–57; Fritz 2004, no. 181, pl. 273.

## 37. The Strahov Madonna

*Prague, ca. 1340s*
*Maple, tempera, and gilding with engraving and punchwork;[1] 94 x 84 cm (37 x 33⅛ in.)*
*Condition: Restored by Mojmír Hamsík in 1987–88.[2] Panel, originally 2 cm thick, later trimmed and reinforced on all sides.*
*Provenance: Unknown Premonstratensian abbey, Bohemia or Moravia; Strahov Monastery, first recorded 1836–46; on loan to Národní Galerie, Prague, 1938–90 (confiscated after 1951 as property of State); Royal*

*Canonry of Premonstratensians of Strahov, restituted 1990–93.*
*Královská Kanonie Premonstrátů na Strahově, Prague (O 539)*

Both style and execution link this painting and a number of others to the Kłodzko Virgin and Child (fig. 3.4), which was commissioned by Arnošt of Pardubice in 1343–44. Another important painting in this group, although slightly less accomplished in terms of technique, is the so-called Vyšší Brod Altarpiece

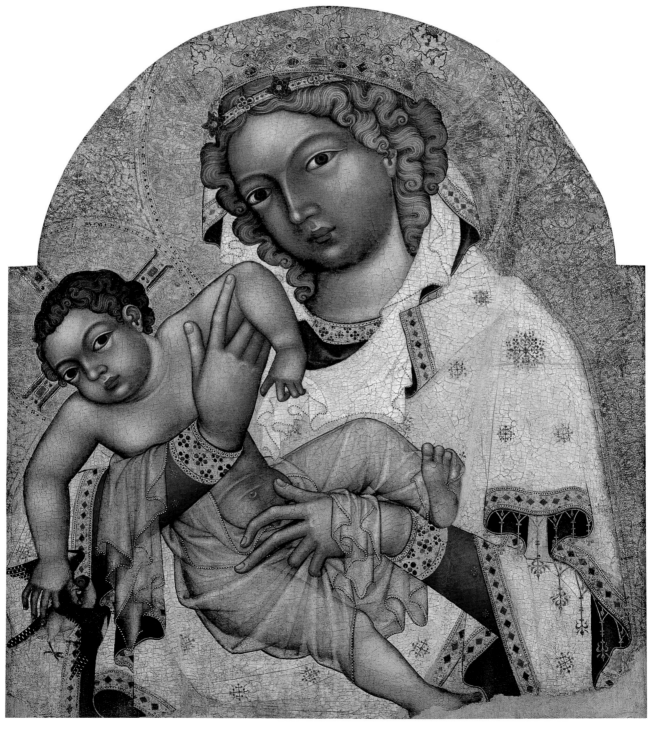

37

(see fig. 3.2), most likely painted in 1347 to commemorate Charles IV's coronation as king of Bohemia.[3] The Strahov Madonna belongs among the best works of this group. The composition, figural types, and realization of flesh tones and drapery are the most reminiscent of the Kłodzko Virgin and Child and, above all, of the Madonna of Veveří (Národní Galerie, Prague).[4] If the latter painting did in fact originally come from the royal castle of Veveří, near Brno, its close formal resemblances to the sculptural group around the Michle Madonna (Národní Galerie, Prague) qualify it as representative of the artistic environment developing in the late 1330s at the court of Charles IV, then margrave of Moravia.[5]

These interrelationships indicate that the Strahov Madonna was commissioned in the 1340s by someone from within Charles's circle, probably in Prague rather than in Brno. Large-scale italianate images of the Virgin Mary became particularly popular at the Moravian court during this period. Unlike earlier sculpted images, the standard decoration for all medieval churches, these iconic paintings displayed an emotionally powerful, expressive style that was well suited to the emerging trend toward internalized spirituality and the moral responsibility of the individual. The relative wealth of surviving contemporary paintings of the Virgin and Child confirms the creation of a large number of these testaments to the Bohemian court's embrace of novelty and "modernity."

The decorative, scallop-shaped leaves arranged in rows on the gilded background of the Strahov Madonna are unique among Bohemian paintings of the era. This ornamentation is a more meticulously and subtly executed version of that found on the Crucifixion (Bührle Collection, Zurich), ascribed by Robert Suckale to artists at the court of Louis the Bavarian during the 1330s.[6] Given the Strahov Madonna's substantially higher quality of execution and the absence of other points of similarity, a common source (perhaps in Italy) is more likely for this decorative technique than a direct link between workshops. The same technique was probably employed for the linear decoration on the borders of the Virgin's and Child's garments in the Madonna of Kłodzko. Though the Italianate style and origin of the technique are incontrovertible, the Strahov Madonna's group cannot be placed in the context of any of the Italian centers, not even Siena or Venice, that previous research has relied upon as points of departure.

The creative autonomy of the painters and the originality of the Bohemian group are also evident from the iconography. The Strahov Madonna portrays the Child in a dynamic posture, but his expression is solemn

and his gestures meaningful—with the left hand, he holds his mother's veil, and with the right a goldfinch. This composition has been adopted from Byzantine images of the Virgin Kykkotissa. The goldfinch nibbling at the hand of the infant presages the martyrdom of Christ.[7] Revealing rather than shrouding the Child, the translucent veil also identifies his vividly rendered body as an image of the Eucharist—the Body of Christ. Among the less common motifs is the Virgin's threefold aureole, comprising her traditional halo and crown but also a circlet resembling a wreath of flowers. This denotes that, apart from venerating her virginity, the artists wished to highlight her place within religious dogma (i.e., her share in the symbolic figure of Divine Wisdom—Sophia) and her own sufferings, which allowed her to share in the Sorrows of Christ.[8] Thus, even though the Strahov Madonna maintains the overall appearance of an Orthodox icon, including the typical Byzantine arrangement of the cloak with fringes at the shoulder, it also displays individual motifs that establish its manifestly Western context.

MB

1. The paint is a yolk-based tempera on a multi-layered chalk-coated foundation applied over a continuous engraved drawing, of which the underlying drawing cannot be ascertained. The gilding is on a thin red-brown bole. The panel is distinguished from other mid-fourteenth-century Bohemian paintings by the use of a darker shade for the flesh tones on an underlying coat of dark brown paint—a technique similar to that of the Byzantine tradition.
2. Archive of Restoration Reports, Národní Galerie, Prague, protocol no. 928, February 29, 1988.
3. Suckale 2003b, pp. 119–50; Royt 1998, pp. 51–60; Bartlová 1994, pp. 9–14; Hlaváčková in Benešovská 1998, pp. 244–58.
4. Matějček and Pešina 1950, p. 47, no. 12, pl. 26.
5. Bartlová in Benešovská 1998, pp. 206–15.
6. Suckale 1993b, pp. 215–18.
7. Friedmann 1946, esp. pp. 22, 110.
8. Hall 1995, pp. 101–26.

LITERATURE: Matějček and Pešina 1950, p. 47, no. 13, fig. 27; Pešina in Prague 1970, p. 214, no. 294; Kořán 1989, p. 194; Kyzourová and Kalina in Prague 1993, pp. 22–23.

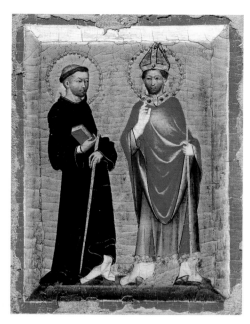

38

## 38. Two Standing Saints

*Prague, 1340s*
*Paint and gold on linen over panel, 20.7 x 16.2 cm*
*(8⅛ x 6⅜ in.)*
*Provenance: [Edward Speelman Ltd., London], 1982; art market, Lugano, Switzerland.*
*Private collection, Turin*

The original context of the two saints—a monk in traditional black Benedictine garb and a bishop with miter and crozier—is unknown. But the exceptional refinement of the painting, noticeable in the delicate glazes of the faces, the incised drawn line defining the outline of a chin or the edge of a hem, the delicate wisps of hair and beard, and the elegance of the figures' bearing, has brought considerable acclaim to this relatively unknown panel. Olga Pujmanová, Andrea De Marchi, and Gaudenz Freuler attribute the painting to the Vyšší Brod Master,[1] while Gerhard Schmidt suggests the panel was made by the same artist who created the Kaufmann Crucifixion (cat. 1). Robert Suckale has suggested that it may have been an element in the original Kłodzko Virgin and Child commissioned by Arnošt of Pardubice (fig. 3.4), and the similarity of the figures to the kneeling archbishop in that monumental composition is compelling. The left edge of the frame once bore hinges.

The linen ground, the profile of the integral frame painted red, and the use of decorative punchwork in the halos are hallmarks of Bohemian panel painting of the fourteenth century.

BDB

1. Freuler, conversations with the author, 2005.

LITERATURE: Suckale 2003b, pp. 119, 141, fig. 9; Schmidt 2005, vol. 1, p. 258.

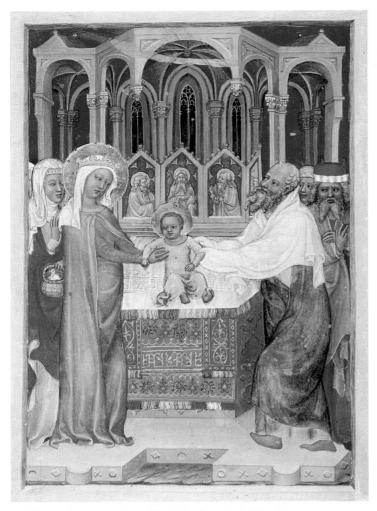

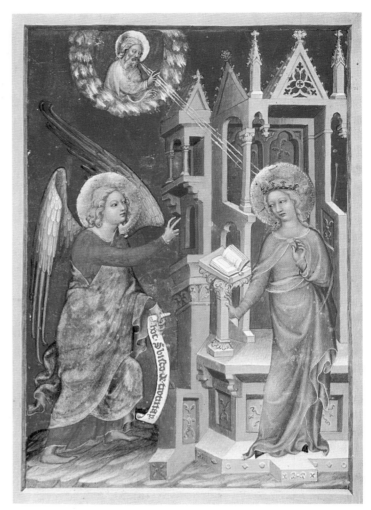

39, fol. 34v, The Presentation of the Infant Jesus in the Temple

39, fol. 55v, The Annunciation

## 39. *Laus Mariae* of Konrad of Haimburg

*Prague, ca. 1360; binding, 15th century*
*Tempera and gold on parchment, 170 fols., 29.4 x 20.8 cm (11⅝ x 8¼ in.)*
*Inscribed in the 19th century by Václav Hanka on the angel's banderole on fol. 55v: Hoc Sbisco de Trotina (fictitious name of the painter).*
*Condition: Restored 1966.*
*Provenance: Hanuš of Kolovraty, 1464–83; Archbishop Václav Leopold Chlumčanský of Přestavlky (1750–1830); his gift to Národní Muzeum, before 1830.*
*Národní Muzeum, Prague (KNM XVI D 13)*

At the invitation of Charles IV and Archbishop Arnošt of Pardubice, the poet Konrad of Haimburg came to live at the Carthusian cloister in the Little Quarter (Malá Strana) in Prague sometime between 1345 and 1350. This manuscript contains an abbreviated version of lectures and prayers he composed in honor of the Virgin Mary, arranged according to the liturgical calendar and illuminated with two full-page paintings of the highest quality.

The Annunciation on folio 55v is remarkable for the intensity and variety of its palette, the beautifully inventive architecture, and the delicacy of the image of the Virgin, who places one hand on her lectern to steady herself as she faces the angelic intruder. The miniature on folio 34v depicts the Presentation of the Infant Jesus in the Temple, rendered as the interior of a Gothic church. The fictive architecture recalls early-fourteenth-century Bolognese painting, the palette, Sienese painting. A number of scholars have noted the similarities between the miniatures in the *Laus Mariae* (Praise to Mary), the Adoration of the Magi of the Morgan Diptych (cat. 25), and the small Virgin and Child in Boston (cat. 18), particularly in the palette

and the profile of the Virgin. The face of Gabriel in the *Laus Mariae* finds its counterpart in the youngest magus of the Morgan Adoration. Also compelling, and also indicative of the close collaboration among the artists working at the court of Charles IV, are comparisons to the *Liber viaticus* of Jan of Středa (see fig. 3.6), which like the *Laus Mariae* came to the Národní Muzeum Library as a gift from Archbishop Václav Leopold Chlumčanský of Přestavlky.                                JF

LITERATURE: Dvořák 1901a, pp. 35–93; Dvořák 1901b, pp. 451–53; Chytil 1915, pp. 7–12; Bartoš 1926–27, p. 354, no. 3689; Kramář 1937, pp. 29–30; Schmidt 1969, pp. 182–84, 428; Stejskal 1969, pp. 433–40; Krása 1970, pp. 244, 268–69; Krása 1974a, pp. 105–6; Krása in Cologne 1978–79, vol. 2, pp. 736–37; Cologne 1985, p. 107; Gibbs 1990, pp. 74–76; Fajt 1997, pp. 298–99, 321–22; Fajt 1998, p. 256, fig. 195; Brodský 2000, pp. 263–65, no. 247, fig. 292.

## 40. Chasuble

*Prague, ca. 1370*
*Chasuble: silk; embroidery: silk and metal thread on*
*linen; 106 x 64 cm (41¾ x 25¼ in.)*
*Condition: Orphrey trimmed and embroidered scenes*
*rearranged when supporting material replaced and*
*restored, after 1784.*
*Provenance: Church of Our Lady of the Snows,*
*Augustinian Monastery, Rokycany.*
*Římskokatolická farnost Rokycany (ZPČG 214,*
*VO 661/2000)*

The embroidered panels decorating the back of
this chasuble celebrate the extraordinary inter-
vention of God and his angels in the life of the
Virgin Mary.[1] At the bottom, a dove represent-
ing the Holy Spirit swoops in through the roof
of the room where Mary sits. A tiny image of
the baby Jesus appears already at her belly.
Above, angels with powerful wings bodily lift
her heavenward, as the Christ Child guides her
and angelic hands crown her. The emphasis on
Marian subjects promoted by the archbishops
of Prague particularly befits the provenance of
this chasuble from the Augustinian monastery
at Rokycany, which was established in 1361
by the first archbishop of Prague, Arnošt of
Pardubice. The canons moved to Rokycany
from the mother house at Roudnice nad Labem
(on the Elbe) in 1363. This chasuble may have
been the gift of Arnošt's successor, Jan Očko of
Vlašim (r. 1364–79), who took a special interest
in the monastery.

The models for these embroidered scenes[2]
were provided by a painter close to the Master
of the Vyšší Brod Crucifixion, as can be seen
from the animated handling of the angel. The
artist was also indebted to the painters from
the circle of Master Theodoric. (Compare the
figures in the initials of the Gospel Book of
Jan of Opava, dated 1368.)[3] Related but some-
what later in date are the embroidered Görlitz
Crucifixion and the chasuble in London.[4]
Their figures bespeak a connection with the
artistic milieu of the 1370s in Prague, which was
inspired in part by French models.[5] The same
holds true for the chasuble from the Benedictine
monastery in Břevnov (cat. 128).[6]          RS, JF

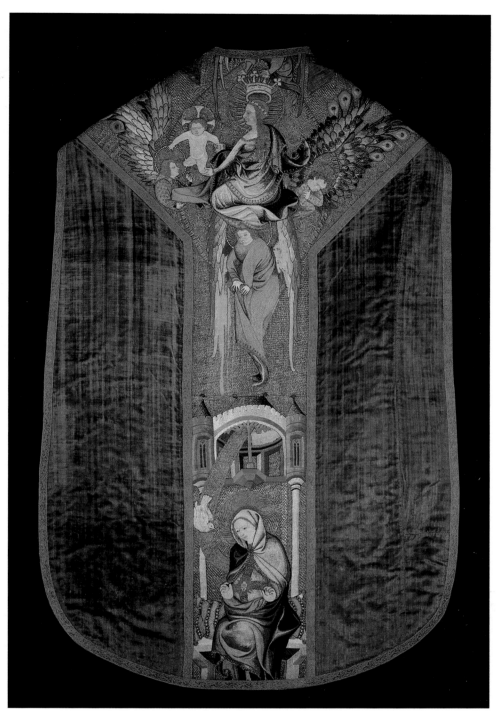

40

1. A ruined Bohemian panel painting in the
   Wilhelm-Hack-Museum, Ludwigshafen,
   follows the same iconographical type as this
   Annunciation (Cologne 1978-79, vol. 2, p. 765).
   In the painting, the Virgin sits in a temple under
   the baldachin, through which the Holy Spirit
   comes to her.
2. When the panels were taken off the chasuble
   and restored, the scenes on the front were trun-
   cated and replaced in random order.
3. Österreichische Nationalbibliothek, Vienna,
   cod. 1182, fol. 149r (Jenni and Theisen 2004,
   no. 6). See also fig. 4.9.

4. Kunsthistorisches Museum, Görlitz, 65; Victoria
   and Albert Museum, London, 1375–1864.
5. The closest point of comparison is offered by
   the Parement de Narbonne (Louvre, Paris); see
   Sterling 1987-90, vol. 1, no. 35, pp. 218-25.
6. Poche (1978, pp. 715-16) dates it too late.

LITERATURE: Wilckens 1965; Cologne 1978-79,
vol. 2, p. 714; Zeminová in Cologne 1985,
pp. 156-57; Wilckens 1991, pp. 221, 226-27,
fig. 253; Prague 1996, vol. 2, no. 214; Wetter 1999.

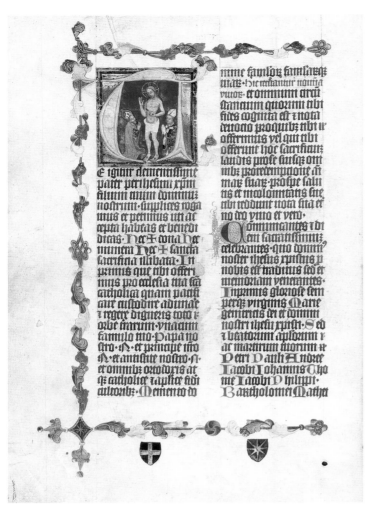

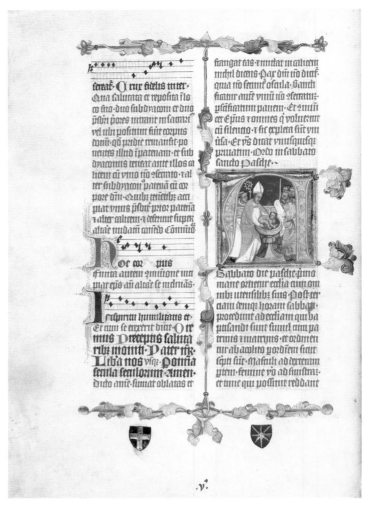

41, Christ as the Man of Sorrows

41, The Sacrament of Baptism

## 41. Pontifical of Albert of Šternberk

*Prague, 1376; binding, 1581*

*Tempera and gold on parchment, 151 fols., 41.5 x 30.5 cm (16⅜ x 12 in.)*

*Inscribed on fol. 1r: Anno domini millesimo trecentesimo septuagesimo sexto reverendus in Christo pater dominus Albertus de Šternberk quintus episcopus Luthomyslensis olim XXX archiepiscopus Magdeburgensis pontificatus sui anno XX⁰ ad honorem dei omnipotentis et intemerate matris ei virginis Marie hunc librum pontificalem per me Hodiconem scribi mandavit*

*Provenance: Written for Albert of Šternberk by the scribe Hodík, 1376; abbot of Louka, by 1581 (his arms on the binding); Library, Premonstratensian Monastery at Strahov.*

*Královská Kanonie Premonstrátů na Strahově, Prague (DG I 19)*

According to the inscription on its opening page, this pontifical containing the texts of Christian liturgy performed by bishops, including ordination, benediction, coronation, and the sacraments, was written by a scribe named Hodík for Albert of Šternberk, bishop of Litomyšl (r. 1364–68 and 1371–80) and archbishop of Magdeburg (r. 1368–71). The opening page of the manuscript represents the bishop with the arms of Bohemia, the Holy Roman Empire, the archbishopric of Magdeburg, and the bishopric of Litomyšl, as well as his family arms, with a gilded Šternberk star. (The last two are repeated on each of the illuminated pages.) Forty-five historiated initials signal the openings of the ceremonies.

The patron is also shown kneeling with Charles IV before an image of Christ as the Man of the Sorrows on folio 36v. By the time this manuscript was made in 1376, Albert was serving his second term as bishop of Litomyšl. Although his first post as bishop was in Schwerin, in northern Germany far from Prague, in the years after his appointment in 1356 he became one of Charles's most influential diplomats, traveling widely in the emperor's service. After he successfully negotiated with Louis the Great, king of Hungary, to secure Charles's marriage to his fourth wife, Elizabeth of Pomerania (d. 1393),

in Kraków in May 1363, Charles brought him to Litomyšl. The first bishop to reside there, he became close to Jan of Středa, bishop of Olomouc, with whom he shared an interest in cultural and intellectual affairs. After Charles supported Albert's appointment as archbishop of Magdeburg in 1368, Albert sold all of Lower Lusatia to the Bohemian Crown for 6,000 marks. His reign in Magdeburg proved problematic, due to squabbles with the chapter there, however, and he resigned in 1371. Although he sought the Olomouc bishopric, he was reappointed to Litomyšl, albeit retaining his privileges as archbishop. Albert brought many relics from Magdeburg to Moravia, including one of Saint Victorin, bishop-martyr of Como, who became the patron saint of the Litomyšl bishopric. He supported the monasteries in his bishopric and as part of his last will founded the Augustinian Canonry of the Virgin of the Annunciation in Šternberk, where he was buried in 1380.[1]

A well-known patron of the arts, Albert commissioned other manuscripts. An unfinished Bible in the Jagiellonian Library in Kraków (cod. 284/1-2) was decorated by the

same illuminator as this pontifical, as was the Gradual of the Augustinian Hermits in Ročov (now in the Regional Archives, Louny). The illuminator, who probably accompanied Albert to Moravia, can be counted among the generation of Bohemian artists who had their roots in the imperial style of the 1360s. His stocky figures, with close-fitting drapery and inelegant faces, correspond to the naturalistic tradition of the Prague court paintings. Other members of this artistic generation are the illuminator of the manuscript of Tomáš of Štítné (cat. 73), who incorporated "modern" French artistic novelties into his work, and the illuminator of the missal of 1372 from the City Library, Wrocław (M III 5, lost during World War II), whose genre scenes, perspectival landscapes, and more relaxed execution made him one the greatest innovators of the group.[2]  JF

1. Brodkorb, Hledíková, and Schulz in Gatz 2001, pp. 346–48.
2. Krása 1990, pp. 125–27.

LITERATURE: Podlaha and Zahradník 1900, pp. 1, 441ff.; Stange 1934–61, vol. 2, p. 18; Krása in Prague 1970, pp. 276–77, no. 358; Stejskal 1978a, p. 266, fig. 55; Cologne 1978–79, vol. 2, p. 741; Krása 1990, pp. 125–27.

## 42. Portable Altar

*Plaques: Upper Rhine(?), first quarter of 14th century; altar: Bohemia (Prague?), 1375*
*Heartwood, amethyst, partially gilded silver, and niello; 27.1 x 19.7 x 1.8 cm (10⅝ x 7¾ x ⅝ in.)*
*Inscribed in Latin around edges of altar: anno d[omi]ni millesimo CCC LXX qui[n]to Reverend[us] pater d[omi]n[u]s albertus de Sternberg Ep[iscopu]s luthomislen[sis] consec[ra]vit hoc altare in honore[m] beate Marie virginis gloriose amen (In the year of our Lord 1375 the Reverend father, Lord Albert of Šternberk, bishop of Litomyšl, consecrated this altar in honor of the blessed glorious Virgin Mary amen).*
*Provenance: Albert of Šternberk, 1375; perhaps taken to the Benedictine abbey at Admont by Abbot Urban (1628–1659).*
*Museum Admont Monastery, Austria (U 24)*

The Admont portable altar features a slab of amethyst embedded in heartwood and framed by partially gilded silver plaques decorated with niello work. In the plaque on the top Jesus is flanked by the apostles Peter and Paul, along the bottom is the Adoration of the Magi, and on the sides are the symbols of the Four Evangelists and two more enthroned apostles, all in quatrefoil frames. According to the inscription engraved around the sides, the altar was consecrated in 1375 by Albert of Šternberk, who served as bishop of Litomyšl in 1364–68 and 1371–80 and in the years between as archbishop of Magdeburg. The coats of arms impressed on the silver sheet covering the bottom of the altar also relate to Albert and his bishopric in eastern Bohemia.

The way the silver plaques are cut, their arrangement, and their style leave no doubt that they are older than the rest of the altar. Karel Otavský has suggested they were originally part of a box-shaped portable altar that he suspects was made in northern France in the first quarter of the fourteenth century.[1] Comparable works influenced by the French High Gothic, with picture panels with niello backgrounds, date from as early as the second half of the thirteenth century.[2] In the Upper Rhine there are more direct parallels to the figural style in works from the early fourteenth century.[3] As Anton Legner has noted, the altar consecrated in 1375 fully conforms to the spirit and style of the chapel appointments in Prague and Karlštejn under Emperor Charles IV.[4] The amethyst slab most likely came from the quarries at Ciboušov, in southern Bohemia, that served the imperial court in Prague.[5] Under Albert of Šternberk, who was a member of Charles IV's inner circle, the semiprecious stone was fitted together with the older silver plaques and a new heartwood

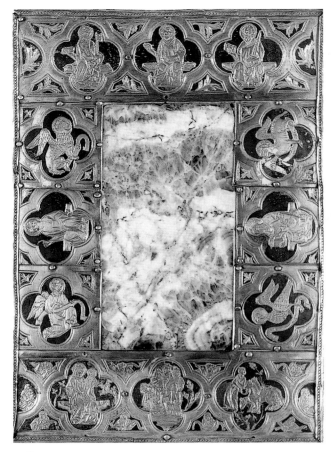

42, front

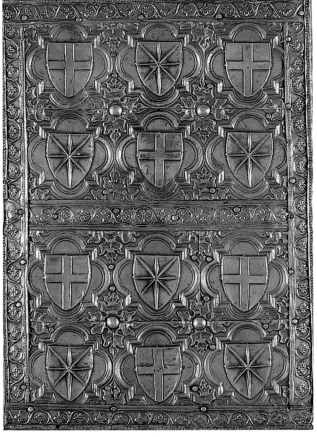

42, back

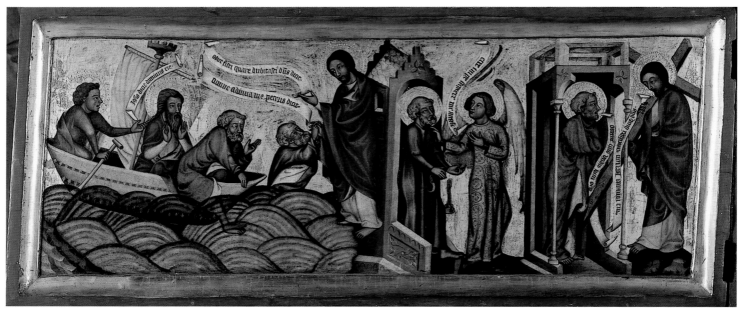

43, Scenes from the Life of Saint Peter

backing.[6] Exactly how and when the altar went to Admont has not yet been explained.[7]

FKI

1. Otavský 1992, pp. 147–48 (citing Dieter Lüdke).
2. See Fritz 1982, p. 222, no. 258 (with other examples). For an example from the Upper Rhine, see the famous book cover from Saint Blasius now in the Abbey of Saint Paul in the Lavanttal, Carinthia, which was presumably made in Strasbourg about 1260–70 (Cologne 1995, pp. 344–46, no. 34).
3. See Heuser 1974, nos. 55, 57, 61, 70, 80, ill. Fillitz (in Saint Lambrecht 1978, no. 268) identified the plaques' indebtedness to the art of the Upper Rhine; others have attributed them to "Austria, ca. 1330." See Fritz 1982, pp. 221–22, no. 258, and Wagner 2000, pp. 578–79, no. 317.
4. Legner in Cologne 1978–79, p. 174. There is no documentation that connects these plaques with a portable altar that Charles IV may have brought from France himself (see Otavský 1992, pp. 146–48), although a portable altar that belonged to Charles and may have been similar to this one is described in detail in the Prague Cathedral inventory of 1355 and mentioned again in the inventory of 1387 (Podlaha and Šittler 1903a, p. IX, no. 298, p. XV, no. 115, p. XXXVII, no. 197).
5. See, for example, a vessel also made of amethyst with a light violet tint with strong white streaks in the Kunsthistorisches Museum, Vienna (Kunstkammer 1621; Distelberger in Vienna 2002–3, p. 57, no. 14).
6. The arrangement of the pieces seems to argue against the general consensus that the plaques were added to the altar even later than 1375, after it was in Austria. See Fillitz 1978, p. 307; Fritz 1982, p. 222; and Wagner 2000, p. 578.
7. No relevant documents have been found in the abbey. List (1974, pp. 155–56) suggested that it came there in the sixteenth century; Otavský (1992, p. 184n329) proposed that it was sent there in the fifteenth century as a consequence of the Hussite Revolution.

LITERATURE: Lind 1873, p. 163; Wichner 1888, p. 146; Braun 1924, vol. 1, p. 454; Graz 1961, no. 4; Krems 1967, no. 215; Wosetschläger, Krenn 1968, p. 25, no. 28; List 1974, pp. 155–56; Saint Lambrecht 1978, no. 268; Nuremberg 1978, no. 104; Cologne 1978–79, vol. 3, pp. 174, 177, ill.; Fillitz 1979, p. 100; Fritz 1982, pp. 221–22, no. 258; Poche 1984, p. 447, fig. 317; Hahnloser and Brugger-Koch 1985, p. 82, no. 11; Brussels 1987, no. 44; Otavský 1992, pp. 147–48; Neuberg an der Mürz 1996, pp. 309, 448, no. 164; Brucher 2000, pp. 578–79, no. 317; Wagner 2000, pp. 578–79, no. 317.

## 43. Saint Paul and Scenes from the Life of Saint Peter

*Bohemia or Mark Brandenburg, 1375*
*Saint Paul: linden wood, h. 78 cm (30¾ in.); predella panel: tempera and gold on spruce panel, 56 x 132.5 x 5.8 cm (22 x 52⅛ x 2¼ in.)*
*Condition: Paint on Saint Paul sculpture now lost.*
*Inscribed on predella panel on banner of Saint John sitting in ship: [I]ohannes dicit dominus est (John said: It is the Lord [John 21:7]); on banner of Saint Peter sinking into water: domine adiuva me petrus dicit (Save me, Lord, Peter said [Matt. 14:30]); on banner of Christ walking on water: [M]odice fidei quare dubitasti dominus dicit (The Lord said, Why did you hesitate? How little faith you have! [Matt. 14:31]); on banner of angel freeing Peter from prison: ecce surge sequere me angelus d[icit] (Behold, stand up and follow me, said the angel [Acts 12:7–8]); on banner of Saint Peter standing under baldachin: [D]omine quo vadis dicit pe(trus) (Lord, where are you going? said Peter [Golden Legend]); on banner of Christ carrying the cross: [V]enio romam iterum crucifigi dicit*
*dominius (I am going to Rome to be crucified a second time, said the Lord [Golden Legend]).[1]*
*Domstift Brandenburg*

These scenes from the life of Saint Peter and seated sculpture of Saint Paul are integral elements from one of the most spectacular altarpieces of the Middle Ages. The painting forms the left wing of the altar predella; the Saint Paul stands to the right inside the shrine. A document in the cathedral archives relates that a Master Nicolaus Tabernaculus completed work on an *archa* on April 12, 1375: "under the authority of the honorable gentlemen and fathers Dietrich von der Schulenburg, bishop of Brandenburg, Provost Otto, called Nogil, Prior Bertram, and with the collaboration of the treasurer Dietrich von Osterode, to the glory of our Lord Jesus Christ and of the blessed Mary, the illustrious Virgin, and of the sainted apostles Peter and Paul, Andrew and Saint Augustine, under the dominion of our Lord Jesus Christ."[2] Although some writers have related this document to a surviving tabernacle from the altar, it is now generally agreed that the *archa* in question was the retable itself.[3] The Brandenburg altar is thus not only one of the few securely dated retables from the Middle Ages but also—given that only individual sculptures survive in the Czech Republic— one of the few surviving carved retables that can properly be called "Bohemian."[4]

The reconstructed altarpiece (fig. 43.1) consists of a rectangular shrine containing a sculptural grouping of a Coronation of the Virgin flanked by standing figures of Saints Peter and Paul and Augustine and Andrew. The shrine rests on an open predella designed to hold reliquary busts.[5] The wings can be folded across the sides and front to close the

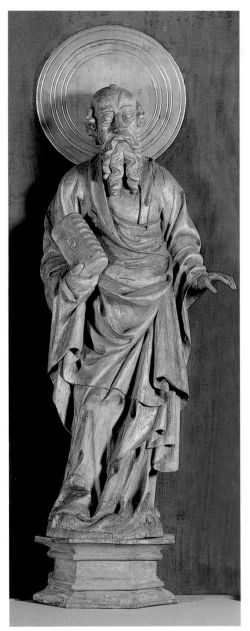

43, Saint Paul

shrine completely. The predella can be closed separately, and its wings are also made up of two hinged sections.[6]

Twenty-eight figures of saints carved in relief—apostles, martyrs, virgins, and other saints—decorate the inner sides of the shrine's wings; the outer sides of the wings are adorned with painted images of saints. On the wider panel of the predella's left wing are scenes of Peter walking on water, the angel freeing him from prison, and Peter meeting the risen Christ on the road to Rome, as recounted in the *Golden Legend*. The narrow panel depicts Peter's martyrdom on an inverted cross. On the panels of the right-hand predella wing are scenes from the life of Saint Paul. The painted busts of prophets in quatrefoil frames on the outer sides of the predella wings are now barely visible.[7]

There is a clear progression in iconography, artistry, and material richness from the exterior of the shrine to its sculptural core. The painted busts of Hebrew prophets (believed to presage the New Testament) and painted figures of saints on the wings' outer faces give way to gilded figures in relief on the inner ones. The culmination is the interior, with the cathedral's patrons arrayed on either side of the Coronation of the Virgin.[8]

The open shelf of the predella—as reconstructed—indicates that the retable was conceived as a showcase for reliquaries. But it was also a kind of reliquary in itself. During the most recent restoration small packets of relics with identifying tags written in Gothic script were discovered behind a number of the relief figures of saints. In only two instances did these relics conform to the saint depicted.[9] Also discovered were a hollow Magdeburg penny from 1513–20 and a restorer's note from 1835.[10] These finds suggest that the original distribution of the relic packets was confused at a later date.[11]

Besides the adoption in the Saint Paul preaching scene on the right wing in Branden-

burg of a group of figures from the Rain of Manna depicted in wall paintings at the Emmaus Monastery in Prague,[12] specific facial types are found in an almost identical form in contemporary Bohemian panel painting. One might compare, for example, the Christ in the Brno Dormition of the Virgin and the one in the Brandenburg Saint Peter scenes.[13] The facial types and drapery are similar to those on a Bohemian embroidered chasuble in the Victoria and Albert Museum, London.[14] It is especially tempting to attribute the Brandenburg paintings to the artist who executed the wings of the Rathenow retable.[15] The Brandenburg painter displayed considerable narrative skill in the panels on the predella wings. The figures on the outer faces, like those on the wings of the Rathenow retable, were meant to be more sculptural and, with their white outlines, legible at a distance.

Robert Nissen associated the carved figures on the Brandenburg altarpiece with the large number of images of the Madonna on Lions.[16] It is difficult to evaluate the shrine figures given their leached-out condition, but they clearly exhibit the quality of such works as the Cunigunde from Stanětice, which Jiří Fajt has dated about 1365–70.[17]

Bohemia's patron saints appear prominently on the outer sides of the wings. Wenceslas and Sigismund can be seen in the upper register of the left-hand wing, Vitus in the register below. Mauritius, patron saint of the empire, appears on the right-hand wing, just opposite Wenceslas. The placement of these two—and the fact that both are outfitted with a lance pennant and shield or pavese displaying the imperial eagle—suggests the commission's political dimension, its linking of Bohemia and the empire. Brandenburg's hereditary union with the kingdom of Bohemia was sealed at the diet in Guben on May 28, 1374. For Bohemia this meant not only a territorial expansion, but also, more importantly, the acquisition of a second electoral vote that

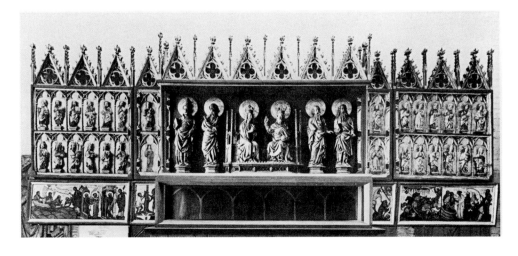

Fig. 43.1 The Brandenburg Altar. Bohemia or Mark Brandenburg, 1375. Domstift Brandenburg

assured the Luxembourgs' dominant role in the empire. Inasmuch as the altarpiece was completed only a year later, and especially since the emperor visited Brandenburg in September 1373 and at Easter 1374, it is tempting to assume that the new ruler of the territory had something to do with the commission, if only as the donor of the embedded relics.[18] In fact, the document recording the completion of the retable mentions only representatives of the cathedral chapter, who had recently assumed their places in the emperor's entourage.

EW

1. Graesse 1890, p. 374. For detailed discussion of the inscriptions, see Schössler 1998, pp. 497–99.
2. Riedel 1838–65, vol. A8, p. 310, no. 310; Schössler 1998, p. 216, no. 298.
3. Sachs and Kunze 1987, p. 178; Suckale 2001a, p. 249. See also Wolf 2002, p. 166.
4. In Mark Brandenburg there is also the retable from the Parish Church of Saint Mary and Saint Andrew, Rathenow; see Wolf 2002, pp. 178–83, and Wetter 2005, pp. 53–54. The retable in Puschendorf, in Franconia, the carver of which also produced the Madonna from Bečov, was reinstalled in a shrine in 1523; see Mudra 2001 and Suckale 2001a, p. 252. Wernicke was the first to apply the term "Bohemian Altar" to the Brandenburg retable, in 1878.
5. See Eichholz 1912, pl. 49.
6. The ensemble was reconstructed in its present form between 1964 and 1974. The entire shrine, including the gables and finials, is modern. The smaller wing elements had already been replaced in a restoration in 1723, when the shrine was probably cut in two and both halves placed atop the Lehnin Altar, which had been moved to Brandenburg as the high altar in 1552. In the process the greater part of the shrine and the predella housing were lost (for the earlier state, see Eichholz 1912, pls. 47a, 47b). The shrine sculptures have now been stripped of the repainting applied in 1928. See Sachs and Kunze 1987, pp. 180–85. I am also indebted to Birgit Malter, Brandenburg, for information about the retable's condition.
7. Nissen 1929, p. 67. Kunze (in Sachs and Kunze 1987, p. 184) writes of evangelists in his restoration report. On the back side of the left-hand predella wing there is also a *Scheibenrissentwurf* (sketch for a stained glass window) later painted over (see Maerker 1986).
8. See Wolf 2002, pp. 170–76.
9. Wolf (2002, p. 177) speaks of the images' "sacred reserve."
10. Domstiftsarchiv Brandenburg, BDS 638/576. The note says that "in September 1835 these figures were restored by the cabinetmaker and instrument maker Heinrich Rudolph Eintner, born September 9, 1808, in Hamburg, with Friedrich Heinrich Zaech as assistant."
11. Otavský in Reihlen 2005, pp. 152–53, no. 5.
12. Nissen 1929, p. 77.
13. Moravská Galerie, Brno (A 507; see Fajt 1998, p. 271).
14. Wetter 2001, p. 118 (1375-1864).
15. Suckale 2001a, p. 249, and see note 4 above.
16. Nissen 1929, p. 80; Białłowicz-Krygierowa 1981.
17. Fajt in Prague 1995b, pp. 643–45, no. 225.
18. Wetter 2001, pp. 80–81.

LITERATURE: Schulze 1836, p. 22; Wernicke 1878; Eichholz 1912, pp. 270–73; Nissen 1929, pp. 64–81; Cologne 1978–79, vol. 2, pp. 544–46, vol. 5, colorpls. 190, 191; Sachs 1979; Pešina 1981, pp. 421–23; Sachs and Kunze 1987; Suckale 2001a; Wetter 2001, pp. 80–81; Wolf 2002, pp. 166–77 (with bibl.); Wetter 2005, pp. 50–53.

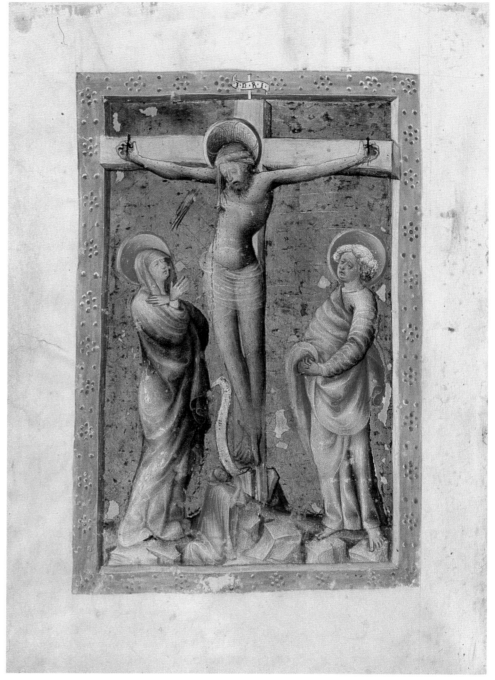

44, fol. 143v (canon page)

## 44. Missal

*Vienna(?), ca. 1375–80; half-calf binding, ca. 1840*
*Tempera and gold on parchment, 355 fols., 38 x 27 cm*
*(14⅞ x 10⅝ in.)*
*Provenance: Stift Klosterneuburg.*
*Stiftsbibliothek Klosterneuburg, Austria (CCl 74)*

This missal's calendar follows the usage of the diocese of Passau, which in the Middle Ages extended east as far as Vienna. Whether the manuscript was originally intended for Klosterneuburg is uncertain, for the donor portrayed in the canon picture and in an

initial on folio 10r wears the costume of an aristocratic layman, not that of an Augustinian canon.

The codex contains seventeen initials in tempera that reflect an early form of the Lower Austrian Border Style and thus can be dated to about 1375–80.[1] Approximately fifteen manuscripts decorated with similar initials and border ornaments survive, all of which were produced either in Vienna or Lower Austria. The majority also contain *fleuronné* initials executed by the same hand as those in the present manuscript.[2]

The important picture on the canon page is nevertheless the work of a painter who did not belong to the group responsible for the missal. His style, as Karl Oettinger long recognized,[3] derives directly from Prague painting of the late 1360s and early 1370s. Along with the altarpiece at Tirol Castle commissioned by Duke Albrecht III,[4] this depiction of the Crucifixion provides significant evidence of the particularly strong Bohemian influence on Austrian painting about 1370–80. That its donor was an aristocrat could suggest that the creator of this miniature was also active within the purview of the ducal court in Vienna, and that the missal came to Klosterneuburg as the gift of a courtier.                    GS

1. Roland 1997, pp. 103, 119.
2. Klosterneuburg 1998, p. 29.
3. Oettinger 1952, pp. 138–39.
4. Brucher 2000, p. 540.

LITERATURE: Stange 1934–61, vol. 2 (1936), p. 18; Oettinger 1952, pp. 138–39; Krems 1959, no. 113; Krems 1967, no. 80; Haidinger 1983, pp. 148–56; Roland 1997, p. 119; Klosterneuburg 1998, pp. 29–30; Brucher 2000, p. 518.

## 45. Tabernacle

*Prague, ca. 1375*
*Gilded iron, h. 208 cm (81⅞ in.)*
*Metropolitní Kapitula u Sv. Víta, Prague (HS 04270a, b [V 00325a, b] Svatovítský fond)*

Documentary evidence suggests that this magnificent shrine was made in about 1375 to serve as a tabernacle for the eucharistic Host in Prague Cathedral's Saint Wenceslas Chapel. The church accounts mention as a contributing artist an ironmonger by the name of Master Wenceslas, who on July 8, 1375, received twenty groschen "for an iron lattice in which was preserved the body of Christ in the Wenceslas Chapel."[1] Probably initially located in the southeast corner of the chapel,

and perhaps supported by a stone base, the tabernacle would have been situated between the scenes of Christ's Crucifixion and Entombment painted on the chapel dado.[2] In this location it would have fittingly juxtaposed the metahistorical body of Christ with his historical body sacrificed on Golgotha.

The tabernacle's function as a permanent residence for Christ's sacramental body is matched by the very preciousness of the structure's overall design and individual forms. Seen from afar, the object resembles a miniaturized church building; seen from up close, it dissolves into a fantastic array of exquisite tracery patterns and delicate architectural elements. Extrapolated from a square ground plan, the tabernacle comprises two principal stories: the shrine proper, which would have contained the Eucharist, perhaps within a monstrance or pyxis, and the microarchitectural superstructure, with its staggering deployment of pinnacles, flying buttresses, and surmounting openwork pyramid. Physical access to the shrine's interior is provided by a lockable door on its front side, that is, the side that would initially have faced the portal linking the choir ambulatory with the Wenceslas Chapel.

Formally, the structure anticipates, at least in part, aspects of the design of the high choirs of Saint Vitus's Cathedral in Prague and the Church of Saint Bartholomew at Kolín, both projects of the Parler workshop that were brought to completion within the decade after 1375. The flying buttresses, with their characteristic hanging friezes of quarter-arches, thus reoccur, albeit much enlarged, around the clerestory of Saint Vitus's, while the swirling tracery patterns surmounting the left side of the tabernacle are paralleled by a tracery configuration in the north clerestory of Saint Bartholomew's. Seen in this light, the commissioning of the tabernacle, while primarily intended to provide a residence for the sacramental Christ, may also have furnished a welcome occasion for architectural experimentation. Alternatively, the design could have been inspired by already existing drawings for large-scale architectural projects, so-called *Visierungen* (see cats. 46, 47).[3]

Within the history of eucharistic architecture the Wenceslas Chapel tabernacle remains something of an oddity, not only in view of its material (metal) and modest size but also in view of its very location in an ancillary chapel. By the time the structure was commissioned about 1375, many other church patrons wishing to permanently reserve, stage, and glorify the sacrament of the Eucharist had begun to favor large stone or wood tabernacles—also known as sacrament houses—that assumed the form of miniaturized church facades or multistoried

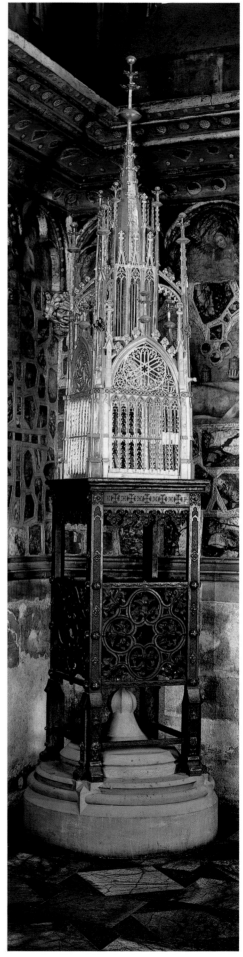

45

towers and were placed close to the high altar, often on the north side of the choir.[4] Why this tabernacle was placed in the Wenceslas Chapel rather than near the cathedral's high altar is not entirely clear. Perhaps its very placement in the chapel was meant to trigger conceptual associations with the chapel's patron saint, Wenceslas, who according to the various versions of his legend throughout his lifetime enthusiastically devoted himself to the making of the eucharistic species of bread and wine.[5]

AT

1. "pro cancello ferreo, in quo corpus Christi servatur in capella sancti Wenceslai."
2. Ormrod 1997, p. 269.
3. Cat. 47, for example, shows a cross section through what appears to be the choir of Prague Cathedral (Timmermann 1999, p. 407 [with bibl.]).
4. Cases in point are the sacrament houses of Saint Sebaldus's in Nuremberg (1361–79), Saint Bartholomew's in Kolín (1360–78), and Brandenburg Cathedral (1375–80). See Timmermann 1999.
5. Ormrod 1997, pp. 270–71.

LITERATURE: Kotrba 1960, p. 341; Kotrba 1971, p. 117; Kostílková 1975; Michna 1976, p. 156; Ormrod 1997, pp. 264–71; *Pražský hrad* 1999, pp. 70–72; Timmermann 2002, pp. 9–10.

## 46. Architect's Drawing of Saint Vitus's Cathedral

*Peter Parler workshop, Prague, ca. 1365*
*Black ink on parchment, 106 x 93 cm (41¾ x 36⅝ in.)*
*Provenance: Lodge of Saint Stephen's Cathedral, Vienna, probably acquired in the 15th century; sold to architect Franz Jäger, 1787; bequeathed by his son to the Akademie der bildenden Künste, 1839.*
*Akademie der bildenden Künste, Vienna, Kupferstichkabinett (16.817)*

This elevation drawing (at a scale of 1 inch = 2 feet) shows the two lower stories of Prague Cathedral's south tower. The plan, which corresponds largely to the section of the tower that was actually built, shows a considerable number of changes made during the drafting process. Most noticeably, on the ground floor the main window was slightly widened but drastically shortened by raising the window sill, the tracery of the smaller window was subsequently moved upward, and finally, the buttress design was gradually changed to its final version. The lower story was thus compressed to serve as the base, while on the second level the buttresses underwent a considerable change from a simple orthogonal arrangement toward a pronounced plasticity. The tracery elements show only first attempts at breaking

46, front

46, back

up the classical form to find the undulating arrangements characteristic of the choir's clerestory windows, but the progression from a still conservative use of Gothic forms to the introduction of a decidedly Late Gothic approach is clear.

The construction of the south tower is supposed to have begun in 1397, when the records show the foundation stone for the nave was laid. The changes to this plan that resulted in the buttress design of the Wenceslas Chapel and the south porch, however, indicate that the drawing in its present form predates the construction of both the chapel and the south transept facade and must therefore date to about 1365, before construction started on the south transept facade, and consequently also on the tower.                                    HJB

LITERATURE: Schmidt 1867, p. 3; Koepf 1969, no. 3; Cologne 1978–79, vol. 2, p. 624, ill.; Aachen 2000, no. 6.37, ill.

## 47. Architect's Drawing of Saint Vitus's Cathedral

*Peter Parler (1332–1399), Prague, ca. 1360*
*Black ink on parchment, 132 x 52.5 cm (52 x 20⅝ in.)*
*Provenance: Lodge of Saint Stephen's Cathedral, Vienna, probably acquired in the 15th century; sold to architect Franz Jäger, 1787; bequeathed by his son to the Akademie der bildenden Künste, 1839.*
*Akademie der bildenden Künste, Vienna, Kupferstich-kabinett (16.821)*

This drawing shows a cross section through the north side of the choir and ground plan of the projected western facade of Prague Cathedral. The section is laid immediately next to the pillar axis without indicating the vaults. The tracery decoration of the buttress corresponds to the early stage of the design as executed on the north side before it was altered to the more elaborate design of the south side. Excluded from execution was the parapet-like band of masonry on the uppermost pair of flyers.

The drawing, often considered a fifteenth-century copy of a lost original, documents all the traces of a genuine planning process. When the roof level above the aisles, originally intended to be horizontal, was redesigned in a slope, the entire triforium had also to be erased and redrawn, pushed 60 centimeters higher. In this way, the proportions changed considerably from the more classical elevation system originally intended. Not yet resolved on this drawing is the joining of the triforium

47

to the frame of the clerestory windows. Further changes occurred to the buttressing system when the outer pillars only reached their final shape after also having been widened in a second step. All these changes indicate that this drawing is the actual planning document of Peter Parler as he explored in stages different possibilities of a new spatial and formal design.

The attached ground plan, drawn prior to the cross section, has often been interpreted as a first design for the south (or north) tower, but as the situation clearly is that of a western facade, it might represent Parler's first design idea for the western termination of Prague Cathedral, based primarily on his knowledge of the western facade of Strasbourg Minster.

HJB

LITERATURE: Schmidt 1865; Koepf 1969, no. 6; Cologne 1978–79, vol. 2, p. 624, ill.; Aachen 2000, no. 6.36, ill.

## 48. Monstrance

*Prague, ca. 1380*
*Gilded silver and rock crystal, h. 71 cm (28 in.)*
*Provenance: Provost's Office, Mělník, by 1899.*
*Římskokatolická farnost–Proboštství Mělník (A-7)*

In inventories listing church possessions, the term *monstrancia* designates objects incorporating carved rock crystal containers that simultaneously show and protect either relics of saints or increasingly the Host, consecrated during the Mass as the Body of Christ. This example, with a support in the form of a crescent moon, was certainly intended to hold the eucharistic wafer.

The goldsmith has used the supple medium of silver to great advantage, forming delicate, open buttresses, tiny gargoyle terminals, and pendant bosses, while simulating in miniature the architectural vocabulary of the Parler workshop. The hexagonal foot is similar to that of the Reliquary of Saint Catherine (cat. 56). The first crystal monstrance appearing in the inventory of Saint Vitus's Cathedral that could have been intended to enshrine the Host was listed in 1387 as a gift of the emperor and empress.[1] Bohemian monstrances survive in numbers greater than those suggested by their relative importance in inventories of the Luxembourg period.

Mělník, set at the confluence of the Vltava (Moldau) and Labe (Elbe) rivers, was a prosperous town; a seat of the queens of Bohemia, it became a center of viticulture under Charles IV.[2] It is reasonable to infer that this monstrance was made either for the chapel of the royal castle or, more likely, for the Church of Saints Peter and Paul, where in the 1380s Johannes of Landstenn, provost of Mělník and a canon in Prague, renovated the sacristy.[3]

BDB

1. Podlaha and Šittler 1903a, no. 132.
2. Durdík 2000, pp. 357–59; Brych and Přenosilová 2002, pp. 84–85.
3. See Podlaha 1899, pp. 107, 137.

LITERATURE: Podlaha 1899, pp. 131–32; Cologne 1978–79, vol. 2, p. 708, vol. 5, fig. T-13.

48

## 49. Arms of Bohemia, Luxembourg, and the Holy Roman Empire

*Peter Parler workshop, Prague, 1372*
*Bohemia: sandstone with traces of paint, 76 x 99 x 30 cm (29⅞ x 39 x 11⅞ in.); Luxembourg: sandstone with traces of paint, 72 x 88 x 30 cm (28⅜ x 34⅝ x 11⅞ in.); Holy Roman Empire: sandstone, 103 x 83 x 30 cm (40½ x 32⅝ x 11⅞ in.)*
*Condition: Overall good condition, darkened with age and slightly weathered, with numerous scratches. Arms of Bohemia and Luxembourg originally one piece.*
*Provenance: Saint Vitus's Cathedral; transferred to Prague Castle Collection, 1902–3.*
*Správa Pražského Hradu, Prague (HS 22742, HS 22743, HS 22744)*

49, arms of Bohemia

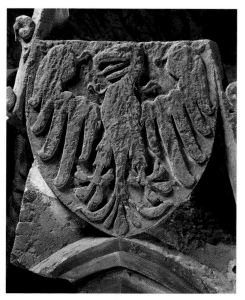

49, arms of the Holy Roman Empire

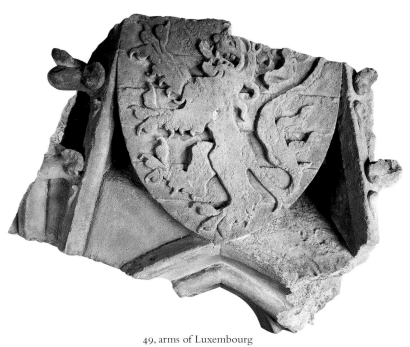

49, arms of Luxembourg

These bas-relief escutcheons with coats of arms decorated the winding staircase attached to the flying buttress on the southeast corner of Saint Vitus's Cathedral's transept. Unique in its architectural form and heraldic adornment, the staircase is noteworthy above all for its structural conception. As the flying buttress diminishes in mass as it moves upward, the staircase recedes along with it, changing the direction of the spiral at each stage. The deterioration of the staircase over time led to the replacement of much of it with a replica in 1902–3.

The stone casing of the staircase has been reduced to vertical columns, interlinked by diagonal cornices and subtly steep gables with pinnacles and tracery. The same columns and gables also serve as a relief covering the facade

of the flying buttress to which the staircase is attached. The escutcheons with coats of arms are inserted in the gables, aside from one that is set in the wall between the supports of the paneling. Almost all the escutcheons bear the coats of arms of the lands of the Bohemian Crown and thus represent the "building contractor," Charles IV, and his most prominent titles. The coat of arms of the Holy Roman Empire symbolizes Charles's status as emperor, that with the fiery eagle represents Wenceslas, the patron of Bohemia, and that with a golden ordinary on a black field indicates the archbishop of Prague. It is difficult to establish conclusively the individual lands represented by the coats of arms because the original paint is completely missing from many of them, and

its restoration on the replicas is not entirely reliable. Similar heraldic series appear on the facade of the Old Town Bridge Tower, Prague, and on the entry gate of Točník Castle.[1]

The escutcheons are particularly significant for the highly accomplished stylization of the heraldic figures, evidenced as well on the six royal sarcophagi in the choir chapels, which are also the work of the masons of Saint Vitus's workshop. On one of these fragments, the mason's mark in the form of a stylized double ax is well preserved in the profile of the pointed arch. Surviving weekly accounts record that the escutcheons on the staircase were painted in 1372 by Master Osvald in conjunction with his assistants.

PC

1. Menclová 1972, vol. 2, pp. 168–71.

LITERATURE: Podlaha and Hilbert 1906, pp. 66–70; Benešovská in Benešovská and Hlobil 1999, pp. 68–72; Líbal and Zahradník 1999, p. 82; Chotěbor 2000, pp. 10–12.

## 50. Chalice

*Eastern Mediterranean, ca. 3rd–4th century; gilded silver mounts, Prague, 1350*
*Agate (sardonyx),[1] gilded silver, and champlevé enameling; h. 15.5 cm (6⅛ in.), w. 17.5 cm (6⅞ in.), d. 13.5 cm (5⅜ in.); chalice only, h. 7.5 cm (3 in.)*
*Inscribed on foot: A[O].D[N]. M[O].CCC L[O] IUBILEO / KARLOLUS ROM AN[O]RU[M] SE[M]P[ER] AU GUST[US]. ET BOEM IE REX . PRAGEN / ECCIE. AD USUS IN FIRMORU. HUC. CIPHUM ONOCHINI*

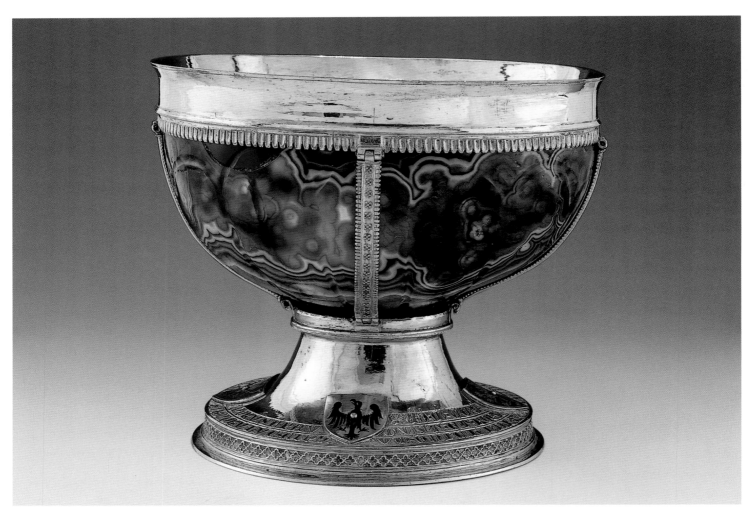

50

*LAPIDIS. DONAVIT (In the jubilee year of the Lord 1350, Charles, forever the emperor of the Romans and the king of Bohemia, gave to the church of Prague, for the use of the sick, this chalice made from onyx).*
*Provenance: Gift of Charles IV to Treasury of Saint Vitus's Cathedral, first mentioned in 1354 inventory. Metropolitní Kapitula u Sv. Víta, Prague (HS 03356 [K 32])*

This sardonyx communion chalice (scyphus) is one of twenty-nine gifts Charles IV bestowed on Saint Vitus's Cathedral treasury between 1344, when the Prague bishopric was elevated to an archbishopric, and 1354, the date of the earliest surviving cathedral inventory. Also among the gifts was the gold reliquary bust of Saint Wenceslas, the coronation crown (fig. 1.4), created about 1345, and the royal scepter, orb, and ring, made sometime before Charles's coronation as king of Bohemia in September 1347. In 1348 Charles donated a rock crystal ewer for the Tablecloth from the Last Supper (cat. 51) and also probably two reliquary panels to decorate the tomb of Saint Wenceslas. In 1350 the treasury was enriched with a considerable number of relics enshrined in busts,

arms, statues, and other reliquaries. Along with even richer donations of 1354 and 1355, these gifts were aimed at enlarging the relatively modest treasury of the old bishopric church so that in number, rarity, and material value of the reliquaries it would attest to the significance of the new metropolitan church.

Vessels dating from antiquity and made of jasper, agate, and other precious stones are among the most remarkable objects found in famous monastic and church treasuries gathered during the early Middle Ages. Charles knew such masterpieces from the royal Abbey of Saint-Denis in Paris, and his recollections probably played a key role in his decision to establish in Prague one of the richest collections of relics. After his return from Italy in 1355 he donated to the cathedral a massive portable altarpiece (now known only from inventory documents) of silver and amethyst slabs that was consecrated in honor of the Virgin by the bishop of Wrocław, Przeclaw of Pogorzela, and bore an unusually long inscription.[2] According to all evidence, this altar, a reworking of the emperor's own traveling table, was obviously modeled on the "holy altar" of Saint-Denis, a remarkable Carolingian

example of the goldsmith's art with a large porphyry slab and relics of Saints Denis, Stephen, and Vincent.[3]

In August 1337 Charles visited Venice, where he saw the treasury of the Basilica of Saint Mark with its even more exquisite vessels made of precious hardstone brought from Byzantium after the crusaders sacked the city in 1204. Indeed, he may have acquired there the late-antique bowl that now forms part of this chalice. Among the many Byzantine sardonyx objects at Saint Mark's is a chalice with an inscription invoking God's assistance for Emperor Romanos that has a bowl similarly decorated with gadroons.[4]

The inventory of 1354 indicates that our chalice was also designated for use as the communion chalice in the Good Friday Liturgy.[5] This link with the memory of the shedding of Christ's blood, an allusion to the legend of Joseph of Arimathea and the romance of the Holy Grail by Robert de Boron, endowed this remarkable vessel with symbolic meaning, so that it became—as Charles IV had intended— a source of spiritual joy to the gravely ill members of the cathedral clergy. The extraordinary function and symbolic message of this

liturgical object is reflected in both the elegant, simple design of the goldsmith's setting and in the material of the bowl itself, for sardonyx is listed in the Apocalypse of Saint John as one of the stones used for the building blocks of the Heavenly Jerusalem.

The stand that Charles commissioned in 1352 for the reliquary cross of Conrad II in the Imperial Treasury is in the same style as the foot of this chalice and was probably created by the same goldsmith.[6]

KO

1. The bowl is cut from a large piece of reddish brown agate with an irregular pattern of white and black stripes.
2. The inscription is transcribed in the cathedral inventory of 1355 (Podlaha and Šittler 1903a, p. XV, no. 115, under the heading "Inventarium altarium viaticorum").
3. Originally the Saint-Denis altar too had been portable. (Abbot Suger's remark [*De administratione*, ll. 240–50, in Speer and Binding 2000, pp. 349–54] that major liturgical feasts often required its provisional removal confirms this.) It had belonged to the treasury of the emperor Charles the Bald, who wanted it placed in front of his tomb in the choir of Saint-Denis. Its Prague counterpart was perhaps intended to assume a similar place in the vicinity of the Luxembourg tombs in the cathedral's new choir.
4. Alcouffe in Paris 1984, pp. 137–39.
5. Podlaha and Šittler 1903a, p. IV, no. 21: "Item cyphus onichinus cum pede argenteo deaurato pro infirmis et pro communicantibus in parascevem deputatus" (scyphus of onyx with foot of gilded silver designated for the communion of the sick and for communion on Good Friday). The inventories of 1355 and 1387 (ibid., p. XVI, no. 146, p. XXXIV, no. 133) merely say "ciphus . . . quem imperator donavit ecclesiae pro communicantibus."
6. Fillitz 1954, p. 53.

LITERATURE: Podlaha and Šittler 1903b, pp. 157–59, no. 194, ill.; Poche in Prague 1970, p. 335, no. 420, ill.; Schramm and Fillitz 1978, p. 59, no. 32, ill.; Fritz 1982, p. 222, no. 259, ill.; Alcouffe in Paris 1984, pp. 137–40, no. 11; Poche 1984, p. 460, fig. 76.

## 51. Reliquary and Tablecloth from the Last Supper

*Paris, first half of 14th century; goldsmith's work: Prague, ca. 1350*
*Reliquary: rock crystal, gilded silver, gems, and pearls; h. 47 cm (18½ in.). Tablecloth: linen and silk, 76 x 122 cm (29⅞ x 48 in.)*
*Inscribed on textile hem near corner: mensale domini ihu xpi (tablecloth of Lord Jesus Christ).*
*Provenance: Gift of Charles IV to Treasury of Saint Vitus's Cathedral, first mentioned in 1354 inventory.*

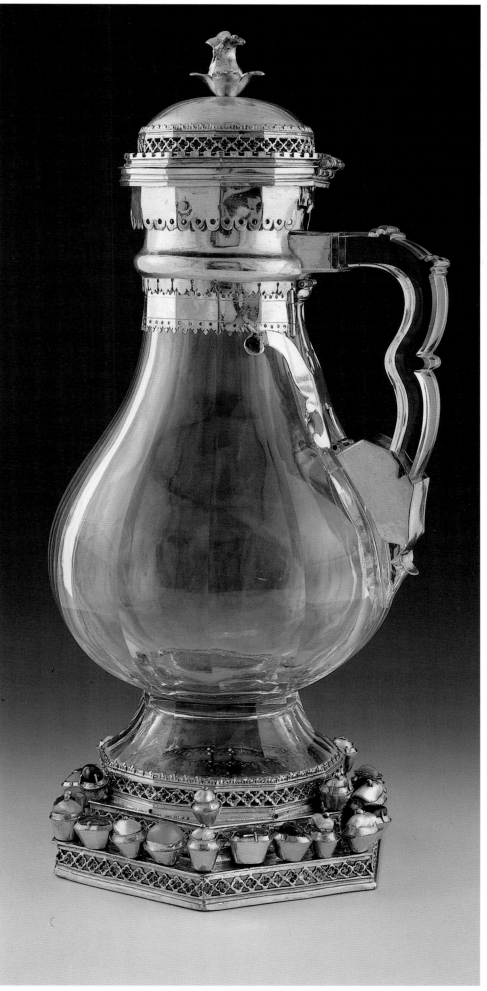

51, reliquary

51, Tablecloth from the Last Supper

## 52. Crystal Cross

*Venice, probably before 1355*
*Rock crystal and gilded silver, 76 x 50.5 cm (29⅞ x 19⅞ in.)*
*Condition: Four fittings with foliate decoration closest to center and rock crystal knop at bottom added in seventeenth century.*
*Metropolitní Kapitula u Sv. Víta, Prague (HS 03355 [K 31])*

Surviving examples and inventories attest to the popularity of rock crystal crosses through-out Europe from the twelfth through the

*Metropolitní Kapitula u Sv. Víta, Prague (HS 003357 [K 33], HS 3686 [K 359])*

In 1348 King Louis of Hungary presented Charles IV with the extraordinary gift of the fabric believed to be the tablecloth used by Jesus and his apostles at the Last Supper. Charles subsequently had the length of fabric set in a costly ewer of rock crystal. Since the form of the ewer, with its elegant handle, con-forms to Parisian examples, the inference is that Charles brought the ewer to Prague from Paris.[1] The openwork lid, which must replace a damaged crystal one, and the foot with densely set gems were probably added by goldsmiths in Prague. (The handle was rein-forced with gilded silver at a later date.)

Its preciousness, transparency, and ability to magnify make rock crystal functionally appro-priate for use as a reliquary. Its choice in this regard reflects long-standing medieval tradi-tion. But there is, in this instance, also a curi-ous resonance in the adaptation of a precious object from a princely table to enshrine an inherently mundane object believed to have been dignified and transformed by its use at Jesus' Passover table.

BDB

1. Paris 1981–82, pp. 213–14, no. 172.

LITERATURE: Podlaha and Šittler 1903b, pp. 66–68, nos. 45, 46, ill.; Schramm and Fillitz 1978, p. 59, no. 31, ill.; Cologne 1978–79, vol. 3, p. 179, 181, ill; Paris 1981–82, pp. 213–14, no. 172; Hahnloser and Brugger-Koch 1985, pp. 82, 230, no. 488, ill.; Vienna 2002–3, pp. 48–51.

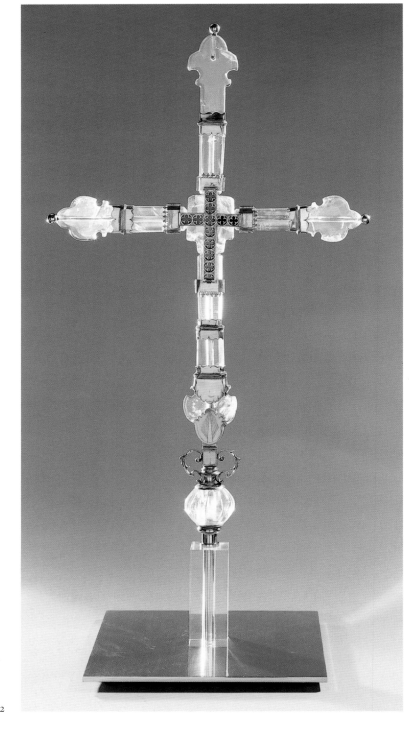

52

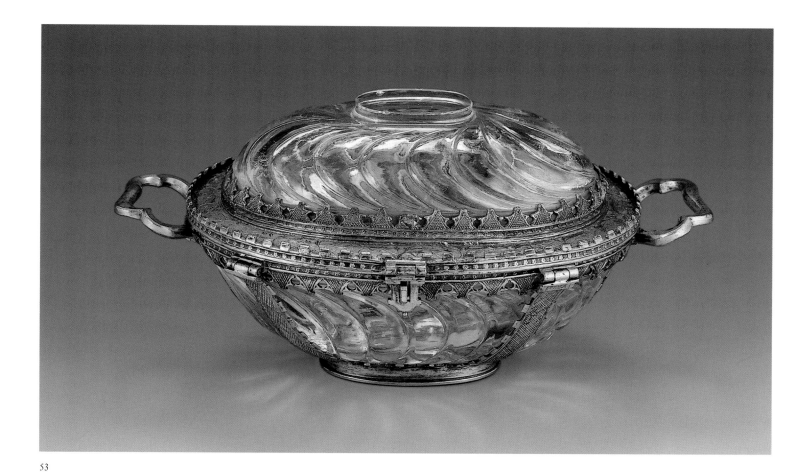

53

fifteenth century. The rarity and preciousness of the hard stone, as well as its association with purity, made rock crystal especially desirable for use in altar furnishings. This cross belongs to the group Hans Hahnloser called lily crosses because of the shape of the terminals.[1] The Prague example is typical in that it is constructed of multiple pieces—eleven in this case—of polished rock crystal joined by rods passing through the hollowed centers of the pieces. The joints between the rock crystal pieces are decorated with gilded metal sleeves.

More than one-third of the approximately 120 medieval hard stone crosses catalogued by Hahnloser are attributed to Venice, and his attribution of this cross to Venice is convincing. A cross of about the same size in the Historisches Museum Bern is the most closely related example.[2] The presence in the Saint Vitus treasury of three rock crystal crosses, described in the inventories of 1354 and 1355 as "two beautiful and one coarse," attests to the refined taste of Charles IV for polished hard stone objects and to his success in making Prague an international center for luxury arts. Also from the treasury are a reliquary and a rock crystal covered dish (cats. 51, 53) that were possibly imported as well and then adapted for use at Saint Vitus's by Bohemian goldsmiths.

PB

1. In Hahnloser and Brugger-Koch 1985, p. 46.
2. Ibid., no. 87.

LITERATURE: Podlaha and Šittler 1903b, no. 27; Cologne 1978, vol. 3, ill. p. 181; Hahnloser and Brugger-Koch 1985, p. 108, no. 88, pl. 79 (with bibl.); Bauer, Klimeš, and Kopřiva, 1991, pp. 35–36.

## 53. Covered Dish

*Vessel: Paris, first half of 14th century; mounts: Bohemia(?), third quarter of 14th century*
*Rock crystal and gilded silver; h. 9.5 cm (3¾ in.), w. with handles 20 cm (7⅞ in.)*
*Metropolitní Kapitula u Sv. Víta, Prague (HS 03340 [K 16])*

Two oval bowls of rock crystal have been fitted together in a gilded silver mounting to form this covered dish with handles. Both bowls have a narrow swelling at the lip and a low foot.[1] The walls of the bowls are ornamented arch-shaped swirls, twenty-five on the bottom bowl, seventeen on the top one. Such complex decoration, producing rich, scintillating effects, is found on a group of twelve objects first thought to have executed in Venice.[2] Daniel Alcouffe, however, drew attention to entries in French inventories of

the treasuries of Charles V (r. 1364–80) and his brothers Louis d'Anjou and Jean de Berry that make repeated mention of rock crystal vessels ("ondoyé en manière de soleil").[3] Accordingly, the group is now believed to have originated in Paris, and this covered dish from Prague and the related carafe in Stará Boleslav[4] have been used to support such an assumption, for both works have been traced back to donations by Charles IV, who had close ties to the French court.[5]

The silver mounting features a lattice of engraved triangles with rows of lugs, small rosettes, and engraved pinnate vine forms. The style of the mounting points to the third quarter of the fourteenth century.[6] It is reasonable to infer that it was produced in Bohemia. The engraving is similar to that on the Brno portable altar (cat. 54).

The dish serves as a reliquary for a piece of the Virgin's veil that Charles IV acquired in Trier in 1354.[7] When the relic was presented to the Prague Cathedral chapter that year it rested in a silver container adorned with jewels.[8] Later cathedral inventories and an old illustration indicate that relic was transferred to this rock crystal dish some time after 1690.[9]

FKi

1. The foot of the bowl used as a cover was left unpolished (Hahnloser and Brugger-Koch 1985,

p. 218, no. 451), indicating that a mounting was originally intended there as well.

2. Ibid., pp. 61–62.

3. Alcouffe in Cologne 1984, p. 313.

4. Hahnloser and Brugger-Koch 1985, p. 217, no. 449.

5. See Distelberger in Vienna 2002–3, pp. 30, 52, and Alcouffe in Cologne 1984, p. 313.

6. Similar details (triangular shapes with lugs, pinnate vines) appear on the Saint Vitus reliquary in Herrieden, dated 1358 (Fritz 1982, p. 223, no. 261) and on a griffin claw from the treasury of the archbishops of Salzburg that has been dated to the fourth quarter of the fourteenth century, perhaps somewhat too late (Cologne 1978–79, vol. 3, p. 166). For additional examples, see Hahnloser and Brugger-Koch 1985, nos. 128, 148, ill.

7. Podlaha and Šittler 1903a, p. 184.

8. According to the cathedral inventory of 1354 (Podlaha and Šittler 1903a, p. IX, no. 299): "Peplum sanctae Mariae matris Domini in cista argento et gemmis circumdata et deaurata, quod in Trever habuit" (The veil of Mary, the holy mother of our Lord, in a gilded box surrounded with silver and gems, which he had in Trier). Another reliquary with a piece of veil was described in the same inventory (ibid., p. III, no. 15).

9. See Podlaha and Šittler 1903a, p. XIV, nos. 70, 71, p. LXII, nos. 1, 28, p. LXIV, nos. 34, 35, p. LXIX, nos. 33, 34. An illustration on a pilgrim's souvenir from 1690 (ibid., p. 131) depicts a vessel that differs from this covered dish with a legend that says it held the relic of the Virgin's veil from Trier.

LITERATURE: Podlaha and Šittler 1903a, pp. 184–85; Podlaha and Šittler 1903b, pp. 68–71, nos. 47, 48; Lamm 1929–30, vol. 1, pp. 235–36, no. 6 (with bibl.); Prague 1948, p. 42, no. 80b; Prague 1970, no. 424; Hahnloser 1971, pp. 164–65; Schramm and Fillitz 1978, p. 61, no. 42; Hahnloser and Brugger-Koch 1985, p. 218, no. 451; Alcouffe in Cologne 1985, p. 313; Venice 1994, p. 203, no. 86; Vienna 2002–3, p. 52.

## 54. Portable Altar with Coats of Arms

*Bohemia, Prague(?), 1350*
*Partially gilded silver, gilded brass, opaque enamel, rock crystal, and yellowish gray limestone with calcite shells of primeval lamellibranches; 25 x 23.5 cm (9⅞ x 9¼ in.)*
*Condition: Repaired and altered in 1380; decoration once fixed around oval crystal on silver sheet on front panel missing, only rivets remain.*
*Inscribed on front of panel: NOTA HOC ALTAR[E] CO[N]SEC[RA]TU[M] E[ST] IN HONO[R]E[M] S[AN]C[T]I SP[IRITU]S [ET] CO[N]TINE[N]T[UR] A[C]T[UM] IN EO RELIQUIE, VIDEL[CET] DE LIGNO D[OMI]NI, DE LACTE B[EA]TE V[IR]GINIS ET [DE] C[R]IN[I]B[US] ET S[ANCT]OR[UM] XII AP[OSTO]LOR[UM] ET S[AN]C[T]OR[UM] WE[N]CE[SLAI], VITI, LAURE[NTII], STEPH[ANI], STANIS[LAI] M[A]R[TYRIS]. .S[AN]C[T]E ADAL[BERTI] M[A]R[TYRORU]M, S[AN]C[T]OR[UM] GREGO[RII], AUG[USTINI], JERO[NI]M[I], AMBRO[SII] PRO[CO]P[II] / sp[iritu]m s[an]c[t]o as[se]bit a[nn]o d[omi]ni m ccc l xxx. Inscribed on side of*

*panel (with additions): NOTA HOC ALTARE CONSECRATUM EST IN HONOREM SANCTI SPIRITUS, IN QUO HOC RELIQUIE CONTINENTUR, SCILICET DE LIGNO SANCTAE CRUCIS, DE LACTE, DE CRINIBUS BEATAE VIRGINIS, DUODECIM APOSTOLORUM, SANCTI VITI, SANCTI ADALBERTI MARTYRORUM, ITEM SANCTI AUGUSTINI, SANCTI IERONYMI, SANCTI GREGORII, SANCTI PROCOPII, SANCTI AMBROSII, SANCTI MARTINI, NYCOLAI, STANYZLAI CONFESSORUM, ITEM BEATAE MARIE MAGDALENAE, SANCTAE ANNAE, ELSCAE[?], SANCTAE KATHERINAE, SANCTAE MARGARETHAE, SANCTAE DOROTHEAE, SANCTAE BARBARAE, SANCTAE CECILIAE, SANCTAE AGNETIS, SANCTAE LYSABETH, ET PLURIMORUM SANCTORUM. TYTULUS ITEM ASSERUNTUR SUPRASCRIPTO[?] SPIRITUI SANCTO ANNO DOMINUM M CCC LXXX.*
*Provenance: Purchased by Moravská Galerie from private collector, 1993.*
*Moravská Galerie, Brno (28.593)*

To create this portable altar a small altar was presumably remodeled into a flat panel that would have been kept in a hollow in the altar table. On the back is a limestone plate with fossilized shells of small lamellibranches (bivalve mollusks), which come from a site near Barrandov, southwest of Prague.[1] The panel is framed by metal strips engraved with angels carrying the Instruments of the Passion and a scene from the infancy of Jesus featuring a group of monks. In the corners are the engraved and enameled symbols of the Four Evangelists. The decorative motif of needlelike tendrils is from the same repertoire as the motifs on the reliquary panel of the Five Brother Martyrs from Stará Boleslav (cat. 11) and the covered crystal dish (cat. 53)

The two coats of arms on the front belonged to the donors or owners of the altar. A gold arrow pointing upward and to the right on a red field was used by the Bavors of Strakonice and Bavorov, a powerful noble family of southern Bohemia who held important court offices during the rule of the last Přemyslids and Luxembourgs. A stylized arrow much like this appears on two seals of Bavor III of Strakonice (1289–1357), one of 1312, the other used after 1315.[2] Bavor III, the son of Bavor II of Strakonice and Anežka of Kuenring, the illegitimate daughter of King Přemysl Otakar II, was burgrave of the castle of Zvíkov in southern Bohemia. The arrow also appears on two variants of the seals of his brother, Vilém of Strakonice (1318–1359), a high court judge.[3]

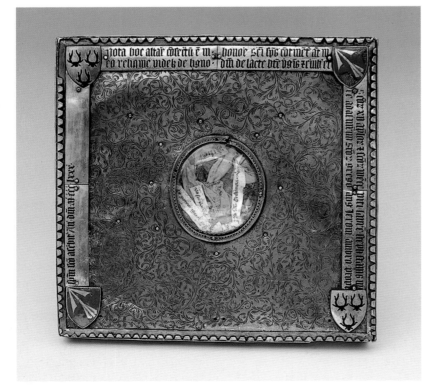

54

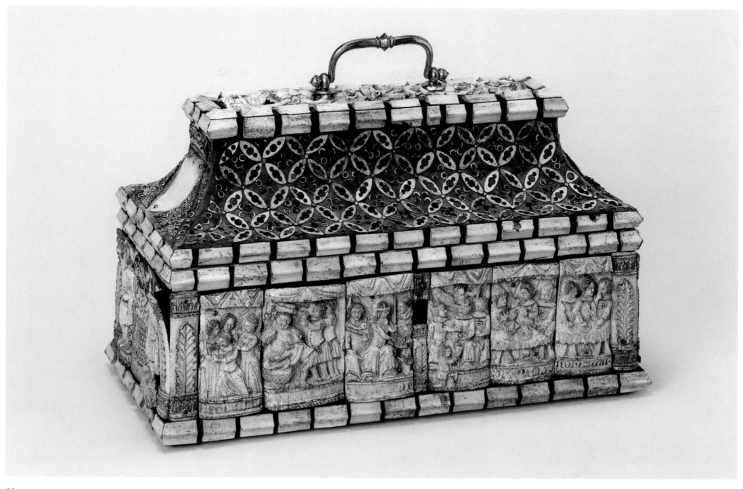

55

Three black horns on a gold field was the coat of arms of the Hroznata family from western Bohemia, which after the end of the thirteenth century divided into two branches, the lords of Vrtba and of Gutštejn. The patriarch of the family founded the Premonstratensian Monastery in Teplá in 1197. No one from this family is documented at the court of Charles IV. Neither is there any direct link between them and the Bavors, but the coats of arms of the two hang near each other in the heraldic hall of the castle at Lauf an der Pegnitz, which dates to 1361.[4]

This piece may have been either a portable altar for celebrating Mass while traveling or a votive gift to a church. The relics it holds include those of Wenceslas and Adalbert, patron saints of Bohemia, and Saint Stanislas, a patron of the Prague Monastery of the Three Martyrs of the Holy Cross of the Order of the Knights of the Cross with the Red Heart, so-called cyri-acs. The rare relic of Mary Magdalen could have come from the family foundation of the Bavors, who were the beneficiaries of the Knights of Saint John of Jerusalem in Strakonice. The relics of Saint Elizabeth of Thuringia were revered at the monastery in Teplá.[5]

The altar might have been commissioned by a priest of the Prague diocese, Jan of Strakonice, who in 1366 was the chaplain of Emperor Charles IV,[6] or by the monks in the Cistercian monastery in Zlatá Koruna, to which Bavor III made large donations and where he is buried. The monk standing with his back to the viewer and turning his head to reveal a tonsure, whose face is portrayed in masterful shorthand, could be the donor.

DS

1. Mineralogical analysis by Blanka Štreinová of the Národní Muzeum, Prague.
2. Beneš 1957, pp. 156–57.
3. SOA Třeboň, fond Cizí statky, no. 315 (November 5, 1318); Archiv NM, letter no. 53 (September 3, 1320); Archiv NM, letter no. 103 (August 9, 1359).
4. Růžek 1988, pp. 200–201, nos. 41, 42.
5. Stehlíková 1998, pp. 150–52.
6. Jenšovský 1944–54, vol. 3, nos. 620, 729: "capel-lanus continuus commensalis."

LITERATURE: Holešovská and Holešovská 1993; Holešovský and Holešovský 1994, pp. 60–62.

## 55. Coffret

*Northern Italy, before 1376*
*Linden wood core with bone, intarsia, and metal mounts with traces of paint; h. 20 cm (7⅞ in.), w. 33.5 cm (13¼ in.)*
*Metropolitní Kapitula u Sv. Víta, Prague (HS 3347 [K 23])*

When the Sigismund Chapel in Saint Vitus's Cathedral in Prague was renovated in 1918, this coffret was discovered inside a lead box that had been inserted into a wall. The lead box was decorated with the seal of Archbishop Jan Očko of Vlašim (r. 1364–79) and contained Latin inscriptions indicating that the bone-encrusted box within was put there by Wenceslas IV and the archbishop on February 17, 1376 (not long after the chapel was completed by the Peter Parler workshop in 1375). Although initially intended for secular use, the coffret contained more than forty bones when it was placed in the chapel. Several contemporary instances of secular ivory boxes containing relics have been documented. In 1405, for example, Martin I of Aragon (1356–1410) donated an ivory casket for relics to Barcelona Cathedral.[1]

This large, oblong coffret with a hipped roof is decorated with carved horse bone embellished with intarsia. The sides of the lid contain lily crowns and blank shields. Originally painted, the coffret probably bore inscriptions identifying the seemingly nonnarrative courtly scenes, some with erotic overtones, carved in panels on its sides, among them consultations, banquets, and departures from a city. The costumes of the musicians, equestrian hunters and warriors, and other figures who people the scenes are characteristic of northern Italy in the mid-fourteenth century.

If Charles IV acquired the coffret during his journey to Italy in 1354–55, this would be the first documented work of the Embriachi family, whose highly regarded production of luxurious carved and painted boxes, altars, and practical items dominated the industry first in Florence and then in the Veneto and elsewhere in the late fourteenth and early fifteenth centuries. A coffret like this would have been assigned to the "bottega a figure inchiodate" (workshop of applied or nailed figures). Others of this type are in Arezzo, Bologna, Amalfi, and Arles.[2] The coffret may also have come to Prague through later contacts. In 1369 Charles IV named Baldassare Embriachi, then head of the atelier, *comte palatin* because he acquired costly jewels for the emperor.

CTL

1. Fité 1993.
2. See Klement 1987, figs. 3 (Arezzo), 4 (Arles), and Merlini 1988.

LITERATURE: Klement 1987; Tomasi 2001, esp. pp. 53–54.

## 56. Reliquary of Saint Catherine of Alexandria

———

*Prague, ca. 1380*
*Cast, embossed, and gilded silver; rock crystal; 44.5 x 14 cm (17½ x 5½ in.)*
*Metropolitní Kapitula u Sv. Víta, Prague (HS 03351 [K 27])*

Made about 1380 and probably identical with one "monstrancia cum crystallo et reliquiis B. Catharinae" mentioned in an inventory of 1420, this ostensorium contains a relic of Saint Catherine of Alexandria, virgin and martyr, who was beheaded in Egypt in about A.D. 310. To a worshiper such as Emperor Charles IV, who was particularly devoted to Saint Catherine, such relics were imbued with miraculous powers and provided a visible and tangible link to the saint, who would, in time,

intercede on his or her behalf before God. This exquisite ostensorium (from the Latin *ostendere,* "to show") furnishes an appropriate setting for such a precious and salvific memento. Saint Catherine's relic, along with a number of smaller relic fragments,[1] is encapsulated in a horizontal rock crystal cylinder that is supported by a hexalobal foot accentuated by microarchitectural tracery and surmounted by a staggered buttressing system topped by a miniaturized spire decorated with openwork tracery. In the niche below the spire stands a tiny figurine of the saint, holding a wheel and a sword, the instruments of her martyrdom.

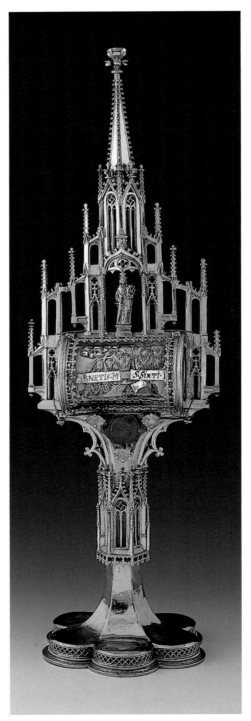

56

In stylistic terms the tracery configurations of both the foot and the superstructure suggest that the ostensorium was made by a goldsmith working within the artistic circle of the Prague Cathedral workshop. The openwork tracery motifs accentuating the sides of each lobe thus reoccur on the balustrade encircling the ancillary and radiating chapels in the cathedral. Other references to the architectural vocabulary of Saint Vitus's include the heart-shaped pattern on the frieze decorating the underside of the shaft's miniature gallery (which recurs at the top of the balustrade encircling the exterior of the cathedral's high choir) and the swirling mouchettes on both the shaft gallery and the spire (which have their counterparts in some of the window tracery of both Prague Cathedral and the Church of Saint Bartholomew in Kolín). That the reliquary with the Parler family arms (cat. 57) incorporates an identical repertoire of tracery motifs implies that both ostensoria were made by the same artist or, at the very least, by members of the same workshop. Like the eucharistic tabernacle from the Wenceslas Chapel (cat. 45), both pieces probably antedate the completion of Prague Cathedral's high choir by a few years and may therefore also be considered, at least in part, products of formal experimental research.

AT

1. Identified by Podlaha and Šittler 1903a, p. 230.

LITERATURE: Podlaha and Šittler 1903a, pp. 229–30; Prague 1970, no. 434; Cologne 1978–79, vol. 2, p. 708 (with bibl.); Hlobil et al. 1994, p. 158.

## 57. Reliquary with the Parler Coat of Arms

———

*Prague, ca. 1380*
*Cast, embossed, and gilded silver; rock crystal; h. 35.7 cm (14 in.)*
*Metropolitní Kapitula u Sv. Víta, Prague (HS 03350 [K 26])*

Produced in about 1380, this ostensorium is closely related to the one of Saint Catherine (cat. 56); stylistic analysis shows that both were made by goldsmiths who operated within the immediate artistic sphere of Peter Parler's Prague Cathedral workshop (see the discussion under cat. 58). The presence of the Parler family arms on the reliquary's foot (or, as an inventory of 1512 phrases it, "insigniis junkarorum in pede") strongly suggests that one or several members of the Parler family were directly involved in the commissioning—and perhaps even in the making—of this object.[1] Certainly

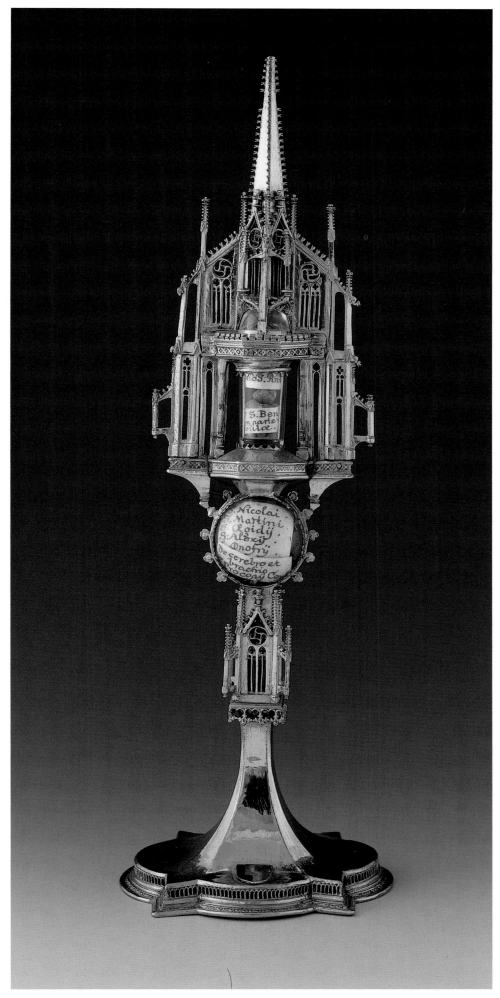

intended as a pious donation to the treasury of Saint Vitus's, the ostensorium showcases three relic fragments of Saints Benedict and Anthony within an elaborate microedifice comprising a quadrilobal foot, a slender shaft accentuated by a traceried miniature gallery, a transparent relic container cut from rock crystal (here placed vertically rather than horizontally, as in cat. 56), and a facadelike microarchitectural crest culminating in a rotated openwork spire. The circular relic capsule between the shaft and the architectural superstructure was probably inserted at a later stage.[2]

AT

1. The names of two of Peter Parler's sons, Nikolaus and Wenzel, have been associated with the reliquary (see Fritz 1982, no. 531, and Cologne 1978–79, vol. 2, p. 710, respectively), but the evidence is inconclusive.
2. See Fritz 1982, no. 531. The individual relics encased by the capsule were identified by Podlaha and Šittler (1903a, p. 230).

LITERATURE: Podlaha and Šittler 1903a, p. 230; Prague 1970, no. 435; Hilger 1973, p. 462; Cologne 1978–79, vol. 2, p. 710 (with bibl.); Fritz 1982, no. 531; Benešovská and Hlobil 1999, pp. 18–19.

## 58. Bust of a Young Woman with the Parler Family Emblem

*Cologne, ca. 1390*
*Limestone with paint, h. 44 cm (17⅜ in.), shoulder w. 31 cm (12¼ in.)*
*Museum Schnütgen, Cologne (K 127)*

Reportedly found near Cologne Cathedral before 1824, this striking bust is celebrated not only for the serene expression of the young woman it portrays but also for the emblem it bears. On the woman's chest is the heraldic device of the famed Parler family, the preeminent architects and sculptors in German-speaking lands from the mid-fourteenth to the early fifteenth century. The most notable members of the Parler family were Heinrich (active 1330s–1371) of Cologne, who directed the construction of the Cathedral of the Holy Cross in Schwäbisch Gmünd, and his son Peter (1332–1399), who at age twenty-three was called by Charles IV to head the architectural and sculpture workshop of Saint Vitus's Cathedral in Prague. The splendor of the cathedral choir, completed in 1386, the now destroyed choir stalls, the bridge over the river Vltava, and the All Saints' Chapel at Prague Castle all attest to Peter Parler's genius and versatility. The form, type, technique, and style of this bust from Cologne are closely linked

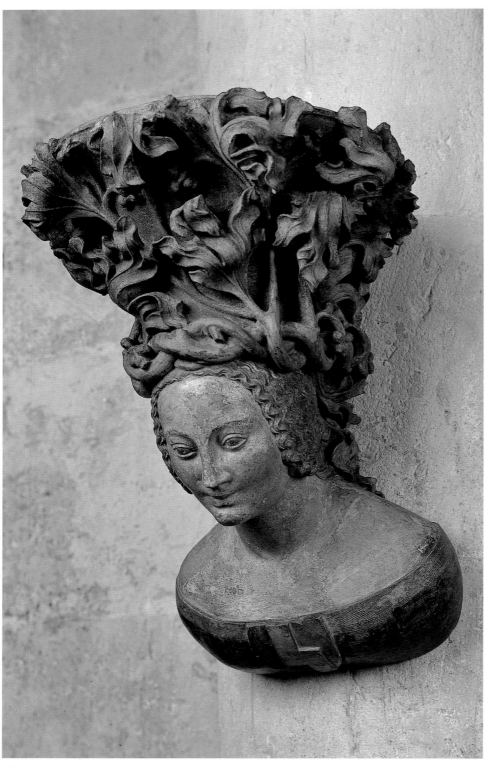

58

cryptoportrait of one of the Parler family, such as Drutgine, the wife of Peter Parler's nephew Heinrich of Gmünd (ca. 1354–after 1387) and the daughter of the master builder of Cologne Cathedral. Heinrich was active in Cologne about 1380 and again in 1387, when he worked on the Saint Peter Portal on the cathedral's west facade. The portal's archivolt sculptures, especially the Saint Catherine, provide compelling parallels to this console bust, which may also have come from the cathedral.

Though it was certainly carved by a Parler, the exact authorship of this great work remains unknown. Nevertheless, linked as it is to one of the pioneering families of medieval sculpture and architecture, and poised between the world of the type and the world of the portrait, this console figure is a pivotal example of the new aesthetic based in realism that was emerging in the late fourteenth century.

CTL

1. See Hilger 1977 and Wortmann 1970, esp. figs. 14, 15.

LITERATURE: Cologne 1978–79, vol. 1, pp. 187–89 (with bibl.); Schmidt 1992, pp. 193, 195, 225; Westermann-Angerhausen 1996; Westermann-Angerhausen and Taübe 2003, p. 95.

## 59. Saint Quirinus and a Prophet

*Cologne, 1378–81; prophet: Michael II of Savoy; Saint Quirinus: Heinrich IV Parler*
*Baumberg sandstone, prophet: h. 70 cm (27½ in.); Saint Quirinus: h. 67 cm (26⅜ in.)*
*Metropolitankapitel der Hohen Domkirche, Cologne (B827, B842)*

These sculptures from the Saint Peter Portal on the south tower of Cologne Cathedral, created between roughly 1375 and 1385, represent two ensembles differing in date and style. One group—five standing figures of apostles in the jamb and six small seated relief prophets on the lintel—belong to the period about 1375 and are the work of a local sculptor trained in the cathedral workshop's style of the 1360s and of western Europe. Other works of his survive elsewhere in the cathedral (a gargoyle on the south tower, the tomb of Gottfried von Arnsberg in the Lady Chapel). But he was unable to complete the cycle; the seven missing apostles were executed in the late nineteenth century by Peter Fuchs.

The second group of sculptures—two bands of tympanum reliefs presenting the legend of Saint Peter and thirty-four seated

to the carved female portrait busts in the triforium of Saint Vitus's Cathedral, to consoles in Ulm Cathedral, and to other Bohemian sculptures of the Virgin.[1]

Without a customary projecting tang to secure it into a wall or column, the back of the statuette has been trimmed, probably in modern times, to conform to a cylindrical shaft. The present paint is of a later date but mimics the original conception. The elaborate

crown the figure wears is made of the leaves of the aromatic plant mugwort (*Artemisia vulgaris*), which was used for treating diseases of the uterus. In the Middle Ages the plant was associated with the Virgin. Thus this figure might represent Eve, and she may have supported a now lost sculpture of the Virgin Mary, the "new Eve" according to Christian thought. Her youthful form and the sculpture's individuality suggest that this may be a

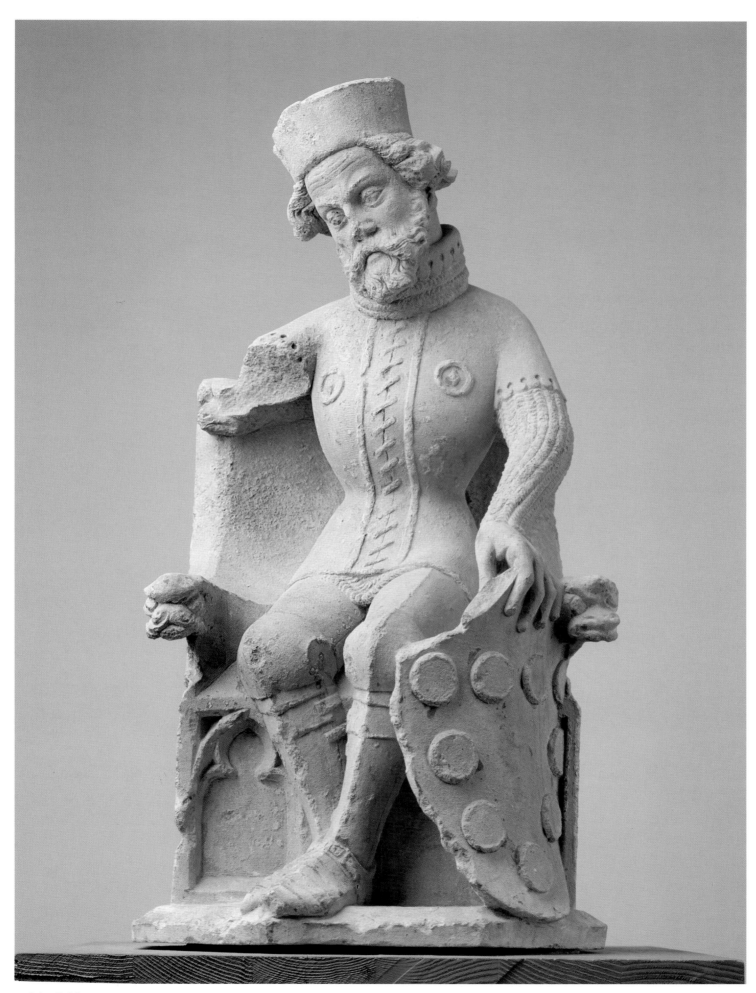

59, Saint Quirinus

figures in the portal's four archivolts—are products of three different ateliers or sculptors.[1] One master created the lower band on the tympanum, depicting the trial and martyrdom of the apostles Peter and Paul, and some of the archivolt figures, among them this seated figure of Saint Quirinus of Neuss in armor, from the upper left of the second archivolt. Quirinus is the last in a series of male saints (George, Lawrence, Stephen, Nicholas) that have female counterparts on the right side. That Quirinus should have been selected is somewhat surprising, for all the other saints portrayed were universally venerated, whereas Quirinus, whose relics had made nearby Neuss an important pilgrimage site since 1050, had merely local repute. The reference to Neuss is explicit, thanks to the inclusion of the town's coat of arms with its distinctive nine balls.

Despite the enhanced naturalism of these figures, previously unknown in Cologne or in the cathedral's sculptural program, and their weighty plasticity and substance, this master's style is distinguished by a narrative restraint that isolates each individual figure and by the linear elegance of the drapery. Gerhard Schmidt described the style as "elegiac" (*elegischer*). For stylistic parallels one need look no further than the recumbent figures of Spytihnev and Bretislav I on their tombs in the central chapel at Saint Vitus's Cathedral in Prague. Only there is the same unusual naturalism in evidence, in the rendering of the armor, for example, and the same slight curve to the body and distinct characterization of the face. The head of Saint Quirinus from the Saint Peter Portal is so similar that it is obviously by the same sculptor. Schmidt attributes the tomb figures to Heinrich IV Parler. Heinrich, who is mentioned in the Prague account books until 1378, was married to Drutginis, a daughter of the Cologne Cathedral architect Michael of Savoy. As Heinrich was summoned to Brno in 1381 as architect for the duke of Moravia, his stay in Cologne and involvement on the Saint Peter Portal can be assumed to have fallen between 1378 and 1381, which accords nicely with the look of the Saint Peter Portal sculptures and also with the history of the building of the south tower in Cologne.

A second sculptor is credited with the upper band on the tympanum, depicting the flight and fall of Simon Magus, and the prophets in the archivolts, including this one. He clearly came from the same stylistic milieu as Heinrich IV Parler, yet his approach to narrative was much more dramatic. His figures are stockier, their garments are stiff, and the features on their large heads are exaggerated to the point of caricature. Paint, traces of which survive only in the eyes, surely heightened the effect of these figures, meant to overwhelm

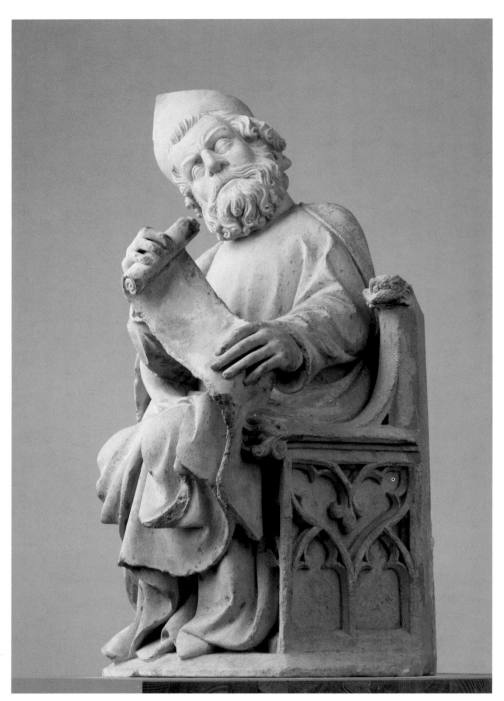

59, Prophet

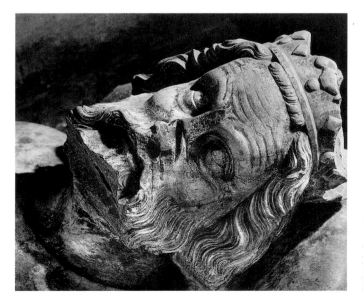

Fig. 59.1 Peter Parler (1332–1399). Tomb of Přemysl Otakar I (detail). Marly limestone; Prague, 1377. Metropolitan Chapter of Saint Vitus's Cathedral, Prague

the viewer with images of extreme vividness. Here too Schmidt provided an apt term to characterize the style: "lumpish excited" (*dumpf-erregt*). It has no precedents in Cologne, but was derived from the tombs of Přemysl Otakar I (fig. 59.1) and Přemysl Otakar II in Saint Vitus's Cathedral, which Peter Parler completed in 1377. The sculptor of the Cologne prophets has been identified, with considerable justification, as Michael II of Savoy, a son of Cologne Cathedral architect Michael of Savoy. Michael II is documented as a stonecutter in Prague in the 1370s and 1380s and was married to one of Peter Parler's daughters. For him as well, we have to assume a Cologne sojourn between 1378 and 1381.

A direct connection to the Prague Cathedral workshop is also indicated by the tracery on the sides of the thrones of the archivolt figures. The only other place in northern Europe where these same motifs—curved teardrops and pendant lilies in fluid, intertwining movement—are found about 1380 is at Saint Vitus's. The Parler contributions to the Saint Peter Portal enhance the understanding of Heinrich IV's artistic abilities. That he was one of the most important sculptors of the waning fourteenth century is evident from a comparison of his archivolt figures with the lyrical, elegant angels of the third sculptor. The so-called Master of the Bell Ringer, he took up the new naturalism of Michael II of Savoy but applied to it, doubtless under the influence of western, mainly French formal notions, a lyrical sense of line that presaged the Beautiful Style of about 1400.                    RL

1. Quincke 1938. Schmidt (1968 and 1992) and Lauer (1978) confirmed and refined his attributions.

LITERATURE: Quincke 1938; Schmidt 1969 (1992); Lauer in Cologne 1978–79, vol. 2, pp. 159–69, vol. 4, pp. 30ff.; Schurr, pp. 22ff.; Steinmann 2003, pp. 220ff.; Lauer 2004.

## 60. Sculpture from the East Facade of the Old Town Bridge Tower

*Peter Parler workshop, Prague; lion and Saint Sigismund, ca. 1380; Saint Procopius or Adalbert, ca. 1389*
*Fine sandstone from Prague, with copper additions in Saint Sigismund, traces of paint on Saint Procopius or Adalbert; lion: h. 72 cm (28⅜ in.), Saint Sigismund: h. 226 cm (89 in.), Saint Procopius or Adalbert: h. 235 cm (92½ in.)*
*Condition: Lion: unmarked; steel bolt added later; decorated with stucco(?), 1650; repaired, 1870. Saints:*
*damage caused by projectiles repaired, 1650 and 1848; crown and hands of Sigismund restored and surface of left hand with book and staff of Saint Procopius or Adalbert reground in situ by V. Kuneš, who carved his name and date into book, 1875; lily-shaped scepter of Sigismund lost, 1945–61; broken miter of Procopius or Adalbert repaired and abrasions filled, 1972; both conserved and cracks in Procopius or Adalbert bonded by Jaroslav Jelínek, 1991–92.*
*Provenance: Saints removed from bridge and deposited in Národní Galerie, Prague, 1972, lion, 1978; transferred to Národní Muzeum, 1990.*
*Národní Muzeum, Prague (H2-180.623, H2-180.621, H2-180.622)*

As the lifeline of commerce between the Old and New Towns on one bank and the castle on the other, and a focal point of the coronation route of Bohemian kings, the masonry bridge spanning the river Vltava assumed great artistic import, as these fine sculptures attest. This distinctive stylization of a rampant young lion, inquisitively turning its head to reveal a flat nose between a pair of round eyes and a mane arranged in radial locks, is characteristic of the lions produced in the Peter Parler workshop. Variations on the type can be found in Saint Vitus's Cathedral on the tombs of Duke Břetislav I and Přemysl Otakar II, on the console of the outer triforium (a lioness with cubs), and on the keystone of the cathedral (now in the Národní Muzeum, Prague), but none of these examples is a freestanding, fully three-dimensional statue like this one. A lengthwise furrow more than 3 centimeters wide carved along the entire length of the neck indicates that the lion was anchored or set into the narrow stone console from above. In photographs from the late nineteenth century it was already in the position in which the replica is seen today (see fig. 5.1).

The lion fits into the three-level political and ideological program of the tower's decoration. As a heraldic figure, it represents the Luxembourg lion, with the eagle of Saint Wenceslas beneath it.[1] It also serves as a link between the earthly and celestial spheres, and, by virtue of its being placed on a vertical axis above the statue of Saint Vitus, it may allude to the role of lions in the martyrdom of Saint Vitus. According to legend, the boy Vitus, originally from Sicily, was thrown to the lions together with his nurse Crescentia and his teacher Modestus on the order of the Roman emperor Diocletian.

The two statues of saints represent an early phase in the Beautiful Style developed by the Parler workshop. Both figures have tall, softly curving bodies and downward-tilted heads, and both gaze at the viewer. Unlike wooden statues of similar subjects (for example, the earlier Saint Nicholas from Vyšší Brod, the

later bishop-saint in the Slovenské Národní Muzeum in Bratislava, and works by the Master of the Týn Crucifixion), the Bridge sculptures were carved from a single block of masonry.[2]

Although the figure that has traditionally been called Saint Adalbert[3] is a significant and monumental product of the Parler workshop, it has been discussed less frequently in recent scholarly literature than other sculptures from the Bridge Tower. The saint's attenuated body stands in slight contrapposto, and the deep vertical folds of his robe pool at his feet. Similar wood sculptures are more voluminous: the closest examples are the torso of a saint from Strakonice and the Kłodzko Virgin and Child (fig. 3.4); the earliest would be Peter Parler's tombstone figure (after 1399), the relief of which has been damaged by pedestrian traffic.[4] This statue of a bearded monk wearing a miter and cowl and carrying a staff and a monastic rulebook represents the saint as an abbot or bishop in his role as a missionary. Fragments of black paint on the cowl suggest that the sculpture was originally intended to represent a member of the Benedictine Order. The legendary bronze relief cycle from the twelfth-century doors at Gniezno Cathedral shows Saint Adalbert as a monk and missionary, but such representations are rare. In images of Bohemian patron saints produced for the court of Charles IV, Adalbert appears bearded and vested as a bishop (as in the antependium from Pirna and the chasuble from Broumov, for example). He does not appear as a simple, barefooted monk until 1541, in illustrations of his raft journey near Neratovice.[5]

In 1997 Jiří Fajt and Jan Royt proposed that the statue represents the hermit Procopius (970–1053), the founder and first abbot of the Slavonic Benedictine Monastery at Sázava who was canonized in 1205.[6] In accordance with history, depictions of Procopius from the thirteenth and fourteenth centuries show the saint without a miter, which the Sázava abbots were not permitted to wear. (A half-length figure of Procopius with a miter in an initial in the Glagolitic portion of the late-fourteenth-century evangelary from Reims is an exception.) An image of Procopius in a mural from a house on Michalská Street (no. 460/1), dated after 1400, has attributes identical to those of the Bridge Tower sculpture. In the mural Procopius appears with his usual counterpart, Saint Adalbert. Pairing Procopius and Sigismund on the Bridge Tower without Adalbert and Wenceslas was probably a later solution to damage incurred during the Thirty Years War.

In contrast to the plunging vertical folds of Procopius's robe, Saint Sigismund's cloak is loosely pleated, with drapery cascading from

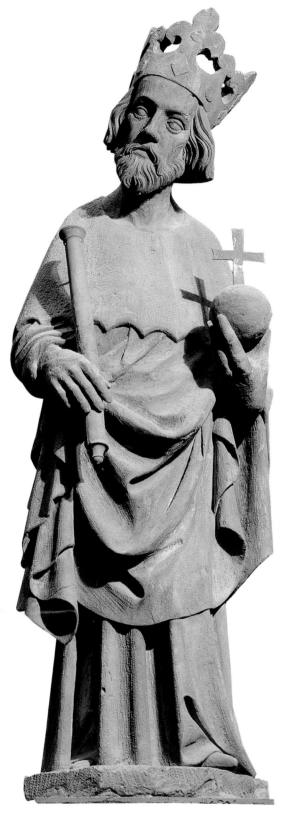

60, Saint Procopius or Adalbert

60, Saint Sigismund

under his arms. The head, with its blunt-cut hair and lily crown, completes the detailed silhouette of the sculpture, the most impressive of the group. The face is similar to those of the Christ figures produced by the Týn Master, but Sigismund's timeless features are introspective and devoid of emotion. The saint wears the Bohemian crown of Saint Wenceslas, a detail that intentionally follows the model of "vera effigy"-type reliquary busts of Saint Sigismund from the treasury of Prague Cathedral, with their characteristic features.[7] Charles IV elevated the Burgundian king and martyr Sigismund (496–535) to the status of a Bohemian patron saint when he brought his remains to Prague in 1355 and 1365 in order to strengthen the genealogical line of royal saints. The reconstruction of the scepter in Saint Sigismund's hand (like the scepters of the statues of Saint Vitus and Wenceslas IV and the sword of Charles IV) is not exact, for it

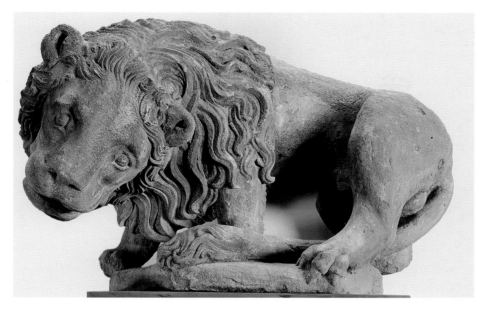

60, lion

for a pair of scepters from Erfurt University that date to the late fourteenth century).[2] That such scepters were also made of more exotic materials is attested by an example carved of narwhal ivory for Kraków University.[3]

CTL

1. Paris 1991, no. 57.
2. See also two Heidelberg University scepters of 1387 and 1403 (Heidelberg 1986, nos. 1, 5).
3. Vorbrodt, Vorbrodt, and Paatz 1971, pl. 212.

LITERATURE: Schnitzler, Volbach, and Bloch 1964, vol. 1, no. 37; New York 2000, no. 15, color ill.; Barnet in *Metropolitan Museum of Art Bulletin* 58, no. 2 (2000), p. 19.

## 62. Reliquary of the Miter of Saint Eligius

*Prague, 1378*
*Gilded silver, rock crystal, and silk damask of ca. 1600;*
*h. 32.5 cm (12¾ in.)*
*Inscribed: Anno domini M. CCC.LXXVIII. infula.*
*s[an]c[t]i. Eligii. apportata. est .per. serenissimu[m]*
*p[rin]cipem at[que] d[ominu]m d[ominu]m*
*Karolum. Quartum, Romanor[um] imp[er]atorem*
*[semper augustum et] Bo[h]em[ie] regem, donatam ei*
*a domino Karolo rege Franci[a]e, que nobis aurifabris*
*Pragen[sibus] per ip[s]um d[omi]n[u]m n[ost]r[u]m*
*imp[er]atorem data est et donata ex gra[ci]a sp[eci]ali.*
*Provenance: Guild of Goldsmiths, Prague, 1378;*
*lent to Národní Muzeum by Association of Prague*
*Goldsmiths, Silversmiths and Jewellers, 1876; acquired*
*by Národní Muzeum, 1946.*
*Národní Muzeum, Prague (H2-60.701)*

Highly unusual in form, this reliquary shaped like a miter, or bishop's headdress, enshrined

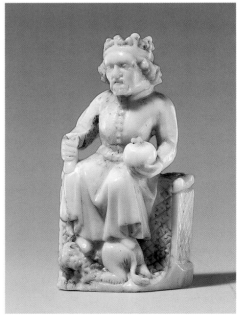

61

does not correspond to the large stone support on his shoulder.

DS

1. Chadraba 1971, p. 31.
2. Prague 1990b, pp. 15–18, 30–31, no. 3.
3. Neuwirth 1893; Opitz 1935, p. 90; Schmidt 1970; Chadraba 1971; Homolka 1976; Kutal 1984 (with bibl.); Fajt and Sršeň 1993, p. 60, no. 184.
4. Opitz 1935, p. 90.
5. See a mural painting in the Church of Saint Bartholomew in Pardubice (Royt 1987, pp. 315–20).
6. Fajt and Royt in Prague 1997, pp. 37, 39, fig. 14.
7. The earlier of the two busts, from 1355, was given to Plock, where it remains today, and the later work, from 1368, was transferred from Prague in 1420, probably to Saxony, where it was part of the treasury of relics of the cathedral of Wittenberg until its destruction (Bellmann, Harksen, and Werner 1979, p. 263, fig. 108).

LITERATURE: Lion: Chadraba 1971, p. 31; Homolka 1978, pp. 37ff. (with bibl.); Kutal 1984, p. 249; Fajt and Sršeň 1993, p. 58, no. 186. Saints: Pinder 1924; Opitz 1935, p. 90; Schmidt 1970; Chadraba 1971, pp. 27, 72; Homolka 1976; Kutal 1976; Kutal 1984 (with bibl.); Fajt and Sršeň 1993, p. 60, nos. 184, 185; Fajt and Royt in Prague 1997, pp. 37, 39, fig. 14.

## 61. Enthroned King

*Cologne, second half of 14th century*
*Walrus ivory, h. 6.4 cm (2¼ in.)*
*Provenance: Ernst and Marthe Kofler-Truniger,*
*Lucerne, by 1964.*
*The Metropolitan Museum of Art, New York, Pfeiffer*
*Fund, 2000 (2000.153)*

Miniature in size but monumentally conceived, this enthroned king rests his feet upon a recumbent lion and holds an orb and a scepter (the top of which is lost). His distinctive surcoat, with prominent buttons up the front; his physiognomy, with a small chin, large forehead, and curly locks; and his overall bearing relate him to the seated figures Heinrich Parler carved for the archivolt of the Saint Peter Portal on Cologne Cathedral about 1380–85, especially the Saint Quirinus (cat. 59a). This is one of the few small-scale works that demonstrate on stylistic grounds the influence of the Parler workshop on the artistic tradition of Cologne. Cologne artisans excelled in walrus ivory carving from the eleventh century on, but works of the Gothic period are rare.

The king was initially thought to be from a chess set, but its diminutive size and general composition do not conform to other examples of chess pieces. Anomalous too is the lion, probably a reference to the biblical throne of Solomon and thus to royal wisdom. The figure may have been intended to surmount a scepter, as it has a small hole in the base. A figure of Charlemagne adorns the top of the staff of a gold scepter made for Charles V of France (Louvre, Paris).[1] Contemporary gilded silver university scepters often feature a figure in an architectural setting (see cat. 72

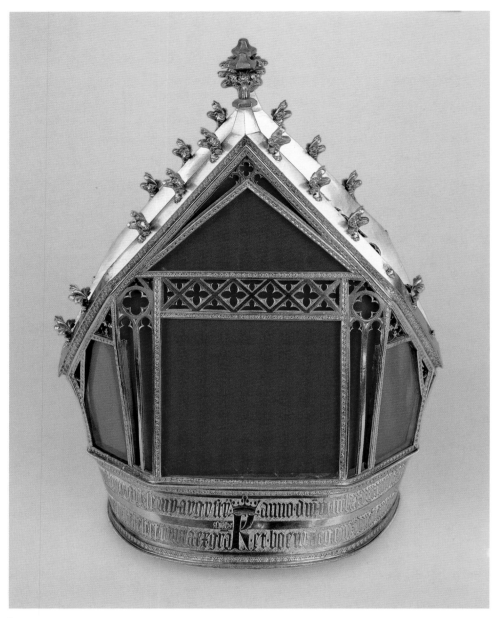

62

LITERATURE: Hájek of Libočany 1541, p. 349; Hammerschmid 1700; Cagliori 1752; Pelzel 1781, p. 931; Delisle 1874, no. 1602; Beckovský 1879, vol. 1, pt. 2, pp. 596–601; Podlaha 1926, vol. 3, pp. 758–60; Braun 1940, p. 456; Brussels 1966, no. 60; Cologne 1978–79, vol. 2, pp. 707–8, vol. 5, fig. T-212 (with bibl.); Cologne 1985, no. 54; Stehlíková et al. 1999, pp. 77–89 (with bibl.); Smahel 2004.

## 63. Three Gothic Rings

### a. Ring with the Monogram Kr

*Prague, second half of 14th century*
*Cast and engraved gold, diam. 2.1 cm (⅞ in.)*
*Inscribed: Kr.*
*Provenance: Excavated in Little Quarter (Malá Strana), Prague, 1898; purchased by Jan Koula (1855–1919), then curator of Národní Muzeum.[1]*
*Národní Muzeum, Prague (H2-2184)*

### b. Ring with the Monogram IR

*Prague, ca. 1400*
*Cast, wrought, and engraved gold, diam. 2.1 cm (⅞ in.)*
*Inscribed: IR.*
*Provenance: Found in Prague, May 10, 1895; gift of František Marsano, Prague merchant, to Národní Muzeum.*
*Národní Muzeum, Prague (H2-2195)*

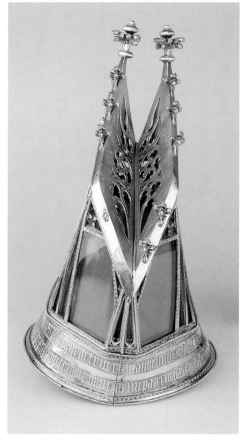

62, side view

the ceremonial head covering associated with Saint Eligius, bishop of Noyon (the original relic is now preserved outside it). To the faithful, the miter of Saint Eligius, like the glove of Saint Adalbert (cat. 14), was suffused with the sacred essence of the holy bishop. The piece of silk fabric now stored outside the reliquary is a testament to the dialogue between the courts in Prague and Paris in the late fourteenth century. According to the inscription, the gilded silver and rock crystal reliquary was created by the goldsmiths of Prague after Emperor Charles IV presented them with the miter, a gift from his nephew Charles V of France. In a detailed account of the many gifts showered on Charles IV during his visit to Paris in 1378, the *Grandes chroniques de France* do not mention the miter. However, the emperor visited four sites where Saint Eligius was venerated: in Noyon the abbey and cathedral with the tomb of Saint Eligius, the Abbey of Saint-Denis outside Paris, and the Abbey of Saint-Maur and

the Saint-Chapelle in the city itself. Still, there are no records confirming the existence of the relic of the miter at any of these.

Eligius, a celebrated goldsmith of the first half of the seventh century, is the patron saint of goldsmiths. The sure engraving of the inscription on this reliquary follows in the tradition of the gilded foot of the sardonyx chalice from the treasury of Saint Vitus's Cathedral (cat. 50), which was likewise made in Prague. The goldsmiths of Prague exhibited their reliquaries during the annual display of imperial relics. The gold of the miter reliquary is worn away on either side, apparently from being held. Records from the early sixteenth century specify that since ancient times on June 25, the feast of Saint Eligius, the reliquary would be pressed against people's heads to ensure their health and protection.[1]                       DS

1. Hájek of Libočany 1541, p. 349.

63a               63b               63c

## c. Amethyst Ring

*Bohemia, 14th century*
*Gold or gilded silver, amethyst cabochon with raised*
*octagonal surface; overall diam. 3 cm (1⅛ in.), without*
*stone 2.4 cm (1 in.)*
*Provenance: Štěpán Emanuel Berger (1844–1897);*
*purchased from his collection by Národní Muzeum,*
*1899.*
*Národní Muzeum, Prague (H2-2316)*

Rings with decorated initials and other elements resembling the border decorations of illuminated manuscripts characterize a group of Bohemian Gothic jewels dating from the middle of the fourteenth to the beginning of the sixteenth century. Two of the finest known examples are included here. They display raised, three-dimensional letters, cast on the outside in high relief (as in printing-press typefaces), that suggest they may have been signet rings. About 1400, such rings, engraved with a single letter or monogram, were often worn by the nobility and wealthy merchants, in religious as well as secular circles. The popularity of using initials—of one's own name, of the Virgin Mary (M, VM, or AVE), or even the first letters of prayers or magical formulas[2]— is demonstrated, for example, in a document of 1393 with twenty-seven attached seals of abbots, priors, and priests, two-thirds of which are signets.[3]

The curving shape of the first ring is formed by a superimposed uppercase K and lowercase r. The letters are decorated with a small engraved pattern resembling masonry work or roof tiles; above them springs a vine with three leaves. These elements identify the object as an engagement ring, with the initials being those of the wearer's betrothed. The building stones allude to the castle of love, a common motif of minnesingers' poetry and chivalric romance, in which a maiden was confined within the walls of a castle that could be entered only by a worthy suitor. The design of a vine branch with three leaves recalls the crest of the noble Bohemian family of Dražice. The illustrious Prague bishop Jan IV of Dražice had a residence in the Little Quarter (Malá Strana), between Mostecka Street and Dražice Square, near where the ring was found. The

K here can also be read as a variant form of the uppercase R, and the bottom of the R ends in the shape of a dragon's tail. Similar forms appear in the initials of fourteenth-century illuminated manuscripts, most notably that of Queen Elizabeth Ryksa of 1320–35. The vine branch decoration could well have been used for sealing, as a signet or countersign, and it is possible that all such rings could have been employed as cylinder seals.

The letters I and R unfurl like tiny decorative ribbons to form the body of the second ring. Rising from a lobed leaf, a small hand holds a letter R whose surface was originally engraved with a pattern of dragon or snake scales, now only faintly visible. While the significance of these forms cannot be precisely determined, this object was probably a secular pledge ring. The letters are most likely the initials of the wearer's betrothed, and the idea of a marital pledge is expressed by the hand clasping the R and by the intertwining of the letter's ends with the snake-shaped band. Of course, Christian symbolism cannot be overlooked in the grape leaf and dragon's body.

The numerous interconnecting motifs on this ring mirror the letters wreathed by dragons' bodies that appear in the margins of manuscripts from the end of the thirteenth century. By the late fourteenth century, border illustrations often included a hand holding a letter or hands "locked" within a patron's initial, as if they belonged to someone imprisoned in stocks. In the first volume of the Wenceslas Bible, a figure holds an initial R that closely resembles the one on this ring, and an initial appears in the hands of wild men in an illuminated version of the *Willehalm* romance.[4]

The third ring, with its amethyst of good dark color, purity, and brilliance, may be either Bohemian or imported; the original location of such gems cannot be definitively established.[5] In a demonstration of highly accomplished gem cutting, the top of the stone has been precisely cut and perfectly polished into an octagonal shape. The work of the goldsmith is less refined: the funnel-shaped setting is unevenly formed at the edges. The round wire prongs securing the stone are comparable to archaeological findings from the thirteenth

and fourteenth centuries.[6] Gem working during this period consisted mostly of polishing the cabochon, with cutting and shaping reserved for the edges. Metal wires were used to cut large slabs of stone.[7] In 1353 the Prague city register first mentions one "Hannussius [Henslinus] politor lapidum" as a gem carver in the Old Town; he is probably the same artist who in the years 1359–63 worked as "Johannes pulierer imperatoris" for Emperor Charles IV.[8] From the 1370s until the Hussite Revolution, gem carving remained a rare profession, with its workshops exclusively located in the New Town. Recorded there are Václav-Vaněk (1376–81), the first artist in the New Town to be explicitly mentioned as a gem cutter and polisher "qui trahit in lapide schlifftein" (who cuts stone by grinding stone); Jakub (1376–96); Petr-Pešek (from 1377); Šimon (1381–85); Leonard (from 1387); and Jindřich (1434).[9]

The amethyst ring comes from a group of seventy-six that belonged to an important Czech art collector, Štěpán Emanuel Berger, who was a major landowner and the first lawyer for the Národní Muzeum in Prague. As with most of his acquisitions, the circumstances of the ring's discovery are not known.

DS

1. On the origins of this and other rings, Koula (1898–99, p. 409) says that they were "collected during a longer period in Prague and environs."
2. See rings H2-2348, H2-2.359, and H2-11.644 in the collection of the Národní Muzeum, Prague. Another discovery from Prague is a ring decorated with the alchemical formula "akarasarar" (Chadour and Joppien 1985, vol. 2, pp. 132–33, no. 203).
3. National Archives, Prague, inventory records of the Premonstratensian Monastery at Strahov, document inv. no. 79, dated June 18, 1393 (unpublished).
4. See the Wenceslas Bible 1981–98, vol. 1, fols. 51 and 47v; *Willehalm*, fol. 200v (Krása 1974a, p. 71, p. 88, colorpl. p. 101).
5. Kouřimský (1968, pp. 37–38) presents amethysts of comparable quality from the area of Kozákov hill in northern Bohemia.
6. Ward et al. 1981, no. 118e; Szendrei 1889, pp. 210, 219–21, nos. 50, 59–64.
7. See, for example, the large slabs of jasper decorating the walls of the Saint Wenceslas Chapel in Prague Cathedral (fig. 6.1; Stehlíková in Siracusa–Caltanissetta–Prague 2004, p. 45, no. 18a,b).
8. Tomek 1866, pp. 39 (Husova Street, no. 157a/I), 237.
9. Tomek 1870, p. 275 (in Podskalí quarter), p. 23 (house no. 542/II, across from Saint Stephen's Church, Prague; a house of uncertain location, "in the new market" at the Coal Market or Rytířská Street), p. 281 (at the Church of Saint Catherine, Prague).

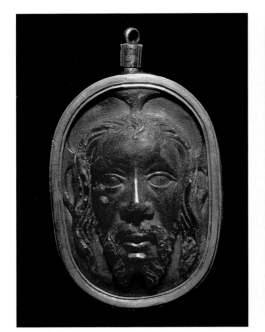

64, front

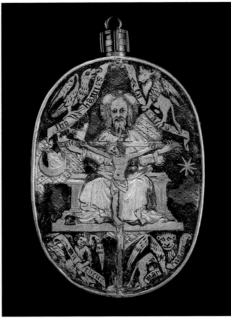

64, back

## 64. Pendant with the Trinity and the Vera Icon

*Prague, ca. 1380*
*Gilded silver, translucent enamel, and amber; 7 x 5 cm (2¾ x 2 in.)*
*Inscribed in Gothic minuscule around edge of frame: Miserere.mei.deus.secundum.magnam.misericordiam.tuam (Have mercy on me, O God, according to thy great mercy [Ps. 50:3])*
*Provenance: Acquired by the Bayerisches National-museum before 1910.*
*Bayerisches Nationalmuseum, Munich (MA 2478)*

The image of the living face of Jesus, the *vera icon* (see cat. 137), emerging in relief from amber on one side of this double-sided pendant seems to echo the Pauline metaphor "We see now through a glass in a dark manner; but then face to face" (1 Cor. 13:12). The power of the image is conveyed by the material, which was considered to have amuletic and healing powers. Rare and infrequently used in the Middle Ages, amber appealed to princely tastes. Charles V of France, nephew of Charles IV of Bohemia, owned a Holy Family in amber; his brother Jean de Berry owned a Virgin and Child made partly of amber.[1] A chandelier dated 1419 that belonged to Sophia, second wife of Wenceslas IV, contains an amber statuette of Saint Catherine (cat. 143). The quality of the carving on this miniature head of Jesus recalls the Parler busts in the triforium in Saint Vitus's Cathedral, with their large eyes, fleshy lips, and long, stringy hair (see figs. 1.2, 8.6).[2]

The Trinity, or Throne of Grace, surrounded by symbols of the Four Evangelists (identified with Latin inscriptions) in translucent enamel on silver on the other side of the pendant

finds its technical and stylistic parallels in Parisian rather than Bohemian works, such as the translucent enamel "Butterfly" locket for a True Cross relic now in Regensburg Cathedral.[3] Its composition and form, however, also occur in Bohemian manuscripts like the Vorau Antiphonary (see fig. 3.7).[4]

CTL

1. Gay 1887–1928, vol. 1, "Ambre."
2. See Schädler in Cologne 1978–79, vol. 2, p. 710.
3. Paris 1998, no. 153.
4. Cologne 1978–79, vol. 2, p. 737.

LITERATURE: Cologne 1978–79, vol. 2, p. 710; Schädler in Nuremberg 1978, no. 112; Seelig in Munich 1992, no. 8.

## 65. The Karlštejn Hoard

*Prague, 1350–1400*
*Gilded silver; beakers h. 7.5–7.7 cm (3 in.), wine bowl 4.3 x 12.5 cm (1⅝ x 4⅞ in.), belt buckle 8.7 x 12.8 cm (3⅜ x 5 in.) and 12.8 x 2.2 cm (5 x ⅞ in.), dress clasp with image of the Virgin 9.7 x 9.7 cm (3⅞ x 3⅞ in.), garment decorations in shape of AM and YS, 1.5–1.6 x 1.2–1.5 cm (⅝ x ½–⅝ in.), garment fasteners 2.8–3.2 x 1.4–2.2 cm (1⅛–1¼ x ½–⅞ in.), buttons diam. 1–3 cm (⅜–1⅛ in.)*
*Condition: Entire collection restored, 1975–78 (per 2004 metallurgical analysis, some unsuitable materials used).[1]*
*Provenance: Discovered during reconstruction of Karlštejn Castle, 1877–99;[2] bought at auction in Berlin by František Borovský, custodian of Umělecko-průmyslové Muzeum, 1911; sold to Jindřich Waldes for Sbírka Šatních Spínadel, Vršovice, 1916; confiscated by State during World War II; transferred to Umělecko-průmyslové Museum, 1947; restituted to Waldes family, New York, 1990s; donated by Waldes family to Uměleckoprůmyslové Museum, 1995.*
*Uměleckoprůmyslové Museum, Prague (UPM 90967, 90973, 90975–77, 90979–82, 90984, 90989, 90993–95)*

The treasure found at the end of the nine-teenth century in a wall at Karlštejn Castle boasts a remarkable collection of secular objects (see also cat. 66). There are four rare drinking vessels and their components, as well as a collection of clothing decorations and accessories. Among the latter are two large clasps for a cloak (or perhaps a pluvial), a pendant pomander, a cast-metal decorative finial for a long belt, and several matching buckles and decorative finials decorated with various motifs: 29 items feature love knots; 4, a grille or trellis; and 2, a four-leaf clover (even then a symbol of good luck). The

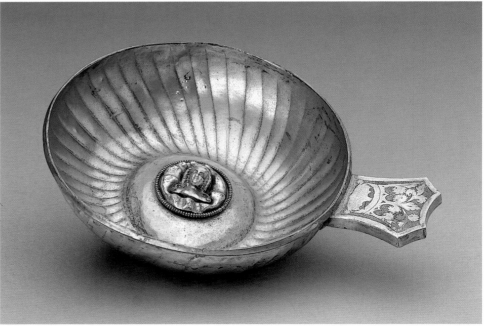

65, wine bowl

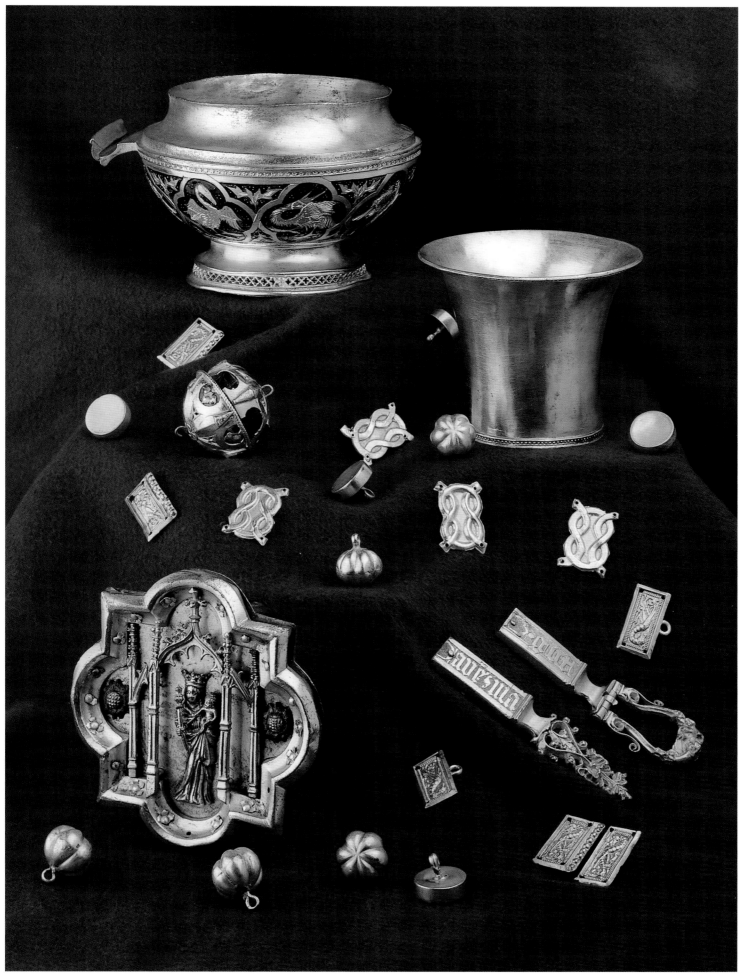

largest group of items consisted of buttons: 119 small and 13 large gourd-shaped, 91 pea-shaped, and 19 pieces each of ball and gourd shapes; several other remnants were in the form of disks, bowls, acorns, or rosettes. The treasure's rare decorative monograms were executed by an unparalleled technique that employed cutting rather than embossing. The hoard also contained two types of paired clasps that were decorated with motifs of four-leaf plants and small dragons. In total, there were 387 items, all of which can be proved conclusively to belong to the culture of the Luxembourg court.

This collection is not merely the most extensive find in the territory of the Czech lands (the only other one of comparable importance being the set of drinking vessels discovered in Kutná Hora; cat. 74). It also provides physical confirmation of period documents that record the rapid flourishing of the goldsmith's trade at the Luxembourg court, particularly in Prague, and of the application of their creations to uses outside the liturgical sphere and the veneration of relics (examples of which survive in greater numbers).[3] The most important object from the find, the bottom of a vessel called a *scyphus*, bears a remarkable wrought quatrefoil decoration of eight birds in motion: a stork, eagle, goose, vulture, heron, swan, and two mythological birds, the phoenix and the pelican.[4] In its extraordinary quality and motifs—particularly the openwork grille with quatrefoils—this work equals that of a group of objects (mostly liturgical) made in Prague about 1350 (see cats. 50, 51).[5]

Similarly, although it is small in scale, the cast of a female bust in a medallion on the bottom of the drinking bowl recalls the famous busts by Peter Parler in the Saint Vitus triforium.[6] The resemblance in materials also suggests a close likeness to the representation found on the Arm Reliquary of Saint George (cat. 31). A comparison might also be made with the heads of the angels on the Baltimore Reliquary of 1347–49 (cat. 10) or on the Saint Vitus Reliquary in Herrieden (cat. 23),[7] which can be dated precisely to 1358. A similar technique of translucent enamel is used on this reliquary and also on related pieces not on exhibition—the bottom and the lid from a no longer extant bowl. The technique is typical of Prague goldsmiths' work at the time.

The great variety of shapes displayed by the buttons and fasteners that decorated cloaks offer exceptional evidence of the fashions of the period. At the court, the close-fitting garments, short jerkins, and numerous adornments became, from the 1360s onward, the butt of criticism by Czech Church reformers. The most telling instance of con-temporary fashion is one of the earliest sculptures thought to portray the emperor himself in the sculpted decoration of the Beautiful Fountain (see cat. 100) of Nuremberg, conceived about 1370, during Charles IV's reign, but completed after his death. Clearly visible are such minute details as the fastener with a love knot on the hem of his cloak and the letter-shaped decorations on the hem of an inner garment. Similar flattened ball-shaped buttons appear on the figure of the flute player called Hansel on the same fountain. The large clasp can be dated to the very end of the fourteenth century. Although its basic shape (a quatrefoil inscribed in a square) is traditional, more significant stylistic parallels occur in Cologne jewelry from the turn of the century, including not only the figural type of a Virgin with Child but also the tiny cut appliqués shaped like rosettes or patina-tion blossoms on the frame.          HK

1. For instance, in bowl 90996, the quatrefoils with birds were filled with resin, without leaving a trace of the original material (conservation report in preparation).
2. Those who found the treasure initially kept it a secret. After František Borovský bought the collection for the Uměleckoprůmyslové Muzeum, it was exhibited there in 1912 for the first time, with the gold brooch (cat. 66). In 1995 the Waldes family donated the collection to the museum to commemorate the 110th anniversary of its foundation.
3. All the relevant literature and sources, particularly those concerning the goldsmiths' art and the fashions of the period, are cited in the first general description of the collection by Libuše Urešová, published in *Acta UPM* (1980) and later qualified in *Umění* (1987). Most of the significant comparisons and dating were presented in those articles. Individual goldsmiths' objects intended for secular use are published by Fritz (1982), who accepts the research results of Urešová (1980), as does Lightbown (1992).
4. At the time of the 2004 metallurgical study, Jiří Mlíkovský of the Národní Muzeum, under the supervision of Petra Matějovičová, curator of the Collection of Metalwork at the Uměleckoprůmyslové Museum, identified the birds depicted through zoological analysis. (Urešová [1980, 1987] originally cited them all merely as water birds.) Mlíkovský's findings also testify to the collection's having being created for the court, since such symbolism would have great significance there.
5. Fritz 1982, nos. 90, 92, 128.
6. See Urešová 1980 and 1987.
7. Ibid.

LITERATURE: Cologne 1985, no. 53.

## 66. Brooch

*Prague, last quarter of 14th century*
*Gold, sapphires, emeralds, rubies, and pearls; diam. 3.7 cm (1½ in.)*
*Provenance: Purportedly Karlštejn Hoard, excavated 19th century; Jindřich Waldes, Prague, early 20th century; George Waldes, New York, from 1940s; given by George Waldes to Uměleckoprůmyslové Museum, 2000.*
*Uměleckoprůmyslové Museum, Prague (UPM 99.837)*

Of all the objects linked to the Karlštejn Hoard (see cat. 65), this is the most spectacular. Studded with numerous gems, the brooch is remarkable in both richness and form. The tiny pearls, while riveted to the backplate, stand on tall gold collars that allow them to shift with the slightest movement, which must have

66

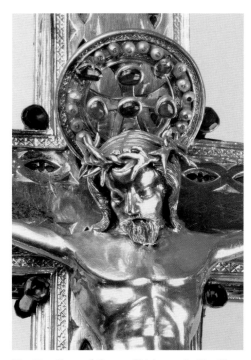

Fig. 66.1 Cross of Georg of Lichtenstein (detail). Trent Cathedral. Gilded silver, enamel, garnets, pearls, emeralds, and colored crystal, ca. 1400. Museo Diocesano Tridentino, Trent (3742)

created a shimmering effect when worn. The backplate itself is exceptionally elegant. Though not visible from the front, it is pierced with heart-shaped loops in the manner of Gothic window tracery. This appears to be a hallmark of Prague goldsmiths, for similar piercing appears on the Eagle Brooch (cat. 16) and most notably on the jeweled halo of Jesus on the cross of the Bohemian prince-archbishop Georg of Lichtenstein preserved in Trent (fig. 66.1).[1]

BDB

1. Trent 2002, pp. 792–95, no. 157.

67a

67b

## 67a, b. Two Floor Tiles

*Bohemia, probably after 1383*
*Ceramic; a: 16.7 x 16.7 x 3.5 cm (6⅝ x 6⅝ x 1⅜ in.); b: 16.5 x 16 x 4 cm (6½ x 6¼ x 1⅝ in.)*
*Provenance: Excavated at Prague Castle: (a) in the Garden on the Ramparts, (b) in the so-called Southern Palace Courtyard, 20th century.*
*Správa Pražského Hradu, Prague (a: 1116 [1710], b: 1726)*

Two groups of tiles, most probably from two different floors with the same complex iconographic concept, were found in the Old Royal Palace (Starý Královský Palác) in Prague Castle. The tiles of one group, which these two represent, are decorated with either a dragon or oak leaves and measure between 16 and 17 centimeters square. The fragmentary tiles of the other group are decorated with either a lion, symbol of the kingdom of Bohemia, or an eagle, the heraldic beast of the Přemyslids, and measure about 19 centimeters.[1] Tiles with lions were found at the east wall of the Assembly wing of the palace; eagle tiles were excavated at the south wall of the Theresian wing. Many oak-leaf tiles were found in the fill above the arches of the Romanesque ground floor of the palace.

The dragon may represent Melusine, the mythical half-woman, half-serpent ancestor of the house of Lusignan who to spite her husband, Raymond of Poitou, metamorphosed into a dragon and disappeared. Jean d'Arras finished his version of the tale, which he connected with the Luxembourgs and the Valois, in 1393, but the roots of the story appear to be much older.[2]

The dragon tiles may be connected with the reconstruction of the Old Royal Palace under Wenceslas IV after 1383. Circumstantial evidence for their date is provided by a find from Hybernská Street in Prague: a tile with the same motif that may have come from a building called Charles's Court

(Králův dvůr) that was used by Wenceslas IV and was mentioned for the first time in 1383.[3]

JFr

1. Frolík 1999.
2. See Nejedlý 2002, with many illustrations.
3. Hejdová and Nechvátal 1970, pp. 178, 428.

LITERATURE: Frolík 1999.

## 67c. Stove Tile

*Bohemia, ca. 1400*
*Ceramic, 40.4 x 18.6 x 14.9 cm (15⅞ x 7⅜ x 5⅞ in.)*
*Condition: Restored from various fragments and slightly filled in with plaster.*
*Provenance: Found during the excavation of the Third Courtyard, Prague Castle, 1926.*
*Správa Pražského Hradu, Prague (329)*

An example of one of the most precious types produced in Bohemia before 1419, the beginning of the Hussite Revolution, this tile comes from the royal palace, possibly a room used by King Wenceslas IV.[1] Soot on the back indicates that it was set into the body of the stove. The ogee at the bottom of the tracery decoration that covers the opening of the niche is surmounted by an arcade of four keyhole arches and a grid of lozenges filled with quatrefoils.

Fragments of similar tiles, also without a chronological context, were found in Hradčanské Square in front of the main entrance to Prague Castle in 1944.[2] But similar tiles excavated at the castle of Melice in the Vyškov region of Moravia must predate the castle's destruction in 1423. Moreover, they bear the shield of Václav Králík of Buřenice, bishop of Olomouc and a courtier of Wenceslas IV,

who owned the castle from 1412 to 1416.[3] A comparison can also be made to finds from ceramic workshops in Sezimovo Ústí, which were abandoned in 1420.[4]

JFr

1. Smetánka 1988, p. 180.
2. Frolík 1988, pp. 172–73.
3. Michna 1981, pp. 335, 339.
4. See Richter 1979.

LITERATURE: Smetánka 1988.

67c

## 68. Pilsner Glass

*Bohemia, 15th century*
*Glass, h. 29 cm (11⅜ in.)*
*Provenance: Excavated in Prague, 19th century.*
*Uměleckoprůmyslové Museum, Prague (UPM 21679)*
*Not exhibited*

In a fourteenth-century Bohemian poem, a
poor Czech laments pawning his belongings for
a glass of beer: "If we go to the pub, they will
not want to pour for us. Ach, how disgusting it
is to drink from a dry glass!"[1] Beer drinking
was so emblematic of Czech culture that it was
illustrated in contemporary manuscripts. The
glass vessels shown in a secular manuscript like
*The Travels of Sir John Mandeville* (cat. 88) and
also in the Bible of Konrad of Vechta (fig. 68.1)
are recognizable as the type known today as
"pilsner glasses," after the Czech city of Pilsen,
which is renowned for its golden beer. Such
beakers, already ubiquitous in the fourteenth
century, are tall, to accommodate at least half a
liter of liquid, and have a splayed foot to ensure
stability and tiny applied beads of molten glass
called prunts to facilitate gripping. Examples
have been found at each of the sixty-five
recorded glass excavation sites in Bohemia.[2]

AS

1. Unknown author, from *Labut je divný pták: Soubor
   ceské svetské lyriky doby gotické* (Prague, 1999).
2. Hejdová 1975, p. 149.

## 69. Beaker in a Leather Case

*Beaker: Siegburg, first half of 14th century; case:*
*Prague, before 1360*
*Beaker: salt-glazed stoneware and gray shard, sulfate;*
*case: tinted leather with engraved decoration, h. 17.7 cm*
*(7 in.), diam. of aperture ca. 5.7 cm (2¼ in.), diam. of*
*base 7.4 cm (2⅞ in.)*
*Provenance: Second floor of cloister of Benedictine*
*Emmaus Monastery, New Town, Prague, found*
*during postwar reconstruction (1946–51); donated*
*by Besta Building Enterprise, CŠSZ, to Národní*
*Muzeum, 1952.*
*Národní Muzeum, Prague (H2-28.486)*

This beaker of hardened stoneware (*Steinzeug*)
comes from the pottery workshops in Sieburg
in the Lower Rhineland. It belongs to a group
of tall beakers introduced about the end of
the thirteenth century and exported mainly in
the first half of the fourteenth century. Their
export to Prague is attested by early archaeo-
logical finds at Prague Castle and in the ware-
houses of traveling merchants in the Týn Court
in the Old Town (Staré Město). This is the only
surviving example from this once large-scale
production that has a sumptuously decorated
unremovable leather case. The leather case fits
the shape of the beaker exactly, including the
finger-shaped indentations on the base. Before
its application the leather must have been
steamed, so that on drying it would shrink to

69

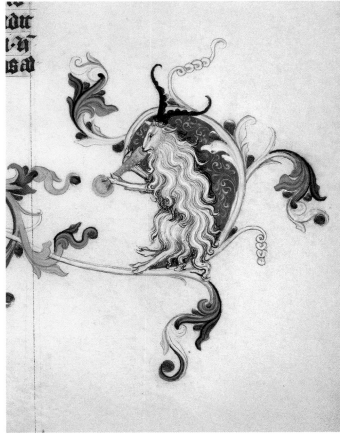

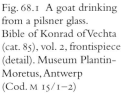

Fig. 68.1 A goat drinking
from a pilsner glass.
Bible of Konrad of Vechta
(cat. 85), vol. 2, frontispiece
(detail). Museum Plantin-
Moretus, Antwerp
(Cod. M 15/1–2)

fit the form of the beaker. It thus serves both
a protective and a decorative function.

A similar floral motif appears on two
earlier leather cases of Bohemian provenance
that were commissioned by Charles IV, one
for the royal crown of Bohemia in 1347 and
the other for the imperial crown in 1352. A
similar technique and similar ornament were
used on the case of the imperial crown in the
Weltliche Schatzkammer in Vienna;[1] on a case
made for personal seals with the coat of arms
of the lords of Říčany from 1376–78 in the
Deutsches Ledermuseum und Schuhmuseum,
Offenbach am Main (see fig. 69.1);[2] and
on the Imperial Box in the Germanisches
Nationalmuseum, Nuremberg (cat. 71).[3]
Acanthus decoration like this can be found
on the binding of the Pontifical of Albert of
Šternberk of 1374 (cat. 41) and on a book
box featuring a noble family's coat of arms in
The Metropolitan Museum of Art (fig. 69.2).[4]

Fig. 69.1 Case with the coat of arms of the Říčany family. Leather with paint; Prague, 1376–78. Deutsches Ledermuseum und Schuhmuseum, Offenbach am Main, Germany (10552)

Fig. 69.2 Book box. Leather with metal mounts; Prague, 14th century. The Metropolitan Museum of Art, New York, Gift of Mrs. Adele O. Friedman, 1951 (51.117)

The decoration is identical on the leather case of the Model Book in the Kunsthistorisches Museum, Vienna (cat. 117).

The foliate repertory was common to leather decoration and painting; in fact, the leather case makers and bookbinders in Prague's Old Town were members of the painters' guild. The case for the Emmaus beaker can probably be assigned to the circle of Prague leather manufacturers and bookbinders. Nearly 140 tanners resided in the immediate vicinity of the Emmaus Monastery in the New Town (Nové Město), mainly along

the Vltava River in the settlements of Podskalí and Jircháře.[5] But artisanal masters were rare in the years 1342–1419: one sheath and case maker and eleven bookbinders are recorded.[6] Bookbindings were first made in monasteries, so this case could also have been made in the Emmaus scriptorium, which was established in 1356.

The beaker was discovered, together with other quotidian objects such as a worn leather shoe and a torn leather belt, in the filling behind the vault of the monastery's cloister, which was sealed before 1360 during the erection of a second floor. It is not significantly damaged. Unless it was thrown out with the refuse by mistake, its disposal in the backfilling might have been intentional, as a ritual deposit of either a personal possession of an important personage or a revered object, a specific relic with a protective role. The leather case illustrates the level of craftsmanship that existed at this monastery of the Benedictine order and of the Slavic rite that was founded by Charles IV in 1347.                VB, DS

1. Fillitz 1986, p. 182, no. 172, ill.; Gall 1965, ill. 36, table 2.
2. Gall 1965, ill. 41, table 3.
3. Herzogenberg in Nuremberg 1978, pp. 79–80.
4. A heart-shaped ornament with an inscribed trefoil (*Herzblattmuster*) appears on a bookbinding of about 1400 (Schmidt-Künsemüller 1980, no. 70).
5. Tomek 1870, pp. 2, 7, 103, 106, 108, 110, 117–19, 122, 140–45.
6. Tomek 1855–1901, vol. 2, pp. 378, 384–85; Winter 1906, p. 139.

LITERATURE: Brych 1986; Winston-Salem 1996, pp. 108–9, no. 27.

## 70. Pilgrim's Badge with Charles IV and Innocent VI

*Prague, 1350–60*
*Lead, 6 x 3.8 cm (2⅜ x 1½ in.)*
*Provenance: Imperial collection of relics in Charles Square, New Town, Prague; excavated in Prague, 19th century(?); Muzeum Hlavního Města, before 1978.*
*Muzeum Hlavního Města Prahy, Prague (2369)*

On a narrow, stagelike setting dominated by a cross, a caricature image of Emperor Charles IV, holding the lance with which Jesus' side was pierced at the Crucifixion, kneels before Pope Innocent VI. This souvenir badge commemorates the display of precious relics for the feast of the Holy Lance and Nail, newly established in 1354 at Charles's urging, with the support of the pope. On that day, according to the Chronicle of Beneš Krabice of Weitmile, "There came to Prague such a multitude of people from all parts of the world that no one would believe it unless he had seen it with his own eyes." The great religious celebration, which offered spiritual benefit for participants in the form of indulgences (remissions from punishment in purgatory) was also an economic boon for Prague. As a result of its success, "a second annual market was made and established at that time in New Town."[1]

Pins with designs stamped in inexpensive metal were produced throughout medieval Europe as souvenirs of visits to important religious shrines and celebrations of feasts. This example is the unique survivor of its type.

BDB

70

1. Beneš Krabice of Weitmile, FRB 1884, p. 519: "conveniebat Pragam de omnibus mundi partibus tanta multitude hominum, quod nullus crederet, nisi qui oculis suis videret. Propter hunc maximum concursum factum est et positum secundum annuale forum eo tempore in Nova civitate Pragensi."

LITERATURE: Nuremberg 1978, p. 106, no. 116,6.

## 71. Imperial Box

*Prague, ca. 1350*
*Leather over wood with paint, 62 x 45 x 18 cm*
*(24⅜ x 17¾ x 7⅛ in.)*
*Condition: Cut down (remnants of animal feet and decoration along top).*
*Inscribed on cover: Salvator mundi salva nos omnes quia per crucem et sanguinem tuum redemsiti nos auxiliare nobis te deprecamur deus noster (Savior of the world, save us all, because by the cross and your blood you have redeemed us, to heal us, we are pardoned by you, our God).* [1]
*Provenance: Acquired by Germanisches National-museum, 1880.*
*Germanisches Nationalmuseum, Nuremberg (HG 3591)*

Emblazoned on the cover of this box, set between an inscription above and two fabulous beasts below, are the shields of the Holy Roman Empire (*Or an Eagle displayed Sable*) and Bohemia (*Gules a Lion rampant queue fourchy Argent*) as used by Charles IV. Technical and stylistic similarities suggest that the box is a product of the same Prague workshop that created cases to house the imperial crown and sword, as well as the Bohemian crown (fig. 1.4).[2] This imperial box seems to highlight the sacred aspects of the Holy Roman Empire, and it is reasonable to infer its close association with the imperial regalia.[3]

The reference to the Passion of Christ, and specifically to the cross,[4] in the inscription suggests that this box served to protect a sacred object or reliquary belonging to the emperor, who was renowned for his devotion to relics of Christ's Passion, fostered during his childhood at the French court. This box, originally probably close to 76 centimeters high, must have sheltered a large precious object, perhaps a cross.                    RTM

1. My thanks to Eric Ramírez-Weaver for this translation.
2. Essenwein 1873.
3. The development of the double-headed eagle for the shield of the empire under Charles's son Sigismund later expresses this imperial duality heraldically. While the exact reasons for its original assumption remain unclear, one head is traditionally thought to be symbolic of the "Holy" and the other of the "Empire."
4. Schramm, Fillitz, and Mütherich 1978, p. 60.

LITERATURE: Essenwein 1873; Gall 1965, pp. 57–58, fig. 41; Schramm, Fillitz, and Mütherich 1978, p. 60; Machilek in Seibt 1978a, p. 88.

71

## 72. University Scepter

*Prague, 1380–90; additions, 17th–19th century*
*Silver and gilded silver, h. 108 cm (42½ in.)*
*Provenance: Purportedly commissioned for Charles University, Prague, late 14th century; purportedly presented by King Sigismund to Amplonius Ratingk de Berka, rector of Erfurt University, 1412; University of Berlin (renamed Humboldt-Universität zu Berlin in 1949), 1818.*
*Humboldt-Universität zu Berlin (A 7)*

The vocabulary of Gothic architecture, which also inspired the creation of reliquaries and monstrances, is adapted here to symbols of university authority. According to documentation from 1729, a pair of scepters, one of which is exhibited, was originally executed for Prague's Charles University. After the Decree of Kutná Hora (1409) favoring the "Bohemian nation" within the university's administration, many German-speaking scholars left Prague. These scepters were purportedly given to Erfurt University by Sigismund in 1412, after that exodus.[1]

The original, crowning elements of the scepters can reasonably be dated to the 1380s, when the new buildings of the Carolinium (fig. 8.7), including lecture halls, a chapel, and a ceremonial hall, were established at Charles University under Wenceslas IV.[2] The scepters would then be nearly contemporary with the microarchitecture of the Parler tabernacle in the Wenceslas Chapel (see cat. 45), for which payment was made in 1375, and with the Scepter of Heidelberg University of 1387, considered the earliest surviving example.[3]

Carrying the scepter was one of the privileges of a university rector, who, in the case of Prague, was also the archbishop. But this right was accorded to other university officials as well. At the Sorbonne, for example, scepters existed for each of the "nations" constituting the university, while in Montpellier, the university's important medical faculty was accorded the right to bear silver scepters.[4] At the Council of Constance (1414–18), a procession of Church dignitaries, among them cardinals, archbishops, and abbots, included university officials from twenty-two European universities, preceded by a young man carrying "gilded, long sticks." Each of these "sticks," or scepters, bore a "castle" and an identifying coat of arms.[5]

Inscriptions added to the shafts of these scepters over the course of the centuries testify to their prolonged use: one from 1692 commemorates the three hundredth anniversary of Erfurt University; one from 1694 and another of 1767 attest to their restoration; and one from 1818 memorializes their passing to a

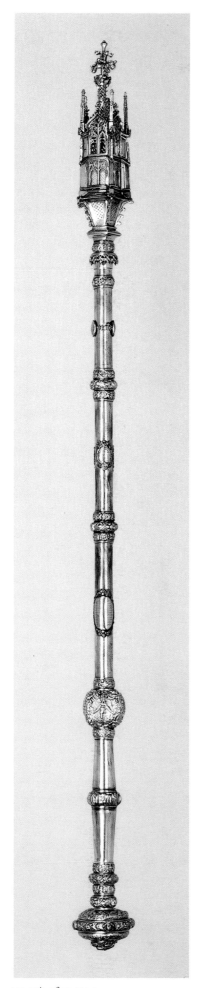

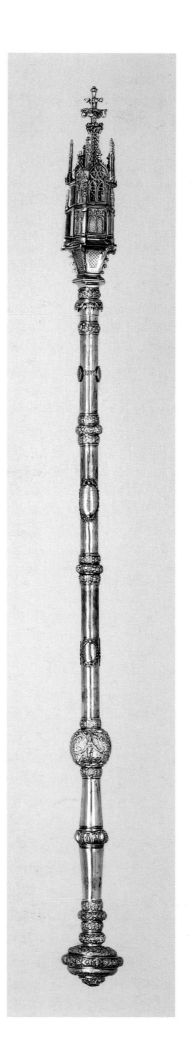

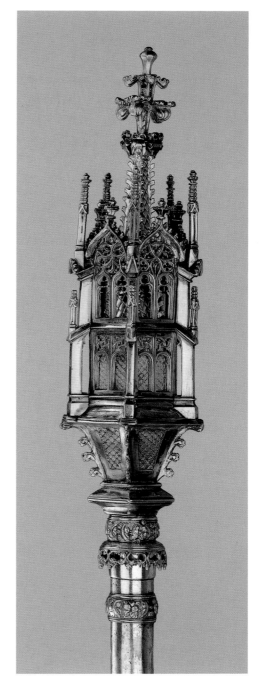

72, detail of scepter

new rector at the University of Berlin (now Humboldt-Universität zu Berlin).

<div align="right">BDB</div>

1. Motschmann 1729, pp. 9, 4, 75.
2. Svatoš in Kavka and Petráň 2001, p. 41.
3. Heidelberg 1986, pp. 16–17, no. 1.
4. Miethke in ibid., p. 10.
5. Fritz in ibid., p. 15.

LITERATURE: Vorbrodt, Vorbrodt, and Paatz 1971, pp. 62ff., figs. 117, 118; Cologne 1978–79, vol. 2, pp. 569–70, ill., vol. 5, p. 275, color ill.

72, pair of scepters

## 73. Six Tracts of Tomáš of Štítné

*Prague, 1376; binding, 16th century*
*Tempera, ink, and gold on parchment; 158 fols.; 30 x*
*21 cm (11⅞ x 8¼ in.)*
*Provenance: Apparently commissioned by the author*
*and dedicated to Vojtěch Raňkův of Ježov; Charles*
*University, Prague, ancient library in the Clementinum.*
*Národní Knihovna České Republiky, Prague (XVII A 6)*
*Prague only*

Tomáš of Štítné, born about 1330 into a family
of landowners in southern Bohemia, belonged
to the first generation of students at Charles
University in Prague, which was founded in
1348. Familial obligations apparently precluded
his finishing his studies at the university and
put an end to his plans to pursue a clerical
career. Consequently, he diverted his interest in
religious issues from theology to practical
questions of lay piety. In addition to reading
and translating others' texts, he wrote his own
tracts, which were meant to help his children
and, later, his friends. In 1380, as a widower,
Tomáš again moved to Prague from southern
Bohemia. He seems to have died about
1401. Tomáš's knowledge of the work of the
Prague reformers Konrad of Waldhausen and
Jan Milíč of Kroměříž is evidenced by his
critical attitude toward certain contemporary
clerical practices. His writings document the
development of lay piety in Bohemia in the
second half of the fourteenth century.[1]

Tomáš himself commissioned this particu-
lar copy of "six booklets on general questions
of Christian belief" in 1376 and dedicated it

to Vojtěch Raňkův of Ježov, a master and pro-
fessor from the University of Paris who was
the scholasticus of the Saint Vitus Chapter.[2]
Written in littera textualis formata, the text
is illustrated with twelve framed narrative
miniatures and seventeen decorated initials,
seven of them historiated. Most of the histori-
ated illuminations are simply pictorial trans-
lations of the headings of sections of the
codex (fols. 27v, 35v, 36r, 47v, 54v, 55r, 58v).
To this group also belong the scenes of
Baptism, Confession, Communion, and the
Communion of the Sick (fols. 114v, 116r, 124r,
127r, 127v), which are iconographically com-
parable to compositions in illuminated
pontificals. Nonetheless, the painter some-
times showed remarkable invention. Drawn
from his own reflections and observations,
these illustrations testify to his perfect under-
standing of Tomáš's thoughts: an apt portrayal
of a seducer and seductress (fol. 36v) docu-
ments the excesses of contemporary fashion;
the illumination of the paragraph on saintly
life (fol. 44v) shows two young women who
appear to be taking a vow, not in a nunnery
but rather in a sort of early house of Sisters of
the Common Life, a community of laypeople
who followed a certain rule of life. The last
part of the book contains Tomáš's reflections
on death. In keeping with official ecclesiasti-
cal doctrine, he wrote of death's role in
the process of human salvation and of the
difference between the deaths of pious people
and those of sinners. The first of the two illu-
minations that accompany this text shows the
personification of Death cruelly grasping a

dying young man by the throat. The second
represents, quite surprisingly, the Coronation
of the Virgin, here evidently symbolizing the
human soul.

The illuminator of the Štítné codex cer-
tainly knew some of the work of the painters
employed by Jan of Středa, bishop of Litomyšl
(1353–64) and Olomouc (1364–80). From
manuscripts like the missal made for Jan
sometime after 1364 (see fig. 3.1),[3] this painter
borrowed the soft modeling of the drapery,
the acanthus decoration of the initials, and
the motif of curtains that he then regularly
used to eliminate the deep, sophisticated pic-
torial space typical of Italian and italianate
painting of the trecento. Instead, he constructed
a sort of proscenium for staging his scenes.
This way of rendering space, as well as the
elongated figures and the new importance
of elegant drawing, reflects developments in
French painting since the beginning of the
fourteenth century.[4] The same painter may
also have illuminated the *Chronica Bohemorum*
of Přibík Pulkava in Kraków (see fig. 8.3).

KO

1. Gebauer 1923.
2. Urbánková 1957, p. 20; Krása in Cologne 1979–
    80, p. 741. On Vojtěch Raňkův, see Kadlec 1969.
3. Krása 1971, p. 110; Krása 1990, p. 125.
4. Krása 1990, p. 125.

LITERATURE: Stange 1934–61, vol. 2, p. 19;
Urbánková 1957, pp. 20, 24; Otavský 1966;
Schmidt 1969b, p. 216; Miodońska 1968; Krása
1970; Krása 1971, pp. 109, 110; Krása in Cologne
1978–79, vol. 2, p. 741; Krása 1990, p. 125.

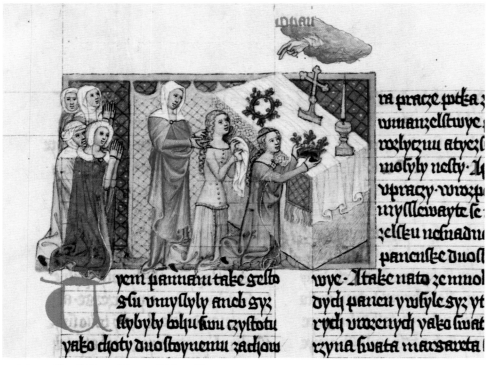

73, fol. 44v (detail), Young Women Taking a Vow

## 74. Set of Nested Beakers

*Prague, 1310–35*
*Partially gilded silver, h. 8.6–9.3 cm (3⅜–3⅝ in.),*
*diam. 6.1–8.4 cm (2⅜–3¼ in.)*
*Inscribed in Hebrew: Ze'ev (Wolfe).*
*Provenance: Gothic house in Kutná Hora, Czech*
*Republic; private collection, sold at auction, 1968.*
*Germanisches Nationalmuseum, Nuremberg, on loan*
*from the Federal Republic of Germany*
*(HG 11628a–e)*

At the bottom of each of the five cups in this
set is an enameled coat of arms. The three that
are the imperial emblems of Austria, Poland,
and Bohemia indicate that the original owner
was Elizabeth Ryksa (1288–1335), daughter
of King Přzemysl II of Poland and wife of
Wenceslas II of Bohemia and later Rudolf III
of Austria. After Ryksa's death in 1335, the set
was owned by a Jew who wrote his Hebrew
name, Ze'ev (Wolfe), in one of the cups.

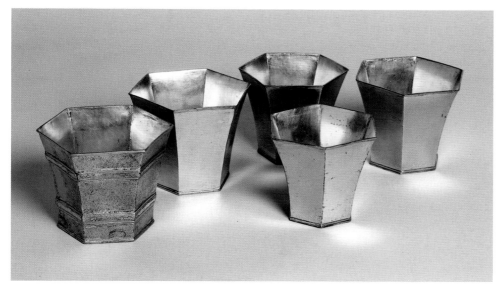

74

Its combination of Jewish and Christian symbols led Timothy Husband to propose that the double cup was commissioned by a Jew for presentation to a Christian patron.[1] Supporting this view are numerous Jewish seals bearing emblems identical to the enamel with three hats (but without the escutcheon). Such seals are affixed to documents dated 1329 and 1332—within the period proposed for the cup on stylistic grounds.[2] As Daniel Friedenberg has pointed out, however, coats of arms with *Judenhüte* were also used by gentiles and by Jewish converts to Christianity. For example, the prominent Jude family of Cologne, which had converted, still displayed these hats on its coat of arms.[3] Patronage of the double cup by such a family would account for all the decoration without necessitating Jewish participation in its making.

VBM

Subsequently, this fine set of beakers must have been used in the ceremonial blessing known as kiddush, recited on Sabbaths, on holy days, and at life-cycle events. An illumination in the early-fifteenth-century Yahuda Haggadah shows a family at the Seder, the ritual meal and service held on the first nights of Passover; on the table is a set of graduated beakers.[1]

Surviving sets of medieval nested beakers are rare. A second faceted and gold-banded set found in Lingenfeld, near Speyer, with a hoard containing coins that date before 1355 was probably hidden in 1349, when the Jews of Speyer were mercilessly attacked. Its date confirms that of the Kutná Hora nested beakers.     VBM

1. Mann 1988, fig. 15.

LITERATURE: Schiedlausky 1975, pp. 300–309; Stein 1981, p. 65; Mann 1988, pp. 17–18 (with bibl.).

wine at weddings and for home devotions such as the Passover Seder.

The Cloisters double cup is unusual in its size, material, and decoration. It is relatively small and fashioned completely of silver. A gilt inscription on the top half names the Three Kings (Caspar, Melchior, and Balthazar), while two enameled roundels show *Judenhüte* (Jewish hats), which medieval Jews were forced to wear as distinguishing signs in German-speaking lands. The roundel on the base of the top half encloses three *Judenhüte* that emerge from an escutcheon; these are centripetally arranged, and their strings touch the escutcheon below. The other roundel, centrally placed on the inside of the lower half, encloses three hats joined by a circle.

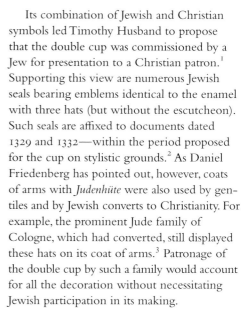

75, detail of coat of arms on top half of cup

## 75. Double Cup Inscribed with the Names of the Three Kings

*Central Europe (perhaps Bohemia), 1325–50*
*Gilded silver and applied opaque enamels; h. 7.6 cm (3 in.), w. with handle 12.5 cm (4⅞ in.)*
*Inscribed in Gothic characters: + CAPAR + MELCHIOR + WALTAZAR*
*Provenance: Sale, Sotheby's, London, March 7, 1983, lot 167.*
*The Metropolitan Museum of Art, New York, The Cloisters Collection, 1983 (1983.125 a,b)*

Widely popular among Christians by the thirteenth century, double cups were employed in Jewish practice for ritual benedictions over

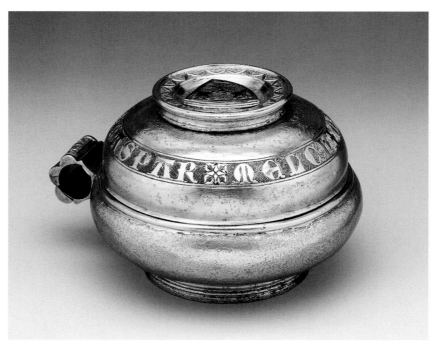

75

1. Husband 1983, pp. 19–21. In my first published discussion of the cup, I agreed with Husband (Mann 1988, p. 19). However, my subsequent study of the evidence published by Friedenberg (see note 2 below) has changed my opinion of the patronage of the Cloisters double cup.
2. Friedenberg 1987, pp. 161, 166.
3. Ibid., p. 168. For examples of such Jewish seals, see nos. 69, 70, 73 (Switzerland), 76–78 (German States).

LITERATURE: Husband 1983, pp. 19–21; Mann 1988, pp. 18–19.

## 76. *Guide for the Perplexed by Maimonides*

---

*Isaac ben Joseph of Warsaw, scribe; Prague, 1396*
*Ink on parchment, 145 fols., 24.5 x 17.5 cm (9⅝ x 6⅞ in.)*
*Provenance: H. B. Levy, late 19th century; his gift to Staats- und Universitätsbibliothek, 1906.*
*Staats- und Universitätsbibliothek Hamburg (Cod. Levy 116)*

Maimonides (1138–1204) completed his great philosophical work, the *Guide for the Perplexed* (*Moreh Nevukhim*), about 1200. Four years later, it was translated from the original Arabic into a literal Hebrew by Samuel ibn Tibbon

(ca. 1160–ca. 1230), and in a slightly later and freer version by the poet Judah al-Harizi (1170–1235). These two translations circulated throughout the medieval Jewish world (as is exemplified by the present manuscript) and influenced the works of later Jewish philosophers, all of whom cited the *Guide.*

In a letter written to Samuel ibn Tibbon, Maimonides cited his sources—mainly Aristotle and his Hellenistic commentators—as well as Islamic philosophers who elaborated on the Greek philosophical tradition. His outlook was broad, ranging far beyond the Jewish community. The *Guide for the Perplexed* was written for an intellectual elite who had studied philosophy and was troubled by its apparent divergence from the Bible, rather than for the larger community, whose faith might be shaken by exposure to philosophical questioning.

The colophon of the manuscript states that it was written for its patron, Simon, by Isaac ben Joseph in Prague in 1396. Another notation records that the book was found hidden in the wall of a house in the town of Trnava (Nagyszombat), set at the junction of roads to Hungary and Poland. At the end of the fifteenth century, the Jewish community there suffered greatly as the result of the Hussite Revolution and was eventually expelled from the town in 1539. Either of these events could

have inspired the owner to immure his copy of the *Guide,* a sign of its value and prestige.

The relatively simple enlarged-script decoration was the work of the scribe. VBM

LITERATURE: Kupfer 1973, p. 147; Róth and Striedl 1984, pp. 164–65.

## 77. Two Tombstone Fragments from the Jewish Garden

---

*Prague, 13th century–1477*
*Calcite, a: 48 x 36.5 x 15 cm (18⅞ x 14⅜ x 5⅞ in.), b: 30 x 54 x 15 cm (11⅞ x 21¼ x 5⅞ in.)*
*Inscribed in Hebrew: a:* . . . וילדה/ פן רשׁה/ לעני . . ./ ואבן ון/ ולאלמנה/ תרדנה צין ון [ . . .] *( . . . and she gave birth . . . / Her hands were o[pen] / to the poor and destitute[1] / and the widowed . . . / May you descend to Zion . . . ); b:* . . . ניסן . . . הלז הול . . ./ ראשׁ ח . . . ניסן *( . . . that one . . . / the New Moon, Nissan).[2]*
*Provenance: Found in cellar of the Gothic house U Řečických, 10 Vodičkova Street, Prague.*
*Židovské Muzeum, Prague (ŽMP 177.710, ŽMP 177.713)*

The first Jewish cemetery in Prague was established in the eleventh century in the vicinity of the castle, as was often the case in cities where Jews were considered *servi camerae* (servants of the royal chamber), whose ruler guaranteed their protection. These fragments come from the second Jewish cemetery, called the Jewish Garden (Židovská Zahrada, or Hortus Judaeorum), which was established at the beginning of the thirteenth century in the area that would become the New Town (Nové Město) and was used until 1477 by the Jews of the city as well as by their coreligionists who lived in the countryside and lacked their own burial grounds. These cemeteries preceded the picturesque Old Jewish Cemetery near the Altneuschul (fig. 77.1), the earliest tombstone of which is that of Avigdor Kara from 1439.

One of the privileges Přemysl Otakar II granted to the Jews of Bohemia in 1254 concerned a Jewish cemetery: "If a Christian by any malicious act devastates or breaks into their cemetery, he shall be condemned to death and all his property shall revert to the royal chamber."[3] This right was confirmed by Wenceslas IV in 1410, but in 1478 Vladislav II Jagiello demanded the cemetery's closure because of the need for more residential space in Prague.

The fragmentary condition of the tombstones allows only a glimpse of their inscriptions, which would have consisted at the least of the deceased's name in patronymic form and the date of his or her death. The Hebrew phrase "May you descend," which appears on

76, fol. 145v

77a

77b

the first stone, is found in only two biblical verses, both associated with death (Jer. 14:17, Job 17:16). 

VBM

1. The second and third lines of the inscription on cat. 77a are based on Proverbs 31:15, which is part of a composition extolling women of valor

that is recited on Friday evenings prior to the Sabbath meal.

2. Another reference to Zion appears on a 1551 Prague tombstone in a later cemetery in the Jewish Quarter. There it specifies that the deceased, Yocheved, the daughter of Akiva, of the priestly class, and leader in Oben (old Buda), would [rest] beneath Zion (Muneles

and Vilímková 1955, no. 65). The allusions to Zion reflect the Jewish belief that all the deceased will be gathered in Jerusalem at the coming of the Messiah.

3. Quoted in Pařík and Hamáčková 2003, p. 17.

LITERATURE: Prague 2001, p. 73, fig. 84(a).

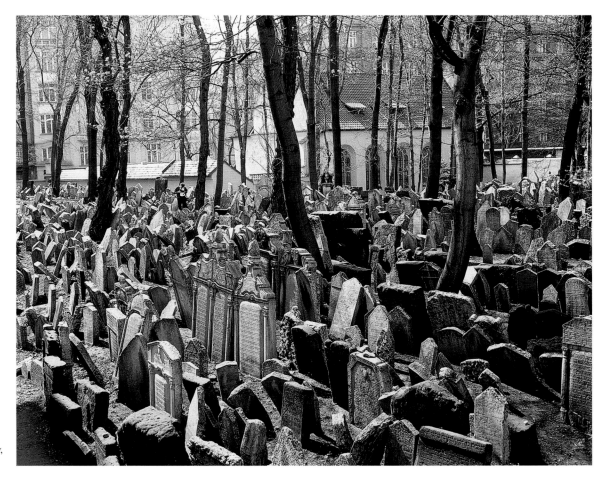

Fig. 77.1  Old Jewish Cemetery, Prague

## 78. *The Row, The Path of Life* by Jacob ben Asher

*Barukh(?), scribe*

*Prague, ca. 1350; later additions, ca. 1390–1410*

*Ink on parchment, 335 fols., 27.5 x 19 cm (10⅞ x 7⅝ in.)*

*Provenance: Cardinal de Richelieu, 1633; Université de Paris Sorbonne, 1660; Bibliothèque Nationale, Paris, 1796.*

*Bibliothèque Nationale de France, Paris, Département des Manuscrits Orientaux (Hébreu 423)*

Jacob ben Asher (1270?–1340) was the son of the German-born rabbi Asher ben Yeḥiel (ca. 1250–1327), whose early career was in Ashkenaz and who later served as head of the rabbinical court in Toledo. As a result, his son's law code, *The Row* (*Tur*), contains numerous comparisons between Ashkenazi and Sephardi customs. The code is divided into four sections or rows; that known as the *Oraḥ Ḥayyim* includes laws concerning blessings and prayers, the Sabbath, festivals, and fasts. The excellence of Jacob ben Asher's code led to its rapid dissemination among Jewish communities.

Sections are introduced by words composed of large letters decorated with floral and geometric motifs—a type of decoration found in Hebrew manuscripts from Germany—and by birds and animals. Drawn in ink, these decorations were presumably the work of the scribe. Later, professional artists seem to have created two, more sophisticated compositions: a depiction of a hunt added at the end of the table of contents and an elaborate treatment of the name Judah. Both decorations resemble illuminations in the Wenceslas Bible.   VBM

LITERATURE: Garel in Paris 1991–92a, no. 107 (with bibl.); Sed-Rajna 1994, no. 90.

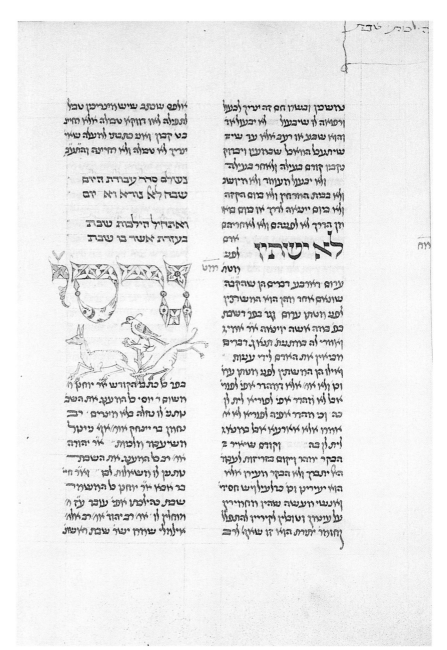

78, fol. 111v

## 79. Hebrew Bible

*Mattathias ben Jonah of Laun (active ca. 1480s), scribe (and illuminator?); Prague, 1489*

*Ink, tempera, and gold on parchment; 3 vols., 922 fols.; 25 x 20.5 cm (9⅞ x 8⅛ in.)*

*Provenance: Israel ben Pinḥas, Prague, from 1489; Zeligman, Kutná Hora; Moses Mendelssohn, Kutná Hora, before 1783; Daniel Itzig, Berlin, by 1785; Mr. Fraenkel, by 1847; Abraham Geiger, by 1855; Hochschule für die Wissenschaft des Judentums, Berlin; sold, after a judicial settlement, to Ludwig and Erica Jesselson, 1984.*

*Mendel Gottesman Library, Yeshiva University, New York, Gift of Ludwig and Erica Jesselson (Ms. 1247)*

78, fol. 11v (detail)

79, vol. 3, opening of the book of Lamentations

In 1489 Mattathias ben Jonah of Laun, Bohemia, copied this three-volume Bible in the home of his patron, Israel ben Pinḥas of Prague. The main text of the Bible is in square (*ashuri*) script, while the commentary of Rashi (Solomon ben Isaac, 1040–1105) is in Ashkenazi cursive. The commentary is unusual in containing variant readings not found in other texts, as well as the names of rabbis unknown from other sources. The vocalization, accentuation, and *masorah* (notes) of this biblical text were cited by later scholars in works written through the twentieth century.[1] At the end of the last volume, the scribe wrote a fourteen-line poem praising

his patron that includes a double acrostic, one spelling the scribe's name and the other, the patron's.

The illumination of the Bible follows a decorative scheme used in Prague manuscripts since the late fourteenth century, in which texts are surrounded and bisected by gold or colored bars bearing balls or leaves.[2] Since Hebrew is a language without capital letters, the incipit of each book and of some pericopes is marked by a panel with a word written in gold that replaces the illuminated letters of similarly decorated Latin manuscripts. The word panels are decorated with foliate motifs on which the letters appear to

float, as on the page with the incipit of Lamentations. Only four pages of the Bible are completely decorated (the openings of Genesis, Joshua, Judges, and Samuel 1): foliate decoration fills the three outer borders of the page and frames the word panel. The closest stylistic parallel to this type of illumination is found in the early-fifteenth-century Breviary of Beneš of Waldstein, but Mattathias may also have worked from a Hebrew manuscript dated to the same period.[3]

Among the distinguished owners of this Bible are the philosopher Moses Mendelssohn; Daniel Itzig, one of Berlin's leading Court Jews, financiers and purveyors who served the

79, vol. 2, opening of the first book of Samuel

rulers of the many German-speaking states of the period; and Rabbi Abraham Geiger, an early leader of Reformed Jewry.　　　VBM

1. Avivi 1998, no. 3.
2. Since an illuminator is not mentioned in the lengthy colophon or elsewhere in the Bible, the scribe most likely was also responsible for the decoration.
3. Another stylistic parallel to the Bible is the Matutinal and Vespers, made in Bohemia in 1411–20, which has ribbed leaves similarly employed. For this and related manuscripts of the second decade of the fifteenth century, see Cologne 1978–79, pp. 756–57.

LITERATURE: Sotheby's (New York) 1984, lot 39 (sale canceled); Fishof 1986–87, p. 76, fig. 7; New York 1996–97, no. 77; Avivi 1998, no. 3.

## 80. Bohemian Bible of Andreas of Austria

*Monastery of Saint Mary, Roudnice nad Labem, or Prague; text completed October 7, 1391; paintings, ca. 1391*
*Tempera and gold on parchment, 424 fols., 48.3 x 35.6 cm (19 x 14 in.)*
*Inscribed in colophon on fol. 418r: Anno domini MCCCXCI finitus est presens liber feria II infra octavam S. Wenceslai martyris gloriosi per manum Andree de australi plaga sive de austria. tunc temporis plebani ecclesiae in Libochauicz Regnante Wenceslao rege Romanorum et Boemie (In the year of the Lord 1391 the book at hand was completed the second day after the octave of Saint Wenceslas, the glorious martyr, by the hand of Andreas from the southern region, or Austria. At that moment in time he was priest of the church in Libochauicz, ruled by Wenceslas, king of the Romans and Bohemia).*
*Provenance: Dukes of Coburg and Gotha (in 1714 catalogue); purchased from the Grand Ducal Library, Gotha, through M. Sinelnikoff by the Pierpont Morgan Library, 1950.*
*Pierpont Morgan Library, New York, Purchased on the Belle da Costa Greene Fund, 1950 (MS. 833)*

Andreas, the scribe of this Bible, ministered in Libochovice, near Roudnice nad Labem, which was a country residence of the Prague episcopate and the site of the Augustinian Monastery of Saint Mary, where the Bible might have been created.[1] The itinerant bishops and archbishops of Prague exerted cultural influence over the regional scriptoria. As a result, even the paintings in manuscripts like the Morgan Bible that were not court commissions display a high level of sophistication.

80, fol. 5r, opening of the book of Genesis

Further evidence of the Bohemian origin of the manuscript is the appearance of *presith* or *bresith,* the Hebrew word for "beginning," on folios 1r and 4v. This term is found in Bohemian Bibles and attests to the Bohemian Christian practice of consulting Jewish texts and scholars.[2] The fact that Saint Mary's was an Augustinian monastery may elucidate the conflated representation of the first and fourth days of creation in the top roundel on folio 5r of the Bible. In the *City of God,* Augustine posited how light could have been created on day one when the sun supposedly came into existence only on day four: "For either there

was some material light, whether in the upper regions of the universe, far removed from our sight, or in the regions from which the sun later derived its light; or else the word 'light' here means the Holy City."[3]

Meta Harrsen first identified the illuminator of the Genesis I initial and creation cycle on folio 5r as the Samson Master, who also worked on the Wenceslas Bible (see fig. 84.4), and William Voelkle attributed twenty-two other initials in the Morgan Bible to that same hand.[4] Harrsen proposed that three other artists also worked on the manuscript: the Wenceslas Bible Balaam Master, the painter of

*David* in the Roudnice Psalter (Saint Vitus's Cathedral, Prague, Cim. 7), and the Master of the Morgan Bible.[5] Voelkle upheld Harrsen's attribution of fifty-three initials to the Morgan Master.[6] Josef Krása argued that the twelve initials attributed to the Balaam Master and the Roudnice Psalter artist were instead early work of the first Master of the Codex of Prague Archbishop Jan of Jenštejn (cat. 96).[7] It is nevertheless reasonable to accept Harrsen's identification of the Samson Master and Voelkle's endorsement of the attributions to the Master of the Morgan Bible, while preferring Krása's assignment of the twelve initials to the painter of the Jenštejn Codex.[8]

ERW

1. Harrsen 1958, p. 54.
2. Ibid.
3. Augustine 1984, p. 436. See also Zahlten 1979, p. 114.
4. Harrsen 1958, p. 53; Voelke in Cologne 1978–79, vol. 2, p. 744. On the I-initial type of creation cycle and its iconographic relationship to the Morgan Bible, see Zahlten 1979, pp. 57, 262.
5. Harrsen 1958, pp. 53–54.
6. Voelkle in Cologne 1978–79, vol. 2, pp. 743–44.
7. Krása 1971, pp. 172, 274.
8. Schmidt (in Swoboda 1969, pp. 236–37) claimed that the Morgan Master worked on the Codex of Jan of Jenštejn himself after assisting the Samson and Exodus Masters on the Wenceslas Bible. That is open to debate, but Schmidt was right to note that the second volume of the *Moralia in Job* in Herzogenburg (Stiftsbibliothek, cod. 94/I, II) was the Morgan Master's most significant accomplishment.

LITERATURE: Adams 1951, pp. 13–17; Harrsen 1958, pp. 53–54; Bond and Faye 1962, pp. 362–63; Swoboda 1969, pp. 236–37; Krása 1971, pp. 172, 274; Cologne 1978–79, vol. 2, pp. 743–44; Zahlten 1979, pp. 57, 262.

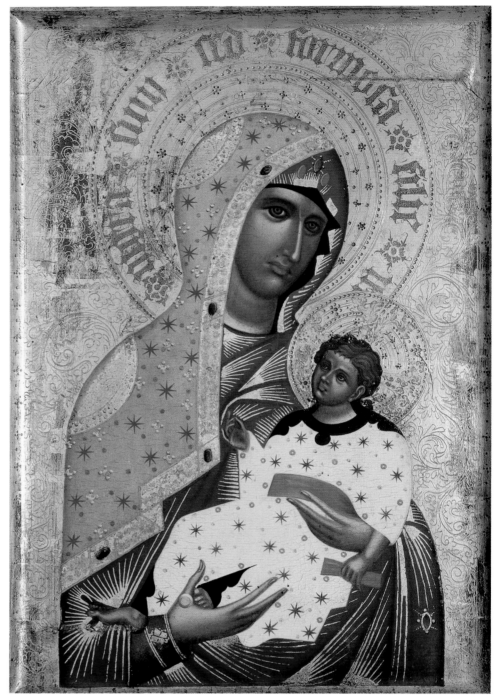

81

## 81. The Madonna of Březnice

*Bohemia, 1396*

*Tempera and gold on parchment and linen over panel, green on reverse; 41.5 x 29.5 cm (16⅜ x 11⅝ in.)*
*Condition: Restored in 1948.*
*Inscribed on halo of Virgin: nigra sum, sed Formosa fili[a] ier[usalem] (I am black, but beautiful, O ye daughters of Jerusalem [Canticles 1:4]); On reverse, [Haec] ymago gloriose virginis marie depicta est procu[rante] Serenissimo principe et domino wencesslao Ro[mano]rum et Boemie illustrissimo Rege ad simili-tudinem [y]maginis que habetur in Rudnycz, quam sanctus lucas propria manu depinxit. Anno dominii m ccc lxxxx sexto (This glorious image of the Virgin Mary, procured by the most serene prince, lord of the Romans, Wenceslas, most illustrious king of Bohemia,*

*was painted to resemble the image that is kept in Roudnice, which Saint Luke with his own hand painted. The year of the Lord 1396).[1]*
*Provenance: By inscription, painted for Wenceslas IV (original provenance unknown); Castle Chapel, Březnice, before 1940; Národní Galerie, Prague, 1945; restituted to Parish Church of Saint Ignatius, Březnice, 1990s; on loan to Národní Galerie, Prague (VO 8647).*
*Biskupství Českobudějovické, České Budějovice, Czech Republic (VO 8.647)*

More closely than any other surviving work, this austere portrait of the Virgin and Child

reflects the presence of Byzantine images in fourteenth-century Bohemia. Its inscription relates it to a now lost work from Roudnice, which most probably belonged to the Augustinian canons or the archbishop of Prague. In the pose of the Infant Jesus, the gold striations on the Virgin's mantle, the skin tones, and most especially the starred veil draped over the Virgin's head, this painting resembles a late-thirteenth-century Byzantine icon of the Virgin Kykkotissa (Gr., Compassionate) preserved at the Monastery of Saint Catherine at Sinai.[2] Both present the Infant reclining, an image suggestive of his future as

82, fol. 39r (detail), Saint Wenceslas in an Initial P

82, fol. 46r (detail), Wenceslas IV and Sophia of Bavaria in an Initial U

*anapesōn,* asleep in death awaiting resurrection.[3] The formal arc of the Virgin's veil, found on the Sinai icon and the original Kykkotissa icon, does not appear on other variants of the theme in Bohemia (see cat. 27).

It has been suggested that the original of this image arrived in Bohemia as a gift to the court from a member of the French Lusignan dynasty, which ruled Cyprus, where the original miracle-working Kykkotissa icon drew multitudes of pilgrims.[4] As the Cypriot icon is one of the three types argued to have been painted from life by Saint Luke the Evangelist, a copy of it would have been a most appropriate gift at a time when the exchange of devotional images and relics was important for consolidating dynastic relations.[5]

As in the other variants on the theme in Bohemia, details of the icon relate to Western traditions. The rinceaux decoration of the ground is typical of Bohemian work.[6] To explain the Virgin's dark complexion—a result of the Byzantine tradition of painting face tones onto a dark green ground—the inscription from the Song of Songs was placed on her halo; the ring on her hand, symbolizing the mystical union described in the same text, is also a Western addition.[7]

<div align="center">HCE</div>

1. Boehm in New York 2004, p. 499, no. 302.
2. Ibid.; Myslivec 1970; Folda in New York 2004, pp. 355–56, no. 214, for the Sinai icon.
3. Belting 1994, p. 336; Ševčenko 1991, p. 439.

4. Boehm in New York 2004, p. 499, no. 302; Myslivec 1970, pp. 343–45; Frinta 1995, p. 108n17.
5. Belting 1994, pp. 333–36; Ainsworth in New York 2004, pp. 581–82, no. 348.
6. For a similar rinceau pattern, see the Madonna of Veveří (ca. 1350; Matějček and Pešina 1950, pl. 26).
7. Prague 1995a, pp. 64, 96.

LITERATURE: Matějček and Pešina 1950, p. 86, no. 283, pl. 278; Myslivec 1970, pp. 337–38, fig. 1; Prague 1970, p. 233, no. 320; Kořán and Jakubowski 1976, pp. 225–27, fig. 6; Cologne 1978–79, vol. 2, p. 770; Stejskal 1988, pp. 159–61, fig. 2; Prague 1988, p. 69, no. 37; Schwarz 1993–94, p. 688, fig. 3; Belting 1994, pp. 335–37, 436; Frinta 1995, pp. 104–13, pls. 39–43; Prague 1995a, p. 96, no. 11; Bartlová 2001, pp. 118–20, fig. 4; Boehm in New York 2004, p. 499, no. 302.

## 82. Hours of Wenceslas IV

*Prague, ca. 1410–19*
*Tempera and gold on parchment, 93 fols., 16.3 x 12 cm (6⅜ x 4¾ in.)*
*Provenance: Franciscus Muijlwijch, 16th century;[1] Pembroke College, Oxford, since the 19th century.[2] By kind permission of the Master and Fellows of Pembroke College, Oxford (MS 20)*

The prayer on folio 16v of this book of hours declares: "I, Wenceslas, your servant, zealously commended by the Lord, with the result that he who established me on the throne of royal honor graces me by the honor of the customs, amen."[3] Moreover, the manuscript is replete with historiated initials of special significance to Wenceslas IV. The saints depicted in the initials include Wenceslas (fol. 39r); Ludmila of Bohemia, the grandmother of Saint Wenceslas (fol. 44r); and Adalbert, the first Bohemian bishop of Prague (fol. 40v). The figure of Saint Wenceslas in the letter P on folio 39r is arguably a representation of Wenceslas IV; the one-headed eagle, his heraldic emblem as King of the Romans, appears in the escutcheon in the lower right portion of the letter. In addition, the couple depicted on folio 46r in a section of prayers devoted to holy matrimony are likely Wenceslas IV and his second wife, Euphemia-Sophie of Bavaria, whom he wed in 1389.[4]

Jonathan J. G. Alexander noted that the manuscript facilitated either extended or

abridged recitations of the prayers. Key words written in blue within the text for the prayers on folios 49r–54v provide coherent devotional thoughts, permitting the reader to elide the remainder of the text.[5]

Milada Studničková upheld Alexander's attribution of the Hours of Wenceslas IV to the workshop of the Gerona Martyrology (cat. 86). She argued further that the same hand from the atelier painted the *Solomon at Prayer* in the Olomouc Bible (University Library, Olomouc, M III-I/I, fol. 194v).[6]

ERW

1. Alexander noted in 1977 that the binding appeared to be of fifteenth- or sixteenth-century Netherlandish origin and therefore proposed that the manuscript was in the Netherlands at that time.
2. A nineteenth-century annotation in pencil on the first supply leaf added to the front of the book says that the manuscript belonged to the Pembroke College library.
3. "Me W. servum tuum domino studiose commenda ut qui me in solio regii honoris constituit morum honestate decoret, amen."
4. Alexander 1977, pp. 28–30.
5. Ibid., p. 29.
6. Studničková 1998a, p. 133. Alexander argued that the initials on folios 33v and 47v of the Hours of Wenceslas IV resemble the work of the Master

of the Gerona Martyrology (cat. 86) but that the preponderance of the initials are stylistically similar to the work of the so-called Joshua Master, the third hand in the Bible of Konrad of Vechta of 1401–3 (cat. 85). Schmidt (in Swoboda 1969, p. 247) identified the Joshua Master. On the *Solomon at Prayer* in the Olomouc Bible, see Pešina in Prague 1970, p. 297.

LITERATURE: Alexander 1977; Studničková 1998a, p. 133.

## 83. Czech Hours of the Virgin

*Prague, 1390–95; binding, late 19th or early 20th century, modern pagination*
*Tempera and gold on parchment, brown leather binding with blind block printing and gilding; 84 folios; 10 x 8 cm (4 x 3⅛ in.)*
*Provenance: Augustinian Monastery of Sadská (destroyed by Hussites, 1421); V. Kasík; his gift to Národní Muzeum, 1872.*
*Národní Muzeum, Prague (KNM V H 36)*

This diminutive codex containing the Hours of the Virgin, or Little Office of the Blessed Virgin (*cursus horae sanctae Mariae*), is one of two surviving manuscripts of the hours written in the Czech language before the end of the fourteenth century.[1] The queen depicted on folio 77r, by inference the recipient of the manuscript or its patron, has not been identified. She could be either Sophia of Bavaria (d. 1425), second wife of Wenceslas IV, or the dowager queen Elizabeth of Pomerania (d. 1393), Charles IV's fourth wife.[2] Or she might be Charles IV's daughter Anne of Bohemia (1366–1394), who married Richard II of England in 1382. The monogram *AB* appears next to the figure of the saint, either Anne or Elizabeth, perhaps the patron saint of the donor, who is pictured on folio 61v.[3]

The manuscript contains a cycle of prayers to be intoned throughout the twenty-four hours of the day, in imitation of monastic prayer. Each hour except lauds[4] opens with a full-page miniature from the Marian cycle and an almost full-page historiated initial H (for *hospodyne,* or Our Lord): matins begins with the Annunciation and the Virgin at Prayer (fols. 1v–2r); prime, the Adoration of the Christ Child and the Annunciation to the Shepherds (fols. 41v–42r); terce, the Adoration of the Magi and the Dream of the Three Magi (fols. 49r–49v); sext, the Resurrection and the Holy Women at

83, fol. 1v (detail), The Annunciation

83, fol. 2r (detail), The Virgin at Prayer

83, fol. 41v, The Adoration of the Christ Child

the Tomb (fols. 55v–56r); none, the Ascension of Christ and the Saint before the Church Portal (fols. 61r–61v); vespers, Pentecost and Saint Peter Preaching (fols. 66v–67r); and compline, the Dormition of the Virgin and a kneeling queen holding an open codex (fols. 76v–77r).

The initials are of high if somewhat uneven artistic quality, with subtly nuanced radiant colors. They were not created in the court workshop of Wenceslas IV, but rather display clear similarities to contemporary manuscripts made for ecclesiastical institutions. The principal artist is beyond doubt identical to the first illuminator of the Missal of Václav of Radeč (Metropolitan Chapter of Saint Vitus's Cathedral, Prague, Library, P 5), who later also collaborated on the Gradual of Václav Sech (Charles University, Prague, Archives b.s.) and

the Vatican Bible (Vatican Library, Pal. lat. 1). I agree with Josef Krása that the artist is not far removed in sensibility from the Samson Master of the Wenceslas Bible,[5] but neither is he identical to him, or to any of the other artists who illuminated that Bible (see figs. 84.2–84.7).

HH

1. The other is in the Národní Knihovna, Prague (XVII H 30, po1390; see Stejskal and Voit 1991, no. 8).
2. Both possibilities are cited in Krása 1971, p. 244n134. See also Hlaváčková in Vienna 1990, pp. 119–20, no. 51.
3. Brauer 1989, pp. 499–521.
4. Lauds has merely an initial *fleuronnée* at the beginning of the text, "Boze na pomocz mnye wezrzy . . ." (Lord, help me . . .).
5. Stejskal (1995, p. 420) also identified the artist with the Samson Master.

LITERATURE: Patera 1901, pp. 86–103, 351–63; Bartoš 1926-27, vol. 1, p. 323, no. 1770; Matějček 1931, p. 338; Stange 1934–61, vol. 2, p. 53; Drobná 1966, p. 234; Krása 1966a, pp. 603–7; Krása 1971, p. 244n134; Pujmanová 1983, pp. 132, 142; Brauer 1989; Hlaváčková in Vienna 1990, pp. 119–20, no. 51; Stejskal and Voit 1991, p. 40; Stejskal 1995; Brodský 2000, p. 69, no. 58.

# WENCESLAS IV'S BOOKS AND THEIR ILLUMINATORS

A small group of opulently ornamented codices identifiable from coats of arms and emblematic figures as Wenceslas's personal possessions can be distinguished as the "Wenceslas manuscripts." Some of them even contain a dedication to the king. Seven such manuscripts have been preserved: in addition to the great Bible, the *Willehalm* romance, and the astrological anthology discussed below, these include the Golden Bull, the display copy of a decree regarding the election of the German ruler of the Holy Roman Empire issued by Charles IV in 1356, and two other astrological manuscripts, all in the Österreichische Nationalbibliothek, Vienna (Cod. 338, 2271, 2352), as well as Nicholas of Lyra's commentary on the Psalms in Salzburg's Universitätsbibliothek (cat. 84). A fourth manuscript (cat. 87) is closely linked to this ensemble. The earliest of these manuscripts is the *Willehalm*, which bears a scribe's date of 1387; the latest is the Golden Bull, from 1400.

The *Willehalm* romance by Wolfram von Eschenbach, the author of *Parzival,* was composed in the early thirteenth century. The manuscript (Österreichische Nationalbibliothek, Cod. Ser. n. 2643) also contains two later supplements to that work: the preceding story, *Arabel* by Ulrich von dem Türlin (fols. 1–66), and the sequel, *Rennewart* by Ulrich von Türheim (fols. 161–421). The colophon relates that the scribe completed his work in 1387 and dedicates the manuscript to King Wenceslas IV.

The three parts of the romance are set in ninth-century France as it is being threatened by the Saracens, who are resisted with varying degrees of success (some even being converted to Christianity). The story line, almost a medieval prototype for *Romeo and Juliet,* centers on the conflict between two princely houses, those of the Christian Henry of Narbonne and the heathen Terramer. Although the two dynasties engage in battle, they are drawn together by romantic relationships, including the love of Henry's son Willehalm for Terramer's daughter Arabel, who becomes a Christian. The most prominent figures are Arabel and Willehalm, later followed by Rennewart, a son of Terramer's who has converted to Christianity, and finally by Rennewart's son Malifer. The illustrations present both battle scenes and scenes at court (fig. 84.1), with only slight variations on generally quite simple compositional patterns.

The text of the Wenceslas Bible (Österreichische Nationalbibliothek, Cod. 2759–64), one of the earliest German translations of the scriptures, was commissioned about 1375–80 by the wealthy Prague burgher Martin Rotlev. Since the medieval Church strictly forbade translation of the Bible into the vernacular, that undertaking itself is a sign of the spirit of reformation then developing in Prague. Wenceslas IV appears to have fostered that spirit; otherwise he would hardly have commissioned such a sumptuous edition of the Rotlev translation.[1]

The king's copy nevertheless remains only a fragment in several respects. The book of Daniel, the Minor Prophets, and the two books of the Maccabees are lacking from the Hebrew scriptures, and the New Testament was not even begun. The unusually rich decoration was also left unfinished: 654 miniatures and historiated initials were completed, but the scribe left spaces for more than 900 additional illustrations, accompanied by detailed instructions in Latin for the illuminators.[2] Assuming an additional 450 pictures for the balance, the completed Wenceslas Bible would have comprised roughly 1,800 leaves with some 2,000 miniatures and would accordingly have surpassed all other medieval manuscript Bibles in length, dimensions, and wealth of artistic ornament.[3]

The Wenceslas emblems common to the royal codices are female bath attendants, kingfishers, love knots, banners with the puzzling Czech inscription "toho bzde toho," and the Gothic

Fig. 84.1 Master of the *Willehalm* Romance (Genesis Master). Frontispiece. The *Willehalm* Romance by Wolfram von Eschenbach. Tempera and gold on parchment; Prague, ca. 1385–95. Österreichische Nationalbibliothek, Vienna (Cod. Ser. n. 2643)

letters E and W. All these motifs appear in the early *Willehalm,* but they are found even more frequently in the great Bible, where some of them are occasionally combined to form small scenes. The king himself is often depicted among these allegorical figures; he may be trapped inside the letter E or W as though in stocks, while waving the banner with the Czech inscription, or be coddled by female bath attendants (see fig. 84.7). Certainly more than simple drolleries, these charming anecdotal emblems must have had some spiritual significance, but a convincing interpretation of them has not yet been offered.[4]

Art historical literature frequently refers to a "Wenceslas workshop" in which these codices were allegedly created. That term is misleading, however, for it suggests that the king of Bohemia maintained a major illuminators' workshop at his court, one that worked exclusively for the monarch and his attendants. In truth, the decoration of these manuscripts was more likely a collaborative effort on the part of several smaller independent ateliers in Prague.[5] The ornament of the seven Wenceslas manuscripts reflects the individual styles of more than a dozen leading masters, working by turns and often with help

from their assistants.[6] The names of two are known—N. Kuthner and Frána (František), who signed some of the quires (nested gatherings of pages) they decorated in the Wenceslas Bible. In the older literature the latter is referred to as the Exodus Master, since he was largely involved in the decoration of the Exodus book of the great Bible. Most of the other painters have come to be identified with their most important contributions to that manuscript. The Genesis Master is named after his large initial for that book (fig. 84.2),[7] the Balaam, Ruth, Ezra, Samson, and Solomon Masters after their illustrations for those stories.

The present-day volumes 1 and 2 of the Wenceslas Bible were fully decorated, as were all but the last three quires of volume 3; the only other planned decorations to be executed appear in two quires of volume 5. The nine illuminators sometimes collaborated and sometimes worked with assistants. At first, packets of quires were apparently presented to their workshops as soon as the scribe had completed them.[8] Volume 1, decorated mainly by the Balaam Master (see fig. 84.3) and the illuminator known as Frána, was produced in this way. The work of the Genesis Master, also called the Master of the *Willehalm* Romance, appears only on the first quire, in the form of the large initial after which he is named. With volume 2, it seems that time was pressing, for other painters—Kuthner and the Ruth, Samson, and Ezra Masters (figs. 84.4–84.6)— were enlisted and were later joined for volume 3 by the Solomon Master. The ninth illuminator, the Morgan Master, named after his work on the Bible in the Pierpont Morgan Library (cat. 80), always worked in collaboration with Frána (see fig. 84.7) or the Samson Master.[9] The two illuminated quires of volume 5 were likely decorated only in the late 1390s, after an extended interruption.[10]

The nine painters of the Wenceslas Bible differ markedly in style and technique.[11] The art of the Balaam Master still reflects the style prevalent in Prague during the 1350s and 1360s, especially in his openness to Italian influences. That of the Genesis Master adheres much more closely to Bohemian wall and panel painting of the 1360s and 1370s, as can be seen in his squat figures and in the loosely applied pigments mixed with opaque white. The slender, flexible figures of the Samson Master and Frána, already betraying the influence of the Master of the Třeboň Altar, are frequently combined in strikingly dramatic compositions. The Ezra Master is the only painter who comes close to the fully developed Beautiful Style of the period about 1400. His charming figures, clothed in copious fabrics with rich folds, their colors aglow against dark backgrounds (see

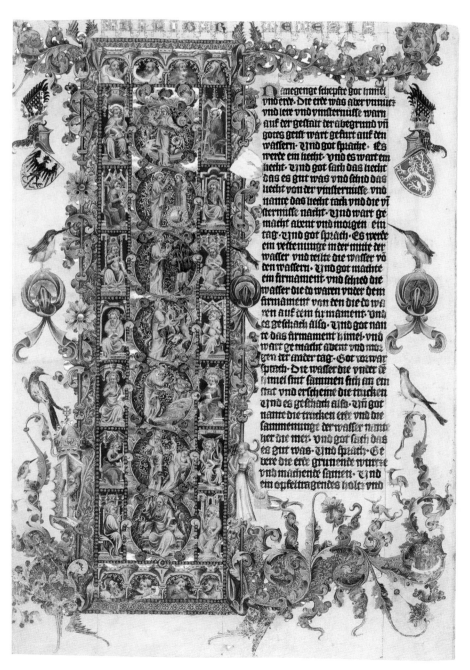

Fig. 84.2 Master of the *Willehalm* Romance (Genesis Master). Seven Days of Creation. The Wenceslas Bible, vol. 1, fol. 2v. Tempera and gold on parchment; Prague, ca. 1390–95, late 1390s. Österreichische Nationalbibliothek, Vienna (Cod. 2759–64)

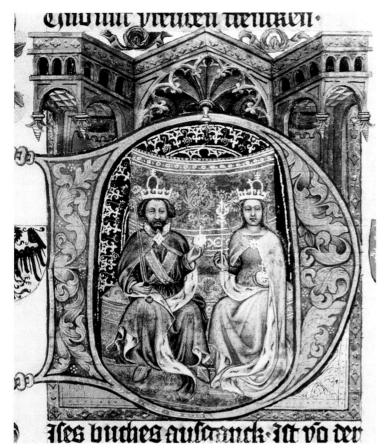

Fig. 84.3 Balaam Master. Wenceslas IV and Queen Sophia of Bavaria. The Wenceslas Bible, vol. 1, fol. 2r (detail). Tempera and gold on parchment; Prague, ca. 1390–95, late 1390s. Österreichische Nationalbibliothek, Vienna (Cod. 2759–64)

Fig. 84.4 Samson Master. Delilah Cuts Samson's Hair; The Blinding of Samson. The Wenceslas Bible, vol. 2, fol. 21r (detail). Tempera and gold on parchment; Prague, ca. 1390–95, late 1390s. Österreichische Nationalbibliothek, Vienna (Cod. 2759–64)

Fig. 84.5 Ezra Master. Joachim. The Wenceslas Bible, vol. 3, fol. 113v (detail). Tempera and gold on parchment; Prague, ca. 1390–95, late 1390s. Österreichische National-bibliothek, Vienna (Cod. 2759–64)

Fig. 84.6 N. Kuthner. The Death of Jezebel. The Wenceslas Bible, vol. 2, fol. 162v (detail). Tempera and gold on parchment; Prague, ca. 1390–95, late 1390s. Österreichische National-bibliothek, Vienna (Cod. 2759–64)

Fig. 84.7 Frána. The Tower of Babel. The Wenceslas Bible, vol. 1, fol. 10v. Tempera and gold on parchment; Prague, ca. 1390–95, late 1390s. Österreichische Nationalbibliothek, Vienna (Cod. 2759–64)

also cat. 80), recall those in the Třeboň Altarpiece and the epitaph to the Prague canon Jan of Jeřeň.[12] The Ruth, Solomon, and Morgan Masters were so strongly influenced by their fellow illuminators that they present no new voices in this concert of stylistic variations. Kuthner stands out from the rest for his especially graphic narrative style. A possible familiarity with Parisian book illumination of the 1380s, borne out by the types of his figures, clearly sets his work apart from the local idioms of his colleagues.

Since most of these painters worked for other patrons as well, some of their careers can be tracked over extended periods. Kuthner, for instance, who was apparently from Silesia, is responsible for one surviving manuscript dated 1387 (before his collaboration on the Wenceslas Bible) and for another of 1407 (after that project).[13] From his example, it is apparent that some book illuminators active in Prague were not native Bohemians. Several of them may have come from Moravia, others from southern Germany, and some were also surprisingly well acquainted with new developments in Italian and French painting. While working on these books for King Wenceslas, however, they adapted to the characteristically Bohemian style of decoration developed in Prague beginning in the 1350s, which found its fullest expression in the exuberant ornament of the Wenceslas manuscripts.

An astronomer and astrologer in Prague known only by his moniker, Terzysko, most likely compiled the incomplete astronomical anthology preserved in the Bayerisches Staatsbibliothek in Munich (Clm. 826).[14] The astronomer is depicted on folio 8r (fig. 87.1), where his nickname is inscribed on a wax tablet for recording his observations of the heavens with a quadrant. Terzysko clearly worked for the king of the Romans in Prague. In 1407 Wenceslas IV took from his residence at Karlštejn to his castle at Točník a completed astronomical atlas (not to be confused with this anthology) that was compiled for him by Teříšek (presumably Terzysko) and another court astronomer, Bušek.[15] Terzysko must have worked alongside the artists responsible for the lavish decoration of the Munich anthology.

This illuminated text represents a remarkable evolution of medieval astronomical science. Avenarius (1093–1169) prepared a revised edition of the seminal medieval Arabic work on astrology, the *Introductorium maius* of the ninth-century Muslim astrologer Abū Ma'shar. This text was subsequently translated into Hebrew, and from the Hebrew version a French edition was prepared in the second half of the thirteenth century. In 1293 Pietro d'Abano availed himself of the French version to prepare the Latin redaction found in the Munich anthology. The illustrations accompanying this text (on fols. 11v–28r of the anthology) include an original cycle that depicts the constellations, or *paranatellonta,* found within the ten-degree partitions of the zodiac, known as *dekanats* (see fig. 84.8). Unlike any other similar series representing the constellations of the zodiac, the Munich anthology includes, in a small, rectangular format, sixty-three combinations of the star formations from diverse traditions—Greek, Persian-Arabic-Egyptian, and Indian.[16] The integrated representations of the *dekanats* evince a tolerance for foreign scientific ideas at the court of Prague.

The Munich anthology includes an incomplete star atlas (fols. 35r–42v), representing eighteen of forty-six constellations found in the northern sky, that was based on Arab scholar 'Abd al-Rahman al-Sufi's tenth-century version of the star catalogue Ptolemy devised in the second century. The atlas was derived from Arabic astronomical and astrological traditions, which relied upon empirical observation to amend traditional statements concerning the positions of the constellations in the heavens. The accompanying cycle of imagery betrays the existence of an earlier model likewise inspired by Arabic tradition. (The constellation Perseus, for example, appears on folio 40r clad as an Arab warrior.) The cycle closely follows the illustrations in the Strahov Atlas (Strahov Library, Prague, DA II 13; see fig. 7.6), a northern Italian star atlas of the mid-fourteenth century that had probably arrived in Prague during the reign of Charles IV.[17]

The illuminations in the Munich astronomical anthology, along with the prefatory cycle of charts and diagrams that visually summarize the key

Fig. 84.8 *Paranatellonta* (Constellations) within a *Dekanat* for Taurus. Astronomical Anthology for Wenceslas IV, fol. 13v (detail). Tempera and gold on parchment; Prague, after 1400. Bayerische Staatsbibliothek, Munich (Clm. 826)

Fig. 84.9 Portrait of Avenarius in an Initial C. Astronomical Anthology for Wenceslas IV, fol. 11v (detail). Tempera and gold on parchment; Prague, after 1400. Bayerische Staatsbibliothek, Munich (Clm. 826)

concepts necessary for the pursuit of astrological prognostication (fols. 1–11r), were probably created by two painters working during the first decade of the fifteenth century. The less accomplished of the two copied the illuminations from the Strahov Atlas, and the other collaborated with Terzysko on the medieval schematics, initials, and other representations of the constellations.[18]

Wenceslas IV was probably the intended recipient of the manuscript (although not necessarily its patron), judging by the presence of iconographic symbols associated with the king. One of the images most closely associated with the king, a bath maid, with a bucket in her hand, appears beside the author portrait of Avenarius on folio 11v (fig. 84.9).                    GS, ERW

1. For the translation, see Heger's philological article in Wenceslas Bible 1981–98, vol. 11, pp. 51–123.
2. These instructions (in Latin) are reproduced in Schlosser 1893, pp. 231–51. For their author and his often idealistic notions of what might be depicted, see Schmidt 1998a, pp. 137–44.
3. In the mid-fifteenth century Frederick III had the previously unbound leaves gathered into three volumes, which were later rebound, for ease of handling, into six volumes of between 144 and 240 leaves each. Roughly two-thirds of the text was written by a single scribe, who toward the end of his labors was joined by a second one; about 1447 a third hand inserted a few additions (see Unterkircher in

Wenceslas Bible 1981–98, vol. 11, pp. 42–47). As a rule, the illuminators of medieval Bibles were content to precede each book with a pictorial initial. The more elaborate decorative program of the Wenceslas Bible was modeled after manuscripts of vernacular knightly epics, such as the *Willehalm* romance (see Schmidt 1998a, pp. 132–34).
4. For the various proposed interpretations, see Schmidt 1998a, pp. 154–79.
5. See ibid., pp. 239–43. Characteristically, one manuscript produced for a Prague nobleman as early as about 1385 was the collaboration of two of the Wenceslas illuminators and their workshops (see Jenni and Theisen 2004a).
6. The designations commonly used today go back to Jerchel 1937, with slight modifications by Schmidt 1969b and Krása 1971.
7. In the German-language literature he is known as the Seven Days Master (Siebentage-Meister) after the depiction of the seven days of Creation in the Genesis initial.
8. For the production sequence and division of labor, see the table in Schmidt 1998a, pp. 230–31.
9. Krása (1971) refers to the Morgan Master as the Master of the Herzogenburg Moralia, after another of his works. See the table in Schmidt 1998a, p. 130.
10. This is proposed in Schmidt 1998a, p. 246.
11. Their artistic characteristics and individual careers are discussed in detail in Krása 1971 and Schmidt 1998a.
12. For reproductions of the panel paintings mentioned, see Matějček and Pešina 1950.
13. For Kuthner, see Krása 1971, pp. 192–93, and Schmidt 1998a, pp. 201–4. The work of the

Master of the Pauline Epistles extends across an even longer span of time: from the 1380s to 1411 (see Krása 1971, p. 276n343).
14. Terzysko is known to have purchased a home in the Prague New Town (Nové Město) in 1405 (see Krása 1971, pp. 56, 258n100).
15. Krása in Cologne 1978–79, vol. 3, p. 104; Krása 1971, p. 56.
16. Krása 1971, p. 212. See also Stejskal and Krása 1964, pp. 74–75, which still provides an excellent introduction to the subject.
17. Krása 1971, vol. 3, pp. 211–12. See also Krása in Cologne 1978–79, vol. 3, p. 105.
18. Krása 1971, pp. 212–14, 277n356. Krása (ibid., p. 214) saw a connection between the style (particularly the acanthus) of the major hand in the Munich codex and that of the painter of the Hazmburk Missal (see fig. 9.1). Schmidt (in Swoboda 1969, pp. 238–39) agrees with Krása (1971, p. 220) in his assessment that the same painter probably also worked on the title page initial for the Office of Saint Jerome made in 1404 and written by Bohemian humanist Johann von Saaz (Národní Muzeum, Prague, Library, XII A 18).

## 84. Psalter of Wenceslas IV

*In German and Latin, translated by Heinrich von Mügeln; Prague, ca. 1395*
*Tempera and gold on parchment, 270 fols, 36.7 x 26 cm (14½ x 10¼ in.)*
*Salzburg University Library (M III 20)*

84, fol. 1r, frontispiece (detail)

The margins of the frontispiece to this psalter are richly decorated with foliate ornament containing numerous signature elements that identfy it as having belonged to Wenceslas IV's private library. The kingfisher, the bath maids, the love knots, and the two wild men in tournament armor who carry heraldic shields with the imperial eagle and the Bohemian lion can all be associated with Wenceslas. The king himself, dressed as a fashionable courtier, sits in a letter W at the upper left. The opening initial shows the learned commentator the Franciscan Nicholas of Lyra; a second, King David, as author of the Psalms, playing the harp. The translation into German, which follows the familiar Latin opening line of each psalm, is that of the court poet and composer Heinrich von Mügeln, who worked not only in Prague, for both John of Luxembourg and Charles IV, but also in Budapest and Vienna. The decorative program of this manuscript may be less ambitious than others from the royal library, but it testifies to the contemporary interest in scriptural texts translated into the vernacular, a trend opposed by Charles IV but embraced by his son Wenceslas.                RS

LITERATURE: Schlosser 1893, p. 256; Tietze 1905, no. 47; Schmidt 1969b, p. 238; Krása 1971, pp. 25, 37, 251.

84, fol. 1r (detail)

## 85. Bible of Konrad of Vechta

*Written by the scribe Laurentius, Prague,*
*1402–3; binding 18th–19th century*
*Tempera, gold, and silver on parchment; vol. 1, 215*
*fols., vol. 2, 221 fols.; 49 x 35 cm (19¼ x 13¾ in.)*
*Provenance: Commissioned by Konrad of Vechta;*
*Moretus family, Antwerp, 1805; bequeathed to*
*Museum Plantin-Moretus, 1877.*
*Museum Plantin-Moretus, Municipal Printroom,*
*Antwerp, Collection Museum (Cod. MS 15.1–15.2)*

The two volumes of the manuscript contain
the Latin text of the Bible, beginning with the
book of Genesis and continuing through the
second book of Ezra, with accompanying
forewords. According to the colophons of the
second volume,[1] the text was completed on
February 22, 1403, by the scribe Laurentius
for the master of the royal mint, Konrad of
Vechta, later named the archbishop of Prague.[2]
The knotted wreath and kingfisher in the bor-
der of folio 1r of volume 1 attest that the
commissioner of the manuscript was a member
of the Order of the King of Bohemia, which
had been founded by Wenceslas IV.[3]

This extraordinarily ornate *manuscrit de*
*luxe* contains two historiated initials, 210
miniatures, drolleries and floral decoration
in the borders, and gold and blue lombard
*fleuronnée* initials at the opening of each chap-
ter. Not only does it represent the highest
achievement of court illuminators during the
1390s, but it also signals the arrival of a new
generation of first-class artists. The older tradi-
tion is embodied by the primary illuminator,
who was responsible for the initial of the
book of Genesis. Together with another
painter, also known from the Bible of the
Provost Franciscus of 1411 (Württembergische
Landesbibliothek, Stuttgart, Cod. bibl. 2° 4a,
fol. 66r),[4] he had probably previously worked
on the Wenceslas Bible, the Jenštejn Codex
(cat. 96), the second volume of the *Moralia*
*in Job* (Stiftsbibliothek Herzogenburg,
Cod. 94), and the Opatovice Breviary.[5]
Among the younger artists were the Master
of the History of Noah, who also helped
decorate the Bible of Provost Franciscus
(fol. 89v); an unknown, rather mediocre
illuminator who later contributed to the
Gerona Martyrology (cat. 86);[6] the Master of
the Roudnice Psalter;[7] and the Master of the
Golden Bull.[8]

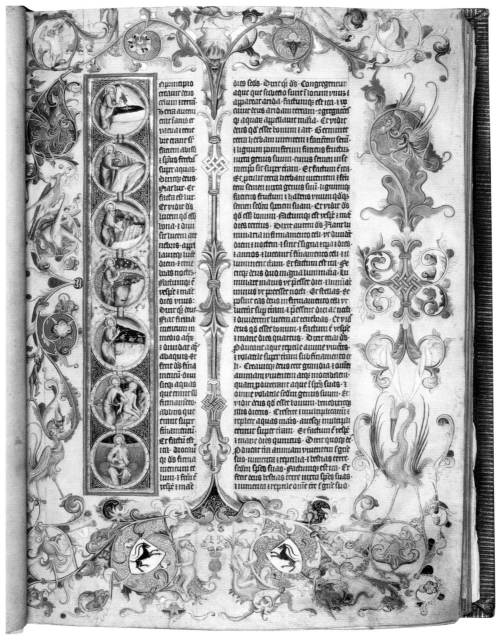

85, vol. 1, fol. 1r, opening of the book of Genesis

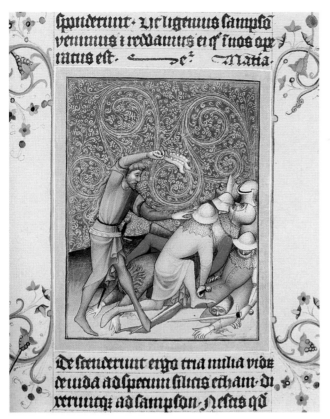

85, vol. 1, fol. 148r (detail), Samson Defeating the Philistines

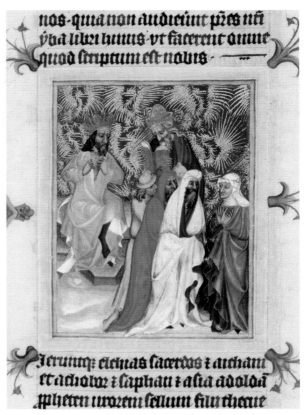

85, vol. 1, fol. 171v (detail), Jonathan Bidding Farewell to David

The most accomplished of the new painters to work on the manuscript was the so-called Master of the Antwerp Bible, or Third Master (also called the Joshua Master), whose significance and influence were to transcend the borders of the Kingdom of Bohemia. With his masterly drawing[9] and sophisticated sense of space, he was able to transform older border motifs into a new, dynamic system of ornamentation.[10] That this master became acquainted about 1400 with the work of Paris illuminators is evidenced by his landscapes with faraway cities set against blue skies or bathed in twilight, by the typology of some of the faces in his paintings, and by his meticulous three-dimensional sculpting of forms. The influence of North Italian painting is also evident in his work. His hand is apparent in the Gerona Martyrology, in the Missal in Vienna (Österreichische Nationalbibliothek, inv. 1850), in the Lucerne Gradual (cat. 104), and, according to Josef Krása, in the Gradual of Master Václav Sech (Archive of Charles University, Prague), whose part of the sanctorale may have included the Dormition of the Virgin miniature in Washington (cat. 105).[11]

MS

The author wishes to thank the Grant Agency of the Czech Academy of Sciences for its support (A 8033202) in developing this text.

1. Vol. 2, fol. 56vb: "Explicit psalterium ingrossat-um Per laurencium scriptorem." Fol. 172rb: "Explicit Prephacio Sa[n]cti Jeronimi Venerabilis PResbiteri In Librum Thobie Anno domini Millesimo Quadringentesimo Secundo Currente Comparatus est et ordinatus Liber Biblie huius Per d[ominum] Conradum M[a]g[ist]r[u]m Monete." Fol. 221vb: "Explicit Secundus Liber Esdre Sacerdotis. In Anno Domini Millesimo Quadringentesimo Secundo Currente In Kathedra Sancti Petri Ap[osto]li. Comparatus per d[ominum] Conradum M[a]g[ist]r[u]m Monete."

2. A financier from Lower Saxony, Konrad was appointed by Wenceslas IV, who brought him to Bohemia. He subsequently served as master of the royal mint (1401–3), royal vice-chamberlain (1405–12), bishop of Werden (1402), bishop of Olomouc (1408–12), and archbishop of Prague (1413–21).

3. Kovács 1987, p. 138; Studničková 1992. Schlosser (1893) assumed that the presence of the king-fisher and the knotted wreath signified that the manuscript was a gift to Wenceslas IV. The coat of arms of the purchaser, with a capricorn on a silver field, appears in vol. 1, fols. 6r and 61v. The wreath tied around the neck of a bird or bear (vol. 1, fols. 6r, 201r, 213v; vol. 2, fol. 15v) alludes to the order.

4. Schmidt (1969b, p. 248) calls him the Hierony-mus Master, after the opening initial portraying Saint Jerome in the Antwerp Bible.

5. The Opatovice Breviary was ascribed to this master by Hlaváčková 2002. Schmidt (1969b, p. 249; 1998a, pp. 194–95) believes the artist to be the so-called Master of the Morgan Bible and, apart from the Jenštejn Codex and the *Moralia,* ascribes to him the decoration of the Orationale (Knihovna Roudnice, VI Fb 12).

6. Krása (1974a) identifies this painter as the Master of the Circle of Masters of the Book of Ezra; see also Schmidt 1969b, p. 248 (as Leuchter-Meister [Candlestick Master]).

7. For a list of the master's works, see the Missale Pragense, now in Zittau.

8. The portions by individual artists are defined by Krása (1974a, p. 271), and the illuminations of the Master of the History of Noah, by Schmidt (1969b, p. 248).

9. See his unfinished miniatures in vol. 1, fols. 161v–176v. The illumination of the second volume ends on fol. 17r.

10. The characteristic tiny blossoms on the pen-drawn branches are found in the Wenceslas Bible (vol. 1, fol. 53v). Similar dragons appear on the borders of Jan of Středa's manuscripts and in the Braunschweig Sketchbook (fol. 8r; fig. 99.1).

11. Krása 1966. Stejskal (in Stejskal and Voit 1991, p. 42, no. 10) also ranks among his works the initial portraying Christ Enthroned in the Breviary of Saint George's Convent (Národní Knihovna, Prague, XIII B 9, fol. 5r). See also Krása 1969.

LITERATURE: Chytil 1885–86, pp. 311–16; Schlosser 1893; Denucé 1927, pp. 139–40; Pächt 1938; Vermeiren 1953; Frinta 1964; Pešina 1965; Schmidt 1969b, pp. 247–50; Swoboda 1969, pp. 237–39, 244–49, 251, 253–55, 257, figs. 182, 183, 185, 189, 190; Krása 1971, pp. 222–32; Krása 1974a, pp. 209–21, 271; Krása 1990, pp. 204–23; Gerona Martyrology 1997–98, vol. 2, pp. 112, 204–24; Studničková 1998a.

## 86. Gerona Martyrology

*Prague, ca. 1410; binding: Naples, 1670–72[1]*
*Tempera, gold, and silver on parchment; 126 fols.; 46 x*
*32 cm (18⅛ x 12⅝ in.)*
*Provenance: Cistercian monastery (possibly Sedlec),*
*Bohemia; Stephanus Radecius, bishop of Varadín and*
*Eger, court counselor, and imperial governor of*
*Hungary; his gift to a member of Ditrichstein family;*
*Franz von Ditrichstein, bishop of Olomouc, 1582;[2]*
*his relative, Pedro Antonio de Aragón Folc de Cardona*
*y Fernández de Córdoba, Spanish ambassador to*
*Rome and later Spanish viceroy in Naples (his coat of*
*arms on binding);[3] his gift to Cistercian Monastery,*
*Pobleto, 1673; Bernardine Convent, Mercadal, 1835–*
*1936; mayor of Gerona; Museu Nacional d'Art*
*Catalunya, Barcelona; restituted to Museo Diocesano*
*de Girona, 1939.*
*Museo Diocesano de Girona, Spain (M.D. 273)*
*Not exhibited*

A list of saints organized according to the days
of the year, a martyrology was read in a monas-
tic or chapter community in addition to the
Liturgy of the Hours[4] in order to call upon
the *communio sanctorum* (communion of saints).
In the Gerona Martyrology, the brief com-
ments on the Bohemian patron saints added
to the original text of Usuard, a ninth-century
Benedictine monk,[5] their limited selection
(Saints Wenceslas, Adalbert, and Procopius), and
the inclusion of the Silesian and Polish saints
Hedwig and Stanislas[6] testify that it was made
for a Cistercian monastery in Bohemia.[7] It may
even have been among the collection of litur-
gical manuscripts commissioned by the Sedlec
Monastery, near Kutná Hora.

Of the few surviving illuminated martyr-
ologies, the Gerona manuscript is exceptional
for the scope and quality of its decorations,
which include more than seven hundred
medallions with portraits of saints. Some
miniatures were executed by a group of less
prominent illuminators of the older genera-
tion,[8] by the Master of the Krumlov Anthol-
ogy,[9] and by the illuminator who collaborated
on the Antwerp Bible with the Master of the
Golden Bull.[10] The most important work,
however, was that of the so-called Masters of
the Martyrology, a group of three artists of
similar styles who were strongly influenced
by contemporary Parisian and North Italian
schools of illumination.[11]

The oldest of these, the influential Master
of the Antwerp Bible, is known from the Bible
of Konrad of Vechta (cat. 85) and the Lucerne
Gradual (cat. 104),[12] as well as from the Gradual
of Master Václav Sech (Archive of Charles
University, Prague). The work of the second
master, the so-called Master of the Martyr-
ology, appears for the first time in the Gerona

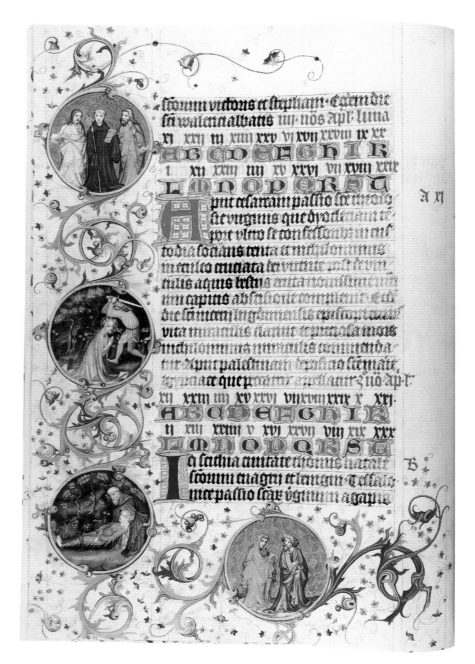

86, fol. 36v, Saints Valerius, Theodosia, Mary of Egypt, Evagrius, and Benignus

manuscript. He used impressive landscapes
with numerous hills that recede into a deep
background (fols. 85r, 96v).[13] About 1414
he participated in the decoration of the
Antiphonary and Gradual of the Cistercian
Monastery in Sedlec,[14] from which the
Budapest miniatures were probably cut
out and which the Washington and Prague
initials depicting the Holy Trinity closely
resemble in style (see cat. 124).

Three pages of the Gerona Martyrology
(fols. 92r–93r) were illuminated by the
youngest member of the group, named, after
his later work, the Master of *The Travels of Sir
John Mandeville* (cat. 88). Probably with the
Master of the Martyrology, this artist decorated

the Oxford Hours of King Wenceslas (cat. 82).
According to Josef Krása, he is responsible for
certain miniatures in the Sedlec manuscripts,[15]
and he also illuminated several folios of the
Boskovice Bible (fols. 1v, 48v, 426r; see cat. 133)
and the Bible of Sixtus of Ottersdorf (Národní
Knihovna, Prague, XIII A 3). The Innsbruck
Garden of Paradise (cat. 120) is ascribed to
him, and stylistically close is the decoration
of the Gradual of the Dominican Monastery
(Österreichische Nationalbibliothek, Vienna,
S.n. 4642).

MS

The author wishes to thank the Grant Agency
of the Czech Academy of Sciences for its support
(A 8033202) in developing this text.

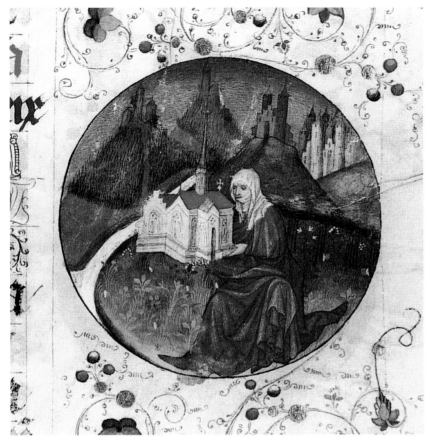

86, fol. 85r (detail), Saint Hedwig and the Convent of Trzebnica

LITERATURE: Pächt 1938; Pla Gargol 1956; Vienna 1962, no. 176, cover ill.; Frinta 1964; Pešina 1965; Krása 1966; Krása 1969; Schmidt 1969b, pp. 247–58; Krása 1983a, p. 33; Krása 1990, pp. 204–23; Stejskal 1990, pp. 89–90; Gerona 1993; Lohr 1996; Gerona Martyrology 1997–98; Studničková 1998b; Studničková and Štěpánek 1999; Suckale 1998–99, pp. 334–37.

## 87. *Dragmaticon philosophiae* by William of Conches

*Prague, ca. 1400*
*Tempera and gold on parchment, 72 fols., 31 x 21 cm*
*(12¼ x 8¼ in.)*
*Provenance: King Matthias Corvinus of Hungary (1443–1490); possibly Queen Christina of Sweden (1626–1689); Cardinal Zelada, Toledo, Spain (1717–1801).[1]*
*Biblioteca Nacional de España, Madrid (Res. 28)*

The *Dragmaticon philosophiae* was probably composed by the Norman scholastic philosopher William of Conches (ca. 1090–1154) during the period 1147–49, while he was tutoring the sons of Geoffrey Plantagenet, who is identified at the beginning of the manuscript as "dux normannorum et comes andegauensium" (duke of Normandy and count of Anjou).[2] An expanded edition of William's earlier *De philosophia mundi* (ca. 1125–30), the *Dragmaticon* was a primer for his pupil the future Henry II of England.

The *Dragmaticon* elucidates various aspects of the physical world and relies upon helpful appeals to the philosophy of Plato. The integration of Christian doctrine and Plato's ideas about the way the universe is fitted together (from Platonic dialogues like the *Timaeus*) interested twelfth-century scholastic philosophers as well as Bohemian humanists.[3] The *Dragmaticon* manuscript thus attests to the Late Gothic integration of scientific investigation and religious devotion at the court in Prague.

The author portrait on folio 1r is a rare depiction of a writer preparing preliminary notes or computations on wax tablets before their transfer to parchment.[4] According to the text of the Madrid codex (fol. 48v, ll. 28–29), William of Conches provided his own set of illustrations: "So that you can understand this better, I shall sketch a figure."[5] The diagram on folio 49r provides a visual proof that the earth is round. Two cities are juxtaposed on either end of the earth beneath the arc defining the sun's daily journey through the sky. William's argument is simple. If the earth were flat, then the quickly ascending sun would cause the Eastern city depicted on the

1. Missing folios 7–9 and 14–16 were filled in by Adam Paulinowsky, scribe of the Olomouc episcopal office, 1613, according to the inscription on fol. 6v.
2. Fol. 2r: "Dietrichtain. Hunc librum michi dono dedit reverendissimus dominus Stephanus Radetius, episcopus Agriensis, Sacrae, Cesarae et Regie Maiestatis consiliarius, regni Hungarie locum tenens." The Gerona Martyrology is listed in the catalogue of manuscripts in the Ditrichstein library, Mikulov, after 1614 (Moravský Zemský Archiv, Brno, Cer. II. 117, p. 154).
3. Pächt (1938) considered whether after the pillaging of Mikulov in 1645 the Swedish soldiers might have taken the manuscript to Sweden. Queen Christina, after converting to Catholicism and being forced to abdicate (1654), might have then transported it along with the rest of her library to Rome. He rejected this theory, however, since the Gerona Martyrology does not appear in inventories of the queen's property.
4. It was read after the hour of prime. A manuscript in the Národní Knihovna, Prague (XIV.C.10, fol. 7), mentions it as also being read after matins.
5. Usuard's text is a historical martyrology that cites not only the saints' names but also the place, date, and circumstances of their deaths, or, in his term, their "birth for heaven" (*Patrologia latina* 123–24; Dubois 1990).
6. The appearance of these saints together with the letter W led researchers to assume, respectively, that the manuscript was intended as a gift from Wenceslas IV to a Polish monastery or chapter (Pächt 1938), that it was created in Moravia upon the commission of the bishop of Olomouc, Václav Králík of Buřenice (Krása 1983a), or that it was made for Václav, bishop of Wrocław (Lohr 1996).
7. Studničková 1998a. The selection of saints corresponds exactly with the Cistercian calendar. See Charvátová and Silagiová 2003, pp. 36, 41, 42.
8. Fols. 10–13, 17–26, 28–29, 30v–32, 41, 43–46, 48, 70–71.
9. Fols. 27, 30r, 42, 47, 59, 62, 65, 68–69, 72. Also called the Master of the Speculum, after a manuscript in the Národní Muzeum, Prague, Library (III B 10).
10. Fols. 57–58, 60–61, 63–64, 66–67. Krása (1974a, p. 210) names him the Master from the Circle of Masters of the Book of Ezra; Schmidt (1969b, pp. 248–49), the Leuchter-Meister (Candlestick Master).
11. Also known as the Workshop of the Martyrology. Differences in execution, as well as the advanced division of labor, suggest that more than three masters collaborated in this workshop. A number of other artists apprenticed there, some of whom were also active outside of Bohemia.
12. Krása 1966.
13. He illuminated the folio with the foreword (3r) and probably also the folio with the beginning of Usuard's text, which was later damaged and, together with other folios (7–9, 14–16), replaced. The Master of the Martyrology also illuminated folios. The decoration was left unfinished, the last illumination appearing on fol. 96v.
14. Moravský Zemský Archiv, Brno, G 11 (Gradual).
15. Krása 1983a, p. 38.

87, fol. 1r, Portrait of William of Conches in an Initial Q

87, fol. 49r (detail)

left in the diagram to experience morning and high noon nearly simultaneously, just as the Western city on the right would experience midday and evening in quick succession. Since this is impossible, the earth is round.

The filigree work in the background of the miniature on folio 49r resembles the allover decoration found in Bohemian historiated initials of the Wenceslas IV era. Stylistically, the frontispiece on folio 1r of the Madrid manuscript is reminiscent of the sprawling border of acanthus and drolleries on the frontispiece to the copy of the commentary on the *Tetrabiblos* (or *Quadripartitus*) of Ptolemy in Vienna (Österreichische Nationalbibliothek, 2271), which dates to about 1400 and can be securely linked to the Wenceslas IV court school of manuscript illumination. Within the border decoration of the Vienna frontispiece the illuminator depicted a hapless man fastened in an initial W resembling stocks. Such motifs are ubiquitous in the borders of the Wenceslas Bible (fig. 84.7) and other court school manuscripts.[6]

The coat of arms of Matthias Corvinus, king of Hungary (r. 1458–90), appears on the Vienna manuscript.[7] Like the Vienna manuscript, the Madrid codex also entered that king's library. His heraldic crest has been painted over the escutcheon in the lower border of the frontispiece on folio 1r, so the original owner is unknown. A dated synthesis of Christian and scientific teaching, William's text could have been a valuable asset to an erudite member of the court of Wenceslas IV who was interested in metaphysics, astronomy, astrology, or medicine, such as the celebrated physician, astronomer, and professor at Prague University Master Křišťan of Prachatice (ca. 1366–1439)[8] or the astrologer Terzysko, who is depicted

in the astronomical anthology he is credited with compiling for Wenceslas IV sometime after 1400 (see fig. 87.1).[9]                    ERW

1. Krása 1971, pp. 21, 61, 261n128.
2. In the excellent translation of the text of the

*Dragmaticon* (William of Conches 1997, pp. xv–xviii), Ronca favors the traditional view that William was a pupil and follower of Bernard of Chartres. Southern (2001, pp. 66–79, 89) has championed an alternative and less widely held position that downplays the importance of the school of Chartres and places William in the university culture of Paris from roughly 1110 to 1140.

3. Krása 1971, p. 61.
4. Gómez Pérez 1963, pp. 238–39, 238n20. See also Domínguez Bordona 1933, no. 820.
5. William of Conches 1997, p. 121.
6. Mazal in Cologne 1978–79, vol. 3, p. 104.
7. See Krása 1971, p. 21; Schmidt in Swoboda 1969, pp. 239, 437n366; and also Mazal in Cologne 1978–79, vol. 3, p. 104.
8. Svobodný 2001, p. 184.
9. Terzysko clearly worked for the King of the Romans in Prague. In 1407 Wenceslas IV took from his residence at Karlštejn to his castle at Točník a completed astronomical atlas (not to be confused with this anthology) that was compiled for him by Teřísek (presumably Terzysko) and another court astronomer, Bušek (Krása 1971, p. 52, 56; Krása in Cologne 1978–79, vol, 1, p. 104).

LITERATURE: Domínguez Bordona 1933, no. 820; Gómez Pérez 1963, pp. 238–39; Swoboda 1969, p. 239; Krása 1971, pp. 21, 52, 61.

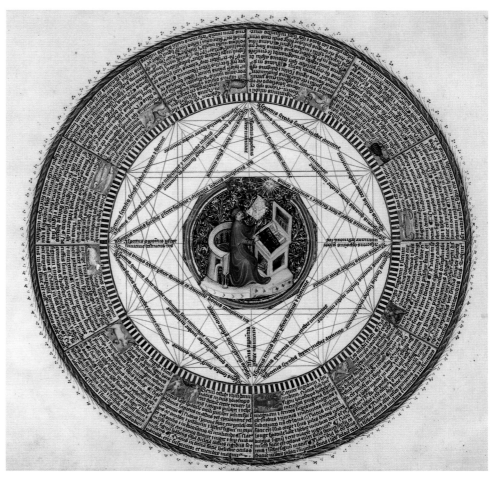

Fig. 87.1  Portrait of the Astrologer Terzysko. Astronomical Anthology for Wenceslas IV, fol. 8r. Tempera and gold on parchment; Prague, after 1400. Bayerische Staatsbibliothek, Munich (Clm. 826)

## 88. *The Travels of Sir John Mandeville*

*Prague, ca. 1410–20*
*Tempera and gold on parchment, 16 fols., 22.5 x 18.1 cm (8⅞ x 7⅛ in.)*
*Provenance: Purchased on June 8, 1861, by William Maskell for the British Museum.[1]*
*British Library, London (Add. Ms. 24189)*

The Travels of Sir John Mandeville recounts the fabulous journeys (and perhaps some real ones) undertaken by the book's protagonist, the putative historical figure Sir John Mandeville. Sir John's voyages supposedly began on Saint Michael's Day (September 29) in 1322 and concluded in 1356, at which point the English knight from Saint Albans reportedly composed the text. Scholars agree that the original text was composed in French but dispute the relationships among the ensuing editions and translations.[2] The Czech translation of the *Travels* by Vavřinec of Březová (b. 1370/71) attests to the increased availability of medieval manuscripts in vernacular editions in about 1400 at the court of Wenceslas IV. Vavřinec of Březová earned his Master of the Liberal Arts degree from the University of Prague in 1394 and is renowned for his Latin chronicle recounting the Hussite years, 1414–21. In the introduction to the Czech edition of the *Travels* he declares himself in service to Wenceslas IV, which securely links the Czech redaction to the period 1395–1410.[3]

The twenty-eight framed miniatures on the last fourteen of the sixteen leaves that constitute the British Library book illustrate the first thirteen chapters of the Czech text of the *Travels*.[4] Several of the scenes depict contemporary Bohemian courtly life. The annual Festival of the Presentation of the Relics held in the cattle market in Prague served as the vehicle for the artist's illustration on folio 11r of Vavřinec of Březová's description of the relics of Constantinople, including the True Cross, Christ's robe, and the sponge from the Passion. The painter relied upon Bohemian customs for the image and depicted Charles IV as the Holy Roman Emperor, wearing the appropriate crown.[5] On folio 15r the astronomers wield an astrolabe and a quadrant, instruments for fixing the positions of the stars, at the crest of arid, windless Mount Athos, while below them the geomancers scrawl arcane messages used for soothsaying.[6] The miniature on folio 16r faithfully represents a late medieval Bohemian glassmaker's atelier.[7]

The atypical green prepared parchment of the *Travels* illuminations relates them to other transalpine-style manuscripts of about 1400. A green preparatory ground was used for

88, fol. 15r, Astronomers and Geomancers on Mount Athos

the Vienna Model Book (cat. 117), but over a paper substrate. A silverpoint stylus was probably employed to create the *Travels* miniatures.[8] Josef Krása argued that three folios from the Gerona Martyrology (cat. 86) are early works of the Master of the Mandeville *Travels*.[9] Otto Pächt proposed that he worked as an assistant to the Master of the Gerona Martyrology and cultivated his melancholy, somber style, with its robust figures.[10] Milada Studničková also attributed the illuminations in a Vienna choral book (Österreichische Nationalbibliothek, Vienna, cod. s.n. 4642) and the monochrome prophets in the Bible of Sixtus de Ottersdorf (Národní Knihovna, Prague, XIII A 3) to the Master of the Mandeville *Travels*.[11]          ERW

1. Krása 1983a, p. 15.
2. See Bennett 1954, pp. 91–92, 121–22, 146, 170–76, 200–204, 227; Schepens 1964; and Seymour

1964, pp. 34–35. The Czech edition is a revised translation of the German edition of Canon Otto von Diemeringen of Metz (d. 1398), who is depicted on folio 3r. The German edition was in turn based on the corrupted French, or Liège, redaction of the text, which was probably placed into circulation in the 1390s by Jean d'Outremeuse (1338–1399). Bennett argued that the Liège redaction of the *Travels* was a corruption of the Parisian, or Continental, redaction composed in 1371 by Raoulet d'Orléans for Charles V, which in turn was an adaptation of the original Norman French edition. According to Bennett, the Norman redaction originated in England, like its hero, Sir John Mandeville. Her thesis has not received unanimous approval from the scholarly community. Regardless of whether Bennett was right about these other considerations, the Liège redaction may well have been the work of Jean d'Outremeuse, but this too remains an open question. Seymour (1964, pp. 34–35) rightly asserted that all three of the redactions (that is, the Continental,

88, fol. 5v, A Hunt and Feast in Cyprus

Liège, and Insular, or Norman French, versions) include variants and putative corruptions of the text.

3. Krása 1983a, pp. 12–13.
4. Krása (ibid., pp. 8, 14–17) followed Lohr's (1981) identification of the passages to which the illustrations refer. See also Krása in Cologne 1978–79, vol. 3, pp. 106–7.
5. Krása 1983a, pp. 65–67.
6. Ibid., pp. 99–101.
7. Ibid., pp. 123–25. See also Hejdová 1966; Hejdová 1975; and Hejdová 1987.
8. Krása 1983a, pp. 26–27.
9. Fols. 92r, 92v, 93r; see Krása 1969, pp. 170–71.
10. Pächt 1938, p. 203. Pächt incorrectly conflated the work of the Master of the Antwerp Bible and the Master of the Gerona Martyrology. See also Krása 1983a, pp. 32–37.
11. Studničková 1998a, pp. 128–31. Krása's (1983a, pp. 36–37) attribution of at least portions of the Boskov Bible and the Innsbruck miniature of the Virgin Mary in the Garden of Eden to the *Travels* Master should remain open to debate.

LITERATURE: Pächt 1938; Hejdová 1966; Krása 1969, pp. 170–71; Cologne 1978–79, vol. 3, pp. 106–7; Lohr 1981; Krása 1983a; Hejdová 1987; Krása 1990, pp. 268–97; Studničková 1998a, pp. 112, 127–31.

## 89. The *Bellifortis* of Konrad Kyeser of Eichstätt

*Prague, completed June 23, 1405; binding, probably 16th century*
*Tempera, ink, and gold on parchment; leather binding; 140 fols.; 32.5 x 24 cm (12¾ x 9½ in.)*
*Provenance: Acquired from the City of Nuremberg, 1773.*
*Niedersächsische Staats- und Universitätsbibliothek Göttingen (2° Cod. Ms. Philos. 63 Cim.)*

The *Bellifortis* (literally, "[he who is] strong in war") is the earliest and most important example of illuminated treatises on military technology. Such works, which began to emerge during the early fifteenth century, are closely related to the tradition of the "firework books" of the late fourteenth and the fifteenth centuries, which dealt with recipes for the manufacture of gunpowder, explosives, and incendiary devices. The *Bellifortis* survives in at least twenty contemporary manuscripts, of which the one in Göttingen appears to be the final version approved by its author. Furthermore, it is the only edition with an "introduction" (*Vorspruch*), a personal dedication, an epicedium (a lament on Kyeser's imminent death), and the author's horoscope. The manuscript is enriched with sumptuous illuminations, some of which are clearly by artists associated with Prague illuminators favored by King Wenceslas IV.[1]

Drawing in part on material from classical authors, especially Marcus Graecus, the widely copied *Bellifortis*[2] is a compilation of state-of-the-art military engineering at the beginning of the fifteenth century (and fanciful inventions, probably from Kyeser's imagination). That period witnessed significant improvements in both civil and military engineering (especially the art of the armorer) as well as the increasing use of firearms. Divided into ten chapters written in Latin hexameter, the work illustrates and describes wagons (for war), siege engines, hydraulic machinery, machines for lifting weights, and firearms. Also included are offensive and defensive weapons and aids for all-terrain warfare, such as spanning devices for crossbows, rockets, a trebuchet (a gravity-driven catapult), and diving suits. Interspersed among the military section are appliances more suitable for civilian life, such as ships driven by paddle wheels, mills, bathhouses (fig. 8.9), fireworks, and a chastity belt. Even recipes for medicines, cooking, and magic spells are presented. In his introduction, Konrad Kyeser states that his work is not intended for craftsmen and military engineers but for a select audience from emperor and king to knights and men-at-arms, and including mayors and city councillors, a fact clearly witnessed by the sumptuous appearance of many of the surviving copies.

Knowledge concerning Kyeser (1366–ca. 1405/6?) is scarce. Born in Eichstätt (Franconia), he appears to have been well educated, most likely having studied medicine, after which he entered the service of various noble patrons. Although the Göttingen manuscript is dedicated to King Rupert I (1352–1410), Kyeser was apparently an ardent supporter of Wenceslas and was forced into exile when the latter was arrested and detained by his half brother Sigismund in 1402. Testimony to his allegiance to Wenceslas can be found in the illumination

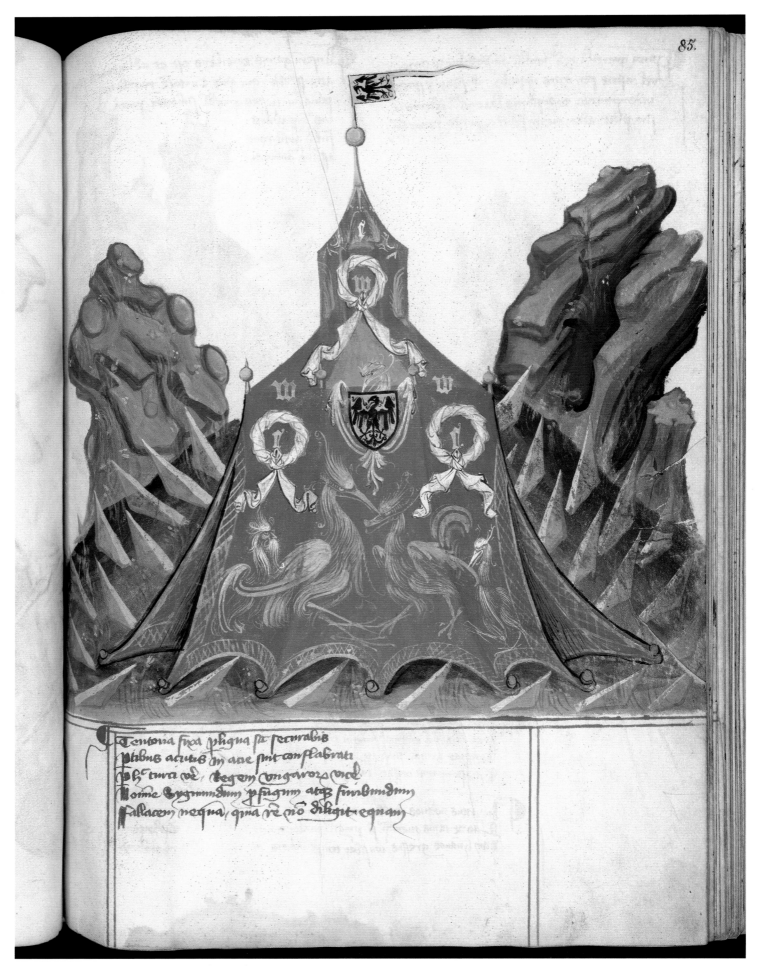

Tentoria ſixa ꝓligna ſꝫ ſecurabis
ſtabꝰ acutis m aƿe ſint conſtabrati
ſcb tuƿa uꝫ ꝛegem ungaꝛoꝛƿ uꝛd
ꝉome ſygiſmundum ꝓfugnm atꝗ furibundm̄
ſallacem negƿa, qƿia re ƿo dihgit eqnam

89, fol. 85r, Royal Tent with the Emblems of Wenceslas IV

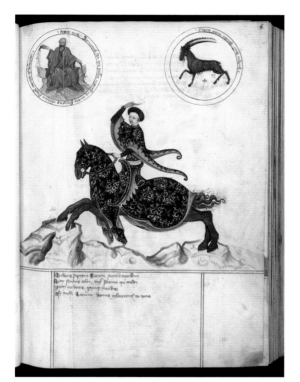

89, fol. 6r, Saturn

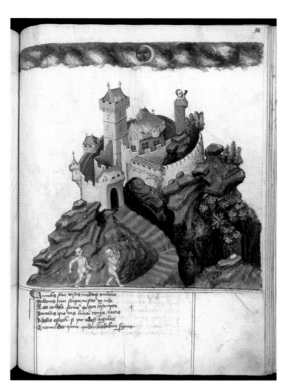

89, fol. 94r, Imps Bent on Magic Approach a Castle at Midnight

on folio 85r (a royal tent displaying specifically Bohemian royal iconography pertaining to Wenceslas) and the scathing polemics against Sigismund throughout the *Bellifortis*.[3]   DHB

1. Quarg, commentary to Kyeser (1405) 1967, vol. 2, pp. XXV–XXXII, XLII; Heimpel 1971, pp. 139–40. Quarg's text and translation of Kyeser's manu-

script are unfortunately so riddled with errors, mistranslations, and a general ignorance of medieval history that they should not be consulted without a close look at the original text, as well as Heimpel's 1971 book review.

2. Illuminations from Kyeser's work served, for example, as illustrations for the first edition of the fourth-century *Epitoma rei militaris* by Vegetius (Ulm, 1471) and remained influential

throughout Europe until the seventeenth century (Ludwig 1991, vol. 5, cols. 1595–96).

3. Quarg, commentary to Kyeser (1405) 1967, vol. 2, pp. 53–54; Heimpel 1971, p. 145.

LITERATURE: Meyer 1893, vol. 1, pp. 164-67; Kyeser (1405) 1967; Heimpel 1971; Krása 1971, pp. 61, 63, 214, 216, ill.; Cologne 1978–79, vol. 3, pp. 107–8; Ludwig 1991, cols. 1595–96.

89, fol. 114v, A Bathhouse

89, fol. 30r, A Catapult

## 90. Saddle, possibly of Wenceslas IV

*Bohemia, ca. 1410–19*
*Carved and painted staghorn over birch armature,*
*33.8 x 52.1 x 34.6 cm (13¼ x 20½ x 13⅝ in.)*
*Provenance: Prince Trivulzio, Milan, by 1872, until*
*1928; [Böhler, Munich], 1928; [Duveen Brothers,*
*Paris, London, New York], 1928; Clarence H. Mackay,*
*Roslyn, N.Y., 1928, until his death, 1938; estate of*
*Clarence H. Mackay, 1938–40 (sold through [Jacques*
*Seligmann, New York]).[1]*
*The Metropolitan Museum of Art, New York, Harris*
*Brisbane Dick Fund, 1940 (40.66)*

Julius von Schlosser identified this support saddle with bilateral backplates as part of a group of twenty-one bone saddles decorated with scenes of courtly life. The saddles have traditionally been dated to between 1400 and 1450. Stephen Grancsay noted that some of the men depicted on the Metropolitan saddle wear tunics with dagged sleeves, which were popular as early as 1350, and that the high female waistlines and low male ones suggest a date of about 1400. In 1977 János Eisler discredited the long-standing connection between the bone saddles and the Order of the Dragon of Holy Roman Emperor Sigismund (appointed 1410, r. 1433–37; see cat. 144). Reinforcing Grancsay's intuition that the saddle was made during the Wenceslas IV period are the buttoned tunic and protruding chest, typical of about 1400, of a king on one of the saddle's back supports; a similar tunic appears on folio 369r of the *Willehalm* romance (fig. 90.1), which dates to about 1385–95. In addition, the "starburst" trees in the scenes on the saddle are a plastic translation of transalpine, Bohemian trees like those in the Torre Aquila fresco *May,* which was painted for Bishop George of Liechtenstein-Nikolsburg about 1400.[2]

The one-headed eagle, symbol of the Germanic-Roman kingdom, on its support plate suggests that this saddle was made for a king of the Romans, and only Wenceslas IV would have been so identified in or about 1400. The same heraldic device appears on the campaign tent of Wenceslas IV on folio 85r of the *Bellifortis* of Konrad Kyeser (cat. 89). As Schlosser apparently suggested in 1894, the initials *v* and *e,* each repeated twice on the saddle, might be interpreted as standing for

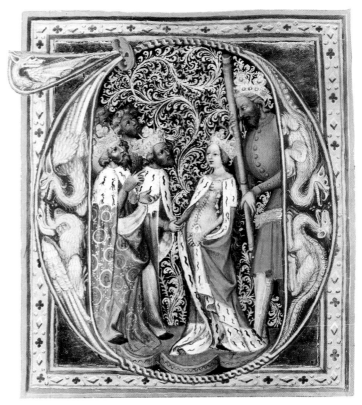

Fig. 90.1 Master of the *Willehalm* Romance. The Meeting of Malifer and Penthesilea. The *Willehalm* Romance by Wolfram von Eschenbach, fol. 369r (detail). Tempera and gold on parchment; Prague, ca. 1385–95. Österreichische Nationalbibliothek, Vienna (Cod. Ser. n. 2643)

Wenceslas and Euphemia-Sophie (Václav and Euphemia-Žophie in Czech orthography).[3] The *b* on the inside of one of the back support plates could then refer to the Bavarian lands Euphemia-Sophie offered to Wenceslas IV when they were married in 1389.

The materials and techniques of construction of this lavishly carved object conform to those used by Bohemian and German saddlemakers in the late fourteenth and early fifteenth centuries.[4] In 1451 the regulations of the Order of Saddle Makers in the Prague New Town (Nové Město) clarified what was probably already standard practice, that bone saddles were to be covered, unless, like this one, they were made of staghorn. Bohemian saddlers made use of birch, visible on the underside of the Metropolitan saddle.                                  ERW

1. Duveen Archive, Getty Research Institute, Los Angeles.
2. De Gramatica 2002, p. 343.
3. Schlosser 1894, p. 272. Hlaváčková (1993), following Krása, pointed out a problem with the similar initials, *w* and *e,* that occur in the Wenceslas Bible (fig. 84.7): the same initials appear in *Willehalm,* the text of which was completed in 1387. Even so, the recurrence of similar initials in manuscripts linked to Wenceslas IV supports the likelihood that the saddle was made for him.
4. Winter 1906, p. 864.

LITERATURE: Schlosser 1894, p. 272; Schlosser 1899; Grancsay 1937; Grancsay 1941; Krása 1971; Eisler 1977; Eisler 1979; Hlaváčková 1993; De Gramatica 2002; Gresch 2004.

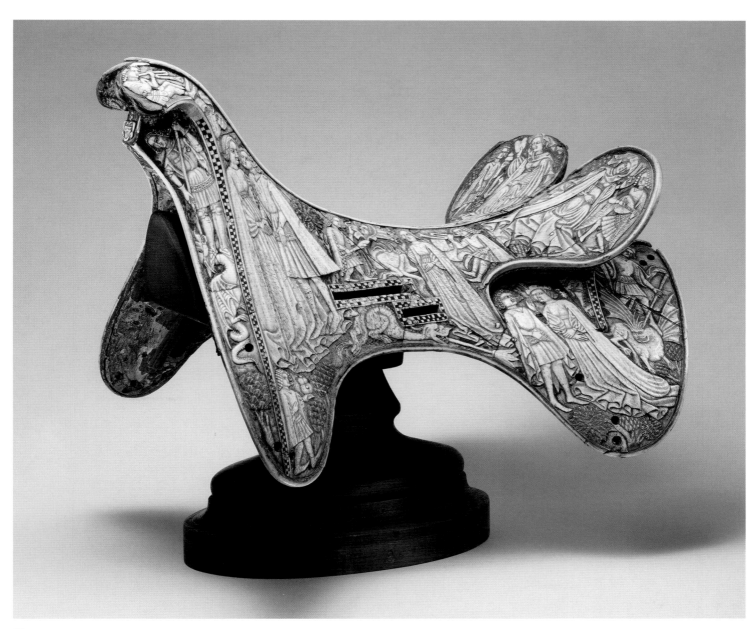

90

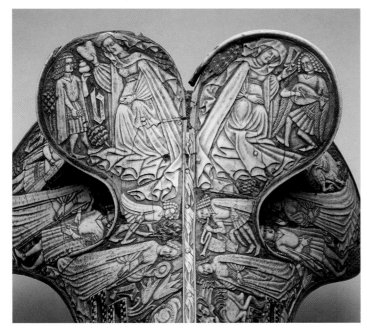

90, top view of saddle

90, back right side of saddle

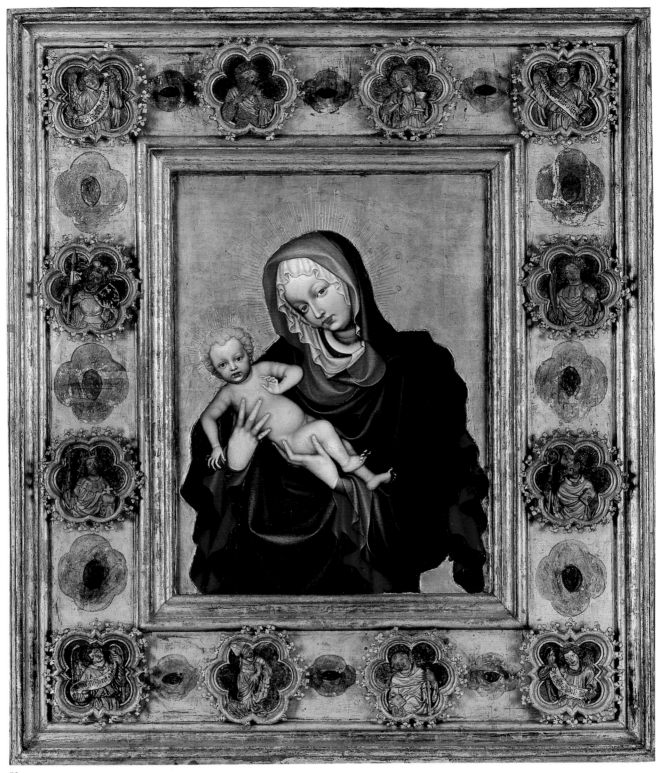

91

## 91. Virgin and Child

*Prague, 1415(?)*
*Tempera and gold on linden wood, 51 x 39.5 cm*
*(20⅛ x 15½ in.) without frame*
*Provenance: Treasury of Saint Vitus's Cathedral, Prague.*
*Painting: Metropolitní Kapitula u Sv. Víta, Prague*
*(HS 03699 A [K 342]). Frame: Národní Galerie,*
*Prague (P 5463)*

This work was probably commissioned in
conjunction with the dedication of an altar to

Saints John the Apostle and John the Baptist
in the Hazmburk Chapel of Saint Vitus's
Cathedral in 1415. The altar was donated by
Oldřich Zajíc of Hazmburk to commemorate
his brother, Prague Archbishop Zbyněk Zajíc
of Hazmburk, who died in 1411 and who may
well be the prelate shown kneeling on the
frame. The traditional dating of the panel to
1396 and the identification of the kneeling
donor on the lower edge of its frame as
Archbishop Jan of Jenštejn (r. 1379–96) are
weakened by the fact that the two Saint Johns

depicted in the frame are probably a reference
to the Church of Saint John Lateran in Rome,
and not to the donor's patron saints.

The pictorial type of the Virgin presenting
her child to the viewer was apparently intro-
duced to Prague from Bologna by Archbishop
Arnošt of Pardubice (r. 1344–64), who studied
in Bologna.[1] This Virgin and Child from the
treasury of Prague Cathedral, however, is not
merely a replica of an enthroned Virgin of this
type, but a reworking of the image as a half-
length icon. Yet this model apparently did not

satisfy the patron. Because the Virgin was too narrowly framed and not centered in the composition, as in other Marian icons such as the one from Most (cat. 27), the painter filled the space to her right with a large humplike bolster of cloth and a richly undulating cascade of folds. The theme of the Virgin presenting the Child acquired new relevance when sculptors like that of the Beautiful Madonna from Krumlov (fig. 9.3) changed the position of the Child and gave his dangling arm a new gesture, clasping his mother's robe. That the painter of this Marian panel from Saint Vitus's had a statue in mind can be seen from the pose of the Virgin, which although the image is truncated is clearly a standing one, and from the precision with which the finger on Mary's right hand presses into the soft flesh of the Child (see cat. 106). The voluminous forms of the garment also recall the sculptural model.

In addition to the two Saint Johns, Saints Wenceslas, Sigismund, Vitus, and Adalbert, all patrons of Bohemia, are portrayed on the frame. Research on Bohemian art has overlooked the fact that there were precedents for Marian icons with painted figural frames in southern Germany.[2]                                   RS, JF

1. For example, see Österreichische National-bibliothek, Vienna, Cod. 2047, fol. 91r. The type of the enthroned Virgin was repeated in a small panel from Jindřichův Hradec in southern Bohemia (now Národní Galerie, Prague) and also in a mural in the church there.
2. See the painting of the Virgin and Child of about 1280 with a painted frame of about 1340 in the Museo Civico, Cremona. See Wentzel 1957–59.

LITERATURE: Matějček and Pešina 1950, no. 184, pls. 142, 143; Schmidt 1969b, p. 242; Prague 1970, nos. 193, 321; Štefanová 1985; Vienna 1990, no. 8, color ill.; Chlíbec et al. 1992, no. 12, color ill.; Bartlová 2001b, pp. 159–66.

## 92. The Mocking of Christ and The Crucifixion

*Bohemia(?), ca. 1380(?)*
*Tempera and gold on panel, each 30 x 23 cm (11¾ x 9 in.)*
*Inscribed on backs under old stamp of Berlin museum: I.1371 (on Mocking); I.1372 (on Crucifixion).*
*Provenance: Solly collection; King Frederick William III; probably his gift to Gemäldegalerie, 1841.*

*Staatliche Museen zu Berlin, Gemäldegalerie (1221, 1219)*

With the inherent drama of Jesus' Mocking and Crucifixion enhanced by gesticulating characters, crowded compositions, richly ornamented costume, and a vibrant palette, these panels have a visual potency that belies their small scale. In all likelihood they are elements from a large polyptych of the Passion like the one once above the altar of the Parish Church of Saint Michael in the Old Town (Staré Město) of Prague, which was probably created in the second half of the fourteenth century and is known from an illustration in a manuscript of the end of the sixteenth century (Národní Muzeum, Prague, Library, I A 15, fol. 218r).[1]

Both panels were prepared, characteristically, by gently scratching the outlines of the design onto the ground, which replaced black underdrawing. Whether these panels also have red underdrawing like that found on the Třeboň Altarpiece (fig. 97.1) is not clear. The crowded composition of the Crucifixion is surely indicative of Italian influence.[2] The portrayal of Jesus on the cross—the rendering of his head, the cupping of his hands, the

92, The Mocking of Christ

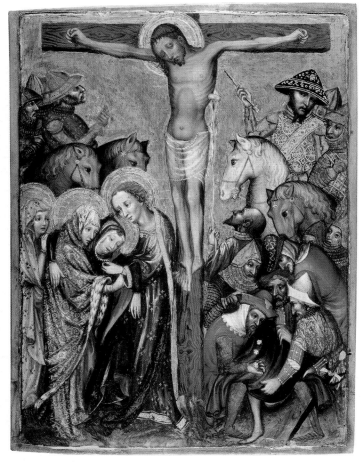

92, The Crucifixion

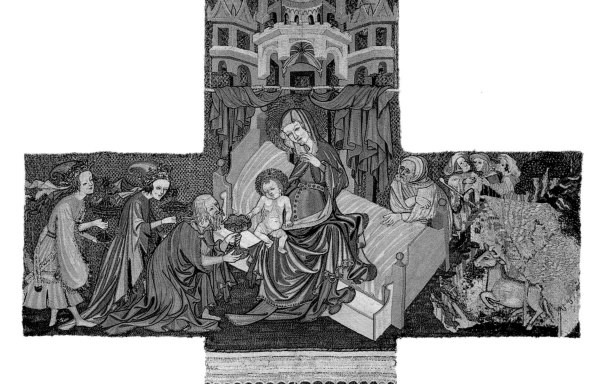

proportions of his body, his long-toed feet—
seems to draw on the same formula as does
the Vyšší Brod Crucifixion from the 1370s.[3]
This in itself is evidence that the painter was
active for a certain time in the milieu of
Prague, although it is difficult to be precise
about the provenance.

The Berlin panels present numerous
anecdotal details of the Crucifixion as
recounted in the gospels, including not only
the centurion (here on horseback) who rec-
ognizes Jesus' divinity but also the soldier who
aggravates Jesus' suffering by offering him a
vinegar-soaked sponge and the men who cast
lots for his clothes. The horses' heads are par-
ticularly beautifully rendered, and the use of
equestrian figures afforded the artist a means
of stacking more figures on a second level
beneath the arms of the cross. The sumptuous
textiles are exquisitely simulated. The tormen-
tors placed in a circle around the enthroned
Jesus and their varied poses—one uses a stick
to push the crown of thorns down on Jesus'
head in order to protect his own hands from
injury and another tightens a noose around
his neck—attest to the narrative sophistica-
tion of the artist.                              BDB

1. Brodský 2000, p. 5, no. 3, fig. 3.
2. See, for example, the Crucifixion by Jacopo di
   Cione in the National Gallery, London, in
   London 1989–90, p. 151, pl. 133.
3. Stange 1934–61, vol. 2 (1936), fig. 64; Chlíbec
   et al. 1992, pp. 28–29, no. 11.

93

LITERATURE: Vienna 1962, p. 84, no. 7, figs. 86,
87; Gemäldegalerie, Berlin, 1996–98, vol. 1, p. 19,
nos. 1219, 1221, figs. 34, 35.

## 93. Embroidered Orphrey from a Chasuble

*Probably Bohemia, ca. 1390*
*Silk and metallic threads on linen, 113 x 64.5 cm*
*(44½ x 25⅜ in.)*
*Provenance: Martin Le Roy, Paris, until 1956.*
*Musée du Louvre, Paris, Département des Objets*
*d'Art (OA 9943)*

Three scenes from the life of the Virgin,
embroidered in vibrantly colored silk thread
on a gold background, decorate this well-
preserved orphrey in the form of a Latin
cross. At the bottom, the Annunciation to the
Virgin is depicted in an interior space. (The
lower portion of the scene has been truncated.)
Immediately above, the Virgin and her cousin
Saint Elizabeth, mother of John the Baptist,
greet each other. This meeting, known as the
Visitation, came to be celebrated annually in
Prague through the efforts of Archbishop Jan
of Jenštjen[1] and thus was particularly impor-
tant in Bohemia at this time. The Adoration of
the Magi fills the horizontal arms of the cross
as well as the upper third of its vertical shaft.

The masterful embroidery of this orphrey
has long been considered a key Bohemian

work. Based in part on a comparison between this Adoration of the Magi and depictions of the same scene in wall paintings at Karlštejn Castle and Saint Vitus's Cathedral in Prague, Emanuel Poche argued strongly for a Bohemian attribution.[2] Leonie von Wilckens believes that the stylized emphasis on detail is atypical of Bohemian embroidery and attributes the Louvre orphrey and the panels in the Metropolitan Museum (cat. 94) to the Tirol or Alpine regions. She failed to cite specific comparisons, however, and in the absence of any other cogent argument to localize the orphrey elsewhere the case for a Bohemian origin remains convincing.    PB

1. See Weltsch 1968, pp. 87–91.
2. Cologne 1978–79, vol. 2, p. 714.

LITERATURE: Vienna 1962, no. 528, pl. 99 (with bibl.); Schuette and Müller-Christensen 1964, pp. 152, 313; Wilckens 1966, pp. 311–12; Cologne 1978–79, vol. 2, p. 714, vol. 5, p. 472 (with bibl.); Wilckens 1991, pp. 251–52; Wetter 2001, pp. 13–16.

## 94. Two Embroidered Panels

*Probably Bohemia, last quarter of 14th century*
*Silk and metallic threads on linen, parchment, and paper; 52.5 x 21.1 cm (20⅝ x 8¼ in.), 42.7 x 19.8 cm (16⅞ x 7¾ in.)*
*Provenance: Emil Delmar, Budapest, until 1961; Schaeffer Galleries, New York, 1961.*
*The Metropolitan Museum of Art, New York, The Cloisters Collection, 1961 (61.16b, c)*

A background pattern of gilded threads organized in regular circles enlivens both these embroidered panels. In the first, Christ the Redeemer, enthroned beneath a vaulted Gothic canopy, gestures in benediction while supporting a closed book on his left knee. In the second panel the Virgin, holding a flowering staff in her left hand, sits on a bench with the standing Christ Child. A winged angel swoops down to place a crown upon her head. The Coronation of the Virgin panel is larger and more sophisticated. The embroiderer has made especially effective use of texture, in the raised metallic threads of the crown, the cruciform halos, and the curly silk hair of the Child. Bright red silk outlines the arms and upper side of the torso of the angel, causing the pale drapery to emerge from the gold background, and the variety of stitches used in the Virgin's throne creates a sense of depth that is not seen in Christ's throne. Paper was used under the threads of the faces, and parchment gives depth to the frames around the figures.

The color scheme, figure style, background pattern, and compositions of these panels all signal the work of the masterful embroidery

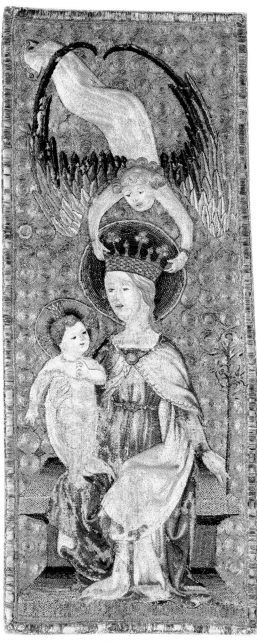

94, The Coronation of the Virgin

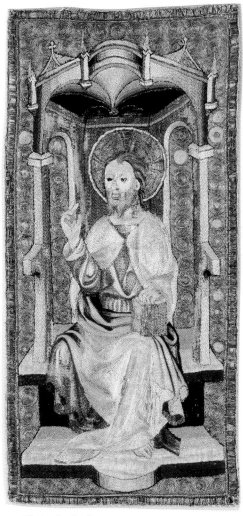

94, Christ the Redeemer

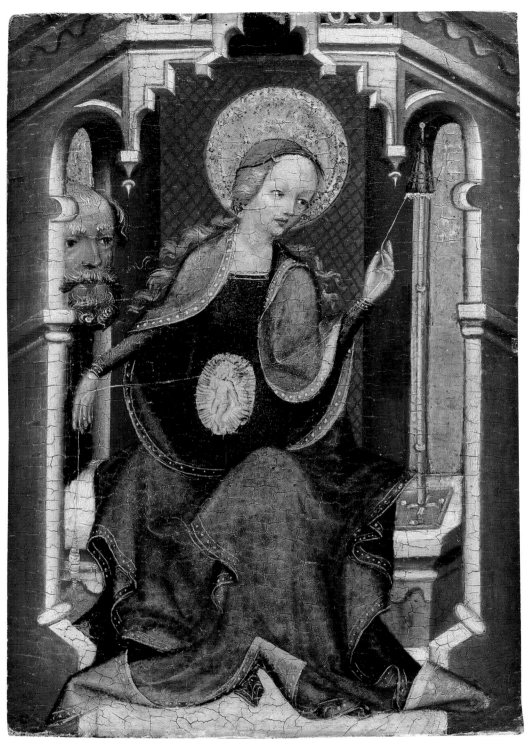

95

workshops active in Prague. The chasuble from Rokycany (cat. 40), for example, provides a point of departure for the figure style, the architectural canopy, and the angel in a flying pose. Leonie von Wilckens has suggested, based on the figure types and gestures, that these two New York panels and the chasuble in Paris (cat. 93) are Austrian or Alpine works dating from the first third of the fifteenth century. In the absence of a specific comparison with an Austrian or Alpine work, however, it seems best to view the New York panels as either Bohemian or produced within the sphere of Bohemian influence.

The panels could have served originally to decorate a vestment, but it is also possible that they were intended for an antependium or some other altar decoration.[1]     PB

1. At the time of their acquisition by the Metropolitan Museum in 1961 these two embroidered panels were being used as orphreys on the back of a chasuble made of late-fifteenth-century Italian velvet. The chasuble has been altered, however, and exhibits considerably more wear than the embroidered panels, suggesting that the elements did not have a long life together. They were separated from the Italian velvet in the Textile Conservation Laboratory at the Museum in the 1980s.

LITERATURE: Mannowsky 1931–33, vol. 1, p. 18, no. 24; Bern 1939–40, no. 48; Weibel 1946, p. 148; Husband 1971, p. 286; Chicago 1975–76, no. 20; State College, Pa., 1980, no. 5; Cologne 1985, p. 156; Wilckens 1991, pp. 249, 252; Wetter 2001, p. 19n49.

## 95. The Pregnant Virgin at the Spindle

*Bohemia(?), ca. 1390[1]*
*Tempera and gold on panel, 27 x 19 cm (10⅝ x 7½ in.)*
*Provenance: Galerie von Diemen, Berlin; its gift to Gemäldegalerie, 1920.*
*Staatliche Museen zu Berlin, Gemäldegalerie (1874)*

Mary, with flowing hair, sits on a wide bench in a little house open at the front. She gazes intently to her left at the thread coming from the distaff in her left hand and passing through her right hand to her spindle. Her cloak, drawn around her shoulders and laid across her knees, frames the unborn child in her womb. The gloriole surrounding the child reflects his divinity. His earthly father, Joseph, bearded and aged, peeps in from the side through a window. There is no contact between him and Mary, who looks the other way; this is clearly not the home of an ordinary married couple but Mary's alone. Legend relates that she grew up in the seclusion of the Temple (which the little house recalls), spinning the wool for its curtain, which would be torn at the hour of Jesus' death. The structure sheltering her was also probably meant as an allusion to her virginity. Joseph appears at first to be only her guardian, a marginal figure, but his approach from without and especially his earnest gaze reflect his care for Mary and the doubts that beset him when he found her pregnant after the Annunciation.

The painting's architecture, rendered in perspective, its pendant knobs, its drapery treatment, already anticipating the Beautiful Style, and Mary's rounded forehead and small mouth would suggest that the painting was executed about 1380–90. However, comparison with the dismantled baldachin altar once thought to be an Erfurt work but then convincingly traced to Nuremberg by Stephan Kemperdick (see cat. 17) reveals that this panel must have been created later—and moreover in imitation of Bohemian art, if not in Bohemia itself.[2] The same style is seen in the Enthroned Virgin between Saints Bartholomew and Margaret of about 1390 (Aleš-Galerie, Hluboká nad Vltavou, Czech Republic).[3]

MH

1. Stephan Kemperdick of the Kunstmuseum Basel believes that this painting is a work of Nuremberg origin, from the circle of the Master of the Retable of the Virgin from the Frauenkirche, and dates it to about 1410 (see his forthcoming *Catalogue of German Paintings from 1230 to 1430 in the Gemäldegalerie, Berlin*).
2. Kemperdick in Frankfurt am Main 2002.
3. Matějček and Pešina 1950, p. 59, no. 179, pls. 130–32.

96, fol. 138v (detail), The Visitation in an Initial C

LITERATURE: Kloos 1935, pp. 33ff.; Stange 1934–61, vol. 2 (1936), p. 157, fig. 196; Vienna 1962, p. 144, no. 78; Gemäldegalerie, Berlin, 1975, p. 145, no. 1874; Gemäldegalerie, Berlin, 1996–98, vol. 1, p. 45, fig. 124.

## 96. The Writings of Jan of Jenštejn

*Prague, 1396–97; binding, 19th century*
*Tempera and gold on parchment, 293 fols., 37 x 24.5 cm (14½ x 9⅝ in.)*
*Provenance: Taken to Rome by Jan of Jenštejn, 1397; entered Vatican Library, ca. 1400.*
*Biblioteca Apostolica Vaticana, Vatican City (Vat. lat. 1122)*

Archbishop of Prague by the age of twenty-eight, Jan of Jenštejn nevertheless described himself in his autobiography as an impious man whose faith blossomed only after he nearly succumbed to the plague. He was to become not only an ardent ecclesiastic but also a prolific author. This manuscript is the single richest compilation of his writings, comprising sermons, his renowned hymns, theological writings, and liturgical texts. Its illustrations, though modest in size, are inventive. Jan was a single-minded advocate of a new feast honoring the Visitation of the Virgin. As archbishop, he convinced Pope Urban VI that the brief account in the gospel of Saint Luke (Luke 1:41) of the meeting of the expectant mothers Mary and her cousin Elizabeth, who would bear John the Baptist, should be officially feted throughout the Church. Celebrated on July 2, that feast is discussed and illustrated five times in the Vatican codex (on fols. 4, 13, 138v, 157, and 187v). Jan of Jenštejn provided notes to the illuminators in the margins, mentioning both an image of the Visitation in his residence and a panel from an altar in Saint Vitus's Cathedral in Prague.

The manuscript apparently owes a debt to the *Liber viaticus* of Jan of Středa (Národní Muzeum, Prague, Library; see fig. 3.6) in its opening folios and perhaps in the charming narrative illustrations in the margins. Comparisons to the Morgan Master (see cat. 80) have also been advanced. Particularly apt are parallels to the *Life and Office of Saint Eligius* (Bibliothèque Historique de la Ville de Paris; see fig. 6.6). Because the Vatican manuscript must date after Jan of Jenštejn's resignation as archbishop in 1396, this comparison provides sure evidence that the Eligius manuscript was created after the death of Charles IV in 1378, and therefore could not have been made in exchange for the gift to the emperor of the relic of Eligius's miter (see cat. 62) from his nephew Charles V of France. The foliate ornament in the borders is clearly consistent with manuscripts from the circle of Wenceslas IV, with whom the ascetic archbishop was otherwise increasingly at odds until his resignation and flight to Rome in 1396.

JF, RS

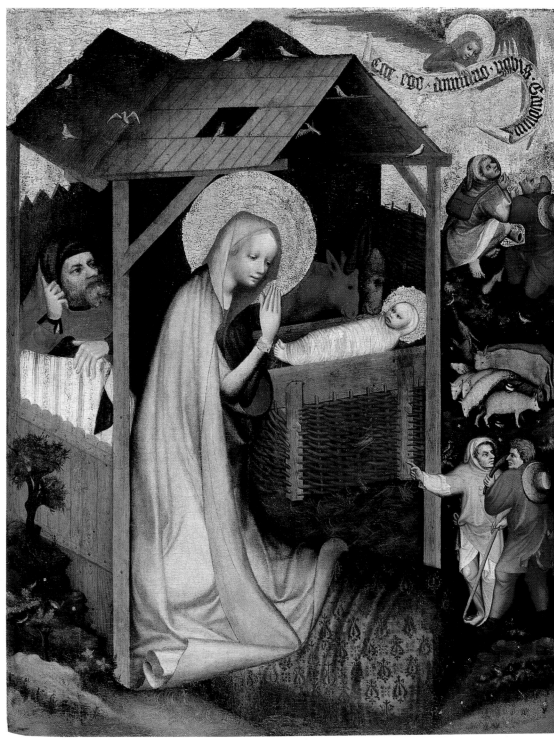

97

LITERATURE: Emler 1871; Poncelet 1910, p. 29; Friedl 1931; Pelzer 1931, pp. 749–63; Weltsch 1968, esp. pp. 87ff.; Schmidt 1969b, p. 236; Krása 1974a, pp. 174, 190, 200, 209; Krása 1984, p. 423, fig. 39; Polc and Herzogenberg in Prague–Munich 1993, pp. 94–96, no. 5.

## 97. The Nativity

*Master of the Třeboň Altar, Prague, 1380s*
*Tempera and gold on panel, 129 x 98 cm (50¾ x 38⅝ in.)*

*Provenance: Schwarzenberg family, Hluboká Castle, 19th century; castle and its contents left to Czechoslovak State Administration, 1939; transferred to Czechoslovak Republic, 1947; National Institute of Historical Monument Care, České Budějovice, since 1990s. Národní Památkový Ústav, Územní Odborné Pracoviště, České Budějovice, Czech Republic (HL 7356)*

The Christmas story unfolds in a remarkably potent blend of anecdotal detail and devotional imagery in this panel by the Master of the Třeboň Altar, the most celebrated painter active in Bohemia in the late fourteenth century. Known for the refined drawing and

highly finished quality of his carefully differentiated figures, he also created dramatic stage sets for sacred history. The elongated, supremely elegant figure of Mary dominates the composition. She prays before the tiny infant Jesus lying in a manger, while the more rough-hewn Joseph looks on from the background. An angel appears in the sky to announce the good news of the Child's birth to two shepherds, whose two companions are already on their way to Bethlehem. To suggest their distance, the artist rendered them in smaller scale, so that they seem oddly Lilliputian. The angles of the stable and its roof

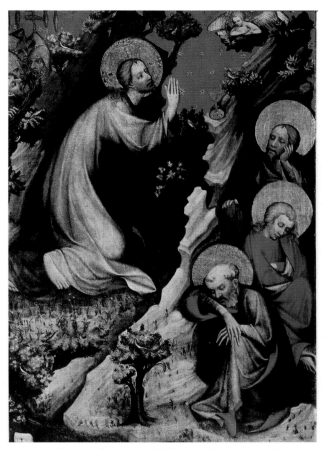

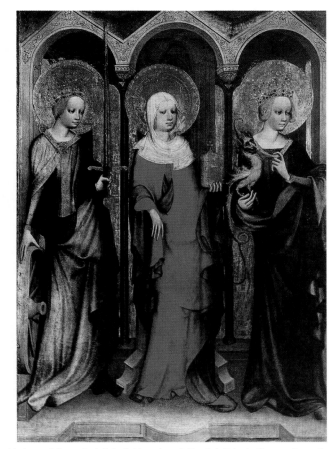

Fig. 97.1 Christ on the Mount of Olives and Three Female Saints. Double-sided panel from the Třeboň Altarpiece. Národní Galerie, Prague (O 476)

would seem implausible but for the fact that the entire narrative defies rational explanation.

The face of the Virgin Mary closely resembles those of the female saints on the wing of the Třeboň Altarpiece (fig. 97.1). This panel and one of the same approximate dimensions representing the Crucifixion (Saint Barbara near Třeboň, now Národní Galerie, Prague)[1] are also thought to come from Třeboň, where they may have been part of the same altarpiece.                    JF

1. Chlíbec et al. 1992, pp. 28–29, no. 11.

LITERATURE: Matějček and Pešina 1950, p. 57, no. 176, pls. 117–19; Prague 1970, p. 228, no. 311; Cologne 1978–79, vol. 2, pp. 769–70, ill., vol. 5, fig. T-220.

## 98. The Adoration of the Magi

*Prague, ca. 1375–78*
*Paint and gold on beechwood panel, 22.5 x 20.5 cm (8⅞ x 8⅛ in.)*
*Provenance: Sold by Christie's, London, to current owner, 1990.*
*Private collection*

With its diminutive scale and its figures and landscape spilling over into the frame, the

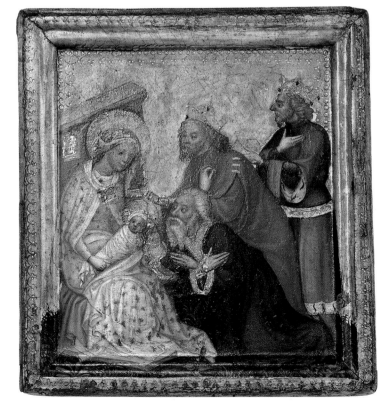

98

panel represents an unusually intimate version of the Adoration. The Virgin wears a white gown, as in the vision of Saint Bridget (d. 1372). The visit of the three wise men from the east to pay homage to the infant Jesus, related in the Gospel of Matthew (2:1–12), was celebrated annually on January 6. In its recognition of Jesus as the King of Kings, the feast of the Epiphany had special meaning for medieval rulers. These earthly kings would often assume the ceremonial roles of the Magi in the liturgy of the feast, and coronations often took place on that day. Charles IV sometimes had his own features imposed on an image of one of the Magi, as at Karlštejn Castle (see fig. 2.4) and on the Morgan Library diptych (cat. 25). Both he and his two sons may even be intended here, with the kneeling Charles, Wenceslas as Dauphin in the middle, and the red-headed Sigismund, with his rugged profile. As such, the panel is a prime example among identification portraits.

It has been noted that the use of beechwood conforms to the exceptional example of Master Theodoric. In its poetic presentation and in details such as the delicate patches of leaves and flowers, the work bears comparison with that of the Master of the Třeboň Altar (cat. 97). The gold punchwork gives the painting the same remarkable jewel-like quality seen in contemporary manuscripts.                    BDB

LITERATURE: Pujmanová 1997; Pujmanová 1998.

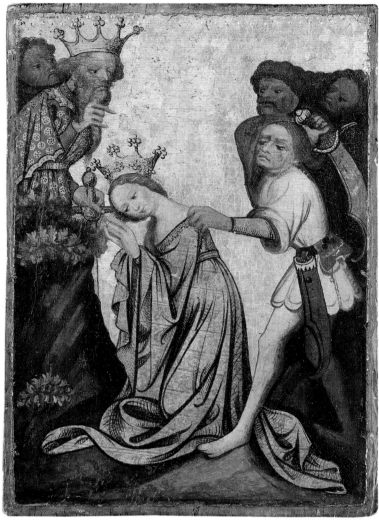

99

## 99. The Martyrdom of a Female Saint

*Magdeburg or Halberstadt, ca. 1390*
*Tempera and gold on panel, 36 x 26.3 cm*
*(14⅛ x 10⅜ in.)*
*Provenance: Richard von Kaufmann, Berlin, until*
*1917; Kaufmann sale, Paul Cassirer, Berlin,*
*December 4, 1917, lot 128; Jindřich Waldes, Prague,*
*purchased 1917.*
*Private collection*

This panel depicts the beheading of a young woman of royal blood, either Saint Barbara or Saint Catherine of Alexandria. An executioner in tights and a short skirt has just pushed up his sleeves and hauled back to bring his broad, curved sword down on his victim's neck. The saint, dressed in a richly patterned décolleté gown, kneels in the center and with lowered head awaits the deadly stroke. On the left is a suggestion of landscape, behind which a crowned ruler gives the order for the execution. Other figures suggest a crowd of onlookers.

Scholars have dated this panel and a companion panel of the Adoration of the Magi[1] to between 1390 and 1410 and linked them to Bohemia because of their similarity to the panels by the Master of the Třeboň Altar (see fig. 97.1), especially in the way the picture

space is suggested by the bit of landscape scenery and the figures crowding in from the back. The facial types, particularly of the women and the bearded men, are also similar. The Crucifixion from the Chapel of Saint Barbara, near Třeboň (Národní Galerie, Prague)

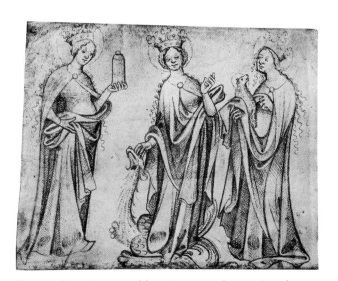

Fig. 99.1 Saints Mary Magdalen, Margaret, and Agnes. Page from a sketchbook, fol. 8r. Herzog Anton Ulrich-Museum, Braunschweig

is especially close,[2] although in this painting the modeling of the patterned clothing is more graphic than painterly, and the hems of the garments lying on the ground are more exaggerated. This panel was thus the work not of the Třeboň Master himself, but of a painter close to him, perhaps a pupil. Similar features link the panels to the sketchbook in the Herzog Anton Ulrich-Museum, Braunschweig (see fig. 99.1).[3] Alfred Stange assumed that the works were executed in the Magdeburg area, referring to the related panels from Flötz in Berlin, presumably commissioned by the counts of Barby for their burial church, Saint John in Barby.[4] Maria Deiters called attention to their affinity to the altarpiece from the Saint George Hospital in Wernigerode, donated at the behest of and to the memory of Count Dietrich of Wernigerode (d. 1386), and to works in stained glass from the Redekin Chapel of Magdeburg Cathedral. Given the many personal ties that linked the archdiocese of Magdeburg and the Halberstadt diocese, such an exchange is not surprising. The link to Bohemian art is equally unsurprising, inasmuch as the archbishops of Magdeburg had been supporters of the emperor (that is to say Prague-oriented) since the time of Charles IV.                    MH

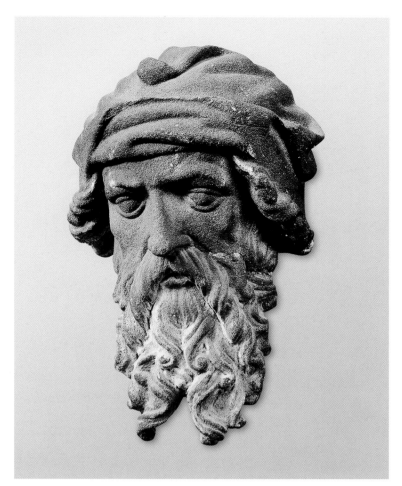

100

1. The two panels entered the Kaufmann collection together. The Adoration of the Magi was on the London art market in 1956 (*Burlington Magazine* [1956], p. 460).
2. Prague 1970, fig. 78 (O 577).
3. Ibid., pp. 313–15, no. 408, figs. 134, 135; Scheller 1995, pp. 211–17.
4. Stange 1934–61, vol. 2, p. 76, figs. 70, 71; see also Deiters 2005.

LITERATURE: Kuchynka 1919, figs. 2, 3, 6; Pešina 1935; Stange 1934–61, vol. 2, p. 76, figs. 70, 71; Pešina in Prague 1970, no. 310; Pešina 1972; Stamm 1981, p. 26; Scheller 1995, p. 214, fig. 98; Deiters 2005 (with bibl.).

## 100. Head of a Prophet from the Beautiful Fountain, Nuremberg

*Nuremberg, 1385–96*
*Sandstone with traces of paint, h. 22 cm (8⅝ in.)*
*Condition: Rear half lost; burn damage suffered in fire of Friedrichshain bunker in Berlin, May 1945; horizontal crack through proper left cheek.*
*Provenance: Acquired in Nuremberg, 1886, as gift from A. Thieme, Leipzig, and B. Suermondt, Aachen.*
*Staatliche Museen zu Berlin, Skulpturensammlung und Museum für Byzantinische Kunst (365a)*

A free imperial city, Nuremberg offered the Luxembourg emperors neutral ground to meet their vassals and thus had strategic importance. Charles IV and Wenceslas IV frequently sojourned in the Franconian city and strengthened its independence through gifts and privileges. In the Golden Bull of 1356, which laid down the rules for the election of future Holy Roman Emperors, Charles decreed that each new emperor must hold the first assembly of his officials (*Hoftag*) in Nuremberg, thereby conferring on the city a status rivaling that of Frankfurt, where the emperor was elected, and Aachen, where he was crowned. The most tangible sign of Charles's esteem for Nuremberg is the Frauenkirche on the Hauptmarkt, which he ordered built (1352–58) and financed. It is generally assumed that he employed the Parler workshop from Schwäbisch Gmünd for this project, which left its mark on the subsequent evolution of architecture and sculpture in Nuremberg.[1]

Directly across the square from the Frauenkirche stands the Beautiful Fountain (Schöner Brunnen) commissioned by the municipal council as an allegory of good government (fig. 100.1). The three-tiered fountain was erected between 1385 and 1396. At the base are figures of the seven electors

of the Holy Roman Empire and the Nine Heroes (three from classical antiquity, three from the Old Testament, and three from Christian history). The middle register, from which this head comes, holds smaller figures of seven prophets and Moses with the Tablets

Fig. 100.1 Beautiful Fountain (Schöner Brunnen), Nuremberg, with the Frauenkirche on the right, photographed before World War II

of the Law. The Four Evangelists and the Church Fathers, each with a figure representing philosophy or one of the Seven Liberal Arts, once stood on separate piers on the perimeter of the basin. Rising nineteen meters, the spirelike structure must have been conceived by a brilliant architect who also supervised the team of sculptors involved in its decoration. In all likelihood he was Heinrich Beheim the Elder, documented in Nuremberg from 1363 until 1406, whose name suggests that he came from Bohemia.[2]

The Beautiful Fountain has been under repair for most of its history, beginning in 1420. The Berlin head was probably removed between 1821 and 1824, when the fountain was taken apart and many elements replaced. The head was carved from a single block of sandstone, originally fully in the round. The carving is remarkably delicate for a sculpture intended to be polychrome and seen from quite a distance. The furrowed brow, strong nose, and pensive eyes convey a resigned, knowing expression. The pointed hat, seemingly made of a soft material, is pulled deep over the forehead, and on one side hair curls up over its edge.[3] It is detailed with as much care as the wavy beard that grows into long, curly strands. The features, especially the protruding cheekbones and heavy lower eyelids, and the accurate rendering of textures allow a general comparison with works by Peter Parler and his workshop in Prague, such as the 1377 effigy of King Přemysl Otakar I in Saint Vitus's Cathedral.[4] Whether the artist built on the sculptural innovations of the Frauenkirche in Nuremberg or was aware of more recent developments in Prague is a matter for debate. The Berlin head bears witness to the original quality of the Beautiful Fountain. Central to municipal identity, this monument emulated the splendor of the Frauenkirche, which Charles IV had "built, founded, and created . . . for the glory and renown of his reign . . . in his imperial city of Nuremberg."[5]               JC

1. Roller (2004) points out that the name Peter Parler is connected with the Frauenkirche neither by documents nor by his signature shield, and questions whether Parler was even involved in the Nuremberg project.
2. On the fountain and its decoration, see Kahsnitz in New York–Nuremberg 1986, pp. 66, 132–35.
3. Fründt 1972, p. 19.
4. For the most recent discussion of this sculpture, see Suckale 2004a, pp. 197, 200.
5. From Charles IV's founding document for the church, 1355, quoted by Kahsnitz in New York–Nuremberg 1986, p. 118.

LITERATURE: Fründt 1972, pp. 19–20 (with bibl.); Suckale 1976, esp. pp. 250–51; Cologne 1978–79, vol. 1, p. 369; Kahsnitz in New York–Nuremberg 1986, pp. 66, 132–35.

## 101. The Crucifixion

*Bohemia, ca. 1390*
*Paint and gold on panel, 22.5 x 20.5 cm (8⅞ x 8⅛ in.)*
*Private collection*

The small, square format of this panel most likely indicates that it, like the small Adoration of the Magi (cat. 98), was intended for personal devotion. That does not, however, preclude an ecclesiastical setting. A square panel of relatively small proportions representing the *vera icon* is pictured on the altar of a church in the Gerona Martyrology (fig. 137.2). Regardless of their original function, these works are so accomplished that their patrons must have come from the highest echelons of society. The composition conforms in large measure to the groupings already presented in the Emmaus Crucifixion of the mid-fourteenth century:[1] The figure of Saint John the Evangelist, who almost canonically appears opposite the Virgin, has been curiously omitted, giving greater prominence to the centurion who holds a shield and points to Jesus on the cross as he recognizes his divinity. Olga Pujmanová posits that the features of Wenceslas IV may have been adopted for the centurion, which conforms to the type in the Crucifixion from the Chapel of Saint Barbara, near Třeboň.[2]

The glazes defining the figures are better preserved than on many large-scale Bohemian paintings, which have more often suffered from cleaning. The pointillé decoration that forms the saints' halos adds shimmering texture to the panel.               BDB

1. Matějček and Pešina 1950, fig. 81.
2. Stange 1934–61, vol. 2 (1936), fig. 64.

LITERATURE: Pujmanová 1998, pp. 215–16.

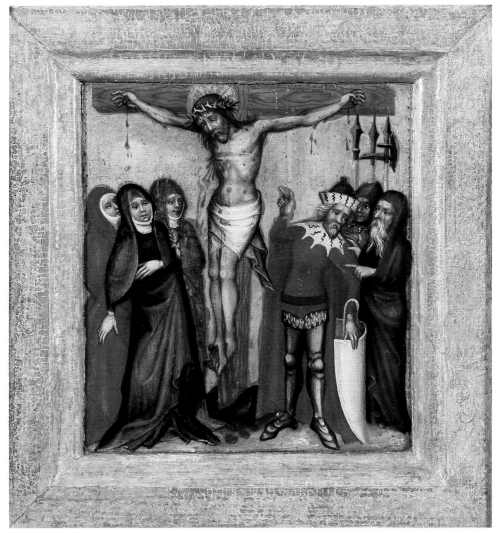

101

## 102. Dalmatic Panels with the Life of Saint Vigilius of Trent

*Prague, 1390–91*
*Gold and silk embroidery (couching, split stitch,*
*stem stitch, French knots) on linen, each 42 x*
*52–56 cm (16½ x 20½–22 in.)*
*Provenance: Cathedral of Saint Vigilius, Trent,*
*commissioned for consecration of Georg of*
*Liechtenstein, prince-bishop of Trent (r. 1390/91–*
*1419); Museo Diocesano Tridentino, since its*
*establishment in 1903.*
*Museo Diocesano Tridentino, Trent (13, 15)*

According to a 1734 inventory, eight panels
illustrating the life of Saint Vigilius (ca. 353–
405) were once mounted on the front and back
of two blue velvet dalmatics. Together with a
chasuble, they were part of the consecration
vestments of Georg of Liechtenstein, elected
bishop of Trent in 1390. The bishop came from
Nikolsburg (now Mikulov) in Moravia and had
previously served as provost of Saint Stephen's
Cathedral in Vienna. He arrived in Trent in
March 1391.[1] Four of the dalmatic panels and
the cross from the chasuble, bearing the bishop's
coat of arms (fig. 102.4), have survived. The
present whereabouts of a fifth panel, last pub-
lished in 1908 (fig. 102.3), are unknown.

The cycle, as depicted in the extant panels,
begins with the mission and martyrdom of
Saints Sisinnius, Martyrius, and Alexander in
the Valle di Non, which serves to prefigure the
Alpine mission of Vigilius and his martyrdom
in the Rendena Valley, followed by the cere-
monial return of the saint's body to Trent, his
entombment, and the delivery of the news of
his martyrdom to the pope and to Emperor
Theodosius. The final panel shows the emperor
in his victorious battle over the fleeing Goths.
The saint's acta are sewn into the banner of
the imperial troops.

The rich embroidery is notable not only
for the narrative density of the individual
scenes but especially for the political exploita-
tion of the saint's legend, particularly as a
strong argument for the Trent bishops' secular
authority: after Theodosius, the acta of Vigilius
were presented to other rulers as well, likewise
to help them in battle. Territories and privi-
leges had been granted to the bishops of Trent
as a result. It was said that Theodosius had
even permitted the diocese to use the imperial
eagle on its coat of arms. For this reason, the
emblem figures prominently on the imperial
banner in the battle scene—the black silk
with which it was embroidered onto the gold
background has fallen away, to be sure, but
its shadow is still clearly visible. The imperial
eagle thus anticipates fiefdoms that would
only later be granted to the bishops. As Georg

Fig. 102.1 The Mission and Martyrdom of Saints Sisinnius, Martyrius, and Alexander. Museo Diocesano Tridentino, Trent (12)

Fig. 102.2 Vigilius Celebrates Mass and Casts Out Idols. Museo Diocesano Tridentino, Trent (11)

of Liechtenstein struggled throughout his
episcopate to become answerable solely to the
emperor and to advance his claims to secular
powers,[2] the vestments' pictorial program can
be understood as a kind of opening argument,
and it was important to that argument that
the work be commissioned from artists in
Prague, the imperial capital.

The narrative cycle, with two scenes on
each panel, reflects its hagiographic model,
with the scene showing the translation of the
saint's body virtually a word-for-word realiza-
tion. The closeness of the design to the text of
the saint's life makes sense if the work was to

be commissioned in Prague, and underlines
its consummate artistry. At the same time, the
architecture of the scene in the Rendena
Valley incorporates structural features com-
mon in Prague painting. The influence of
Prague book illumination of the 1370s and in
1389, most notably the workshop that pro-
duced the 1389 Bible of the vicar Kuneš,[3] is
felt here, both in the softly modeled drapery
rendered in split-stitch embroidery and in
the protagonists' physiognomies and such
Italianizing motifs as the plowed earth studded
with delicate plants and stunted, gnarled trees.
It has been claimed that the design for the

102, Translation of the Body of Vigilius

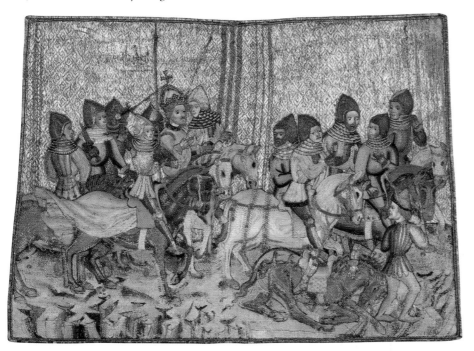

102, The Emperor Defeats the Ostrogoths

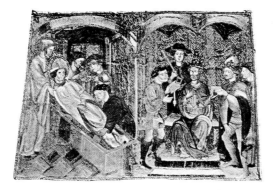

Fig. 102.3 Embroidered panel with the Entombment of Saint Vigilius and the Delivery of the News of His Martyrdom to the Pope and to Emperor Theodosius. Present location unknown

embroideries was by the Master of the Cycle of the Months frescoes in Trent's Eagle Tower,[4] a painter documented to have been a certain Wenzel from Bohemia who incorporated French and Lombard influences in his work. The embroidered panels, however, though not totally isolated examples, must be treated as independent works. Discussing them in the context of the "Wenzel debate" and the fresco cycle in Trent only detracts from their artistic and programmatic importance.          EW

1. Vareschi 1997, p. 293.
2. Wetter 1996–98, pp. 24–28; Wetter 2001, p. 38.
3. Národní Knihovna, Prague (Ms. 1). See Wetter 1996–98, pp. 71–85, and Wetter 2001, pp. 60–61.
4. Gerola 1923; Rasmo 1957; Castelnuovo 1986; Devoti et al. 1999, p. 48 (d. Digilio). "Magist[er] Winceslao pictor[.]" is documented as being in the service of the bishop beginning in 1397 (Curzel 2000; see also Wetter in Trent 2002, p. 335).

LITERATURE: Wetter 2001, pp. 38–59, 123–25, no. 2; Wetter in Trent 2002, pp. 514–17, no. 45.

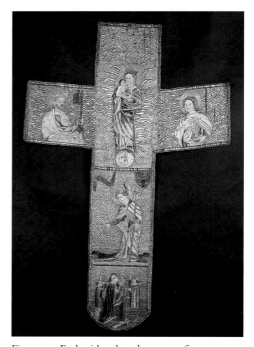

Fig. 102.4 Embroidered orphrey cross from the chasuble of Georg of Liechtenstein. Museo Diocesano Tridentino, Trent (10)

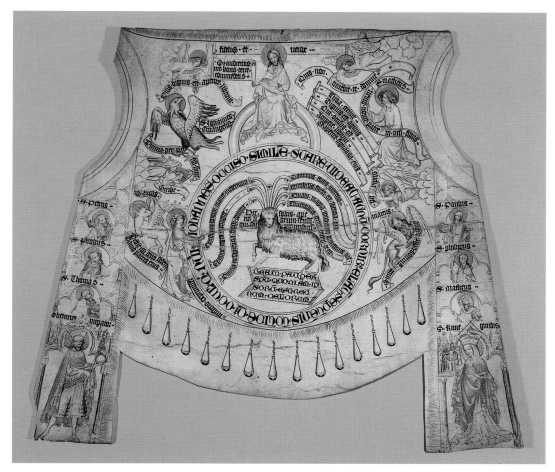

103

## 103. Copy of the Bamberg Rationale

*Bohemia, ca. 1421*
*Ink and wash on parchment, 61 x 52 cm (24 x 20½ in.)*
*Collection Graf von Schönborn, Pommersfelden*

During the Middle Ages the pope conferred the rationale, a humeral worn over the chasuble, on a number of bishops in German-speaking lands. (It is today worn only by the bishops of Eichstätt, Paderborn, Toul, and Kraków.) The episcopal equivalent of the pallium that the pope bestows on archbishops, the rationale was based, at least in name, on the breastplate of the high priest Aaron.[1]

This drawing on parchment reproduces the rationale the emperor Henry II probably presented to the first bishop of his newly founded bishopric of Bamberg on the occasion of the dedication of the cathedral church in 1012. The largely ruined original is still in Bamberg Cathedral.[2] Its sophisticated design incorporates numerous inscriptions. At the center, Christ in Majesty stands above the Lamb of God, which represents his human manifestation and sacrifice according to the vision of John the Evangelist (Apoc. 5–7), who appears on the side. The four apocalyptic beasts symbolic of the Four Evangelists and four angels surround the visions. Three apostles stand to the left and three to the right. The saintly imperial couple, Henry II and Cunigunde, must have been added to the Bamberg original after they were canonized (in 1146 and 1200, respectively).

Attempts have been made to connect this drawing with a report that the Bamberg Rationale was repaired by the silk painter Jörg Spiess in 1476.[3] But the copyist belonged to the much earlier group of illuminators associated with the Master of the Gerona Martyrology (cat. 86).[4] The same artist executed the design for the embroidered half-length figure of Saint Cunigunde on the back panel of her so-called choir mantle in 1421–22.[5] The drawing after the Bamberg Rationale probably was made at about the same time. It could either have served as a model for repair work or have been preparatory to a complete replica of the original, perhaps at the behest of Albrecht von Wertheim, who was bishop of Bamberg between 1399 and 1421 and one of the closest advisers of Wenceslas IV's rival Ruprecht of the Palatinate (r. 1400–1410).

This artist is closely related to the illuminator of the German translation of the Moral Apologues of Saint Cyril (British Library, London, Egerton 1121), a painter who settled in Salzburg in the 1420s.[6] But even more remarkable is the kinship between this depiction of the imperial couple and the refined, softly undulating Bohemian-influenced forms of the tomb monument of Albrecht von Wertheim in Bamberg Cathedral, which dates to before 1421.

RS, JF

1. See Bamberg 2002, pp. 386–87, no. 207.
2. Messerer 1952, p. 67, no. 73.
3. Pölnitz n.d.
4. He cannot, however, be identified with the painter of the compendium from Metten dated 1414–15 (Bayerische Staatsbibliothek, Munich, Clm. 8201), as Steingräber maintained in Munich 1955, p. 22.
5. Bamberg 2002, pp. 384–85, no. 205. According to a documentary note, the needlework was carried out by "Friedrich the silk embroiderer" in 1421–22.
6. Schmidt 1986, pp. 41–57, 245–52.
7. Noack 1930, p. 98.

LITERATURE: Messerer 1952, p. 67, no. 72.

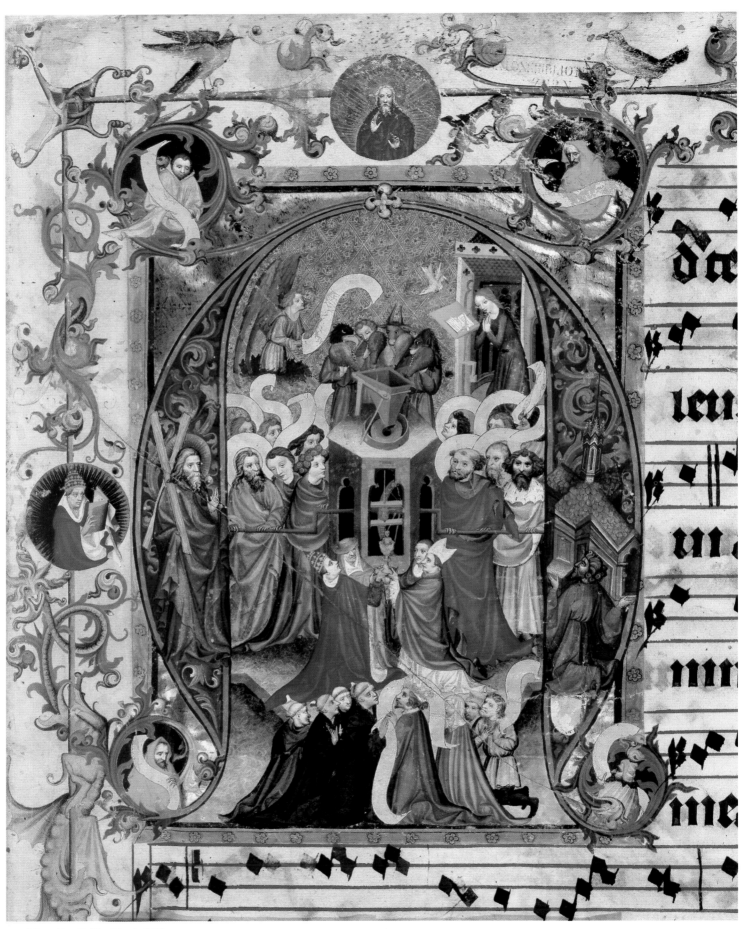

104, fol. 1r (detail), The Mystic Mill

## 104. Gradual

*Prague, ca. 1410*

*Tempera and gold on parchment with original binding, 237 fols., 61 x 41 cm (24 x 16⅛ in.)*

*Provenance: Bohemian Cistercian Monastery, later Gnadenthal (Aargau); donated to Cistercian Abbey of Saint Urban, 1833;[1] given to the Kantonsbibliothek, Lucerne, upon dissolution of abbey, 1848; now Zentral- und Hochschulbibliothek, before 1951.*

*Zentral- und Hochschulbibliothek, Lucerne, Sondersammlung Handschriften und Alte Drucke (P.19.fol)*

This gradual contains chants for the Mass from the first Sunday of Advent through Easter Saturday, with the sanctorale from the feast of Saint Andrew to the Conversion of Saint Paul. Judging from the liturgy and the rubrics, the manuscript was designed for a Cistercian monastery.

The Introit for Advent (fol. 1r) opens with the allegorical image of the Mystic Mill: Christ, the incarnation of God's Word, proclaimed by the evangelists as the grain ground in the mill by the apostles into the redeeming Bread of Life, which would nourish the souls of the faithful.[2] The Eucharist, emblematic of the Logos, lifted in a chalice by the four Church Fathers, is revered by a community of Cistercian monks[3] and by representatives of secular society, headed by the king. These laypeople are probably the founders or benefactors of the monastery. Although the donor is portrayed in the stem of the letter, the empty coat of arms makes it impossible to establish his identity.[4] Allusions to biblical texts are found in the figures of the Hebrew prophets in the corners of the initial, accompanied by the medallions of Saints Gregory, Jerome, Dorothy, Catherine, and Elizabeth in the borders.

The illumination of the opening page and of folio 29, which originally contained an initial of the text for the third Christmas Mass, now cut out, are the work of the Master of the Antwerp Bible. His earliest miniatures survive in the Bible of Konrad of Vechta (cat. 85). The same hand can be recognized in some of the illuminations in the Gerona Martyrology (cat. 86), and the same artist created the signs of the zodiac in the Missal in Vienna (Österreichische Nationalbibliothek, Cod. 1850).[5] Gerhard Schmidt attributes to the Master of the Antwerp Bible only the frame with the medallions on folio 1r of the Lucerne Gradual. He gives the initial with the mill to the master's close assistant, who also created the initial with the Resurrection in the Gradual of Master Václav Sech (Archive of Charles University, Prague), the sanctorale portion of which could have contained the Washington miniature of the Dormition of the Virgin (cat. 105).[6]

The remaining decoration of the Lucerne gradual[7] is the work of the artist who collaborated with the Master of the Antwerp Bible on the Gradual of Master Václav Sech[8] and who independently illuminated the Gelnhausen Law Manuscript of the City of Jihlava (1407–19).[9] Of the illuminations that were cut out of the Lucerne Gradual, the initial E(cce) featuring an image of the Adoration of the Magi (fig. 104.1) survives in an unknown collection.[10]       MS

The author wishes to thank the Grant Agency of the Czech Academy of Sciences for its support (A 8033202) in developing this text.

1. As noted in *Ex Dono Monasterii Monialium O.C. in Valle Gratiarum vulgo Gnadenthal Die 22. Octobr. 1833.*
2. Similar images with the iconography of the eucharistic mill are preserved in Cistercian monasteries at Doberan and Rostock. The empty inscription scrolls probably bore the text of the Creed.
3. Depictions of Cistercians in black habits can be found, for instance, in the Lectionary of Marienstern (Národní Knihovna, Prague, Osek 76, fol. 16r) and in the Gerona Martyrology (fol. 82v).
4. According to Frinta (1964, p. 294n24), the presence of Saint Andrew in the second part of the letter implies that the donor may be Ondřej (Andrew) of Dubá, the high justice (d. 1412/13).

Fig. 104.1 The Adoration of the Magi in an Initial E. Present location unknown

105

The depiction of Saint Andrew need not be in connection with the donor. The Cistercian monastery in Zbraslav preserved the apostle's remains in a reliquary donated by Queen Elizabeth Přemysl of Bohemia. Charvátová 2002, vol. 2, p. 244. Zbraslav, founded by King Wenceslas II in 1292, was chosen by Wenceslas IV as his burial place.

5. For other works, see cat. 85.
6. Schmidt 2005, pp. 349–50.
7. Figural initials: fols. 22v (Adoration of Christ), 24v (Annunciation to the Shepherds), 34r and cutout initial (Adoration of the Magi), 153v (Entry into Jerusalem), 204v (The Stoning of Saint Stephen), 207r (Saint John the Evangelist), 221v (Saint Anthony), 236r (Saint Paul). For descriptions, see Schmid 1941, pp. 25–27.
8. Charles University, Prague, Archives, without signature, fols. 152r, 159r; Stejskal and Voit 1991, p. 41, no. 9
9. State Regional Archives, Jihlava, almanac 3. The illuminator is identified by Stejskal in Stejskal and Voit 1991, p. 42n6.
10. Eich 1945, ill. 77.

LITERATURE: Schmid 1941, pp. 25–27; Pešina 1960, p. 119; Frinta 1964, p. 294; Krása 1990, p. 238, fig. 143; Gerona Martyrology 1997–98, vol. 1, ill. p. 119; Schmidt 2005, pp. 345–46, 349–50.

## 105. The Dormition of the Virgin in an Initial G

---

*Prague, ca. 1410*
*Tempera and gold on parchment, 16.2 x 16.8 cm (6⅜ x 6⅝ in.)*
*Provenance: E. Rosenthal, Berkeley, Calif.; L. J. Rosenwald, Jenkintown, Pa., 1951; acquired by National Gallery of Art, 1951.*
*National Gallery of Art, Washington, D.C., Rosenwald Collection 1951 (1951.10.1)*

In monastic choir books, the initial B signaled the opening hymn, "G[audeamus Omnes]" (Let Us All Rejoice), of the Mass for the Assumption of the Virgin, celebrated on August 15. Here, the apostles gather around the bed of the Virgin, who is at the point of death. The bearded and balding Saint Peter, his lips parted, reads the last rites, while the youthful Saint John helps him hold his place in the prayer book. The already crowned Christ, in a cloud, holds his mother's soul, which is rendered as a doll-like figure in a white robe.

The illumination, which conforms to a well-established formula for this scene, bears all the hallmarks of the best manuscript painting at the time of Wenceslas IV: the bright palette with surprising juxtapositions of color, the accomplished realization of faces, the sophisticated drapery, the delicate scrolling background,

the thick burnished and punched gold leaf. The facial types of the apostles are especially reminiscent of those in the Mystic Mill of the Lucerne Gradual (cat. 104). This illumination could not have been intended for the same choir book, however, as the notation is distinct.

BDB

LITERATURE: Schmidt 1969a, pp. 153ff., fig. 202; Washington 1975, pp. 162–63, no. 43 (with bibl.); Gerona Martyrology 1997–98, vol. 2, pp. 120, 125, 155; Studničková 1998, p. 125.

## 106. Virgin and Child

---

*Prague, ca. 1390*
*Limestone with extensive original paint and gilding, h. 84 cm (33⅛ in.)*
*Provenance: Probably Church of Augustinian Canons, Šternberk; sacristy of the church at Babitz, Olomouc district, 1957.*
*Římskokatolická farnost Šternberk (I/B-22)*

The importance of this figure, first discovered in 1957, was long ignored because its subject and visual rhetoric were misinterpreted. Viewed frontally, the infant Jesus looks out with a penetration found in the late fourteenth century only in certain devotional images, such as the Man of Sorrows.[1] The Child commands complete attention. His head is almost at the same level as his mother's, and Mary's movement, her gestures, and the arrangement of her garments all lead our gaze to him. Yet instead of presenting the Child, she grasps his body as if to protect him from imminent danger, and with her left hand she lifts his small foot, drawing attention to it. The sculptor was attempting to convey, by novel means, Mary's and Jesus' foreknowledge of the Passion. Saint Bridget of Sweden heard Mary speak in a vision: "As I saw the holes made by the nails in his hands and feet, which, as I understood from the prophets, he would suffer at the Crucifixion, my eyes filled with tears, and my heart was torn by pain."[2] The Passion had traditionally been symbolized by a goldfinch in Jesus' hand.[3] The sculptor of the Šternberk Virgin and Child dared to express these intense feelings through such details as the earnest facial expression and solemn pose of the Child as well as the dreamy look of the Virgin and the gesture of her right hand. This new emotionalism is enhanced through the burning red of the Virgin's mantle, the rhythm of the folds in the garment under her arm, and above all the rich contrasts and tensions that pervade the entire composition.

The preconditions for this new style were the simplified yet emotionally loaded forms established by Peter Parler in the Virgin from the Church of Saint Mary Magdalen in Wrocław[4] and a renewed interest in French sculpture from the time of Saint Louis (1214–1270), with its dynamic drapery and highly active and extenuated forms. This statue was most likely carved in the circle of Prague Cathedral's sculpture atelier about 1390.[5]

RS, JF

1. The point of view has been shifted in this manner in the photograph in Cologne 1978–79, vol. 2, p. 687.
2. Clarus 1888, vol. 4, pp. 79–81, and see also vol. 1, p. 170.
3. Friedmann 1940.
4. See Schmidt 1992, pp. 279–80; Kaczmarek 1999, pp. 177–78, 272; Suckale 2004a, pp. 197–205; and Kaczmarek in Prague 2002–3, pp. 140–61.
5. Hlobil's proposal (in Olomouc 1999–2000, pp. 267–74) that it was meant for the Castle Chapel at Šternberk is contradicted by the figure's orientation, never mind that it does not fit on the console. Most likely it was commissioned for the Church of the Augustinian Canons in Šternberk, for which its founder, Albert of Šternberk, endowed masses in honor of the Virgin.

LITERATURE: Kutal 1958; Prague 1970, no. 210, color ill.; Clasen 1974, pp. 60–62, figs. 33–35; Bachmann 1977, fig. 63; Cologne 1978–79, vol. 2, pp. 687–88, ill., vol. 5, pp. 120, 191, figs. 5, T-204, T-205; Suckale 1981; Schmidt 1992, pp. 287–96; Hlobil in Olomouc 1999–2000, pp. 267–72; Rome 2000–2001, no. 1, color ill.

## 107. Virgin and Child

---

*Bohemia, ca. 1395*
*Limestone with traces of paint, h. 117.5 cm (46¼ in.)*
*Condition: Child's upper body and feet and Virgin's crown, right hand, and left index finger missing; losses in drapery and along edges of plinth; tip of Virgin's nose a 19th-century replacement; perpendicular scratches on the Virgin's sternum mark the location of a brooch once glued to the sculpture.*
*Provenance: Possibly acquired in Silesia by Karl Thewaldt, mayor of Cologne;[1] Thewaldt sale, Lempertz, Cologne, November 4–14, 1903, lot 784.*
*Rheinisches Landesmuseum Bonn (16058)*

Among the most celebrated creations of Bohemian art are exquisite sculptures of the standing Virgin with the Christ Child like this one, popularly known as Beautiful Madonnas, an adjective used since the late fourteenth century to describe this form of art.[2] Although conceived with a crown, Beautiful Madonnas

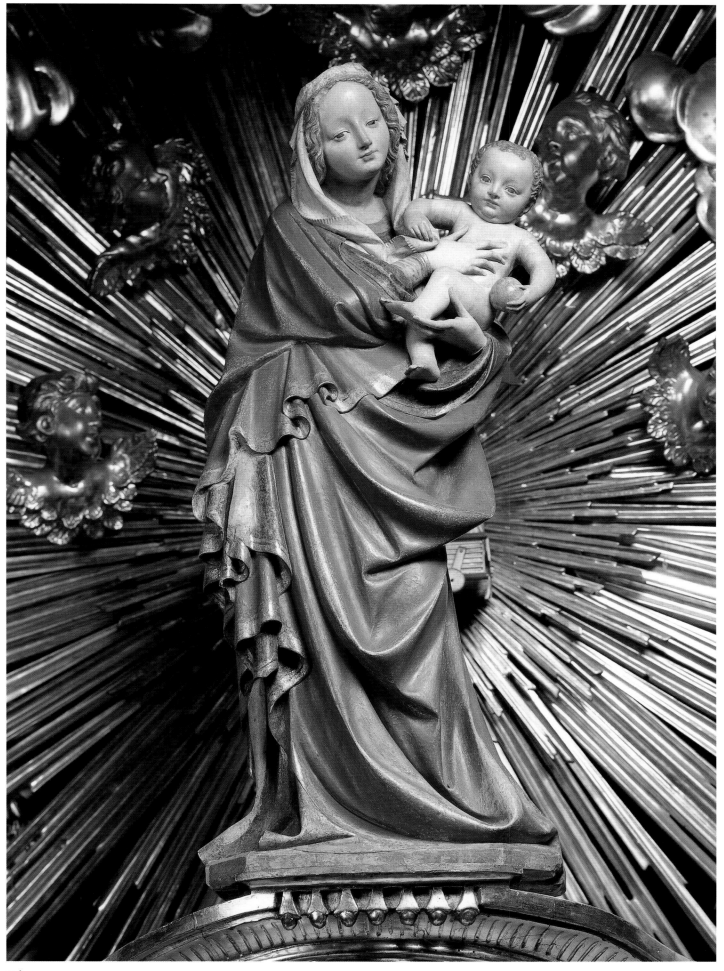

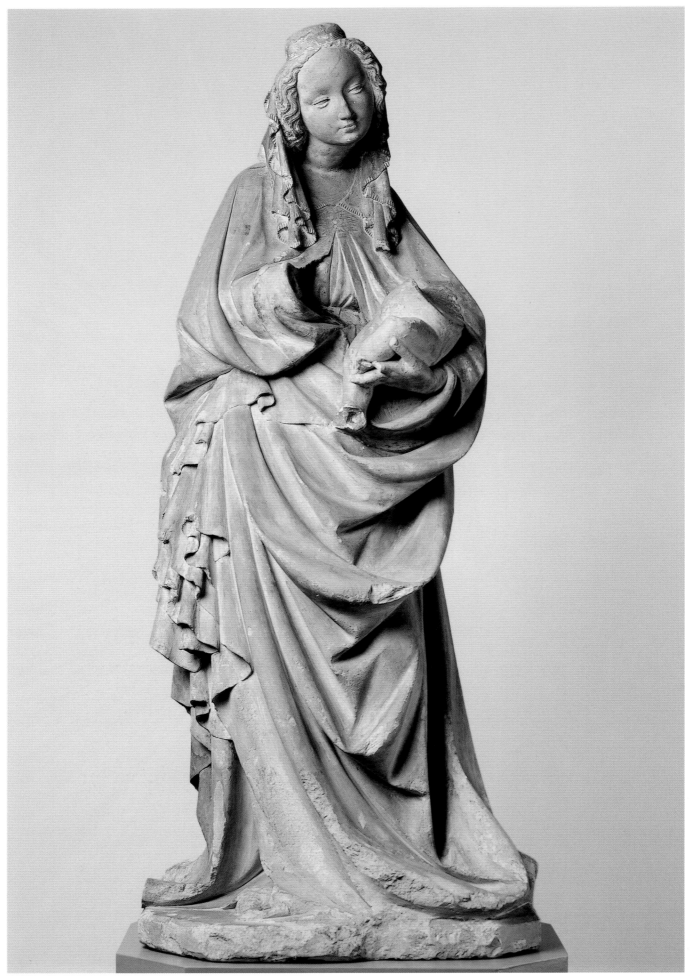

depict Mary as a young mother tenderly engaging her playful child. The Virgin most often holds an apple in front of the Child, a symbol of the original sin and hence of Christ's Passion. Mary's expression is wistful as she seems to reflect on the Child's future suffering. Although less than lifesize, these sculptures achieve a monumental character through the exceptional arrangements of their heavy draperies. Their garments seem to be made of a thick cloth, like wool, that does not break in angular creases but creates a calligraphic play of corresponding curves. Combining weight and grace, the Beautiful Madonnas were among the earliest sculptures in Europe to fully engage the space around them. Their complex compositions play off void against full, with crests of folds reaching out in alpine formations. Equally remarkably, these figures have no fixed viewpoint. One vantage point flows effortlessly into the next, the curves of the drapery inviting the viewer to walk around the figure. The best Beautiful Madonnas are fully resolved sculptures nearly as complex in the rear as they are in the front.

The degree to which the Bonn figure is finished in the back suggests that it was conceived to stand in an environment where it could be approached from every direction, as would have been the case if it had been installed against a church column. The exuberant drapery enveloping the figure underscores the rapport of mother and child. The staggered, generous curves under the Virgin's left arm echo the Child's contour, the mass of drapery directly under the Child contributes to the impression that Mary is leaning forward, and the long folds running obliquely from the base to her shoulders suggest to the viewer coming from the back that she is turning toward the Child.

The demand for Beautiful Madonnas led to the repetition of aesthetically pleasing compositions. This happened not only within the workshops that had formulated them; a sculpture could also be copied once it was installed in a church and had entered the public domain, sometimes far away from its place of origin. Furthermore, an apprentice-sculptor would make drawings after his master's works to build a repertoire of motifs that he could use when he opened his own workshop. All this explains how difficult it is to attribute Beautiful Madonnas to specific locales, to establish a

107, back view

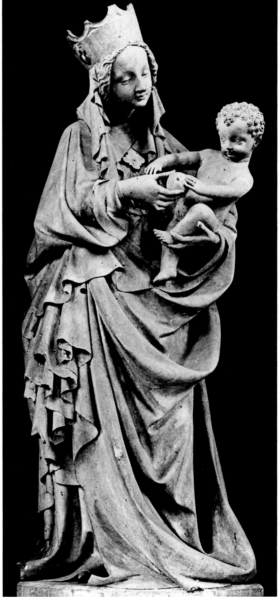

Fig. 107.1 Virgin and Child. Limestone, ca. 1395. Church of Saint John, Toruń, until World War II

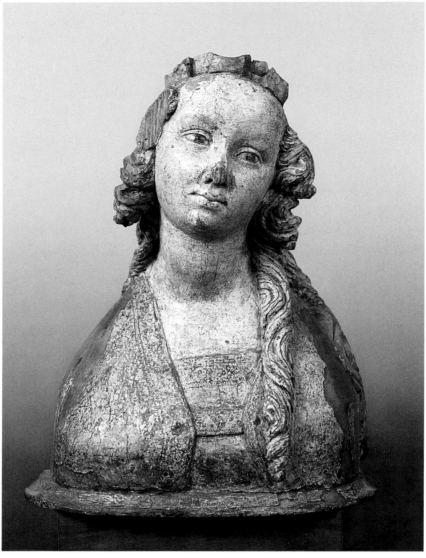

108a

precise sequence of works, or to conclude that two sculptures with similar compositions are by the same hand. In the case of the Bonn Virgin and Child, however, it is fair to assume a workshop connection with one of the seminal works of the Beautiful Style, a superb group that was in the Church of Saint John in Toruń until World War II (fig. 107.1).[3] Although slightly less three-dimensional, the Bonn sculpture is virtually the same size as the one from Toruń (115 cm tall), and it repeats the composition from every angle. This suggests that the Bonn sculpture was carved while the Toruń figure was still in the workshop, so that measurements of corresponding points could be taken. The Bonn and Toruń sculptures, along with a Virgin and Child from Wrocław (Muzeum Narodowe, Warsaw) and Christ on the Mount of Olives from Malbork (cat. 109), are among the best exponents of the Beautiful Style in Silesia and Prussia.

Whether they were imported from Prague or carved by artists trained there is an open question.                                    JC

1. Pinder 1924, p. 169. Clasen (1974, pp. 27–28) rejects this provenance, arguing instead that Thewaldt acquired the sculpture in the Rhineland.
2. Homolka in Cologne 1978–79, vol. 2, p. 646.
3. The polychrome group from Šternberk (cat. 106) also reflects the composition of the Toruń sculpture, especially in the lower half.

LITERATURE: Pinder 1924, pp. 168–69; Clasen 1974, pp. 27–30; Suckale 1976, pp. 244–55, esp. p. 246; Schürmann in Cologne 1978–79, vol. 2, p. 519 (with bibl.).

## 108. Three Busts of Female Saints

*Probably Prague, ca. 1380–90*
*Painted and gilded linden wood; a: h. 32 cm*
*(12⅝ in.); b, c: h. 33 cm (13 in.)*
*Provenance: All three: Parish Church of Saint*
*Linhart, Dolní Vltavice. a: J. Starhon, Český*
*Krumlov; purchased by Municipal Museum, České*
*Budějovice, 1929; Alšova Jihočeská Galerie, 1953.*
*b, c: Acquired by Kunstmuseum, Düsseldorf, 1934.*
*a: Alšova Jihočeská Galerie, Hluboká nad Vltavou*
*(P 18); b, c: Stiftung Museum Kunst Palast,*
*Düsseldorf (1934-11, 12)*

Of imprecise provenance and uncertain function, the Hluboká image is a bust-length realization in painted wood of the Beautiful Style for which Prague was celebrated. Its form has prompted comparisons with the bust of Anna of Świdnica in the triforium of Saint Vitus's

108b, c

Cathedral.[1] But the painting of the face and the gilding of the bodice soften the lines and make this image much more sensual. The two busts in Düsseldorf, of similar proportion and also from Dolní Vltavice, have circular openings to support relics cut into the chest cavity. On the Hluboká bust, however, no cavity is evident for the placement of a relic, either at the front or on the crown of the head.[2]

From about the mid-thirteenth century, ensembles of bust-length images appeared that depicted similarly comely female saints presented as elegant, noble ladies. These represented Saint Ursula and her reputed entourage of eleven thousand virgins, martyred in Cologne after an epic pilgrimage to Rome. Their relics were widely dispersed throughout Europe.[3] In Cologne in particular, Ursuline bust reliquaries were traditionally carved in wood, then painted and gilded. Remarkably, there is no strong tradition of venerating

Ursula in Bohemian lands, although it is not entirely unknown: skulls of Ursuline saints were preserved at the Marienstern Convent, for example (on that community, see cat. 15).[4] Given the artistic and political links between Cologne and Prague in the Parler era, these figures may very well have been executed as part of that dialogue. Their survival in the church at Dolní Vltavice has led to the plausible, but unconfirmed, suggestion that they come from the wealthy nearby Cistercian Monastery of Vyšší Brod.                    BDB

1. Cologne 1978–79, vol. 2, ill. p. 658.
2. The same is true of a female bust from Adelhausen in Freiburg; see Essen–Bonn 2005, pp. 394–95, no. 292.
3. See Holladay 1997.
4. See Essen–Bonn 2005, p. 395, no. 293.

LITERATURE: a: Kutal 1962, pp. 76–77; Prague 1970, p. 148, no. 192 (with bibl.); Cologne 1978–79, vol. 2, p. 678, vol. 5, fig. T-199; Vienna 1990, p. 91, no. 25. b, c: Paris 1957, no. 182; Brussels 1966, no. 7; Prague 1970, p. 148, no. 192, pl. 25; Cologne 1978–79, vol. 2, p. 679, vol. 5, fig. T-200.

109

## 109. Christ on the Mount of Olives

*Toruń, ca. 1390–95*
*Limestone with traces of original paint, h. 84 cm*
*(33⅛ in.)*
*Condition: Restored between 1964 and 1989.*
*Provenance: Saint Lawrence Chapel, Malbork,*
*recorded 1700 and 1742; parish church, Malbork,*
*early 19th century; Muzeum Zamkowe, since its*
*foundation, 1961.*
*Muzeum Zamkowe, Malbork, Poland (MZM/Rz/19)*

On the eve of his crucifixion, Jesus retired with his disciples to the Mount of Olives, outside Jerusalem, to pray. The gospel accounts tell how Jesus' faith allowed him to overcome his fear of what was to come, even as his apostles slept, despite his pleas that they stay awake and help keep him strong.[1] The Malbork Christ on the Mount of Olives is an exceptionally refined and powerful realization of the subject. As Jesus kneels he lifts his gaze and turns his head slightly, with his mouth open as if in prayer. The viewer is necessarily drawn into the world beyond Jesus' private prayer and by

implication becomes a partner in the apostles' human failing. In its emotional intensity, the Malbork Christ is the sculptural equivalent of the Třeboň Altarpiece (see fig. 97.1).

The head of Christ is beautifully and subtly rendered, with a delicate curling beard, worry lines across his forehead, and veins of tension at his temples (see fig. 9.5). Equally compelling is the way the soft underside of Christ's foot is exposed, to suggest the vulnerability of his flesh. Its effective simulation brings to mind Pliny's description of the Pergamon altar as seemingly carved from flesh rather than marble.[2]

Particularly in certain details—the rendering of the hair, the elegant smooth surface, the broad planes of the drapery—the image resembles other sculpture from the region, especially the Moses, Virgin and Child (fig. 107.1), and Assumption of the Magdalen from the Church of Saint John in Toruń.[3] All these works may be attributed to the same sculptor or his atelier.

At the beginning of the fifteenth century the region near Gdańsk was controlled by the Teutonic Knights, whose stronghold Malbork Castle was. The order is known to have commissioned other works by artists who were active in Prague, such as the Madonna of Pilsen.[4] This sculpture was almost certainly made for a high-ranking member of the order for his residence at Malbork. While it may have been part of a larger ensemble that included figures of the apostles, it was more likely created as a devotional image, as Gerhard Schmidt suggested.          JF

1. According to the gospels of Matthew (26:36–39), Luke (22:41–44), and Mark (14:32–39).
2. Pliny, *Natural History,* 1962, books 36–37, p. 18.
3. Clasen 1974, figs. 8, 9 (Virgin and Child), 15, 152 (Moses), 205 (Magdalen relief).
4. Ibid., figs. 44–46; Frinta 1960, pp. 178–81.

110, head of the Virgin

110, head of Christ

LITERATURE: Ermland 1907, pp. 12, 152ff.; Clasen 1939, pp. 139–43, 336ff., no. 435, figs. 162, 163; Clasen 1974, pp. 40–42, 209, figs. 18, 19; Nuremberg 1990, pp. 120–21, no. II.7.43, ill.; Schmidt 1992, pp. 282–87.

## 110. Two Fragments of a Pietà

*Prague, ca. 1400*
*Marly limestone with traces of gilding and paint,[1]
head of Christ: h. 18 cm (7⅛ in.), head of Virgin:
h. 20 cm (7⅞ in.), original group: h. 77 cm (30¼ in.)*
*Condition: All that survives from group carved from
single block and originally well preserved but almost
entirely destroyed in fire of Friedrichshain bunker in
Berlin, May 1945. Burn damage; tip of Christ's nose
missing; some losses in Mary's head veil.*
*Provenance: Said to come from Baden, near Vienna;
purchased in Vienna, 1903.*
*Staatliche Museen zu Berlin, Skulpturensammlung
und Museum für Byzantinische Kunst (2743)*

Until its near destruction in 1945 the Pietà (*Vesperbild*) from Baden (fig. 110.1) was celebrated as one of the seminal works of the Beautiful Style. The qualities generally associated with the finest Bohemian sculptures were

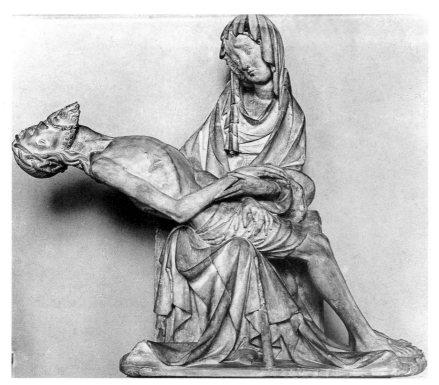

Fig. 110.1 Pietà from Baden, Austria. Marly limestone with traces of paint; Prague, ca. 1400, destroyed 1945

evidenced to an exceptional degree in this group: a composition that effected formal and psychological tensions; a differentiated treatment of surfaces, from highly detailed to almost abstract; and draperies that emphasized parts of a figure's anatomy while concealing others. Unlike the sculpture at The Cloisters (cat. 112), in which Mary presents her son's body to the viewer and seems numb with grief, this composition focuses on her emotions. Her slanted eyebrows and pinched lips suggest that she can barely hold back her tears. She stares at Christ's head and recoils in disbelief at his suffering, which was more tangible when wooden thorns protruded from the holes in the crown. The Virgin is here a frailer figure, less shielded by an abundance of folds. She does not turn Christ's body toward us, and she supports his head, unwilling to allow it to fall back. Whereas in the Cloisters group she barely lifts her son's hand to display the nail mark, here she grabs it forcefully, as if to raise Christ's body toward her in a last embrace.

The scholarship on the Baden Pietà reflects the lack of consensus on the chronology and attribution of works in the Beautiful Style. Two publications from 2000 describe the work as having been carved either in Vienna about 1375–85 or in Prague about 1400.[2] The sculpture was acquired in Vienna by the Berlin Museums and is said to have come from nearby Baden. It may have adorned the Corpus Christi Chapel in the church of the Augustinian monastery in that city. The chapel had received an endowment in 1374 for a

perpetual mass from Hans von Liechtenstein-Nikolsburg, *Hofmeister* of Duke Albrecht III of Austria, who had himself married Elizabeth of Bohemia, daughter of Emperor Charles IV.[3] Works in the Beautiful Style, particularly Pietàs, were famous across central Europe, and there is documentary, archaeological, and petrographic evidence that finished stone sculptures were shipped from Prague over long distances.[4] This underscores not only the widespread appeal of the Beautiful Style but also the identification of the style with Prague in the minds of the European elite about 1400. The Bohemian capital was a trendsetter, and commissioning a work there must have given it a mark of prestige.                    JC

1. Fründt 1972, p. 29: "Mergel—als Hauptbestandteil und Bindemittel Calciumkarbonat, ausserdem Ton und Kaliumaluminiumsilikat, Siliciumdioxyd und Akzessorien" (Marl—calcium carbonate as the main component and binding agent, with some clay and potassium aluminosilicate, silicon dioxide and others).
2. Schultes 2000, p. 360; Krohm 2000, p. 75.
3. Schultes 2000, p. 360.
4. The chronicle of the Dominicans in Mainz mentions in conjunction with a tomb from about 1400 "a sculpted image of the Blessed Virgin from Prague" (Suckale 1976, p. 250: "ymago beate virginis sculpta de Praga"). Likewise, in 1404 a Pietà from Prague was installed outside the Chapel of the Virgin in Strasbourg Cathedral (Sladeczek 1999, pp. 174, 181n21). Fragments of a Pietà in the Beautiful Style whose composition was very close to that of the Baden Pietà were excavated in the 1980s

in front of Bern Cathedral in a pit filled with sculptures that had been destroyed in the iconoclasm of 1528. The stone of the Bern sculpture was identified as a marly chert quarried in Přední Kopanina, five kilometers northwest of Prague. Jiří Konta (in Sladeczek 1999, pp. 173–74), professor at the Institute for Petrology of Prague University, identified the material of the Bern Pietà as "mergeligen Zilizit" (marly chert), which he identified also as the material of the Pietà in the Hermitage, Saint Petersburg (ibid., p. 180n15).

LITERATURE: Fründt 1972, pp. 29–30 (with bibl.); Clasen 1974, pp. 4, 8, 141; Schultes 2000, pp. 345, 360 (with bibl.); Krohm 2000, pp. 75–88, esp. pp. 75, 87n1.

## III. Pietà

*Prague, ca. 1380–90*
*Limestone with original paint, 61 x 63.5 cm (24 x 25 in.)*
*Condition: Original paint uncovered in 1969 during restoration by W. Brückner.*
*Elisabethkirche zu Marburg*
*Not exhibited*

As Mary holds the stiffened body of her crucified son on her lap, she raises his right hand, drawing attention to the nail mark. Her delicate display of the wound recalls Jesus' suffering for the sake of mankind's salvation. His hollow abdomen and his narrow face, with his slanted eyes still slightly open in death and his brows drawn together in pain, present ample evidence of his agony. The gaping wound in his side takes on allegorical significance: because blood and water flowed from it, Christ's body becomes the source of the baptismal and altar sacraments, and consequently of the Church itself.

According to the medieval interpretation of the Song of Songs, Mary's youth characterizes her as the bride of Christ, so that she too stands for the Church. From the front, her face appears wholly expressive of sorrow. Viewed from the right side, however, she has a hint of a smile, suggesting that she already senses the joy that will follow Christ's resurrection.

Between Mary's knees hang two flat, draping folds with eyelets, but then the hem is turned back above her left knee and falls, accompanied by a highly three-dimensional cylindrical fold, in a curving diagonal back to her right foot. This motif, unusual in Pietàs in the Beautiful Style, is combined with a few short gathers on the right, and together with another piece of fabric behind them that falls down to Christ's feet, forms the support for his lower body. The drapery motifs above Mary's left knee, in particular, are reminiscent

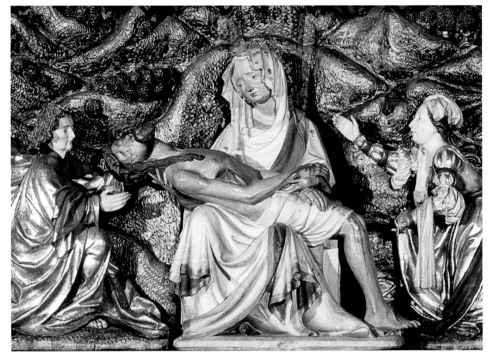

III

and Marienstatt.[8] That Pietà is also related in the types of the heads and the form of the loincloth, but a number of less felicitous details—the way Christ's large head bends backward and the prosaic cascade of folds above Mary's right knee—show it to be the work of an imitator.

The Marburg Pietà is closer to the one in Kreuzenstein Castle. There even the fingers of Mary's left hand, which again lifts Christ's right forearm, are splayed in a gesture of agony. It is probably a somewhat later product of the same workshop. The Altenmarkt Madonna does not belong to this group. The configuration of the drapery is forced and mannered, as is the way the fingers make indentations in the child's flesh. The facial expressions are also more doll-like. Closer to the Marburg Pietà is the Pilsen Madonna, and accordingly I would also date the Marburg sculpture to the 1380s.

The sculptor's workshop was surely in Prague, and these were doubtless genuine export articles. Perhaps Wenceslas IV donated the Pietà to the Teutonic Order in Marburg. In 1384 he traveled to his family's ancestral seat to see to the legacy of Wenceslas of Luxembourg. Not yet fully discredited within the empire, he also sojourned in west central Germany in that year, convening a diet in Frankfurt in July and spending Christmas

of those in early works such as the Virgin and Child from Prague's Old Town Hall (fig. 4.5). The plasticity of specific drapery motifs also compares with that stylistic stage, as does this relatively simple configuration. This is not a derivative "late work" but a highly inventive, masterful sculpture for which the frequently suggested date of about 1390 seems apt.

Albert Kutal first argued that the Marburg Pietà is Bohemian,[1] based on a parallel to the Altenmarkt im Pongau Virgin and Child of 1393 and the Pietà at Kreuzenstein Castle.[2] Gerhard Schmidt attributed the Marburg and Marienstatt Pietàs and the Altenmarkt Virgin and Child to one workshop, the Kreuzenstein Pietà and the Virgins from Šternberk and Wrocław to another.[3] Dieter Grossman, however, grouped the Pietàs of Marburg and Kreuzenstein together.[4] Lothar Schultes, once again following Kutal's lead,[5] chose to identify the sons of Peter Parler, Wenzel and Janco, as the most important sculptors of the time, to whom he attributed, among other works, the painted Virgin of Saint Vitus's Cathedral, citing a late inventory in which it is listed as the work of the "squires from Prague." This would allow the attribution of the Kreuzenstein Pietà to Vaclav, who presumably served as cathedral architect in Vienna from 1397 until his death in 1404 and could even have carved the work in Vienna.

The Pietà in the Cistercian Abbey at Marienstatt in the Westerwald, not too far from Marburg, is very similar in sculptural concept, the facial types, and the form of the body of Christ[6] and is doubtless the work of the same sculptor. The Marburg sculpture is perhaps the

earlier, especially as the motif of the strand of hair is later varied and as the eyelets are no longer present in the Marienstatt figure.

There is a certain relationship between the veil of the Pietà in Saint Columba's in Cologne[7] and those of the groups in Marburg

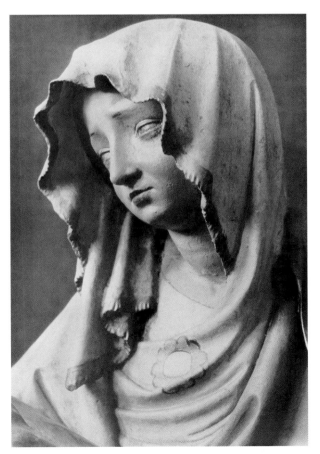

III, detail

in Würzburg, not very far from Marburg and Marienstatt. The commission for Marienstatt's Pietà, which is made of cast stone, could easily have been a response to the abbey's desire for a votive image from Prague of the quality of the Marburg sculpture.

In Marburg's Church of Saint Elizabeth the Pietà probably originally stood on the Altar of the Virgin in the north transept, which was next to the narrow side of the mausoleum of Saint Elizabeth of Hungary.[9] Between 1512 and 1517 Ludwig Juppe executed a retable with a Coronation of the Virgin for that altar, and the Pietà was incorporated into its predella, flanked by mourning figures of John the Evangelist and Mary Magdalen. In the course

of renovations in the nineteenth century it was moved from its original location.[10]    MH

1. Kutal 1963, p. 337.
2. Brucher 2000, nos. 117, 120, figs. pp. 85–86.
3. Schmidt 1977a, p. 97.
4. Salzburg 1970, pp. 61–63, no. 14.
5. Schultes in Brucher 2000, p. 369; Kutal 1962, pp. 89–90.
6. Wellstein 1953, p. 37; Clasen 1974, pp. 85, 209, fig. 103; Frankfurt am Main 1975, p. 140, no. 44, fig. 110.
7. Clasen 1974, fig. 108.
8. Schürmann (in Cologne 1978–79, vol. 1, p. 256) discovered a similarity between the veil motif in the Marienstatt figure and that in the Pietàs in Saint Alban's, Cologne, and in Kraków, but I fail to see it.
9. Köstler (1995, p. 67) writes that it was not placed there until the fifteenth century.
10. Lange 1849, fols. 17v–19r.

LITERATURE: Lange 1849; Kutal 1962; Kutal 1963, esp. p. 337; Clasen 1974, p. 85, figs. 100–102; Schmidt 1977a, esp. p. 97; Schürmann in Cologne 1978–79, vol. 1, p. 256.

## 112. Pietà

*Bohemia, ca. 1400*
*Limestone with traces of paint, h. 38.1 cm (15 in.)*
*Condition: Carved from single block of fine-grained limestone; back finished. Christ's toes missing; losses in*

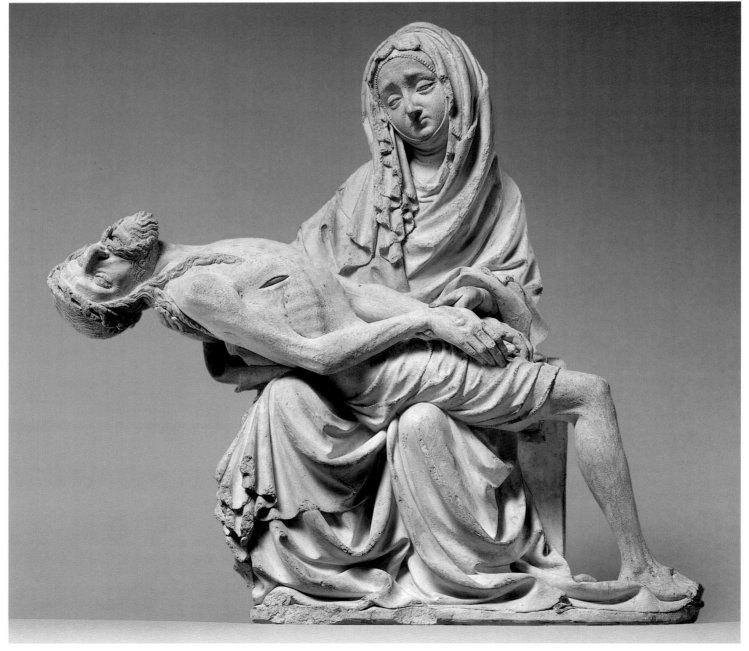

112

*drapery and base; wooden thorns originally protruding from crown missing. Tip of Virgin's nose and part of Christ's mustache repaired. Conserved by Michele Marincola at the Metropolitan Museum in 2001: discolored retouches integrated and Mary's right hand (carved separately and possibly an old replacement) moved from Christ's shoulders to base of his neck.*
*Provenance: Michel collection, Paris; Julius Böhler, Munich, 1895; Julius Wilhelm Böhler, Munich, by 1934; Julius Harry Böhler, Munich, by 1965; Marion Eitle, née Böhler, Munich, by 1979; Christoph Eitle, Munich, 1991.*
*The Metropolitan Museum of Art, New York, The Cloisters Collection, 2001 (2001.78)*

Seated on a shallow bench, the Virgin gazes at her son's corpse spread across her lap. With her right hand under his neck, she tilts his torso forward to expose the wound in his side, while her left hand gently lifts his right wrist to display the nail mark. Still crowned with thorns, Christ's lifeless head falls back with half-opened eyes and a gaping mouth in which the tongue and teeth are visible. Christ's broken, emaciated body, naked except for the loincloth, offers a stark contrast to the Virgin's youthful figure, clad in abundant folds. The veil surrounding Mary's head and falling on one side underscores her expression of solemn resignation.

Images of the Virgin with the dead Christ, a subject extracted from representations of the Lamentation but not mentioned in the Gospels, reflect late medieval developments in mysticism that encouraged a direct emotional involvement in the biblical stories. Conceived to be seen from below, as from a prie-dieu (it is only from a low vantage point that one notices the undercutting of the three intertwined hands on the Virgin's lap), this group served as an object for private devotion. Mary's quiet sorrow over her son's suffering offered the devout a model to emulate. The wear on Christ's shins, caused by the caresses and kisses of worshipers, attests to medieval viewers' intimate rapport with the image.

This group is a strikingly pure expression of the Beautiful Style (Krásny sloh, Schöne Stil), an artistic idiom that emerged at the imperial court in Prague at the end of the fourteenth century and subsequently resonated in artistic centers throughout Europe. The sculptor exploited the formal and psychological tensions inherent in the composition, combining a selectively abstract treatment of surfaces with a precise rendering of such details as Christ's minutely striated loincloth and the vital delineation of his arms. The articulation of the drapery as juxtapositions of deep, sweeping folds with cascades of smaller pleats bears comparison with the superb Virgin and Child from Toruń (fig. 107.1). The blending of sensuality

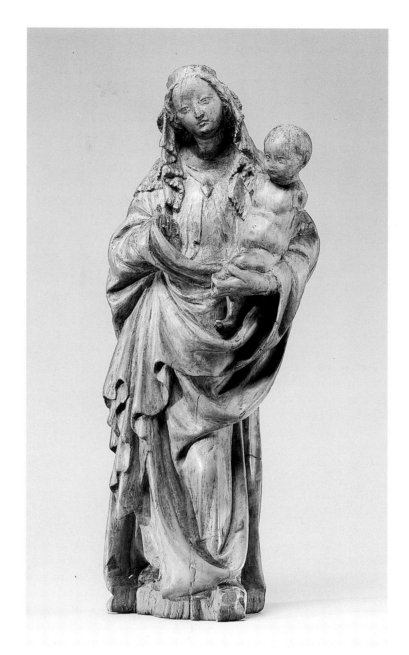

113

and restraint gives the Cloisters sculpture immediate emotional appeal.     JC

LITERATURE: Burger 1907, pp. 146–63, esp. p. 155; Habich 1907, pp. 66–92, esp. p. 88; Pinder 1924, p. 175; Chapuis 2001, p. 20; "A Selection of 2001 Museum Acquisitions," *Apollo* (December 2001), p. 28.

## 113. Virgin and Child

*Prague, ca. 1380*
*Pearwood, h. 34.8 cm (13¾ in.)*
*Provenance: Professor Klofat, near Horažd'ovice in western Bohemia; brought by him to Bavaria, 1945; Emil G. Bührle, Zurich, acquired in Meersburg, 1952;*
*gift to Bayerischen Nationalmuseum from its chairman, Heinz Fuchs, 1987.*
*Bayerisches Nationalmuseum, Munich (88/105)*

This refined wood carving of the Virgin and Child, which comes from a south Bohemian collection, is a fully realized, if diminutive, example of the Beautiful Style. As has frequently been noted in the literature, it is closely related to monumental examples. For example, the relationship between mother and son recalls the Krumlov Virgin and Child (fig. 9.3), which is demonstrably from Prague by virtue of its provenance and its material. The composition as a whole, both front and back views, closely parallels the Virgin and Child from Bonn (cat. 107). Both are close to the lost Virgin and Child from Toruń (fig. 107.1);[1] that figure held an apple in her hand, allowing

the suggestion that this sculpture and the one in Bonn once did as well. The realization of the back of the figure, especially the fall of the veil, also relates to the Altenmarkt Virgin and Child.

The drapery is rendered with exceptional three-dimensionality. While hardwood was often used in the second half of the fourteenth century for workshop models, this sculpture is a fully finished wood sculpture. In that regard, it has also been compared, appropriately, to the Busts of Female Saints from Hluboká and Düsseldorf (cat. 108). One wonders what the relationship of this sculpture may have been to the choir stalls completed by Peter Parler for Saint Vitus's Cathedral in 1385, which were unfortunately destroyed by fire in 1541.

Some wear to the left hand of Mary and the left leg of Jesus indicate that the sculpture was touched in veneration. The image would have originally been fitted with a metal crown. The sculpture was probably originally enshrined in a folding tabernacle, as was often the case with French ivory or silver images of the Virgin and Child.[2]                           JF

1. Clasen 1974, figs. 8, 9.
2. See, for example, Paris 1981–82, no. 187.

LITERATURE: Kutal 1958, esp. p. 122; Müller 1958, p. 47, no. 28; Kutal 1962, p. 94, pl. 375a; Homolka 1963, p. 429; Kutal 1963, p. 25; Salzburg 1965, pp. 88–89, no. 36; Grossmann 1966, p. 98; Kutal 1966b, pp. 433, 444; Clasen 1974, pp. 33, 116, 216, fig. 255; Hilger 1988, pp. 51–72.

## 114. Saint Peter

*Bohemia, second half of 14th century*
*Pot metal glass and vitreous paint; modern leading,*
*green replacement glass (except in top left section);*
*77 x 18.5 cm (30¼ x 7¼ in.)*
*Provenance: Parish Church of All Saints, Slivenec;*
*transferred to Uměleckoprůmyslové Museum, 1896.*
*Uměleckoprůmyslové Museum, Prague (58.959/1–6)*

Since the late nineteenth century the Saint Peter panel has been housed at the Uměleckoprůmyslové Museum, Prague's Museum of Decorative Arts, where it is installed above the Man of Sorrows (cat. 130), as part of an ensemble of three lancet windows (see fig. 130.1) brought from the apse of the Church of All Saints in Slivenec.[1] Commissioned by the Augustinian Order of the Red Star Cross in the last quarter of the thirteenth century,[2] the Church of All Saints may have become a repository for stained glass from several of the order's holdings in

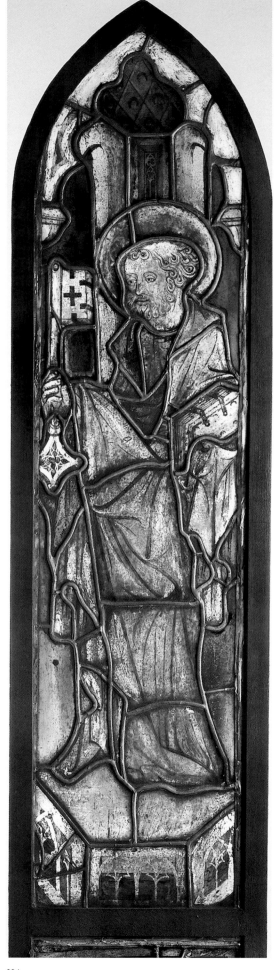

114

Fig. 114.1 Master of the Třeboň Altar. Three Male Saints (detail, Saint Philip). From the Třeboň Altarpiece. Národní Galerie, Prague (O 477)

the wake of the Hussite Revolution.[3] Given the heterogeneous nature of the museum's ensemble, Saint Peter's original context remains in doubt. The truncation of the saint's left arm indicates that the panel was cut down when installed in the right lancet of the apse in Slivenec.

Saint Peter is portrayed with a large key in his hand, a depiction appropriate to his role as heavenly gatekeeper. The design—attenuated figure, elegant drapery folds, and ornately articulated architectural framework—rivals the best of contemporary panel painting. Both Saint Peter and, for instance, the Saint Philip in the Třeboň Altar (fig. 114.1, and see also fig. 97.1) are evidence of the contemporary aesthetic known as the Beautiful Style. In fact, glass artists (*sklenaře*) were active members of Saint Luke's Confraternity, the Prague painter's guild. Accordingly, this panel is visual confirmation of the harmonious dialogue between artists working in different media.          AS

1. The Uměleckoprůmyslové Museum's archives date the Slivenec group's arrival to the late 1890s.
2. Poche 1977–82, vol. 3, p. 363.
3. The Order of the Red Star Cross gained control over Slivenec in the form of a gift from King Wenceslas II on April 6, 1253. Zdeněk, master of the Order of the Red Star Cross between 1380 and 1407, is arguably the patron of some of these panels (see *Kniha Památní* 1933, p. 44).

LITERATURE: Matouš 1975, pp. 75–78, figs. 64, 66; Homolka and Pešina 1970, no. 451, fig. 171; Cologne 1978–79, vol. 2, p. 717; Poche 1977–82, vol. 3 (1980), pp. 363–64; Hejdová et al. 1986, p. 34, no. 299a; Benda et al. 1999, pp. 110–11.

## 115. Saint Peter

*Prague, ca. 1385*
*Marly limestone (argillite) with traces of original paint, carved in the round; h. 91.5 cm (36 in.)*
*Condition: Saint Peter's key missing; dish-shaped fold added on front; restored by Josef Tesař, 1961–63.*
*Provenance: Parish office, Slivice (district of Příbram); on loan to Národní Galerie, since 1961.*
*Římskokatolický farní Úřad Slivice-Milín (VP 3)*

This statue of Saint Peter from Slivice represents an important link between the older sculptural style of the Saint Vitus's Cathedral workshop under Peter Parler and the Beautiful Style. The strikingly realistic features of the saint's face belong to the same tradition as the sharply cut faces of the Přemyslid princes on the tombs in the apsidal chapels of the cathedral (see fig. 59.1). The radical, dynamic composition, however, was heralded by the

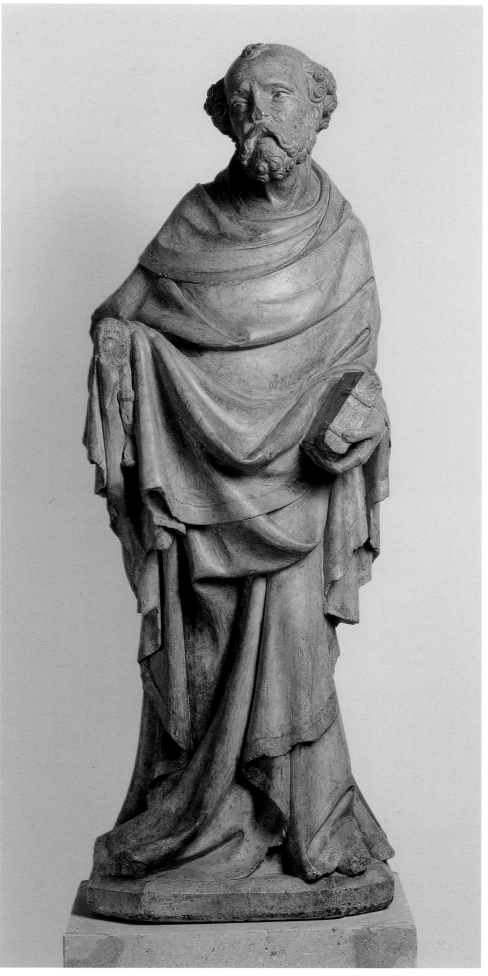

115

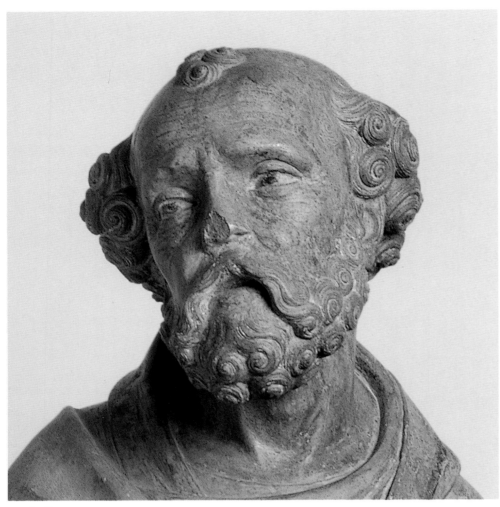

115, detail

Its notoriety and exceptional devotional value could have been based on its connection with the archbishop, which is evidenced by the existence of a fairly faithful reproduction on a stained glass panel from a church in Slivenec, near Prague (cat. 114).

In any case, the Saint Peter from Slivice was carved in Prague by a stone sculptor active in proximity to the stonemasons' workshop at Saint Vitus's Cathedral, if not by one of the workshop's own masters. The stone has been identified as the distinctive marly limestone quarried at Bílá Hora (White Mountain), near Prague.[5] Relatively soft when first quarried, the stone lent itself to the simulation of supple bodies and drapery. Although a precise art historical evaluation has thus far been complicated by later repainting, this sculpture, along with the Pilsen Madonna, a tiny statue of Saint Elizabeth in Vienna, the Pietà of Marburg (cat. 111), and the Saint Anne with Virgin and Child of Nová Říše, forms the core of a group of sculptures from the early stages of the Beautiful Style that must date to the 1380s.                                    JF

1. Clasen 1974, figs. 44–46; Frinta 1960, pp. 178–81.
2. Quoted in Strnad 1891, no. 143, p. 152: "in ecclesia parochiali in Nouapilzna singulis diebus ad laudem et gloriam gloriose et intemerate Marie Virginis in diluculo et aurora diei vna missa per clerum." The connection between the indulgences and the statue was confirmed in 1672 by the archdeacon Joannes Alexius Czapek in his treatise on the miraculous Pilsen Mother of God: "Anno 1384, 2. Decembris Joannes archiepiscopus pragensis sacro matutino ad hanc sacram imaginem fieri solito concessit 40dierum indulgatias" (original document deposited at the municipal archives in Pilsen [rkp. 19688], cited in Čadík 1967, pp. 228–29). I thank the municipal archivist in Pilsen, Dr. Jaroslav Douša, for his kind help in providing this information.
3. The statue had been heavily damaged in a fire, which according to the parish chronicle is probably why it was transferred to the Catholic church in Ludwigsburg, near Stuttgart, where it was restored in the nineteenth century (a new head was added and the whole statue newly painted).
4. See Homolka in Cologne 1978–79, vol. 3, pp. 35–39.
5. See protocols of technological analyses made by Peter Kotlik, Institute of Restoration Technology, Chemical Faculty, Technical University, Prague (ČVUT).

LITERATURE: Kutal 1962, p. 88, figs. 142, 143, pl. 20c; Homolka and Pešina 1970, p. 152, no. 197; Clasen 1974, p. 116, figs. 234, 235; Homolka in Cologne 1978–79, vol. 2, p. 675, vol. 5, figs. T-196, T-197; Kutal 1984, p. 270; Recht 1987, p. 370; Bartlová, Schultes, and Štefanová in Vienna 1990, pp. 29, 88, no. 22, ill.; Chlíbec et al. 1992, p. 72; Schmidt 1992, p. 294, fig. 355; Fajt and Bartlová 1996, pp. 30–31, no. 3.

monumental statue of Saint Sigismund on the east facade of the Old Town Bridge Tower (cat. 60). The symmetrical composition of the Saint Sigismund, framed by cascading draperies, inspired one of the basic figural types of the Beautiful Style, as manifested by the best-known example surviving in Bohemia: the Madonna of Pilsen.[1]

The analogies in composition, form, and motif that link the Slivice Saint Peter to the statue in Pilsen are no mere coincidence, the result of two sculptors in two different places working in the popular style of the day. Indeed, they indicate that the two were created in the same workshop. And this in turn helps date the Saint Peter statue more exactly, for on December 2, 1384, Jan of Jenštejn, the archbishop of Prague, granted forty-day indulgences to all believers present at the morning Mass venerating the Virgin in the Parish Church of Saint Bartholomew in Pilsen.[2] If this is so, then the Pilsen statue could have been made no later than 1384, a date corroborated by stylistic comparisons and by the existence of a cheaper wood version of the Pilsen statue, which together with the painted altarpiece now in the Staatsgalerie, Stuttgart (1038), was commissioned in 1385 by the

Prague burgher Reinhard of Mühlhausen for the Chapel of Saint Vitus in his hometown.[3] Of equal significance is the fact that both statues can be connected, albeit to different degrees, to the erudite Prague archbishop Jan of Jenštejn (r. 1379–96), whose personal contributions to the intellectual profile of the Prague art world at the end of the fourteenth century have been established beyond a doubt.[4] Jan did issue the letter of indulgence in Pilsen in 1384, but it is difficult to determine whether he might have commissioned the statue at the behest of the Order of the Teutonic Knights, which was a great benefactor of the Pilsen church and about 1400 was active elsewhere as a patron of the arts (see cat. 109), or if he perhaps donated the statue himself to the main church serving the western Bohemian royal town. Far clearer is Jan's personal involvement in the case of the Saint Peter statue. A church dedicated to Peter lies on the former property of the archbishop of Prague in Slivice, with its administrative center at the nearby castle in Příbram. Whether the statue was originally intended for the Slivice church or whether it was transferred there only later, possibly from the chapel of the archbishop's Příbram residence, is not known.

# 116. Ten Leaves from an Antiphonary

*Prague, ca. 1405*
*Tempera and gold on parchment, originally 296 fols.,*
*57 x 38.5 cm (22⅜ x 15⅛ in.)*
*Provenance: Unknown Benedictine monastery, Bohemia;*
*Benedictine Monastery of Saint Peter, Salzburg; donated*
*to Cistercian abbey, Raitenhaslach, Bavaria, 1504;*
*monastery of Seitenstetten, Austria, until ca. 1927; for*
*later fate of single leaves, see individual headings.*

## a. King David in Prayer (fol. 51v)

*Provenance: [Maggs Bros., London] (Maggs sale 1928,*
*no. 300); Rosenwald collection, Jenkintown, Pa.;*
*donated to National Gallery of Art, 1950.*
*National Gallery of Art, Washington, D.C.,*
*Rosenwald Collection 1950 (1950.17.3)*

## b. The Nativity (fol. 58r, 65: bifolium)

*Provenance: Rosenthal, Lucerne; sold to L. V. Randall,*
*Montreal, early 1930s; purchased by Cleveland*
*Museum of Art, 1976.*
*Cleveland Museum of Art, Andrew R. and Martha*
*Holden Jennings Fund (1976.100)*

## c. Saint Stephen (fol. 77r)

*Provenance: [Maggs Bros., London] (Maggs sale 1928,*
*no. 293); Dr. and Mrs. Francis C. Springell, London;*
*Heinrich Eisemann, London; Eric Korner sale,*
*Sotheby's, London, June 19, 1990, lot 20.*
*J. Paul Getty Museum, Los Angeles (Ms. 97, leaf 1)*

## d. The Adoration of the Magi (fol. 101r)

*Provenance: [Maggs Bros., London] (Maggs sale 1928,*
*no. 291, pl. 33); Coella Lindsay Ricketts, Chicago,*
*purchased 1930–61.*
*Lilly Library, Indiana University, Bloomington*
*(Ricketts 97)*

## e. Christ Enthroned (fol. 127v)

*Provenance: Dr. and Mrs. Francis C. Springell,*
*London; sale, Sotheby's, London, June 28, 1962,*
*lot 46; Martinson; Mr. and Mrs. Fielding Lewis*
*Marshall, sold W. & F. C. Bonham and Sons Ltd.,*
*London, March 28, 1974, no. 70; [Maggs Bros.,*
*London], 1974.*
*Pierpont Morgan Library, New York, Purchased for the*
*Mary Flagler Cary Music Collection, 1974 (Ms. M 961)*

## f. Seated Man (Abraham?) (fol. 194v)

*Provenance: [Maggs Bros., London] (Maggs sale 1928,*
*no. 299); Francis C. Springell, London; Heinrich*
*Eisemann, London; Eric Korner sale, Sotheby's,*
*London, June 19, 1990, lot 19.*
*J. Paul Getty Museum, Los Angeles (Ms. 97, leaf 3v)*

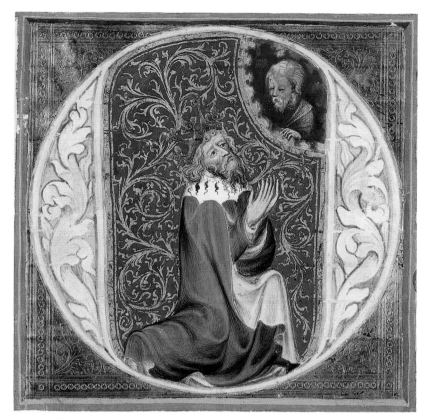

116a (detail), King David in Prayer in an Initial O

## g. Isaac Blessing Jacob (fol. 206v)

*Provenance: [Maggs Bros., London] (Maggs sale 1928,*
*no. 302); Rosenwald, Jenkintown, Pa.; donated to*
*National Gallery of Art, 1950.*
*National Gallery of Art, Washington, D.C.,*
*Rosenwald Collection 1950 (1950.17.4)*

## h. The Prodigal Son Returns to His Father(?) (fol. 217v)

*Provenance: [Maggs Bros., London] (Maggs sale 1928,*
*no. 301); Francis C. Springell, London; Heinrich*
*Eisemann, London; Eric Korner sale, Sotheby's,*
*London, June 19, 1990, lot 18.*
*J. Paul Getty Museum, Los Angeles (Ms. 97, leaf 2v)*

## i. The Stoning of Christ (fol. 243r)

*Provenance: [Maggs Bros., London] (Maggs sale 1928,*
*no. 294); sale, Sotheby's, London, April 3, 1957, lot 51.*
*Nationalmuseum, Stockholm (NMB 1714)*

## j. The Flagellation (fol. 255r)

*Provenance: [Maggs Bros., London] (Maggs sale 1928,*
*no. 297); Rosenwald collection, Jenkintown, Pa.;*
*donated to National Gallery of Art, 1950.*
*National Gallery of Art, Washington, D.C.,*
*Rosenwald Collection 1950 (1950.17.1)*

All of these leaves come from a splendid antiphonary intended for a Bohemian monastery of the Benedictine Order. In the time of need after World War I, the monks of Seitenstetten Abbey in Lower Austria, then its owners, sold the manuscript to a dealer who cut it apart. The illuminated leaves were placed on the market separately. Text pages were apparently reused as document folders and incorporated into desk sets.[1] Thirteen of the painted leaves were sold by Maggs Bros. in London in 1928.[2] Three others (fols. 58, 86, 127) were eventually identified in the Rosenthal collection in Lucerne, the Askonas collection in Vienna, and a third, unknown private collection. The present whereabouts of five of those sixteen folios (2, 97, 154, 186, 231) are not known; another (fol. 86) was destroyed immediately after World War II. All ten of the other fragments are included in this exhibition. They testify to the splendor of what was certainly one of the finest Bohemian manuscripts illuminated during the first decade of the fifteenth century.

Gerhard Schmidt made the first attempt to reconstruct the antiphonary in 1969, proposing the original sequence of ten leaves and establishing their provenance from Seitenstetten Abbey. William Wixom added further information in 1977, and in 1990, when three leaves that Schmidt had not been able to locate were sold at Sotheby's, the sale catalogue provided a reconstruction comprising thirteen leaves.[3] Just this year, in March 2005, Martin Roland discovered the detailed description of the manuscript, then still intact, that Josef Neuwirth had

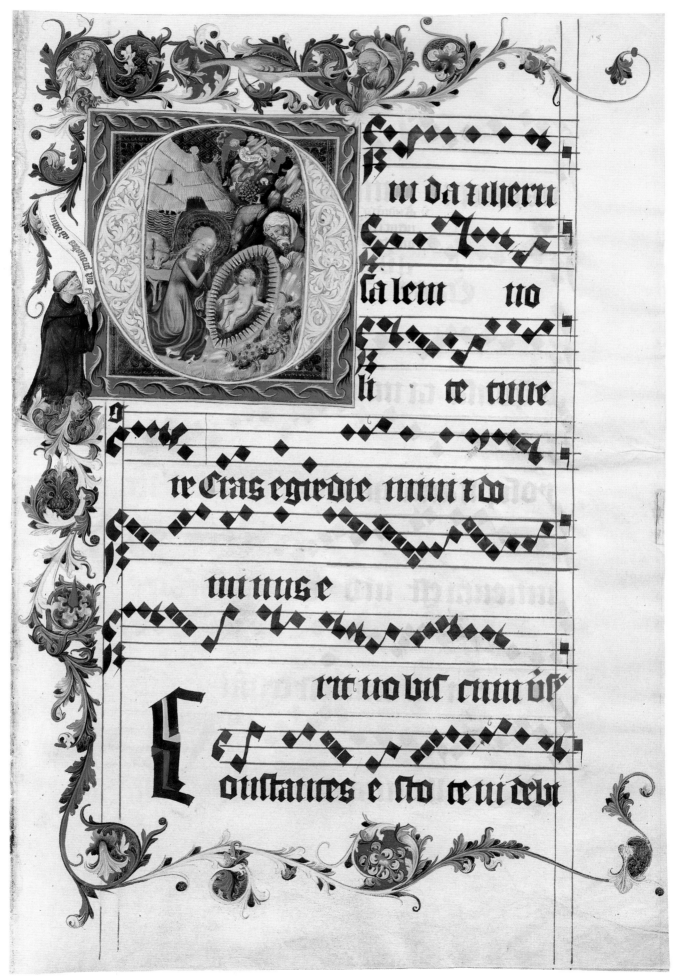

116b, The Nativity in an Initial O

116c (detail), Saint Stephen in an Initial H

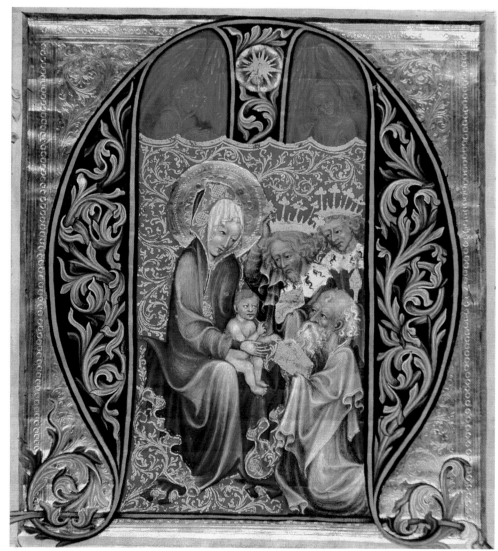

116d (detail), The Adoration of the Magi in an Initial M

published in 1886. According to Neuwirth, by the early sixteenth century the manuscript was already in Austria, probably because its original owners had been expelled from Bohemia by the Hussites. A Latin poem pasted on the inside of the front cover of the codex related its transfer from the Benedictines of Saint Peter in Salzburg to the Cistercians of Raitenhaslach in Bavaria. Neuwirth unfortunately knew nothing about the circumstances that finally brought the manuscript to Seitenstetten.

Based on Neuwirth's description, a complete reconstruction of the illumination of the Seitenstetten Antiphonary is now possible, for all fifteen of the historiated initials he found in the codex (he overlooked the initial on fol. 255v) can be identified with the known fragments. As Neuwirth (and others) have in some cases given misleading information, this list provides a more accurate view of the destroyed manuscript:[4]

fol. 2r  First Sunday in Advent: "A(spiciens a longe) . . ." (Long had I been waiting). Christ Enthroned (Maggs sale 1928, no. 289, pl. 31). Christ is adored by two angels and an abbot in a Benedictine habit who was possibly added by another hand.

fol. 51v  December 17: "O (sapientia) . . ." (O wisdom). King David in Prayer (cat. 116a). The antiphons of the week before Christmas are called *antiphones maiores,* the first of which is sung on December 17. King David is presented as the author of the Psalms.

fol. 58r  Christmas Day: "O (Iuda et Iherusalem) . . ." (O Judah and Jerusalem). The Nativity (cat. 116b). Mary and Joseph kneel in front of the Child, as an angel announces the birth of Jesus to the shepherds. Outside the initial a Benedictine monk adores the scene.

fol. 77r  December 26: "H(esterna die dominus natus est) . . ." (Yesterday the Lord was born). Saint Stephen (cat. 116c). Saint Stephen, the first Christian martyr, appears as a deacon, holding three stones symbolic of his martyrdom.

fol. 86v  December 27: "V(alde honorandus est beatus Johannes) . . ." (Truly venerable is blessed John). Saint John the Evangelist (formerly Askonas collection, Vienna, destroyed immediately after World War II).[5]

fol. 97v  December 28. "H(erodes iratus occidit multos pueros) . . ." (Enraged

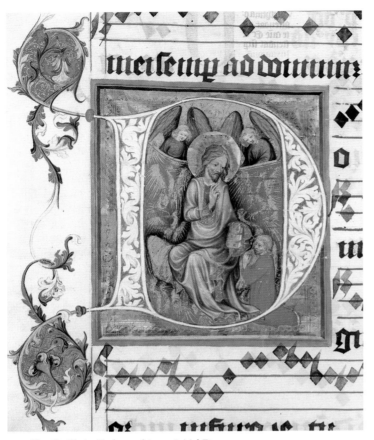

116e (detail), Christ Enthroned in an Initial D

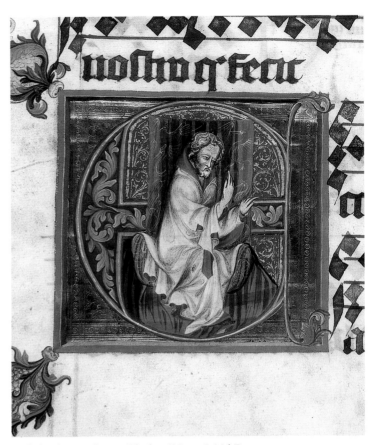

116f (detail), Seated Man (Abraham?) in an Initial E

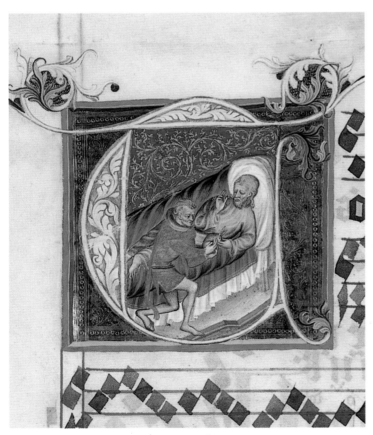

116g (detail), Isaac Blessing Jacob in an Initial T

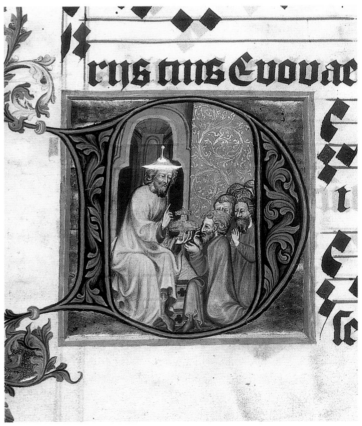

116h (detail), The Prodigal Son Returns to His Father(?) in an Initial D

116i (detail), The Stoning of Christ in an Initial E

116j (detail), The Flagellation in an Initial C

Herod killed many boys). Massacre of the Innocents (Maggs sale 1928, no. 295). That the initial should be read as an O, as proposed by Neuwirth and the Maggs catalogue, is unlikely because there are no antiphons or responses for this feast that begin with an O.

fol. 101r Epiphany: "M(agi videntes stellam) . . ." (Wise men looking upon a star). Adoration of the Magi (cat. 116d). The red angels portrayed against a red ground holding the cloth of honor give this leaf a particularly rich palette. Similar angels *en camaieu* are used often in the Wenceslas Bible.

fol. 127v First Sunday after the Octave of Epiphany: "D(omine ne in ira tua) . . ." (O Lord, rebuke me not in your anger). Christ Enthroned (cat. 116e). This figure of Christ has no obvious relation to the liturgical texts but is appropriate to the season that focuses on the manifestation of Christ. As on the Christmas leaf (fol. 58r, cat. 116b), a figure adores him. Here the figure is obviously a layman, perhaps the one who paid for the magnificent book. The wispy images of birds on the cloth of honor recur on the tent of Wenceslas IV in the *Bellifortis* manuscript (cat. 89).

fol. 154r Third, Fourth, or Fifth(?) Sunday after Epiphany: "F(ratres existimo enim quod non sunt condignae passiones huius temporis) . . ." (Brethren, I reckon that the sufferings of this present time are not worthy). Saint Paul Writing (Maggs sale 1928, no. 303). The Maggs catalogue read the initial as an L and gave a very vague description.

fol. 186r Eighth Sunday before Easter (Dominica in Sexagesima): "Q(uadraginta dies et [quadraginta] noctes) . . ." (Forty days and forty nights). Noah's Ark (Maggs sale 1928, no. 305).

fol. 194v First Sunday in Lent: "E(cce nunc tempus acceptabile) . . ." (Behold, now is the acceptable time). Seated Man (cat. 116f). The figure has no attribute. The Sotheby's catalogue proposed that he is the prophet Isaiah without giving a reason. More likely he represents Abraham, as the first reading of the nocturn deals with Abraham's divine mission to Canaan (Gen. 12:1–3).

fol. 206v Second Sunday in Lent: "T(olle arma tua) . . ." (Take your weapons). Isaac Blessing Jacob (cat. 116g). The story of the blind Isaac blessing his younger son,

who brought him his favorite food (here shown as rabbit) is recounted in Genesis 27; it is read on the Wednesday following the second Sunday in Lent.

fol. 217v Third Sunday in Lent: "D(ixit autem pater ad servos suos) . . ." (But the father said to his servants). The Prodigal Son Returns to His Father(?) (cat. 116h). The identification of this scene showing a seated man wearing a Jew's hat receiving a golden bowl from several kneeling men is controversial. Neuwirth proposed (obviously referring to the following reading) that it depicts the Return of the Prodigal Son; the 1990 Sotheby's catalogue and Schmidt identified it with Abraham and Melchisedech. As the readings of the nocturns are usually illustrated, it is also possible that the scene shows Joseph receiving his brothers in Egypt.

fol. 231r Fourth Sunday in Lent: "N(emo te condemnavit) . . ." (Hath no man condemned thee). Jesus and a Standing Female (Maggs 1928, no. 296). Neuwirth identified Jesus' companion as the woman of Samaria (John 4:7–19); the Maggs catalogue described the scene as "the Magdalen being consoled by Jesus." The text of the antiphon

suggests it is more probably Jesus and the woman taken in adultery (John 8:1–11).

fol. 243r Fifth Sunday in Lent (Dominica Passionis): "E(go sum qui testimonium perhibeo de me ipso) . . ." (I am one that bears witness of myself). The Stoning of Christ (cat. 116i). The scene illustrates John 10:31–39. Josef Krása noted that the composition depends upon a fresco of about 1355–60 in the Emmaus Monastery.[6]

fol. 255r Palm Sunday: "C(ircumdederunt me gemitus mortis) . . ." (The groans of death were all around me). The Flagellation (cat. 116j). This initial was overlooked by Neuwirth in 1886. Nevertheless, there can be no doubt that the leaf was part of the antiphonary.

The artistic accomplishment of the creator of this antiphonary was near or equal to that of the two most prominent workshops in contemporary Prague, the ateliers responsible for the Antwerp Bible of 1402–3 (cat. 85) and the Hazmburk Missal of 1409 (see fig. 9.1). Seeing the ten leaves together offers an opportunity to verify Schmidt's supposition that the initials are by more than one hand.[7] The individual style of the antiphonary's principal illuminator cannot be definitively identified in any other surviving manuscript of the period. The gilding at the lower right of the Cleveland leaf (cat. 116b) bears a previously undetected punchmark in the form of a single-headed eagle, perhaps a hallmark of an atelier.

This artist was demonstrably familiar with, and to a certain degree influenced by, the work of several of his contemporaries, among them the Master of the Golden Bull (named after Cod. 338 in the Österreichische National-bibliothek, Vienna, dated 1400) and the so-called Noah Master of the Antwerp Bible, whose drapery styles and facial types he adapted. The acanthus vines that sprout from these initials and fill the margins of the pages are particularly close to the ornament in the center section of the missal of the Prague canon Václav of Radeč (Metropolitan Chapter of Saint Vitus's Cathedral, Prague, Library, P 5).[8] The illuminator of that missal may also have provided the models for certain technical devices in the Seitenstetten miniatures: the occasional hatching of shaded areas, for example, or the skillful modeling of the faces.[9]

The principal master of the Seitenstetten Antiphonary was thus firmly rooted in Prague book illumination of the Beautiful Style. His contribution to the heyday of this art form, about 1400–1410, was without doubt a notable one.                                  GS, MR, BDB

1. De Hamel 2000, p. 11.
2. Maggs sale 1928, nos. 289, 291, 293–97, 299–303, 305.
3. Eric Korner sale, Sotheby's, London, June 19, 1990, pp. 49–51; see also the addendum in Schmidt 2005, vol. 1, pp. 348–50.
4. Our main sources for the liturgical identification were two databases: www.cursus.uea.ac.uk and www.lib.latrobe.edu.au/MMDB.
5. Schmidt 2005, vol. 1, p. 338, fig. 1.
6. Krása in Prague 1970, p. 414.
7. Schmidt (1969b, pp. 148–50) considers the possibility that the smaller initials were in part painted by assistants.
8. Podlaha 1904, pp. 232–36, no. 115.
9. These stylistic affinities are discussed in more detail in Schmidt 1969b, pp. 151–52.

LITERATURE: Neuwirth 1886, pp. 202–7 (entire manuscript); Vienna 1962, no. 183 (b); Schmidt 1969b, figs. 193, 197, 201, 205, 207 (a–c, f–j); Washington 1975, no. 41 (a, g, j); Pierpont Morgan Library 1976, p. 43 (e); Wixom 1977 (b); Nordenfalk 1979, no. 30 (i); Schmidt 2005, vol. 1, pp. 337–40, 343, 347–49, figs. 1, 2, 5–7, 10, 13 (a–c, e–j).

## 117. Model Book

*Prague, ca. 1410–20; additions, Vienna, ca. 1430*
*Silverpoint and brush with white highlights and touches of red on paper with green tinted ground mounted on 14 maple panels connected by parchment strips, all in a leather (cuir-bouilli) case; 9.5 x 9 cm (3¾ x 3½ in.)*
*Provenance: Possibly Margaret of Austria, Mechelen, by 1524; Archduke Ferdinand of Tirol (1529–1595), Ambras Castle (probably identical with one mentioned in 1596 inventory).[1]*
*Kunsthistorisches Museum, Vienna, Kunstkammer (KK 5003, KK 5004)*

An itinerant manuscript illuminator would have used this presentation book to show potential patrons his artistic abilities and the thematic range of his work. Four individual drawings of heads are mounted on each of the fourteen small wood panels, which can be folded like an accordion and stored in a leather case complete with a silverpoint stylus. The first two sections of the fully preserved book are dedicated to religious subjects: the Crucifixion, the Man of Sorrows, the Annunciation, and the infant Jesus. Then come the apostles, although on the third panel there are also two dramatically foreshortened heads based on northern Italian models. Next are a group of faces both holy and worldly, idealized and noble, along with the crude, distorted physiognomies of evil characters. At the end of the book is a series of sketches of animals, from a stylized griffin head to a horse to

117, panel I (detail), The Angel Gabriel

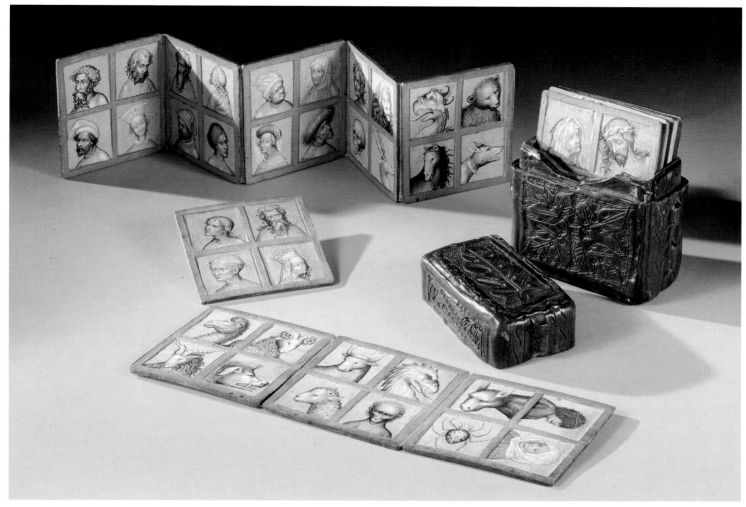

117

117, panel XIV, dragon, bear, horse, dog

a larger-than-life spider, followed by two real-istic portraits that were added later.

Only a manuscript illuminator would have used such a fine hair brush. The technique, the green ground, and the way of adding colored highlights relate this artist to the Master of *The Travels of Sir John Mandeville* (see cat. 88).[2] Comparing the apostle on the third panel of the presentation book with the early work of the Mandeville Master in the Gerona Martyrology (cat. 86) shows how close the two artists were.[3] This group of artists who worked principally for the court of King Wenceslas IV put little value on elaborate folds and ornamental draperies, which may explain why this illuminator included only heads on his panels, instead of the full figures like those that appear in other contemporary model and presentation books (see cat. 35, figs. 99.1, 117.1).

Despite the artist's virtuosity, evident in the artful variation of hairstyles and beards, and skillful observation of nature, particularly in the portraits, the types left relatively little room for individuality. The heads and faces are simplified and stylized, as are the locks of hair and the drapery. Also closely related are the drawing of two heads from an Annunciation in the Fogg Art Museum, Cambridge,

Fig. 117.1 Three Noblewomen. Ink on parchment; Prague, ca. 1410. Musée du Louvre, Paris, Département des Arts Graphiques (3811)

Massachusetts (see fig. 9.8),[4] a drawing in a private collection (cat. 118), the copy of the Bamberg Rationale in Pommersfelden (cat. 103), and the illuminations in the Metten codices dated 1414–15 in the Bayerische Staatsbibliothek, Munich (Clm. 8201). The work of those artists grew more stylized and uniform.                                     RS, JF

artist has shaped her facial features in tiny pointillist strokes, in a technique similar to that of book illumination. The way the figure was drawn, its type and size, and the use of parchment as drawing material are all features of early drawings and typical of artists' pattern books from about 1400. In illumination and

painting workshops, collections of patterns, or model books, served both as the basis for work in hand and as designs that could be shown to patrons, and also as training material and a repertoire of forms for journeymen. Only a few outstanding examples of these practice and pattern drawings, which must once have been very numerous, have survived.

Among the examples most like this drawing, and one of the most outstanding of its kind, is the so-called Vienna Model Book (cat. 117). These drawings, pasted in groups of four, accordion-like, in flat wood frames, provide an idea of how this kind of pictorial material was preserved, organized, and used. Among the fifty-six drawings of "typical" heads in the Vienna collection there are also—as separate renderings, one sheet each—a Mary and an Angel of the Annunciation. Almost indistinguishable are two other drawings of Mary and the Angel of the Annunciation—perhaps somewhat earlier, from about 1400–1405—in the Harvard University Art Museums, Cambridge, Massachusetts (1947.79, 80; see fig. 9.8). Further evidence of the fixed tradition represented by both works are the drawings of the Metten Bible (Bayerische Staatsbibliothek, Munich, Clm. 8201, for example fol. 37r). This luxury manuscript,

1. Degenhart 1943; Scheller 1995.
2. Krása 1983a; Studničková 1998, pp. 201, 228. The grayish green ground imitates Paduan models; see, for example, the *Liber de principibus Carraresibus et gestis eorum* of Petrus Paulus Vergerius (1370–1444) in the Museo Civico, Padua (Ms. 144).
3. The unusual lion's head on folio 95r of the Gerona Martyrology (Studničková 1998a, ill. p. 207) is identical to the lion's head in the Vienna book.
4. Stejskal 1953, pp. 323–27; Suckale 1982; Studničková 1998a, pp. 120–23.

LITERATURE: Schlosser 1902; Baldass 1956; Drobná 1956, p. 44; Jenni in Cologne 1978–79, vol. 3, pp. 146–48, colorpl. 4; Scheller 1995, pp. 225–32, no. 20, colorpl. 9; Studničková 1998a, pp. 120–27.

## 118. The Virgin from an Annunciation

*Prague, ca. 1405–10*
*Gray, ocher, red, and black crayon on parchment glued onto backing paper, 9.2 x 7 cm (3⅝ x 2¾ in.)*
*Private collection*

This small drawing of a young woman's head was executed in crayon on parchment. The

118

produced by a most outstanding draftsman a bit later, in 1414–15, documents even in the tiniest heads of its exquisitely rendered pen drawings the enduring, definitive influence of this formal tradition and draftsmanly training. This small head departs from these examples in that it has slightly different proportions. It has a more rounded shape, wider at the back, the forehead is slightly higher, and the cheeks are noticeably fuller. The nose and chin, however, are clearly more pointed. In its use of colors it appears to be unique, the earliest and only example known. That the technique of drawing adopted here was typical of the time is confirmed by a drawing in the Louvre, Paris, of three young noblewomen (fig. 117.1) skillfully rendered on parchment with a brush in shades of gray to black with red on the cheeks, lips, neck, and hands.

Representing the Virgin of the Annunciation, the head has close formal parallels to Bohemian art in the International Gothic style of European art about 1400. It is particularly similar to the Virgin in the Nativity from the Seitenstetten Antiphonary (cat. 116b). That Virgin's large head, with clinging, wavy hair, broad skull, high forehead above dotlike eyes, round cheeks, small mouth, and characteristic pointed chin set off by shadows, is so startlingly like this drawing that it is possible to connect the two works with absolute assurance. The proportions of the facial features, the pointed shape of the nose and chin, the play of light, and the form of the head, the hair, and the part shifted to the left of center—all indicate that the drawing and the miniature were at least executed in the same workshop.

These links not only indirectly confirm the authenticity of this hitherto unpublished drawing—for no forger could have produced such connections by chance, and could certainly not have thought them through in such detail—they also allow a more precise attribution than is possible for any of the other comparable drawings. Given the relatively reliable dating for the Nativity miniature of about 1405, derived from and assured by the much richer inventory of book illumination, the drawing so closely related to it in style becomes of great importance for the history and development of the art of drawing in Bohemia: it provides fresh arguments that help to place the Vienna Model Book and the Harvard drawings in a more precise geographical and temporal context, definitely linking them to developments in Prague. This drawing from a private collection is of exceptional importance within the handful of contemporary examples because of its size and because of its much greater use of color. Moreover, this newly discovered pattern drawing represents an important link between

119

book illumination and drawing in Prague in the first decade of the fifteenth century.     FK

## 119. Chasuble with an Embroidered Orphrey

---

*Embroidery: Bohemia, ca. 1380–90*
*Chasuble: silk velvet, orphrey: silk and metallic*
*threads on linen; 112.5 x 44.5 cm (44¼ x 17½ in.)*
*Provenance: Church of Saints Peter and Paul, Brno.*
*Moravská Galerie, Brno (27 414)*

Originally Y-shaped, the orphrey represents Christ on a Latin cross with a half-length angel hovering at his right side. The angel bears a chalice to collect blood from the wound at

Jesus' side, and he covers the left side of his face with his left hand in a gesture of grief. At the foot of the cross the swooning Virgin is supported by Saint John the Evangelist and another mourning woman, while behind them Mary Magdalen raises her clasped hands in grief. The grain of the wood cross is skillfully evoked.

The orphrey was given to the Church of Saints Peter and Paul in Brno by Margrave Jodok (1351–1411), nephew of Charles IV. Jodok had a court in Brno and was noted for his architectural patronage and his sophisticated collecting activity.[1] Like the embroidery of the orphrey from Břevnov (cat. 128), also depicting the Crucifixion, this silk embroidery is among the masterworks produced by Bohemian needleworkers of the fourteenth century.

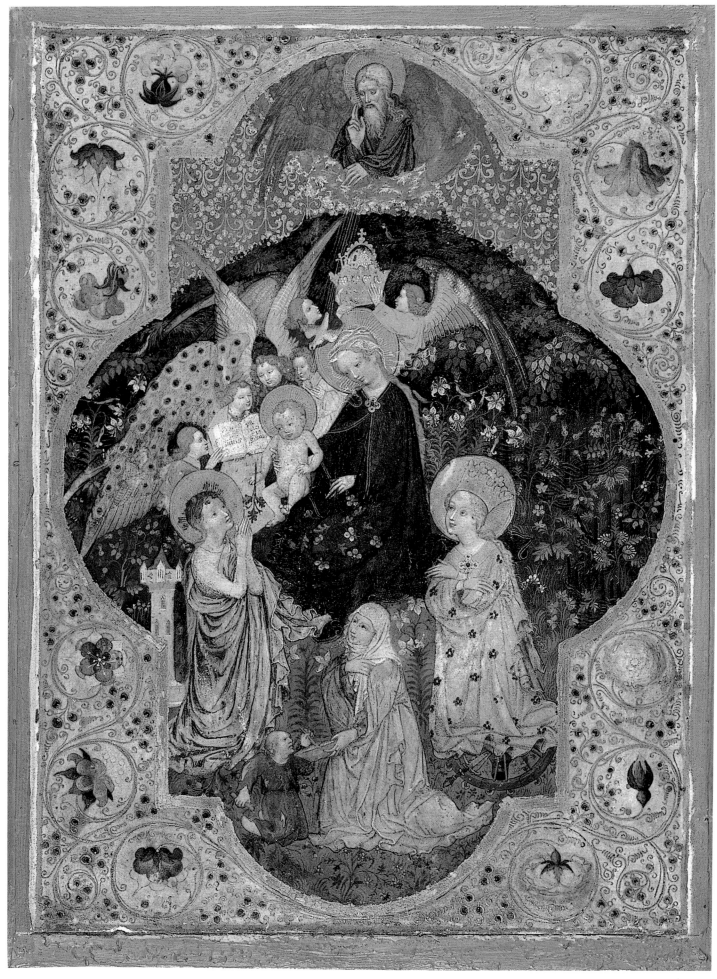

120

Although Emanuel Poche saw French and Italian influence in the Brno chasuble,[2] its pictorial style and delicate, slender figures seem to derive from the paintings of the Master of the Třeboň Altar (see cat. 97) and other Bohemian works.                                        PB

1. Prague 1970, no. 458.
2. Cologne 1978–79, vol. 2, p. 715.

LITERATURE: Drobná 1950, p. 56, pls. 31–34; Paris 1957, no. 223, pl. 58; Schuette and Müller-Christensen 1964, p. 313, pls. 238, 239; Brussels 1966, no. 62; Prague 1970, no. 458; Cologne 1978–79, vol. 2, p. 715 (with bibl.); Wilckens 1991, p. 227; Wetter 2001, pp. 8, 13–16, 19.

## 120. Virgin and Child in the Garden of Paradise

*Prague, ca. 1415*[1]
*Tempera and gold on parchment mounted on wood, 26.4 x 19.8 cm (10⅜ x 7¾ in.)*
*Condition: Leaf glued to a larger panel; coarse reddish border, itself surrounded by a white and green border, covers edges of leaf.*
*Provenance: Acquired before 1886.*[2]
*Tiroler Landesmuseum Ferdinandeum, Innsbruck (Gem 54)*

A quadrilobate opening in a surface filled with flowers and golden tendrils affords us a glimpse into paradise. Sitting in a flowery meadow surrounded by birds, the Virgin holds the Child on her lap. A group of angels on the left call his attention to a book, but Jesus looks instead at Saint Barbara, who kneels before him. He hands her the palm of martyrdom, while Saint Catherine, on the right, looks on. The veiled woman kneeling at the bottom of the page who offers a bowl of food to a cripple may be Saint Elizabeth of Hungary, who was often venerated together with Barbara and Catherine. As the figure has no halo, however, she may be the patron of the manuscript to which this leaf was probably the frontispiece,[3] presented with Elizabeth's attributes. The apparition at the top of the page, showing God the Father blessing, confirms the divine nature of the Child.

The Song of Songs compares a bride to a rose and a fenced garden,[4] imagery that the Christian Middle Ages grafted onto Mary. The motif of the Virgin and Child in a *hortus conclusus* inhabited by angels or female saints emerged in the early years of the fifteenth century and was soon adopted throughout Europe. The roses on Mary's lap and in the border allude to her love for her son. The lilies

are reminders of her virginity, as is the enclosed nature of the garden. Her humility (*humilitas*), reflected by her closeness to the ground (*humus*) and by the violets in the border, is rewarded by the gem-studded crown, its arches reminiscent of the crown of the Holy Roman Empire, held over her head by two angels.

The page is executed with mastery. The palette, in which gold and saturated yellows, vermilions, and blues contrast with cooler tones like the mauve and gray of the draperies, reveals a consummate colorist at work. The softly blushing faces, the gracefully articulated draperies, and the almost audible bristle of the angels' wings confer immediate charm. The accurate portrayal of the birds and plants implies that the artist studied actual specimens.

Comparing the female saints with heads in the Vienna Model Book (cat. 117) offers insight into the miniaturist's working methods. Catherine repeats with minor variations the head of the crowned Virgin in the model book, while Barbara, looking up, seems based on the mourning Virgin. Although they are grouped together, the figures on the Innsbruck page do not really look at one another. The illuminator thus most likely assembled widely circulated stock models to create the composition. But refined painterly execution turned the fruit of an expedient mode of production into a work of staggering beauty.          JC

1. Schmidt (in Swoboda 1969, p. 256) considered the Innsbruck leaf a late work of the Joshua Master, the most talented illuminator to work on the Antwerp Bible (cat. 85) and the Boskovice Bible (cat. 133). The Genesis page of the Boskovice Bible reveals the same aesthetic sensibility apparent in the Innsbruck miniature.
2. The miniature is included in the museum's catalogue for that year (Schmidt [1889], pp. 39–46, esp. p. 44); the year of acquisition is unknown.
3. If he had known that his work would be exposed to light for long periods, the artist would probably not have left the parchment of the border bare in places.
4. "I am the flower of the field, and the lily of the valleys"; "My sister, my spouse, is a garden enclosed" (Canticles 2:1, 4:12).

LITERATURE: Studničková 1998a, esp. pp. 127, 134; Ammann in Trent 2002, pp. 638–39 (with bibl.).

## 121. Saint Dorothy

*Prague, ca. 1400*
*Gilded silver and paint, h. 22 cm (8⅝ in.) with base*
*Provenance: Giulhou collection, Boucau, Basses-Pyrénées; Henry Oppenheimer, London, sold 1936.*
*Musée du Louvre, Paris, Département des Objets d'Art (OA 8946)*

Whether she represents Saint Dorothy, holding the rose that was her emblem, or the Virgin Mary from an Annunciation group, this beguiling statue of a female saint epitomizes the kind of image that, by its comeliness, enraged early fifteenth-century church reformers. In 1417 Jakoubek of Stříbro complained that "from a vision of beautiful virgins comes the carnal love of saints."[1] With porcelain skin simulated by paint, a necklace to define her neck, a graceful pose and swelling bodice, she is the quintessence of the Beautiful Style for which Prague was renowned. A fine and rare example in silver, she is the precious counterpart of monumental figures like the Saint Catherine from Jihlava.[2] Small standing saints from surviving Bohemian silver tabernacles never attain the sculptural quality of this image. The saint was once secured at the back, which is not fully finished, but whether it was set in a reliquary or served in some other context is unknown.          BDB

1. Quoted in Kalina 1995, p. 254: "Ex visione pulchrorum virginum . . . venit talibus solum amor carnalis ad sanctos."
2. Kutal 1971, p. 149, fig. 130.

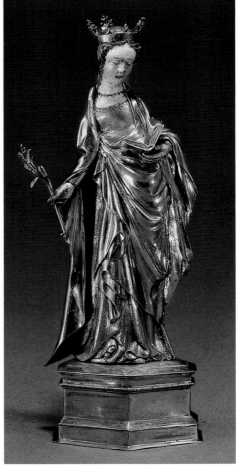

121

LITERATURE: London 1932, no. 580c; Verlet 1957, pp. 6–7, ill.; Vienna 1962, no. 463; Cologne 1978–79, vol. 2, p. 713, vol. 5, fig. T-214; Lüdke 1983, vol. 1, pp. 72, 82, 137, 140, ill. 86, vol. 2, pp. 410–12, no. 82.

## 122. Virgin and Child

*Austria (Salzburg or Vienna), ca. 1400–1410*
*Raised, cast, chased, engraved, and gilded silver with semiprecious stones, glass, and pearls; h. 25.5 cm (10 in.)*
*Condition: Virgin's scepter, two of her fingers, and several points on her crown missing. Some stones and pearls replaced.*
*Museo Nazionale del Bargello, Florence (696C)*

The crowned Virgin, who originally held a scepter in her right hand, supports the naked baby Jesus on her left side. The infant holds an apple in his left hand, while his right hand appears to reach toward his mother's veil. The octagonal base, pierced with a double row of Gothic tracery, may once have held a relic.

This Virgin and Child was initially published as a French or German work. The *Maria Säul* from the Benedictine Monastery of Saint Peter in Salzburg has traditionally been considered its closest parallel, and even its model,[1] but there is no specific evidence that it necessarily depends on any particular monumental sculpture. Rather, its style and details correspond to the Beautiful Madonnas (Schönen Madonnen) from about 1400, and its closeness to the classic Beautiful Madonna type suggests an approximate date in the first decade of the fifteenth century. The drapery is very similar, for example, to that on the Saint Catherine in Saint Stephen's Cathedral in Vienna, which can be dated to just after 1396, when the chapel dedicated to Saint Catherine was consecrated.[2] Both Salzburg and Vienna were major centers for works created in the Beautiful Style, and there is evidence that goldsmiths were working in both cities about 1400.[3] Among Austrian inventory references is one of 1509 from Saint Peter's in Salzburg that describes a gilded silver image of the Virgin from the time of Abbot Otto II (r. 1375–1413).[4]

This silver statuette is thus one of the few surviving Beautiful Madonnas worked in precious metal and an important example of the style interpreted on a small scale (see also cat. 121). The iconography and the effects of the drapery, notably the engraving of the veil to simulate fabric, are consistent with works in other media from the period. The use of silver and gilded silver to distinguish between flesh tones and the figures' hair and clothing

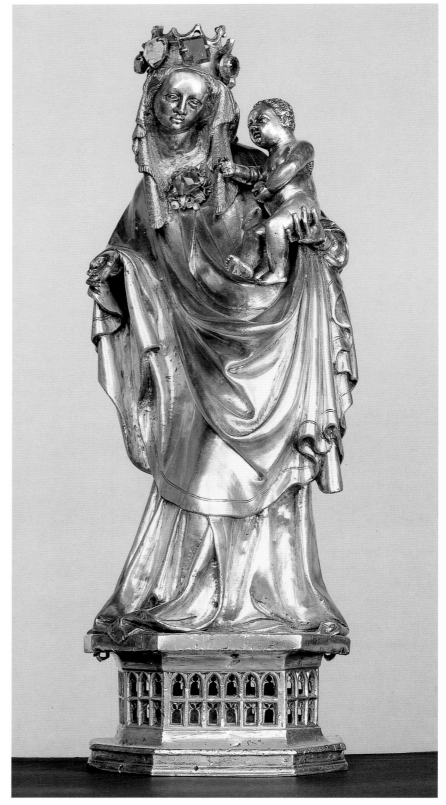

122

illustrates the goldsmiths' distinctive ability to achieve a masterful and brilliantly colored effect.

CEB

1. Kieslinger 1932, pp. 191, 196.
2. Brucher 2000, no. 149, ill. I thank Charles T. Little for calling this work to my attention.
3. See Fritz 1982, pp. 336, 338.
4. Cited in Brucher 2000, p. 581.

LITERATURE: Sangiorgi 1895, no. 50 (as French); Supino 1898, no. 696 (as German); Kieslinger 1932, pp. 191, 196, fig. 29 (as ca. 1420); Vienna 1962, no. 343; Müller 1966, p. 41; Salzburg 1976, no. 88, fig. 91; Schmidt 1978, pp. 89–90, n. 93, fig. 19 (as 1400–1425); Lüdke 1983, no. 30, fig. 83; Florence 1989, no. 139, ill.; Schmidt 1992, pp. 264, 332–33, fig. 283; Brucher 2000, no. 321, pl. 192 (as 1400–1425); Trent 2002, no. 66, ill. (as 1400–1425).

## 123. Monstrance

*Bohemia, ca. 1400–1410*
*Cast, embossed, and gilded silver; h. 96 cm (37¾ in.)*
*Condition: Restored in 1856, 1880, and 1910.*
*Římskokatolická farnost Kutná Hora–Sedlec (30051)*

Monstrances such as this superb example from the former Cistercian Abbey Church of Sedlec, near Kutná Hora, datable to about 1400–1410, were used to display (*monstrare*) the eucharistic Host to the faithful, particularly on feast days such as Easter Sunday or Corpus Christi and its octave. Placed on the high altar or carried in procession through the church building or the streets of the medieval city, monstrances were designed to promote a visual dialogue between the devout viewer and the sacramental Christ of the Host. This particular example is supported by a four-lobed foot engraved with the symbols of the evangelists and accentuated in the middle by a bulbous nodus (inscribed *IHESUS*) that would have enabled the monstrance to be firmly gripped when carried in procession. The actual Host would have been placed into the central compartment above the socle zone, held in an upright position by two angelic wings (which replace the more traditional crescent-shaped lunula or Melchisedech on other, contemporary monstrances) and protected from the elements by a glass or rock crystal cylinder, which no longer survives. The facadelike microarchitecture framing the Host compartment, with its staggered arrangement of buttresses, pinnacles, baldachins, miniature towers, and statuettes, would have furnished a theatrical visual and semantic backdrop to the eucharistic wafer. The four-sided baldachins on either side of the central tower surmount the figurines of two angels holding a lance and a sponge, powerful pictograms of Jesus' sacrifice on Calvary, while the central tower itself sets the stage for the Virgin and Child and a Crucifixion scene. Mary was the patron saint of Sedlec Abbey, and, perhaps more important here, it was through her body that the work of Incarnation was effected in the first place. The Sedlec monstrance dramatizes the tension between God's sacramental body, present in the Host transubstantiated, and his human body, a body whose existential parameters were the womb of the Virgin and the cross, the lance, and the sponge of Calvary.

Like the reliquary of Saint Catherine and its close relative, the reliquary with the shield of the Parler family (cats. 56, 57), the Sedlec monstrance presents itself as an architectural facade with an ascending array of buttresses and pinnacles and a crowning central tower. In the Sedlec monstrance, however, the buttressing systems flanking the central

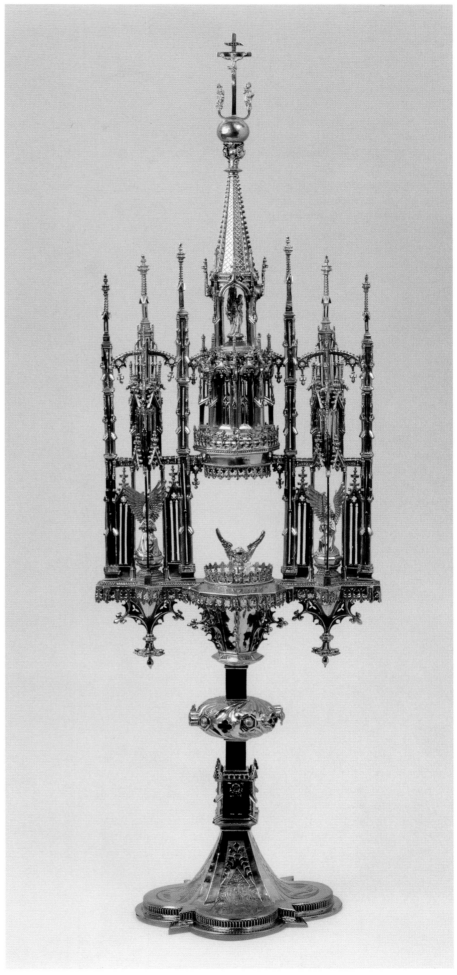

123

compartment and tower play a more dominant visual role; not only are they more articulated in their individual forms, they also serve as architectural settings for statuary (i.e., the two angels holding Instruments of the Passion). This arrangement brings to mind the buttress- and pinnacle-encrusted basilican choirs of Saint Vitus's Cathedral in Prague, the Church of Saint Bartholomew in Kolín, and the Church of Saint Barbara in Kutná Hora, all projects of the Parler workshop. The architectural plan exemplified by the Sedlec monstrance was to have a considerable influence on fifteenth-century monstrance design, in both Bohemia and Moravia[1] and, in the decades around 1500, in Franconia (as is evinced by a number of examples from Nuremberg).[2]                                          AT

1. See, for instance, the examples from Cheb, Velká Bíteš (cat. 132), and Rajhrad (Fritz 1982, no. 530; Rome 2000–2001, nos. 50, 51).
2. See Fritz 1982, nos. 780–82.

LITERATURE: Chytil 1898–99; Wirth 1913–15, vol. 1, no. 74; Leminger 1926, pp. 7–8; Fritz 1966, p. 273, no. 671; Prague 1970, p. 440 (with bibl.); Fritz 1982, no. 527; Kuthan 1988, pp. 135–36.

## 124. Choir Books from the Monastery of Sedlec

*Prague, 1414*
*Tempera and gold on parchment*
*Provenance: Cistercian Monastery of Sedlec.*

### a. Antiphonary

*171 fols., 57.5 x 39.8 cm (22⅝ x 15⅝ in.)*
*Inscribed in Latin on fol. 172: Hunc librum comparavit venerabilis in Christo pater et dominus, dominus Jacobus divina providential Abbas Czedliczenis qui finites est Sexta feria in vigilia Epiphanie sub anno domini Millesimo CCCC°XIII°.*
*Kanonie Premonstrátů, Nová Říše (NŘ 81)*

### b. Pentecost in an Initial D

*From the Antiphonary*
*15 x 15 cm (5⅞ x 5⅞ in.)*
*Provenance: Esterházy collection, Budapest, before 1918.*
*Szépművészeti Múzeum Budapest (3109)*

### c. The Holy Women at the Tomb

*From the Antiphonary*
*15.5 x 16.2 cm (6⅛ x 6⅜ in.)*
*Provenance: Esterházy collection, Budapest, before 1918.*
*Szépművészeti Múzeum Budapest (3111)*

Along with the choir books from Seitenstetten (cat. 116), those illuminated for the monks from Sedlec represent the most ambitious campaign of choral manuscripts carried out in Bohemia. The commission comprised both the gradual, containing the hymns to be sung during the celebration of the Mass, and the antiphonary, containing the music to be intoned during the daily office throughout the year. What survives represents only a fraction of the original: one partial volume from the gradual (in a later, perhaps seventeenth-century binding), one from the antiphonary, and a number of isolated initials.

The richness of the campaign can be explained by simple economics. The manuscripts were created for the Monastery of Sedlec, a Cistercian community that lay just outside the populous city of Kutná Hora, the most important in Bohemia after Prague. Kutná Hora was a renowned center for the mining of silver and minting of coin, and some of its mines were owned by the Sedlec Monastery.[1]

Though the Sedlec choir books are now dispersed and fragmentary, the sophisticated painting and technique bear witness to the importance of the original commission. The bold palette, with its surprising juxtapositions of vibrant hues, is matched by graceful compositions, elegant figural movement, and accomplished drawing. Each of the miniatures

124a, fol. 14r (detail), The Annunciation in an Initial M

124b, Pentecost in an Initial D

124c, The Holy Women at the Tomb

is framed by thick gold leaf that is first bur-
nished and then patterned by ruling, punch-
ing, and stippling in a manner consistent from
one illumination to another. Exceptionally,
several of the miniatures are not set within
initials, but within miniature frames: a quatre-
foil shape for the Rule of Saint Benedict and
the Entry into Jerusalem and a devotional
panel for the Holy Women at the Tomb
(cat. 124c). Some scenes, such as the Entry
into Jerusalem, are enhanced by architectural
and landscape details, while others, including
the Saint Benedict, use gesture to emphasize
subtle emotional bonds among the figures.

The Sedlec illuminations share the remark-
able narrative quality displayed in the illumi-
nated roundels of the Gerona Martyrology
(cat. 86). The inventive anecdotal aspects are
particularly noticeable in the miniature of
Christ and Zaccheus. The gospel account of
Jesus' calling the rich man Zaccheus (Luke
19:1–10) to a new life of discipleship and
Christian charity is not often illustrated.[2] The
selection of a converted patrician's call to piety
to illustrate the hymn for the "Dedication of
a Church" seems particularly poignant for an
abbot and a monastic community so closely
linked to the mineral riches of Kutná Hora.

Illuminated manuscripts generally repre-
sent a collaborative effort on the part of artists
working with a variety of materials—parch-
ment, ink, tempera paint, gold leaf—but the
division of labor is often difficult to discern.
For the Sedlec miniatures, no fewer than three
distinct illuminators have been suggested.[3]
One, responsible for the miniature of Philip
and James, focuses on the subtle modeling of
faces and uses a characteristically striated halo
for his holy figures. A second employs line to
define faces and drapery, and often clusters
figures into groups, as in the Ascension. Is a
third responsible for the rough-hewn faces of

figures such as the soldier at the tomb of Christ in the same work? Did the same three artists also execute the foliate initials and borders, or did other members of an atelier specialize in nonfigural ornamentation?

What is readily apparent is that each of the figural illuminators who contributed to the Sedlec choir books also seems to have participated in the painting of the Gerona Martyrology. The leafy tendrils and floral decoration in the margins of the Sedlec manuscripts also resemble those in the Martyrology, as well as in the Antwerp Bible of Konrad of Vechta (cat. 85), both created within the court circle of Wenceslas IV.[4] The Gerona Martyrology sometimes juxtaposes, on a single full-page opening, the work of two distinct figural artists and two different patterns of foliate border ornament. The relatively simple punches used in the Sedlec books to decorate the gold leaf recur in the leaves from Seitenstetten and in the Boskovice Bible (cat. 133). Appropriately praised by Gerhard Schmidt for its "kaleidoscopic nature," this mixture of individual styles born of artistic collaboration—both within a single commission and across numerous separate ones—is among the most remarkable aspects of Bohemian illumination about 1400.

The original commission for the Sedlec choir books has been gradually reconstructed in scholarly literature. An explicit written on folio 172 of the Antiphonary proclaims that James of Sedlec, who became abbot in 1409 (following an earlier appointment at Hradišti), ordered the manuscript for the Cistercian monastery at Sedlec and that it was completed on the eve of the Epiphany (January 5) in 1414.[5]

Part of the original Antiphonary is preserved at the Premonstratensian abbey of Nová Říše. The leaves remaining in that volume correspond to fixed feasts: the Annunciation (March 25), the feast of Saints Philip and James (May 1), perhaps given special prominence by the patron of the same name, and the Dedication of a Church. The later binding and the truncated decoration of the foliate borders indicate that the bound book has been altered. The isolated miniatures ordinarily associated with this antiphonary are the Pentecost in an Initial D, the Entry into Jerusalem, Rule of Saint Benedict, the Holy Women at the Tomb, and the Trinity in an Initial V. None of these, however, has been excised from the present bound volume.

A portion of the original Gradual is preserved in Brno. While it presently contains 141 folios, an index of its contents at the beginning of the manuscript indicates that there were originally 239. The sole illumination preserved within the bound codex depicts the Annunciation in an Initial R, the

Fig. 124.1 The Ascension of Christ in an Initial V. Szépművészeti Múzeum Budapest (Cod. 3105)

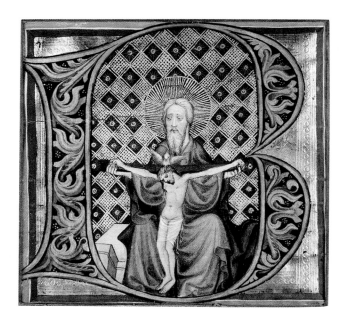

Fig. 124.2 The Trinity in an Initial B. Národní Muzeum, Prague, Library (Cod. 1 Da 1/7a)

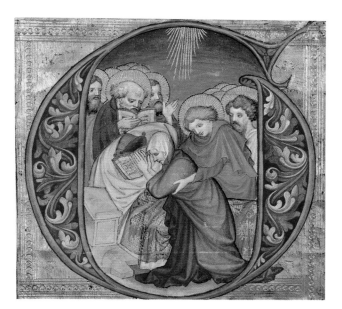

Fig. 124.3 The Last Prayer of the Virgin in an Initial G. Szépművészeti Múzeum Budapest (Cod. 3105)

opening letter of the hymn "Rorate Coeli de Super" (Drop Down Dew, Ye Heavens from Above), which is associated with the feast. Surviving miniatures from the Gradual include the Ascension of Christ in an Initial V (fig. 124.1), the Pentecost in an Initial S, corresponding to the Gradual hymn for that feast, the Trinity in an Initial B (fig. 124.2), the Last Prayer of the Virgin (the Feast of the Dormition) in an Initial G (fig. 124.3), and the Dream of Jacob in an Initial T. All celebrated between the spring and the fall, the holy days related to these subjects include both moveable and fixed feasts.

The very richness of the manuscript and the monastery proved to be their undoing. Concerned about the fate of precious objects at Sedlec during the Hussite Revolution, Abbot James took his concerns to Emperor Sigismund and persuaded him to write an official letter stopping the sale of objects and proclaiming the right of the abbot to return to the monastery.[6] A note in a sixteenth-century hand on folio 172 of the Antiphonary recounts that, during the revolution, the manuscript was transported to the Cistercians of Lilienfeld, Austria, for safekeeping. In 1506 Abbot Clement of Sedlec repurchased it. The manuscript remained at Sedlec until the secularization of the monastery by Emperor Joseph II in 1799, at which time it was given to the monastery of Nová Říše. Its three miniatures were published in 1925. In 1942 the Nazis deported the abbot and several of the monks to Auschwitz, where they were subsequently martyred, but the manuscript remained successfully hidden, reappearing only in 1967.[7] It was placed in the University Library, Brno, until restitution to Nová Říše after the Velvet Revolution. The history of the Gradual and its illuminations is only partially documented, but presumably it was kept with the Antiphonary until the suppression of the monastery in 1799. After that, the Gradual entered the collection of the former Musée François I, which became the Moravská Galerie, Brno, in 1817.[8]

BDB

1. Studničková 1998a, pp. 143–44.
2. Index of Christian Art, Princeton University: http://index4.princeton.edu:4505. Examples include a thirteenth-century lectionary from Brandenburg Cathedral and another of the same date from the Church of Gross Sankt Martin, Cologne.
3. First isolated by Frinta (1964, pp. 292ff.). Studničková (1998a) suggests further refinements of these attributions.
4. The similarity to the Bible of Konrad of Vechta is particularly interesting given Konrad's role as master of the mint at Kutná Hora and his advocacy on behalf of the Monastery of Sedlec in a dispute with the Cathedral of Saint Vitus. See Studničková 1998a, p. 144.

5. Matějček 1924–25, p. 216.
6. Ibid., p. 217.
7. Prague 1970, p. 294, no. 387.
8. Drobná 1968, pp. 42–43.

LITERATURE: Hoffmann 1918; Matějček 1924–25, pp. 216–19; Drobná 1957; Aggházy 1958; Frinta 1964, pp. 292–96; Drobná 1968; Krása 1969; Cologne 1978–79, vol. 2, pp. 753–54; Studničková 1998a, pp. 131–32; Brodský 2000, p. 320, no. 303.

## 124d. The Trinity in an Initial V

*Prague, ca. 1414*
*Tempera and gold on parchment, 15.7 x 18.2 cm (6¼ x 7⅛ in.)*
*Provenance: Edward Shultze; Robert Forrer, Strasbourg; J. Rosenthal, Munich, 1931; E. Rosenthal, Berkeley, Calif.; Lessing J. Rosenwald, Jenkintown, Pa., 1946.*
*National Gallery of Art, Washington, D.C., Rosenwald Collection 1946 (1946.21.2)*

The Trinity in an Initial V has long been associated with the choir books of Sedlec (cat. 124a–c). To be sure, some considerations argue in favor of that hypothesis. The size and richness of the initial are consistent with that ensemble. Moreover, the figures, with their carefully modeled faces, are apparently by the same artist who painted the images of Saints Philip and James in the Sedlec Antiphonary in

Nová Říše. The sophistication of the illuminator is particularly noticeable in the subtle evocation of the bond between the figures, the perspectival rendering, and the simulation of the wood of the cross. This artist's ability to evoke great pathos is particularly manifested by the figure of God the Father, who, with downcast and averted eyes, gently places his hand on Jesus' shoulder. The foliate decoration within the initial and the punchwork of the burnished gold surrounding it are especially reminiscent of the Sedlec leaves in Budapest, including the Pentecost (cat. 124b) and the Dream of Jacob.

The text of the reverse corresponds to the Ambrosian hymn "Veni, Redemptor Gentium" (Come, Savior of Mankind).[1] Associated in medieval liturgies with the seasons of Advent, Christmas, and Epiphany,[2] the hymn recalls the image of Jesus leaving his father's throne and the necessity that he die before returning. The text here is not, however, notated for choral use, and the writing—an elegant book hand with tightly compressed Gothic letters and ornamental serifs—is distinct from the highly legible, if squat, script of the bound volumes and cuttings from the Sedlec choir books. This suggests that the cutting comes from a different text, perhaps an elaborately illustrated breviary. It is even possible that it was created for the use of James, abbot of Sedlec and the patron of the choir books, who would then have had a companion

124d

volume to enable him to say the office in concert with the community. BDB

1. I am grateful to Eric Ramírez-Weaver for identifying the text for me. The reverse comprises most of the second three stanzas of the hymn. Accordingly, the first three might have been aligned beneath the initial, making the page, with marginal foliation, rather more than double the height of the initial.
2. See *Cantus,* a database for Latin ecclesiastical chant: http://bach.music.uwo.ca/cantus/search.asp.

LITERATURE: Washington 1975, pp. 164–67, no. 44 (with bibl.); Studničková 1998a, p. 111.

## 125. Busts of Saints Peter and Paul

*Attributed to Johann de Kotbus, called Newenmeister(?), goldsmith;[1] Prague, 1413*
*Gilded copper and enamel, Peter: h. 38.5 cm (15⅛ in.), Paul: h. 37.7 cm (14⅞ in.)*
*Inscribed (punched) on the bases of both: albicus arcepus, on Saint Peter with arms of Prague archbishopric and Vyšehrad Chapter.*
*Provenance: Discovered during renovation of Archbishop's Palace, Prague, 1883.*
*Arcibiskupství Pražské, Prague (015363, 015364)*

The name of Albík of Uničov is engraved on the base of each of these busts. Initially a professor of medicine at Prague University, as well as the personal physician of Wenceslas IV, Albík became archbishop of Prague in 1411 and provost of Vyšehrad the following year. It was surely during his tenure at Vyšehrad, with its church dedicated to Saints Peter and Paul, that Albík, an active patron of the arts, commissioned these reliquaries.

Variations in the faces of the two saints and distinctions in the decoration of the bases have led some authors to suggest that they do not constitute a homogenous ensemble. But images of Peter and Paul have traditionally been distinguished to make them recognizable—a round face and tufted, balding hair signaled Peter, while a leaner, more ascetic face and long beard denoted Paul, as in the panels of the Capuchin Cycle (cat. 147).[2] Very refined pointillé decorates both busts. Champlevé enamel simulates a decorative stole for Peter, and each bust once had gems around the circumference of the base. Dana Stehlíková's conclusion, based on technical grounds, that the two represent an original pair is compelling, and the logical inference to be drawn from their provenance. BDB

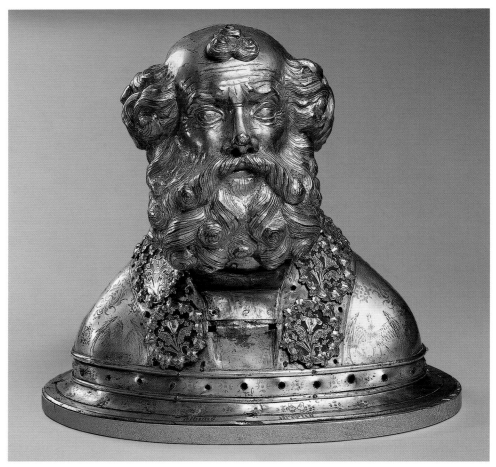

125, Saint Peter

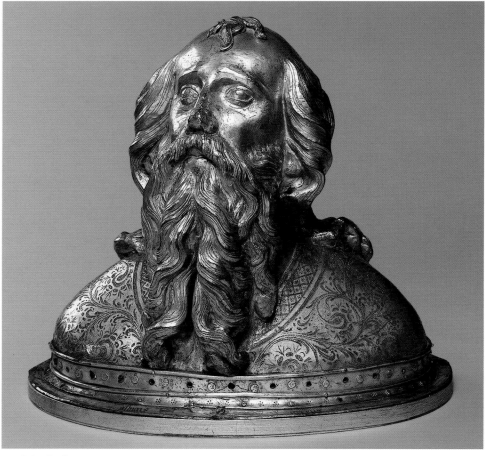

125, Saint Paul

126

long strands of hair flowing down her back, all combine to impart an air of exalted humanity.

The compelling rapport between this mother and child and the type of the child can be related to Bohemian works,[1] but this sculpture also seems to confirm the impact of Bohemian style in other parts of Europe. Elongated drapery like this, belted at the waist and flowing in soft tubular folds with undulating edges, can also be seen on figures sculpted in the Middle Rhine in the early fifteenth century, especially the Virgin from the abbey of Eberbach (Louvre, Paris) and the one in the parish church at Hallgarten.[2] A contemporary sculpture in the parish church at Bingen also conforms to this elegant style, which clearly is an offshoot of the Beautiful Style.[3]     CTL

1. See, for example, the Virgin and Child published by Denkstein and Matouš 1955, no. 65.
2. Paris 1991–92b, no. 6; Frankfurt am Main 1975–76, nos. 72, 74.
3. Frankfurt am Main 1975–76, no. 75, pl. 5.

LITERATURE: New York 1968–69, no. 43; Bober in New York 1969 (1975), vol. 1, pp. 233–41.

1. State Archives, AKVŠ, document no. 355, dated May 15, 1448. The attribution is after Stehlíková 2004, pp. 54–55, nos. 25, 26.
2. Cibulka 1949, pp. 109–11.

LITERATURE: Cibulka 1949, pp. 106–16; Cologne 1978–79, vol. 2, pp. 711–12 (with bibl.); Fritz 1982, pp. 263–64, no. 539; Poche 1984, p. 477, fig. 340; Kořán 1987, pp. 540–41, ill.; Stehlíková in Brussels 1998–99, pp. 214–15, no. 50.

## 126. Christ and the Virgin Enthroned in an Initial G

*Prague, ca. 1410–20*
*Tempera and gold on parchment, 13.7 x 11.8 cm (5⅜ x 4⅝ in.)*
*Provenance: Sold through L'Art Ancien to Lessing J. Rosenwald, Jenkintown, Pa., 1962.*
*National Gallery of Art, Washington, D.C., Rosenwald Collection 1964 (1964.8.10)*

The image of Christ enthroned beside his mother once marked the opening of the hymn "Gaudeamus Omnes" (Let Us All Rejoice), sung during the Mass of the Assumption of the Virgin, celebrated on August 15. As Gerhard Schmidt has noted, Jesus' face and garments are drawn here in a manner that recalls the Bible of Konrad of Vechta (cat. 85). The rinceaux

background and foliate decoration of the initial are classic examples of Bohemian book illumination during the time of Wenceslas IV. While the high crowns and vivid halos are quite distinctive, neither sister leaves nor the gradual from which the cutting comes has been identified. Given the ubiquity of the subject, informed speculation about its particular original context is impossible. Nonetheless, it is noteworthy that choral manuscripts of this level of ambition were being created nearly at the same time as the religious upheavals of the Hussite era.     BDB

LITERATURE: Schmidt in Washington 1975, pp. 160–61, no. 42.

## 127. Standing Virgin and Child

*Middle Rhine, ca. 1410*
*Painted and gilded wood, h. 33.5 cm (13¼ in.)*
*Private collection*

This tender image of the Virgin and Child is exquisitely rendered. The torsion of the drapery encloses the Virgin within her mantle. The playful charm of the Child as he holds an apple in one hand and clutches his foot with the other and the girlish appeal of the Virgin, with her small mouth and high forehead and the

127

THE BEAUTIFUL STYLE 287

128

distraught Virgin, and the head and halo of a second mourning woman can be seen just below Christ's feet. The other three evangelists, from left to right Mark, Matthew, and Luke, appear at the top of the cross with their symbols. Halos are decorated with tiny pearls and stones, and the gold background of the orphrey is richly textured in a basket-weave pattern.

Although for most of its history the embroidery was at the Benedictine Abbey at Broumov in northern Bohemia, it was made originally for the abbey in the district of Břevnov in Prague. The Břevnov Abbey was renowned for its artistic patronage in the fourteenth century, particularly during the abbacy of Diwissius (1385–1409). This is presumed to be the orphrey mentioned in the Břevnov inventory of 1390–94, when it belonged to a member of the community named Alsonis. It was transferred to Broumov in the early fifteenth century, during the Hussite Revolution. PB

LITERATURE: Prague 1970, no. 457, pl. 179; Cologne 1978–79, vol. 2, pp. 715–16, vol. 5, pls. 216, 217 (with bibl.); Cologne 1985, no. 59; Wilckens 1991, pp. 224, 227; Wetter 2001, pp. 14–17, 36–37, 104.

## 128. Chasuble with an Embroidered Orphrey

*Embroidery: Prague, ca. 1380–90*
*Chasuble: silk velvet, orphrey: silk and metallic*
*threads, stones, and pearls on linen; h. 106 cm*
*(41¾ in.)*
*Provenance: Benedictine Abbey, Břevnov district,*
*Prague; Benedictine Abbey, Broumov, since early*
*15th century.*
*Benediktinské Arciopatství Sv. Vojtěcha a Sv. Markéty*
*v Praze-Břevnově, Prague (52.901)*

This embroidery is among the finest Bohemian works of its kind. The delicacy of the drawing, the refined use of color, and the sense of space evoke the seminal paintings of the Master of the Třeboň Altar (see cat. 97).

The Y-shaped orphrey represents the dead Christ on a Y-shaped cross flanked by flying angels. The angel on Jesus' left swings a censer; the one on his right bears a chalice to collect the drops of blood issuing from the wound in his side. At the foot of the cross Saint John the Evangelist and another woman support the

## 129. Reliquary of Saint Margaret

*Prague, 1406*
*Gilded silver on an oak core, mother-of-pearl, translu-*
*cent and opaque enamel, and semiprecious stones; 37 x*
*30.5 cm (14⅝ x 12 in.)*
*Inscribed: Around the edge of the frame: Anno dni*
*MCCCCVI ego Fr. Wen. Sacs fei huc libru plenu*
*diva disponente clemencia madavi de novo ad honore*
*dei et glorise vgis Maie et storu adalb'ti gutheri*
*margaete et oum scru gubnante abbaciam brewnoyense*
*diwissio abbate vicssimo quinto ame (In the year of the*
*Lord 1406, I, Frater Wenceslas, happily commissioned*
*anew this rich book, set out by divine mercy, for the*
*honor of God and the glory of the Virgin Mary and*
*the saints Adalbert, Gunther, and Margaret and all the*
*saints, at the time when Diwissius, the twenty-fifth*
*abbot, was governing the abbey of Břevnov. Amen).*
*Underneath: Ego augustinus abb, brev. huius olim libri*
*partem pio affectu pro reliquiis ss includendis aptari*
*feci. A. 1653 regiminis primo (In 1653, I, Abbot*
*Augustine, commissioned a small part of this book to*
*be adapted for the inclusion of holy relics).*
*Benediktinské Arciopatství Sv. Vojtěcha a Sv. Markéty*
*v Praze-Břevnově, Prague*

The frame of this reliquary served originally as the border for an earlier panel, probably from the early fourteenth century. The four enameled Evangelist symbols at the corners,

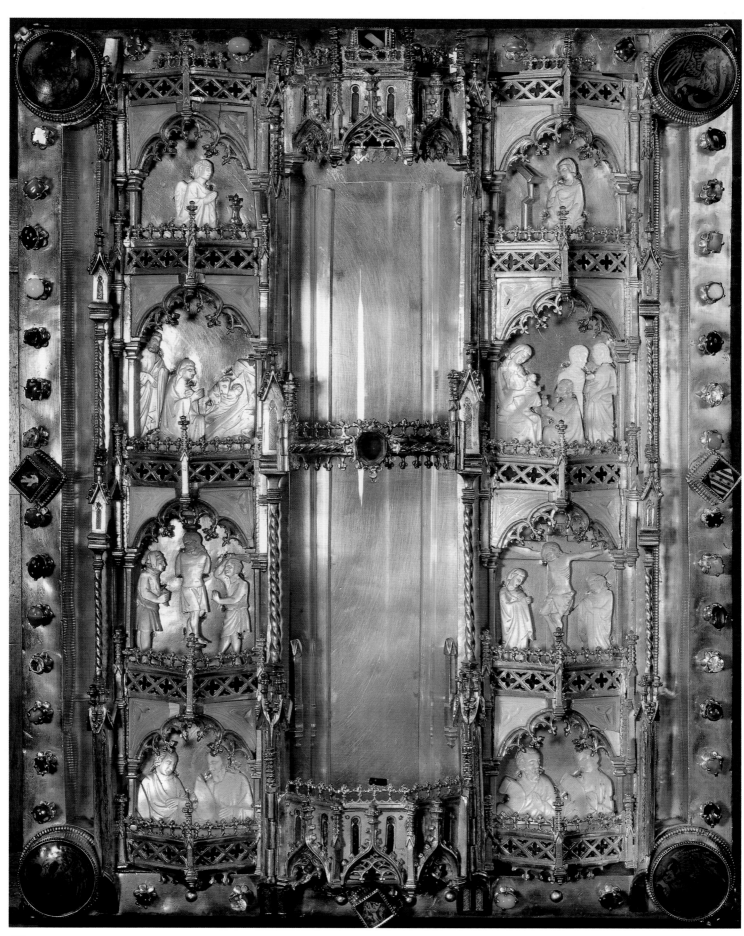

129

the settings for gemstones (six are missing and nine are replacements), and the enameled arms of the archbishop of Prague, Saint Adalbert, the Benedictine Abbey of Břevnov, and Bohemia all belong to this earlier monument. In 1406 the frame was adapted from an earlier book cover at the order of Brother Wenceslas, whose kneeling image appears near the inscription, to honor Saints Adalbert, Gunther, and Margaret. The object was restored and relics were added in 1653 (when Abbot Augustine Seyfert, as head of the General Chapter of Benedictine Congregations for Bohemia and Moravia, was actively involved in reconstruction of the abbey)[1] and on several subsequent occasions.[2]

The abbey of Břevnov is the oldest Benedictine monastery in Bohemia, founded by Saint Adalbert in 993. The historical circumstances of this important community's acquisition of the relic of Saint Margaret are unclear, but there is no doubt that relics of Margaret have been venerated both in Bohemia and at Břevnov since the mid-thirteenth century. The relic was displayed at the center of the panel in a (later) glass cylinder surmounted by an architectural baldachin with a similar base below. The cylinder is flanked by two vertical rows of four niches surmounted by cusped trefoil arcades and separated by openwork railings. The niches house reliefs carved from mother-of-pearl. On the left side, reading down, the reliefs depict the Annunciate angel (a replacement of 1981), the Nativity, the Flagellation of Christ, and two evangelists holding scrolls. On the right are the Annunciate Virgin, the Adoration of the Magi, the Crucifixion, and two more evangelists.

This reliquary of 1406 is precocious for its embellishment with mother-of-pearl, a material that did not see widespread popularity in central European goldsmith work until the second half of the fifteenth century. Yet the style of the carving is entirely consistent with a date of 1406; the stocky figures in profile and their costumes resemble those on contemporary bone carvings of the Embriachi (cat. 55). Mother-of-pearl is documented in Bohemian inventories. For example, a partial inventory of the abbey of Břevnov of 1390, when it was under the abbacy of Diwissius, patron of this work, mentions a "tabula antique fracta de nobilibus conchis tamquam margaritas" (an old, broken [or divided] rectangular object of mother-of-pearl) with the Assumption of the Virgin.[3] The Saint Margaret reliquary survives as eloquent testimony of the appreciation of exotic and precious materials in Bohemia.          PB

1. Schwager 1993, p. 77.
2. For a discussion of the history of the relics and reliquary, see Stehlíková 1993.

3. As Stehlíková notes, mother-of-pearl is sometimes designated in medieval inventories as "concha margaritifera" and "Margarita lapis" and pearls as "margaritas." See Gay 1887-1928, vol. 2, p. 227. Was the material therefore considered particularly appropriate to a work honoring Saint Margaret?

LITERATURE: Pazaurek 1937, p. 29, fig. 25; Prague 1970, no. 442, pl. 163; Cologne 1978-79, vol. 2, p. 711 (with bibl.); Stehlíková 1993, pp. 325-40 (with bibl.); Büttner 2000, pp. 53-54.

## 130. Man of Sorrows

*Prague, 1370s*
*Pot metal glass and vitreous paint, 67 x 18.5 cm*
*(26⅜ x 7¼ in.)*
*Condition: Modern leading; left arm panel cracked; loincloth newly glazed.*
*Provenance: Church of All Saints, Slivenec; transferred to Uměleckoprůmyslové Museum, 1896.*
*Uměleckoprůmyslové Museum, Prague (58.959/1–6)*

The iconoclasm of the Hussite Revolution brought widespread destruction of Bohemian stained glass. This Man of Sorrows panel survives as an extraordinarily rare testament to that art form. In spite of its art historical importance, the history of this panel, and indeed of all the glass removed from three lancets at the church of Slivenec (fig. 130.1), remains shrouded in uncertainty.

The partially clad, lifeless Christ appears exposed and vulnerable. Standing alone against a blood-red background, he holds the instruments of the Passion and conveys an arresting sense of pain and suffering. Despite the frequent occurrence of Man of Sorrows imagery in contemporary painting, the panel from Slivenec apparently represents the sole surviving illustration in stained glass of Jesus holding the implements of his flagellation.[1]

The chalice and Host in the lower left corner of the composition allude to the eucharistic sacrament and might indicate that the panel was originally placed in the immediate vicinity of an altar as a focus of devotion. A contemporary drawing (cat. 131), for instance, shows the Man of Sorrows as the object of prayer of a Dominican friar. Such a tiny detail as the Crucifixion scene that is incised upon the Host also suggests that the image might have been viewed at close range. The intricate rinceau pattern of the background finds parallels in manuscript illumination of the Wenceslas era.          AS

1. The motif occurs with frequency in contemporary western European sculpture, as in the Man of Sorrows from the Brunnenkirche in Erfurt (Osten 1935, fig. 125). It is rarely found in other media.

130

LITERATURE: Prague 1970, no. 451, fig. 171; Matouš 1975, pp. 75-78, pl. iv, figs. 64, 66; Poche 1977-82, vol. 3 (1980), pp. 363-64; Hejdová et al. 1986, p. 34, no. 299a; Kořán 1986; Benda et al. 1999, pp. 110-11.

Fig. 130.1 Three lancets from the apse of the Church of All Saints, Slivenec. Pot metal glass and vitreous paint; Bohemia, second half of 14th century. Uměleckoprůmyslové Museum, Prague (58.959/1-6)

## 131. Man of Sorrows with a Donor

*Prague, ca. 1390*
*Tempera and ink on parchment, 13.2 x 8.1 cm
(5¼ x 3¼ in.)*
*Provenance: Sale, Sotheby's, London, July 13, 1977,
lot 6.*
*Jonathan J. G. Alexander*

This diminutive but refined drawing, outlined in red, seems to be a preparatory study for a larger composition. This may have been a panel of stained glass (see cat. 130) or, as the simulated three-dimensional red frame suggests, a painting on panel; in either case the kneeling monk praying for God's mercy would have been the patron. A truncated inscription in German Gothic letters running in the opposite direction on the reverse indicates that it was cut from a larger sheet; musical tones written in a later hand (sol / la / re / fa, etc.) testify to the reuse of the sheet over the centuries.

The attenuated proportions of the figure of Christ and features such as the finely detailed wavy hair falling in wisps about the shoulders suggest that the drawing is contempory with the Třeboň Altarpiece (fig. 97.1).

The idiosyncratic pockets of drapery and strong outlining recall conventions adopted in the Braunschweig sketchbook (see fig. 99.1), but this drawing does not display the heavy crosshatching seen in that volume. The drapery pockets, which appear overly vigorous here, translate well into painting, as in the panels from Třeboň, or even into embroidery.

The prominence of the chalice into which Jesus' blood spills and of the Host, or eucharistic wafer, above it reflects the belief among Bohemian Church reformers that the faithful should be allowed to partake of the wine that is believed to become Jesus' blood during the celebration of the Mass, rather than just the bread of his body, as was then the custom. Gazing out with the wounds from his crucifixion exposed and his hand poised over the chalice and Host, this Man of Sorrows seems to be recommending the two eucharistic species to the viewer. BDB

## 132. Monstrance

*Brno(?), before 1414; alterations, 1471*
*Gilded silver, gold, clear and colored glass stones, and rock crystal; h. 85.7 cm (33¾ in.), w. of foot 27.5 cm (10⅞ in.)*
*Condition: Repaired 1651, 1770 (including regilding), 1970.*
*Provenance: Municipal inventory of Velká Bíteš, 1414; stored in the church tower until 1878.*
*Městské Muzeum Velká Bíteš*
*Not exhibited*

131

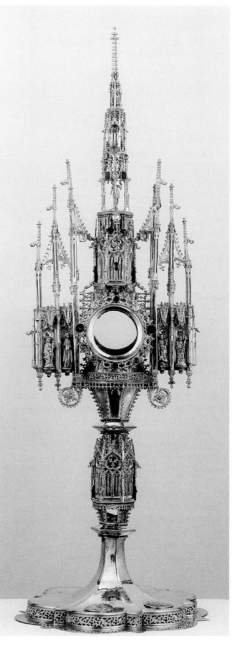

132

Under the spire of the monstrance is a small statuette of Jesus as the Man of Sorrows, dressed in a loincloth and wearing the crown of thorns from the Crucifixion. The image reflects the function of the monstrance, which was to display the Host, the round bread wafer consecrated during Mass as the body of Christ. Set within the architectural niches, saints stand in witness to the presence of Jesus: on the front, Peter, John the Baptist, and Andrew, along with the Virgin and Child; on the reverse, Catherine, Mary Magdalen, Margaret, and a holy bishop.

The base has one medallion bearing the arms of the town of Velká Bíteš, in Moravia, and a second representing a kneeling priest with the arms of the Jasenice family, who were important property owners in the region.

Incomplete documentation concerning the town and the family offers tantalizing hints about the possible history of the monstrance and its decoration. Municipal records in Velká Bíteš mention this work in 1414.[1] The town church is dedicated to John the Baptist, which may explain his inclusion among the saints on the front of the monstrance. Two priests from the Jasenice family, both named Hynek, are associated with Velká Bíteš, one in the late fourteenth century and one in the late fifteenth, the second apparently descended through the sister of the first.[2] The first Hynek, a notary to the bishop of Olomouc, founded the Chapel of Mary Magdalen in Tasov and arranged for his sister's family to retain control over it. The younger Hynek is recorded as its chaplain before 1464. The statuette of the Magdalen on the reverse of the monstrance, distinguished by its different style and base, is not original. This figure, along with alterations to the foot (including at the very least the addition of the date), was conceivably the donation of the younger Hynek to the monstrance of which his family, and perhaps his ancestral namesake, was the original donor. The monstrance was probably made in Brno, the largest city in Moravia, where the guild of goldsmiths was active by 1364.[3]

BDB

1. Stehlíková in Rome 2000–2001, p. 65.
2. Ibid., pp. 196–97, no. 50. A 1954 letter of František Jedlička in the Municipal Archives, Velká Bíteš, provides the additional information about the family cited here.
3. Stehlíková in Rome 2000–2001, p. 65.

LITERATURE: Stehlíková in Rome 2000–2001, pp. 65, 196–97, no. 50 (with bibl.).

133, fol. 21r, The Rain of Manna and The Rock of Horeb

## 133. The Boskovice Bible

*Prague, ca. 1420–25; binding, 1539*
*Tempera and gold on parchment, 536 fols., 41.7 x 29.7 cm (16⅜ x 11¾ in.)*
*Provenance: Čeněk of Vartenberk;[1] Václav Černohorský of Boskovice;[2] given by him to Třeboň official Henrych Rychenboch, May 17, 1565; donated by Countess Elizabeth of Tovar to the Brno Jesuits, ca. 1597 (fol. IIr); listed in catalogue of Brno Monastery library, June 9, 1604; transferred to Olomouc Lyceum Library, 1773, which later became part of University Library, later renamed Vědecká Knihovna. Vědecká Knihovna, Olomouc (M III 3)*

Jan Hus's exposition of the Decalogue, used as a prologue to the book of Exodus in this Old Czech translation of the Bible, attests to its patron's close affinity to the reformist movement in Bohemia.[3] The text of Exodus opens with a portrayal of two of the miracles of Moses, the Rain of Manna and the Rock of Horeb (fol. 21r), typological prototypes for the bread and wine of the Mass, which evoke the Hussites' advocacy of communion under both species.[4] Čeněk of Vartenberk,[5] the probable patron of the Bible, was burgrave of Prague Castle (1414–20), administrator, protector, and councillor to the widowed Queen Sophia of

133, fol. 376v (detail), Daniel in the Lions' Den

133, fol. 426r (detail), The Adoration of the Christ Child

Bavaria, as well as a leader of the Utraquist gentry. His death in 1425 is usually given as the reason that the decoration of the manuscript was not finished: there are eighty-four complete miniatures and historiated initials, including a charming portrayal of Daniel in the Lions' Den (fol. 376v), but only underdrawings from folio 498 on.

The Bible is of such extraordinary importance largely because the Master of *The Travels of Sir John Mandeville* (cat. 88) participated in its illumination.[6] The opening full-page miniature (fol. IIv) with medallions depicting the Creation, surrounded by delicate gold ornaments, ranks among his finest works. A number of the motifs point to Parisian models from the beginning of the fifteenth century.[7] The image of God on the Seventh Day, surrounded by seraphim resplendent in the divine light and a choir of cherubim modeled in gold against the heavenly blue,[8] calls to mind the image of God in the Innsbruck Garden of Paradise (cat. 120). In a break with tradition, the New Testament features a medallion with the master's Adoration of the Christ Child (fol. 426r), as related in the vision of Saint Bridget.[9] The eucharistic motif of ears of corn scattered on the ground alludes to the etymological interpretation of Bethlehem as the "House of Bread."[10] The Annunciation to the Shepherds appears in the background, with a landscape in skillfully rendered perspective reminiscent of the panoramas of the Master of the Gerona Martyrology (cat. 86).

The remaining illuminations are the work of four artists, including the Master of the Krumlov Anthology (see figs. 10.1, 10.4),[11] who for the most part adhere to the patterns of the workshop of the Gerona Martyrology. The tiny scenes found in the borders (fols. 98v, 130r) display a similarity to the illuminations of the third artist of the Vienna Missal (Österreichische Nationalbibliothek, Cod. 1850).[12]

MS

The author wishes to thank the Grant Agency of the Czech Academy of Sciences for its support (A 8033202) in developing this text.

1. The Vartenberk coat of arms on folio 21r suggests Čeněk as the most likely patron of the Bible; a second coat of arms, that of the Lords of Lipá, was probably added later. See Čihalík 1998 for an overview of the various hypotheses to date.
2. A signature on folio 534v (in a seventeenth-century Latin translation of folio IIv) testifies to Černohorský's ownership.
3. Most of the text belongs to the first Czech translation of the Bible; the New Testament together with several books of the Old Testament are from the second translation. The Psalter is from a third translation (see Kyas 1997, pp. 67–72, and Boháček and Čáda 1994, pp. 616–20, no. 356). Two copyists wrote the manuscript in diacritical orthography, the character of which indicates, according to Eliáš (1971), that it was created between 1415 and 1430.
4. Krása 1974b.
5. Čihalík 1998. Regarding Vartenberk's policies and financial circumstances, see Raková 1982.

6. In addition to folios IIv and 426r, he created folio 48v, with the help of an assistant. The master was first identified by Krása in Cologne 1978–79, vol. 2, p. 757; on his oeuvre, see Krása 1983a.
7. Compare, for instance, the image of God on the Seventh Day with the miniature of the Limbourg brothers in the *Très riches heures* of Jean, duke of Berry (fol. 153r; Cazelles and Rathofer 1988, p. 157). Also probably of similar origin is the composition of the Creator blessing, in profile, and folding his cloak with his left hand to his right side, which can be compared with the illuminations of the Limbourg brothers for the book of Genesis in Paris (Bibliothèque Nationale de France, Fr. 166, fols. IV, 2r; Meiss 1974, pl. vol., ills. 281, 282). God placing the Sun and the Moon on the firmament with both arms outstretched is a traditional figure in French biblical manuscripts.
8. God's face is very close to the type seen in depictions of the Trinity in Prague and Washington, D.C. (fig. 124.2; cat. 124d). The medallion with God blessing on the opening folio of the Lucerne Gradual (see cat. 104) by the Master of the Antwerp Bible displays a similar but earlier form of this countenance.
9. Seventh Book of Revelations. The Swedish mystic Bridget appealed mainly to the reformist masters of Prague University, including Matěj of Janov, Jindřich Totting of Oyta, and Matouš of Kraków. The Revelations was among the favorite reading material of Wenceslas IV (Metropolitan Chapter of Saint Vitus's Cathedral, Prague, Library, CL XXXVII, from 1392: *Hunc librum rex Wenceslaus prae aliis legebat et bibliam*); about 1400 Tomáš of Štítné translated portions of the texts into Czech (see cat. 73).

10. The Divine Word incarnate is the grain of corn, and the Virgin Mary is an uncultivated field that has received the grain. A general awareness of evident etymology is in Hus's sermon on the first Mass on the Feast of the Nativity, which also cites the verse "I am the living bread which came down from heaven" (John 6:41).

11. He assisted the Masters of the Martyrology in the decoration of the Gerona Martyrology, the Vienna Missal (Österreichische Nationalbibliothek, 1850), and the Bible of Sixtus of Ottersdorf (see cat. 134). The example of the Boskovice Bible clearly proves that there was not a single artist but a workshop, where at least two illuminators were active, together with assistants.

12. The illuminator is probably identical with the second artist of the Gniezno Bible (Biblioteka Kapitulna, Ms. 46a).

LITERATURE: Chytil 1885–86, p. 363; Pächt 1938; Šourek 1944; Drobná 1965; Pešina 1965, pp. 233–84; Schmidt 1969b, p. 255; Krása 1974b, pp. 95–100; Krása in Cologne 1978–79, vol. 2, p. 757; Krása 1983a; Krása 1983b; Stejskal and Voit 1991, p. 50, no. 25; Boháček and Čáda 1994, pp. 616–20, no. 356; Stejskal 1994a; Kyas 1997 (with bibl.); Čihalík 1998; Studničková 1998a; Stejskal in Olomouc 1999–2000, pp. 469–70, no. 367 (with bibl.).

## 134. The Zamojski Bible

*Prague, after 1430; binding, 18th century*
*Tempera, gold, and silver on parchment; 310 fols.;*
*30.9 x 21.9 cm (12⅛ x 8⅝ in.)*
*Provenance: Zamojski family, Poland, by 1804;[1]*
*Biblioteka Narodowa, Warsaw (sign. BOZ 7); donated by Polish Government to Národní Knihovna as compensation for original autograph manuscript of Copernicus, 1954.*
*Národní Knihovna České Republiky, Prague (MS XVII C 56)*

134, fol. 25r, opening of the book of Exodus

This manuscript comprises the book of Genesis to the book of Psalms, in the second version of the Czech translation of the Bible.[2] As with older manuscripts of the psalter,[3] the Psalms are accompanied by hymns from other biblical books, as well as by the Hymn of Saint Ambrose and the Athanasian Creed.[4] In its small format, economical script, and use of diacritical orthography, the Zamojski codex ranks among the most typical biblical manuscripts of the Hussite era. The system of decoration here, and in most such works, is derived from a Parisian prototype, with tiny figural initials opening each book and ornamental initials accompanying the forewords. The rich decoration of the borders and the application of costly pigments and gold leaf with refined punchwork (fols. 25r, 95v, 254v), however, testify to the high standards of the commissioner.

The manuscript was illuminated in the workshop of the Master of the Krumlov Anthology (see figs. 10.1, 10.4).[5] Its principal artist delegated some of the decoration to his assistant, who also worked on the Rabštejn New Testament (Bayerische Staatsbibliothek, Munich, Cod. Clm. 10024),[6] which displays similarly rendered headings with acanthus leaves weaving under the scriptal line,[7] and on the more modestly decorated Martinice Bible (cat. 135). The Master of the Krumlov Anthology participated in the major commissions of the Masters of the Martyrology, who were responsible for the Gerona Martyrology (cat. 86), the missal in Vienna (Österreichische Nationalbibliothek, Cod. 1850), the Boskovice Bible (cat. 133), and the Sixtus Bible (Národní Knihovna, Prague, XIII A 3). Certain compositions and elements of the masters' border decorations were adopted by him, including the grotesques in the present work (see fol. 25r), which are simplified variations on the dragons of the Master of the Antwerp Bible.[8]

Frequent use of workshop examples is evident in the nearly identical figures found in the various manuscripts of the group. The image of Samson fighting the lion in the Zamojski Bible (fol. 107v) has its predecessor in the Krumlov Anthology (fol. 67r) or

134, fol. 254v (detail), opening of the book of Esther

possibly in the Boskovice Bible (fol. 87v), while the fool who does not believe in God, an illustration to Psalm 52 (fol. 285v), is a variation on the "ribald youth" of the Anthology (fol. 169r).[9] The fool in the Psalms, customarily portrayed with a cudgel and in ragged garments alluding to his simplemindedness, is here a man in contemporary courtly dress— apparently a reformist critique of the morals of high society. MS

The author wishes to thank the Grant Agency of the Czech Academy of Sciences for its support (A 8033202) in developing this text.

1. From the library of this Polish noble family (ex libris with signature: *Stanislaus C.O.Zamoyski, Anno 1804, Ex Bibliotheca C.O.Zamoyski,* stamp on fol. 1r).
2. Chronicles is influenced by the third redaction, and Psalms is considered to be a compilation of several translations, see Kyas 1997, pp. 91–98.
3. See ibid., p. 32. These texts are common in psalters used as prayer books.
4. For a detailed description, see Svobodová 1996, pp. 29–34, no. 16.
5. Also called the Master of the Krumlov Speculum, this artist is named after a manuscript in the Národní Muzeum, Prague, Library (III B 10). He is also thought responsible for some of the decoration in the following works: the Vienna Missal (Österreichische Nationalbibliothek, Cod. 1850), the Gerona Martyrology (cat. 86), the Nuremberg Bible of 1410 (Stadtbibliothek Nuremberg, Cent I/1), the Boskovice Bible (cat. 133), the Bible in Washington, D.C. (Library of Congress, Ms. 7), the Munich New Testament (Bayerische Staatsbibliothek, Cod. Clm. 10024), and the Martinice Bible (cat. 135). According to Stejskal (in Stejskal and Voit 1991, p. 53), the decoration of a Bible in Vienna from 1434 (Österreichische Nationalbibliothek, Cod. 1217) belongs to the workshop, as do the manuscripts in the

Národní Knihovna with Wycliffian texts (III B 5 and X D 11). The Master of the Krumlov Anthology, together with his disciple, also participated in the decoration of the Vatican Comestor (Cod. vat. lat. 5697).
6. Boldan and Studničková 2001.
7. This design, which could have been common in the Martyrology workshop, is found in the Bibles of Zikmund of Domažlice of 1419 and Sixtus of Ottersdorf (Národní Knihovna, Prague, XIII A 3).
8. For example, masks from the Bible of Konrad of Vechta (vol. 1, fols. 129r, 137r, 139v, 145r, 147r, 153r), and dragons with twisted bodies and a monster blowing a trumpet in the Gerona Martyrology (fols. 33r–34v, 36v, 39r, 40r, 47r).
9. Illumination to the Štítné tract (*Knížky o smrti mládence bujného;* see Stejskal and Voit 1991, fig. 49).

LITERATURE: Krása 1974b, p. 32; Kyas in Kutnahorská Bible 1989, vol. 2, pp. 25, 65; Stejskal and Voit 1991, p. 52, no. 28; Stejskal 1992, p. 336; Stejskal 1994a, p. 110; Svobodová 1996, pp. 29–34, no. 16 (with bibl.); Kyas 1997, pp. 91–98.

134, fol. 95v (detail), opening of the book of Joshua, Joshua Leads the Israelites

## 135. The Martinice Bible

*Prague, 1430–34*
*Tempera and gold on parchment with original binding,*
*435 fols., 35 x 24 cm (13¾ x 9½ in.)*
*Provenance: Acquired by Academy of Sciences before 1929.*
*Knihovna Akademie věd České Republiky, Prague*
*(1 TB 3)*

In this manuscript is the oldest surviving
image portraying Jan Hus, revered in Hussite
communities as a holy martyr immediately
after his death at the Council of Constance in
1415. At the base of the initial I at the begin-
ning of the book of Genesis (fol. 11v), Hus is
shown bound with ropes and a chain to a
massive wooden beam as burning bundles of
wood are placed around him. Beardless, like
most medieval priests, and clad in a long pale
shirt, he wears a heretic's cap decorated with
three devils. This cap is mentioned in the
report of the execution written by the univer-
sity master Petr of Mladoňovice, Hus's com-
panion in Constance, who is almost certainly
the figure in a dark robe and beretta depicted
in the same illustration. His presence suggests
that Mladoňovice may have commissioned
the manuscript. Further evidence for this pos-
sibility can be found in the numerous margin-
al notes, which reveal that the manuscript was
created for a prominent theologian for the
purpose of study.

The manuscript contains a complete text
of the Latin Vulgate Bible, written in cursive
script. Its adornment is comparatively modest,
consisting of 108 painted initials, of which
only five are figurative. The ornamental char-
acters themselves are small and surrounded
by acanthus motifs. The illuminator of the
Bible is likely the same artist who worked
on a manuscript, now in the Österreichische
Nationalbibliothek, Vienna (Cod. 1217), that
has an explicit referring to the defeat of the
radical Hussite party at the Battle of Lipany in
1434. This helps to date the Martinice Bible
to between 1430 and 1434. Jan Květ and later
Karel Stejskal proposed that the main illumi-
nator of the Krumlov Anthology (see figs. 10.1,
10.4) had a small share in the work on this
Bible's illuminations, specifically the one
portraying a kneeling Moses (fol. 46v) and
probably also the underlying initial drawing
for the one depicting the burning of Hus.[1]

JR

1. See Royt 2001, p. 407.

LITERATURE: Květ 1929; Stejskal and Voit 1991,
p. 53, no. 31; Royt 2001, p. 407.

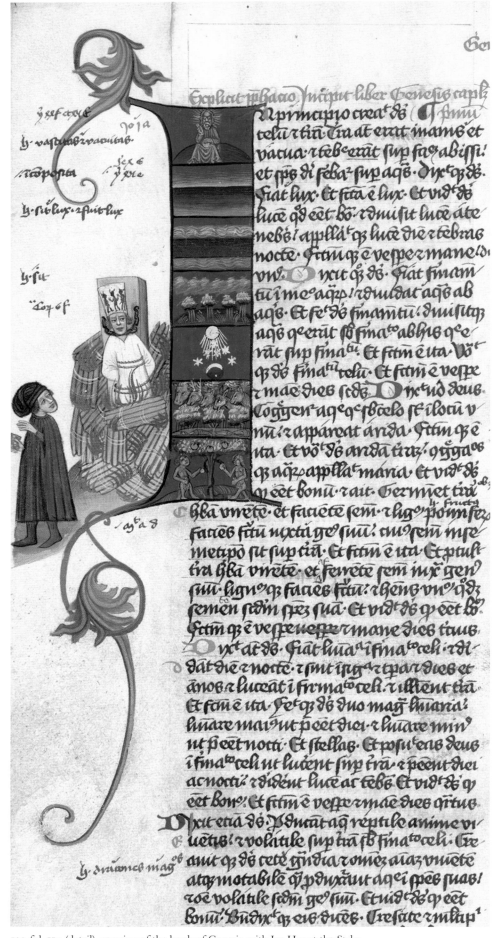

135, fol. 11v (detail), opening of the book of Genesis, with Jan Hus at the Stake

## 136. Czech Bible

*Prague, ca. 1430–40*
*Tempera, gold, and ink on parchment; 37 x 25 cm*
*(14⅝ x 9⅞ in.)*
*Provenance: Acquired by Národní Knihovna by 1906.*
*Národní Knihovna České Republiky, Prague*
*(MS XVII A 34)*
*Prague only*

The epochal events of Hebrew scriptures come alive with exceptional vivacity in this Bible. It is written in Czech, the spoken language of Bohemia, rather than the formal Latin of the Church and court. Even the lettering is in a less formal Gothic hand that was more quickly written, and therefore less expensive, making ownership of a Bible feasible for an audience that might include university masters, priests, and affluent townspeople.[1] A charming scene of Moses in the Bulrushes signals the opening of the book of Exodus. At the opening of the second book of Kings (fol. 115r), however, war between the Israelites and the Philistines is represented as a violent, chaotic contemporary Hussite battle, with armored knights, crossbows, pavise (the large shields for which Bohemia was renowned; see cat. 157), and spears (see cat. 156). The sense of chaos is palpable, with figures intruding on the text and spilling asymmetrically across the lower margin of the page. The layout of the pages and the foliate ornament of this Czech Bible conform to the design of the vernacular Zamojski Bible (cat. 134).

BDB

1. See Krása 1974b.

LITERATURE: Krása 1974b, pp. 18, 32–33, ill.; Kejř 1988, pp. 124–25, ill.

136, fol. 115r (detail), The Israelites Battle the Philistines

136, opening of the book of Exodus (detail), Moses in the Bulrushes

136, fol. 198r, Tobias and the Archangel Raphael

## 137. Vera Icon

*Probably Prague, ca. 1410*
*Tempera on parchment, 32.1 x 21.1 cm (12⅝ x 8¼ in.)*
*Condition: Parchment apparently cut down slightly on left and right sides.*
*Inscribed in Latin on reverse: Anno a nativitate domini milesimo quadricentesimo . . . quarto die Mercurii decimal sexta mensis aprilis pontificatus domini Alexandre pape sexti regnante Maximiliano roma-norum rege Marcus Hirschvogel preppositus eclesie S: ti Sebaldi Nurgergensis Bambergensis dioceses, hanc imaginem salvatoris nostrii Jesu Christi a maioribus suis habitam in hunc modum adornari. Que hodie luxte eorundum maiorem suorum relationem plusquam centrannis est (In the year 1400 from the Nativity of the Lord, . . . on the fourth day, Wednesday, the six-teenth of the month of April, the pontificate of Lord Pope Alexander VI [r. 1492–1503], in the days of the ruling king of the Romans Maximilian [r. 1493–1519], Marcus Hirschvogel, leader of the Church of Saint Sebaldus in the dioceses of Nuremberg and Bamberg, considered this image of our Savior Jesus Christ from his ancestors to be adorned in that manner. Nowadays he has a greater rapport with his ancestors than with the people of Savoy, generally the Centrones).*
*Provenance: Marcus Hirschvogel (1456–1504), provost of the Church of Saint Sebaldus, Nuremberg; Church of Saint Sebaldus, as early as 1484 as a gift from Dr. Hirschvogel; Prince Joseph Clemens of Bavaria (1902–1990).*
*Private collection*

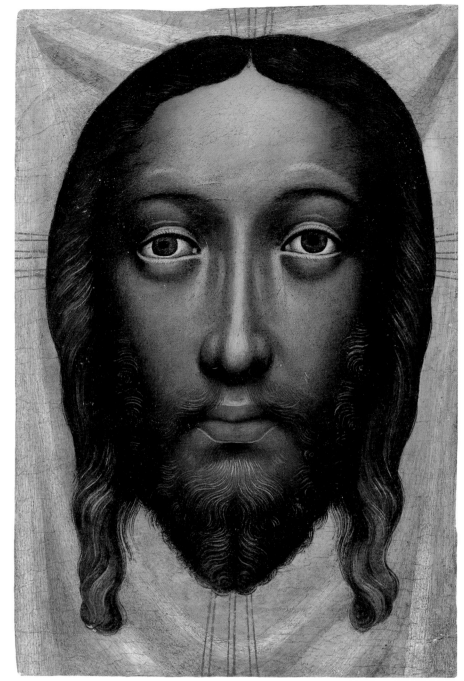

137

One of the greatest Roman relics of the later Middle Ages was the linen towel believed to bear the actual image of the face of Jesus, miraculously transferred to the cloth when, according to legend, Saint Veronica wiped his face as he carried his cross to Calvary.[1] The spiritual power of "Veronica's veil" was docu-mented in 1216, when Pope Innocent III created an Office of the Holy Face for the cloth kept at Saint Peter's in Rome and composed a prayer in its honor. Those who recited the prayer were granted ten days' indulgence, or remission from punishment of sin in purgatory. Until it was lost in 1527, many lifesize simu-lacra were made of the relic in Rome. The perfect image of this Holy Face from the Church of Saint Sebaldus in Nuremberg may reflect one of the popular "Salve sancta facies" prayers for indulgence composed about 1330 that were linked to Pope John XXII (r. 1316–34): "Hail, holy face of our redeemer, in which shines the semblance of divine splen-dor, Impressing the linen white as snow."[2]

Charles IV probably commissioned such a *vera icon,* now lost, to conform to the true, Roman image. Among the items in the 1355 inventory of Saint Vitus's Cathedral in Prague was an "item tabula parva cum veronica et lamina aurea crucifixo aurea parva" (item: a small panel with Veronica's [veil] and a thin gold [panel] with a small gold crucifix).[3] The *vera icon* is depicted in a miniature in a breviary by Grand Master Leo that is dated 1356 (Národní Knihovna, Prague, XVIII, fol. 1v).[4] The motif appears on the base of a reliquary (cat. 23) given by Charles to Herrieden and datable to 1358 and also on the mosaic above the south transept portal of Saint Vitus's Cathedral (see frontispiece).[5] In 1505 Johann Butzbach (1476–1526), the humanist prior of the Benedictine Monastery of Maria Laach, wrote to Gertrude Buchel, a nun and calligrapher, about an icon of Jesus in Prague displayed "annually to the people" that was modeled upon the image displayed in Rome.[6]

The celebrity of the particular version of the famous image that Charles evidently acquired in Rome in 1355 is evinced by the many copies that proliferated in Prague. The *vera icon* show-ing just the lifesize face of Jesus on the cloth appears in several Bohemian panel paintings. Like the stylistically related paintings from the Muzeum Narodowe, Warsaw, and Saint Vitus's Cathedral, Prague (fig. 137.1; cat. 149), this image on parchment (perhaps intended to sim-ulate cloth, but more durable) from Nuremberg may have been based on the Holy Face that Charles commissioned for Saint Vitus's.

Fig. 137.1 *Vera Icon*. Tempera and gold on linden wood panel; Prague, ca. 1400–1410. Muzeum Narodowe, Warsaw (Śr. 80)

Fig. 137.2 A Priest Administering the Eucharist with a *Vera Icon* Displayed on the Altar. Gerona Martyrology (cat. 86), fol. 237. Tempera, gold, and silver on parchment; Prague, ca. 1410. Museo Diocesano de Girona, Spain (M.D. 273)

The Latin inscription on the reverse of the parchment suggests that Marcus Hirschvogel donated this *vera icon,* which had long been in his family's possession, to the Church of Saint Sebaldus in Nuremberg during his tenure as provost there (1484–94/95). The artistic links between Prague and the imperial city of Nuremberg were strong throughout the reigns of Charles IV and his son Wenceslas IV, who was born at Nuremberg Castle and baptized at Saint Sebaldus's in 1361.

The feast honoring the Holy Face was the second Sunday after the Epiphany—not part of Holy Week, as one might expect—because liturgically it was associated with the season celebrating Jesus' manifestation on earth. Because these images had their own liturgy they were placed on the altar, where they represented the body of Christ present in the Eucharist. This is actually depicted on folio 237 of the Gerona Martyrology of about 1410 (fig. 137.2). That image and the *vera icon* from Nuremberg closely correspond to the description in the 1437 Saint Vitus inventory of an image "cum facie Christi" on parchment on the altar of Saint Matthew.[7] A Holy Face in the Psalter of Hanuš of Kolovraty (cat. 148) evokes both this *vera icon* from Nuremberg and the panel from Saint Vitus's (cat. 149). The psalter dates to 1438, suggesting that this image predates it. The modulation of the flesh tones, with highlights above the eyebrows, and the blond highlights in the hair and beard on this Holy Face bring to mind the work of the evidently Bohemian-trained artist who painted an altar, possibly panels for the Frauenkirche in Nuremberg, about 1410.[8]

CTL

1. The "original" miraculous portrait, or Mandylion, first recorded by Eusebius about A.D. 325, was an imprint of Jesus' face upon a linen cloth requested by Abgar of Edessa (present-day eastern Turkey) during Jesus' lifetime. In the West both the Mandylion and the Veronica veil gained widespread popularity.
2. Friedman 1995, p. 157.
3. Podlaha and Šittler 1903a, p. xvi.
4. Hamburger 1998, pl. 3.
5. See Pujmanová 1992.
6. Hamburger 1998, p. 373
7. Podlaha and Šittler 1903a, p. 166.
8. New York–Nuremberg 1986, no. 23, color ill.

## 138. Tondo of Bartholomew Boreschow

*Frombork, before 1426(?)*
*Tempera on wood, diam. 150 cm (59 in.)*
*Inscribed on frame: Anno d[omi]ni M° · cccc° · xxvi° · XXIV mens[is] Januarii obiit ven[er]abil[is] d[omin]us m[a]g[iste]r Bartholome[us] Boreschow decanus [et] Canonicus warmiensis · orate pro eo· (In the year of Our Lord 1426, on the 24th day of January, the noble Sir Master Bartholomew Boreschow, dean and canon of Warmia, died; pray for [his soul]).*
*Provenance: Frombork Cathedral.*
*Własnóśí Archidiecezji Warmińskiej, Poland*

The tondo, with its engraved epitaph, was originally placed in the cathedral in Frombork

(then Frauenburg, lands of the Teutonic Order) above the tomb of the deceased, Bartholomew Boreschow, who is represented in the vestments of a canon, kneeling before the Virgin and Child. The coats of arms of the Boreschow family, a silver horse collar on a black shield and a red cross on a silver shield, appear at the bottom edge. The deceased, small in scale and clearly aged, still belongs to the earthly realm, and it is possible that the portrait of Boreschow was executed while he was alive.

A native of Prussia, Boreschow studied in Prague in 1381 and in Italy, where in 1386 he was awarded a medical degree. He chose a clerical vocation and swiftly advanced in the diocese of Warmia. At the same time, he practiced medicine in the employ of the Grand Masters of the Teutonic Order. The figure of Mary Magdalen in the tondo, holding a vial of healing ointment, probably refers to his medical profession. Trusted by the Teutonic Knights, Boreschow negotiated for them with Polish and Bohemian kings. After the war of 1410 he went over to the Polish side and left Prussia for refuge in Bamberg, whence he returned to Frombork in 1420.

Many elements in the painting are symbolic: the enclosed garden alludes to Mary's virginity; her being seated on the ground demonstrates her humility; and the vine and the angel handing the Child a grape refer to his blood and, therefore, to his death. The circular field of the painting, rare in the Middle Ages, is very effective for highlighting the epitaphic function of the panel and suggests the Early Christian *imagines clipeatae* (literally, "images on shields"), scenes on sarcophagi that showed the deceased being lifted up into heaven.

The earliest studies of the painting discussed the Western elements, especially links to depictions of the Virgin in an enclosed garden.[1] Indeed, the peaceful, sensual ambience of the setting recalls Rhenish works (Master of the Frankfurt Garden of Paradise, 1410, Städelsches Kunstinstitut, Frankfurt; the Saint Lawrence Master, Wallraf-Richartz-Museum, Cologne). At the same time, the facial features of the women and the Child, the drapery, and especially the veil of Mary Magdalen suggest local execution, with links to works of Bohemian provenance. Hermann Ehrenberg and Gregor Brutzer, for instance, noted the connections between the painting and the Elbląg *Meadow Book* of 1421 (cat. 139), while Werner Deusch and Alfred Stange discerned the roots of the epitaphic style in the Grudziądz Retable (Muzeum Narodowe, Warsaw). The blend of Western iconography and Bohemian style led to the theory that the painting was executed in Nuremberg in Franconia, perhaps during the patron's long sojourn in Bamberg.[2] Polish researchers, especially Maria Otto and

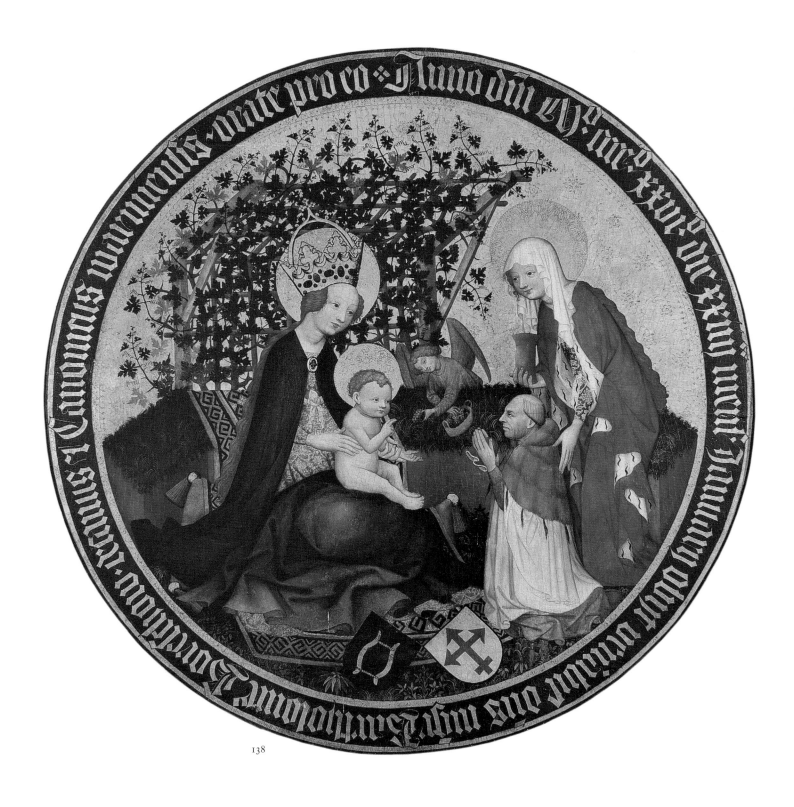

138

Alicja Karłowska-Kamzowa, emphasized the Bohemian connections. Otto pointed out analogies with the Holy Women at the Tomb in the Resurrection of Christ in the Rajhrad Altarpiece (fig. 154.2),[3] as well as the influence of the Madonna from Vyšší Brod from 1420 and the later works of the Master of the Rajhrad Altar (see cat. 153), especially the Nativity (Kunsthistorisches Museum, Vienna). Dating the Nativity to about 1440 and citing the iconographic analogies with the works of Stefan Lochner (Madonna of the Rose Bower,

1447–50, Wallraf-Richartz-Museum), Otto dated the tondo to the mid-fifteenth century. Jerzy Domasławski has discussed French and German analogies of the tondo form.

ASL

1. See, for example, Dexel 1919; for the early research, see Otto 1963 and Wróblewska in Labuda et al. 2004, vol. 2.
2. Ehrenberg 1920; Obłąk 1957.
3. For the dating of the altar from Rajhrad, see Bartlová 2002.

LITERATURE: Dexel 1919, p. 14; Ehrenberg 1920, pp. 82–83; Brutzer 1936, pp. 62–64; Deusch 1936, pp. 220–22; Stange 1934–61, vol. 3 (1938), pp. 229–30; Obłąk 1957; Otto 1963 (with earlier literature); Karłowska-Kamzowa in Cologne 1978–79, vol. 4, p. 162; Domasławski in Domasłowski, Karłowska-Kamzowa, and Labuda 1990, pp. 113–16; Arszyński in Nuremberg 1990, p. 127, no. II.8.7, color ill. (with bibl.); Kahsnitz in Andrian-Werburg 1992, p. 36; Wróblewska in Labuda et al. 2004, vol. 2.

## 139. *The Meadow Book*

*Elbląg, 1421*
*Tempera and gold on parchment with original binding*
*of leather on panel fastened with metal studs, 249 fols.,*
*34.1 x 21 cm (13⅜ x 8¼ in.)*
*Inscribed on fol. 249: Finitus et completus est liber iste*
*Anno d[omi]ni m° ccccxx primo / feria qu[in]ta*
*an[te] d[omi]nicam l[a?]etare magnis gravib[us]*
*[et] [con]tinuis optimis sub labo[ri]b[us] / per*
*Wilhelmu[m] Merczan de Marchia brandenburgen[si]*
*tu[n]c t[em]p[or]i[s] hic no[ta]rium / Hoc opus*
*exegit, festum sepissime fregit / Completo libro sit laus*
*et gl[ori]a Cristo (This book was finished and fully*
*decorated in the year of the Lord 1421 on Thursday*
*before the Sunday of rejoicing, with great pains and*
*with recurring goodness through the labor of Wilhelm*
*Merchan for the margrave of Brandenburg; in those*
*days this one was a scribe; he finished this work [on]*
*that feast day that often disheartens; may praise and*
*glory be to Christ by this fully decorated book).*
*Provenance: Elbląg City Hall(?).*
*Archiwum Państwowe, Gdańsk (369, 1/126)*

The codex, written in German by the Elbląg
notary Wilhelm Merchan, contains the results
of a survey undertaken in 1421 of the mead-
ows belonging to the burghers of Elbląg, then

139, fol. 5r, A Farmer Cutting Hay in an Initial D; coat of arms of the town of Elbląg; Castor and Pollux

139, fol. 87r (detail), Raking Hay

139, fol. 157r (detail), Stacking Hay

Elbing, in the lands of the Teutonic Order.
The provenance of the manuscript is con-
firmed by the town's coat of arms (on fols. 5,
87, and 246) and the inscription.

Both the agricultural theme and the lavish
decoration of a legal, secular manuscript are a
rare occurrence in the lands of the Teutonic
Order. The historiated initials, surrounded by
luxuriant and fleshy acanthus leaves, measure
7 by 7 centimeters (2¾ by 2¾ in.). They depict
the cutting (fol. 5r), raking (fol. 87r), and
stacking (fol. 157r) of hay. Barbara Miodońska

has interpreted the two boys in the bas-de-page
of folio 5r (one is naked, taking his first steps
with the help of a walker, while the other lifts
up his shirt to urinate) as the twins Castor
and Pollux, representations of Gemini, the
sign under which haymaking takes place.
The rabbit accompanying the girl raking hay
is a symbol of fertility.

According to Bernhard Schmid, the first to
evaluate the manuscript's sophisticated deco-
rative system, subtle coloring, and fresh real-
ism, the artist was a painter of Bohemian

provenance trained in the style of the court of
Wenceslas IV and having connections to the
Master of the Hazmburk Missal (see fig. 9.1).
He may have left Bohemia about 1420 because
of religious unrest and come to Prussia, where
he executed these paintings. Gregor Brutzer,
in contrast, supported a local artist's having
been responsible for the decorative illumina-
tions—the same artist, in fact, who painted
the Boreschow Epitaph (cat. 138). Later stud-
ies have generally upheld Schmid concerning
the painter's provenance, but the connection
with Bohemian miniature painting has been
differently interpreted. Alicja Karłowska-
Kamzowa pointed out the resemblance of
the Elbląg initials to the agrarian depictions
in the illuminated manuscript of Petrus de
Crescentiis' *Liber ruralium commodorum* (Národní
Knihovna, Prague) and also to the work of the
Master of the Gerona Martyrology (cat. 86),
especially in its formal character. Miodońska
concurred with the latter comparison. Pavel
Brodský, in a detailed analysis of the manu-
script's illuminations, considered the painter a
close and greatly talented collaborator of the
Master of *The Travels of Sir John Mandeville*
(cat. 88).                                          ASL

LITERATURE: Schmid 1919–20; Brutzer 1936,
pp. 63–64; Karłowska-Kamzowa in Cologne
1978–79, vol. 4, pp. 160, 162; Karłowska-
Kamzowa 1980, p. 42 and n. 19; Błaszczyk 1981,
pp. 111–13; Karłowska-Kamzowa in Domasłowski,
Karłowska-Kamzowa, and Labuda 1990, pp. 214–
15; Nowak in Nuremberg 1990, p. 77, no. II.3.7,
color ill.; Miodońska 1993, pp. 89, 133; Brodský
1992; Miodońska and Błaszczyk in Labuda et al.
2004, vol. 2.

## 140. Emperor Sigismund

*Upper Lusatia, ca. 1450*
*Oil, tempera, and gold on spruce panel; 75 x 46.3 cm*
*(29½ x 18¼ x 1⅛ in.)*
*Condition: Restored 1909 (addition of glass beads),*
*1960 (removal of overpaint and cradling), and 1988.*
*Inscribed beneath the portrait: T.V. PI[VS]+IVST[VS].*
*Q[VO]NDA[M]. REX. MAXI[MVS]. O[RBI]S /*
*LAVDIB[VS]. ETH[ERN]IS. NV[N]C.*
*SIGISMV[N]DE. N[ITES] (You, Sigismund,*
*pious and just, once the greatest king on earth, may*
*you be praised eternally in glory).*
*Provenance: Town Hall, Görlitz; Kulturhistorisches*
*Museum, since 1908.*
*Kulturhistorisches Museum Görlitz (233–72)*

If Sigismund ever visited Görlitz, it was in his
youth. It was said that he stopped there, along
with Charles IV and Wenceslas IV, in June
1377. The Upper Lusatian city was nonetheless

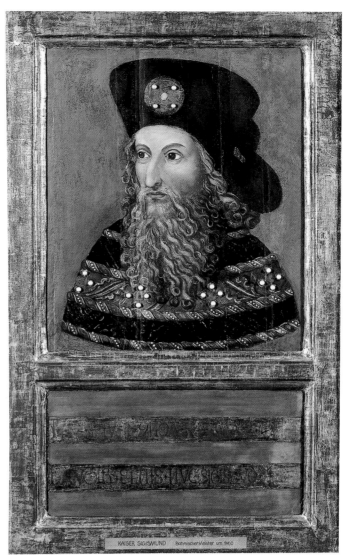

140

very dear to him. Upper Lusatia, a border
area belonging to Wenceslas, played an
important role in Luxembourg dynastic poli-
tics as a bridge between Bohemia, Silesia,
and Brandenburg. In 1420, when the strug-
gle for Bohemian succession flared during
the course of the Hussite Revolution, the
Upper Lusatians sided with Sigismund.
Görlitz especially, enjoying special privileges
as the wealthiest and largest city in the
realm, repeatedly sent troops to support him.
After Sigismund was crowned emperor,
the Görlitz town clerk journeyed to Italy
to present the city's congratulations and to
secure confirmation of its former privileges.
In gratitude for the city's loyalty, Sigismund
issued letters patent authorizing a grant of
arms on August 29, 1433. The divided shield
with the imperial eagle, the lion of Bohemia,
and emperor's crown remains the Görlitz
coat of arms to this day.

In his council annals for 1536 the city's
chief clerk and burgomaster Johannes Hass
documented the origin of the portrait of
Sigismund that hung in the small council

chamber of the town hall for centuries: "From
such devotion . . . the council commissioned a
likeness of His Majesty's person and had it hung
in the council chamber as a lasting memorial
to their pious sovereign."[1] Though Hass does
not say when the portrait was painted, the
inscription indicates that it was sometime after
the emperor's death in 1437.

The emperor's long gray hair and beard
and the prominent beaver cap with its orna-
mental brooch are reminiscent of portraits
produced by Pisanello and other artists
during Sigismund's lifetime (see fig. 147.1).
Accordingly, the Görlitz painter must have
either received precise instructions or worked
from a model. It is odd that the torso, unlike
the head, is rendered in such a schematic
manner, despite the costly contemporary
garments. The likeness floats before the red
ground like a reliquary bust. The artist thereby
heightened the sacral character of the portrait,
which was further embellished with semi-
precious stones (now replaced with glass
beads) and a punched gold frame with a blue-
striped inscription field.

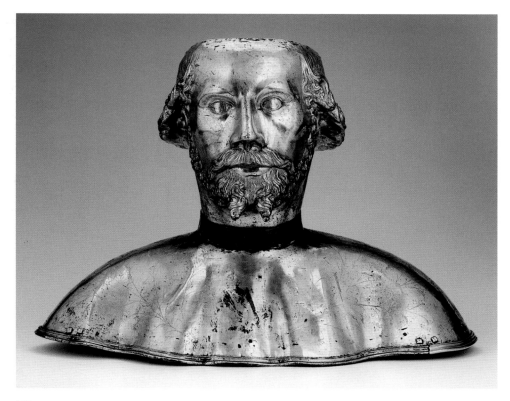

141

It is conceivable that the panel was pro-
duced in Görlitz itself. A painter named Paul
from Löwenberg in Silesia fulfilled numer-
ous commissions for the Görlitz city council
between 1428 and 1464.[2] This work appears
to be related to an altarpiece from the Frauen-
kirche in Görlitz (now Kulturhistorisches
Museum Görlitz) that can be dated stylistically
to the second quarter of the fifteenth century
and reveal close ties to contemporary painting
in Wrocław.                                    MW

1. "Aus solcher erkanter liebe . . . hat ein rathe seiner
   mt. Person abecontirfeyn lassen, vnd zu einem
   langen gedencknus ihres fromenn herns, jn die
   ratsstube hengen lassen" (Hass 1870, pp. 131–32).
2. Wernicke 1876.

LITERATURE: Hass 1870, pp. 131–32; Lutsch 1891,
p. 692; Wallis 1912, p. 39; Bucher 1953, pp. 28–29;
Lemper 1961; Kéry 1972, pp. 142–43; Budapest
1987, vol. 2, no. 41, pp. 61–62; Lemper 1988;
Lemper in Panschwitz-Kuckau 1998, no. 4.5.

## 141. Reliquary Bust

*Hungary(?), 1380s*
*Gilded copper, h. 37.7 cm (14⅞ in.)*
*Provenance: Mayor's office, Trenčín (Trencsén), until*
*1812; gift of János Horency, mayor of Trenčín, to*
*Magyar Nemzeti Múzeum, 1812.*
*Magyar Nemzeti Múzeum, Budapest (Cim.*
*Sec. II.IX.1)*

This reliquary bust came to the Magyar
Nemzeti Múzeum as a gift from the town of
Trenčín (Slovakia) in 1812, when its subject
was identified as Count Matthew Csák, a lord
of upper Hungary in the early fourteenth cen-
tury and a political rival of Charles I of Anjou.
As this local tradition has been revealed as a
legend of nineteenth-century origin, József
Ernyey and others have hypothesized that the
bust is a reliquary of Saint Ladislas that was
perhaps taken during the plundering of the
treasury of Esztergom and then was inherited
by Count Stibor the Younger in 1434. As the
top of the head has been broken off the subject's
attribute is missing. It was probably a miter,
and if so the bust would portray a bishop-saint.
His precise identity and provenance remain,
however, a mystery.

The copper bust was created by hammer-
ing two sheets of copper, one for the shoulders
and one for the head. The shoulder section has
an undulating shape, imitating a textile, and is
decorated with finely punched (*poinçonné*)
foliate ornament. The symmetrical hair and
beard on the plastically rendered face reflect
fourteenth-century taste. Theodor Müller has
compared this head with the Saint Cassian
reliquary bust in Vienna (Kunsthistorisches
Museum, 8867), which can be attributed
generally to a South German goldsmith.[1]
A possible Hungarian provenance and a
fourteenth-century date for the reliquary are
supported by its similarity to the miniature
busts (above the coats of arms from the Polish

region of Dobrzyn) on the great mantle clasps
from the Hungarian Chapel at Aachen (see
fig. 11.4), which date to before 1381.        EM

1. Cologne 1978–79, vol. 2, p. 440.

LITERATURE: Ernyey 1926; Müller 1935, p. 52;
London 1967–68, p. 75, no. 179; Székesfehérvár
1982, p. 309, no. 167; Marosi 1987, p. 496; Buda-
pest 2000, p. 126, no. I-1; Fontevrault 2001, p. 338,
no. 110.

## 142. Horn of Sigismund

*Eastern Prussia(?), before 1408*
*Aurochs horn, gilded silver, and enamel; l. 48.5 cm*
*(19⅛ in.)*
*Condition: Enameled image of Saint John the Baptist*
*in a round field and ornament on top of lid added*
*during restoration in 1880.[1]*
*Provenance: Presented to Sigismund of Luxembourg*
*by Ulrich von Jungingen, grand master of Teutonic*
*Order, 1408; Esztergom Cathedral Treasury, first*
*recorded 1528 inventory.*
*Főszékesegyházi Kincstár, Esztergom, Hungary*
*(1964.18.1,2)*

Ulrich von Jungingen (1360–1410), grand
master of the Teutonic Order, presented two
horns to Sigismund, both recorded in the
Marienburger Tresslerbuch of the order in
1408. The larger horn (also in the Cathedral

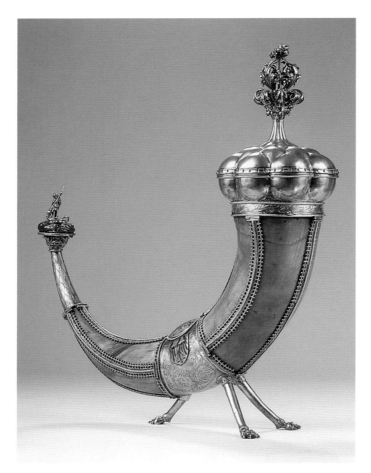

142

## 143. Chandelier of Queen Sophia of Bavaria

*Baltic region or Pomerania(?), ca. 1400*
*Gilded silver, amber, walrus tusk, and wood; h. 28 cm (11 in.), with chains 44 cm (17⅜ in.), l. 45 cm (17¾ in.), diam. of horn 21 cm (8¼ in.), h. of statuette 12.5 cm (4⅞ in.)*
*Inscribed on pedestal below figure: S[an]c[t]a kath[er]ina ora p[ro] nobis (Saint Catherine, pray for us).*
*Condition: Tusk scratched, metal rings bent in places, some gilding on canopy missing. Wood pedestal, metal fittings at top, and suspension chains recent additions. Amber figure repaired; crown and both hands missing. Perforation at knees perhaps for another component (figure of Jesus?). Restored by Lubor Krchňavý, 2004–5.*
*Provenance: Probably court of Wenceslas IV, Prague; Chapel of Queen Sophia, Collegiate Church of Saint Martin, Bratislava, from early 15th century; Brotherhood of Corpus Dei, Bratislava, late 15th century (perhaps 1492, from secondary sources); Chapter of Canons, Collegiate Church of Saint Martin, 17th and 18th centuries; City of Bratislava, 1868–84; acquired by Mestské Múzeum, 1884–91.*
*Mestské Múzeum, Bratislava (F-355)*

This chandelier originally belonged to Queen Sophia of Bavaria (1376–1428), second wife of Wenceslas IV. After the death of her husband in 1419, Sophia was forced to remain in Bratislava under the protection of Wenceslas's half brother, Sigismund of Luxembourg. She had a private chapel at the Collegiate Church of Saint Martin, the decorative and architectural program of which shows a direct kinship with Bohemian art at the turn of the fifteenth century.[1] In addition to the chandelier itself, the inventory of the queen's effects after her death includes objects, paintings, and manuscripts evidently of Bohemian provenance.[2]

The chandelier consists of the upper front jawbone of a walrus, on which is fitted a gilded and engraved canopied structure containing an amber statuette whose face is formed from a less malleable type of bone. Although the inscription suggests an identification with Saint Catherine, the statuette was probably originally one of the Virgin Enthroned (or of Saint Anne with the Virgin and Child); damage has made identification difficult. The materials and the eclectic style of the lamp are virtually unique in the medieval art of Hungary, or of Bohemia, for that matter. It is therefore likely that the queen received the object as a gift while she was still at the Prague court.[3] The lamp may also have been assembled in its present form only in Prague, incorporating an existing amber statuette.

The function of the artifact remains unclear. A vessel for oil could have been

142, detail

Treasury, 1964.17.1,2) bears the coat of arms of Archbishop György Pálóczi (r. 1424–39), who may have received it from Sigismund.

Three griffin's feet attached to the central belt form a stand for this horn. The belt has engraved foliate decoration; the enameled coats of arms on the sides show a double-headed and a single-headed eagle. On the horn's tip is a figure of Saint George slaying the dragon. This horn is evidently of the same provenance as the larger one. Despite varying opinions concerning their artistic relationship, both can be attributed (according to the Tresslerbuch entry) to a goldsmith named Werner, who most probably belonged to a very accomplished workshop in the service of the Teutonic Order in eastern Prussia.    EM

1. An inscription concerning a restoration of the horn in 1880 on behalf of the Austrian archbishop Johannes Simor is on the inside of the lid.

LITERATURE: Genthon 1948, pp. 230–31, fig. 243; London 2003–4, p. 56, no. 9, color ill.

143

Michael's, Lüneburg, in 1432 (Kestner Museum, Hannover, w. m. xxi and 43). Wetter (in Bratislava 2003, p. 806) points to a similarity with the altar of Thiel von Lorich in Elblag (Muzeum Wojska Polskiego, Warsaw). The style of the statuette, however, seems to point to western Europe. See, for instance, an ivory Enthroned Virgin of Parisian origin in the treasury of Bruges Cathedral (Taburet-Delahaye in Paris 2004, pp. 111–13).

LITERATURE: Toranová in Žáry et al. 1990, pp. 132–34; Vítovský 1991; Francová in Bratislava 1999, pp. 107–9 (with bibl.); Wetter in Bratislava 2003, pp. 806–7, no. 7.4, fig. 151.

## 144. Badge of the Order of the Dragon

*South German lands or Hungary(?), 1408–18*
*Linen embroidered with silk, metal threads, and gold cord, glass pearl (eye); 27 x 39 cm (10⅝ x 15⅜ in.)*
*Provenance: Martin Joseph von Reider, Bamberg, 1843; acquired by Bayerisches Nationalmuseum, 1860.*
*Bayerisches Nationalmuseum, Munich (T 3792)*

The circular dragon, with its tail coiled twice around its neck and with the red cross of Saint George representing the wound on its back, was the badge of the Order of the Dragon, the chivalric association founded by Sigismund in 1408 for the protection of himself and his wife, Barbara. The first members of the society came from the Hungarian aristocracy, but by 1409 twenty-four lords of Styria and Austria had also joined, followed seven years later by thirty Aragonese nobles. In 1429 Duke Witold of Lithuania was given the right to enroll members.

placed under the statuette, but X-ray analysis shows that the tusks are not hollow. It is therefore doubtful that the metal "hooks" on the four surviving brackets could have been a conduit for oil. Several historical sources identify the lamp as a *kerzstal,* or candelabra, which would indicate that candles were used in connection with it. A flickering light of some kind must have formed an integral part of the object, since only such reflection would have brought out the high quality of the amber used for the statuette.     DB

la Matte?) in the service of Konrad von Jungingen, grand master of the Teutonic Order, based on Sophia's visit to Konrad in 1399. He also cites (ibid., pp. 49–50) several analogies between the style of that goldsmith's work and sculpture for small altarpieces, the closest of which is an amber statue of the Virgin from the so-called Goldene Tafel endowed by Duke Bernhard in Saint

1. Žáry 1990; Žáry in Žáry et al. 1990, pp. 45–48.
2. The inventory describes the chandelier as "ain kerczenstal mit czwain helffant czeunden mit ainer vergulten keten mit sant Kathrein pilt" (a two-sided candelabrum holding flaming [candles] with a golden chain with an image of Saint Catherine). The inventory, compiled in January 1429, is in the Bayerisches Staatsarchiv, Munich (Geheimes Hausarchiv, Korrespondenzakt 543; see Vítovský 1991, pp. 54–57). Some items, including the lamp, were not taken to Bavaria. They remained instead in Bratislava in the possession of the Brotherhood of Corpus Dei (ibid., pp. 48, 57n14). Regarding the accessories of the Altar of the Corpus Dei, see Hlaváčková 2001, p. 93.
3. Vítovský (1991, pp. 48–49) proposes a Prussian goldsmith, in particular Master Johannes (Jehan de

144

This rare and splendid emblem of medieval heraldry displays a vivid coloration, ranging from yellow and green tones to dark red and blue with gold highlights, that results in an enamel-like effect. Because of the wide distribution of pictorial needlework in early-fifteenth-century International Gothic art, its production cannot be precisely localized. The South German territories are a possibility, as is Hungary, if the object bearing the badge was a donation of the Hungarian court. Worked in relief and padded with wool, the badge was surely applied to a textile ground, either a secular ceremonial dress or a liturgical vestment.

There were variations in the design of the badge. Examples with the cross above, rather than on, the dragon's back—first described in 1418 in the armorial letter of the Chapi family—are known from various representations and may be of later date. Among these is the silver badge from the Livland find, now in the Kunstgewerbemuseum, Berlin (03.44), which is most probably the one mentioned in the 1429 donation charter of Duke Witold. The dating of the present work to the decade after 1408, which is also suggested by its style, thus appears likely.                                    EM

LITERATURE: Vienna 1962, p. 482, no. 530; Schuette and Müller-Christensen 1963, p. 44, fig. 283; Nuremberg 1978, no. 187; Durian-Ress 1986, pp. 60–61; Budapest 1987, pp. 70–71, no. 48.

## 145. Three Heads from Buda Castle

*Buda, 1420–30*
*Limestone, apostle or prophet with traces of paint; girl: 17 x 17 x 12 cm (6¾ x 6¾ x 4¾ in.), man: h. 25 cm (9⅞ in.), prophet or apostle: h. 24 cm (9½ in.)*
*Condition: Man: relatively well preserved; some damage to headgear and especially nose. Apostle or prophet: face well conserved but nose, portions of mouth, and folds of mantle drapery broken.*
*Provenance: Excavated at Royal Castle of Buda, girl before 1950, man and apostle or prophet in 1974.*
*Budapesti Történeti Múzeum (51.3250, 75.1.59, 75.1.54)*

The small head of a girl, found in the first archaeological excavation of Buda Castle, had been dated by Tibor Gerevich on the basis of the indulgence Pope Urban V granted in 1366 for a royal chapel, identified until recently as Visegrád. Fragments found later in the same area of the castle, however, indicate that the sculptors in Sigismund's workshop were also

responsible for parts of the Late Angevin palace, including the chapel. This female head was once considered a product of the royal workshop under the mason Master John (whose services for Louis the Great have been documented). Later, Dénes Radocsay noted the head's stylistic affinity with the statue of Saint Martha from Thann Castle in Austria and dated it to about 1400.[1] Other discoveries in 1974 made clear that this head was among the finest of the statues at the castle and was closest to the work of the Master of Grosslobming (active ca. 1380–1420), who is named for the figures from the parish church of Grosslobming, in Styria.

In type and detail this head resembles a statue of the Virgin as well as other fragments of young female and male heads in the Buda group.[2] This sort of girlish face belongs to a series that begins with the busts in the triforium of Saint Vitus's Cathedral in Prague (see figs. 1.2, 8.6), particularly that of Empress Anna of Świdnica, and leads to the Beautiful Madonnas of the late fourteenth century. The type was also adopted by contemporary sculptors of Lower Austria. The Šternberk Virgin (cat. 106) was a crucial work for both groups of artists. Given that this head belongs to the Viennese stylistic tradition, an Austrian connection and a chronology of the type elaborated by Lothar Schultes are the most useful for dating the activity of the Buda workshop,[3] which can be estimated to have begun about 1419, the date of Sigismund's return from the Council of Constance.

Judging by the broken back surface and the regularity of the carving at the top, this small head perhaps formed the corner piece of a corbel. Two other corbels at Buda Castle, depicting prophets or apostles, are attributed to the Grosslobming workshop, which may also have had a part in determining the placement of the sculptural decoration.

The man's head was once part of a statue of medium size (approximately 135–40 cm, or 53–55 in., in height). It belongs to a series of similar "cubically" conceived heads wearing contemporary headgear, in this case a chaperon of the kind depicted in Netherlandish painting of the period. The slight inclination of the face to the right is the only evidence of the original composition. The lower surface of the neck shows signs of friction, incurred after the head broke off, suggesting that it was not separated from the trunk when the fragments were buried at Buda Castle.

Arthur Saliger has interpreted this head as a more mature, bearded manifestation of the figure of Saint George from Grosslobming (now in the Österreichische Galerie, Vienna).[4] Yet technical evidence does not help in

attributing any other pieces to the author of this head. Only formal criteria (a preference for summary forms) and the choice of a local, rougher limestone indicate that the head corresponds to the torsos dressed in fashionable courtly costumes (pourpoints, surcotes), which is also confirmed by visual sources documenting Sigismund's court, such as the illustrations of Ulrich von Richenthal's *Chronicle of the Council of Constance*. In addition to having their roots in late-fourteenth-century French secular images,[5] the Buda Castle sculptures betray the influence of Parisian style under Charles VI.[6] This type of male head with a mustache also recalls Hans Multscher's model for the tomb monument of Louis the Bearded of Ingolstadt (Bayerisches Nationalmuseum, Munich, MA936), whose debt to Early Netherlandish portrait realism is well known. The younger master's position in the Viennese (rather than Grosslobming) circle can thus be determined in the same manner as that of the sculptor of the altarpiece in San Sigismondo, Italy (in which Saint Sigismund perhaps bears a likeness to the later king Albert).[7] This younger member of the Buda workshop can be hypothetically identified with the Master of the Stibor Gravestones, a sculptor working in red marble, most probably in Buda, who is named for two gravestones that date to before 1434, one from Buda, the other from Székesfehérvár. This master's oeuvre also includes tomb effigies of Bosnian kings from Bobovac Castle.[8]

The length of the rear shoulder piece on the third head indicates that it belonged to a full-length figure about 80 centimeters (31½ in.) high, which is exactly the average measurement of a series of saints' figures found on the same site at Buda Castle in 1974. The wide, bearded face—a type harking back at least to Gothic versions of Late Antique portrayals of Socrates—does not occur in the formal repertory of the Grosslobming Master's workshop, which was responsible for most of the statuary of Buda Castle. The influence of the circle of André Beauneveu (see, for example, the prophets from the Sainte-Chapelle, Bourges) can be seen in both the modeling and the rendering of the beard. Another prophet's head (Budapesti Történeti Múzeum, 75.1.53), which displays various ways of carving hair, and a series of torsos with the same proportions are also identified with the same French sculptural style. Michael Schwarz offers a dissenting view, however, proposing instead the Master of the Apostle Figures, whose activity he dates to the time of the Battle of Nicopolis in 1396.[9] We consider definitive the similarities between this head and the Saint Simon in the choir of Saint

145, head of a girl

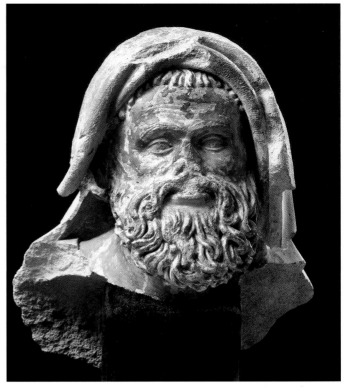

145, head of an apostle or prophet

145, head of a man

Martin's in Hal, attributed with other figures on the Hakendover altarpiece to the same South Netherlandish master active in Brabant.

These observations make it more plausible that this style was transmitted through the Lower Rhine in the early fifteenth century, as seen, for instance, in the prophet figures from Cologne City Hall and the sculptures of the monument to Archbishop Friedrich von Saarwerden (d. 1414) in Cologne Cathedral. The Saarwerden Master's workshop was also involved in the sculptural decoration of the choir pillars of Aachen Cathedral, which continued after the consecration in 1414 (before Sigismund's coronation as King of the Romans on Christmas of the same year). In fact, a group of workmen from Cologne in the service of the king, including masons and carpenters, was traveling to Hungary in December 1414 when their master, Dietrich, was arrested in Regensburg. Sigismund's employment in 1418–19 of a number of masters from Germanic lands, especially from the south, is documented in written sources concerning his building projects and also corresponds to the general chronology of the statuary of Buda Castle.[10]

EM

1. Radocsay 1969. For the Thann sculpture, see Vienna 1994, p. 135, no. 23.
2. The Virgin is no. 30 in the series. See also the recently discovered Schulhof Madonna in the Österreichische Galerie, Vienna (Schmidt 1992, p. 306, fig. 330; Vienna 1994, no. 47, p. 183).
3. Schultes 1986.
4. Vienna 1994, pp. 109ff., 172, no. 16.
5. Schwarz 1986, pp. 455–56, 461–67 (Tour Maubergeon, Poitiers).
6. See Heinrichs-Schreiber 1994, pp. 25–26 (Pierrefonds); and also Paris 2004, pp. 222–23, 319–20, nos. 133, 199.
7. See Brucher 2000, pp. 550–51, no. 293.
8. Lővei 1999.
9. Schwarz 1986, pp. 457–60.
10. Liedtke 1975, pp. 18–20.

LITERATURE: Girl: Gerevich 1966, p. 280; London 1967–68, no. 63; Radocsay 1969, pp. 49ff.; Zolnay 1976; p. 226, ill.; Cologne 1978–79, vol. 2, pp. 453–55, ill.; Schultes 1986; Budapest 1987, p. 258, no. 13; *Museums in Budapest* 1989, p. 71, no. 139, color ill.; Zolnay and Marosi 1989, no. 70, p. 156, ill.; Schultes 1994, p. 295, fig. 39. Man: Marosi 1976, pp. 344, 362; Schwarz 1986, p. 466; Kovács in Marosi 1987, pp. 239–41; Zolnay and Marosi 1989, p. 154, no. 61, ill.; Vienna 1994, p. 172, no. 42. Apostle or prophet: Marosi 1976, p. 348, fig. 7; Budapest 1987, p. 261, no. 18; Zolnay and Marosi 1989, p. 153, no. 56, fig. 46; Vienna 1994, p. 176, no. 44.

# 146. The Resurrection and The Easter Miracle of Saint Benedict

*Tamás of Koloszvár (Hungarian, active first half of 15th century), 1427*
*Tempera and gold on panel; Resurrection: 87 x 68.5 cm (34¼ x 27 in.), Easter Miracle: 90 x 68.5 cm (35⅜ x 27 in.)*
*Inscribed in Latin on banderoles in Easter Miracle: Scio q[uia] pascha est q[ui]a te merui hodie videre (I know that it is Easter because I was permitted to see you today); Serve d[omin]i surge et sumamus cibum quia hodie pascha est (Rise, servant of God, we will take the food, for today is the feast of Easter).*
*Provenance: Benedictine Monastery, Hronský Beňadik, Slovakia; Archbishop Janos Simor, Esztergom, ca. 1872; transferred to Keresztény Múzeum, 1887.*
*Keresztény Múzeum, Esztergom, Hungary (54.6, 54.9)*

These two panels were portions of the wings, painted on both sides, from the Passion Altarpiece of the Monastery of Saint Benedict on the Hron River in Upper Hungary. At some unknown point, the wings were sawed apart and the panels broken up. The center panel has preserved its unusual ogee shape, but the two upper panels of the wings were cut down before dismantlement in order to fit into a different sort of frame. When opened to its fullest width, nearly four meters (thirteen feet), the original retable presented four Easter and Passion scenes—the Agony in the Garden, the Way to Calvary, the Resurrection, and the Ascension—flanking a central Crucifixion. The four scenes from the insides of the wings have now been reframed with the Crucifixion panel (fig. 146.1) to simulate the original

146. The Easter Miracle of Saint Benedict

146, The Resurrection

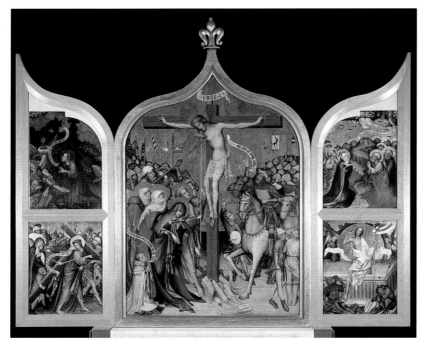

Fig. 146.1 Tamás of Koloszvár (active first half of 15th century). Passion Altarpiece. From the Monastery of Saint Benedict, Upper Hungary. Tempera and gold on panel, 1427. Keresztény Múzeum, Esztergom, Hungary (54.3-10)

1. Takács 2001, pp. 630–31.
2. Published in Knauz 1890, pl. 9. Scholars have long questioned whether this panel came from the retable. See, most recently, Tóth 1998, p. 74, and Takács 2001, p. 630.
3. In 1412 Sigismund engaged the abbot of Saint Benedict's, Nicholas of Bologna, to serve as his attendant and confessor; Nicholas later accompanied the emperor to the Council of Constance. Regesta Imperii XI, no. 190 (February 9, 1412); Knauz 1890, p. 38.
4. Mályusz 1990, p. 322; Lukcsics 1931, no. 341.
5. See, for example, the depiction of the king in a group portrait with Sigismund, John VIII Palaiologos, and Erich of Pomerania from 1424 (Musée du Louvre, Paris, Collection Edmond de Rothschild (Kéry 1972, fig. 49) or the corresponding depiction in the Bamberg Altarpiece from 1429 (Bayerisches Nationalmuseum, Munich, MA 2625 [Strieder 1993, fig. 28]; compare cat. 140; fig. 147.1).
6. See Török 1978, 1989, and 1990.

LITERATURE: Gerevich 1923; Radocsay 1955, pp. 307–10 (with bibl.); Lukács 1973; Mucsi 1978; Török 1978; Prokopp in Cologne 1978–79, vol. 2, p. 460; Vegh in Marosi 1987, vol. 1, pp. 619–23; Török 1988; Török 1989; Mályusz 1990, pp. 322–23; Neuhausen and Neuhausen 1990; Török 1990; Török in Esztergom 1993, pp. 172–74, no. 1 (with bibl.); Marosi 1995, pp. 131–34; Tóth 1998; Takács 2001, pp. 629–31; Bartlová in Bratislava 2003, pp. 698–99, no. 4.18.

configuration. The Easter Miracle of Saint Benedict, the Miracle of the Grain of Saint Nicholas, and the Wounding of Saint Giles were depicted on the outsides of the wings. (The fourth outer panel has been lost.) The retable may have originally stood on the Holy Cross altar in front of the choir screen in the monastery church, or, despite its considerable size, may have been placed in the Church of Saint Giles in Saint Benedict's cemetery.[1]

Also from the same monastery was an inscription panel, destroyed by fire in 1905, that is thought to have been part of the altarpiece's lost predella.[2] Its text, on either side of King Sigismund's coat of arms, named not only the donor, Nicholas of Saint Benedict, but also the painter, "Magister Thomas Pictor de Coloswar," and the date of the work's completion, 1427. Nicholas, whose patron saint is represented on the outside of the altarpiece, had himself portrayed in the center Crucifixion panel, wearing a choir robe trimmed with ermine and with the opening lines of the Gregorian prayer "Adoro te in cruce pendentem" on his banderole: "Domine ihesu christe adoro te in cruce pendentem spineam coronam" (Lord Jesus Christ, I adore thee hanging on the cross, crowned with thorns).

The Monastery of Saint Benedict, a donation of King Geza I (r. 972–97), had always been closely associated with the Hungarian royal house.[3] The donor's close ties to the court can be inferred from the inscription panel, and it was presumably the king's doing that he was awarded the lectorship and prebendary in Győr

in 1421. Moreover, he appears to have served as royal chaplain.[4] Therefore, the assumption frequently expressed in the critical literature, namely, that the figure of the centurion in the center Crucifixion panel (see fig. 11.1) bears Sigismund's features, seems reasonable.[5] Considering the contemporary political pressures—the Hussite Revolution and the menace of the Turks—Sigismund's depiction as a centurion would have been significant, amounting to casting the king in the role of a Christian commander. Such an interpretation is bolstered by his presence, not in the crowd standing at the foot of the cross, but at the head of the cavalry charging toward the site of the executions.

It is noteworthy that the dedicatory text gives the names of the painter and the donor equal prominence. Tamás of Koloszvár in Transylvania (present-day Cluj-Napoca, Romania) was apparently so well known that naming him added distinction to the donation. It thus seems probable that he belonged to the circle of Sigismund's court artists in Buda. Stylistically, his pictures reveal the distinct Bohemian orientation in Hungarian court art under Sigismund, as seen in their similarities with the Vienna Model Book (cat. 117),[6] the London *Mandeville* illustrations (cat. 88), the folios from the Gerona Martyrology executed by the *Mandeville* Master (see cat. 86), and panels from the Capuchin Cycle (cat. 147). Many of the Franco-Netherlandish and Italian elements that have repeatedly been noted could well have been transmitted by way of Prague.

WF

## 147. Three Panels from a Capuchin Cycle

*Prague, ca. 1420(?) or 1436(?)*
*Tempera on linden wood panels, each 47.5 x 34.5 cm (18¾ x 13⅝ in.)*
*Provenance: Church of the Virgin Mary, Capuchin Monastery, Hradčany, Prague (founded 1600); on loan to Národní Galerie since 1939.*
*Provincie Kapucínů v České Republice, Prague (VO 2089–91).*

Of unknown origin and function, the fourteen panels of this cycle represent bust-length images of Jesus, Mary, John the Baptist, and ten apostles, plus Saint Paul (two panels with apostles are lost). The key to understanding the cycle of images is a portrait of the emperor Sigismund (fig. 147.1) painted at the same time and, we believe, by the same artist, probably on the occasion of the court's move to Prague in 1436–37.[1] This date is more likely than the previous dating of the cycle to about 1410.[2] It is true that almost all the motifs and characteristics of these panels are found as early as 1410–20. (Compare, for example, the Model Book in Vienna [cat. 117], with its similar head types and the same simplification and linear

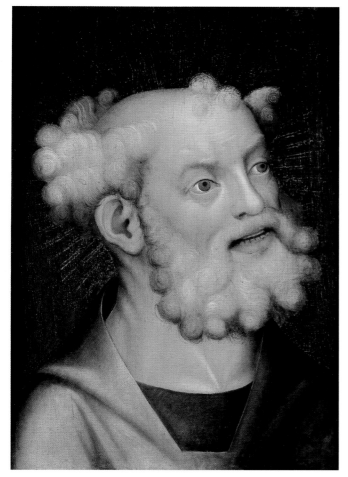

147, Saint Peter

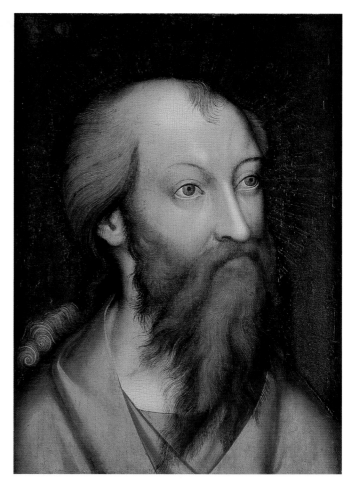

147, Saint Paul

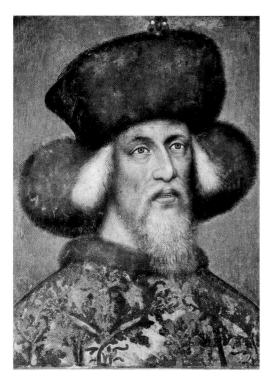

Fig. 147.1 Emperor Sigismund. Paint on parchment on panel, probably 1436–37. Kunsthistorisches Museum, Vienna

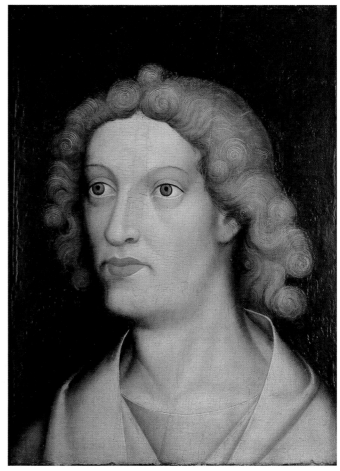

147, Saint John the Evangelist

quality of the forms, including the bust-length format.) The same repertory remained in use until the mid-fifteenth century, however, although the images became increasingly stylized, the colors darker and gloomier, and the forms harder. Certain shifts in meaning occurred in this cycle: instead of being shown as a young woman, for instance, the Virgin appears as a matron.[3]

That this style can be associated with the patronage of the emperor Sigismund can be seen from the altar panels (cat. 146) by Tamás of Koloszvár (Cluj-Napoca, Romania), from 1427.[4] Similarly linear and angular in conception is the civic record book of Jihlava, dated 1430.[5] Until the mid-fifteenth century many images in areas loyal to the emperor, such as Nuremberg and Silesia, conformed to the types and ideals of Bohemia. This was a time that saw the creation of numerous copies of older, venerated Bohemian images.[6]

Previous proposals for a reconstruction of the cycle—as part of a triptych or an iconostasis in the Byzantine manner—are unrealistic. By this time interest in a Byzantine aesthetic, witnessed early in the imperial reign of Charles IV (see cat. 27) and exceptionally under Wenceslas (see cat. 81) had diminished. It could have had a function similar to that of the fresco cycle with apostles holding consecration crosses and scrolls with the articles of the Creed that was painted about 1360 on the walls of side chapels in the Church of Saint

Lawrence in Nuremberg.[7] Furthermore, these panels descend from a tradition seen in the sculpture of the apostles at the Saint-Chapelle in Paris and the Cathedral of Cologne (which also included the Virgin and Child).

RS, JF

1. Gemäldegalerie, Vienna, 1965, vol. 1, pp. 96–97. Rasmo first proposed the localization to Bohemia in 1956.
2. Matějček and Pešina 1950, pp. 126–27; Prague 1970, p. 237; Royt 2003, p. 114.
3. Suckale 1993a, vol. 2, pp. 65–70.
4. Cologne 1978–79, vol. 2, ill. p. 460; Bartlová in Bratislava 2003, pp. 698–99, no. 4.18.
5. Olomouc 1999–2000, pp. 476–79. In the same vein, many manuscripts customarily placed prior to 1420 should also be redated.
6. For example, the Imhof Virgin in the Church of Saint Lawrence in Nuremberg, dated 1449, is a variation on the Virgin from Roudnice nad Labem in the Národní Galerie in Prague (Strieder 1993, p. 180, no. 17, fig. 247). This kind of pictorial politics was continued after Sigismund's death by his successors, Albert II and Frederick III (see Pirker-Aurenhammer 2002).
7. Schädler-Saub 2000, pp. 158–60.

LITERATURE: Matějček and Pešina 1950, nos. 192–205 (with bibl.), pls. 157–70; Rasmo 1956; Prague 1970, p. 237; Vienna 1990, pp. 65–69, no. 12, ill.; Chlíbec et al. 1992, no. 17, ill.; Bartlová 2001b, pp. 177–83.

## 148. Psalter of Hanuš of Kolovraty

*Nuremberg illuminator working in Prague, 1438*
*Tempera and gold on parchment, 167 fols., 27.7 x*
*18.6 cm (10⅞ x 7⅜ in.)*
*Provenance: Purchased by Abbot Laurentius (1611–*
*1691), Osek Monastery, 1650s; registered in library at*
*Osek, 1714; private collection, 1950; Národní*
*Muzeum, Library, since 1970s.*
*Národní Knihovna České Republiky, Prague (Osek 71*
*CimC104)*

This psalter was made for Hanuš of Kolovraty (d. 1452–53), Emperor Sigismund's administrator and later military governor in Prague.[1] Its decoration can be attributed not to a painter trained in Prague, as has previously been maintained, but rather to an artist from Nuremberg who was active in the Bohemian capital. Although he adopted the ornamental style of Prague illuminators, the types of heads he employed, as well as his manner of painting, follow Nuremberg patterns. Between 1400 and 1450 painters in Nuremberg, who were primarily panel painters but who also worked as manuscript illuminators, modeled their art closely on that of Bohemia.[2] The formal vocabulary of Nuremberg painters was thus well suited to the efforts of Wenceslas IV, and Sigismund after him, to establish a new Bohemian court art that emulated the Prague style from about 1400 (see cat. 147).

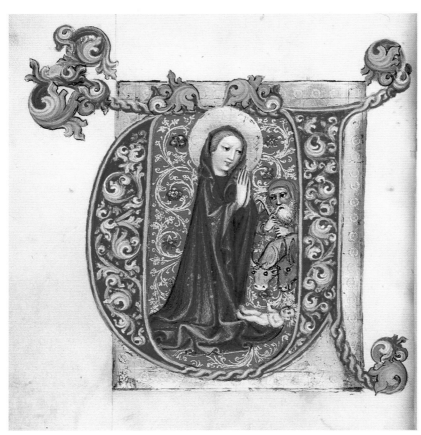

148, fol. 125v (detail), The Adoration of the Christ Child in an Initial V

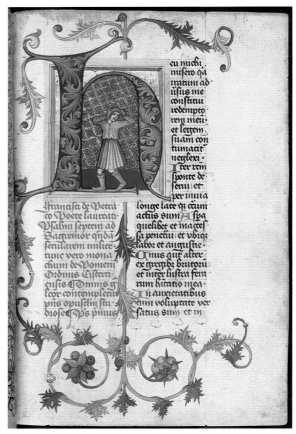

148, fol. 126r, Pseudo-Petrarch as the Wretched Man in an Initial H

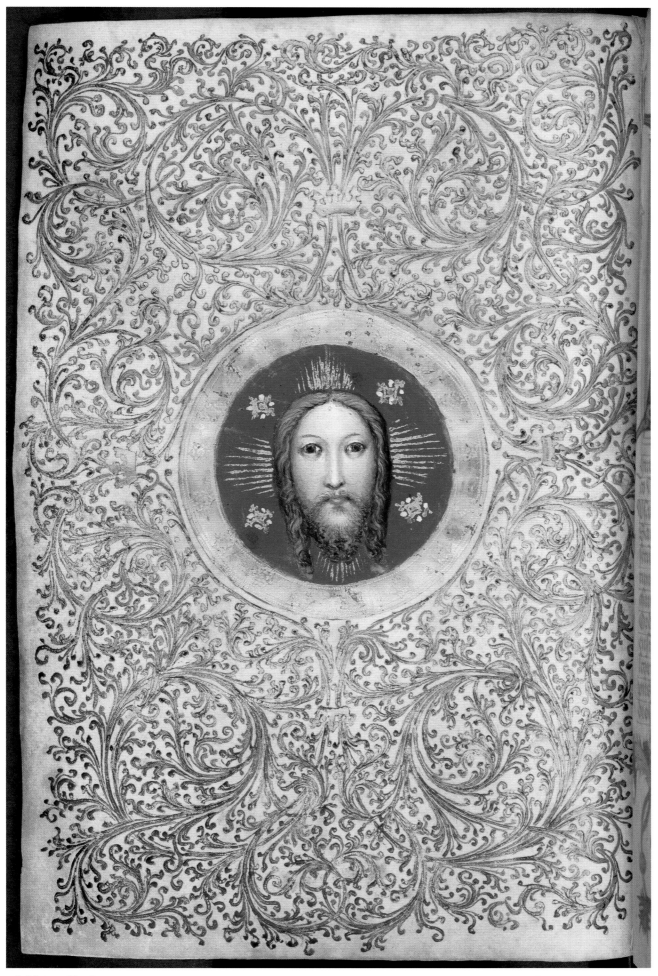

148, fol. 142v, *Vera Icon*

Nuremberg received numerous privileges from the rulers of the house of Luxembourg. Its role as the site of the first diet of every newly crowned German king was prescribed by Charles IV in the Golden Bull of 1356. In 1415 Sigismund elevated the burgraves of Nuremberg to margraves of Brandenburg.[3]

RS, JF

1. Hanuš of Kolovraty had his principal residence in Krašov, but he also possessed castles in Libštejn, Žebrák, and Točník, among others.
2. It has not previously been recognized that the miniatures of the twelve apostles in the ivory miniature book in the Bayerische National-museum, Munich (MA 2033; see Wentzel 1962), are also the work of a painter from this group. The same holds true for a gradual (winter section) from the Church of Saint Lawrence in Nuremberg that was completed in 1421 by the scribe Lorenz Gredinger (Landeskirchliches Archiv, Nuremberg, LKAN Pf. A. St. Lorenz 460).
3. It is therefore not surprising that in the Franciscan altarpiece from Bamberg, which was painted in 1429 (Bayerische Nationalmuseum, Munich), Sigismund's elegant features appear on the good centurion at the foot of the cross. Kéry (1972, pp. 175–79) erroneously saw portraits of Sigismund in the two figures of Pilate on the reverse. On Nuremberg, see also Stange 1978, pp. 24–32, and Strieder 1993, pp. 26–36, 170–80.

LITERATURE: Stejskal and Voit 1991, no. 45; Osek 1996, no. 14.

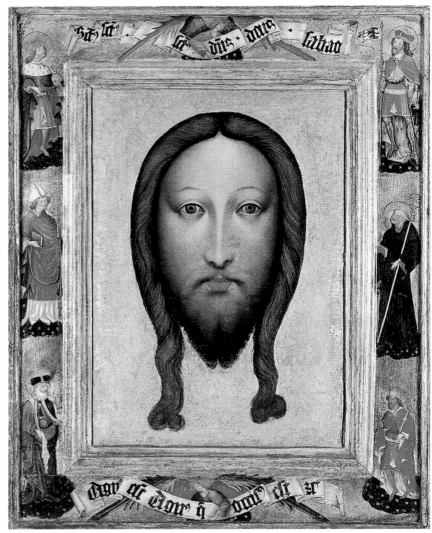

149

## 149. Vera Icon with the Patron Saints of Bohemia

*Prague, ca. 1400–1410 or 1430–40*
*Tempera and gold on linen-covered pinewood panel with original linden wood frame, 62 x 50.5 cm (24⅜ x 19⅞ in.)*
*Inscribed on titulus held by angel at top: Sanctus sanctus sanctus dominus deus sabaot (Holy, holy, holy, the Lord God of hosts [Isa. 6:3]); on titulus at bottom: Dignus est Agnus qui occisus est (The Lamb that was slain is worthy [Apoc. 5:12]).*
*Metropolitní Kapitula u Sv. Víta, Prague (HS 03423 [K 99])*

Paintings of the *vera icon* (true image) like this one witnessed a sudden profusion from about 1400. Such images were meant not only "to stimulate the mind further toward devotion" (as was inscribed on one famous image),[1] but also to focus the worshiper's contemplation and to accompany a prayer for indulgences. They clearly emphasize the beauty of the incarnate God rather than his suffering and torment on Calvary.

The ruddy features of this humanized, even aristocratic face of Jesus are highlighted in gold or yellow, as on the *vera icon* from Nuremberg (cat. 137). On the gilded frame the patron saints of Bohemia turn toward the Holy Face. On the right, from the top down, are Saints Vitus, Adalbert, and Ludmila; on the left are Wenceslas, Procopius, and Sigismund. The frame populated by standing saints is characteristically Bohemian and could suggest a date in the second quarter of the fifteenth century. A frame with a similar format appears, for example, on the Ara Coeli Madonna in the Národní Galerie, Prague.[2]

This *vera icon* was certainly at Saint Vitus's Cathedral in Prague by the end of the fifteenth century and may have been among the images saved by Hanuš of Kolovraty (see cat. 148),

administrator to Archbishop Konrad of Vechta (r. 1413–21), at the time of the Hussite Revolution.[3] In the 1397 inventory of Saint Vitus's a *tabula cum veronica* was on the altar of Saint Matthew and another was on the altar of Saint Wenceslas.

CTL

1. Grabar 1931, p. 8.
2. Pujmanová 1992, fig. 8.
3. Pujmanová in Rome 2000–2001, no. IV.19; Kořán 1991, pp. 287, 312n14.

LITERATURE: Cologne 1985, no. 10; Vienna 1990, no. 9, color ill.; Kořán 1991; Pujmanová 1992; Rome 2000–2001, no. IV.19; Wolf 2002, p. 125.

## 150. Crucifix

*Master of the Týn Crucifixion, Prague, ca. 1437(?)*
*Lime wood with paint; corpus h. 90 cm (35⅜ in.),*
*newer cross h. 155 cm (61 in.)*
*Condition: Very good, with only toes and fingers*
*missing. Tears on face made from translucent resin; top*
*layer of dark glaze present in some areas also contains*
*blood stains modeled from resin.[1] Original paint*
*(applied in fine layer on thin two-layer undercoat after*
*raised areas covered with canvas) uncovered during*
*restoration by Mojmír Hamsík, 1972.*
*Provenance: Treasury of Saint Vitus's Cathedral.*
*Metropolitní Kapitula u Sv. Víta, Prague (HS 04217*
*[V 292], Svatovítský fond)*

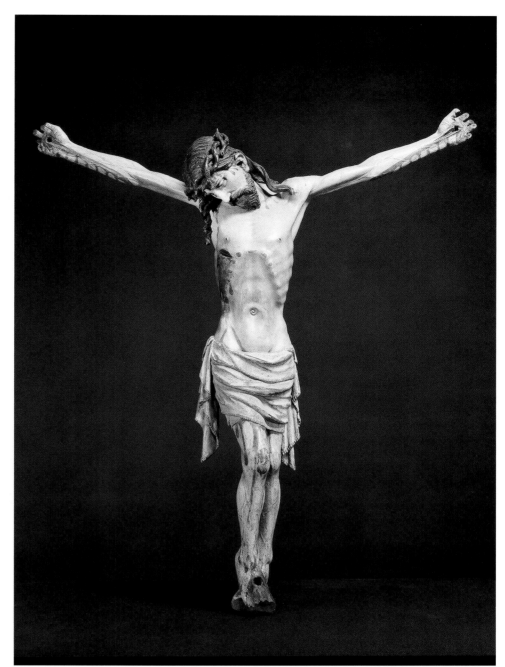

150

This crucifix is one of five that survive from the workshop of the Master of the Týn Crucifixion, the most important atelier of Bohemian sculpture during the second quarter of the fifteenth century. Each of the crucifixes may have been the center of a Crucifixion group based on the monumental work from the Týn Church in Prague, after which the master is named. That replicas were made of the Týn Crucifixion is attested by the statue of Saint John the Evangelist in the Národní Galerie, Prague.[2] Conversely, each may simply have formed an independent part of an altar decoration. The great significance of the Crucifixion theme accounts for the survival of such a comparatively large number of crucifixes from this workshop and suggests that there were almost certainly even more.

The shape of Christ's body here, which is similar to others carved by the Master of the Týn Crucifixion, can be closely linked to the tradition of the Beautiful Style. The decreased emphasis on expressive qualities and the slightly softer fold of the loincloth do not necessarily denote an earlier date than the Týn Crucifixion and the crucifix from the Church of Saint John the Baptist in Svatý Jan pod Skalou. These variations may either reflect the instructions of the patron or have been motivated by purely artistic considerations.

The period from 1436, when Emperor Sigismund arrived in Bohemia, to 1462, when Pope Pius II canceled the Compactata, has been very little researched. Religious practice (in contrast to political life) was then characterized by a wide-ranging mutual tolerance between the Roman (Catholic) and Bohemian (Utraquist) Churches. Successors of the Hussites regarded the visual arts as a means of legitimizing their claim to a lawful, yet autonomous, integration in the Christian community. Depictions of the Crucifixion were basic components of the obligatory church furnishings that both groups commissioned at the time of the Compactata. The denominational status of Saint Vitus's—the metropolitan church of a diocese without an archbishop and with two-thirds of its population Utraquists—is not quite clear. In any case, Saint Vitus's artistic and liturgical furnishings, damaged by the Hussites in 1421 and by the years of neglect that followed, would have been restored after the return of the emperor and also of the chapter, which returned to Prague from Zittau in Lusatia in 1437. In the same year the cathedral was consecrated by Philibert de Montjeu, the legate of the Council of Basel.  MB

1. Prague 1985, app., pp. 21–22.
2. Bartlová 2004, pp. 57–58.

LITERATURE: Pinder 1924, p. 178; Kutal 1962, p. 110; Chlíbec in Prague 1990b, pp. 25–27, no. 1; Bartlová 2004, esp. pp. 52–56, 130.

## 151. The Last Judgment

*Prague(?), ca. 1435*
*Paint on panel, 133 x 104 cm (52⅜ x 41 in.)*
*Condition: Generally well preserved, with original*
*dimensions intact. Conservator P. Pracher (Würzburg)*
*detached a nineteenth-century cradle, consolidated the*
*panel joints with blocks of balsa wood, and removed*
*overpaint.*
*Provenance: Earl of Sternberg and Princess of*
*Lobkowitz (sold, Munich, 1884); Priest Schmitt*
*(d. 1923), Rannungen, Lower Franconia; unknown*
*private collection, Würzburg; Episcopal Chair,*
*Museum am Dom, after 1923.*
*Museum am Dom Würzburg (BOW 122)*

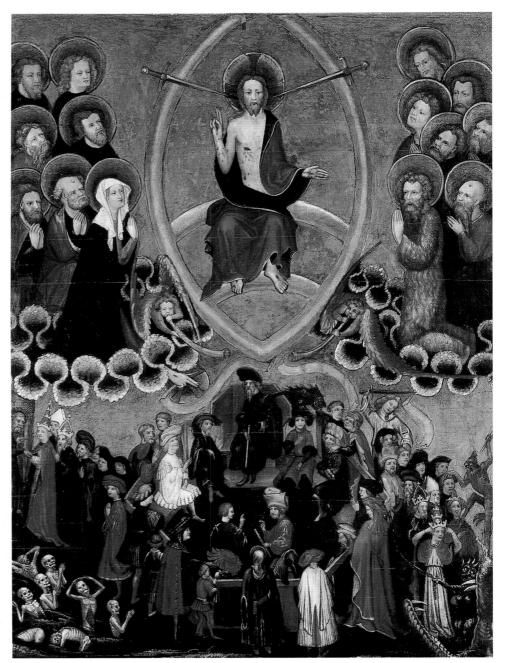

151

Of the countless Last Judgment pictures once placed in town halls and other courtrooms, this panel is unusual in combining the theme of divine justice with a scene of a secular trial. Christ sits upon a double rainbow in a mandorla, as Mary, John the Baptist, and the apostles kneel on either side near two angels sounding the trumpets of the Last Judgment. The swords pointing to Christ's head symbolize his passing the sentence that separates the condemned from the righteous. At the head of each of those two groups, depicted below, stand a pope, an emperor, and a bishop. The bearded man seated on a high-backed chair beneath the mandorla is a judge, who points the tip of his staff downward to indicate that he has reached his verdict.

The judge here is presented with two alternatives. Directly beneath the clouds on his right (the side of the blessed) is the scarred hand of Christ giving benediction as it hovers over a cross-shaped nimbus and a scroll with no inscription. On his left, a devil, apparently tugging on a tonsured monk, turns toward a beardless man gazing absently to the right. The demon seems to be whispering something into the ear of the man, who may be the same one being touched by the archangel Michael a bit farther to the right. Beyond the general allusion to the seductive powers of devils, some actual, historical event is being referenced here, although it has yet to be determined. The clearest indication of this intent is the beardless man with a red tasseled robe and cap who looks up at the devil as though receiving instructions while pointing with his left hand at the man with the large fur cap seated directly in front of him.

Inside the secular court, a hexagon made up of benches, there are eight men of various ages dressed in splendid clothing. One pair, on the bench opposite the judge, is especially prominent. They appear to be swearing an oath, for unlike the others they have their right hands raised. The man on the right carries

a staff, which probably indicates he is the leader of the men on the right side of the hexagon, who seem to wear slightly more modest clothes. He may be the mayor of Prague's Old Town, finishing the discussion with Sigismund's envoys. The young man at the left, with his impressive white fur coat, seems especially to belong to a noble sphere. Thus the painting may commemorate the conclusion of the Compactata in 1433, which marked a rapprochement between the Utraquists and the Roman Catholic Church. This made it possible for Sigismund to return to his kingdom in the last year of his life (1436/37). The courtly bearing of the figure dressed in red, seen in profile from the right, recalls Franco-Flemish art; the man seen from the back in

the foreground evokes Italian narrative traditions of the fourteenth century (though judging by his costume, perhaps via Flemish art).

According to a late-fourteenth-century gloss on Article 16 of the Saxon Municipal Law (Magdeburg Law), every judge was required to place a picture of the Last Judgment in the town hall.[1] In the list compiled by Georg Troescher, only two other such panels contain a secular trial scene as well: one from the town hall in Graz (1478) and the other from the Wesel council chamber (1494).[2] Since the present work came from an aristocratic collection in Bohemia, it may once have hung in a courtroom there or in Moravia, most likely in Prague or Kutná Hora, where artistic activity had by no means been extinguished by the

Hussite Revolution. In fact, such a narrative picture could well have been produced to reflect the situation under the Utraquist government of the Old Town in Prague. It is less likely to have been intended for a royal court, for the judge (the king's representative) is not distinguished by royal insignia.

Hans Ramisch[3] identified the style of the work quite generally as falling between that of the Luxembourg Genealogy at Karlštejn, most probably painted by Nicholas Wurmser of Strasbourg (see figs. 1.6, 2.1), and that of the Rajhrad Altarpiece (cat. 154) and thought that drawings from the Vienna Model Book (cat. 117)[4] could have been used in Prague workshops. Yet the Würzburg Last Judgment stands much closer to the Rajhrad retable, which also supports a dating to about 1435.

<div align="right">MH</div>

1. Troescher 1939, p. 148.
2. Ibid., p. 172, fig. 126, p. 198, fig. 128.
3. Ramisch in Cologne 1978–79, vol. 1, pp. 357–59.
4. Drobná 1956, pl. 72.

LITERATURE: Sternberg and Lobkowitz sale 1884; Troescher 1939, pls. 124, 125; Ramisch in Cologne 1978–79, vol. 1, pp. 357–59 (with bibl.); Schild 1988; Meier 1999; Machilek 2005.

## 152. Man of Sorrows

*Master of the Týn Crucifixion, Prague, ca. 1440*
*Wood, paint, and gilding; Christ h. 131 cm*
*(51⅝ in.), console h. 75 cm (29½ in.)*
*Inscribed on band held by angel: Iuste iudicate filii*
*hominum (Judge righteously, O sons of men).*
*Condition: Very good; mixture of older and more*
*recent paint may cover original pigment; paint and*
*gilding on angel and figure of same type.*
*Provenance: Old Town Hall, Prague; on loan to*
*Municipal Museum since 1886.*
*Magistrát Hlavního Města Prahy, Prague*

That this sculptural group has survived in its original setting—on the wall of a council chamber of the Old Town Hall—is extraordinary in the context of Bohemian art. An almost identical carving, without a console, from the New Town Hall (Muzeum Hlavního Města, Prague, 456) indicates that in the late 1430s or early 1440s, the Master of the Týn Crucifixion created identical statues for both municipalities. Why he did so is revealed by the iconographic meaning of this specific type of Man of Sorrows, which combines the traditional corporeal figure, linking Jesus' physical body with the sacrament of the Eucharist, and a gesture

152

alluding to his role in the Last Judgment. By this merging of themes, the artist strove to present the Divine Law as embodied in Christ the Word Made Flesh, according to the gospel of Saint John, and as transmitted through the eucharistic community of the renewed Church. Such an image, placed before the eyes of the town councilors, not only showed the authority granted them by their jurisdiction but also legitimized it by referring directly to Christ, without need for the king's mediation. Thus, both statues must date to approximately 1439–48, when the central power of the monarchy did not exist and Prague aspired to be itself the "Head of the Kingdom."

Although the figure and console are closely related, both iconographically and technically, the console was long thought to be an independent work, created as many as fifty years later. Only when the activity of the Master of the Týn Crucifixion was redated to the years around 1439 was it possible to understand both works as an integral whole. A detailed formal comparison then revealed numerous motifs and formal features shared by the angel and the monumental sculptures in the Týn Church. The high quality of the angel's carving and its stylistic similarity to central European sculpture of the Late Gothic period (its links, for instance, to the work of Hans Multscher) show quite persuasively that the Master of the Týn Crucifixion, despite his close adherence to the Beautiful Style, was acutely aware of contemporary developments.

Both Prague statues of the Man of Sorrows display an accurate knowledge of the male anatomy. In contrast to the less realistic forms found on crucifixes, these figures are persuasive physically, given weight by their strong corporeality and dramatic expressiveness. Such radical mimesis in the context of the Hussite Revolution was undoubtedly meant to underline the derivative nature of a work of art, which cannot approach an essence, being merely its representation.[1] In this deeper sense, the Prague statues of the Man of Sorrows are sophisticated articulations of the Hussites' relationship to the visual arts.                MB

1. Freedberg 1994.

LITERATURE: Pinder 1924, p. 178; Braune and Wiese 1929, pp. 24–25; Kutal 1962, pp. 112–13; Homolka in Prague 1970, p. 169, no. 237; Homolka in Cologne 1978–79, vol. 2, p. 694; Chlíbec in Prague 1990b, pp. 35–39, no. 6; Fajt 1995, pp. 17–20; Bartlová 2004, esp. pp. 52–56, 130; Bartlová 2005.

## 153. The Martyrdom of Saint James the Great

*Master of Rajhrad, 1436–37(?)*
*Tempera and gold on spruce panel, 82.4 x 75.4 cm (32½ x 29¾ in.)*
*Condition: At some point, panel separated from its reverse side, planed to thickness of 1–3 mm, and cradled. Inscribed on banderole: Iussu Herodis decolat[ur] s[ancti] Ja[cobus] cum Iosias (At the command of Herod, Saint James is beheaded along with Josias); Discipuli tulerunt corp[us] et navi i[m]po[suerunt] (The apostles take the body and lay it in the ship). Provenance: Baroness von Redl, Neulengbach, Austria, until 1930(?); purchased on Vienna art market by Moravská Galerie, 1932. Moravská Galerie, Brno (A 571)*

The Martyrdom of Saint James the Great is one of a group of thirteen panels of identical format that recount episodes from the legend of the apostle and the life of the Virgin. The panels are now dispersed among collections in the Czech Republic (see figs. 153.1, 153.2), Austria, and Germany.[1] Together with three now lost panels, they constituted two pairs of movable wings of a retable of Saint James. This polyptych must have been approximately 3.5 meters (11½ feet) wide when opened. Nothing is known about the center part.[2]

The iconography and dimensions of the polyptych indicate that it was the high altar retable for a church of Saint James, probably that in Prague.[3] The restoration of the church's interior decor, which had been destroyed during the Hussite Revolution, was begun during the brief reign of Sigismund in Bohemia (1436–37), in tandem with reassertion of Roman Catholic control in Prague.[4] Saint James's functioned as the town church for the kings of Bohemia, and it was there that the legate from the Council of Basel, Bishop Philibert de Montjeu, consecrated seven altars on March 14, 1437, in the presence of the emperor and his consort and numerous members of the court.[5]

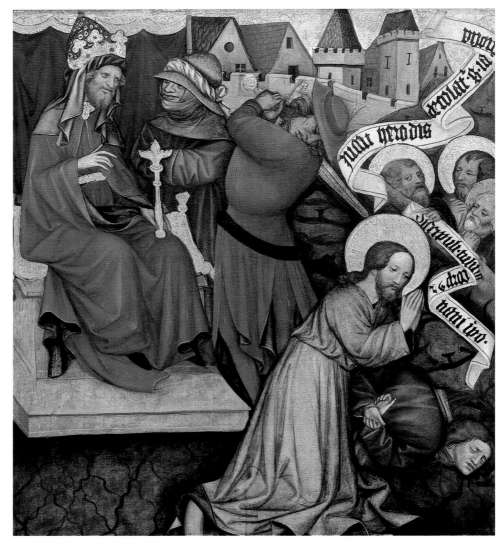

153

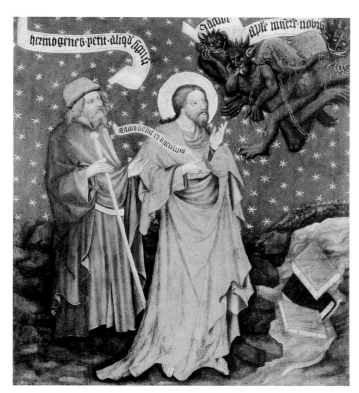

Fig. 153.1 Master of Rajhrad. Destroying the Books of Hermogenes. From Saint James Altarpiece. Národní Galerie, Prague (O 598)

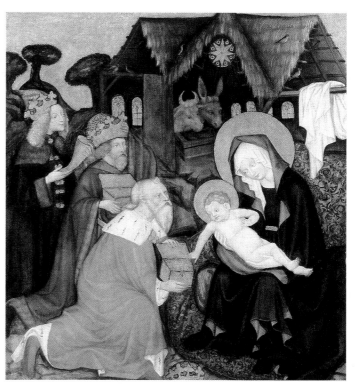

Fig. 153.2 Master of Rajhrad. Adoration of the Magi. From Saint James Altarpiece. Národní Galerie, Prague (O 1485)

The program of the Saint James Altarpiece reflects this historical context. Outside of feast days, the viewer was presented with an unusually detailed portrayal of James's conversion of the magician Hermogenes, ending with the emphatic destruction of his occult books (fig. 153.1)—an episode that can be understood as a metaphor for the crushing of the Hussite heresy. Yet even on holy days when the retable stood open, the theme of James's legendary conversions of heathens was evident, with depictions of Josias, who repented of his complicity in James's martyrdom and was therefore beheaded along with him, and Queen Lupa of Galicia, who made her palace into a church. Especially striking in the outside panels is the simple style of the narrative, which is reduced to the essential protagonists and largely omits any reference to specific settings. The events are explained mainly through the inscriptions, which endow the scenes with a didactic quality. The inside panels employ a similarly reduced pictorial vocabulary.

The workshop that created the retable (differences in execution suggest the participation of various artists) followed the style of the pre-Hussite period, thus reflecting the conservative tendency of Prague court art after 1436.                                    WF

1. Seven are in the Národní Galerie, Prague; two in the Kunsthistorisches Museum, Vienna; two in an Austrian private collection; and one in the Germanisches Nationalmuseum, Nuremberg. See Bartlová in Brno 1999–2000, pp. 287ff. On the provenance, see also Bartlová 2001b, p. 339.
2. Recent examinations of the measurements of the panel joints (undertaken with the help of Hana Logan, Národní Galerie, Prague) seem to confirm the reconstruction by Kropáček (1946, pp. 154ff.).
3. Other proposals are Brno (Kropáček 1946, pp. 156–57) and Jihlava or Telč in Moravia (Bartlová 2001b, pp. 339ff.).
4. Fajt in Prague 2005; see also Fajt 1996, p. 42.
5. Additional consecration ceremonies took place the following day. Philibert's activities in Prague are extensively documented in the daily notes of his secretary, Jean of Tours; see *Monumenta Conciliorum Generalium seculi decimi quinti*, vol. 1, p. 856 (for March 14 and 15, 1437).

LITERATURE: Baldass 1935; Kropáček 1946, pp. 151–74; Matějček and Pešina 1950, pp. 171–79; Chamonikola 1992, no. 12 (with bibl.); Bartlová in Brussels 1998–99, pp. 102–3, no. 4; Bartlová in Brno 1999–2000, pp. 287–98, no. 135; Bartlová 2001b, pp. 338–59; Bartlová 2002; Fajt in Prague 2005.

## 154. Two Panels from the Rajhrad Altarpiece

### a. The Way to Calvary

*Master of Rajhrad, ca. 1440*
*Tempera and gold on spruce panel, 99 x 147 cm (39 x 57⅞ in.)*
*Provenance: Benedictine Monastery of Rajhrad, southern Moravia, until 1936.*
*Moravská Galerie, Brno (A 626)*

### b. The Crucifixion

*Master of Rajhrad, ca. 1440*
*Tempera and gold on spruce panel, 101 x 142 cm (39¾ x 56 in.)*
*Provenance: Church of Saints Philip and James, Olomouc-Nové Sady, until 1937.*
*Národní Galerie, Prague (O 1584)*

These two panels once made up the center of a Passion retable from which four wing panels have also survived, representing scenes of the Last Supper, the Agony in the Garden, the Resurrection, and the Proof of the True Cross.[1] The original form of the retable is unclear; at the least, there would have been scenes on the backs of the wings.[2] That the Crucifixion panel came from a church that was once a branch of Olomouc's town church, Saint Mauritius's, makes it likely that the retable's original location was Saint

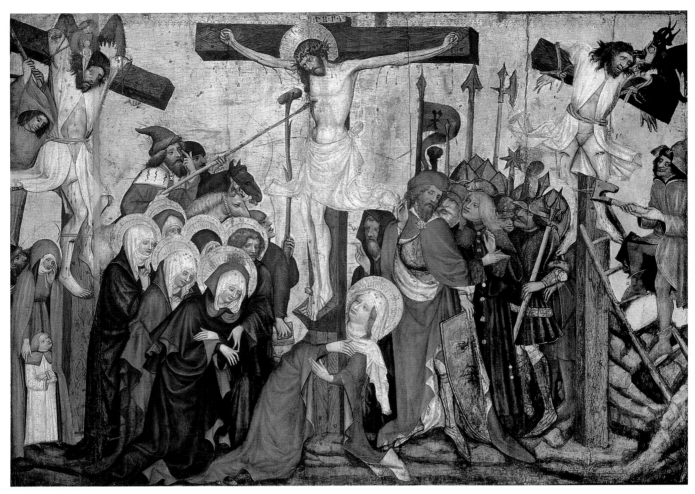

154, The Crucifixion

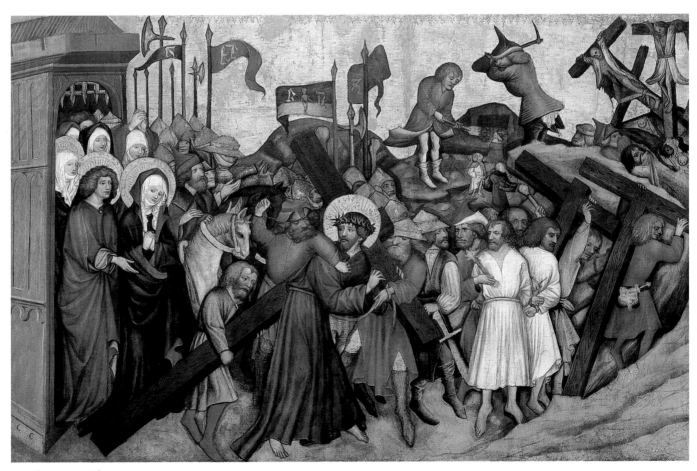

154, The Way to Calvary

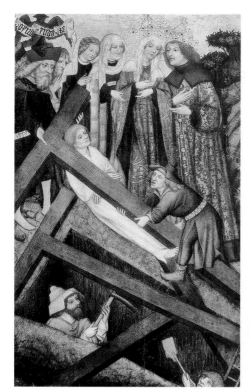

Fig. 154.1 Master of Rajhrad. The Finding and Proof of the True Cross. From Rajhrad Altarpiece. Tempera and gold on panel, ca. 1440. Moravská Galerie, Brno (A 628)

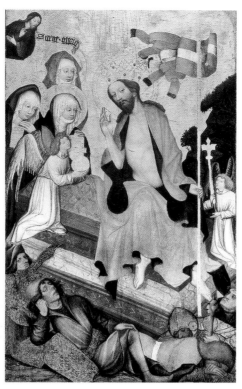

Fig. 154.2 Master of Rajhrad. The Resurrection. From Rajhrad Altarpiece. Tempera and gold on panel, ca. 1440. Moravská Galerie, Brno (A 627)

Mauritius's,[3] either in front of the choir screen at the main lay altar (first documented in 1424) or at the altar of the Finding of the True Cross in the crypt beneath the north tower (consecrated in 1440).[4]

This altarpiece reflects even more clearly than does the Martyrdom of Saint James the Great (cat. 153), also by the Rajhrad workshop, the pictorial reforms in Bohemia and Moravia following the Hussites' condemnation of ornament.[5] Everything merely decorative and festive has been minimized, as pictures were meant primarily to be instructive and to instill the fear of God. Hence the emphasis on the brutality of Christ's Passion. For example, in the background of the Way to Calvary are the rotting corpses of men previously executed on Golgotha, the stench of which forces the spectators to hold their noses. In the Crucifixion the executioners use axes to crush the legs of the thieves, a motif that originated in Italy.[6] The women's veils spotted with Christ's blood, however, allude to the *peplum cruentatum,* the blood-stained veil of the Virgin, an important relic presented to the Cathedral of Saint Vitus by Charles IV.[7]

Instead of a single, dominant image in the center, the scenes are placed one above the other. This division gives greater prominence to the Way to Calvary below, which doubtless reflects the contemporary *devotio moderna* and its emphasis on the imitation of Christ's

sufferings.[8] When the pictures are viewed together, the disproportionate relation between the foreground and background figures in the Way to Calvary is neutralized and appears instead to be deliberate, serving as a transition to the scene immediately above.[9] This arrangement makes even more apparent the parallel between the Magdalen embracing the shaft of the cross and Jesus weighed down by it.[10]

The conspicuous emphasis on Golgotha in the Way to Calvary—some crosses have already been erected there, and the executioners are digging holes for new ones—must be seen in connection with the retable's sixth preserved scene, as a reference to the Finding and Proof of the True Cross. The Proof panel offers clues to the work's historical context. In a departure from the written sources for the legend, Saint Helena's Proof of the True Cross takes place in the presence of her son, the emperor Constantine,[11] who has been given the unmistakable features of Albert II of Habsburg, the son-in-law and successor of Sigismund of Luxembourg. Since we can assume that Albert would not have been portrayed as a Roman emperor while Sigismund was still alive, but only after his election to the kingship in 1438 (or posthumously), this provides a means of dating the work.[12] A possibly new, metaphorical interpretation of the scene is suggested, against the background of Albert's struggles with the Hussites: just as there is only

one true cross, so is there only one true faith.[13] In one of the few other works from these years to depict the Proof of the True Cross taking place in the presence of Constantine, a tapestry from Saint Lawrence's in Nuremberg showing the Finding and the Proof, the emperor has been given Sigismund's features.[14] The model for both of these depictions is of course the portrait in Karlštejn of Charles IV and Anna of Świdnica as Constantine and Helena (fig. 1.6).

For two years, beginning in 1440, the priest of Saint Mauritius's parish in Olomouc, which always remained Roman Catholic, was Heinrich Senftleben, who had served at the courts of both Sigismund and Albert.[15] Did the donation of the retable coincide with his tenure at Saint Mauritius's? If so, might the commission have been granted to the Prague workshop that, we assume, worked for Sigismund's court only a few years earlier (see cat. 153)?                                                   WF

1. The four wing panels are in the Moravská Galerie, Brno: Last Supper (A 624), Agony in the Garden (A 625), Resurrection (A 627), and Proof of the True Cross (A 628).
2. Bartlová (2001b, pp. 310–11) assumes that it was a triptych, whereas Kropáček (1946, pp. 54–55) reconstructs the retable as a polyptych with two pairs of movable wings.
3. Kutal 1936, pp. 67ff.; Hlobil 1980.
4. Engstová 2000, p. 369. Hlobil (1980) and Bartolová (2001b, pp. 306ff.) have proposed the latter, thereby suggesting a new date for the retable of after 1450, rather than the 1415–20 that had been posited.
5. See Suckale 1993a, p. 68.
6. See especially the Crucifixion fresco in the baptismal chapel of Padua Cathedral.
7. See Pujmanová 1995–96. The relic was displayed every year along with the coronation treasure.
8. Suckale 1993a, p. 68. See also Möhring 1997, pp. 60ff.
9. The Way to Calvary is also placed beneath the Crucifixion in the only slightly later (about 1445) "Tabula Magna" from the Benedictine Monastery at Tegernsee, Bavaria (now Bayerisches Nationalmuseum, Munich [7537b], Germanisches Nationalmuseum, Nuremberg [1434], and other collections).
10. A related depiction of the Magdalen is found in the missal of Pietro Donato, bishop of Padua, which was produced while he attended the Council of Basel in 1433–36 (Biblioteca Apostolica Vaticana, Vatican City, Vat. lat. 8700, fol. 122v).
11. Wiegel 1973, pp. 196ff.
12. This date corresponds with the observations of Studničková (2003).
13. The same notion can be found in the frescoes of the cemetery chapel in Riffian, South Tirol, for example, which juxtapose the Finding of the True Cross with a depiction of idolatry.
14. On loan to the Germanisches Nationalmuseum, Nuremberg (Gew 3715). In the corners of the tapestry are the coats of arms of the Rummel

and Haller families, both of whom were supporters of Sigismund in Nuremberg.

15. Wolný 1855, p. 236; Regesta Imperii XI, no. 7988 (December 5, 1430), XII, no. 645 (February 25, 1439). Senftleben later served as councillor to Frederick III (Regg. F. III. H. 7, no. 129 [October 22, 1454]).

LITERATURE: Baldass 1935; Kutal 1936; Kropáček 1946, pp. 53–72; Matějček and Pešina 1950, pp. 131–40 (with bibl.); Stejskal 1955; Wiegel 1973, pp. 196–99; Pešina 1976, pp. 56–64; Hlobil 1980; Kesner in Vienna 1990, pp. 77–78, no. 19; Chamonikola 1992, nos. 9, 10 (with bibl.); Suckale 1993a, pp. 68–69; Bartlová in Olomouc 1999–2000, vol. I, pp. 430–40, nos. 338–43; Engstová 2000; Bartlová in Rome 2000–2001, pp. 150–61, nos. 32–37; Bartlová 2001b, pp. 306–37; Bartlová 2002; Studničková 2003.

## 155. *The Play of Chess (Tractatus de ludo Scacorum)* by Jacobus de Cessolis

*Bohemia, 1430–40; modern binding by A. Ménard*
*Tempera, gold, and silver on parchment; 44 fols.;*
*18.3 x 12.8 cm (7¼ x 5 in.)*
*Inscribed on fol. 47: F Innocenzo Romano.*
*Provenance: F. Innocenzo Romano; Cardinal Francisco Javier Zelada (1717–1801), probably acquired in Rome; donated by him to Toledo Chapter (Sign. Cajon 87. Num. 25. Zelada); transferred to Biblioteca Nacional, 1869.[1]*
*Biblioteca Nacional de España, Madrid (Vit. 25-6)*

This slim illuminated manuscript[2] contains a Latin text of *Liber de moribus hominum et officiis nobilium sive super ludum scaccorum,* a tract written in the early fourteenth century by Jacobus de Cessolis, an Italian Dominican.[3] This work discusses the game of chess as an allegory of society, the pieces representing the various social orders, with the king and queen at the head and each figure expected to perform its assigned duties to secure the common good.

As chess was among the seven knightly skills,[4] it was most probably a member of the nobility who commissioned the manuscript, which contains scenes that were likely derived from a lost manuscript of the Prague court. The existence of tracts on chess in Bohemia can be safely assumed: Wenceslas IV was given a chess set as a gift from the Teutonic Knights in 1421,[5] and a chess set is listed in the inventory of the effects of Queen Sophia.[6] The origin of the manuscript in Bohemia is indicated by the coats of arms of Bohemian and Moravian noble families[7] that appear on the escutcheons of the knights depicted in a sym-

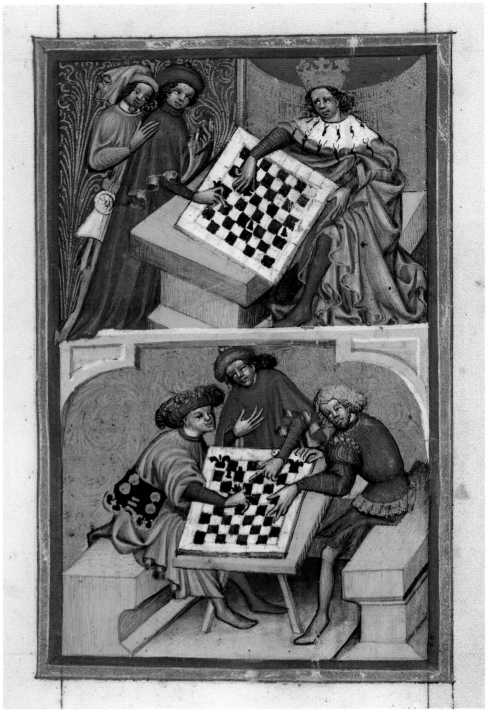

155, fol. 6r, Courtiers Playing Chess

bolic portrayal of a chess game as two royal armies standing opposite one another.

In this depiction (fol. 14v), the members of the eight orders of commoners (pawns) are not represented as independent figures, as is customary in central European manuscripts, but are instead engaged in conversation with the king, queen, councillor, knight (*miles*), and administrator in the row behind them on the chessboard.[8] This conception accords with the tradition of French court manuscripts,[9] in which the chessboard is also used as a metaphor for the city of Babylon, and thus for the

world.[10] The unusual opening miniature of this manuscript (fol. 2r) depicts the legendary origins of chess as they are being played out in various areas of the Babylonian royal palace. Evil Merodachus, obeying the advice of Joachim, king of Judea, chops the body of Nebuchadnezzar, his dead father, into pieces, while the oppressed Babylonian councillors and knights ask Xerxes to set rules for proper governance.

The portrayal of the city and the design of thrones with alcoves or textile patterns testify that this illuminator apprenticed in

the workshop of the Master of *The Travels of Sir John Mandeville* (cat. 88).[11] The general cast of the facial features is greatly simplified, however, as is the drapery of the garments. The hard, sharp folds of the cloaks around the feet attest to a later date than the *Travels,* sometime between 1430 and 1440. Stylistically similar illustrations appear in the Vienna New Testament (Österreichische Nationalbibliothek, Cod. 485), dating from the same period.[12]

MS

The author wishes to thank the Grant Agency of the Czech Academy of Sciences for its support (A 8033202) in developing this text.

1. Octavio de Toledo 1903, p. 126, no. CCLVII; Foradada y Castán 1877; Vázquez de Parga in *Tractatus de ludo Scacorum* 1970, pp. 11–12.
2. The text is divided by one ornamental initial (fol. 2v) and fifteen miniatures accompanying the first four chapters of the text (fols. 2r, 6r, 9r, 14v, 20r, 22r, 24v, 25v, 26v, 27r, 28r, 28v, 29r, 30r, 30v); four full-page illustrations appear at the openings of chapters.
3. Vetter 1892. The popularity of this tract in Bohemian lands is attested to by a number of transcripts (Vidmanová 1979, n. 9) as well as by a translation into Czech by Tomáš of Štítné of about 1400 (1956, pp. 351–405).
4. Petrus Alphonsi 1911.
5. Ziesmer 1911, p. 31.
6. Staatsarchiv, Geheimes Hausarchiv, Munich, Korrespondenzakt 543 (item 20). See Vítovský 1991.
7. For an attempt at identification, see Krása 1974b, pp. 42–43. Two black crossed *ostrve* in a gold (yellow) field may be the lords of Lichtenburk, Lipá, and Dubá, a black coiled missile in a silver (white) field, the Hrochs of Mezilesice.
8. The plebeian orders are peasant, blacksmith, notary, tailor, merchant, doctor, landlord, and municipal servant. The councillor (*alphilus, assessor, judex*) corresponds to the modern bishop. The knight (*miles*) is represented uncharacteristically as a courtier in fashionable attire. Shown in a ducal hat and a cloak with an ermine collar, the administrator (*roche, vicarius*) is today's rook (Euw and Plotzek 1979–85, vol. 4, pp. 131–32). For the more usual representation of the positioning of the pieces (common also in Italian manuscripts), see Metropolitan Chapter of Saint Vitus's Cathedral, Prague, Library, G42.
9. See Pierpont Morgan Library, New York, G.52; Bibliothèque de l'Arsenal, Paris, fr. 1586; and Bibliothèque Nationale de France, Paris, fr. 2148.
10. Compare chapter 2, folio 9r, for instance, with Bibliothèque de l'Arsenal, Paris, fr. 1586, which is also similar to the oldest French copy (Kungliga Biblioteket, Stockholm, Vu 18).
11. Compare the portrayal of the city of Babylon on folio 9 with the images of urban architecture on folios 8r, 9v, 10r, 10v, 11r, and 14r of *The Travels of Sir John Mandeville* (cat. 88).
12. Vázquez de Parga (in *Tractatus de ludo Scacorum* 1970) located the manuscript at the court of Wenceslas IV on the basis of comparative materials provided by M. T. d'Alverny. Krása

(1974b, pp. 42–43) stressed stylistic analogies to the illuminations of the Master of the Antwerp Bible (cat. 85) and the Master of the Krumlov Anthology (see figs. 10.1, 10.4), redating the work to the 1430s, while also considering possible origins in Moravia. Stejskal (in Stejskal and Voit 1991, pp. 58–59) pointed out parallels to the illuminations in the Vienna manuscript, explaining them by noting that both masters began their careers in the workshop of the Master of the Gerona Martyrology (cat. 86).

LITERATURE: Domínguez Bordona 1933, vol. 1, pp. 423–25, no. 985; Vázquez de Parga in *Tractatus de ludo Scacorum* 1970, pp. 11–87; Krása 1974b, pp. 42–43; Vidmanová 1979; Stejskal and Voit 1991, pp. 58–59, no. 41; Karłowska-Kamzowa 2000, p. 76.

## 156. Heads of Ceremonial Crossbow Bolts

Bohemia (Prague?), ca. 1437–39
Steel, engraved and inlaid with brass; a: h. 30.6 cm (12 in.); b: h. 27.5 cm (10⅞ in.); c: h. 31.8 cm (12½ in.)

a. Inscribed on obverse, left flange: ar (probably monogram for albertus rex, or King Albert), mamyla (my dear, or my love; repeated twice encircling top of socket); right flange: warvy | woka (protect your eye), æ (probably monogram for albertus elisabeth), t.
On reverse, left flange: x (monogram for Christ), ZdarZ | bvo[h] (All hail, O God); right flange: s, marya | pano (Virgin Mary; repeated twice on diagonal bands on socket), m (monogram for marya, or Mary; repeated four times on diagonal bands on socket).
Provenance: Ottoman Arsenal of Saint Irene, Constantinople.
The Metropolitan Museum of Art, New York, Rogers Fund, 1966 (66.199)
b. Inscribed on obverse, right flange: ar (probably monogram for albertus rex, or King Albert), m (monogram for marya, or Mary). On reverse: S (reversed; probably a scroll, possibly a monogram) with pane | bozy | sanse[y | . . . kly | racys(?)] | amen (O Lord God [indecipherable] Amen); left flange: y (monogram for yhesus, or Jesus); right flange: r(?) (perhaps monogram for rex, or king).
Provenance: Castle Engelstein, near Weitra, Austria; Archduke Eugen, Veste Hohenwerfen, near Salzburg; Clarence H. Mackay, Roslyn, New York.
The Metropolitan Museum of Art, New York, Purchase, David and Dorothy Alexander and Mrs. Ridgeley Hunt Gifts, Bequest of Stephen V. Grancsay, by exchange, and funds from various donors, 1984 (1984.17)
c. Inscribed on obverse, left flange: vak | sem | nabozre | myloste (Go with God's grace), ma | myla (my dear, or my love); right flange: ar (probably monogram for

albertus rex, or King Albert), m (monogram for marya, or Mary). On reverse, left and right flanges: y (monogram for yhesus, or Jesus); right flange: pane | myley (sweet Lord).
Provenance: Ottoman Arsenal of Saint Irene, Constantinople; sale, Sotheby's, London, October 28, 1987, lot 138.
The Metropolitan Museum of Art, New York, Gift of Mr. and Mrs. Ronald S. Lauder, 1988 (1988.170)

These three objects are among the largest and most elaborately decorated of a group of arrow and bolt heads, more than thirty examples of which are recorded. Besides being especially noteworthy for their ornamentation, this group far exceeds in size the ordinary, plain missile heads for war and hunting, which usually range from 5 to 7.5 centimeters (2 to 3 inches). Along with an example now in Turkey (Askeri Müzesi, Istanbul, inv. 1597), the three present examples are the size of proper spearheads.[1] The engraved and inlaid decoration consists of emblematic monograms, inscriptions, heraldry, characteristic scale patterns, and floral scrolls. Although the bolt heads in the group do not appear to share an identical combination of motifs, specifically Bohemian iconography found on all the examples (sometimes in conjunction with inscriptions in medieval Czech) indicates that these arrow and bolt heads undoubtedly come from Bohemia.

The dense surface decoration comprises extensive religious and political symbolism, including a variety of monograms and pious invocations, although the precise meaning of some motifs and inscriptions still awaits conclusive interpretation. The only motif common to all three is the monogram "ar," which most probably stands for *albertus rex*, an allusion to Emperor Sigismund's son-in-law Albert II of Habsburg (Duke Albert V of Austria; 1397–1439), who was elected king of Hungary in 1437 and became king of Bohemia and of Germany in 1438. The presence of this monogram suggests a date of manufacture for all three heads within the years 1437–39.[2] Only one of the three heads (a) shows the "ar" monogram beneath a crown issuing from a single ostrich feather, a heraldic badge that is extensively used in fifteenth-century royal Bohemian iconography (but subsequently appears to have been adopted by the Hussite movement, which substituted religious monograms for the royal ones),[3] as well as the monogram "æ" (the letters are intertwined crosswise), probably alluding to Albert and his wife, Elizabeth of Luxembourg (1409–1442).

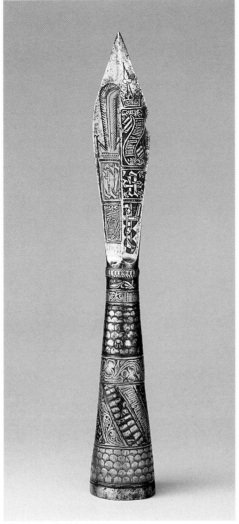

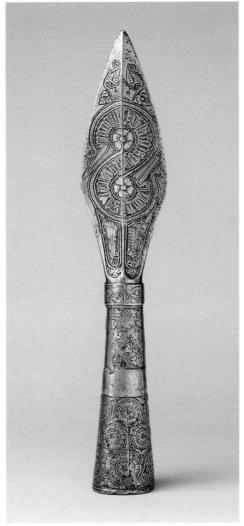

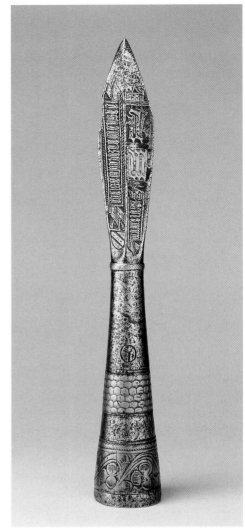

156a

156b

156c

The second head (b) differs from all the others in the group, both in shape and decoration.[4] Although its tip is of rhomboid section, its shape is closer to that of an arrow or spearhead. The socket is almost entirely covered by two sheets of copper alloy, which are engraved with dense foliate scrolls of roses and clover leaves. On what appears to be the obverse of the tip, almost the entire surface of both flanges bears the combined cloverleaf and rose-vine engraving, with only sparse use of copper-alloy inlay. The unusual iconography includes a pelican (a symbol of Christ) that stands on a rosette containing the royal monogram "ar." Issuing from the rosette and threaded through the minims of a Gothic letter M is an elongation that appears to be the stem of the rose. The entire width of the reverse is dominated by a large, inverted S-shaped scroll beneath a crown, bearing an only partially legible inscription that is undoubtedly a pious invocation.

Two of the specimens (a and c) have the characteristic shape of crossbow bolt heads.

The tips are of rhomboid section and are widest near the point (not near the base as in arrows and spearheads). The socket of the latter (c) shows two bands of copper-alloy inlay, engraved with a foliate scroll of clover leaves and scales, as well as two sections of steel with traces of engraved decoration.[5]

The precise function of these arrowheads is not known. The use of royal monograms and the apparent similarity in decoration suggest that the group was made in the same workshop, presumably the royal armory at Prague. Their size and elaborate ornamentation leave no doubt, however, that the objects must have served a ceremonial rather than a practical purpose. Judging from contemporary illustrations that depict men-at-arms and military commanders holding oversize arrows, they may well be insignia of rank or batons of command, perhaps for officers in the royal household serving as captains of archers or crossbowmen. Two of the heads (a and c), as well as the above-mentioned example in Istanbul, are engraved with the so-called Turkish arsenal mark,

indicating that they were taken as loot or trophies from castles or wagon trains captured by the Turks during the fifteenth century.[6]

DHB

1. Nickel 1984, p. 20; Nickel 1988.
2. The meaning of the monogram "S"—found on the first head and, perhaps in reverse, on the second—is more difficult to determine (at least when accompanied by the monogram "ar"). An allusion to Saint Sebastian as the patron saint of archers has been proposed (Kalmár), an unlikely theory since Sebastian appears to have been far more popular among archers in western Europe than in Bohemia (Nickel). Similarly improbable here is a reference to Emperor Sigismund, since the "ar" monogram indicates as the earliest possible date of manufacture, December 18, 1437, nine days after Sigismund's death, when Albert was elected king of Hungary. See Kalmár 1939, pp. 220–21; Nickel 1968, p. 75.
3. Nickel 1971, p. 180.
4. Nickel 1984, pp. 20–21.
5. Nickel 1988.
6. Ibid.

LITERATURE: Nickel 1968, pp. 61–63, ill. (a); Nickel 1969, pp. 102–6, ill. (a); Nickel 1984 (b); Nickel 1988 (c).

## 157. Pavise

*Bohemia (possibly Chomutov), ca. 1440*
*Wood (spruce?), leather, canvas, gesso, silver leaf, and paint; 108 x 52 cm (42½ x 20½ in.), wt. 7,000 g (15 lb. 7 oz.)*
*Inscribed at lower center: y (monogram for yhesus, or Jesus).*
*Provenance: Prince Heinrich von Preussen, Castle Rheinfels, near Sankt Goar; W. Wilbrand, Darmstadt; Bashford Dean, New York.*
*The Metropolitan Museum of Art, New York, Bashford Dean Memorial Collection, Funds from various donors, 1929 (29.158.595)*

The pavise, probably developed in Bohemia during the fourteenth century, became the standard infantry shield carried by crossbow-men, hand gunners, and other foot soldiers in central Europe until the early sixteenth century. Varying in size, it was often fitted with a support so as to be freestanding, allowing the man-at-arms to fight with both hands or to take cover while reloading his weapon. During the early fifteenth century, the Hussite armies in particular employed pavises, along with crossbows and the *Wagenburg* (circle of fortified wagons), to form almost impenetrable positions on the battlefield, a tactic that was soon copied by their adversaries.[1]

Bohemian pavises are noteworthy for both their sturdy construction and their exceptionally elaborate painted decoration. This example is painted in the center with a crown surmounted by three ostrich feathers, a badge of the kings of Bohemia; below is the letter y, most likely the monogram for *yhesus* (Jesus), amid a radiant cloud or sunburst. The coat of arms at the top is that of the Saxon town of Zwickau (*Gules three Swans Argent armed Sable*—in red, three silver swans with black beaks and feet).[2] Although a later addition,[3] the arms suggest that the shield belonged to a group of forty pavises commissioned by Zwickau from the Bohemian town of Chomutov in the spring of 1441, perhaps as a response to renewed Hussite uprisings in neighboring Bohemia after the death of Albert II in October 1439.[4] The presence of specifically Bohemian iconography on shields ordered by a German town can perhaps be explained by the fact that the Bohemian shield makers—famous for their products—apparently kept a supply of ready-made pavises in stock. In times of crisis,

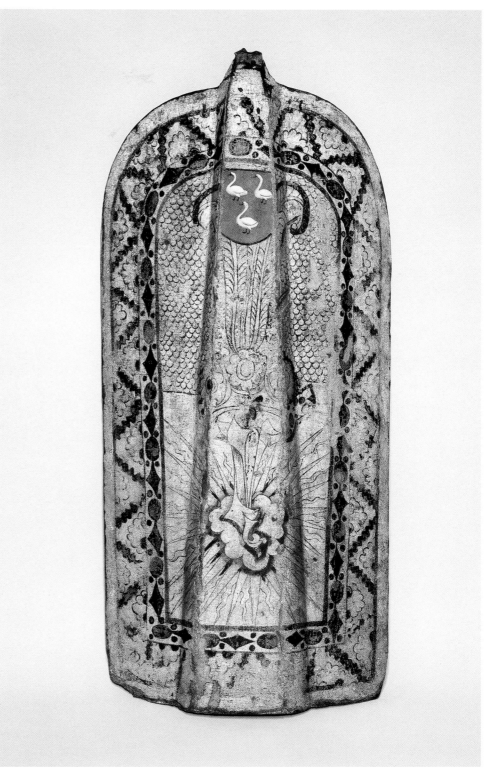

157

they were able to satisfy large commissions at short notice.                    DHB

1. Denkstein 1962; Denkstein 1964.
2. Nickel 1968, pp. 68–73.
3. Prior to 1444 the town's coat of arms featured three towers.
4. Diener von Schönberg 1944, p. 49.

LITERATURE: Diener von Schönberg 1944, p. 56; Denkstein 1962; Nickel 1968, pp. 68–73.

## 158. Four Heraldic Roundels

*Bohemia, 1438–39*
*Painted forest glass and lead, diam. 35–37 cm*
*(13¾–14⅝ in.)*
*Provenance: Probably town hall or Dominican cloister,*
*Brno; acquired by Moravská Galerie, 1822.*
*Moravská Galerie, Brno (24.617/1, 2, 4, 5)*

These colorful stained glass roundels are
emblazoned with heraldic symbols represent-
ing Bohemia, Moravia, Silesia, and the Holy
Roman Empire (the last as used by Sigismund
after 1433). Part of an eight-piece program
first recorded in 1822, the roundels are said
to have originally adorned the windows of
either Brno's town hall or its Dominican
cloister, where regional governmental assem-
blies convened.[1] Brno was given the status
of a royal city in 1243, during the reign of
Wenceslas I,[2] and as the official seat of the
Moravian margrave, the city enjoyed a position
of relative prominence in medieval Bohemia.

The roundel bearing the Austrian arms
(*Gules a Fesse Argent*) from the ensemble (all
eight roundels are preserved in the Moravská
Galerie) allows the group to be dated to
1438–39, during the short reign of Sigismund's
successor as king of Bohemia and of Hungary,
Albert II of Habsburg (Duke Albert V of
Austria). The roundels provide a window
through which to view the aesthetic sensi-
bility established in Bohemia during the
Luxembourg era. In particular, the peripheral
secular figures perpetuate the pictorial
vocabulary of the manuscripts associated with
Wenceslas IV (see cats. 82, 84–89), with their
wild men and courtly couples. These person-
ages, animated, playful, and elegant, exemplify
the Beautiful Style. In addition to the variety
of figures adhering to a common theme and
style, a vibrant palette of purples and acidic
greens complements the requisite heraldic
colors and makes these glass roundels particu-
larly captivating. A lighthearted atmosphere
has been blended with powerful political
symbolism.                                    AS

1. Matouš 1975, p. 21.
2. Dostál et al. 1974, p. 136.

LITERATURE: Matouš 1975, pp. 21–24, pls. 7, 8,
figs. 1, 3; Chamonikola in Brno 1999–2000,
no. 305; Stehlíková in Rome 2000–2001,
pp. 239–40, fig. 69.

158, arms of the Holy Roman Empire after 1433

158, arms of Moravia

158, arms of Silesia

158, arms of Bohemia

# BIBLIOGRAPHY, INDEX, AND PHOTOGRAPH CREDITS

SAC. CÆS. MAI. PRIVILEGIO
EIUSDEM MAI. SCULPTOR
ÆGIDIUS SADELER EXCUDIT.

Philippus vanden Bosche sac. Cæs. Mai.
phrygiarius designauit
Iohannes Wechter æri incidit

# BIBLIOGRAPHY

**Aachen**
2000    *Krönungen: Könige in Aachen. Geschichte und Mythos.* Exh. cat. edited by Mario Kramp. 2 vols. Mainz. Exhibition, Verein Aachener Krönungsgeschichte.

**Abrahams, Israel**
1896    *Jewish Life in the Middle Ages.* Philadelphia.

**Adámek, Karel**
1873    *Památky českých reformátorů.* Prague.

**Adams, Frederick, Jr.**
1951    *Second Annual Report to the Fellows of the Pierpont Morgan Library.* New York.

**Adelson, H. L.**
1966    "The Holy Lance and the Hereditary German Monarchy." *Art Bulletin* 48, pp. 177–92.

**Aggházy, Mária**
1958    "Remarques sur la question des 'huit miniatures tchèques de Budapest.'" *Bulletin du Musée National Hongrois des Beaux-Arts,* no. 12, pp. 45–46.

**Ahrens, Hermann**
1895    *Die Wettiner und Kaiser Karl IV: Ein Beitrag zur Geschichte der wettinischen Politik, 1364–1379.* Leipziger Studien aus dem Gebiet der Geschichte I, no. 2. Leipzig.

**Áldásy, Antal**
1902    "Rozgonyi István levele Párizsból 1416." *Történelmi Tár,* n.s., 2, pp. 575–77.

**Alexander, Jonathan J. G.**
1977    "A Book of Hours Made for King Wenceslaus IV of Bohemia." In Lavin and Plummer 1977, pp. 28–31.
1997    "The Portrait of Richard II in Westminster Abbey." In Gordon, Monnas, and Elam 1997, pp. 197–206.

**Altermatt, Alberich M., et al.**
1994    *Sankt Urban, 1194–1994: Ein ehemaliges Zisterzienserkloster.* Bern.

**Ameisenowa, Zofia**
1949    "Animal-Headed Gods, Evangelists, Saints, and Righteous Men." *Journal of the Warburg and Courtauld Institutes* 12, pp. 21–45.

**Amsterdam**
1947    *Kunstschatten uit Wenen: Meesterwerken uit Oostenrijk. Catalogus.* Exh. cat. Amsterdam. Exhibition, Rijksmuseum.

**Andrian-Werburg, Irmtraud**
1992    Review of Nuremberg 1990. *Anzeiger des Germanischen Nationalmuseums,* 1992, p. 36.

**Appuhn, Horst**
1990    *Wenzelsbibel: König Wenzels Prachthandschrift der deutschen Bibel.* 8 vols. Commentary by Horst Appuhn; introduction by Manfred Kramer. Die bibliophilen Taschenbücher 1001. Dortmund.

**Arndt, Hella, and Renate Kroos**
1969    "Zur Ikonographie der Johannesschüssel." *Aachener Kunstblätter* 38, pp. 243–328.

**Aschbach, Joseph, Ritter von**
1838–    *Geschichte Kaiser Sigmunds.* 4 vols. Hamburg.
45    Reprint, Aalen, 1964.

**Augustine, Saint**
1984    *Concerning the City of God against the Pagans.* New translation by Henry Bettenson; introduction by John O'Meara. Harmondsworth and New York.

**Avivi, Yosef**
1998    *Osef kitve-ha-yad ha-rabaniyim. Sifriyat Mendel Gotesman, Yeshivah-Universitah / Rabbinic Manuscripts. Mendel Gottesman Library Yeshiva University.* Translated by Gertrude Hirschler; edited by Pearl Berger. New York.

**Avril, François**
1978    *Buchmalerei am Hofe Frankreichs, 1310–1380.* Munich.

**Bacher, Ernst**
1970    "Zur Frage der Vesperbilder des Schönen Stils." *Österreichische Zeitschrift für Kunst und Denkmalpflege* 24, pp. 175–88.
1979    *Die mittelalterlichen Glasgemälde in der Steiermark.* Vol. 1, *Graz und Strassengel.* Corpus Vitrearum Medii Aevi: Österreich, vol. 3. Vienna.

**Bachmann, Erich**
1969    "Architektur bis zu den Hussitenkriegen." In Swoboda 1969, pp. 34–109.
1977    as editor. *Gothic Art in Bohemia: Architecture, Sculpture, and Painting.* Translated by Gerald Onn. New York.

**Bachmann, Hilde**
1943    *Gotische Plastik in den Sudetenländern vor Peter Parler.* Brno, Munich and Vienna.

**Balbín, Bohuslav**
1677    *Epitome historica rerum Bohemicarum seu Historia Boleslaviensis.* Prague.
1682    *Miscellanea Historica Regni Bohemiae . . . Decadis* I, *Liber IV hagiographicus seu: Bohemia Sancta,* Prague.

**Baldass, Ludwig**
1935    "Eine südböhmische Malerwerkstatt um 1420." *Zeitschrift für Kunstgeschichte* 4, pp. 301–19.
1956    "Wiener Bildnisse um 1430 bis 1440." *Zeitschrift für Kunstwissenschaft* 10, pp. 180–82.

**Balogh, Jolán**
1952    "A budai királyi várpalota rekonstruálása a történeti források alapján." *Művészettörténeti értesítő* 1.
1981    "Az Anjou-kor kérdéseiről." *Művészettörténeti értesítő* 30, pp. 144–49.
1982    *Varadinum - Várad vára.* 2 vols. Budapest.

**Bamberg**
2002    *Kaiser Heinrich II., 1002–1024.* Exh. cat. edited by Josef Kirmeier. Stuttgart. Exhibition, Bayerischen Landesausstellung.
2002a    *Bamberg: Ein Führer zur Kunstgeschichte der Stadt für Bamberger und Zugereiste.* Edited by Robert Kuckale, Markus Hörsch, Peter Schmidt, and Peter Ruderich. Bamberg.

**Baranyai, Béla**
1925–    "Zsigmond király ún. Sárkány-rendje." *Századok*
26    59–60, pp. 561–91, 681–719.

**Baron, Françoise**
1996    *Musée du Louvre, Département des Sculptures. Sculpture française.* Vol. 1, *Moyen Âge.* With the assistance of Corinne Jankowiak and Christine Vivet. Paris.

**Bartlová, Milena**
1992    "Imago. K pojetí obrazu v předhusitské a husitské době." *Umění* 40, pp. 276–79.
1994    "Rorate celi desuper et nubes pluant iustum: New Additions to the Iconography of the Annunciation from the Altarpiece from Vyšší Brod." *Source: Notes in the History of Art* 13, no. 2 (Winter), pp. 9–14.
1998    "The Style of the Group of the Madonna from Michle: Perspectives of Methodology." In Benešovská 1998, pp. 206–15.
2001a    "Ikonografie kalich, symbolu husitství." In *Husitský Tábor: Supplementum I,* pp. 453–59. Tábor.
2001b    *Poctivé obrazy: Deskové malířství v Čechách a na Moravě, 1400–1460.* Prague.
2001c    Review of Wetter 2001. *Umění* 49, pp. 349–51.
2002    "Eine Neudatierung des sog. Raigerner Altars und die Folgen für die Chronologie der böhmischen Tafelmalerei des 15. Jahrhunderts." *Zeitschrift für Kunstgeschichte* 65, pp. 145–79.
2004    *Mistr Týnské kalvárie.* Prague.
2005    "The Divine Law Incarnated in the Man of Sorrows: Specific Iconography of the Hussite Bohemia." *Iconographica* 3. Forthcoming.

**Bartoš, František M.**
1924    "Mistr Jan Hus v bohoslužbě církve podobojí." *Národopisný věstník československý* 17, pp. 20–38.
1926–    *Soupis rukopisů Národního muzea v Praze.* 2 vols.
27    Prague.
1940    "Václav IV. a arcibiskup Jan z Jenštejna." *Jihočeský sborník historický* 13, pp. 1–31.
1947    *Čechy v době Husově, 1378–1415.* České dějiny, ser. 2, no. 6. Prague.
1966    *Husitská revoluce.* Vol. 2, *Vláda bratrstev a její pád 1426–1437.* České dějiny, ser. 2, no. 8. Prague.

**Baťková, Růžena, ed.**
1998    *Umělecké památky Prahy (Nové Město, Vyšehrad, Vynohrady).* Prague.

**Bauer, Jaroslav, Josef Klimeš, and Jiří Kopřiva**
1991    *Crystals from the St. Vitus Treasury.* Prague.

**Baum, Wilhelm**
1993    *Kaiser Sigismund: Hus, Konstanz und Türkenkriege.* Graz.

**Baumgärtner, Ingrid**
1993    "Art. Marignolli, Giovani de' OFM." In *Lexikon des Mittelalters,* edited by Robert Auty, vol. 6, col. 292. Stuttgart.

**Baumüller, Barbara**
1994    *Der Chor des Veitsdomes in Prag; die Königskirche Kaiser Karls IV: Strukturanalyse mit Untersuchung der baukünstlerischen und historischen Zusammenhänge.* Berlin.

**Bečková, Katerina**
1998    *Zmizelá Praha. Nové Město.* Prague.

**Beckovský, Jan**
1879    *Poselkyně starých příběhův českých. Díl 1, svazek II. (1526–1715).* Edited by Antonín Rezek. Prague.

**Beer, K.**
1951    "Der gegenwärtige Stand der Forschung über die Reformatio Sigismundi." *Mitteilungen des Österreichischen Instituts für Geschichtsforschung* 59, pp. 55–93.

**Bellaguet, Louis François, trans.**
1994    *Chronique du religieux de Saint-Denys, contenant le règne de Charles VI de 1380 à 1422.* Vol. 1. Translation of the Latin text by Michel Pintoin (ca. 1349–1421). Paris.

**Bělohlávková, Jana**
**1987** "Jakoubek ze Stříbra a Petr Payne. O obrazech (rozbor a edice traktátů)." PhD diss., deposited in the library of ÚDU AV ČR, Prague.

**Belting, Hans**
**1991** *Bild und Kult: Eine Geschichte des Bildes vor dem Zeitalter der Kunst.* 2nd ed. Munich.
**1994** *Likeness and Presence: A History of the Image before the Era of Art.* Translated by Edmund Jephcott. Chicago.

**Belting-Ihm, Christa**
**1976** *"Sub matris tutela": Untersuchungen zur Vorgeschichte der Schutzmantelmadonna.* Abhandlungen der Heidelberger Akademie der Wissenschaften, Philosophisch-Historische Klasse, Jahrgang 1976, 3. Heidelberg.

**Benati, Daniele**
**1985** "Pittura del Trecento in Emilia Romagna." In *La pittura in Italia: Il Duecento a il Trecento,* edited by Carlo Pirovano, vol. 2. Milan.

**Benda, Klement, et al.**
**1999** *Od Velké Moravy Po Dobu Gotickou.* Prague.

**Beneš, František**
**1957** "Jezdecká pečet' Bavora III. z Bavorova z roku 1315." *Časopis společnosti přátel starožitností českých* 65, pp. 156–57.

**Beneš Krabice of Weitmile**
**1884** *Chronicon Benessii de Weitmil.* Edited by Josef Emler. In *Fontes Rerum Bohemicarum.* Vol. 4, pp. 459–548. Prague.

**Benesch, Otto**
**1936** *Oesterreichische Handzeichnungen des XV. und XVI. Jahrhunderts.* Die Meisterzeichnung, vol. 5. Freiburg im Breisgau.

**Benešovská, Klára**
**1991** "Eliška Přemyslovna a Vyšehrad." *Umění* 39, pp. 214–22.
**1994** "Gotická katedrála: Architektura." In Merhautová 1994, pp. 25–65.
**1995** "Gotická podoba kostela sv. Jindřicha a sv. Kunhuty na Novém Městě pražském a jeho stavebník." *Průzkumy památek* 1, pp. 87–90.
**1996** "Benediktinský klášter Na Slovanech s kostelem Panny Marie a slovanských patronů." *Umění* 44, pp. 118–30.
**1998** as ed. *King John of Luxembourg (1296–1346) and the Art of His Era. Proceedings of the International Conference, Prague, September 16–20, 1996.* Prague.
**1999a** "Das Frühwerk Peter Parlers am Prager Veitsdom." *Umění* 47, pp. 351–63.
**1999b** "Petr Parléř—architekt." In *Petr Parléř, Svatovítská katedrála, 1356–1399,* edited by Petr Chotěbor, pp. 16–19. Prague.
**2001a** "La haute tour de la cathédrale Saint-Guy dans ses rapports avec la façade sud." *Umění* 49, pp. 271–89.
**2001b** "Pramen ideální podoby kapitulního chrámu sv. Petra a Pavla?" In *Královský Vyšehrad* 1971, vol. 2, pp. 90–101.
**2003a** "Podoby královského majestátu v Českých zemích kolem roku 1300. In *Ars Longa: Sborník k nedožitým sedmdesátinám Josefa Krásy,* edited by B. Bukovinská and L. Konečný, pp. 27–42. Prague.
**2003b** "Die Prager Kirche zur Zeit des Erzbischofs Aenestus von Pardubice." *Miscellanea Musicologica* 37, pp. 29–46.
**2004** "Aménagement des tombeaux royaux dans la cathédrale de Prague à l'époque des Luxembourg." *Hortus Artium Medievalium* 10, pp. 63–74.

**Benešovská, Klára, and Ivo Hlobil**
**1999** *Peter Parler and St. Vitus's Cathedral, 1356–1399.* Prague: Prague Castle Administration. Also published in Czech.

**Bennert, Uwe**
**1992** "Art et propagande politique sous Philippe IV le Bel: Le cycle des rois de France dans la Grand'salle du palais de la Cité." *Revue de l'art* 97, pp. 47–59.

**Bennett, Josephine Waters**
**1954** *The Rediscovery of Sir John Mandeville.* New York.

**Berger, Natalia**
**1990** *Where Cultures Meet: The Story of the Jews of Czechoslovakia.* Tel Aviv.

**Berliner, Rudolf**
**1955** "Arma Christi." *Münchner Jahrbuch der bildenden Kunst,* ser. 3, 6, pp. 35–152.

**Bern**
**1939–**
**40** *Sonderaustellung.* Exh. cat. Bern. Exhibition, Kunstmuseum.

**Bern–Strasbourg**
**2001** *Iconoclasme: Vie et mort de l'image médiévale.* Exh. cat. edited by Cécile Dupeux, Peter Jezler, and Jean Wirth. Paris. Exhibition, Musée d'Histoire de Berne; Musée de l'Oeuvre Notre-Dame; Musées de Strasbourg.

**Białłowicz-Krygierowa, Zofia**
**1968** "Figura Marii z dzieci tkiem na lwie z ukowa. Ze studiów nad kr giem stylowym madonn na lwie." *Muzeum Narodowe w Poznaniu. Studie Muzealne* 6, pp. 7–33.
**1981** *Studia nad snycerstwem XIV wieku w Polsce, Część I: Początki śląskiej tradycji ołtarza szafowego, Katalog.* Monographie Muzeum Narodowego w Poznaniu, vol. 17. Poznań.

**Biedermann, Gottfried**
**1982** *Katalog Alte Galerie am Landesmuseum Joanneum. Mittelalterliche Kunst, Tafelwerke, Schreinaltäre, Skulpturen.* Graz.

**Billot, Claudine**
**1998** *Les Saintes-Chapelles royales et princières.* Paris.

**Binski, Paul**
**1995** *Westminster Abbey and the Plantagenets: Kingship and the Representation of Power, 1200–1400.* New Haven.
**1997** "The Liber Regalis: Its Date and European Context." In Gordon, Monnas, and Elam 1997, pp. 233–46.

**Birnbaum, Vojtěch**
**1947** "Karel IV. jako sběratel a Praha (1933)." In *Listy z dějin umění,* edited by Alzeta Birnbaumová. Prague.

**Bláhová, Marie**
**1987** as editor. *Kroniky doby Karla IV.* Prague.
**2003** "Karel IV. Zákonodárce a zakladatel." In *Karel IV.: Státnické dílo,* edited by Marie Bláhová und Richard Mašek. Prague.

**Blair, Claude**
**1970** "A Royal Swordsmith and Damascener: Diego de Çaias." *Metropolitan Museum Journal* 3, pp. 149–98.

**Blaschka, Anton**
**1934** *Die St. Wenzelslegende Kaiser Karls IV.* Quellen und Forschungen aus dem Gebiete der Geschichte 14. Prague.

**Błaszczyk, Iwona**
**1981** "Ilustracje średniowiecznych rękopisów ze zbiorów pomorskich." *Gdańskie Studia Muzealne* 3, pp. 107–25.

**Bloch, Marc**
**1973** *The Royal Touch: Sacred Monarchy and Scrofula in England and France.* London.

**Bloch, Peter**
**1970** "Die Muttergottes auf dem Löwen." *Jahrbuch der Berliner Museen* 12, pp. 253–94.

**Blohm, Katharina**
**1990** "Die Frauenkirche in Nürnberg (1352–1358). Architektur, Baugeschichte, Bedeutung." PhD diss., Technische Universität Berlin.

**Bobková, Lenka**
**2003** *Velké dějiny zemí Koruny české.* Vol. 4a,b, 1310–1402. Prague and Litomyšl.

**Bock, Elfried, ed.**
**1929** *Die Zeichnungen in der Universitätsbibliothek Erlangen.* 2 vols. Frankfurt am Main.

**Boehm, Barbara Drake**
**1990** *Medieval Head Reliquaries of the Massif Central.* Ann Arbor.
**1999** *The Hours of Jean d'Evreux: Prayer Book for a Queen.* CD-ROM. New York: The Metropolitan Museum of Art.
**2000** Commentary to *The Hours of Jeanne d'Evreux,* pp. 284–94. Facsimile. Lucerne.
**2004** "Madonna of Březnice." In New York 2004, no. 302.

**Boháček, Miroslav, and František Čáda**
**1994** *Beschreibung der mittelalterlichen Handschriften der Wissenschaftlichen Staatsbibliothek von Olmütz.* Cologne.

**Bohatec, Miloslav**
**1970** *Illuminated Manuscripts.* Translated by Till Gottheiner. Prague.

**Böhmer, Johann Friedrich**
**1877** *Die Regesten des Kaiserreichs unter Kaiser Karl IV., 1346–1378.* Innsbruck.

**Boldan, Kamil, and Milada Studničková**
**2001** "Rabštejnský Nový zákon." *Studie o rukopisech* 34, pp. 97–111.

**Bond, W. H., and C. U. Faye**
**1962** *Supplement to the Census of Medieval and Renaissance Manuscripts in the United States and Canada.* Originated by C. U. Faye, continued and edited by W. H. Bond. New York.

**Bony, Jean**
**1979** *The English Decorated Style: Gothic Architecture Transformed, 1250–1350.* Oxford.

**Bork, Robert O.**
**2003** *Great Spires: Skyscrapers of the New Jerusalem.* Veröffentlichung der Abteilung Architektur-geschichte des Kunsthistorischen Instituts der Universität zu Köln, 76. Cologne.

**Boskovits, Miklós**
**1988** *Frühe italienische Malerei: Gemäldegalerie Berlin, Katalog der Gemälde.* Translated and edited by Erich Schleier. Berlin.

**Branner, Robert**
**1977** *Manuscript Painting in Paris during the Reign of Saint Louis: A Study of Styles.* Berkeley and Los Angeles.

**Bratislava**
**1999** *Gotické Umenie z Bratislavských Zbierok.* Exh. cat. by Anton C. Glatz. Bratislava. Exhibition, Mestské Múzeum v Bratislave, Slovenská Národná Galéria.
**2003** *Gotika: Dejiny slovenského výtvarného umenia.* Exh. cat. edited by Dušan Buran, Ludka Kratochvílová, and Irena Kucharová. Bratislava. Exhibition, Slovenská Národná Galéria.

**Brauer, Barbara**
**1989** "The Prague Hours and Bohemian Manuscript Painting of the Late 14th Century." *Zeitschrift für Kunstgeschichte* 52, pp. 499–521.

**Braun, Joseph**
**1924** *Der christliche Altar in seiner geschichtlichen Entwicklung.* 2 vols. Munich.
**1940** *Die Reliquiare des christlichen Kultes und ihre Entwicklung.* Freiburg im Breisgau.

**Braune, Heinrich, and Erich Wiese**
**1929** *Schlesische Malerei und Plastik des Mittelaters.* Exh. cat. Breslau.

**Braunfels, Wolfgang**
**1972** *Der Hedwigs-Codex von 1353: Sammlung Ludwig.* 2 vols. Berlin.

**Bredekamp, Horst**
1975 *Kunst als Medium sozialer Konflikte: Bildkämpfe von der Spätantike bis zur Hussitenrevolution.* Frankfurt am Main.

**Bredt, Ernst Wilhelm, ed.**
1903 *Katalog der mittelalterlichen Miniaturen des Germanischen Nationalmuseums.* Nuremberg.

**Brejon de Lavergnée, Arnaud, and Dominique Thiébaut, eds.**
1981 *Catalogue sommaire illustré des peintures du Musée du Louvre.* Vol. 2, *Italie, Espagne, Allemagne, Grand-Bretagne et divers.* Paris.

**Bresslau, Harry, ed.**
1922 *Die Chronik Heinrichs Taube von Selbach, mit den von ihm verfassten Biographien Eichstätter Bischöfe.* Monumenta Germaniae historica, Scriptores Rerum Germanicarum, n.s., 1. Berlin.

**Breuer, Tilmann, and Reinhard Gutbier, eds.**
1997 *Stadt Bamberg: Bürgerliche Bergsstadt.* Die Kunstdenkmäler von Bayern, Regierungsbezirk Oberfranken VI, Stadt Bamberg, vol. 4, parts 1, 2. Munich.

**Brinkmann, Bodo, and Stephan Kemperdick**
2002 *Deutsche Gemälde im Städel, 1300–1500.* Kataloge der Gemälde im Städelschen Kunstinstitut Frankfurt am Main, vol. 4. Mainz am Rhein.

**Brinkmann, U., and R. Lauer**
1998 "Die mittelalterlichen Glasfenster des Kölner Domchores." In Cologne 1998, pp. 23–32. Cologne.

**Brno**
1999– *Od gotiky k renesanci: Výtarná kultura Moravy a*
2000 *Slezska, 1400–1550.* Exh. cat. Vol. 2, Brno, edited by Kaliopi Chamonikola. Brno, 1999. Exhibition, Moravská Galerie.

**Brodský, Pavel**
1984 "Bibliografie k Jenskému kodexu." *Sborník Národního Muzea v Praze,* ser. C, 29, pp. 55–88.
1992 "Kniha Lučních Praci z Elblagu—český rukopis z počátku husitského období." *Umění* 40, pp. 29–33.
2000 *Katalog iluminovaných rukopisů Knihovny Národního Muzea v Praze / Catalogue of the Illuminated Manuscripts of the Library of the National Museum, Prague.* Prague.

**Brosche, W.**
1978 "Zu einem Modell der Prager Neustadt." In Seibt 1978a, pp. 242–49.

**Brown, Elizabeth A. R.**
1984 "The Chapels and Cult of Saint Louis at Saint-Denis." *Mediaevalia,* 10, pp. 279–331.

**Brucher, Günter, ed.**
2000 *Geschichte der bildenden Kunst in Österreich.* Vol. 2, *Gotik.* Contributions by Ernst Bacher et al. Munich.

**Brussels**
1966 *Les primitifs de Bohême: L'art gothique en Tchécoslovaquie, 1350–1420.* Exh. cat. by František Kavka, Albert Kutal, and Jan Krofta. Brussels. Exhibition, Palais des Beaux-Arts.
1987 *Kunstschatten uit de benedictijnerabdij van Admont / Merveilles de l'abbaye benedictine d'Admont / Kunstschätze aus dem Admonter Benediktinestift.* Exh. cat. Onbekend.
1998– *L'art gothique tardif en Bohême, Moravie et Slésie,*
99 *1400–1550.* Exh. cat. edited by Kaliopi Chamonikola. Brussels, 1998. Exhibition, Chapelle Charles Quint.

**Brutzer, Gregor**
1936 *Mittelalterliche Malerei im Ordenslande Preussen.* Vol. 1, *Westpreussen.* Danzig.

**Brych, Vladimir**
1986 "Středověké nálezy z Emauzského kláštera ve sbírkách Národního Muzea v Praze— Mittelalterliche Funde aus dem Kloster Emaus

in den Sammlungen des Nationalmuseums in Prag." *Časopis Národního muzea—řada historická* 155, pp. 13–28.

**Brych, Vladimír, and Věra Přenosilová**
2002 *České hrady a tvrze ve starých vyobrazeních.* Prague.

**Buben, Milan M.**
2000 *Encyklopedie českých a moravských sídelních biskupů.* Prague.

**Buchner, Ernst**
1953 *Das deutsche Bildnis der Spätgotik und der frühen Dürerzeit.* Berlin.

**Budapest**
1985– *Kódexek a középkori Magyarországon: Kiállítás az*
86 *Országos Széchényi Könyvtárban.* Exh. cat. edited by András Vizkelety and Béla Belák. Budapest, 1985. Exhibition, Budávari Palota.
1987 *Művészet Zsigmond király korában, 1387–1437.* Exh. cat. edited by László Beke, Ernő Marosi, and Tünde Wehli. 2 vols. Budapest. Exhibition, Budapesti Történeti Múzeum.
1994– *Pannonia Regia. Művészet a Dunántúlon, 1000–1541 /*
95 *Kunst und Architektur in Pannonien, 1000–1541.* Exh. cat. edited by Á Mikó and Imre Takács. Budapest, 1994. Exhibition, Magyar Nemzeti Galéria.
2000 *Történelem-Kép: Szemelvények múlt és művészet kapcsolatából Magyarországon / Geschichte-Geschichtsbild: Die Beziehung von Vergangenheit und Kunst in Ungarn.* Exh. cat. edited by Á. Mikó and K. Sinkó. Exhibition, Magyar Nemzeti Galéria Kiadványai.

**Bühler, A.**
1963 "Die Heilige Lanze. Ein Ikonographischer Beitrag zur Geschichte der Deutschen Reichskleinodien." *Das Münster* 16, pp. 85–116.

**Buntak, Franjo**
1963 "Da li su praški Parleri klesali srednjovekovni portal Sv. Marka u Zagrebu?" *Iz starog i novog Zagreba* 3, pp. 65ff.

**Buran, Dušan**
2002a "Az Eleven kereszt és Szent Gergely miséje: Kontinuitás vagy konkurencia?" *Művészettörténeti értesítő* 51, nos. 1–2, pp. 1–16.
2002b *Studien zur Wandmalerei um 1400 in der Slowakei: Die Pfarrkirche St. Jakob in Leutschau und die Pfarrkirche St. Franziskus Seraphicus in Poniky.* Weimar.

**Buran, Dušan, and Juraj Šedivý**
2003 "Písmo a knižné maliarstvo: Objednávatelia, umelci a adresáti." In Bratislava 2003.

**Burdach, Konrad**
1893–1937 *Vom Mittelalter zur Reformation: Forschungen zur Geschichte der deutschen Bildung.* Halle and Berlin.

**Burger, Fritz**
1907 "Ausstellung plastischer Bildwerke des 15. und 16. Jahrh. in München." *Zeitschrift für bildende Kunst,* n.s., 18, pp. 146–63.

**Büttner, Andreas**
2000 *Perlmutt: Von der Faszination eines göttlichen Materials.* Petersberg, Germany.

**Buzás, Gergely**
1990 "A visegrádi királyi palota kápolnája és észak-keleti palotája." In *Lapidarium Hungaricum,* vol. 2, *Pest megye I, Visegrád, királyi palota,* edited by Pál Lővei. Budapest.
1994 *A visegrádi királyi palota kápolnája és északkeleti épülete.* Visegrád.
1995 "The Remains of the Royal Palace of Visegrád from the Angevin Period." In *Medieval Visegrád: Royal Castle, Palace, Town and Franciscan Friary,* edited by József Laszlovszky. Budapest.
1997 "Einige Fragen zur Baugeschichte des Schlosses von Buda: Die Epoche von Ludwig dem

Grossen und Sigismund." *Acta Historiae Artium* 39, pp. 71–116.

**Čadík, Jindřich**
1967 "K datování Plzeňské madony." *Minulostí západočeského kraje* 5, pp. 228–29.

**Cagliori, Liborius**
1752 *Kurtze Lebens Verfassung deren von Heiligkeit Weltberühmten der löbl. Gold- und Silber-Arbeither Kunst-Verwandten fünff Heiligen Männern, Eligii, Tylonis, Anastasii, Andronici und Facii… der mahlen sich befindete Khunst….* Prague.

**Camille, Michael**
1996 *Gothic Art: Glorious Visions.* New York.

**Campenhausen, Hans von**
1957 "Die Bilderfrage in der Reformation." *Zeitschrift für Kunstgeschichte* 68, pp. 96–128.

**Castelnuovo, Enrico**
1986 *I mesi di Trento: Gli affreschi di Torre Aquila e il gotico internazionale.* Trent.

**Castelnuovo, Enrico, and Francesca de Gramatica**
2002 See Trent 2002.

**Cazelles, Raymond, and Johannes Rathofer**
1988 *Das Stundenbuch des Duc de Berry: Les Très Riches Heures.* Munich.

**Černý, Václav**
1948 *Staročeská milostná lyrika.* Prague.

**Chadour, Anna Beatriz**
1994 *Ringe: Die Alice und Louis Koch Sammlung / Rings: The Alice and Louis Koch Collection.* 2 vols. Leeds.

**Chadour, Anna Beatriz, and Rüdiger Joppien**
1985 *Kunstgewerbemuseum der Stadt Köln.* Vol. 10, *Schmuck.* 2 vols. Cologne.

**Chadraba, Rudolf**
1971 *Staroměstská mostecká věž a triumfální symbolika v umění Karla IV.* Prague.
1974 *Die Karlsbrücke.* Prague.
1984 as editor. *Dějiny českého výtvarného umění.* 4 vols. Prague.

**Chaloupecký, Václav**
1946 *Arnošt z Pardubic: První arcibiskup pražský (1346–1364).* 2nd ed. Prague. First published 1941.
1948 *The Caroline University of Prague: Its Foundation, Character, and Development in the Fourteenth Century.* Translated by V. Fried and W. R. Lee. Prague.

**Chamonikola, Kaliopi**
1992 *Gotika: Katalog Moravské Galerie v Brně.* Brno.

**Champeaux, Alfred de**
1889– *Portefeuille des arts décoratifs.* 10 vols. Paris.
98

**Chapuis, Julien**
2001 "Pietà (Vesperbild)." *The Metropolitan Museum of Art Bulletin* 59, no. 2 (Fall), p. 20.

**Charles IV,** *Autobiography*
2001 *Karoli IV Imperatoris Romanorum vita ab eo ipso conscripta; et, Hystoria nova de Sancto Wenceslao Martyre / Autobiography of Emperor Charles IV; and, His Legend of St. Wenceslas.* Edited by Balázs Nagy and Frank Schaer; introduction by Ferdinand Seibt. Budapest and New York.

**Charles IV,** *Legend*
2001 *Karoli IV Imperatoris Romanorum vita ab eo ipso conscripta; et, Hystoria nova de Sancto Wenceslao Martyre / Autobiography of Emperor Charles IV; and, His Legend of St. Wenceslas.* Edited by Balázs Nagy and Frank Schaer; introduction by Ferdinand Seibt. Budapest and New York.

**Charles IV,** *Vita*
1978 *Vita Caroli Quarti / Karel IV. Vlastní životopis.* Czech section edited by J. Pavel and B. Ryba. Prague.

**Charvátová, Kateřina**
2002 *Dějiny cisterciáckého řádu v Čechách.* Vol. 2, *Kláštery založené ve 13. a 14. století.* Prague.

**Charvátová, Kateřina, and Zuzana Silagiová**
2003    *Fiant festa per ordinem universum: Cisterský Kalendár bohemikálniho puvodu z. 1. poloviny 13. století / A Cistercian Calendar of Bohemian Origin of the First Half of the 13th Century.* Prague.

**Chicago**
1975–   *Raiment for the Lord's Service: A Thousand Years of*
76      *Western Vestments.* Exh. cat. by Christa C. Mayer; essays by Aiden Kavanagh et al. Chicago. Exhibition, Art Institute of Chicago.

**Chlíbec, Jan**
1985    "K vývoji názorů Jana Rokycany na umělecké dílo." *Husitský Tábor* 8, pp. 39–58.

**Chlíbec, Jan, et al.**
1992    *Galerie Nationale de Prague. L'art ancien de Bohême: Abbaye Saint-Georges.* Paris and Prague.

**Chotěbor, Petr**
2000    "Obnovení barevnosti znakových štítů na jižním vřetenovém schodišti katedrály sv. Víta, Václava a Vojtěcha." *Pražský hrad—programový čtvrtletník* 3, pp. 10–12.
2001    "Der Grosse Turm des St. Veitsdoms. Erkenntnisse, die bei den Instandzetzungsarbeiten im Jahr 2000 Gewonnen wurden." *Umění* 49, pp. 262–70.

*Chronicon Benessii de Weitmil*
1884    *See* Beneš Krabice of Weitmile.
*Chronicon Francisci Pragensis. See* **František of Prague.**

**Chudárek, Zdeněk**
2003    "Contribution to Understanding the History of the Construction of the Great Tower at Karlštejn Castle." In Fajt 2003a, pp. 258–68.

**Chytil, Karel**
1885–   "Vývoj miniaturního malířství v době králů z
86      rodu lucemburského." *Památky archeologické* 13, pp. 311–16.
1891    "Mistr Osvald a jeho účastenství při výzdobě v chrámu Svatovítském." *Památky archeologické* 15, pp. 25–30.
1898–   "Monstrance sedlecká." *Památky archaeologicke a*
99      *místopisné* 18, cols. 375–84.
1906    *Malířstvo pražské XV. a XVI. věku a jeho cechovní kniha staroměstská z let 1490–1582.* Prague.
1915    *Památky českého umění iluminátorského.* Vol. 1, *Knihovna Národního Musea.* Prague.
1918    *Antikrist v naukách a umění středověku a husitské obrazné antithese.* Prague.

**Cibulka, Josef**
1934    *Český řád korunovační a jeho původ.* Prague.
1949    "Poprsí sv. Petra a Pavla v arcibiskupském palace na Hradčanech." *Čestami umění* (Prague), 1949, pp. 106–16.

**Čihalík, Martin**
1998    "K otázkám pořizovatelů Bible boskovické." *Umění* 46, pp. 195–200.

**Clarus, L., ed.**
1888    *Leben und Offenbarungen der hl. Birgitta.* 4 vols. Regensburg.

**Clasen, Karl Heinz**
1939    *Die mittelalterliche Bildhauerkunst im Deutschordensland Preussen: Die Bildwerke bis zur Mitte des 15. Jahrhunderts.* 2 vols. Berlin.
1974    *Der Meister der Schönen Madonnen: Herkunft, Entfaltung und Umkreis.* Berlin.

**Claussen, Peter Cornelius**
1980    "Der Wenzelsaltar in Alt St. Peter. Heiligenverehrung, Kunst und Politik unter Karl IV." *Zeitschrift für Kunstgeschichte* 43, pp. 280–99.

**Clemen, Paul**
1922    In *Die Kirchen der Stadt Aachen,* edited by Karl Faymonville. Die Kunstdenkmäler der Stadt Aachen, vol. 2. Düsseldorf.

**Cleveland**
1963    *Gothic Art, 1360–1440.* Exh. cat. Cleveland. Exhibition, Cleveland Museum of Art.

*Codex diplomaticus et epistolaris Moraviae*
1858–   *Codex diplomaticus et epistolaris Moraviae.* Vol. 7,
68      parts 1–3, *Urkunden-Sammlung zur Geschichte Mährens,* edited by Peter Chlumecky, Joseph Chytil, and Vincenz Brandl. Brno.

**Cologne**
1963–   *Monumenta Judaica: 2000 Jahre Geschichte und*
64      *Kultur der Juden am Rhein.* Exh. cat. edited by Konrad Schilling. 3 vols. Cologne, 1963. Exhibition, Kölnischen Stadtmuseum.
1978–   *Die Parler und der Schöne Stil, 1350–1400:*
79      *Europäische Kunst unter den Luxemburgern.* Catalogue edited by Anton Legner. 6 vols. Cologne, 1978–80. Cologne. Exhibition, Schnütgen-Museum.
1984    *Der Schatz von San Marco in Venedig.* Exh. cat. Cologne. Exhibition, Römisch-Germanisches Museum.
1985    *Kunst der Gotik aus Böhmen: Präsentiert von der Nationalgalerie Prag.* Exh. cat. edited by Anton Legner. Cologne. Exhibition, Schnütgen-Museum.
1995    *Schatz aus den Trümmern: Der Silberschrein von Nivelles und die europäische Hochgotik.* Exh. cat. edited by Hiltrud Westermann-Angerhausen. Cologne. Exhibition, Schnütgen-Museum.
1998    *Himmelslicht: Europäische Glasmalerei im Jahrhundert des Kölner Dombaus (1248–1349).* Exh. cat. edited by Hiltrud Westermann-Angerhausen. Cologne. Exhibition, Schnütgen-Museum.

**Cook, William R.**
1971    "Peter Payne, Theologian and Diplomat of the Hussite Revolution." PhD diss., Cornell University, Ithaca, N.Y.

**Corblet, J.**
1868    "Précis de l'histoire de l'art chrétien en France et en Belgique." *Revue de l'art chrétien* 12, pp. 499–504.

**Čornej, Petr**
1995    "Husův kult v 15. a 16. století." *Časopis společnosti přátel starožitností českých* 4, pp. 247–48.

**Corrie, Rebecca W.**
1990–   "The Political Meaning of Coppo di Marco-
91      valdo's Madonna and Child in Siena." *Gesta* 29, pp. 61–75.

**Cosmas of Prague**
1874    Cosmas *Chronicon Boemorum.* In *Fontes Rerum Bohemicarum,* vol. 2, pp. 1–198. Prague.

**Crossley, Paul**
1981    "Wells, the West Country, and Central European Late Gothic." In *Medieval Art and Architecture at Wells and Glastonbury* (British Archaeological Association Conference Transactions for 1978), pp. 81–109. Leeds.
1985    *Gothic Architecture in the Reign of Kasimir the Great: Church Architecture in Lesser Poland, 1320–1380.* Kraków.
1999    "Bohemia sacra: Liturgy and History in Prague Cathedral." In *Pierre, lumière, couleur: Études d'histoire de l'art du Moyen Âge en l'honneur d'Anne Prache,* edited by F. Joubert and D. Sandron, pp. 341–65. Paris.
2000    "The Politics of Presentation: The Architecture of Charles IV of Bohemia." In *Courts and Regions in Medieval Europe,* edited by A. J. Minnis, pp. 99–172. York.
2003    "Peter Parler and England: A Problem Revisited." *Wallraf-Richartz-Jahrbuch* 64, pp. 53–82.
2005    "'Ara patriae': St. Stanislaus, the Jagiellonians and the Coronation Ordinal for Cracow Cathedral." In Fajt and Hörsch 2005.

**Csapodi, Csaba**
1973    *The Corvinian Library: History and Stock.* Budapest.

**Csemegi, József**
1955    *A budavári főtemplom középkori építéstörténete.* Budapest.

**Csernus, Sándor**
1995    "Francia források Zsigmond párizsi tartózkodásáról (1416 március)." In *Kelet és Nyugat között. Történelmi tanulmányok Kristó Gyula tiszteletére,* edited by L. Koszta. Szeged.

**Curzel, Emanuele**
2000    "Venceslao pittore a Trento. Un nuovo documento per l'attribuzione dei 'Mesi' die Torre Aquila?" *Studi trentini di scienze storiche,* ser. 2, 79, pp. 5–8.

**Daňhelka, Jiří ed.**
1950    *Nová rada.* Prague.

**David, Avraham, ed.**
1993    *A Hebrew Chronicle from Prague, c. 1615.* Translated by Leon J. Weinberger and Dena Ordan. Tuscaloosa, Ala.

**Debický, Jacek**
1992    "Ein Beitrag zur Bildertheologie der vorhussitischen und hussitischen Zeiten in Böhmen." *Umění* 40, pp. 415–23.

**Debruge-Duménil sale**
1849    *Catalogue des objets d'art qui composant la collection Debruge-Duménil....* Sale cat. Hôtel Drouot, Paris, January 23–March 12.

**Deér, Josef**
1966    *Die Heilige Krone Ungarns.* Österreichische Akademie der Wissenschaften; Philosophisch-Historische Klasse, Denkschriften, vol. 91. Graz.

**Degenhart, Bernhard**
1943    *Europäische Handzeichnungen aus fünf Jahrhunderten.* Berlin.

**De Gramatica, Francesca**
2002    "Il ciclo dei Mesi di Torre Aquila." In Trent 2002, pp. 343–65.

**De Hamel, Christopher**
2000    "Medieval Manuscript Leaves as Publishers' Wrappers in the 1920s." In *'For the Love of the Binding': Studies in Bookbinding History Presented to Mirjam Foot,* edited by David Pearson, pp. 9–11. London.

**Deiters, Maria**
2002    *Kunst um 1400 im Erzstift Magdeburg. Studien zur Rekonstruktion eines verlorenen Zentrums.* PhD diss., Berlin. Published Berlin, 2005. Neue Forschungen zur deutschen Kunst 7.
2005    "Flötz—Barby—Magdeburg—Prag: Zur Kunst des magdeburgischen Raumes im späten 14. Jahrhundert." In Fajt and Hörsch 2005.
n.d.    Monograph on Albrecht von Querfurt. Berlin: Deutscher Kunstverlag. Forthcoming.

**Delaborde, F.**
1884    "Le procès du chef de saint Denis en 1410." *Mémoires de la Société de l'Histoire de Paris et de l'Île-de-France* 11, pp. 297–409.

**Delachenal, R[oland], ed.**
1910–   *Les grandes chroniques de France: Chronique des*
20      *règnes de Jean II et de Charles V.* 4 vols. Paris.

**Delehaye, Hippolyte**
1908    *Le pèlerinage de Laurent de Pászthó au purgatoire de S. Patrice.* Brussels. Extracted from *Analecta Bollandiana* 27, pp. 35–60.

**Delisle, Léopold**
1874    *Mandements et actes divers de Charles V (1364–1380) recueillis dans les collections de la Bibliothèque Nationale.* Paris.

**Denkstein, Vladimír**
1962    "Pavézy českého typu" (Pavises of the Bohemian type), part 1, with full English translation. *Sborník Národního Muzea v Praze—Acta Musei Nationalis Pragae,* ser. A, 16, nos. 4–5, pp. 185–228.
1964    "Pavézy českého typu" (Pavises of the Bohemian type), part 2, with full English translation. *Sborník Národního Muzea v Praze—Acta Musei Nationalis Pragae,* ser. A, 18, nos. 3–4, pp. 107–94.
1965    "Pavézy českého typu" (Pavises of the Bohemian type), part 3, with full English translation. *Sborník*

*Národního Muzea v Praze—Acta Musei Nationalis Pragae,* ser. A, 19, no. 1–5, pp. 1–202.

**Denkstein, Vladimír, and František Matouš**

**1955** *Gothic Art in South Bohemia.* Translated by Roberta Finlayson Samsour. Prague.

**Denucé, Jean**

**1927** *Catalogue des manuscrits / Catalogus der Handschriften.* Antwerp: Museum Plantin-Moretus.

**Derbes, Anne, and Amy Neff**

**2004** "Italy, the Mendicant Orders, and the Byzantine Sphere." In New York 2004, pp. 449–61, 603–6.

**Deusch, Werner R.**

**1936** "Das Boreschow-Epitaph des Frauenburger Doms." *Pantheon* 18, pp. 220–22.

**Devoti, Donata, et al., eds.**

**1999** *Vesti liturgiche e frammenti tessili nella raccolta del Museo Diocesano Tridentino.* Trent.

**Dexel, Grete**

**1919** *Ostdeutsche Tafelmalerei in der letzten Hälfte des 14. und im ersten Drittel des 15. Jahrhunderts.* Danzig.

**Didier, Robert**

**1970** "Contribution à l'étude d'un type de Vierge française du XIVe siècle: À propos d'une réplique de la Vierge de Poissy à Herresbach." *Revue des archéologues et historiens d'art de Louvain* 3, pp. 48–72.

**Didier, Robert, and Roland Recht**

**1980** "Paris, Prague, Cologne et la sculpture de la seconde moitié du XIVe siècle." *Bulletin monumental* 138, pp. 173–219.

**Diener von Schönberg, Alfons**

**1944** "Setzschilde der Stadt Zwickau aus der Werkstatt eines Schildmachers von Komotau 1441." *Zeitschrift für historische Waffenkunde,* n.s., 8, pp. 45–56.

**Dinzelbacher, Peter**

**1989** "Der Traum Kaiser Karls IV." In *Träume im Mittelalter: Ikonologische Studien,* edited by A. Paravicini-Bagliani und G. Stabile. Stuttgart and Zürich.

**2002** *Himmel, Hölle, Heilige: Visionen und Kunst im Mittelalter.* Darmstadt.

**Distelberger, Rudolf**

**2002** See Vienna 2002–3.

**Dohna, L.**

**1960** *Reformatio Sigismundi: Beiträge zum Verständnis einer Reformschrift des fünfzehnten Jahrhunderts.* Veröffentlichungen des Max-Planck-Instituts für Geschichte, vol. 4. Göttingen.

**Domasłowski, Jerzy, Alicja Karłowska-Kamzowa, and Adam S. Labuda**

**1990** *Malarstwo gotyckie na Pomorzu Wschodnim.* Warsaw and Poznań.

**Domínguez Bordona, Jesús**

**1933** *Manuscritos con Pinturas: Notas para un inventario de los conservados en colecciones públicas y particulares de España.* Vol. 1, *Ávila–Madrid.* Madrid.

**Dostál, Eugen**

**1922** "Čechy a Avignon." *Časopis Matice Moravské* 66, pp. 1–106.

**Dostál, Oldřich, Jiří Hrůza, Dobroslav Líbal, Svotopluk Voděra, and Tibor Zalčik**

**1974** *Československá Historická Města.* Prague.

**Dreves, Guido Maria, ed.**

**1961** *Conradus Gemnicensis. Konrads von Haimburg und seiner Nachahmer, Alberts von Prag und Ulrichs von Wessobrunn, Reimgedichte und Leselieder.* Leipzig. Reprint of 1888 ed. New York and London.

**Drobná, Zoroslava**

**n.d.** *Gothic Drawing.* Translated by Jean Layton. Prague, [195-].

**1950** *Les trésors de la broderie religieuse en Tchécoslovaquie.* Translated by Arnold Wloszczowski. Prague.

**1956** *Die gotische Zeichnung in Böhmen.* Prague.

**1957** "Les huit miniatures tchèques de Budapest." *Bulletin du Musée National Hongrois des Beaux-Arts,* no. 11, pp. 28–49.

**1965** "K problematice Bible boskovské." *Umění* 13, pp. 127–38.

**1966** "Nejkrásnější iluminované rukopisy Národního Muzea v Praze." *Časopis Národního Muzea,* 1966.

**1968** "Quelques remarques sur l'antiphonaire de Sedlec de 1414." *Sborník prací filosofické fakulty Brněnské University* 12, pp. 39–50.

**1970** *Jenský kodex: Husitská obrazová satira z konce středověku.* Prague.

**Dubois, Jacques**

**1990** *Martyrologes d'Usuard au martyrologe romaine.* Abbeville.

**Durdík, Tomáš**

**1984** "Nový hrad u Kunratic a jeho postavení ve vývoji české hradní architektury." *Archeologické památky* 5, no. 1, pp. 173–90.

**1986** "Hrady Václava IV. v pražských městech a jejich nejbližším okolí." *Documenta Pragensia* 6, no. 1, pp. 24–43.

**2000** *Ilustrovaná Encyklopedie Českých Hradů.* Prague.

**Durian-Ress, Saskia**

**1986** *Meisterwerke mittelalterlicher Textilkunst aus dem Bayerischen Nationalmuseum: Auswahlkatalog.* Munich.

**Dvě Legendy**

**1959** *Dvě Legendy z doby Karlovy: Legenda o svatém Prokopu, Život svaté Kateřiny.* Prague.

**Dvořák, Max**

**1899** "K dějinám malířství českého doby Karlovy." *Český časopis historický* 5, pp. 238–48.

**1901a** "Die Illuminatoren des Johann von Neumarkt." *Jahrbuch der kunsthistorischen Sammlungen des allerhöchsten Kaiserhauses* 22, pp. 35–126.

**1901b** "Mariale Ernesti." *Český časopis historický* 7, pp. 451–53.

**Eberhard, W.**

**1978** "Herrschaft und Raum—Zum Intinerar Karls IV." In Seibt 1978a, pp. 101–8.

**Edgell, G. H.**

**1935** "Madonna of the School of Avignon (?)." *Bulletin of the Museum of Fine Arts* (Boston) 33, pp. 33–36.

**Egger, Gerhard**

**1967** "Kunstgewerbe." In Krems 1967, pp. 227–42.

**Ehrenberg, Hermann**

**1920** *Deutsche Malerei und Plastik von 1350–1450. Neue Beiträge zu ihrer Kenntnis aus dem ehemaligen Deutschordensgebiet.* Bonn and Leipzig.

**Ehrend, Helfried**

**1975** *Die Münzschatz von Lingenfeld 1969.* Contributions by Günter Stein and Friedrich Wielandt. Speyer.

**Eich, Ernst**

**1945** *Portraits de Princes d'un tableau religieux du Moyen Âge dans la collection de Lenzbourg, Étude V.* Vie, art, cité 5. Unpaged.

**Eichholz, Paul, ed.**

**1912** *Die Kunstdenkmäler von Stadt und Dom Brandenburg.* Die Kunstdenkmäler der Provinz Brandenburg, vol. 2, part 3. Berlin.

**Eisler, János**

**1977** "Zu den Fragen der Beinsättel des Ungarischen Nationalmuseums I." *Folia Archaeologica* 28, pp. 189–209.

**1979** "Zu den Fragen der Beinsättel des Ungarischen Nationalmuseums II." *Folia Archaeologica* 30, pp. 205–44.

**Elhen von Wolfhagen**

**1883** See Wyss 1883.

**Eliáš, J. O.**

**1971** "Rukopisy českých biblí v našich knihovnách." PhD diss., FF Masarykovy Univerzity, Brno.

**Emler, Josef**

**1871** *Vita Johannis de Jenczenstein archiepiscopi Pragensis.* In *Fontes Rerum Bohemicarum,* vol. 1, pp. 439–68. Prague.

**1884** See Beneš Krabice of Weitmile 1884.

**1892** as editor. *Regesta diplomatica nec non epistolaria Bohemiae et Moraviae,* IV. Prague.

**Engel, Evamaria**

**1982** "Brandenburgische Bezüge im Leben und Wirken des Magdeburger Erzbischofs Dietrich von Portitz." In *Karl IV: Politik und Ideologie im 14. Jahrhundert,* edited by Evamaria Engel. Weimar.

**Engstová, Karin**

**2000** "Několik poznámek k archivním zprávám k tzv. rajhradskému oltári." *Umění* 48, pp. 369–71.

**Erdmann, Wolfgang**

**1995** *Zisterzienser-Abtei Doberan. Kult und Kunst.* Königstein/T.

**Ermland**

**1907** "Kirchliche Altertümer von Marienburg." *Pastoralblatt für die Diözese Ermland* 39.

**Ernyey, József**

**1926** "A Magyar Nemzeti Múzeum 'Csák Máté' hermája." *Az Országos Magyar Régészeti Társulat Évkönyve* 2 (1923–26) pp. 198–223.

**Érszegi, Géza**

**1992** "A Nagy Lajos-kori királyi kápolna kérdéséhez." *Várak a későközépkorban / Die Burgen im Spätmittelalter,* edited by Juan Cabello, pp. 94–99. Budapest. Papers from a conference, Castrum Bene II, Gyöngyös, Hungary, 1990.

**Essen–Bonn**

**2005** *Krone und Schleier: Kunst aus mittelalterlichen Frauenklöstern.* Exh. cat. edited by Jutta Frings. Munich. Exhibition, Ruhrlandmuseum Essen; Kunst- und Ausstellungshalle der Bundesrepublik Deutschland in Bonn.

**Essenwein, August von**

**1873** "Zwei zu den Reichskleinodien gehöhrige Futterale." *Anzeiger für Kunde der deutschen Vorzeit,* n.s., 20.

**Esztergom**

**1993** *Az Esztergomi Keresztény Múzeum.* Edited by Pál Cséfalvay. Budapest. German ed.: *Christliches Museum Esztergom.* Budapest.

**Euw, Anton von, and Joachim M. Plotzek**

**1979–** *Die Handschriften der Sammlung Ludwig.* 4 vols.
**85** Cologne.

**Evans, Helen C.**

**2004** "Byzantium: Faith and Power (1261–1557)." In New York 2004, pp. 5–15, 594–95.

**Evans, Joan**

**1953** *A History of Jewellery, 1100–1870.* New York.

**Fajt, Jiří**

**1995** "Pozdně gotické řezbářství v Praze a jeho sociální pozadí (1430–1526) / Spätgotische Schnitzkunst in Prag und ihre gesellschaftlichen Hintergründe." *Průzkumy památek* 2, pp. 1–112.

**1996** "Die gesellschaftlichen Voraussetzungen der Bildschnitzerei im nachhussitischen und podiebradschen Prag." In *Ars baculum vitae: Sborník k 70. narozeninám Pavla Preisse,* edited by Vít Vlnas, pp. 40–51. Prague.

**1997** as editor. *Magister Theodoricus, dvorní malíř císaře Karla IV: Umělecká výzdoba posvátných prostor hradu Karlštejna.* Prague.

**1998** as editor. *Magister Theodoricus, Court Painter to Emperor Charles IV: The Pictorial Decoration of the Shrines at Karlštejn Castle.* Exh. cat. Prague.

**1999** "Madona z cisterciáckého kláštera v Oseku u Duchcova. K figurálnímu typu a způsobům jeho šíření / Die Madonna aus dem Zisterzienserkloster in Osseg bei Duchcov. Zum Figuraltyp und zu den Weisen seiner Verbreitung." In *Gotické sochařství a malířství v severozápadních Čechách: Opitzův sborník, Tagungsband, Ústí nad Labem/Aussig,* pp. 131–41. Ústí nad Labem.

**2000** "Karl IV.—Herrscher zwischen Prag und Aachen. Der Kult Karls des Grossen und die karolinische Kunst." In Aachen 2000, pp. 489–500.

**2003a** as editor. *Court Chapels of the High and Late Middle Ages and Their Artistic Decoration*. Prague.

**2003b** Review of Rosario 2000. *Speculum* 78, pp. 1382–85.

**2004** "Peter Parler und die Bildhauerei des dritten Viertels des 14. Jahrhunderts in Prag." In Strobel and Siefert 2004, pp. 207–20.

**2004a** "Karlštejn a norimberská malba / Karlštejn und die Nürnberger Malerei." Paper presented at the symposium "The Staircase Cycles of the Large Tower at Karlštejn Castle: Condition after Restoration," organized by the Academy of Sciences of the Czech Republic in the Emmaus Monastery, Prague, 5–7 May.

**2005** "Erfurt—Praha—Brandenburg—Havelberg. Zum Itinerar eines Bildhauers." In *Tagung "Gemeinsames und Unterschiedliches. Die Böhmische Krone im Leben und Bewusstsein ihrer Bewohner im 14–17. Jahrhundert."* Institut für Tschechische Geschichte des Philosophischen Fakultät der Karlsuniversität in Prag/Archiv der Hauptstadt Prag, 12.–13. 5. 2004. Prague. Forthcoming.

**2005a** *Medieval Art in Bohemia and Central Europe: Guide through the Permanent Installation of the Collection of Medieval Art of the National Gallery in Prague at St. Agnes Convent*. Prague. Forthcoming.

**Fajt, Jiří, and Milena Bartlová**

**1996** *Světice s knihou: Nově zakoupené dílo gotického umění / Saint Virgin Holding a Book: Newly Acquired Masterpiece of Gothic Art*. Exh. cat. edited by Jiří Fajt. Malé katalogy starého umění, 4. Prague.

**Fajt, Jiří, and Hana Hlaváčková**

**2003** "The Family of Charles IV in the Stairway of the Karlštejn Great Tower." In Fajt 2003a, pp. 16–20.

**Fajt, Jiří, Hana Hlaváčková, and Jan Royt**

**1993–** "Das Relief von der Maria-Schnee-Kirche in der
**94** Prager Neustadt." *Bulletin of the National Gallery in Prague* 3–4, pp. 16–27.

**Fajt, Jiří, and Markus Hörsch, eds.**

**2005** *Künstlerische Wechselwirkungen in Mitteleuropa*. Studia jagellonica lipsiensia 1. Ostfildern.

**Fajt, Jiří, and Jan Royt**

**1997** "Umělecká výzdoba Velké věže hradu Karlštejna." In Fajt 1997, pp. 155–254.

**Fajt, Jiří, and Lubomír Sršeň**

**1993** *Lapidarium of the National Museum Prague: Guide to the Permanent Exhibition of Czech Sculpture in Stone of the 11th to 19th Centuries*. Translated by Joanne Dominová. Prague.

**Falke, Otto von**

**1913** *Kunstgeschichte der Seidenweberei*. 2 vols. Berlin.

**Feld, Helmut**

**1990** *Der Ikonoklasmus des Westens*. Studies in the History of Christian Thought 41. Leiden.

**Feld, István**

**1993** "Castles and Mansions in Hungary in the Late Middle Ages." *IBI Bulletin* 49, pp. 9–16.

**1999** as editor. "A Szent Zsigmond templom és a Zsigmond kor budai szobrászata." Contributions to a colloque, held in 1996 in the Museum for the History of Budapest. *Budapest Régiségei* 33, pp. 5–139.

**Fiala, Zdeněk**

**1965** "O životě a díle Petra z Mladoňovic." In *Petra z Mladoňovic Zpráva o mistru Janu Husovi v Kostnici*, pp. 9–30. Prague.

**Fillitz, Hermann**

**1954** *Die Insignien und Kleinodien des Heiligen Römischen Reiches*. Vienna.

**1977** "Das Kunstgewerbe der romanischen Zeit in Böhmen." In *Romantik in Böhmen*, edited by Erich Bachmann, pp. 235–53. Munich.

**1978** "Kunstgewerbe." In *Gotik in der Steiermark*, pp. 304–19. Exh. cat. Graz: Stift St. Lambrecht.

**1979** "Bildende Kunst: Kunstgewerbe." In Vienna 1979, pp. 98–102.

**1986** *Die Schatzkammer in Wien: Symbole abendländischen Kaisertums*. Salzburg and Vienna.

**Fingernagel, Andreas, ed.**

**2003** *Im Anfang war das Wort: Glanz und Pracht illuminierter Bibeln*. Cologne.

**Fischerová, K.**

**1974** "Francouzští mistři a architektura první poloviny 14. století v českých žemích." PhD diss., Faculty of Philosophy, Charles University, Prague.

**Fishof, I.**

**1986–** "The Origin of the *Siddur* of the Rabbi of
**87** Ruzhin." *Jewish Art* 12–13, pp. 73–82.

**Fité, Frances**

**1993** "Jàson I Medea, un cicle iconoràfic de la llegenda troiana a l'arquete de sant sever de la cathedral de Barcilona." *D'art* (Barcelona) 19, pp. 169–86.

**Flor, Ingrid**

**1992** "Die Krönung Mariä und der 'Christus-Adler': Zur Herrschaftssymbolik spätmittelalterlicher Endzeitprophetie. Die Marienkrönungsminiatur im Buch der Heiligen Dreifaltigkeit des Franziskaners Ulmannus." *Umění* 40, pp. 392–412.

**Florence**

**1989** *Arti del Medio Evo e del Rinascimento: Omaggio ai Carrand, 1889–1989*. Exh. cat. by Paola Barocchi et al. Florence. Exhibition, Museo Nazionale del Bargello.

**Folz, Robert**

**1950** *Le souvenir et la légende de Charlemagne dans l'empire germanique médiéval*. Paris.

**1973** *Le souvenir et la légende de Charlemagne dans l'empire germanique médiéval*. Reprint. Geneva.

**Fontevrault**

**2001** *L'Europe des Anjou: Aventure des princes angevins du XIIIe au XVe siècle*. Exh. cat. by Guy Massin Le Goff et al. Paris. Exhibition, Abbaye Royale de Fontevraud.

**Foradada y Castán, José**

**1877** "Reseña histórica de la Biblioteca del Cabildo de la Central de Toledo." *Revista de archivos, bibliotecas y museos* 7, pp. 49–54, 65–69.

**Fracassetti, Giuseppe**

**1890** *In epistolas Francisci Petrarcae de rebus familiaribus*. Edited by Camilli Antona-Traversi and Philippi Raffaelli. Firmi.

**Frank, Isnard, et al.**

**1985** *Balduin von Luxemburg, Erzbischof von Trier, Kurfürst des Reiches, 1285–1354: Festschrift aus Anlass des 700. Geburtsjahres*. Mainz.

**Frankfurt am Main**

**1975–** *Kunst um 1400 am Mittelrhein: Ein Teil der
**76** Wirklichkeit*. Exh. cat. by Herbert Beck, Wolfgang Beeh, and Horst Bredekamp. Frankfurt am Main, 1975. Exhibition, Liebieghaus Museum Alter Plastik.

**2002** *Avantgarde 1360: Ein rekonstruierter Baldachinaltar aus Nürnberg*. Exh. cat. by Stephan Kemperdick. Kabinettstücke. Frankfurt am Main. Exhibition, Städelsches Kunstinstitut und Städtische Galerie.

**František of Prague**

**1884** *Chronicon Francisci Pragensis*. Book III/2. In *Fontes Rerum Bohemicarum*, vol. 4. Prague.

**1997** *Kronika Františka Pražského / Chronicon Francisci Pragensis*. Edited by Jana Zachová. Fontes Rerum Bohemicarum, n.s., vol. 1. Prague.

**FRB**

**1873–** *Fontes Rerum Bohemicarum*. Vols. 1–6, edited by
**1932** Josef Emler; vol. 8 edited by Václav Novotný; vol. 7 never published. Prague.

**Freedberg, David**

**1994** "Imitation and Its Discontents." In *Künstleriches Austausch / Artistic Exchange: Akten des 28. Internationalen Kongresses für Kunstgeschichte, Berlin, 15.–20. Juli 1992*, edited by Thomas Gaehtgens, pp. 483–91. Berlin.

**Freigang, Christian**

**1992** *Imitare ecclesias nobiles: Die Kathedralen von Narbonne, Toulouse und Rodez und die nordfranzösische Rayonnantgotik im Languedoc*. Worms.

**1998** "Köln und Prag: Der Prager Veitsdom als Nachfolgebau des Kölner Domes." In *Dombau und Theologie im mittelalterlichen Köln: Festschrift zur 750–Jahrfeier der Grundsteinlegung des Kölner Domes und zum 65. Geburtstag von Jochim Kardinal Meisner*, pp. 49–86. Cologne.

**2002** "Werkmeister als Stifter: Bemerkungen zur Tradition der Prager Baumeisterbüsten." In *Nobilis Arte Manus (Festschrift zum 70. Geburtstag von Antje Middeldorf Kosegarten)*, edited by B. Klein and H. Walter von dem Knesebeck, pp. 244–64. Dresden and Kassel.

**Frenzel, Gottfried**

**1962** "Kaiserliche Fensterstiftungen des 14. Jahrhunderts in Nürnberg." *Mitteilungen des Vereins für die Geschichte der Stadt Nürnberg* 51, pp. 1–17.

**Frey, Beat**

**1978** *Pater Bohemiae—Vitricus Imperii. Böhmens Vater, Stiefvater des Reichs. Kaiser Karl IV. in der Geschichtsschreibung*. Bern, Frankfurt am Main, and Las Vegas.

**Friedenberg, Daniel M.**

**1987** *Medieval Jewish Seals from Europe*. Detroit.

**Friedl, Antonín**

**1931** *Kodex Jana z Jenštejna. Iluminovaný rukopis české školy malířské ve Vatikánu (Vat. Lat. 1122)*. Prague.

**1950** *Mistr karlštejnské apokalypsy*. Prague.

**Friedländer, Max J., ed.**

**1914** *Handzeichnungen deutscher Meister in der Herzoglich Anhaltschen Behörden-Bibliothek zu Dessau*. Stuttgart.

**1917** *Die Sammlung Richard von Kaufmann*. Vol. 2, *Niederländischen, französischen und deutschen Gemälde*. Sale cat. Berlin: Paul Cassirer, December 4.

**Friedman, John B.**

**1995** *Northern English Books, Owners, and Markers in the Late Middle Ages*. Syracuse.

**Friedmann, Herbert**

**1946** *The Symbolic Goldfinch: Its History and Significance in European Devotional Art*. Bollingen Series, 7. Washington, D.C.

**Friedrich, Gustav, ed.**

**1904–7** *Codex diplomaticus et epistolaris regni Bohemiae*. Prague.

**Frind, Anton**

**1864–** *Die Kirchengeschichte Böhmens im Allgemeinen
**78** und in ihrer besonderen Beziehung auf die jetzige Leitmeritzer Diöcese in der Zeit vor dem erblichen Königthume*. 4 vols. Prague.

**Frinta, Mojmír S.**

**1960** "The Beautiful Style in the Sculpture around 1400 and the Master of the Beautiful Madonnas." PhD diss., University of Michigan, Ann Arbor.

**1964** "The Master of the Gerona Martyrology and Bohemian Illumination." *Art Bulletin* 46, pp. 283–306.

**1965** "An Investigation of the Punched Decoration of Mediaeval Italian and Non-Italian Panel Paintings." *Art Bulletin* 47, pp. 261–65.

**1995** "The Kykkotissa and Her Variants: In Search for Italian Painters on Cyprus." In *Visitors, Immigrants, and Invaders in Cyprus*, edited by Paul W. Wallace, pp. 104–13. Albany.

**2004** "Le portrait du Louvre de Jean le Bon." *Umění* 52, pp. 402–13.

**Frisch, Ernst**

**1949** *Mittelalterliche Buchmalerei: Kleinodien aus Salzburg.* Vienna.

**Fritz, Johann Michael**

**1966** *Gestochene Bilder: Gravierungen auf deutschen Goldschmiedearbeiten der Spätgotik.* Beihefte der Bonner Jahrbücher, 20. Cologne and Graz.

**1978** "Goldschmiedekunst." In Cologne 1978–79, vol. 3.

**1982** *Goldschmiedekunst der Gotik in Mitteleuropa.* Munich.

**2004** *Das evangelische Abendmahlsgerät in Deutschland: Vom Mittelalter bis zum Ende des alten Reiches.* Contributions by Martin Brecht, Jan Harasimowicz, and Annette Reimers. Leipzig.

**Fritzsche, Gabriela**

**1983** *Die Entwicklung des "Neuen Realismus" in der Wiener Malerei, 1331 bis Mitte des 14. Jahrhunderts.* Dissertationen zur Kunstgeschichte, 18. Vienna.

**Frolík, Jan**

**1988** "Archeologický výzkum na Hradčanském náměstí v r. 1944 / Archaeological Excavations at Hradčany Square in 1944." *Castrum Pragense* 1, pp. 137–75.

**1999** "Dlaždice 12.–13. století z Pražského hradu / Fliesen aus dem 12.–13. Jahrhundert auf der Prager Burg." *Castrum Pragense* 2, pp. 203–18.

**2000** "Die Prager Burg." In *Europas Mitte um 1000,* edited by A. Wieczorek and H.-M. Hinz, pp. 376–78. Stuttgart.

**Fründt, Edith**

**1972** *Staatliche Museen zu Berlin. Skulpturen-Sammlung. Bildwerke aus sieben Jahrhunderten.* Vol. 2. Berlin.

**Fry, R. E.**

**1903** "Two Pictures in the Possession of Messrs. Dowdeswell." *Burlington Magazine* 2 (June), pp. 89–90.

**Fudge, Thomas**

**1993** "Art and Propaganda in Hussite Bohemia." *Religio: Revue pro religionistiku* 1, pp. 135–52.

**1996** "The Crown and the Red Gown: Hussite Popular Religion." In *Popular Religion in Germany and Central Europe, 1400–1800,* edited by Bob Scribner and Trevor Johnson, pp. 38–57. London.

**1998** "'Neither Mine nor Thine': Communist Experiments in Hussite Bohemia." *Canadian Journal of History* 33, pp. 25–47.

**Gaborit-Chopin, Danielle**

**1992** "The Shrine of Elizabeth of Hungary at The Cloisters." In *The Cloisters: Studies in Honor of the Fiftieth Anniversary,* edited by Elizabeth C. Parker and Mary B. Shepard, pp. 327–54. New York.

**1996** *L'inventaire du trésor du dauphin futur Charles V, 1363: Les débuts d'un grand collectionneur.* Société de l'Histoire de l'Art Français, Archives de l'art français, n.s., vol. 32. Paris and Nogent-le-Roi.

**2004** "Réapparition d'une Vierge d'ivoire gothique." In *Objets d'art: Mélanges en l'honneur de Daniel Alcouffe,* pp. 47–55. Dijon.

**Gall, Günter**

**1965** *Leder im europäischen Kunsthandwerk: Ein Handbuch für Sammler und Liebhaber.* Braunschweig.

**Gamber, Ortwin**

**1961** "Die mittelalterlichen Blankwaffen der Wiener Waffensammlung." *Jahrbuch der Kunsthistorischen Sammlungen in Wien,* n.s., 21, pp. 7–38.

**Garel, Michel**

**1991** See Paris 1991–92.

**Gatz, Erwin, ed.**

**2001** *Die Bischöfe des Heiligen Römischen Reiches 1198 bis 1448: Ein biographisches Lexikon.* Contributions by Clemens Brodkorb. Berlin.

**Gay, Victor**

**1887–** *Glossaire archéologique du Moyen Age et de la*
**1928** *Renaissance.* 2 vols. Paris.

**Gaye, Johann Wilhelm, ed.**

**1839** *Carteggio inedito d'artisti dei secoli XIV, XV, XVI.* Vol. 1, *1326–1500.* Florence.

**Gebauer, Jan**

**1923** *O životě a spisech Tomáše ze Štítného.* Prague.

**Gemäldegalerie, Berlin**

**1975** *Katalog der ausgestellten Gemälde des 13.–18. Jahrhunderts.* Berlin.

**1996–** *Gemäldegalerie Berlin.* 2 vols. Contributions by
**98** Henning Bock et al. Berlin.

**Gemäldegalerie, Vienna**

**1965** *Katalog der Gemäldegalerie Wien.* Vol. 1, *Italiener, Spanier, Franzosen, Engländer.* 2nd ed. Vienna.

**Genthon, István, ed.**

**1948** *Esztergom műemlékei.* Vol. 1, *Múzeumok, kincstár, könyvtár.* Budapest.

**Gerevich, László**

**1954** "Prager Einflüsse auf die Bildhauerkunst der Ofner Burg." *Acta Historiae Artium* 2, pp. 51–63.

**1958** "Mitteleuropäische Bauhütten und die Spätgotik." *Acta Historiae Artium* 5, pp. 241–82.

**1966** *A budai vár feltárása.* Budapest.

**1971** *The Art of Buda and Pest in the Middle Ages.* Translated by L. Halápy; revised by G. Dienes. Budapest.

**Gerevich, Tibor**

**1923** *Kolozsvári Tamás az első magyar péptábla-festő.* Budapest.

**Gerola, Giuseppe**

**1923** "A proposito degli affreschi della Torre del Aquila." *Il Giornale di Trento,* October 24–25.

**Gerona**

**1993** *El Martirologi: Un llibre miniat entorn del 1400.* Exh. cat. Gerona.

**Gerona Martyrology**

**1997–** *Martirologio de Usuardo.* Facsimile of manuscript
**98** Inv. MD 273 owned by the Museu Diocesà de Girona. Commentary volume, with transcription and translation into Spanish, by Maria Rosa Ferrer i Dalgà et al. Barcelona: Moleiro.

**Ghyczy, Paul**

**1926–** "Zum Aufsatz: Berittener Grieswärtel usw."
**28** *Zeitschrift für historische Waffen- und Kostümkunde,* n.s., 2, no. 8, pp. 195–96.

**Gibbs, Robert**

**1989** *Tomaso da Modena: Painting in Emilia and the March of Treviso, 1340–80.* Cambridge.

**1992** "Bolognese Influence on Bohemian Art of the 14th and Early 15th Century." *Umění* 40, pp. 280–89.

**Gillerman, Dorothy, ed.**

**2001** *Gothic Sculpture in America.* Vol. 2, *The Museums of the Midwest.* Turnhout, Belgium.

**Girke-Schreiber, Johanna**

**1974** "Die böhmische Devotio moderna." In *Bohemia Sacra,* edited by Ferdinand Seibt, pp. 81–91. Düsseldorf.

**Glasschröder, Franz Xaver**

**1888** "Markwart von Randeck, Bischof von Augsburg und Patriarch von Aquileja." *Zeitschrift des Historischen Vereins für Schwaben und Neuburg* 15, pp. 1–88; 22 (1895), pp. 97–160.

**Glatz, Anton C.**

**1999** See Bratislava 1999.

**Goitein, S. D.**

**1999** *A Mediterranean Society: The Jewish Communities of the Arab World as Portrayed in the Documents of the Cairo Geniza.* Vol. 5, *The Individual.* Berkeley and Los Angeles.

**Gómez Pérez, José**

**1963** "Elaboración de la Primera Crónica General de España y su trasmisión manuscrita." *Scriptorium* 17, pp. 233–76.

**Gordon, Dillian, Lisa Monnas, and Caroline Elam, eds.**

**1997** *The Regal Image of Richard II and the Wilton Diptych.* London.

**Gottschalk, Joseph**

**1964** *St. Hedwig Herzogin von Schlesien.* Cologne and Graz.

**Grabar, André**

**1931** *Le sainte face de Laon: Le Mandylion dans l'art orthodoxe.* Prague.

**Graesse, Theodor, ed.**

**1890** *Jacobi a Voragine Legenda aurea, Vulgo historia lombardica dicta, ad optimorum librorum fidem.* Dresden. Reprinted Osnabrück, 1969.

**Graf, Agnes**

**1992** "Winand von Steeg: Adamas colluctacium aquilarum, ein Aufruf zum Kreuzzug gegen die Hussiten." *Umění* 40, pp. 344–51.

**Grancsay, Stephen V.**

**1937** "An Early Sculptured Saddle." *Bulletin of The Metropolitan Museum of Art* 32, pp. 92–94.

**1941** "A Mediaeval Sculptured Saddle." *Bulletin of The Metropolitan Museum of Art* 36, pp. 73–76.

**Grass, N.**

**1965** "Zur Rechtsgeschichte der abendländischen Königskirche: Einwirkung französisch-böhmischer Sakralarchitektur auf die Capella Regia Austriaca." In *Festschrift Karl Siegfried Bader: Rechtsgeschichte, Rechtssprache, Rechtsarchäologie, rechtliche Völkskunde,* edited by Ferdinand Elsener and W. H. Ruoff, pp. 159–83. Zürich.

**Graus, Igor**

**1996** "Dračí rád Žigmunda Luxemburského a jeho symbolika." *Slovenská archivistika* 31, no. 2, pp. 86–106.

**Graz**

**1961** *Goldschmiedekunst.* Exh. cat. Graz. Exhibition, Kunstgewerbemuseum am Landesmuseum Joanneum in Graz.

**1982** See Biedermann 1982.

**Gresch, Diethelm**

**2004** "Das 'e' in der Wenzelsbibel." *Kunstchronik,* no. 3, pp. 131–37.

**Grimme, Ernst-Günther**

**1962** "Mittelalterliche Plastik in der Sammlung Hermann Schwartz." *Pantheon* 20, pp. 76–81.

**1966** *Deutsche Madonnen.* Cologne.

**1972** *Der Aachener Domschatz.* Aachener Kunstblätter 42. Düsseldorf.

**Grossmann, Dieter**

**1966** "'Schöne Madonnen 1350–1450': Ein Nachbericht zur Ausstellung in den Salzburger Domoratorien vom 17. Juni bis 19. September 1965." *Mitteilungen der Gesellschaft für Salzburger Landeskunde* 106, pp. 71–114.

**Grotefend, Siegfried**

**1909** "Die Erwerbungspolitik Kaiser Karls IV: Zugleich ein Beitrag zur politischen Geographie des deutschen Reiches im 14. Jahrhundert." PhD diss., Halle, Germany. Published in part in *Historische Studien* 66, pp. 65–113.

**Grüns, K.**

**1843** "Die Corporis Christi-Kirche in Prag." *Libussa* 2, pp. 313–29.

**Guiffrey, Jules**

**1894–** *Inventaires de Jean duc de Berry (1401–1416).* 2 vols.
**96** Paris.

**Gümbel, Albert**

**1923–** "Sebald Weinschröter, ein Nürnberger Hofmaler
**24a** Kaiser Karls IV." *Repertorium für Kunstwissenschaft* 44, pp. 13–23.

**1923–** "Ein Nachtrag zu 'Sebald Weinschröter. . . .'"
**24b** *Repertorium für Kunstwissenschaft* 44, pp. 512–14.

**Güntherová, Alžbeta, and Ján Mišianik**
**1977** *Stredoveká knižná maľba na Slovensku.* 2nd ed. Bratislava. First published 1961.

**Habich, Georg**
**1907** "Renaissance-Ausstellung des Bayerischen Museums-Vereins, I. Plastik." *Münchner Jahrbuch der bildenden Kunst* 1, pp. 66–92.

**Hadravová, A., and P. Hadrava**
**2002** "Tycho Brahe and Iohannes Sindel." In *Tycho Brahe and Prague: Crossroads of European Science.* Frankfurt am Main.

**Hahnloser, Hans R., ed.**
**1971** *Il Tesoro di San Marco.* Vol. 2, *Il Tesoro e il Museo.* Florence.

**Hahnloser, Hans R., and Susanne Brugger-Koch**
**1985** *Corpus der Hartsteinschliffe des 12.–15. Jahrhunderts.* Berlin.

**Haidinger, Alois**
**1983** *Katalog der Handschriften des Augustiner Chorher- renstiftes Klosterneuburg.* Veröffentlichungen der Kommission für Schrift- und Buchwesen des Mittelalters, ser. 2, vol. 2, no. 1. Vienna.
**1998** See Klosterneuburg 1998.

**Hájek of Libočany, Václav**
**1541** *Kronika česká.* Prague.

**Halama, Ota**
**2002** *Otázka svatých v české reformaci: Její promeny od doby Karla IV. do doby České konfese.* Prague.

**Hall, Edwin, and Horst Uhr**
**1995** "Das Kronenmotiv bei Maria und anderen Heiligen in der Altkölner Malerei." *Wallraf- Richartz-Jahrbuch* 56, pp. 101–26.

**Hamann, Richard, and Kurt Wilhelm-Kästner**
**1924– ** *Die Elisabethkirche zu Marburg und ihre künst- lerische Nachfolge.* 2 vols. Marburg an der Lahn.
**29**

**Hamburg**
**1999** *Die Kunst des Mittelalters in Hamburg: Goldgrund und Himmelslicht.* Exh. cat. edited by Uwe M. Schneede. Hamburg. Exhibition, Hamburger Kunsthalle.

**Hamburger, Jeffrey F.**
**1998** *The Visual and the Visionary: Art and Female Spirituality in Late Medieval Germany.* New York and Cambridge, Mass.
**2002** *St. John the Divine: The Deified Evangelist in Medieval Art and Theology.* Berkeley.

**Hammerschmidt, Johann Florian**
**1700** *Prodromus Gloriae Pragenae.* Prague.

**Hamsík, Mojmír**
**1967** "Die Technik der böhmischen Tafelmalerei des 14. Jahrhunderts." In *Kunst des Mittelalters in Sachsen: Festschrift Wolf Schubert,* edited by Elisabeth Hütter et al., pp. 321–26. Weimar.

**Harnisch, Harriet M.**
**1997** "Königs- und Reichsnähe Thüringischer Grafenfamilien im Zeitalter Karls IV." In Lindner et al. 1997, pp. 181–212.

**Harrsen, Meta, comp.**
**1958** *Central European Manuscripts in the Pierpont Morgan Library.* New York.

**Hass, Johannes**
**1870** *Goerlitzer Rathsannalen III.* Scriptores Rerum Lusaticarum, n.s., 4. Görlitz.

**Haupt, Moriz, ed.**
**1858** *Neidhart von Reuenthal.* Leipzig.

**Haussherr, Reiner**
**1971** "Zu Auftrag, Programm, und Büstenzyklus des Prager Domchores." *Zeitschrift für Kunstgeschichte* 34, pp. 21–46.

**Haverkamp, Alfred**
**1978** "Studien zu den Beziehungen zwischen Erz- bischof Balduin von Trier und König Karl IV." *Blätter für deutsche Landesgeschichte* 114, pp. 463–503.
**1995** "The Jewish Quarters in German Towns during the Late Middle Ages." In *In and Out of the Ghetto: Jewish-Gentile Relations in Late Medieval and Early Modern Germany.* Washington, D.C., and Cambridge.

**Heger, Hedwig, Ivan Hlaváček, Gerhard Schmidt, and Franz Unterkircher; with contributions by Katharina Hranitzky and Karel Stejskal**
**1998** *Kommentar.* Vol. 11 of Wenceslas Bible 1981–98.

**Heidelberg**
**1986** *Mittelalterliche Universitätszepter: Meisterwerke europäischer Goldschmiedekunst der Gotik.* Exh. cat. by Jürgen Miethke and Johann Michael Fritz. Heidelberg. Exhibition, Ruprecht-Karls- Universität Heidelberg.

**Heimpel, Hermann**
**1971** "Conrad Kyeser aus Eichstätt / *Bellifortis:* Umschrift und Übersetzung von Götz Quarg" (book review). *Göttingische Gelehrte Anzeigen* 223, pp. 115–48.

**Heinrichs-Schreiber, Ulrike**
**1994** "Die Bedeutung der französisch-höfischen Bildhauerkunst für den Meister von Gross- lobming." In Vienna 1994, pp. 9–30.
**1997** *Vincennes und die höfische Skulptur: Die Bildhauerkunst in Paris, 1360–1420.* Berlin.

**Heinrich Truchsess von Diessenhofen**
**1868** *Heinricus Dapifer de Diessenhofen (1316–1361).* In *Fontes Rerum Germanicarum,* edited by J. F. Böhmers and A. Huber, vol. 4, pt. 1, pp. 16–126. Stuttgart.

**Hejdová, Dagmar**
**1966** "Archeologický výzkum sklářské huti ve Sklen- ařicích, okres Semily." *Ars Vitraria* 1, pp. 11–26.
**1975** "Types of Medieval Glass Vessels in Bohemia." *Journal of Glass Studies* 17, pp. 142–50.
**1987** "Na okraj ilustrací Mandevillova cestopisu." *Umění* 35, pp. 515–19.

**Hejdová Dagmar, Olga Herbenová, Helena Koenigsmarková, Jan Rous, Libuše Urešová, Věra Vokáčková, and Milena Zeminová**
**1986** *Středověké umělecké řemeslo.* Prague.

**Hejdová, Dagmar, and B. Nechvátal**
**1970** "Raně středověké dlaždice v Čechách I, II.: Frühmittelalterliche Fliesen in Böhmen." *Památky archeologické* 61, pp. 100–183, 395–471.

**Hejnic, Josef**
**1959** "Náhrobky v Lapidáriu Národního muzea v Praze." *Sborník Národního Muzea,* ser. A, 13.

**Hensle-Wlasak, Helga**
**1988** "Der Bildschmuck im Codex 259 der Vorauer Stiftsbibliothek. Ein Beitrag zur böhmischen Buchmalerei des Spätmittelalters." PhD diss., Universität Graz.

**Henwood, Philippe**
**1980** "Jean d'Orléans, peintre des rois Jean II, Charles V et Charles VI (1361–1407)." *Gazette des Beaux- Arts,* ser. 6, 95, pp. 137–40.
**1981** "Peintres et sculpteurs parisiens des années 1400." *Gazette des Beaux-Arts,* ser. 6, 98, pp. 95–102.

**Hergemöller, Bernd-Ulrich**
**1999** *Cogor adversum te: Drei Studien zum literarisch- theologischen Profil Karls IV. und seiner Kanzlei.* Studien zu den Luxemburgern und ihrer Zeit, vol. 7. Warendorf.

**Herkommer, Hubert**
**1980** "Kritik und Panegyrik. Zum literarischen Bild Karls IV. (1346–1378)." *Rheinische Vierteljahrsblätter* 44, pp. 68–116.
**1984** "Die Geschichte von Leiden und Sterben des Jan Hus als Ereignis und Erzählung." In *Literatur und Laienbildung im Spätmittelalter und in der Reformationszeit: Symposion Woltenbüttel 1981,* pp. 114–45. Stuttgart.

**Hermann, Hermann-Julius**
**1929** *Die italienischen Handschriften des Dugento und Trecento.* Vol. 2, *Oberitalienische Handschriften der zweiten. Hälfte des XIV. Jahrhunderts.* Leipzig.

**Hertfelder, Bernard**
**1627** *Basilica SS. Udalrici et Afrae Augustae Vindelicorum, historice descripta atqua aeneis figuris illustrata.* Augsburg.

**Heuser, Hans-Jörgen**
**1974** *Oberrheinische Goldschmiedekunst im Hochmittelalter.* Berlin.

**Heyen, Franz-J., et al., eds.**
**1985** *Balduin von Luxemburg, Erzbischof von Trier, Kurfürst des Reiches (1285–1354). Festschrift aus Anlass des 700. Geburtsjahres.* Quellen und Abhandlungen zur mittelrheinischen Kirchen- geschichte, vol. 53. Mainz.

**Hildegard of Bingen**
**1990** *Scivias (Know the Way).* Translated by Mother Columba Hart and Jane Bishop. New York and Mahwah.

**Hilger, Hans Peter**
**1972** Eine Statue der Muttergottes aus dem Prager Parler-Kreis im Dom zu Köln." *Pantheon* 30, pp. 95–114.
**1973** "Zur Goldschmiedekunst des 14. Jahrhunderts an Rhein und Maas." In *Rhein und Maas: Kunst und Kultur, 800–1400,* edited by Anton Legner, vol. 2, pp. 457–66. Exh. cat. Cologne.
**1978** "Der Weg nach Aachen." In Seibt 1978a, pp. 344–56.
**1988** "Die Schöne Madonna aus Horažďovice im Bayerischen Nationalmuseum." *Münchner Jahr- buch der bildenden Kunst* 39, pp. 51–72.
**1991** "Eine unbekannte Statuette der Muttergottes auf dem Löwen." *Städel-Jahrbuch* 13, pp. 145–54.

**Hilsch, P.**
**1978** "Die Krönungen Karls IV." In Seibt 1978a, pp. 108–11.

**Historica XVII**
**1969** *Historica XVII.* Prague.

**Hlaváček, Ivan**
**1987** "Wenzel IV., sein Hof und seine Königsherr- schaft vornehmlich über Böhmen." In *Das spät- mittelalterliche Königtum im europäischen Vergleich,* edited by Reinhard Schneider, pp. 201–32. Vorträge und Forschungen 32. Sigmaringen.
**1991** *K organizaci státního správního systému Václava IV.: Dvě studie k jeho itineráři a radě.* Prague.
**1992** "Prag als Aufenthaltsort westmitteleuropäischer geistlicher Fürsten in der Zeit Karls IV." In *Westmitteleuropa Ostmitteleuropa: Festschrift für Ferdinand Seibt,* pp. 153–63. Munich.
**2000** "Wenzel (IV.) und Giangaleazzo Visconti." In *Festschrift für Peter Moraw,* pp. 203–26. Berlin.
**2002** "Hof und Hofführung König Wenzel IV." In *Deutscher Königshof, Hoftag und Reichstag,* edited by Peter Moraw, pp. 105–36. Stuttgart.
**2003** "Dvorské a zemské elity v Čechách v době Václava IV." In *Genealogia: Stan i perspektywy badań nad spolezenstwem Polski średniowieczej na tle porównawczym,* pp. 299–314. Toruń.

**Hlaváčková, Haná J.**
**1987** "Joseph erat decurio." *Umění* 35, pp. 507–14.
**1993** "Courtly Body in the Bible of Wenceslas IV." In *Künstlerischer Austach / Artistic Exchange: Akten des XXVIII. Internationalen Kongresses für Kunst- geschichte, Berlin, 15.–20. Juli 1992,* edited by Thomas Gaehtgens, vol. 2, pp. 371–82. Berlin.
**1998** "Panel Paintings in the Cycle of the Life of Christ from Vyšší Brod (Hohenfurth)." In Benešovská 1998, pp. 244–55.
**2002** "Herzogenburská moralia." In *Pro arte: Sborník k poctě Ivo Hlobila,* edited by Dalibor Prix, pp. 169–74. Prague.

**Hlaváčková, Hana J., and Hana Seifertová**
**1985** "La Madone de Most: Imitation et symbole," translated by Jacques Foucart-Borville. *Revue de l'art* 67, pp. 59–65.

1986 "Mostecká Madona—Imitatio a Symbol." English translations by Věra Koubová. *Umění* 34, pp. 44–57.

**Hlaváčková, Miriam**

2001 "Oltárne beneficiá v bratislavskom Dóme sv. Martina v 15. storočí." *Galéria: Ročenka Slovenskej Národnej Galérie v Bratislave,* 2001, pp. 85ff.

**Hledíková, Zdeňka**

1972 "Die Prager Erzbischöfe als ständige päpstliche Legaten. Ein Beitrag zur Kirchenpolitik Karls IV." In *Regensburg und Böhmen: Festschrift zur Tausendjahrfeier des Regierungsantrittes Bischof Wolfgangs von Regensburg und der Errichtung des Bistums Prag,* edited by G. Schwaiger and J. Staber, pp. 221–56. Beiträge zur Geschichte des Bistums Regensburg 6. Regensburg.

1982 "Fundace českých králů ve 14. Století." *Sborník historický* 28, pp. 5–55.

1984 "Karel IV. a Církev." In *Karolus Quartus,* edited by V. Vaněček. Prague.

1991 *Biskup Jan IV. z Dražic (1301–1343).* Prague.

2001 "Vyšehradské proboštství a české kancléřství v první polovině 14. století." In *Královský Vyšehrad* 2001, vol. 2.

**Hlobil, Ivo**

1980 "K olomoucké provenienci Novosadského Ukřižování Mistra rajhradské archy." *Historická Olomouc a její současné problémy* 3, pp. 42–49.

1987 "Přemyslovec Jan Volek: Rodopisné, heraldické a sfragistické otázky." *Umění* 35, pp. 478–82.

1998 "Zur stilistischen Entwicklung der Michler-Madonna-Gruppe (um 1320 bis Mitte des 14. Jahrhunderts)." In Benešovská 1998, pp. 216–22.

1999 "Petr Parléř—sochař." In *Petr Parléř, Svatovítská katedrála, 1356–1399,* edited by Petr Chotěbor, pp. 20–22. Prague.

**Hlobil, Ivo, et al.**

1994 *The Prague Castle and Its Treasures.* New York.

**Hoberg, Hermann, ed.**

1944 *Die Inventare des päpstlichen Schatzes in Avignon, 1314–1376.* Vatican City.

**Hoepffer, Ernest, ed.**

1908– *Œuvres de Guillaume de Machaut.* 3 vols.
21 Paris.

**Hoffmann, Edith**

1918 "Cseh miniatűrők a Szépművészeti Múzeumban." *Az Országos Magyar Szépművészeti Muzeum évkőnyvei* 1, pp. 49–74.

**Höfler, Carl**

1863 *Prager Concilien.* Prague.

**Hofmann, Hans-Hubert**

1963 "Karl IV. und die politische Landbrücke von Prag nach Frankfurt/Main." In *Zwischen Frankfurt und Prag: Sammelband des Collegium Carolinum,* pp. 51–74. Munich.

**Hofmann, Johannes, ed.**

1993 *Tausend Jahre Benediktiner in den Klőstern Břevnov, Braunau und Rohr.* Studien und Mitteilungen zur Geschichte des Benediktiner-Ordens und seiner Zweige; Ergänzungsband, vol. 33. St. Ottilien.

**Hohensee, Ulrike**

1997 "Zur Erwerbung der Lausitz und Brandenburg durch Kaiser Karl IV." In Lindner et al. 1997, pp. 212–43.

**Holešovský, Lea, and Karel Holešovský**

1993 "Zpráva o středověkém prenosném oltári v Moravské galerii v Brne." *Umění* 41, pp. 386–89.

1994 "Zpráva o středověkém přenosném oltáři v Moravské Galerii v Brně." *Bulletin Moravské Galerie v Brně* 50, pp. 60–62.

**Holeton, David Ralph**

1985 "Oslava Jana Husa v životě církve." *Husitský Tábor* 8, pp. 83–111.

1995 "O felix Bohemia. O felix Constantia: Liturgická úcta Mistra Jana Husa." In *Mezi epochami, národy*

a *konfesemi,* edited by Jan Blahoslav Lášek, pp. 154–70. Prague.

**Holladay, Joan A.**

1997 "Relics, Reliquaries, and Religious Women: Visualizing the Holy Virgins of Cologne." *Studies in Iconography* 18, pp. 67–118.

**Hölscher, Wolfgang**

1985 *Kirchenschutz als Herrschaftsinstrument: Personelle und funktionale Aspekte der Bistumspolitik Karls IV.* Studien zu den Luxemburgern und ihrer Zeit, vol. 1. Warendorf.

**Holter, Kurt**

1938 "Die Korczek-Bibel der Nationalbibliothek in Wien." *Die graphischen Künste,* n.s., 3, pp. 81–90.

**Holter, Kurt, and Karl Oettinger**

1938 "Manuscrits allemands." In *Les principaux manuscrits à peintures de la Bibliothèque Nationale de Vienne,* vol. 2. Bulletin de la Société Française de Reproduction de Manuscrits à Peintures 21. Paris.

**Homolka, Jaromír**

1963 "K problematice české plastiky, 1350–1450." *Umění* 11, p. 429.

1976 *Studie k počátkům umění krásného slohu v Čechách.* Acta Universitatis Carolinae, Monographia 55. Prague.

1982 *Umění doby posledních Přemyslovců.* Edited by Jiří Kuthan. Prague.

1990 "Prag und die mitteleuropäische Kunst um 1400: Einige Bemerkungen." In "Internationale Gotik in Mitteleuropa," *Kunsthistorisches Jahrbuch Graz* 24, pp. 178ff.

1997 "Umělecká výzdoba paláce a Menší věže hradu Karlštejna." In Fajt 1997, pp. 95–142.

1998 "The Pictorial Decoration of the Palace and the Lesser Tower of Karlštejn Castle." In Fajt 1998, pp. 46–93.

2004 "Paris-Gmünd-Prag: Die Königliche Allerheiligenkapelle auf der Prager Burg." In Strobel and Seifert 2004, pp. 135–39.

**Horvat, Andela**

1959 "Skulptura Parlerovog kruga u Zagrebačkoj katedrali." *Zbornik za umetnostno zgodovino,* n.s., 5–6, pp. 245ff.

**Horváth, Henrik**

1937 *Zsigmond király és kora.* Budapest.

**Hrdlička, L., and B. Nechvátal**

2001 "Nedestruktivní průzkumy v kostele sv. Petra a Pavla na Vyšehradě v letech 1980–1998." In *Královský Vyšehrad* 2001, vol. 2, pp. 102–12.

**Hughes, Charles, ed.**

1967 *Shakespeare's Europe: Unpublished Chapters of Fynes Moryson's Itinerary.* 2nd ed. New York.

**Hus, Jan**

1930 *Výklad víry.* Edited by F. Žilka. Jilemnice.

**Husband, Timothy B.**

1971 "Ecclesiastical Vestments of the Middle Ages: An Exhibition." *The Metropolitan Museum of Art Bulletin* 29, no. 7 (March), pp. 285–89.

1983 "Double Cup." In *Notable Acquisitions, 1982–83,* pp. 19–21. New York.

**Huszti, József**

1955 "Pier Paolo Vergerio s a magyar humanizmus kezdete." *Filológiai Közlöny* 1, pp. 521–33.

**Jacob, Paul L.**

1848– *Le Moyen Âge et la Renaissance: Histoire et description*
51 *des moeurs et usages, du commerce et de l'industrie, des sciences, des arts, des littératures, et des beaux-arts en Europe.* 5 vols. Paris.

**Jähnig, Bernhard**

1978 "Der deutsche Orden und Karl IV." *Blätter für deutsche Landesgeschichte* 114, pp. 151–64.

**Janssen, Wilhelm**

1978 "Karl IV. und die Lande an Niederrhein und Untermaas." *Blätter für deutsche Landesgeschichte* 114, pp. 203–41.

**Jékely, Zsombor**

1998 "The Garai Tomb Slab at the Augustinian Church of Siklós." *Acta Historiae Artium* 40, pp. 125–43.

**Jenni, Ulrike**

1976 *Das Skizzenbuch der internationalen Gotik in den Uffizien: Der Übergang vom Musterbuch zum Skizzenbuch.* 2 vols. Wiener kunstgeschichtliche Forschungen, 4. Vienna.

**Jenni, Ulrike, and Maria Theisen**

2004a "Die Bibel des Purkart Strnad von Janovic aus der Zagreber Metropolitan-Bibliothek, Cod. MR 156 (lat.), Prag um 1383." *Codices manuscripti* 48–49, pp. 13–34.

2004b *Mitteleuropäische Schulen III (ca. 1350–1400): Böhmen—Mähren—Schlesien—Ungarn (mit Ausnahme der Hofwerkstätten Wenzels IV. und deren Umkreis.* 2 vols. Vol. 12 of *Die illuminierten Handschriften und Inkunabeln der Österreichischen Nationalbibliothek: Fortsetzung des Beschreiben Verzeichnisses der illuminierten Handschriften der Nationalbibliothek in Wien.* Vienna.

**Jenšovský, Friderici**

1944– *Monumenta Vaticana Res gestas Bohemicas illustrantia.*
54 Vol. 3, *Acta Urbani V (1362–70).* Prague.

**Jerchel, Heinrich**

1937 "Das Hasenburgische Missale von 1409, die Wenzelswerkstatt und die Mettener Malereien von 1414." *Zeitschrift des Deutschen Vereins für Kunstwissenschaft* 4, pp. 218–41.

**Johannes de Thurocz.** See **Thuróczy, János.**

**Jopek, Norbert**

1988 "Zur Datierung der Helena-Schale im Trierer Domschatz." *Zeitschrift des Deutschen Vereins für Kunstwissenschaft* 42, pp. 71–76.

**Kaczmarek, Romuald**

1999 *Rzeźba architektoniczna XIV wieku we Wrocławiu.* Wrocław.

**Kadlec, Jaroslav**

1969 *Mistr Vojtěch Raňkův z Ježova.* Prague.

2004 *Klášter augustiniánských kanovníků v Třeboni.* Prague.

**Kaemmerer, Ludwig**

1926 "Berittener Grieswärtel aus einem Kampfspiel um 1430." *Zeitschrift für historische Waffen- und Kostümkunde,* n.s., 2, no. 4, pp. 73–74.

**Kaigl, J.**

1992 "Kostel Všech Svátých na Pražském hradě před požárem v roce 1541." *Zprávy památkove péče,* 2, pp. 1–8.

**Kalina, Pavel**

1995 "Cordium Penetrative: An Essay on Iconoclasm and Image Worship around the Year 1400." *Umění* 43, pp. 247–57.

1996 "Symbolism and Ambiguity in the Work of the Vyšší Brod Master." *Umění* 45, pp. 149–66.

2004 "Architecture as a Mise-en-scene of Power: The Týn Church of the Virgin Mary in Prague in the Pre-Hussite Period." *Umění* 52, pp. 123–35.

**Kalinowski, Lech**

1991 "Średniowieczne witraże w Kościele Mariackim." *Rocznik Krakowski* 57, pp. 19–35.

**Kalista, Zdeněk**

1971 *Karel IV: Jeho duchovni tvář.* Prague.

2004 *Karel IV. a Itálie.* Prague.

**Kalmár, Johann von**

1939 "Pfeilpitzen als Würdezeichen." *Zeitschrift für historische Waffen- und Kostümkunde,* n.s., 15, pp. 218–21.

**Kammel, Frank Matthias**

2000 *Kunst in Erfurt, 1300–1360: Studien zu Skulptur und Tafelmalerei.* Berlin.

**Kantor, Marvin**

1990 *The Origins of Christianity in Bohemia.* Evanston, Ill.

**Karłowska-Kamzowa, Alicja**

**1980** "Kontakty artystyczne z Czechami w malarstwie gotyckim Śląska, Pomorza Wschodniego, Wielkopolski i Kujaw." *Folia Historiae Artium* 16, pp. 39–66.

**2000** *Społeczeństwo średniowieczne na szachownicy życia: Studium ikonograficzne.* Poznań.

**Kavka, František**

**1978** "Karl IV. und die Oberlausitz." *Letopis: Jahresschrift des Instituts für sorbische Volksforschung,* ser. B, *Geschichte* 25, no. 2, pp. 141–60.

**1989** *Am Hofe Karls IV.* Leipzig.

**1993** *Vláda Karla IV. za jeho císařství (1355–1378),* part 1, *(1355–1364),* part 2, *(1364–1378).* Prague.

**2002** *Čtyři ženy Karla IV.: Královské sňatky.* Prague.

**Kavka, František, and Josef Petráň, eds.**

**1995** *Dějiny Univerzity Karlovy.* Vol. 1, *1347/48–1622.* Prague.

**2001** *A History of Charles University.* Vol. 1, *1348–1802.* Prague.

**Kedar, Benjamin Z.**

**1973** "Toponymic Surnames as Evidence of Origin: Some Medieval Views." *Viator: Medieval and Renaissance Studies* 4, pp. 123–29.

**Kehrer, Hugo**

**1912** *Die gotischen Wandmalereien in der Kaiser-Pfalz zu Forchheim.* Abhandlungen der Königlich Bayerischen Akademie der Wissenschaften, Philosophisch-philologische und historische Klasse, vol. 26, Abh. 3. Munich.

**Keival, Hillel**

**1984** "Autonomy and Independence: The Historical Legacy of Czech Jewry." In *The Precious Legacy: Judaic Treasures from the Czechoslovak State Collections.* New York.

**Kejř, Jiří**

**1988** *The Hussite Revolution.* Translated by Till Gottheinerová. Prague.

**Kelly, Samantha**

**2003** *The New Solomon: Robert of Naples (1309–1343) and Fourteenth-Century Kingship.* Leiden.

**Kéry, Bertálan**

**1972** *Kaiser Sigismund—Ikonographie.* Vienna.

**Kessler, Herbert L., and Johanna Zacharias**

**2000** *Rome 1300, on the Path of the Pilgrim.* New Haven.

**Kieslinger, F.**

**1932** "Österreichs frühgotische Madonnen." *Jahrbuch der Österreichischen Leo-Gesellschaft,* pp. 180–203.

**Kinder, Hermann, and Werner Hilgemann**

**1964** *DTV: Atlas zur Weltgeschichte.* Vol. 1, *Von den Anfängen bis zur französischen Revolution.* 2nd ed. Munich.

**Kirchweger, Franz**

**1996** "Zum Kunsthandwerk an der Wende vom 14. zum 15. Jahrhundert." In *Neuberg an der Mürz* 1996, pp. 301–10.

**2005** as editor. *Die Heilige Lanze in Wien: Insignie— Reliquie—"Schicksalsspeer."* Schriften des Kunsthistorischen Museums, vol. 9. Vienna.

**Klaes, Monica**

**1993** *Vita Sanctae Hildegardis.* Turnhout.

**Klagsbald, Victor**

**1981** *Catalogue raisonné de la collection juive du Musée Cluny.* [Paris.]

**Klaniczay, Gábor**

**1990** "Le culte des saints dynastiques en Europe centrale (Angevins et Luxembourg au XIVe siècle)." In *L'Église et le peuple chrétien dans les pays de l'Europe du centre-est et du nord (XIVe–XVe siècles): Actes du colloque . . . Rome, 27–29 janvier, 1986,* pp. 221–47. Rome.

**2002** *Holy Rulers and Blessed Princesses: Dynastic Cults in Medieval Central Europe.* Cambridge.

**Klapper, Joseph**

**1964** *Johann von Neumarkt, Bischof und Hofkanzler. Religiöse Frührenaissance in Böhmen zur Zeit Kaiser Karls IV.* Erfurter theologische Studien, 13. Leipzig.

**Klein, Wolfgang**

**1926** "Kaiser Karls IV. Jugendaufenthalt in Frankreich und dessen Einfluss auf seine Entwicklung." PhD diss., Berlin.

**Kleinert, Christian**

**2004** *Philibert de Montjeu (ca. 1374–1439).* Ostfildern.

**Klement, Benda**

**1987** "Časná Emriachiovská Truhlička z Kaple sv. Zikmunda ve Svatovítském Chrámu." *Umění* 35, pp. 483–89.

**Klemm, Alfred**

**1882** *Württembergische Baumeister und Bildhauer bis ums Jahr 1750.* Stuttgart.

**Kletzl, Otto**

**1931–ns** "Die Wenzelsstatue mit einem Parlerzeichen." **32** *Zeitschrift für bildende Kunst* 65, pp. 136–55.

**1936** *Die Junker von Prag in Strassburg.* Frankfurt am Main.

**1939** "Planfragmente aus der deutschen Dombauhütte von Prag in Stuttgart und Ulm." *Veröffentlichungen des Archivs der Stadt Stuttgart* 3, pp. 103ff.

**Kloos, Werner**

**1935** *Die Erfurter Tafelmalerei von 1350–1470: Ein Beitrag zur Kunstgeschichte Mitteldeutschlands.* Berlin.

**Kloss, Ernst**

**1942** *Die schlesische Buchmalerei des Mittelalters.* Berlin.

**Klosterneuburg**

**1998** *Verborgene Schönheit: Die Buchkunst im Stift Klosterneuburg.* Exh. cat. by Alois Haidinger. Klosterneuburg and Vienna. Exhibition, Stiftsmuseums Klosterneuburg.

**Knauer, E. R.**

**1977** "Kaiser Sigismund: Eine ikonographische Nachlese." In *Festschrift für Otto von Simson zum 65. Geburtstag,* edited by L. Grisebach and K. Renger, pp. 173–96. Frankfurt am Main.

**Knauz, Nandor**

**1890** *A Garam melletti Szent-Benedeki apátság.* Budapest.

**Kniha Památní**

**1933** *Kniha Památní na Sedmisetleté Založení Českých Křížovníků s Č HV. (1233–1933).* Prague.

**Koechlin, Raymond**

**1924** *Les ivoires gothiques français.* 2 vols. and portfolio. Paris.

**Koepf, Hans**

**1969** *Die gotischen Planrisse der Wiener Sammlungen.* Studien zur österreichischen Kunstgeschichte, vol. 4. Vienna.

**Koeppe, Wolfram, and Michelangelo Lupo**

**1991** "Appendice documentaria." In *Ori e argenti dei santi: Il tesoro del duomo di Trento,* edited by Enrico Castelnuovo, pp. 250–82. Trent.

**Kohlhaussen, Heinrich**

**1968** *Nürnberger Goldschmiedekunst des Mittelalters und der Dürerzeit, 1240–1540.* Berlin.

**Koller, Heinrich**

**1964** *Reformation Kaiser Siegmunds.* Monumenta Germaniae Historica, 500–1500: Staatsschriften des späteren Mittelalters, vol. 6. Stuttgart.

**Kořán, Ivo**

**1986** "Corpus Christi: Vitráže ze Slivence v kontextu České gotické malby." *Umění* 34, pp. 58–63.

**1987** "Vyšehradské inventáře mezi gotikou a barokem." *Umění* 35, pp. 540–47.

**1989** "Život našich gotických madon." *Umění* 37, pp. 193–220.

**1991** "Gotické veraikony a svatolukasské madony v Pražské katedrále." *Umění* 39, pp. 286–316.

**Kořán, Ivo, and Zbigniew Jakubowski**

**1976** "Byzantské vlivy na počátky: České malby gotické a Roudnická madona v Krakově." *Umění* 24, pp. 218–42.

**Kostílková, Marie**

**1975** "Pastoforium katedrály sv. Vita v Praze." *Umění* 23, pp. 536–43.

**Köstler, Andreas**

**1995** *Die Ausstattung der Marburger Elisabethkirche: Zur Ästhetisierung des Kultraums im Mittelalter.* Berlin.

**Kostowski, Jakub**

**1999** "Slezské umění a husitství." In Brno 1999–2000, pp. 101–9.

**Kotrba, Viktor**

**1960** "Kaple Svatováclavská v pražském katedrále." *Umění* 7, pp. 329–56.

**1969** "Die Bronzeskulptur des Hl. Georg auf der Burg zu Prag." *Anzeiger des Germanischen Nationalmuseums,* 1969, pp. 9–28;

**1971** "Kdy přišel petr Parléř do Prahy." *Umění* 19, pp. 109–35.

**1975** "Nové Město pražské–'Karlstadt' v universální koncepci císaře Karla IV." In Petr and Šabouk 1975, pp. 53–66.

**Kotrba, Viktor, Jaromír Homolka, Karel Stejskal, Jaromír Pešina, and Josef Krása**

**1971** Review of Swoboda 1969. *Umění* 19, pp. 358–401.

**Koula, Jan**

**1898–ns** "Nové prsteny ze sbírek. Musea království **99** českého." *Památky archeologické a místopisné* 17, 1898–99, pp. 407–8.

**Kouřimský, Jiří**

**1968** *The Catalogue of the Collection of Precious Stones of the National Museum in Prague.* Prague.

**Kovács, Éva**

**1964** *Kopfreliquiare des Mittelalters.* Leipzig.

**1987** "A Luxemburgi-uralkodók rendjei." In Budapest 1987, pp. 135–47.

**2004** *L'âge d'or de l'orfèvrerie parisienne au temps des princes de Valois.* Dijon.

**Kraft, Klaus**

**1971** "Ein Reliquienkreuz des Trecento." *Pantheon* 29, pp. 102–13.

**Kraków**

**1967** *Polskie hafty średniowieczne.* Exh. cat. edited by Maria Gutkowksa-Rychlewska and Maria Taszicka. Kraków.

**2000** *Wawel, 1000–2000: Jubilee Exhibition.* Exh. cat. 3 vols. Vol. 1, *Artistic Culture of the Royal Court and the Cathedral,* edited by Magdalena Piwocka and Dariusz Nowacki; vol. 2, *1000 Years of the Bishopric of Cracow,* edited by Jósef Andrzej Nowobilski and Andrzej Wlodarek; vol. 3, *Illustrations.* Exhibition, Muzeum Archidiecezjalne w Krakowie.

**Královský Vyšehrad**

**2001** *Královský Vyšehrad: Sborník příspěvků k 900. výročí úmrtí prvního českého krále Vratislava II. (1061–1092).* Edited by J. Huber et al. 2 vols. Prague.

**Kramář, Vincenc**

**1937** *Madona se sv. Kateřinou a Markétou.* Prague.

**Krása, Josef**

**1964** "Na okraj nové studie o mistru Geronského martyrologia." *Umění* 12, pp. 466–86. Reprinted in Krása 1990, pp. 231–52.

**1966** "Na okraj nové studie o Mistru geronského martyrologia." *Umění* 14, pp. 394–405.

**1966a** "Výstava rukopisů Knihovny Národního Muzea v Praze." *Umění* 14, pp. 603–7.

**1969** "Deux dessins du Louvre et la peinture de manuscripts en Bohême vers 1400." *Scriptorium* 23, pp. 163–76.

**1970** "Knižní malba." In Prague 1970, pp. 244–303.

**1971** *Die Handschriften König Wenzels IV.* Translation by Herta Sowinski of *Rukopisy Václava IV.* Prague.

1974a  *Rukopisy Václava IV.* 2nd ed. Prague.

1974b  "Studie o rukopisech husitské doby." *Umění* 22, pp. 17–50, 95–100.

1978  "O zlotnících Karla IV." *Umění a řemeslo* 4, pp. 14–22, 70.

1982  "Pečeti Karla IV." In *Doba Karla IV. v dějinách národů ČSSR,* edited by Michal Svatoš, pp. 291–301. Prague.

1983a  *The Travels of Sir John Mandeville: A Manuscript in the British Library.* Translated by Peter Kussi. New York. Also published in German.

1983b  "Der hussitische Biblizismus." In *Von der Macht der Bilder: Beiträge des C.I.H.A.-Kolloquiums "Kunst und Reformation,"* edited by Ernst Ullmann, pp. 54–59. Leipzig.

1984  "Knižní malba." In *Dějiny českého výtvarného umění,* vol. 1, part 2, edited by Jaroslav Chadraba. Prague.

1990  *České iluminované rukopisy 13.–16. století.* Edited by Jiří Dvorský and Jiří Kropáček. Prague.

**Kraus, Arnošt**

1917–  *Husitství v literatuře, zejména německé.* Vols. 1–3.
24  Prague.

**Krautheimer, Richard**

1927  *Mittelalterliche Synagogen.* Berlin.

**Krems**

1959  *Die Gotik in Niederösterreich: Kunst und Kultur einer Landschaft in Spätmittelalter.* Exh. cat. Krems. Exhibition, Minoritenkirche Krems-Stein.

1967  *Ausstellung Gotik in Österreich.* Exh. cat. edited by Harry Kühnel. Krems. Exhibition, Minoritenkirche Krems-Stein.

**Kren, Thomas, et al.**

1997  *Masterpieces of the J. Paul Getty Museum: Illuminated Manuscripts.* Los Angeles.

**Krieger, Michaela, and Gerhard Schmidt**

1996  *Erläuterungen zu den illuminierten Seiten.* Vol. 10 of Wenceslas Bible 1981–98.

**Krofta, Jan**

1958  "K problematice karlštejnských maleb." *Umění* 6, pp. 2–30.

1975  "Rodokmen císaře Karla IV. na Karlštejně a jeho domnělé kopie." *Umění* 23, pp. 63–66.

**Krofta, Kamil**

1900  "Kněz Jakub, stoupenec Matěje z Janova." *Český časopis historický* 6, pp. 278–80.

**Krohm, Hartmut**

2000  "Die Berliner Agnesfigur des 'Schönen Stils': Ein Hauptwerk Prager Provenienz?" In *Unter der Lupe: Neue Forschungen zu Skulptur und Malerei des Hoch- und Spätmittelalters. Festschrift für Hans Westhoff zum 60. Geburtstag,* edited by Anna Moraht-Fromm and Gerhard Weilandt, pp. 75–88. Stuttgart and Ulm.

**Kroos, Renate**

1989  "Quellen zur Liturgischen Benutzung des Domes und seiner Ausstattung." In *Der Magdeburger Dom: Ottonische Gründung und staufischer Neubau,* edited by Ernst Ullmann, pp. 88–97. Leipzig.

**Kropáček, Pavel**

1946  *Malířství doby husitské: Česká desková malba prvé poloviny XV. století.* Prague.

**Kroupová, J., and P. Kroupa**

2003  "On the Question of Depositing the Sacramentalia of the Holy Roman Empire in Bohemia." In Fajt 2003a, pp. 142–55.

**Kubíková, Milena**

1985  "Husova kacířská čepice." *Husitský Tábor* 8, pp. 637–46.

**Kuchynka, R.**

1919  "Czech Panels in the Waldes's Picture Gallery." *Archeological Antiquities* 31, pp. 61–65.

1923  In *Památky Archaeologické* 33.

**Kudrnáč, Jaroslav**

1985  "Archeologický výzkum středověké těžby drahých kamenů u Ciboušova v Krušných horách." *Památky a příroda* 10, pp. 594–603.

**Kumorovitz, Lajos Bernát**

1963  *A budai várkápolna és a Szent Zsigmond-prépostság történetéhez.* Tanulmányok Budapest múltjából 15, pp. 109–51.

**Kunsthistorisches Museum Wien**

1989  *Kunsthistorisches Museum Vienna: Guide to the Collections.* Vienna.

**Künstler, G.**

1976  "Sinn und Zweck der Darstellung Sigismunds in dem Wiener Bildnis." *Mitteilungen der Österreichischen Galerie* 19–20 (1975–76), pp. 5–31.

**Kupfer, Ephraim**

1973  "Concerning the Cultural Image of German Jewry and Its Rabbis in the Fourteenth and Fifteenth Centuries" (in Hebrew). *Tarbiz* 42, no. 1–2, pp. 113–47.

**Kurmann, P.**

2001  "Sens, Reims, Magdeburg und Prag. Echte und unechte gotische Zwerggalerien als politische Würdeformel?" In *Medievalia Augiensia. Forschungen zur Geschichte des Mittelalters,* pp. 439–49. Vorträge und Forschungen 54. Stuttgart.

**Kutal, Albert**

1936  "Ukřižování novosadské." *Volné směry* 32, pp. 67–74.

1958  "Madona ze Šternberku a její mistr." *Umění* 6, pp. 1–150, 213–14.

1961  "The Brunswick Sketchbook and the Czech Art of the Eighties of the Fourteenth Century." *Sborník prací filosofické fakulty Brněnské University,* ser. F, 5, pp. 205–28.

1962  *České gotické sochařví, 1350–1450.* Prague.

1963  "K problému gotické horizontalních piét." *Umění* 11, pp. 321–59.

1966a  "Bemerkungen zur Altstädter Madonna in Prag." *Sborník prací filosofické fakulty Brněnské University* 10, pp. 5–23.

1966b  "K problému krásných madon: Poznámka k výstavě 'krásné madony' v Salzburku." *Umění* 14, pp. 433–60.

1971  *Gothic Art in Bohemia and Moravia.* Translated from Czech by Till Gottheiner. London and New York.

1971a  "Výstava Stabat Mater v Salvburku." *Umění* 19, pp. 402–41.

1972  "Erwägungen über das Verhältnis der horizontalen und schönen Pietàs." *Umění* 20, pp. 485–520.

1984  "Gotické sochařství." *Dějiny českého výtvarného umění* (Prague) 1, no. 1, pp. 216–83.

**Kuthan, Jiří**

1988  "Poklady cisterciáckých klášterů v Čechách a na Moravě." *Umění* 36, pp. 127–41.

**Kutnahorská Bible**

1989  *Kuttenberger Bibel / Kutnahorská Bible bei Martin von Tišnov.* 2 vols.; vol. 1 edited by Reinhold Olesch and Hans Rothe; vol. 2 edited by Vladimír Kyas, Karel Stejskal, and Emma Urbánková. Paderborn. Facsimile of edition published in 1489.

**Kutzner, M.**

1998  "Schlesische Sakralarchitektur aus der ersten Hälfte des 14. Jahrhunderts: Zwischen allgemeinem Stil und regionalem Modus." In Benešovská 1998, pp. 164–77.

**Květ, Jan**

1929  "Nejstarší české vyobrazení upálení Mistra Jana Husi v bibli Martinické." In *Českou minulostí, práce žáků V. Novotného,* pp. 175–93. Prague.

**Kyas, Vladimír**

1997  *Česká Bible v dějinách národního písemnictví.* Prague.

**Kybal, Vlastimil**

2002  *Mistr Matěj z Janova. Jeho život, spisy a učení.* Reprint of 1905 ed. Prague.

**Kyeser, Conrad**

1967  *Bellifortis.* 2 vols. Facsimile of 1405 ms.; commentary volume edited by Götz Quarg. Düsseldorf.

**Laabs, Annegret**

2000  *Malerei und Plastik im Zisterzienserorden: Zum Bildgebrauch zwischen sakralen Zeremoniell und Stiftermemoria, 1250–1430.* Petersberg.

**Labande, L.-H.**

1932  *Les primitifs francais: Peintres et peintres-verriers de la provence occidentale.* Vol. 2. Marseille.

**Labarte, Jules**

1847  *Description des objets d'art qui composent la collection Debruge-Duménil, précédée d'une introduction historique.* Paris.

1864–  *Histoire des arts industriels au Moyen Âge et à l'époque*
66  *de la Renaissance.* 4 vols. plus Album. Paris.

**La Brocquière, Bertrandon de**

1892  *Le voyage d'Outremer de Bertrandon de la Brocquière premier écuyer tranchant et conseiller de Philippe le Bon, duc de Bourgogne.* Edited and annotated by Charles-Henri-Auguste Schefer. Recueil de voyages et de documents pour servir à l'histoire de la géographie depuis le XIIIe jusqu'à la fin du XVIe siècle, vol. 12. Paris.

**Labuda, Adam S.**

2004  "Die Retabelkunst im Deutschordensland, 1350–1450." In *Malerei und Skulptur des späten Mittelalters und der frühen Neuzeit in Norddeutschland. Künstlerischer Austausch im Kulturraum zwischen Nordsee und Baltikum,* edited by Hartmut Krohm, Uwe Albrecht, and Matthias Weniger, pp. 37–54. Berlin.

**Labuda, Adam S., et al., eds.**

2004  *Malarstwo gotyckie w Polsce.* Vol. 2, *Katalog.* Warsaw.

**Lamm, Carl Johan**

1929–  *Mittelalterliche Gläser und Steinschnittarbeiten aus*
30  *dem Nahen Osten.* 2 vols. Berlin.

**Lanc, Elga**

1983  *Die mittelalterlichen Wandmalereien in Niederösterreich und Wien.* Vienna.

**Lange, F.**

1849  "Die Kirche der heiligen Elisabeth zu Marburg: Beschreibung derselben und Plan zu ihrer Wiederherstellung." Ms. Fulda.

**Langer-Ottersböck, B. A.**

1972  "Early Gothic Calvary Scenes of Central Europe." PhD diss., Pittsburgh.

**Lauer, Rolf**

2004  "Die Parler stecken im Detail [part 2]: Masswerk am Petersportal des Kölner Domes." In *Parlerbauten. Architectur, Skulptur, Restaurierung,* pp. 63–71. Landesdenkmalamt Baden-Württemberg, Arbeitsheft 3. Stuttgart.

**Lavin, Irving, and John Plummer, eds.**

1977  *Studies in Late Medieval and Renaissance Painting in Honor of Millard Meiss.* 2 vols. New York.

**Lechner, Gregor M.**

1981  *Maria Gravida: Zum Schwangerschaftsmotiv in der Bildenden Kunst.* Münchner Kunsthistorische Abhandlungen 9. Munich.

**Legner, Anton**

1978  "Wände aus Edelstein und Gefässe aus Kristall." In Cologne 1978–79, vol. 3, pp. 169–82.

**Lehmann, Curt Otto**

1913  *Die Burggrafen von Nürnberg-Zollern in ihrem Verhältnis zu Kaiser Karl IV.* Halle, Germany.

**Leminger, Emanuel**

1926  *Umělecké řemeslo v Kutné Hoře.* Prague.

**Lemoisne, P. A.**

1931  *Gothic Painting in France: Fourteenth and Fifteenth Centuries.* Florence and New York.

**Leonhard, Walter**

**1978**   *Das grosse Buch der Wappenkunst: Entwicklung; Elemente; Bildmotive; Gestaltung.* 2nd ed. Munich.

**Lemper, Ernst-Heinz**

**1961**   "Ein spätotisches Bildnis Kaiser Sigismunds in den Städtischen Kunstsammlungen Görlitz." *Kunstmuseen der Deutschen Demokratischen Republik, Mitteilungen und Berichte* 3, pp. 36–41.

**1988**   "Das Görlitzer Bildnis des Kaisers Sigismund." *Görlitzer Magazin* 2, pp. 91–93.

*Lexikon der christlichen Ikonographie*

**1968–**   *Lexikon der christlichen Ikonographie.* Edited by
**76**   Engelbert Kirschbaum, with Günter Bandmann et al. 8 vols. Rome.

**Líbal, Dobroslav**

**1983**   "Architektura." In Poche 1983, pp. 167–356.

**Líbal, Dobroslav, and Pavel Zahradník**

**1999**   *Katedrála svatého Víta na Pražském hradě.* Prague.

**Liedke, Volker**

**1975**   "Meister Dietrich, König Sigismunds Baumeister und Meister Rapolt von Köln." *Ars Bavarica* 3, pp. 18–20.

**Lightbown, Ronald W.**

**1992**   *Mediaeval European Jewellery; with a Catalogue of the Collection in the Victoria and Albert Museum.* London.

**Lind, Karl**

**1873**   "Die österreichische kunsthistorische Abtheilung der Wiener Weltausstellung." *Mittheilungen der k.k. Central-Commission zur Erforschung und Erhaltung der Baudenkmale* 18, pp. 149–220.

**Lindner, Michael**

**1997**   "Kaiser Karl IV. und Mitteldeutschland (mit einem Urkundenanhang)." In Lindner et al. 1997, pp. 83–180.

**Lindner, Michael, Eckhard Müller-Mertens, and Olaf B. Rader, with Mathias Lawo, eds.**

**1997**   *Kaiser, Reich und Region: Studien und Texte aus der Arbeit an den Constitutiones des 14. Jahrhunderts und zur Geschichte der Monumenta Germaniae Historica.* Berichte und Abhandlungen, Sonderband, 2. Berlin.

**Lippert, Woldemar**

**1894**   *Wettiner und Wittelsbacher sowie die Niederlausitz im 14. Jahrhundert.* Dresden.

**List, Rudolf**

**1974**   *Stift Admont, 1074–1974: Festschrift zur Neunhundertjahrfeier.* Ried im Innkreis.

**Lohr, Otto**

**1981**   "Studien zum Londoner Mandeville." Master's thesis, Universität Bamberg.

**1996**   "Das Martyrologium von Gerona. Ein böhmisches Märtyrerbuch zu Beginn des 15. Jahrhunderts." *Umění* 44, pp. 276–302.

**London**

**1932**   *Exhibition of French Art, 1200–1900.* Exh. cat. edited by W. G. Constable and Trenchard Cox. London: Burlington House. Exhibition, Royal Academy of Arts.

**1965**   *Bohemian Glass.* Exh. cat. London. Exhibition, Victoria and Albert Museum.

**1967–**   *Hungarian Art Treasures, Ninth to Seventeenth*
**68**   *Centuries.* Exh. cat. London, [1967]. Exhibition, Victoria and Albert Museum.

**1989–**   *Italian Painting before 1400.* Exh. cat. edited by
**90**   David Bomford, Jill Dunkerton, Dillian Gordon, and Ashok Roy. Art in the Making. London. Exhibition, National Gallery.

**Lorenc, Vilém**

**1973**   *Nové Město pražské.* Prague.

**Loserth, Joseph**

**1892**   "Das Granum catalogi praesulum Moraviae nach der Handschrift des Olmützer Domcapitelarchivs." *Archiv für österreichische Geschichte* 78, part 1, pp. 41–97.

**Lővei, Pál**

**1987**   "A Sárkányrend fennmaradt emlékei." In Budapest 1987, pp. 148–79.

**1991**   "Néhány címeres emlék a 14–15. századból." *Művészettörténeti Értesítő* 40, pp. 49–67.

**1999**   "A Stibor-síremlékek mestere." *Budapest Régiségei* 33, pp. 103–21.

**2003**   "Drache und Schlange: Heraldische Elemente auf den Mittelalterlichen Wandbildern der Pfarrkirche von Siklós." *Acta Historiae Artium* 44, pp. 59–70.

**Lüdke, Dietmar**

**1983**   *Die Statuetten der gotischen Goldschmiede. Studien zu den "autonomen" und vollrunden Bildwerken der Goldschmiedeplastik und den Statuetten reliquiaren in Europa zwischen 1230 und 1530.* 2 vols. Munich.

**Ludwig, K.-H.**

**1991**   "Kyeser, Conrad." In *Lexikon des Mittelalters,* edited by Robert Auty, vol. 5, cols. 1595–96. Stuttgart.

**Lukács, Zsuzsa**

**1973**   "Kolozsvári Tamás passió-sorozatának burgundiai kapcsolatai." *Építés- és Építészettudomány* 5, pp. 331–39.

**Lukcsics, Pál**

**1931**   *XV. századi pápák oklevelei.* Vol. 1, *V. Márton Pápa (1417–1431).* Budapest.

**Lutsch, Hans**

**1891**   *Verzeichnis der Kunstdenkmäler der Provinze Schlesien* Vol. 3, *Der Regierungs-Bezirk Liegnitz.* Breslau.

**Lutze, Eberhard**

**1930–**   "Die Buchmalerei." *Anzeiger des Germanischen*
**31**   *Nationalmuseums* 1930–1931, pp. 7–21.

**Macek, Josef, Ernő Marosi, Ferdinand Seibt, eds.**

**1994**   *Sigismund von Luxemburg, Kaiser und König in Mitteleuropa, 1387–1437. Beiträge zur Herrschaft Kaiser Sigismunds und der europäischen Geschichte um 1400. Vorträge der internationalen Tagung in Budapest vom 8.–11. Juli 1987, anlässlich der 600. Wiederkehr seiner Thronbesteigung in Ungarn und seines 550. Todestages.* Warendorf.

**Machilek, Franz**

**1978**   "Privatfrömmigkeit und Staatsfrömmigkeit." In Seibt 1978a, pp. 87–101.

**1986**   "Die Heiltumsweisung." In *Nürnberg—Kaiser und Reich,* pp. 57–66. Exh. cat. Ausstellung des Staatsarchivs Nürnberg, hg. von Generaldirektion der Staatlichen Archive Bayerns, Nr. 20. Munich.

**2001**   "Lamprecht von Brunn († 1399): Ordensmann, päpstlicher Finanzmann und Diplomat, herzoglicher und königlicher Rat, Fürstbischof." *Bericht des historischen Vereins Bamberg* 137, pp. 185–225.

**2002–3**   "Karl IV. und Karl der Grosse." *Zeitschrift des Aachener Geschichtsvereins* 104–5, pp. 113–45.

**2005**   "Illuminierte Stadtrechtsbücher des 14–16. Jahrhunderts aus Mähren." In Fajt and Hörsch 2005.

**MacKinney, Loren**

**1965**   *Medical Illustrations in Medieval Manuscripts.* Vol. 1, *Early Medicine in Illuminated Manuscripts;* vol. 2, *Medical Miniatures in Extant Manuscripts.* Publications of the Wellcome Historical Medical Library, n.s., 5. London.

**Maercker, Karl-Joachim**

**1986**   "Überlegungen zu drei Scheibenrissen auf dem 'Böhmischen Altar' im Dom zu Brandenburg." *Österreichische Zeitschrift für Kunst und Denkmalpflege* 40, pp. 183–89.

**1988**   *Die mittelalterliche Glasmalerei im Stendaler Dom.* Corpus Vitrearum Medii Aevi, Deutsche Demokratische Republik 5, 1. Berlin.

**Maggs Bros.**

**1928**   *Music, Early Books, Manuscripts, Portraits and Autographs.* Dealer's cat. no. 512. London.

**Małkiewicz, H.**

**1996–**   "Les vitraux au cycle des Miracles du Christ à
**97**   l'église Notre-Dame de Cracovie." *FHA* 2–3, pp. 16–17.

**Mályusz, Elemér**

**1951–**   as editor. *Zsigmondkori oklevéltár.* Budapest.

**1984**   *Zsigmond király uralma Magyarországon, 1387–1437.* Budapest.

**1990**   *Kaiser Sigismund in Ungarn, 1387–1437.* Translated by Anikó Szmodits. Budapest.

**Mann, Vivian B.**

**1988**   "'New' Examples of Jewish Ceremonial Art from Medieval Ashkenaz." *Artibus et Historiae* 17, pp. 13–24.

**Mannowsky, Walter**

**1931–**   *Der Danziger Paramentenschats: Kirchliche*
**33**   *Gewänder und Stickereien aus der Marienkirche.* 2 vols. in 4 parts. Berlin.

**Marek, Jan**

**1985**   "Naleziště ametystů a jaspisů u Ciboušova a jeho vztah k tektonoice Krušných hor." *Památky a příoda* 10, pp. 628–32.

**Mareš, Frantisek**

**1893**   *České Sklo: Příspěvky k dějinám jeho až do konce XVIII. století.* Prague.

**Margue, Michel, ed.**

**1996**   *Un itinéraire européen: Jean l'Aveugle, comte de Luxembourg et roi de Bohême, 1296–1346.* Brussels.

**Marienstern**

**1998**   See Panschwitz-Kuckau (Germany) 1998.

**van Marle, Raimond**

**1930**   "Ein Altarbild aus der Schule von Avignon." *Der Cicerone* 22, pp. 185–91.

**Marosi, Ernő**

**1976**   "Vorläufige kunsthistorische Bemerkungen zum Skulpturenfund von 1974 in der Burg von Buda." *Acta Historiae Artium* 22, pp. 333–73.

**1982**   "Das grosse Münzsiegel der Königin Maria von Ungarn: Zum Problem der Serialität mittelalterlicher Kunstwerke." *Acta Historiae Artium* 28, pp. 3–22.

**1984**   "Zsigmond király Avignonban." *Ars Hungarica* 1984, pp. 11–27.

**1986**   "König Sigismund von Ungarn in Avignon, Orient und Okzident im Spiegel der Kunst." In *Festschrift Heinrich Gerhard Franz zum 70. Geburtstag,* pp. 229–49. Graz.

**1987**   as editor. *Magyarországi művészet, 1300–1470 körül.* 2 vols. A magyarországi művészet története, 2. Budapest.

**1993**   "Ujabb Zsigmond-portrék." In *Horler Miklós hetvenedik születésnapjára: Tanulmányok,* pp. 133–40. Budapest.

**1994**   "Zu 'Werkstatt' und 'Künstler' in der Skulpturenreihe der Sigismundzeit von Buda: Beobachtungen an der Figur des Apostels Bartholomäus." In Vienna 1994, pp. 36–63.

**1995**   *Kép és hasonmás: Művészet és valóság a 14–15. századi Magyarországon.* Budapest.

**1997**   "Erzsébet királyné Madonnája." *Ars Hungarica* 25, pp. 89–96.

**1998**   "Pentimenti. Korrekciók a 14–15. századi magyar művészet képén." In *Koppány Tibor hetvenedik születésnapjára: Tanulmányok,* pp. 97–117. Budapest.

**1999**   "A budavári Zsigmond-kori szobrok kérdései huszonkét év (és a Szent Zsigmond templom feltárásai) után." In Feld 1999, pp. 98ff.

**1999a**   "Probleme der prager St.-George-Statue aus dem Jahre 1373." *Umení* 47, pp. 389–99.

**Marschall, Werner**

**1980**   *Geschichte des Bistums Breslau.* Stuttgart.

**Matějček, Antonin**

**1924–**   "Sedlecký antifonář z r. 1414 v knihovně kláštera v
**25**   Nové Říši." *Pomátky Archeologické* 34, pp. 216–19.

**1931** "Malířství." In *Dějepis výtvarného umění v Čechách,* edited by Zdeněk Wirth. Prague.

**1938** *Česká malba gotická deskové malířství, 1350–1450.* Prague.

**Matějček, Antonín, and Jaroslav Pešina**

**1950** *Czech Gothic Painting, 1350–1450.* Prague.

**Matouš, František**

**1975** *Mittelalterliche Glasmalerei in der Tschechoslowakei.* Corpus Vitrearum Medii Aevi. Prague.

**Matthew of Neuenburg**

**1924–** *Die Chronik des Mathias von Neuenburg /*

**40** *Chronica Mathiae de Nuwenburg.* Edited by Adolf Hofmeister. 3 vols. Monumenta Germaniae Historica, Scriptores Rerum Germanicarum, n.s., vol. 4. Berlin.

**Medek, Václav**

**1971** *Osudy moravské církve do konce 14. věku.* Prague.

**Meersseman, Gilles Gérard**

**1958–** *Der Hymnos Akathistos im Abendland.* 2 vols.

**60** Spicilegium Friburgense, 2–3. Fribourg.

**Meier, Ulrich**

**1999** "Vom Mythos der Republik. Folgen und Funktionen spätmittelalterlicher Rathausikonographie in Deutschland und Italian." In *Mundus in imagine: Festschrift für Klaus Schreiner zum 65. Geburtstag,* edited by Andrea Löther et al., pp. 345–87. Munich.

**Meiss, Millard**

**1974** *French Painting in the Time of Jean de Berry: The Limbourgs and Their Contemporaries.* 2 vols. New York.

**Mencl, Václav**

**1948** *Česká architektura doby Lucemburské.* Prague.

**1971** "Poklasická gotika jižní Francie a Švábska a její vztah ke gotice české." *Umění* 19, pp. 217–54.

**Menclová, Dobroslava**

**1972** *České hrady.* 2 vols. Prague.

**Mengel, David Charles**

**2003** *Bones, Stones, and Brothels: Religion and Topography in Prague under Emperor Charles IV (1346–1378).* Notre Dame, Ind.

**Menhardt, Hermann**

**1960–** *Verzeichnis der altdeutschen literarischen Handschriften*

**61** *der Österreichischen Nationalbibliothek.* 3 vols. Berlin.

**Merhautová, Anežka**

**1994** as editor. *Katedrála sv. Víta v Praze.* Prague.

**Merlini, Elena**

**1988** "La 'Bottega degli Embriachi' e i cofanetti Eburnei fra Trecento e Quattrocento: Una proposta di classificazione." *Arte cristiana,* no. 727, pp. 267–82.

**Messerer, Wilhelm**

**1952** *Der Bamberger Domschatz in seinem Bestande bis zum Ende der Hohenstaufen-Zeit.* Munich.

**Metropolitan Museum**

**1975** *The Metropolitan Museum of Art: Notable Acquisitions, 1965–1975.* New York.

**Meyer, Wilhelm ed.**

**1893** *Die Handschriften in Göttingen.* Vol. 1. Verzeichniss der Handschriften im Preussischen Staate 1, no. 1. Berlin.

**Mezník, Jaroslav**

**1969** "Berichte der französischen königlichen Rechnungen über den Aufenthalt des jungen Karl IV. in Frankreich." In *Francisco Michálek Bartoš, Octogenario de Studiis Hussianis optime merito dant, donant, dedicant sodales discipuli amici,* pp. 291–95. Mediaevalia Bohemica, 1, no. 2. Prague.

**Michna, Pavel J.**

**1976** "Melická skupina gotyckých kachlů." *Umění* 24, pp. 148–58.

**1981** "Gotická kachlová kamna z hradu Melic na Vyškovsku. Pokus o rekonstrukci—Ein gotischer Kachelofen aus Burg Melice in der Wischauer Legend (Versích einer Rekonstruktion)." *Archaeologia Historica* (Brno) 6, pp. 333–60.

**Mikuláš Biskupec of Pelhřimov**

**1981** "Mikuláš Biskupec z Pelhřimova: Kronika obsahující při táborských kněží a její napadání ze strany pražských mistrů." In *Ze zpráv a kronik doby husitské.* Prague.

**Miller, Johannes**

**1690** *Historia Beatissimae Virginis Glacensis. Das ist kurtze Beschreibung Von dem Uralten Wunderthätigen Maria-Bild welches zu Glatz auf dem Hohen-Altar In der Pfarrkirche der Societät Jesu, Von viel hundert Jahren her Zu öffentlicher Verehrung vorgestellt und schon im Jahr 1364 Von Ernesto Dem ersten Ertz-Bischoff zu Prag Wunderthätig erkläret.* Glatz.

**Miłobędzki, A.**

**1965** "Późnogotyckie typy sakralne w architekturze ziem polskich." In *Późny gotyk: Studia nad sztuka przełomu średniowiecza i czasów nowożytnych,* pp. 83–112. Warsaw.

**Miodońska, Barbara**

**1968** "Dekoracia malarska rękopisu Kroniky czeskiej Přibíka z Radenína w zbiorach Czartoryskich." *Rozprawy i sprawozdania Muzeum Narodowego w Krakowie 9.*

**1993** *Małopolskie malarstwo książkowe, 1320–1540.* Warsaw.

**Möckshoff, Meinolf**

**1954** In *Collectanea Franciscana* 24, pp. 397–402.

**Möhring, Helmut**

**1997** *Die Tegernseer Altarretabel des Gabriel Angler und die Münchner Malerei von 1430–1450.* Munich.

**Mohrmann, Wolf D.**

**1978** "Karl IV. und Herzog Albert II. von Mecklenburg." *Blätter für deutsche Landesgeschichte* 114, pp. 353–89.

**Mollay, Károly**

**1959** *Das Ofner Stadtrecht: Eine deutschsprachige Rechtssammlung des 15. Jahrhunderts aus Ungarn.* Monumenta Historica Budapestinensia 1. Budapest.

**Molnar, Enrico**

**1953** "The Strange Ecumenical Story of Peter Payne the English Hussite." *Anglican Theological Review* 35 (July).

**Morand, Kathleen**

**1991** *Claus Sluter: Artist at the Court of Burgundy.* Austin.

**Moraw, Peter**

**1978** "Räte und Kanzlei." In Seibt 1978a, pp. 285–92, 460.

**1982** "Kaiser Karl IV., 1378–1978: Ertrag und Konsequenzen eines Gedenkjahres." In *Politik, Gesellschaft, Geschichtsschreibung: Giessener Festgabe für František Graus zum 60. Geburtstag,* edited by Herbert Ludat et al., pp. 224–318. Cologne.

**1985** "Grundzüge der Kanzleigeschichte Kaiser Karls IV. (1346–1378)." *Zeitschrift für historische Forschung* 12, pp. 11–42.

**1987** "Königliche Herrschaft und Verwaltung im spätmittelalterlichen Reich (ca. 1350–1450)." In *Das spätmittelalterliche Königtum im europäischen Vergleich,* edited by Reinhard Schneider, pp. 185–200. Sigmaringen.

**2002** as editor. *Raumerfassung und Raumbewusstsein im späteren Mittelalter.* Stuttgart.

**Möseneder, Karl**

**1981** "Lapides Vivi: Über die Kreuzkapelle der Burg Karlstein." *Wiener Jahrbuch für Kunstgeschichte* 34, pp. 39–69.

**Motschmann, Just Christoph**

**1729** *Erfordia Literata; oder, Gelehrtes Erffurth, worinnen so wohl von der Beschaffenheit und Einrichtung der Erffurthischen Universität als auch von denen gelehrten Leuten, welche sich hieselbst mit Schrifften berühmt oder bekannt gemacht ausführliche Nachricht ertheilet wird.* Vol. 1. Erffurth.

**Mucsi, András**

**1978** *Koloszvári Tamás Kálvária-óltára az ezstergomi Keresztény Múzeumban.* Budapest.

**1980** *Der Passionsaltar des Thomas de Coloswar im Christlichen Museum zu Esztergom.* Translation of Mucsi 1978. Budapest.

**Mudra, Aleš**

**2001** "Madonna z Bečova." *Ustecký sborník hisorický,* pp. 298–334.

**Mulin, Leo**

**1991** *La vie des étudiants au Moyen Âge.* Paris.

**Müller, Markus**

**1996** "Beobachtungen zur ikonographischen Kanonbildung der höfischen Minne. Das Braunschweiger Musterbuch im Herzog-Anton-Ulrich-Museum." *Niederdeutsche Beiträge zur Kunstgeschichte* 35, pp. 43–68.

**Müller, Theodor**

**1935** *Mittelalterliche Plastik Tirols: Von der Frühzeit bis zur Zeit Michael Pachers.* Berlin.

**1958** *Katalog der mittelalterlichen Bildwerke: Sammlung Emil G. Bührle.* Zürich.

**1966** *Sculpture in the Netherlands, Germany, France, and Spain, 1400 to 1500.* Translated by Elaine and William Robson Scott. Harmondsworth and Baltimore.

**Mulzer, Erich**

**1992** "Die Moritzkapelle; oder, Das Loch im Stadtbild." *Nürnberger Altstadtberichte* 17, pp. 37–84.

**Muneles, Otto, and Milada Vilímková**

**1955** *Starý židovský hřbitov v Praze.* Prague.

**Munich**

**1955** *Sakrale Gewänder im Mittelalter.* Exh. cat. edited by Sigrid Müller-Christensen. Exhibition, Bayerisches Nationalmuseum.

**1974** *Altdeutsche Zeichnungen aus der Universitätsbibliothek Erlangen.* Exh. cat. Introduction by Dieter Kuhrmann. Exhibition, Staatliche Graphische Sammlung München.

**1992** *Schatzkammerstücke aus der Herbstzeit des Mittelalters: Das Regensburger Emailkästschen und sein Umkreis.* Exh. cat. edited by Reinhold Baumstark, with contributions by Hans Peter Hilger et al. Munich. Exhibition, Bayerisches Nationalmuseum.

**Munich–Berlin–Hamburg**

**1956** *Deutsche Zeichnungen, 1400–1900.* Exh. cat. Munich. Exhibition, Haus der Kunst, Staatliche Graphische Sammlung München; Museum Dahlem, Kupferstichkabinett der Ehem. Staatlichen Museen Berlin; Kunsthalle Hamburg.

**Munich–Nuremberg**

**1978** See Nuremberg 1978.

**Munzer, Zdenka**

**1928** *Die Altneusynagoge in Prag.* Prague.

**Museums in Budapest**

**1989** *Museums in Budapest: Hungarian National Museum, Museum of Fine Arts, Hungarian National Gallery, Museum of applied Arts, Ethnographical Museum, Budapest Historical Museum.* Translated by Maria Steiner, trans. revised by Margaret Davies. 2nd ed. Budapest.

**Myslivec, Josef**

**1970** "Česká Gotika a Byzanc." *Umění: Časopis Ústavu dějin umění Československé akademie věd* 18, pp. 333–51.

**Nagy, Emese**

**1955** "Zsigmond király budavári Friss-palotája." *Budapest Régiségei* 16, pp. 105–31.

**Nagy, Géza**

**1894** "Harcias Fridrik első szász választó fejedelem magyar kardja." *Archaeologiai Értesítő,* n.s., 14, pp. 315–23.

**Narkiss, Bezalel**

**1970** *Hebrew Illuminated Manuscripts.* Jerusalem.

**Národní Galerie v Praze**
1992 See Chlíbec et al. 1992.

**Nechutová, Jana**
1964 "Traktát Mikuláše z Drážďan De ymaginibus a jeho vztah k Matěji z Janova." In *Sborník prací filosofické fakulty Brněnské Univerzity* 9, pp. 153–59.
1985 "Prameny předhusitské a husitské ikonofobie." *Husitský Tábor* 8, pp. 29–37.

**Nejedlý, Martin**
2002 "Od krásné dívky až k hadům a drakům. Proměny víly Meluzíny a jejich odraz v ikonografii středověkých pramenů / From Beautiful Maiden to Snakes and Dragons: The Transformation of the Nymph Melusina and Its Depiction in the Iconography of Medieval Source Material." *Archeologické rozhledy* 54, pp. 457–94.

**Nejedlý, Vratislav**
1974 "Jihočeská pozdně gotická nástěnná malba a její sociální pozadí." PhD diss., Masaryk University, Brno.

**Nejedlý, Zdeněk**
1913 *Dějiny husitského zpěvu I. za válek husitských.* Vol. 2. Prague.

**Netzer, Nancy**
1991 *Catalogue of Medieval Objects: Metalwork.* Boston: Museum of Fine Arts.

**Neuberg an der Mürz**
1996 *Schatz und Schicksal.* Exh. cat. edited by Otto Fraydenegg-Monzello. Graz. Exhibition, Steirische Landesausstellung.

**Neuhausen, Monika and Walter Neuhausen**
1990 "Oswald von Wolkenstein in Ungarn: Zu einem Kryptoporträt des Tiroler Dichters auf dem Altar des Thomas von Klausenburg." *Veröffentlichungen des Tiroler Landesmuseums Ferdinandeum* 70, pp. 183–97.

**Neuwirth, Josef**
1886 "Studien zur Geschichte der Miniaturmalerei in Oesterreich." *Sitzungsberichte der philosophisch-historischen Classe der kaiserlichen Akademie der Wissenschaften* 113, pp. 129–211.
1893 *Geschichte der bildenden Kunst in Böhmen vom Tode Wenzels III. bis zu den Hussitenkriegen.* Vol. 1, *Allgemeine Verhältnisse, Baubetrieb und Baudenkmale.* Prague.
1895 "Die Junker von Prag." *Mitteilungen des Vereins für Geschichte der Deutschen in Böhmen* 33, pp. 17–93.
1896 *Mittelalterliche Wandgemälde und Tafelbilder der Burg Karlstein in Böhmen.* Prague.
1897a *Das Braunschweiger Skizzenbuch eines mittelalterlichen Malers.* Prague.
1897b *Der Bilderzyklus des Luxemburger Stammbaumes aus Karlstein.* Prague.
1898 *Die Wandgemälde im Kreuzgang des Emmausklosters in Prag.* Prague.

**Newman, William Mendel**
1937 *Le domaine royal sous les premiers Capétiens (987–1180).* Paris.
1971 *Les seigneurs de Nesle en Picardie (XIIe–XIIIe siècle): Leurs chartes et leur histoire.* 2 vols. Paris.

**New York**
1915– *Catalogue of a Special Exhibition of Textiles.* Exh.
16 cat. New York. Exhibition, The Metropolitan Museum of Art.
1968– *Medieval Art from Private Collections: A Special*
69 *Exhibition at the Cloisters.* Exh. cat. by Carmen Gomez-Moreno. New York, 1968. Exhibition, The Cloisters.
1969 *The Guennol Collection.* Exh. cat. Vol. 1, edited by Ida Rubin. New York, 1975. Exhibition, The Metropolitan Museum of Art.
1975– *Patterns of Collecting: Selected Acquisitions, 1965–*
76 *1975.* Exh. cat. New York, 1975. Exhibition, The Metropolitan Museum of Art.

1994– *Painting and Illumination in Early Renaissance*
95 *Florence, 1300–1450.* Exh. cat. by Laurence B. Kanter, Barbara Drake Boehm, Carl Brandon Strehlke, Gaudenz Freuler, Christa C. Mayer Thurman, and Pia Palladino. New York, 1994. Exhibition, The Metropolitan Museum of Art.
1996– *From Court Jews to the Rothschilds: Art, Patronage,*
97 *and Power, 1600–1800.* Exh. cat. by Vivian B. Mann and Richard I. Cohen; essays by Fritz Backhaus et al. Munich and New York, 1996. Exhibition, Jewish Museum.
2000 *Collecting Treasures of the Past: The Kofler-Truniger Collection and Other Important Early Works of Art.* Exh. cat. New York and Munich. Exhibition, Blumka Gallery.
2004 *Byzantium: Faith and Power (1261–1557).* Exh. cat. edited by Helen C. Evans. New York. Exhibition, The Metropolitan Museum of Art.

**New York–Nuremberg**
1986 *Gothic and Renaissance Art in Nuremberg, 1300–1550.* Exh. cat. New York. Exhibition, The Metropolitan Museum of Art; Germanisches Nationalmuseum Nürnberg.

**Nice**
1996 *L'art gothique en slovaquie aux limites de la chrétienté occidentale, de la Galerie Nationale Slovaque, Bratislava.* Exh. cat. by Juraj Žáry, Alexej Fried and Luc Thevenon. Bratislava. Exhibition, Musée d'Art et d'Histoire, Palais Masséna.

**Nickel, Helmut**
1968 "Ceremonial Arrowheads from Bohemia." *The Metropolitan Museum of Art Journal* 1, pp. 61–90.
1969 "Böhmische Prunkpfeilspitzen." *Sborník Národního Muzea v Praze—Acta Musei Nationalis Pragae,* ser. A, 23, no. 3, pp. 102–63.
1971 "Addenda to 'Ceremonial Arrowheads from Bohemia.'" *The Metropolitan Museum of Art Journal* 4, pp. 179–81.
1984 "Ceremonial Arrowhead." *The Metropolitan Museum of Art—Notable Acquisitions, 1983–84,* pp. 20–21. New York.
1988 "Ceremonial Arrowhead." *The Metropolitan Museum of Art—Recent Acquisitions: A Selection 1987–88,* p. 23. New York.

**Nissen, Robert**
1933 "Ein Beitrag zu Konrad von Soest." *Westfalen* 18, pp. 107–14.

**Nissen, Rudolf**
1929 "Die Plastik in Brandenburg a. H. von ca. 1350 bis ca. 1450." *Jahrbuch für Kunstwissenschaft,* 1929, pp. 61–99.

**Noack, Werner**
1930 *Der Dom zu Bamberg.* Deutsche Bauten, 4. Burg bei Magdeburg.

**Nordenfalk, Carl**
1975 See Washington 1975.
1979 *Bokmålningar från medeltid och renässans i Nationalmusei samlingar.* Stockholm.

**Norman, Diana**
1999 *Siena and the Virgin: Art and Politics in a Late Medieval City State.* New Haven.

**Nováček**
1890 "Dietrich v. Portitz, Ratgeber Karls IV." *Časopis musea království Českého* 64 pp. 459–535.

**Novák, Jozef**
1967 *Slovenské mestské a obecné erby.* Bratislava.

**Novotný, Kamil, and Emanuel Poche**
1947 *The Charles Bridge of Prague.* Translated by Norah Robinson-Hronková. Prague.

**Novotný, Václav**
1921 *M. Jan Hus. Život a dílo* 2. Prague.
1923 *L'Université Charles IV dans le passé et dans le present.* Prague.

**Nový, Rostislav, Jiří Sláma, and Jana Zachová**
1987 *Slavníkovci ve středovékém písemnictví.* Prague.

**Nuremberg**
1903 See Bredt 1903.
1965 See Stafski 1965.
1978 *Kaiser–Karl IV., 1316–1378: Führer durch die Ausstellung des Bayerischen Nationalmuseums, München auf der Kaiserburg Nürnberg.* Exh. cat. edited by Johanna von Herzogenberg. Munich. Exhibition, Kaiserburg Nürnberg.
1990 *800 Jahre deutscher Orden.* Exh. cat. edited by Gerhard Bott and Udo Arnold. Gütersloh. Exhibition, Germanisches Nationalmuseum Nürnberg.

**Nussbaum, Norbert**
2000 *German Gothic Church Architecture.* Translated by Scott Kleager. New Haven.

**Oberhammer, Vinzenz**
1948 *Der Altar vom Schloss Tirol.* Innsbruck and Vienna.

**Obłąk, Jan**
1957 "Dzieje Boreschowa i jego obrazu." *Biuletyn Historii Sztuki* 19, pp. 70–73.

**Obrist, Barbara**
1983 "Das illustrierte "Adamas colluctancium aquilarum" (1418–1419) von Winand von Steeg als Zeitdokument." *Zeitschrift für Schweizerische Archäologie und Kunstgeschichte* 40, pp. 136–43.

**Octavio de Toledo, José M.**
1903 *Catálogo de la Librería del Cabildo Toledano.* Vol. 1, *Manuscritos.* Madrid.

**Oettinger, Karl**
1933 "Der Illuminator Michael." *Mitteilungen der Gesellschaft für vervielfältigende Kunst: Beilage der "Graphischen Künste,"* no. 1.
1952 "Wiener Hofmaler um 1360–1380. Zur Entstehung des ersten deutschen Porträts." *Zeitschrift für Kunstwissenschaft* 6, pp. 137–54.

**Oliver, Judith H.**
1995 "The Herkenrode Indulgence, Avignon, and Pre-Eyckian Painting of the Mid-Fourteenth-Century Low Countries." In *Flanders in a European Perspective: Manuscript Illumination around 1400 in Flanders and Abroad,* pp. 187–206. Leuven.

**Olomouc**
1999– *Od goticky k Renesanci: Výtvarná kultura Moravy*
2000 *a Slezska, 1400–1550.* Exh. cat. Vol. 3, Brno, edited by Ivo Hlobil. Exhibition, Muzeum Umění Olomouc.

**Opačić, Zoë**
2003 "Charles IV and the Emmaus Monastery: Slavonic Tradition and Imperial Ideology in Fourteenth-Century Prague." PhD diss., Courtauld Institute of Art, University of London. Currently in preparation for publication.
2005a "The Emmaus Monastery and the New Town: Slavonic Tradition, Imperial Ideology, and Public Ritual in Fourteenth-Century Prague." In *Emauzy 2003: Dvacet zastavení. Sborník konference, pořádané k znovuotevření chrámu Panny Marie a sv. Jeronýma benediktinského kláštera Na Slovanech,* edited by Klára Benešovská. Prague. Forthcoming.
2005b "*Reduktionsgotik* or 'Anti-Gothic'? Hall-Church Development in 14th-Century Prague." *Journal of the Society of Architectural Historians.* Forthcoming.

**Opitz, Josef**
1935 *Sochařství v Čechách za doby Lucemburkův.* Prague.

**Ormrod, Lucy C.**
1997 "The Wenceslas Chapel in St. Vitus' Cathedral, Prague. The Marriage of Imperial Iconography and Bohemian Kingship." PhD diss., Courtauld Institute of Art, University of London.

**Osten, Gert von der**
1935 *Der Schmerzensmann.* Berlin: Deutscher Verein für Kunstwissenschaft.

**Otavský, Karel**
1966 "Malířská výzdoba Klementinského sborníku Tomáše ze Štítného." PhD diss., University Karlovy v Praze.
1980 "Aachener Goldschmiedearbeiten des 14. Jahrhunderts." In Cologne 1978–79, vol. 4, pp. 77–84, discussion on pp. 85–88.
1992 *Die Sankt Wenzelskrone im Prager Domschatz und die Frage der Kunstauffassung am Hofe Kaiser Karls IV.* Europäische Hochschulschriften ser. 28, Kunstgeschichte, vol. 142. Bern.
2003 "Reliquien im Besitz Kaiser Karls IV., ihre Verehrung und ihre Fassungen." In Fajt 2003a, pp. 129–41.

**Otto, Maria**
1963 "Obraz epitafijny kanonika Bartłomieja Boreschowa." *Rocznik Olsztyński* 5, pp. 53–71.

**Outrata, J. J.**
1986 "Kostel Panny Marie před Týnem v Praze: Architektonický vývoj ve středověku a současná oparava." *Staletá Praha* 16, pp. 147–69.

**Paatz, Walter**
1971 See Vorbrodt, Vorbrodt, and Paatz 1971.

**Pächt, Otto**
1938 "A Bohemian Martyrology." *Burlington Magazine* 73, pp. 192–204.
1956 "Un tableau de Jacquemart de Hesdin?" *Revue des arts* 6, pp. 144–60.

**Palacký, František**
1829 as editor. *Scriptorum Rerum Bohemicarum.* Vol. 3, *Annales patrio sermone scripti vulgo Pulkavae et Benessii de Horowic chronicorum continuatores anonymi.* Prague.
1869 as editor. *Documenta Mag. Ioannis Hus: Vitam, doctrinam, causam in Constantiensi concilio actam . . . illustrantia.* Prague.
1896 *Documenta M. J. Hus.* Prague.

**Pangerl, Matthias, ed.**
1878 *Das Buch der Malerzeche in Prag.* Contributions by Alfred Woltmann. Quellenschriften für Kunstgeschichte und Kunsttechnik des Mittelalters und der Renaissance, vol. 13. Vienna.

**Pannonhalma**
1996 *Mons Sacer 996–1996. Pannonhalma 1000 éve.* Exh. cat. edited by Imre Takács. 3 vols. Pannonhalma. Exhibition, Szent-Benedek-Rendi Foapátság.
2001 *Paradisum plantavit: Bencés monostorok a középkori Magyarországon / Benedictine Monasteries in Medieval Hungary.* Exh. cat. edited by Imre Takács. Pannonhalma. Exhibition, Bencés Foapátságban (Benedictine Archabbey).

**Panschwitz-Kuckau (Germany)**
1998 *Zeit und Ewigkeit: 128 Tage in St. Marienstern.* Exh. cat. edited by Judith Oexle, Markus Bauer, and Marius Winzeler. Halle, Germany. Exhibition, Saint Marienstern Abbey.

**Paret, Oscar, et al.**
1952 *Neue Beiträge zur Archäologie und Kunstgeschichte Schwabens: Julius Baum zum 70. Geburtstag am 9. April 1952 gewidmet.* Stuttgart.

**Pařík, Arno, and Vlastimila Hamáčková**
2003 *Pražské židovské hřbitovy / Prague Jewish Cemeteries / Prager jüdische Friedhöfe.* Translated by Stephen Hattersly and Peter Zieschang. Prague.

**Pařík, Arno, and Pavel Štecha**
1992 *The Jewish Town of Prague.* Translated by Gita Zbavitelová and Dušan Zbavitel. Prague.

**Paris**
1904 *Exposition des primitifs français.* Exh. cat. edited by Henri Bouchot et al. Paris. Exhibition, Palais du Louvre.
1957 *L'art ancien en Tchécoslovaquie.* Exh. cat. Paris. Exhibition, Musée des Arts Décoratifs.
1968 *La Librairie de Charles V.* Exh. cat. by François Avril and Jean Lafaurie. Paris. Exhibition, Bibliothèque Nationale.
1981 See Paris 1981–82.
1981– *Les fastes du gothique: Le siècle de Charles V.*
82 Exh. cat. by Bruno Donzet and Christian Siret. Paris, 1981. Exhibition, Galeries Nationales du Grand Palais.
1984 *Le trésor de Saint-Marc de Venise.* Exh. cat. Milan. Exhibition, Galeries nationales du Grand Palais, Paris.
1991 *Le trésor de Saint-Denis.* Exh. cat. by Daniel Alcouffe. Paris. Exhibition, Musée du Louvre.
1991– *D'une main forte: Manuscrits hébreux des collections*
92a *françaises.* Exh. cat. by Michel Garel. Paris. Exhibition, Bibliothèque Nationale, Galerie Mansart.
1991– *Sculptures allemandes de la fin du Moyen Âge dans*
92b *les collections publiques françaises, 1400–1530.* Exh. cat. edited by Sophie Guillot de Suduiraut. Paris, 1991. Exhibition, Musée du Louvre.
1998 *L'art au temps des Rois maudits: Philippe le Bel et ses fils, 1285–1328.* Exh. cat. Paris. Exhibition, Galeries Nationales du Grand Palais.
2001 *Les gemmes de la couronne.* Exh. cat. by Daniel Alcouffe. Paris. Exhibition, Musée du Louvre.
2001a *Le trésor de la Sainte-Chapelle.* Exh. cat. edited by Jannic Durand and Marie-Pierre Laffite. Paris. Exhibition, Musée du Louvre.
2004 *Paris 1400: Les arts sous Charles VI.* Exh. cat. edited by Elisabeth Taburet-Delahaye with contributions by François Avril. Paris. Exhibition, Musée du Louvre.

**Paris–Prague**
1992 See Chlíbec et al. 1992.

**Passarge, Walter**
1924 *Das deutsche Vesperbild im Mittelalter.* Cologne.

**Patera, Adolf**
1901 "Hodiny sv. Mařie ze XIV. století." *České muzeum filologické* 7, pp. 86–103, 351–63.

**Patrologia Latina**
1844– *Patrologiae cursus completus . . . Series Latina.*
55 Edited by Jacques-Paul Migne. 217 vols. Paris.

**Patze, Hans**
1978 as editor. *Kaiser Karl IV, 1316–1378: Forschungen über Kaiser und Reich.* Blätter für deutsche Landesgeschichte. Neue Folge des Korrespondenzblattes 114. Neustadt / Aisch.

**Pazaurek, Gustav E.**
1937 *Perlmutter.* Berlin.

**Pečírka, Jaromír**
1933 "K dějinám sochařství v lucemburských Čechách." *Český časopis historický* 39, pp. 12–35.

**Pekař, Josef**
1927– *Žižka a jeho doba.* Vols. 1–3. Prague.
33

**Pelzel, Franz Martin**
1781 *Kaiser Karl der Vierte.* Vol. 2. Prague.

**Pelzer, Augustus**
1931 *Bibliothecae Vaticanae Apostolicae codices manu scripti.* Codices Vaticani Latini, II/1. Rome.

**Pertz, G. H.**
1847 "Reise nach Böhmen, Oesterreich, Salzburg und Mähren." *Archiv der Gesellschaft für ältere Geschichtskunde* 9, pp. 463–85.

**Pesek, J., and B. Zilynskyj**
1988 *Králowská Cesta.* Prague.

**Pešina, Jaroslav**
1935 "On the Dating of Panel Paintings in Waldes's Picture Gallery." *The Yearbook of the Circle of Cultivating Art History,* 1935, pp. 131–37.
1960 "Nový pokus o revizi dějin českého malířství 15. století." *Umění* 8, pp. 109–34.
1965 "Obraz krajiny v české knižní malbě kolem roku 1400." *Umění* 13, pp. 233–89.
1970 See Prague 1970.
1972 "Zur Frage des 'Schönen Stils' in der Tafelmalerei Böhmens." *Jahrbuch des Kunsthistorischen Institutes der Universität Graz* 7, pp. 1–28.
1976 *Česká gotická desková malba.* Prague.
1977 "Studie k ikonografii a typologii obrazu Madony s dítětem v českém deskovém malířství kolem poloviny 14. století." *Umění* 25, pp. 130–60.
1978 "Imperium et sacerdotium. Zur Inhaltsdeutung der sogenannten Morgan-Täfelchen." *Umění* 26, pp. 521–28.
1980 "Zur Herkunftsfrage der Kaufmannschen Kreuzigung." *Zeitschrift für Kunstgeschichte* 43, pp. 352–59.
1981 "Bohemica pravá a nepravá (na okraj studie M. Frinty českém deskovém malířství)." *Umění* 29, pp. 418–26.
1982 *Mistr vyšebrodského cyklu.* Prague.
1984 "Desková malba." *Dějiny českého výtvarného umění* 1, no. 1.
1986 *Master of the Altarpiece from Vyšší Brod.* Prague.
1989 *The Master of the Hohenfurth Altarpiece and Bohemian Gothic Panel Painting.* Translation of Pešina 1982. London.

**Pešina of Čzechorodu, Tomáš Jan**
1673 *Phosphorus septicornis.* Prague.

**Petersohn, Jürgen**
1960 "Eine neue Handschrift der Summa cancellaria des Johann von Neumarkt." *Mitteilungen des Österreichischen Instituts für Geschichtsforschung* 68, pp. 333–47.

**Petr, Jan, and Sáva Šabouk, eds.**
1975 *Z tradic slovanské kultury v Čechách: Sázava a Emauzy v dějinách české kultury.* Prague.

**Petr of Mladoňovice**
1981 "Zpráva o Mistru Janu Husovi v Kostnici," translated by František Heřmanský. In *Ze zpráv a kronik doby husitské.* Prague.

**Petrarca, Francesco**
1974 *Listy velkým i malým tohoto světa.* Translated by D. Rausch. Prague.

**Petrus Alphonsi**
1911 *Disciplina clericalis.* Edited by A. Hilka and W. Söderhjelm. Helsingfors.

**Pfeil, Christoph, Graf von**
1986 *"Die Altenburg ob Bamberg": Baugeschichte und Funktion.* Bamberg.

**Pferschy-Maleczek, Bettina**
1996 "Der Nimbus des Doppeladlers: Mystik und Allegorie im Siegelbild Kaiser Sigmunds." *Zeitschrift für historische Forschung* 23, pp. 433–72.

**Piccolomini, Eneas Silvio**
1998 *Historia Bohemica / Historie ská. Enea Silvio.* Translated by Dana Martínková, Alena Hadravová, and Jiří Matl. Fontes Rerum Regni Bohemiae, vol. 1. Prague.

**Pierpont Morgan Library**
1976 *Seventeenth Report to the Fellows of the Pierpont Morgan Library, 1972–74.* Edited by Charles Ryskamp. New York.

**Pinder, Wilhelm**
1920 "Die dichterische Wurzel der Pietà." *Repertorium für Kunstwissenschaft* 42, pp. 145–63.
1923 "Zum Problem der 'Schönen Madonnen' um 1400." *Jahrbuch der Preussischen Kunstsammlungen* 44, pp. 147–71.
1924 *Die deutsche Plastik vom ausgehenden Mittelalter bis zum Ende der Renaissance.* Vol. 1. Wildpark-Potsdam.

**Pirchan, G.**
1953 "Karlstein." In *Forschungen zur Geschichte und Landeskunde der Sudetenländer,* vol. 1, *Prager Festgabe für Theodor Mayer,* edited by Rudolf Schreiber. Freilassing.

**Pirker-Aurenhammer, Veronika**
2002 *Das Gebetbuch für Herzog Albrecht V. von Österreich. Wien ÖNB, Cod. 2722.* Graz.

**Piur, Paul, ed.**

1937 *Briefe Johanns von Neumarkt*. Vom Mittelalter zur Reformation, vol. 8. Berlin.

**Pla Gargol, J.**

1956 *Los museos de Gerona*. Gerona and Madrid.

**Pliny, the Elder**

1962 *Natural History*. Vol. 10. Translated by D. E. Eichholz. Loeb Classic Library. London.

**Poche, Emanuel**

1965 "Einige Erwägungen über die Kameen Karls IV." In *Sborník k sedmdesátinám Jana Květa*. Prague.

1972 "Plenáře svatojiřské." *Umění* 20, pp. 226–33.

1977– as editor. *Umělecké Památky Čech*. 4 vols. Prague.
82

1983 as editor. *Praha Středověká: Architektura, sochařství, malířství, umělecké řemeslo. Čtvero knih o praze*. Prague.

1984 "Umělecká řemesla gotické doby." In Chadraba 1984, vol. 1, part 2, pp. 440–96.

**Podlaha, Antonin**

1899 *Topographie der historischen und Kunstdenkmale im Königreich Böhmen*. Vol. 6, Bezirk Melnik. Prague.

1904 *Die Bibliothek des Metropolitankapitels*. Topographie der Historischen und Kunst-Denkmale im Königreich Böhmen, vol. 2, part 2. Prague.

1926 *Český slovník bohovědný*. Vol. 3. Prague.

1931 *Catalogi ss. Reliquiarum, quae in sacra metropolitana ecclesia pragensi asservantur, annix 1673, 1691 et 1721 typis editi*. Prague.

1948 See Prague 1948.

**Podlaha, Antonin, and Kamil Hilbert**

1906 *Metropolitní chrám sv. Víta v Praze*. Soupis památek historických a uměleckých v Království českém od praveku do počátku XIX. století, vol. 1. Prague.

**Podlaha, Antonin, and Eduard Šittler**

1901 *Soupis Památek historických a uměleckých v politickem okresu Karlínském*. Prague.

1903a *Chrámový Poklad u. sv. Víta v Praze: Jeho Dějiny a Popis*. Prague.

1903b *Der Domschatz in Prag*. Topographie der His-torischen und Kunst-Denkmale im Königreiche Böhmen: Die Königl. Hauptstadt Prag: Hradschin, vol. 2, Abteilung 1. Prague.

**Podlaha, Antonín, and Josef Zahradník**

1900 "Rukopisy drobnomalbami vyzdobené v knihovně kláštera strahovského." *Památky archeo-logické* 19.

**Pogány-Balás, E.**

1975 "Observations in Connection with the Antique Prototype of the St. George Sculpture of Márton and György Kolozsvári." *Acta Historiae Artium* 21, pp. 333–58.

**Polívka, M.**

1983 "K šíření husitství v Praze. Bratstvo a kaple Božího těla na Novém Městě pražském v předhusitské době." *Folia historica Bohemica* 5, pp. 95–118.

**Pölnitz, Sigmund, Freiherr von**

n.d. *St. Kunigundes Chormantel*. Nürnberg.

**Poncelet, Albert**

1910 *Catalogus codicum hagiographicorum latinorum Bibliothecae Vaticanae*. Brussels.

**Popp, Dietmar**

1996 *Duccio und die Antike. Studien zur Antikenvorstellung und zur Antikenrezeption in der Sieneser Malerei am Anfang des 14. Jahrhunderts*. Munich.

**Porta, Johannes, de Annoniaco, 14th century**

1913 *Iohannis Porta de Annoniaco Liber de coronatione Karoli IV., imperatoris*. Edited by Richard Salomon. Scriptores Rerum Germanicarum in usum scholarum ex Monumentis Germaniae historicis recusi, 35. Hannover and Leipzig.

**Prague**

1948 *Poklad v Chramu Sv. Víta v Praze*. Exh. cat. by Antonín Podlaha. Prague.

1970 *České umění gotické, 1350–1420*. Exh. cat. edited by Jaroslav Pešina. Prague. Exhibition, Academia Praha.

1985 *Restaurátorský ateliér Národní Galerie v Praze*. Exh. cat. by Mojmír Hamsík and Ladislav Kesner. Prague. Exhibition, Národni Galerie v Praze.

1988 *Staré české umění: Sbírky Národní Galerie v Praze, Jiřský Klášter*. Exh. cat. edited by Otakara Votočka and Lubomíra Slavíčka. Katalog stálé expozice, 2. Prague.

1990a See Stejskal and Voit 1991.

1990b *Mistr Týnské kalvárie*. Exh. cat. edited by Jan Chlíbec. Prague. Exhibition, Národni Galerie v Praze.

1993 *Strahovská obrazárna: Od gotiky k romantismu; vybraná díla ze sbírek Kláštera Premonstrátu na Strahove*. Edited by Michael Josef Pojezdný and Ivana Kyzourová. Prague. Exhibition, Klášter Premonstrátu na Strahove.

1995a *The Bride in the Enclosed Garden*. Exh. cat. by Martin Zlatohlávek; translated by Katerina Hilská. Prague. Exhibition, Convent of St. Agnes of Bohemia.

1995b *Gotíka v západních Čechách / Gothic Art and Architecture in Western Bohemia / Gotik in Westböhmen (1230–1530)*. Exh. cat. by Jiří Fajt et al. Prague. Exhibition, Národní Galerie v Praze.

1997 *Svatý Vojtěch: Tisíc let svatovojtěšské tradice v čechách*. Exh. cat. by Milena Bartlová et al. Prague. Exhibition, Národní Galerie v Praze.

1997– See Fajt 1997 and Fajt 1998.
98

2001 *Coutumes et traditions juives: Les fêtes, la synagogue et le cours de la vie*. Exh. cat. Prague. Exhibition, Zidovské Muzeum.

2001a *Ten Centuries of Architecture*. Vol. 2, *Architecture of the Gothic*. Exh. cat. by Klára Benešovská et al. Prague. Exhibition, Prague Castle.

2002–3 *Těšínská Madona a vzácné sochy Petra Parléře / Cieszynska madonna i cenne rzezby Piotra Parlera / Die Teschener Madonna und wertvolle Statuen von Peter Parler*. Exh. cat. edited by Helena Dáňová and Ivo Hlobil. Prague. Exhibition, Národní Galerie v Praze.

2005 *Medieval Art in Bohemia and Central Europe, 1200–1550: Guide to the Exhibition of the Collection of Old Masters of the National Gallery in Prague*. Exh. cat. by Jiří Fajt and Štěpánka Chlumská. Prague. Exhibition, Convent of Saint Agnes.

**Prague–Munich**

1993 *Johannes von Nepomuk, 1393–19993*. Exh. cat. edited by Reinhold Baumstark, Johanna von Herzogenberg, and Peter Volk. Munich. Exhibition, Kloster Strahov; Bayerisches Nationalmuseum.

**Prague Castle**

2003 *The Story of Prague Castle*. Contributions by Gabriela Dubská et al.; translated by Kathleen Hayes. Prague: Prague Castle Administration.

*Pražský hrad*

1999 *Pražský hrad, Kaple sv. Václava*. Prague.

**Preyss, Dorothea**

2001 "'Die Auferweckung der Druisana und die Kreuzigung Christi': Kunsthistorische und malerische Untersuchungen zu zwei Tafelgemälden des 14. Jahrhunderts aus dem Bayerischen Nationalmuseum in München." In *Beiträge zur Kunstgeschichte Ostmitteleuropas*, edited by Hanna Nogossek and Dietmar Popp, pp. 61–73. Marburg.

**Prinz, Friedrich**

1988 *Frühes Mönchtum im Frankenreich*. 2nd ed. Darmstadt.

**Prokop, August**

1884– *Kunstgewerbliche Objekte der Ausstellung kirchlicher*
85 *Kleinkunst im Mährischen Gewerbe-Museum*. Brünn.

1904 *Die Markgrafschaft Mähren in kunstgeschichtlicher Betrachtung: Grundzüge einer Kunstgeschichte dieses Landes mit besonderer Berücksichtigung der Baukunst*. Vol. 3. Vienna.

**Pujmanová, Olga**

1980 "Několik poznámek k dílům Tomasa da Modena na Karlštejně." English summary by T. Gottheinerová. *Umění* 28, pp. 305–32.

1983 "Nová gotická deska českého původu." *Umění* 31, pp. 132–42.

1992 "Studi sul culto della Madonna di Aracoeli e della Veronica nella Boemia tardomedievale." *Arte cristiana* 80, no. 751, pp. 243–64.

1995– "The Vyšši Brod Crucifixion." *Bulletin of the*
96 *National Gallery in Prague* 5–6, pp. 105–12.

1997 "Portraits of Kings Depicted as Magi in Bohemian Painting." In Gordon, Monnas, and Elam 1997, pp. 247–67.

1998 "Neznámé Bohemicum." In *Gotíka v Západních Čechách (1230–1530), Sborník Příspěvků z Mezinárodního Vědeckého Symposia*, pp. 215–21. Prague.

2003 "On the Sources of Inspiration of the Art at the Court of Charles IV." In Fajt 2003a, pp. 86–102.

**Pulkava, Přbík**

1893 *Cronica Przibicionis dicti Pulkaua*. In *Fontes Rerum Bohemicarum*, vol. 5, pp. 3–326. Prague.

**Puppi, L.**

1982 "Il mosaico del 'Guidizio Universale' nella Cattedrale di S. Vito a Praga." In *Mezinárodní vědecká konference doba Karla IV. v dějinách národů ČSSR*, pp. 194–216. Prague.

**Pustejovsky, Otfrid**

1975 *Schlesiens Übergang an die böhmische Krone: Machtpolitik Böhmens im Zeichen von Herrschaft und Frieden*. Forschungen und Quellen zur Kirchen- und Kulturgeschichte Ostdeutschlands, vol. 13. Cologne.

**Putík, Alexandr, and Olga Sixtová**

2002 *History of the Jews in Bohemia and Moravia from the First Settlements until Emancipation*. Exh. cat. Prague.

**Putzger, Friedrich Wilhelm**

1954 *Historischer Schulatlas, von der Altsteinzeit bis zur Gegenwart*. 65th ed., edited by Alfred Hansel. Bielefeld.

**Quincke, Wilhelm**

1938 *Das Petersportal am Dom zu Köln*. Kunstgeschicht-liche Forschungen des Rheinischen Vereins für Denkmalpflege und Heimatschutz, vol. 3. Bonn.

**Rader, Olaf B.**

1997 "Zwischen Friedberg und Eco. Die Interpretation von Urkundentexten Karls IV. oder Vom Gang durch die Säle der Erkenntnis." In Lindner et al. 1997, pp. 246–93.

**Radocsay, Dénes**

1955 *A középkori magyarország táblaképei*. Budapest.

1958 "Gotische Wappenbilder auf ungarischen Adelsbriefen." *Acta Historiae Artium* 5, pp. 317–58.

1969 "Die schönen Madonnen und die Plastik in Ungarn." *Zeitschrift des Deutschen Vereins für Kunstwissenschaft* 23, pp. 49ff.

1971 "Über einige illuminierte Urkunden." *Acta Historiae Artium Academiae Scientiarum Hungaricae* 17, pp. 31–61.

**Rajman, Jerzy**

2002 *Średniowieczne patrocinia krakowskie*. Kraków.

**Raková, Ivana**
**1982** "Čeněk z Vartenberka (1400–1425)." *Sborník historický* 28, pp. 57–93.

**Rasmo, Nicolò**
**1956** "Il Pisanello e il ritratto dell'Imperatore Sigismondo a Vienna." *Cultura atesina* 9.
**1957** "Venceslao da Trento e Venceslao da Merano." *Cultura atesina* 11, pp. 21–34.

**Rathe, Kurt**
**1938** *Die Ausdrucksfunktion extrem verkürzter Figuren.* Studies of the Warburg Institute, no. 8. London. Reprint, Nendeln, 1968.

**Rau, J.**
**2000** *See* Aachen 2000.

**Raymund, Elisabeth**
**1782** *Der Hohen Geistlichkeit in Böhmen unbewegte Grundlage: Das achthundertjährige Gotteshaus und das allererste uralte Klosterstift St. Georgen.* Prague.

**Recht, Roland**
**1980** "Strasbourg et Prague." In Cologne 1979–80, vol. 4, pp. 106–17.
**1987** "Motive, Typen, Zeichnungen." In *Skulptur des Mittelalters: Funktion und Gestalt,* edited by Friedrich Mobius and Ernst Schubert. Weimar.

**Regensburg**
**1987** *Regensburger Buchmalerei: Von frühkarolingischer Zeit bis zum Ausgang des Mittelalters.* Exh. cat. edited by Florentine Mütherich and Karl Dachs. Munich. Exhibition, Museen der Stadt Regensburg.

*Regesta diplomatica*
**1958–** *Regesta diplomatica nec non epistolaria Bohemiae et*
**60** *Moraviae.* Vol. 4, edited by Jiří Spěváček. Prague.

**Reihlen, Helmut, ed.**
**2005** *Liturgische Gewänder und andere Paramente im Dom zu Brandenburg.* Regensburg-Riggisberg.

**Reincke, Heinrich**
**1924** "Machtpolitik und Weltwirtschaftspläne Kaiser Karls IV." *Hansische Geschichtsblätter* 49, pp. 78ff.

**Reiners, Heribert**
**1944** "Ein von Kaiser Karl IV. gestifteter Reliquien-schrein." *Pantheon* 32, pp. 119–24.

**Rejchrtová, Noemi**
**1984** *Traktát Jana Bechyňky Praga Mystica.* Prague.
**1985** "Obrazoborecké tendence utrakvistické mentality jagellonského období a jejich dosah." *Husitský Tábor* 8, pp. 59–68.

**Richter, M.**
**1979** *Středověká keramika ze Sezimova Ústí: Katalog stejnojmenné výstavy v Bechyni.* Hluboká nad Vltavou.

**Rieckenberg, H.-J.**
**1975** "Zur Herkunft des Johann von Neumarkt, Kanzler Karls IV." *Deutsches Archiv* 31, pp. 555–69.

**Riedel, Adolf Friedrich**
**1838–** *Codex diplomaticus Brandenburgensis. Sammlung der*
**65** *Urkunden, Chroniken und sonstigen Quellenschriften für die Geschichte der Mark Brandenburg und ihrer Regenten.* Part A, 25 vols.; part B, 6 vols.; part C, 3 vols.; part D, 1 vol.; Suppl. vol. Berlin.

**Říhová, Milada**
**1999** In *Regimen ad Wenceszlaum regem,* pp. 98–117.
**2001** "Vyšehradský probošt Albík z Uničova." In *Královský Vyšehrad* 2001, vol. 2, pp. 154–92.

**Rode, Herbert**
**1974** *Die mittelalterlichen Glasmalereien des Kölner Domes.* Corpus Vitrearum Medii Aevi: Deutschland, vol. 4, Köln, Dom, vol. 1. Berlin.

**Roland, Martin**
**1997** "Der Niederösterreichische Randleistenstil." *Codices manuscripti* 18–19, pp. 97–123.

**Roller, Stefan**
**2004** "Die Nürnberger Frauenkirche und ihr Verhältnis zu Gmünd und Prag. Beobachtungen und Überlegungen zur frühen 'Parler-Skulptur.' " In Strobel and Siefert 2004, pp. 229–38.

**Rome**
**2000–** *The Last Flowers of the Middle Ages: From the*
**2001** *Gothic to the Renaissance in Moravia and Silesia.* Exh. cat. edited by Ivo Hlobil, with Ladislav Daniel et al.; translated by Jaroslav Peprník. Olomouc, 2000. Exhibition, Palazzo di Venezia, Rome.

**Ronig, Franz J.**
**1985** "Kunst unter Balduin von Luxemburg." In Frank et al. 1985, pp. 489–558.

**Rosario, Iva**
**2000** *Art and Propaganda: Charles IV of Bohemia, 1346–1378.* Woodbridge, Eng.

**Rossacher, Kurt**
**1970** "Zum Problem des Vesperbildes um 1400." *Alte und moderne Kunst* 15, no. 112, pp. 2–7.

**Rossi, Filippo**
**1956** *Capolavori di oreficeria italiana dall'XI al XVIII secolo.* Milan.

**Roth, A.**
**1966** *Abtei Marienstatt.* Hachenburg.

**Roth, Elisabeth**
**1967** *Der volkreiche Kalvarienberg in Literatur und Bildkunst des Spätmittelalters.* Philologische Studien und Quellen 2. Berlin.

**Róth, Ernst, and Hans Striedl**
**1984** *Hebräische Handschriften.* Part 3, *Die Handschriften der Sammlung H. B. Levy an der Staats- und Universitätsbibliothek Hamburg.* Wiesbaden.

**Rouse, Richard H., and Mary A. Rouse**
**2000** *Manuscripts and Their Makers: Commercial Book Producers in Medieval Paris, 1200–1500.* 2 vols. Illiterati et Uxorati. Turnhout.

**Royt, Jan**
**1987** "Příspěvek k poznání svatovojtěšské ikonografie 17. století." *Umění* 35, pp. 314–21.
**1995** "Husité a obrazy." In *Jan Hus: Mezi epochami, národy a konfesemi,* edited by Jan Blahoslav Lášek, pp. 295–99. Prague.
**1998** "Die ikonologische Interpretation der Glatzer Madonnentafel." *Umění* 46, pp. 51–60.
**2001** "Ikonografie Mistra Jana Husa v 15. až 18. století." In *Husitský Tábor: Supplementum I.* Tábor.
**2003** *Mittelalterliche Malerei in Böhmen.* Prague.

**Rubin, Miri**
**2004** *Gentile Tales: The Narrative Assault on Late Medieval Jews.* Philadelphia.

**Rüger, Günther, and Heinz Stafski**
**1959** "Saint Veit und sein Reliquiar zu Herrieden." *Jahrbuch des historischen Vereins für Mittelfranken,* 78, pp. 54–68.

**Růžek, Vladimír**
**1988** "Česká znaková galérie na hradě Laufu u Norimberka z roku 1361." *Sborník archivních prací* 38, pp. 37–312.

**Ryneš, Václav**
**1962** "Inventář kapitulního kostela ve Staré Boleslavi z roku 1564." *Umění* 10, pp. 298–300.

**Sachs, Hannelore**
**1979** "Böhmische Gotik in der Mark Brandenburg." *Bildende Kunst,* 1979, pp. 122–26.

**Sachs, Hannelore, and Wolf-Dieter Kunze**
**1987** "Der böhmische Altar im Dom zu Brandenburg." In *Denkmale in Berlin und in der Mark Brandenburg: Ihre Erhaltung und Pflege in der Hauptstadt der DDR und in den Bezirken Frankfurt Oder und Potsdam,* pp. 171–87. Weimar.

**Salač, A., and K. Hrdina**
**1933** "Římská mince v majetku císaře Karla IV." *Listy filologické* 1933.

**Saliger, Arthur**
**2003** "Aspekte zur künstlerischen Einmaligkeit der Heiligkreuzkapelle auf Burg Karlstein bei Prag." In Fajt 2003a, pp. 103–13.

**Salzburg**
**1965** *Ausstellung Schöne Madonnen, 1350–1450.* Exh. cat. by Dieter Grossmann. Salzburg. Exhibition, Domoratorien.
**1970** *Stabat Mater: Maria unter dem Kreuz in der Kunst um 1400.* Exh. cat. by Dieter Grossmann. Exhibition, Salzburger Domkapitel.
**1976** *Spätgotik in Salzburg: Skulptur und Kunstgewerbe, 1400–1530.* Exh. cat. by Anton Legner et al. Jahresschrift, Salzburger Museum Carolino Augusteum, vol. 21. Salzburg. Exhibition, Neuen Haus and Gotishcen Saal, Salzburger Museum Carolino Augusteum.

**Salzburger Museum Carolino Augusteum**
**1976** *See* Salzburg 1976.

**Samek, Bohumil**
**1999** *Umělecké památky: Moravy a Slezska.* Vol. 2. Prague.

**Sándor, Mária, et al.**
**1999** *Die Bischofsburg zu Pécs: Archäologie und Bauforschung.* ICOMOS. Hefte des deutschen Nationalkomitees 22. Munich.

**Sangiorgi, G.**
**1895** *Collection Carrand au Bargello.* Guides des musées d'Italie. Rome.

**Satkowski, Jane Immler, ed.**
**2000** *Duccio di Buoninsegna: The Documents and Early Sources.* Edited by Hayden B. J. Maginnis. Athens, Ga.

**Sauerländer, Willibald**
**1970** *Gotische Skulptur in Frankreich, 1140–1270.* Munich.
**1994** "Two Glances from the North: The Presence and the Absence of Frederic II in the Art of the Empire; the Court of Frederic II and the opus francigenum." In *Intellectual Life at the Court Frederic II Hohenstaufen,* edited by W. Tronzo, pp. 197–201. Studies in the History of Art, 44. Washington, D.C.: National Gallery of Art.

**Sauerlandt, Max**
**1919** "Ein Schmuckfund aus Weissenfels vom Anfang des 14. Jahrhunderts." *Cicerone* 11, pp. 519–26.

**Schädler-Saub, Ursula**
**2000** *Gotische Wandmalereien in Mittelfranken. Kunstgeschichte, Restaurierung, Denkmalpflege.* Arbeitshefte des Bayerischen Landesamtes für Denkmalpflege 109. Munich.

**Schawe, Martin**
**1992** "Fasciculus myrrhae: Pietà und Hoheslied." *Jahrbuch des Zentralinstituts für Kunstgeschichte* 5–6 (1989–90), pp. 161–212.

**Scheller, Robert W.**
**1995** *Exemplum: Model-Book Drawings and the Practice of Artistic Transmission in the Middle Ages (ca. 900–ca. 1470).* Amsterdam.

**Schepens, Luc**
**1964** "Quelques observations sur la tradition manuscrite du *Voyage de Mandeville.*" *Scriptorium* 18, pp. 49–54.

**Schiedlausky, Günter**
**1975** "Ein gotischer Becherschatz." *Pantheon* 33, no. 4, pp. 300–314.

**Schild, Wolfgang**
**1988** "Gerechtigkeitsbilder." In *Recht und Gerechtigkeit im Spiegel der europäischen Kunst,* edited by Wolfgang Schild and Wolfgang Pleister, pp. 86–171. Cologne.

**Schlosser, Julius von**
**1893** "Die Bilderhandschriften Königs Wenzel I." *Jahrbuch der kunsthistorischen Sammlungen des allerhöchsten Kaiserhauses* 14, pp. 214–317.
**1894** "Elfenbeinsättel des ausgehenden Mittelalters." *Jahrbuch der kunsthistorischen Sammlungen des allerhöchsten Kaiserhauses* 15, pp. 260–94.
**1899** "Die Werkstatt der Embriachi in Venedig." *Jahrbuch der kunsthistorischen Sammlungen des allerhöchsten Kaiserhauses* 20, pp. 220–82.

1902 "Vademecum eines fahrenden Malergesellen;
Zur Kenntnis der künstlerischen Überlieferung
im späten Mittelalter." *Jahrbuch der kunsthis-
torischen Sammlungen des allerhöchsten Kaiserhauses*
23, pp. 314–38.

**Schmale-Ott, Irene**
1979 *Translatio Sancti Viti Martyris / Übertragung des hl.
Märtyrers Vitus.* Münster in Westfalen.

**Schmid, Bernhard**
1919– "Die Miniaturmalerei des Elbinger Wiesenbuchs."
20 *Elbinger Jahrbuch* 1, pp. 95–100.

**Schmid, Josef**
1941 *Schöne Miniaturen aus Handschriften in schweizer-
ischen bibliotheken.* Vol. 1, *Schöne Miniaturen aus
Handschriften der Kantonsbibliothek Luzern.* Lucerne.

**Schmidt, Aloys**
1967 "Winand von Steeg, ein unbekannter mittel-
rheinischer Künstler." In *Festschrift für Alois Thomas,*
pp. 363–72. Trier.

**Schmidt, Aloys, and H. Heimpel**
1977 *Winand von Steeg (1371–1453): Ein mittelrheinischer
Gelehrter und Künstler und die Bilderhandschrift über
Zollfreiheit des Bacharacher Pfarrweins auf dem Rhein
aus dem Jahr 1426.* Handschrift 12 des Bayer-
ischen geheimen Hausarchivs zu München;
Bayerische Akademie der Wissenschaften, phil.
hist. Klasse, Abhandlungen, n.s., 81. Munich.

**Schmidt, Friedrich**
1865 "Grundriss des Thurmes und Strebepfeilersistem
vom Dom zu Prag: Facsimile einer alten
Pergamentzeichnung aus der Bauhütte zu St.
Stephan." *Wiener Bauhütte* 4, no. 2, pp. 71ff.
1867 "Die Pergamentzeichnungen der alten Bauhütte
zu Wien." *Mitteilungen der Central-Commission* 12,
pp. 3ff.

**Schmidt, Gerhard**
1962 *Die Malerschule von St. Florian.* Graz and
Cologne.
1964 "Neues Material zur österreichischen Buch-
malerei der Spätgotik in slowakischen Hand-
schriften." *Österreichische Zeitschrift für Kunst und
Denkmalpflege* 18, pp. 34–39.
1967 "Johann von Troppau und die vorromanische
Buchmalerei: Vom ideellen Wert altertümlicher
Formen in der Kunst des 14. Jahrhunderts." In
*Studien zur Buchmalerei und Goldschmiedekunst des
Mittelalters: Festschrift für Karl H. Usener,* pp. 279–
92. Marburg.
1969a "Fragmente eines böhmischen Antiphonariums
des frühen 15. Jahrhunderts (ehemals in
Seitenstetten) und eine Marientod-Initiale der
Rosenwald Collection." *Wiener Jahrbuch für
Kunstgeschichte* 22, pp. 148–56.
1969b "Malerei bis 1450: Tafelmalerei—Wandmalerei—
Buchmalerei." In Swoboda 1969, pp. 167–321.
1969c See Schmidt 1970.
1970 "Peter Parler und Heinrich IV. Parler als
Bildhauer." *Wiener Jahrbuch für Kunstgeschichte* 23,
pp. 108–53. Reprinted in Schmidt 1992, app. 2,
"Das Petersportal des Kölner Domes vor dem
Auftreten der Parler," pp. 212–19.
1975 "Zur Datierung des 'kleinen' Bargello-
Diptychons und der Verkündigungstafel in
Cleveland." In *Études d'art français offertes à
Charles Sterling,* pp. 47–63. Paris.
1977 "Painting up to 1450." In Bachmann 1977.
Abridged version of Schmidt 1969b.
1977a "Vesperbilder um 1400 und der 'Meister der
Schönen Madonnen.'" *Österreichische Zeitschrift
für Kunst und Denkmalpflege* 31, pp. 94–114.
1978 Review of Clasen 1974. *Zeitschrift für
Kunstgeschichte* 41, pp. 61–92.
1986 "Egerton Ms. 1121 und die Salzburger Buch-
malerei um 1430." *Wiener Jahrbuch für Kunst-
geschichte* 34, pp. 41–57, 245–52.

1987 "Kaiser Sigismund und die Buchmalerei." In
Budapest 1987, vol. 2.
1990 "Kunst um 1400. Forschungsstand und
Forschungsperspektiven." In *Internationale Gotik
in Mitteleuropa,* edited by Götz Pochat et al., pp.
34–39. Graz.
1992 *Gotische Bildwerke und ihre Meister.* 2 vols. Vienna.
1993 "Die Fresken von Strakonice und der Krumauer
Bilderkodex." *Umění* 41, pp. 145–52.
1995 "Die Rezeption der italienischen Trecentokunst
in Mittel- und Osteuropa." In *Gotika v Sloveniji
Gotik in Slowenien / Il gotico in Slovenia,* edited by
J. Höfler, pp. 25–36. Ljubljana.
1998a "Kunsthistorischer Kommentar." In Heger et al.
1998, pp. 125–250.
1998b "Die Kunst in den habsburgischen Ländern zur
Zeit Johanns von Luxemburg." In Benešovská
1998, pp. 153–63.
2005 *Malerei der Gotik: Fixpunkte und Ausblicke.* 2 vols.
Edited by Martin Roland. Graz.

**Schmidt, Lothar**
1978 "'Gekrönte Reliquien': Beobachtungen an der
Johannesbüste in Aachen Burtscheid." In *Der Christ
und die Geschichte seiner Kirche,* edited by Hans
Hermann Henrix and Horst Dieter Rauh. Aachen.

**Schmidt, Wilhelm**
[1889] "Varia." *Repertorium für Kunstwissenschaft* [1889],
pp. 39–46.

**Schmidt-Künsemüller, Friedrich A.**
1980 *Corpus der gotischen Lederschnitteinbände aus dem
deutschen Sprachgebiet.* Stuttgart.

**Schmitt, Otto**
1926 "Art. 'Junker von Prag.'" In Thieme and Becker
1907–50, vol. 19, pp. 338–40.

**Schmoll, J. A.**
1961 "Die Sammlung Hermann Schwartz." *Kunst-
chronik* 14 (July), pp. 177–82.

**Schnitzler, Hermann, Fritz Volbach, and Peter
Bloch**
1964 *Skulpturen: Elfenbein, Perlmutter, Stein, Holz;
Europäisches Mittelalter.* Sammlung E. und M.
Kofler-Truniger, Kataloge, vol. 1. Lucerne.

**Schnitzler, Norbert**
1996 *Ikonoklasmus—Bildersturm: Theologischer Bilderstreit
und ikonoklastisches Handeln während des 15. und
16. Jahrhunderts.* Munich.

**Schöffel, Paul**
1934 "Nürnberger in Kanzleidiensten Karls IV."
*Mitteilungen des Vereins für die Geschichte der Stadt
Nürnberg* 32, pp. 49–68.

**Scholz, Hartmut**
2002 *Die Mittelalterlichen Glasmalereien in Mittelfranken
und Nürnberg.* Vol. 2. Berlin.

**Schössler, Wolfgang**
1998 *Regesten der Urkunden und Aufzeichnungen im
Domstiftsarchiv Brandenburg, Teil 1: 948–1487.*
Veröffentlichungen des Brandenburgischen
Landeshauptarchivs Potsdam 36. Weimar.

**Schott, J.**
1778 *De legatis natis.* Bamberg.

**Schramm, Percy, Hermann Fillitz, and Florentine
Mütherich**
1978 *Denkmale der deutschen Könige und Kaiser.* Vol. 2,
*Ein Beitrag zur Herrschergeschichte von Rudolf I. bis
Maximilian I., 1273–1519.* Munich.

**Schuette, Marie, and Sigrid Müller-Christensen**
1963 *Das Stickereiwerk.* Tübingen.
1964 *A Pictorial History of Embroidery.* Translated by
Donald King. New York.

**Schultes, Lothar**
1986 "Der Meister von Grosslobming und die Wiener
Plastik des Schönen Stils." *Wiener Jahrbuch für
Kunstgeshichte* 39, pp. 1–40.
1987 "Zur Herkunft und kunstgeschichtlichen
Stellung des Znaimer Altars." *Österreichische*

*Zeitschrift für Kunst und Denkmalpflege* 42,
pp. 14–37.
1988 "Der Wiener Michaelermeister." *Wiener Jahrbuch
für Kunstgeschichte* 37, pp. 41–46.
1994 "Der Skulpturenfund von Buda und der Meister
von Grosslobming." In Macek, Marosi, and Seibt
1994.
1998 "Die Marienfigur von Schinckau und der
Admont-Freiburger Madonnentypus." In *Gotika
v západních Čechách (1230–1530): Tagungsband und
Festschrift für Jaromír Homolka,* edited by Jiří Fajt.
Prague.
2000 "Die Plastik: Vom Michaelermeister bis zum
Ende des Schönen Stils." In Brucher 2000.
2002 *Die gotischen Flügelaltäre Oberösterreichs.* Vol. 1:
*Von den Anfängen bis Michael Pacher.* Weitra.

**Schultz, Alwin**
1889 *Das höfische Leben zur Zeit der Minnesinger.* 2 vols.
Leipzig.
1892 *Deutsches Leben im XIV. und XV. Jahrhundert.* 2 vols.
Vienna.

**Schultze, H. W.**
1836 *Einige Notizen über das Altar, die historische
Bedeutung und die gegenwärtige Restauration der
bischöflichen Stifts- und Domkirche zu Burg
Brandenburg wie auch über mehrere in derselben noch
vorhandene Merkwürdigkeiten. Zur Einweihung der
Dom-Kirche am 11. October 1836 in Gegenwart sr
Majestaet des Königs Friedrich Wilhelm III. und des
Königlichen Hauses.* Brandenburg.

**Schurr, Marc Carel**
2003 *Die Baukunst Peter Parlers.* Ostfildern.
2004 "Die Münster von Freiburg i. Üe., Strassburg
und Bern im Spiegel der europäischen Baukunst
um 1400—Gedanken zur Legende der 'Junker
von Prague.'" *Zeitschrift für schweizerische
Archäologie und Kunstgeschichte* 61, pp. 95–116.

**Schwager, Helmut**
1993 "Tausend Jahre Benediktiner in den Klöstern
Břevnov, Braunau und Rohr: Eine Zeittafel."
In Hofmann 1993.

**Schwarz, Michael**
1986 *Höfische Skulptur im 14. Jahrhundert. Entwicklungs-
phasen und Vermittlungswege im Vorfeld des Weichen
Stils.* Manuskripte für Kunstwissensxhaft in der
Wernerschen Verlagsgesellschaft, vol. 6. Worms.
1992 "Neue Überlegungen zum Prager Büstenzyklus."
In *Der Künstler über Sich und sein Werk,* edited by
M. Winner, pp. 55–84. Weinheim.
1993– "Die schone Madonna als complexes Bildform."
94 *Wiener Jahrbuch für Kunstgeschichte* 46–47,
pp. 663–78.
2004 "Kathedralen verstehen (St. Veit in Prag als
räumlich organisiertes Mediensemble)."
In *Virtuelle Räume: Rauwahrnehmung und Raum-
vorstellung im Mittelalter,* edited by E. Vavra,
pp. 47–68. Vienna.

**Schwarzenberg, Karl, Fürst zu**
1960 *Die Sankt Wenzels-Krone und die böhmischen
Insignien. Die Kronen des Hauses Österreich,*
vol. 2. Vienna.

**Šedinová, Hana**
1997 "Symbolika drahý Kamenů v kapli sv. Václava."
*Umění* 45, pp. 32–46.
1999 "The Symbolism of the Precious Stones in St.
Wenceslas Chapel." *Artibus et Historiae,* no. 39,
pp. 75–94.

**Šedinová, Jiřina**
1981 "Alttschechische Glossen in mittelalterlichen
hebräischen Schriften und älteste Denkmäler der
tschechischen Literatur." *Judaica Bohemiae* 17,
no. 2, pp. 73–89.

**Sed-Rajna, Gabrielle**
1983 *Le Mahzor enluminé: Les voies de formation d'un
programme iconographique.* Leiden.

1994   *Les manuscrits hébreux enluminés des bibliothèques de France.* Leuven.

**Seeburg, J.**
1869   "Die beiden Juncker von Prag." *Naumann's Archiv für die zeichnenden Künste* 25, pp. 160–223.

**Seibt, Ferdinand**
1978a   as editor. *Kaiser Karl IV.: Staatsman und Mäzen.* Munich.
1978b   *Kaiser Karl IV.: Ein Kaiser in Europa, 1346–1378.* Munich.
1994   "Zur Krise der Monarchie um 1400." In Macek, Marosi, and Seibt 1994.
1997   as editor. *Jan Hus: Zwischen Zeiten Völkern, Konfessionen.* Veröffentlichungen des Collegium Carolinum, vol. 85. Munich.

**Seidel, Max, ed.**
2000   *L'Europa e l'arte italiana.* Venice.

**Sello, Georg**
1890   "Erzbischof Dietrich Kagelwit von Magdeburg (1361–1367)." *Jahresbericht des Altmärkischen Vereins für vaterländische Geschichte* 23, pp. 1–90.

**Ševčenko, Nancy P.**
1991   "Christ Anapeson." In *The Oxford Dictionary of Byzantium,* edited by Alexander P. Kazhdan, vol. 1, p. 439. New York.

**Ševčíková, Jana**
1974   *Chebská gotická plastika.* Exh. cat. Cheb.

**Seymour, M. C.**
1964   "The Scribal Tradition of Mandeville's *Travels:* The Insular Version." *Scriptorium* 18, no. 2, pp. 34–48.

**Shaw, Henry**
1843   *Dresses and Decorations of the Middle Ages.* Vol. 2. London. Text not paginated.

**Sherman, Claire Richter**
1969   *The Portraits of Charles V. of France (1338–1380).* Monographs on Archaeology and the Fine Arts 20. New York.

**Shorr, Dorothy C.**
1954   *The Christ Child in Devotional Images in Italy during the XIV Century.* New York.

**Simon, Eckehard**
1968   *Neidhart von Reuenthal: Geschichte der Forschung und Bibliographie.* Harvard Germanic Studies, vol. 4. Cambridge, Mass.

**Siracusa–Caltanissetta–Prague**
2004   *Bohemia Sancta: Poklady křesťanského umění v českých zemí.* Exh. cat. edited by Dana Stehlíková. Prague.

**Skřivánek, František**
1985   "Inkrustace z drahého kamene—vrcholný projev interiérové úpravy v české gotické architektuře." *Památky a příoda* 10, pp. 579–93.

**Skubiszewski, Piotr**
1978   "Klein- und Grosspolen." In Cologne 1978–79, vol. 2.

**Sladeczek, Franz-Josef**
1999   *Der Berner Skulpturenfund: Die Ergebnisse der Kunsthistorischen Auswertung.* Bern.

**Šmahel, František**
1985   "Antitéze české kultury pozdního středověku." In *Ústecký sborník historický,* pp. 9–29. Ústí.
1988   *Dějiny Tábora I.* České Budějovice.
1992a   "Husa na korouhvi a ve znaku" In *Seminář a jeho hosté. Sborník prací k 60. narozeninám Rostislava Nového,* pp. 107–14. Prague.
1992b   "Die Tabule veteris et novi coloris als audiovisuelles Medium hussitischer Agitation." *Studie o rukopisech* 29, pp. 95–105.
1993   "Smuteční ceremonie a rituály při pohřbu císaře Karla IV." *Český časopis historický* 91, pp. 401–16.
1994   *Zur politische Präsentation und Allegorie im 14. und 15. Jahrhundert.* Otto-von-Freising-Vorlesungen der Katholischen Universität, Eichstätt 9. Munich.
1999a   "Die Prager Judengemeinde im hussitischen Zeitalter." *Jüdischer Gemeinden und ihr christlicher*

Kontext in kulturräumlich vergleichender Betrachtung *(5.–18. Jahrhundert),* pp. 31–34. Kleine Schriften des Arye-Maimon-Instituts, 2. Trier.
1999b   "Život Najtharta: Tradice literárního žánru prostřednictvím obrazu." *Česká literatura* 47, pp. 534–39.
2004   "Payne, Peter (d. 1455/6?)." In *Oxford Dictionary of National Biography,* vol. 43, pp. 208–13. Oxford.

**Smetánka, Z.**
1988   "Gotický prolamovaný kachel z Pražského hradu —A Gothic-Style Openwork Stove Tile from Prague Castle." *Castrum Pragense* 1, pp. 177–80.

**Smitmer, F. P. von**
1895   "Über den Drachen-Orden." *Jahrbuch der k.k. heraldischen Gesellschaft Adler,* n.s., 5–6, pp. 65–82.

**Sokol, J.**
1969   "Parlerův kostel Všech svatých na Pražském hradě." *Umění* 17, pp. 547–82.

**Soltykoff sale**
1861   *Catalogue des objets d'art et de haute curiosité composant la célèbre collection du prince Soltykoff....* Sale cat. Paris, Hôtel Drouot, Paris, April 8–May 1.

**du Sommerard, Alexandre**
1838–   *Les arts au Moyen Âge.* 5 vols., plus Atlas and
46   Album. Paris: Hôtel de Cluny.

**Sotheby's (London)**
1990   *Medieval Illuminated Miniatures from the Collection of the Late Eric Korner.* Sale cat., Sotheby's, London, June 19.

**Sotheby's (New York)**
1984   *Highly Important Hebrew Books and Manuscripts.* Sale cat., Sotheby's, New York, June 26.

**Šourek, Karel**
1944   *Miniatury české bible zvané Boskovská z let 1420–30 v Studijní knihovně v Olomouci sign. III/3.* Prague.

**Southern, R. W.**
2001   *Scholastic Humanism and the Unification of Europe.* Vol. 2, *The Heroic Age.* Oxford and Malden, Mass.

**Speer, Andreas, and Günther Binding, eds.**
2000   *Abt Suger von Saint-Denis ausgewählte Schriften: Ordinatio, De consecration, De administratione.* Darmstadt.

**Spěváček, Jiří**
1968   "Die Anfänge der Kanzlei Karls IV. auf italienischem Boden in den Jahren 1332/33." *MIÖG* 76, pp. 299–326.
1976   "Lucemburské konsepce českého státu a jejich přemyslovské kořeny." *Sborník historický* 24, pp. 5–51.
1979   *Karel IV.: Život a dílo (1316–1378).* 2nd ed. Prague.
1982   "Frömmigkeit und Kirchentreue als Instrumente der politischen Ideologie Karls IV." *Karl IV.: Politik und Ideologie im 14. Jahrhundert,* edited by Evamaria Engel. Weimar.
1986   *Václav IV., 1361–1419: K předpokladům hussitské revoluce.* Prague.

**Speyer (Germany)**
1992   *Das Reich der Salier, 1024–1125: Katalog zur Ausstellung des Landes Rheinland-Pfalz.* Exh. cat. Sigmaringen. Exhibition, Historischen Museum der Pfalz.
2004–5   *The Jews of Europe in the Middle Ages.* Exh. cat. [Speyer.] Exhibition, Historisches Museum der Pfalz Speyer.

**Spicer, Joaneath**
1996   "The Star of David and Jewish Culture in Prague around 1600, Reflected in Drawings of Roelandt Savery and Paulus van Vianen." *Journal of the Walters Art Gallery* 54, pp. 203–24.

**Spunar, Pavel**
1987   "Poznámky k husitskému ikonoklasmu." *Listy filologické* 110, no. 2, pp. 124–28.

**Staffelbach, Georg**
1946   "Die Darstellung der Hostienmühlen in Bern und Luzern." *Heimatland, Illustrierte Monatsbeilage des "Vaterland,"* no. 3, pp. 18–21.

**Stafski, Heinz**
1965   *Die Bildwerke in Stein, Holz, Ton und Elfenbein bis um 1450. Die Mittelalterlichen Bildwerke 1.* Nürnberg.

**Stamm, Lieselotte E.**
1981   *Die Rüdiger-Schöpf-Handschriften: Die Meister einer Freiburger Werkstatt des späten 14. Jahrhunderts und ihre Arbeitsweise.* Aarau.
1983   "Buchmalerei in Serie: Zur Frühgeschichte der Vervielfältigungskunst." *Zeitschrift für schweizerische Archäologie und Kunstgeschichte* 40, pp. 128–35.

**Stange, Alfred**
1934–   *Deutsche Malerei der Gotik.* 11 vols. Berlin.
61   Reprinted, Nendeln, 1969.
1978   *Kritisches Verzeichnis der deutschen Tafelbilder vor Dürer.* Vol. 3, *Franken.* Edited by Norbert Lieb. Munich.

**State College, Pa.**
1980   *The Art of the Needle.* Exh. cat. by O. K. Preisner. [State College.] Exhibition, Pennsylvania State University Museum of Art.

**Státníková, P., et al.**
n.d.   *The Historic Faces of Vyšehrad.* Prague.

**Stauber, Richard**
1908   *Die Schedelsche Bibliothek: Ein Beitrag zur Geschichte der Ausbreitung der italienischen Renaissance.* Edited by Otto Hartig. Freiburg im Breisgau.

**Štech, Václav V.**
1915   "Jan Hus ve výtvarném umění." In *Mistr Jan Hus v životě a památkách českého lidu.* Prague.

**Stefanová, Milená**
1985   "Figurálně zdobení ramy českých gotických obrazu." *Umění* 33, pp. 315–29.

**Stehlíková, Dana**
1993   "Das Plenar und der Arm der hl. Margarete in Břevnov." In Hofmann 1993, pp. 325–40.
1998   "K počátkům pokladnice kláštera v Teplé." In *Gotika v západních Čechách (1230–1530), díl IV., sborník z mezinárodního vědeckého sympozia, věnováno k 70. narozeninám prof. Jaromíra Homolky,* pp. 148–54. Prague.
2001   "Poklad vyšehradské kapituly a klenoty vyšehradských prelátů." In *Královský Vyšehrad* 2001, vol. 2, pp. 193–208.
2004   See Siracusa–Caltanissetta–Prague 2004.
2005   Review of "Nobiles officinae" exhibition. *Umění* 53, no. 3. In press.

**Stehlíková, Dana, Martin Mádl, Marie Flore Heude-Levoir, and Odile Valansot**
1999   "La reliquaire de la mitre de Saint Eloi à Prague: Étude pluridisciplinaire." *Bulletin du CIETA,* no. 76, pp. 77–89.

**Stein, A.**
1904   *Die Geschichte der Juden in Böhmen.* Brünn.

**Stein, Gunter**
1981   "Der Schatzfund von Lingenfeld." In *Geschichte der Juden in Speyer.* Beiträge der Speyerer Stadtgeschichte, 6. Speyer.

**Steinmann, Marc**
2003   *Die Westfassade des Kölner Domes. Der mittelalterliche Fassadenriss F.* Forschungen zum Kölner Dom, vol. 1. Cologne.

**Stejskal, Karel**
1953   "Dve neznámé české kresby z konce 14. století." *Umění* 18, pp. 323–27.
1955   "Archa rajhradská a její místo ve vývoji českého umění první poloviny 15. století." *Acta Universitatis Carolinae — Philophica* 1, pp. 61–94.
1959   "Husitské obrazoborectví." *Dějiny a současnost* 1, pp. 16–19.
1960   "Votivní obraz v klašterní knihovně v Roudnici." *Umění* 8, pp. 568 ff.
1967   "O malířích nástěnných maleb kláštera Na Slovanech." *Umění* 15, pp. 1–65.

**1969** "Spor o Theodorika pokračuje II." *Umění* 17, pp. 425–89.

**1970** "Výstava 'La Librairie de Charles V' a některé otázky českého umění XIV. století." *Umění* 18, pp. 31–60.

**1974** "Vitrail z postavou Jana Křtitele z Oseku." *Umění a Řemesla*, no. 4, pp. 43–51.

**1978a** *European Art in the 14th Century.* Translated by Till Gottheinerová. London.

**1978b** *Umění na dvoře Karla IV.* Prague.

**1984** "Klášter Na Slovanech, pražská katedrála a dvorská malba doby Karlovy." In Chadraba 1984, pp. 328–42.

**1985** "Funkce obrazu v husitství." *Husitský Tábor* 8, pp. 15–28.

**1988** "Die byzantinischen Einflüsse auf die gotische Tafelmalerei Böhmens." In *Ikone und frühes Tafelbild,* edited by Heinrich L. Nickel, pp. 157–62. Halle, Germany.

**1990** "K situaci českého malířství po roce 1400." *Umění* 38, pp. 89–100.

**1992** "Die Prager Buchmalerei der Hussitenzeit und Beziehung zu Mähren." *Umění* 40, pp. 334–43.

**1994** "Obvinění Mistra Jeronýma Pražského z ikonoklasmu a modlářství na kostnickém koncilu." In *Husitství, renesance, reformace,* vol. 1, pp. 369–80. Prague.

**1994a** "Iluminované bible v Čechách a jejich vztah k Západoevropské knižní malbě." In *Česká bible v dějinách evropské kultury,* pp. 97–116. Brno.

**1995** "Nové poznatky o iluminovaných rukopisech husitské doby." *Český časopis historický* 93, pp. 419–25.

**2000** "Ikonoklasmus Českého Středověku a Jeho Limity." *Umění* 48, pp. 206–17.

**2003** *Dejiny Umění: Umění na dvoře Karla IV.* 2nd ed. of Stejskal 1978b. Prague.

**Stejskal, Karel, and Josef Krása**

**1964** "Astralvorstellungen in der mittelalterlichen Kunst Böhmens." *Sborník prací filosofické fakulty Brněnské University* 8, pp. 61–85.

**Stejskal, Karel, and Petr Voit**

**1991** *Iluminované rukopisy doby husitské.* Prague.

**Stengel, Edmund E.**

**1921–** as ed. *Nova Alamanniae. Urkunden, Briefe und*
**30** *andere Quellen besonders zur deutschen Geschichte des 14. Jahrhunderts, vornehmlich aus den Sammlungen des Trierer Notars und Offizials, Domdekans von Mainz, Rudolf Losse aus Eisenach in der ständischen Landesbibliothek zu Kassel und im Staatsarchiv zu Darmstadt.* 2 vols. Berlin.

**1937** *Baldewin von Luxemburg: Ein grenz-deutscher Staatsmann des 14. Jahrhunderts.* Weimar. Reprinted in *Abhandlungen und Untersuchungen zur mittelalterlichen Geschichte* 1960, pp. 180–215.

**Sterling, Charles**

**1941** *Les peintres du moyen age.* Paris.

**1987–** *La peinture médiévale à Paris, 1300–1500.* 2 vols.
**90** Paris.

**Sternberg and Lobkowitz sale**

**1884** *Catalog eines Theils der nachgelassenen Gemälde-Sammlungen Sr. Erlaucht des Herrn Franz Grafen von Sternberg-Manderscheid . . . sowie aus dem Besitze Ihrer Durchlaucht der Fürstin Maria Lobkowitz und Anderer.* Sale cat., Carl Maurer, Art Expert, Munich, April 16, 22, 24.

**Štingl, Martin, ed.**

**2004** *Velká mezeříč Františka Ignáce Kontera, 1401–1723: Městská kronika barokní Moravy.* Tišnov.

**Stoob, Heinz**

**1970** "Kaiser Karl IV. und der Ostseeraum." *Hansische Geschichtsblätter* 88, pp. 163–214.

**1990** *Kaiser Karl IV. und seine Zeit.* Graz.

**Strieder, Peter**

**1993** *Tafelmalerei in Nürnberg, 1350–1550.* Königstein im Taunus.

**Strnad, Josef**

**1891** *Listář královského města Plzně a druhdy poddaných osad I. (1300–1450).* Plzeň.

**Strobel, Richard, and Annette Siefert, eds.**

**2004** *Parlerbauten, Architektur, Skulptur, Denkmalpflege: Internationales Parler-Symposium Schwäbisch-Gmünd 17.–19. Juli 2001.* Contributions by Klaus Jürgen Herrmann. Landesdenkmalamt Baden-Württemberg, Arbeitsheft 13. Stuttgart.

**Studničková, Milada**

**1992** "Hoforden der Luxemburger." *Umění* 40, pp. 320–28.

**1998a** "Las iluminaciones del *Martirologio de Usuardo.*" In Gerona Martyrology 1997–99, pp. 93–162.

**1998b** "Nové poznatky k rukopisu Martyrologia z Gerony." In *Problematika historických a vzácných knižních fondů Čech, Moravy a Slezska, 1998,* pp. 34–46. Brno.

**2003** Review of Bartlová 2001b. *Umění* 51, pp. 240–45.

**2004** "Schodiště Velké věže hradu Karlštejna jako scala coeli." Paper presented at the symposium "The Staircase Cycles of the Large Tower at Karlštejn Castle: Condition after Restoration," organized by the Academy of Sciences of the Czech Republic in the Emmaus Monastery, Prague, May 5–7.

**Studničková, Milada, and Pavel Štěpánek**

**1999** *Usuardovo Martyrologium z Gerony. Faksimile středověkého iluminovaného rukopisu vydané nakladatelstvím M. Moleiro v Barceloně / Martyrology of Usuardus from Gerona.* A facsimile of a medieval illuminated manuscript published by M. Moleiro Publishing Company in Barcelona. Prague.

**Suckale, Robert**

**1976** Review of Clasen 1974. *Kunstchronik* 29, pp. 244–55.

**1980** "Peter Parler und das Problem der Stillagen." In Cologne 1980, vol. 4, pp. 75–184. Reprinted in Suckale 2003b, pp. 257–86.

**1981** "Die Sternberger Schöne Madonna." In Cologne 1978–79, vol. 5: *Resultatband,* pp. 117–22. Reprinted in Suckale 2003b, pp. 87–101.

**1982** "Das geistliche Kompendium des Mettener Abtes Peter, Klosterreform und Schöner Stil um 1414/15." *Anzeiger des Germanischen Nationalmuseums,* 1982, pp. 7–22.

**1986** "Das Diptychon in Basel und das Pähler Altarretabel: Ihre Stellung in der Kunstgeschichte Böhmens." In "Nobile claret opus: Festgabe für E. J. Beer zum 60. Geburtstag," edited by L. Stamm, *Zeitschrift für Schweizerische Archäologie und Kunstgeschichte* 43, pp. 103–12. Reprinted in Suckale 2003b, pp. 103–18.

**1990** "Die Buchmalerwerkstatt des Prager Examerons. Ein Beitrag zur Kenntnis der Prager Buchmalerei um 1400–1440." *Umění* 38, pp. 401–18.

**1993a** "Die Bedeutung des Hussitismus für die bildende Kunst, vor allem in den Nachbarländern Böhmens." In *Künstlerischer Austausch — Artistic Exchange: Akten des XXVIII. Internationalen Kongresses für Kunstgeschichte, Berlin, 15.–20. Juli 1992,* edited by Thomas W. Gaehtgens. vol. 2, pp. 65–70. Berlin.

**1993b** *Die Hofkunst Kaiser Ludwigs des Bayern.* Munich.

**1993–** "Die Glatzer Madonnentafel des Prager
**94** Erzbischofs Ernst von Pardubitz als gemalter Marienhymnus. Zur Frühzeit der böhmischen Tafelmalerei, mit einem Beitrag zur Einordnung der Kaufmannschen Kreuzigung." In "Festschrift für Gerhard Schmidt," *Wiener Jahrbuch für Kunstwissenschaft* 46–47, pp. 737–56, 889–92. Reprinted in Suckale 2003b, pp. 119–50.

**1994** See Suckale 1993a.

**1996a** "Eine unbekannte Madonnenstatuette der Wiener Hofkunst um 1350." *Österreichische Zeitschrift für Kunst und Denkmalpflege* 49, pp. 147–59. Reprinted in Suckale 2001, pp. 225–51.

**1996b** "Die Passionstafel in Pechüle: Ein Retabel der Klosterkirche Zinna?" In *Zisterzienser in Brandenburg,* edited by Oliver H. Schmidt and Dirk Schumann, pp. 128–35. Studien zur Geschichte, Kunst und Kultur der Zisterzienser 1. Berlin.

**1998** *Kunst in Deutschland: Von Karl dem Großen bis heute.* Cologne.

**1998–** Review of Gerona Martyrology. *Zeitschrift*
**99** *des Deutschen Vereins für Kunstwissenschaft* 52–53, pp. 334–37.

**1999** "'Die Löwenmadonna': Ein politischer Bildtyp aus der Frühzeit Kaiser Karls IV.?" In *Iconographica: Mélanges offerts à Piotr Skubiszewski par ses amis, ses collègues, ses élèves,* edited by Robert Favreau and Marie-Hélène Debiès, pp. 221–29. Poitiers. Reprinted in Suckale 2001, pp. 172–84.

**2001** *Das mittelalterliche Bild als Zeitzeuge. Sechs Studien.* Berlin.

**2001a** "Beiträge zur Kenntnis der böhmischen Retabel aus der Zeit Kaiser Karls IV. (Renate Kroos gewidmet)." In *Entstehung und Frühgeschichte des Flügelaltarschreins,* edited by Hartmut Krohm, Klaus Krüger, and Matthias Weniger, pp. 247–65. Berlin.

**2002** *Das mittelalterliche Bild als Zeitzeuge: Sechs Studien.* Berlin.

**2003b** *Stil und Funktion: Ausgewählte Schriften zur Kunst des Mittelalters.* Edited by Peter Schmidt und Gregor Wedeking. Munich and Berlin.

**2003c** "Die Porträts Kaiser Karls IV. als Bedeutungsträger." In *Das Porträt vor der Erfindung des Porträts,* edited by Martin Büchsel and Peter Schmidt, pp. 191–204. Mainz.

**2004a** "Über die Schwierigkeiten, Peter Parler Skulpturen zuschreiben." In Strobel and Siefert 2004, pp. 197–205.

**2004b** "Zur Chronologie der Kölner Malerei der zweiten Hälfte des 14. Jahrhunderts." In *Dortmund und Conrad v. Soest im spätmittelalterlichen Europa,* edited by Thomas Schilp and Barbara Welzel, pp. 45–72. Bielefeld.

**Sűcs, Jenő**

**1958** "A középkori építészet munkaszervezetének kérdéséhez." *Budapest Régiségei* 18, pp. 313ff.

**Suermondt Museum**

**1961** "Bewahrte Schönheit: Mittelalterliche Kunst der Sammlung Hermann Schwartz, Aachen: Suermondt Museum, 1961." *Aachener Kunstblätter* 21, no. 22.

**Supino, Igino Benvenuto**

**1898** *Catalogo del R. Museo Nazionale di Firenze (Palazzo del Potestà).* Rome.

**Suttner, Joseph Georg**

**1860** "Zum eichstättischen Kirchenkalendarium, IX: Urkunde über die Reliquie des hl. Vitus in Herrieden." *Eichstätter Pastoralblatt* 7, p. 100.

**Svec, Victor**

**1994** *Bildagitation: Antipäpstliche Bildpolemik der böhmischen Reformation im Göttinger Hussitenkodex.* Weimar.

**Svobodný, Petr**

**2001** "The Medical Faculty." In *A History of Charles University, 1348–1802,* vol. 1, pp. 171–86. Translated by Anna Bryson. Prague.

**Svobodová, Milada**

**1996** *Katalog českých a slovenských rukopisů sign. XVII získaných Národní (Universitní) knihovnou po vydání Truhlářova katalogu z roku 1906.* Prague.

**Swarzenski, Hanns**
1952 "A Masterpiece of Bohemian Art." *Bulletin of the Museum of Fine Arts* [Boston] 50, no. 282 (December), p. 65.
1959 Preface. In *Czechoslovakia: Romanesque and Gothic Illuminated Manuscripts,* pp. 5–9. UNESCO World Art Series, no. 12. Greenwich, Conn.

**Swoboda, Karl M., ed.**
1969 *Gotik in Böhmen: Geschichte, Gesellschaftsgeschichte, Architektur, Plastik und Malerei.* Munich.

**Székesfehérvár (Hungary)**
1982 *Művészet I. Lajos király korában, 1342–1382.* Exh. cat. edited by Ernő Marosi, Melinda Tóth, and Lívia Varga. [Budapest.] Exhibition, István Király Múzeum.

**Szendrei, János**
1889 *Catalogue descriptif et illustré de la collection de bagues de Mme. Gustave de Tarnóczy.* Budapest and Paris.

**Taburet–Delahaye, Elisabeth**
1987 "Un groupe de bijoux vénitiens du XIVe siècle." *Razo,* no. 7, pp. 145–81.
1989 *L'orfèvrerie gothique (XIIIe–début XVe siècle) au Musée de Cluny: Catalogue.* Paris.
1994 "I gioielli della pala d'oro." In *La pala d'oro,* edited by H. R. Hahnloser and R. Polacco. Venice.

**Tadra, Ferdinand**
1879 "Cancellaria Arnesti. Formelbuch des ersten Prager Erzbischofs," parts 1, 2. *Archiv für österreichische Geschichte* 61.
1886a "Cancellaria Johannis Noviforensis, episcopi Olomucensis (1364–1380): Briefe und Urkunden des Olmützer Bischofs Johann von Neumarkt." *Archiv für österreichische Geschichte* 68, pp. 1–157.
1886b "Jan ze Středy." *Časopis českého muzea* 60, pp. 85–101.
1892 *Kanceláře a písaři v zemích českych za kralů z rodu Lucemburského Jana, Karla IV, a Václava IV, 1310–1420: Prispevek k diplomatice české.* Rozpravy České Akademie Cisare Frantiska Josefa pro Vedy, Slovesnost a Umeni v Praze, 1, no. 1. Prague.
1893 *Soudní akta konsistoře pražské.* Vol. 2. Prague.

**Takács, Imre**
1989 "Feldarabolt idő." *Buksz* 1, pp. 51–55.
2001 "The Church at Garamszentbenedek and Its Liturgical Fittings." In Pannonhalma 2001, pp. 625–33.

**Tångeberg, Peter**
1989 *Holzskulptur und Altarschrein: Studien zu Form, Material und Technik.* Munich.

**Teige, Josef**
1915 *Základy starého místopisu pražského (1437–1620). Staré Město pražské, II. Díl.* Prague.

**Theisen, Maria**
2004 "Der Willehalm-Codex Ser. n. 2643 für König Wenzel IV. Bildprogramm und Illumination." PhD diss., Universität Wien.

**Theodosian Code**
1952 *The Theodosian Code and Novels and the Sirmondian Constitutions.* Translation and commentary by Clyde Pharr, with Theresa Sherrer Davidson and Mary Brown Pharr. Princeton.

**Thieme, Ulrich, and Felix Becker**
1907– *Allgemeines Lexikon der bildenden Künstler, von der*
50 *Antike bis zur Gegenwart.* 37 vols. Leipzig.

**Thomas, Alfred**
1998 *Anne's Bohemia: Czech Literature and Society, 1310–1420.* Minneapolis.

**Thomas, Bruno, and Ortwin Gamber**
1976 *Katalog der Leibrüstkammer, I. Teil—Der Zeitraum von 500 bis 1530.* Vienna.

**Thomson, Harrison**
1950 "Learning at the Court of Charles IV." *Speculum* 25, pp. 1–20.

**Thümmel, Hans G.**
1991 *Bildlehre und Bildstreit. Das östliche Christentum,* n.s., 40. Würzburg.

**Thuróczy, János**
1985– *Johannes de Thurocz. Chronica Hungarorum.* Vol. 1,
88 *Textus,* edited by Elisabeth Galántai and Julius Kristó; *Commentarii,* parts 1–2, edited by Elemér Mályusz and Julio Kristó. Budapest.

**Tietze, Hans**
1905 *Die illuminierten Handschriften in Salzburg.* Leipzig.
1931 *Geschichte und Beschreibung des St. Stephansdomes in Wien.* Österreichische Kunsttopographie 23. Vienna.

**Timmermann, Achim**
1999 "Two Parlerian Sacrament Houses and Their Microarchitectural Context." *Umění* 47, pp. 400–412.
2002 "Architektur und Eucharistie: Sakramentshäuser der Parlerzeit." *Münster* 55, pp. 2–13.

**Tischler, Maria**
1992 "Das Kaschauer Stadtsiegel von 1404 und die Städtische Wappenbildung unter König Sigismund in Ungarn." In *Genealogica et Heraldica: 19. Internationale Kongress für genealogische un heraldische Wissenschaften, Keszthely, 2–6. 10. 1990. Kongressberichte,* edited by Iván Bertényi and László Czoma. Keszthely.

**Tischlerová, Mária**
1975 "Stredoveký Richtár Hanns Hebenstreyt v Košiciach." *Zborník filozofickej fakulty Univerzity Komenského: Historica* 26, pp. 51ff.

**Toch, Michael**
2001 "Dunkle Jahrhundert": Gab es in jüdisches Frühmittelalter? Kleine Schriften des Arye-Maimon-Instituts, 4. Trier.

**Toledo**
2002–3 *Memoria de Sefarad.* Exh. cat. edited by Isidro Bango Treviso. [Madrid, 2002]. Exhibition, Centro Cultural de San Marcos.

**Tomáš of Štítné**
1956 *Knížky o hře šachové a jiné.* Edited by František Šimek. Prague.

**Tomasi, Michele**
2001 "Baldassare Umbriachi, le maître, le public." *Revue de l'art* 134, no. 4, pp. 51–60.

**Tomek, Wácslaw Wladiwoj**
1855– *Dějepis města Prahy.* 12 vols. Prague.
1901
1866 *Základy starého místopisu pražského.* Vol. 1. Staré Město. Prague.
1870 *Základy starého místopisu pražského.* Vol. 2, Nové Město. Prague.
1871 *Základy starého místopisu pražského.* Vols. 3–4. Malá Strana a Hradčany. Prague.
1872 *Základy starého místopisu pražského.* Vol. 5. Registřík. Prague.
1892 See Tomek 1855–1901.

**Török, Gyöngyi**
1978 "Táblaképfestészetünk korai szakasza és európai kapesolatai." *Ars Hungarica* 6, pp. 7–27.
1988 "Thomas de Coloswar und die europäische Kunst um 1400." *Niedzika Seminars* 3, pp. 45–51.
1989 "Problems of Central European Art, c. 1400: The Thomas de Coloswar Altarpiece in Hungary." In *World Art: Themes of Unity in Diversity; Acts of the XXVIth International Congress of the History of Art,* edited by Irving Lavin, vol. 1, pp. 133–36. University Park, Pa.
1990 "Zur Frage der Internationalität in der gotischen Buch- und Tafelmalerei." In "Internationale Gotik in Mitteleuropa," edited by G. Pochat and B. Wagner, *Kunsthistorisches Jahrbuch Graz* 24, pp. 50–61.

**Tóth, Sándor**
1998 "Képesség és képtelenség." *Buksz* 10, pp. 67–75.

**Toulouse**
1992 *Plaisirs et manières de table aux XIVe et XVe siècles.* Exh. cat. Toulouse. Exhibition, Musée des Augustins.

**Toussaint, Gia**
2003 *Das Passional der Kunigunde von Böhmen: Bildrhetorik und Spiritualität.* Paderborn.

***Tractatus de ludo Scacorum***
1970 *Tractatus de ludo Scacorum.* Facsimile ed. with transcription, translation, and introduction by Luis Vázquez de Parga. Madrid.

**Trattner, Irma**
1998 "Die Kaufmannsche Kreuzigung. Überlegungen zu einem umstrittenen Gemälde in der Berliner Gemäldegalerie." *Acta Historiae Artis Slovenica* 3, pp. 5–21.

**Trent**
2002 *Il Gotico nelle Alpi, 1350–1450.* Exh. cat. edited by Enrico Castelnuovo and Francesca de Gramatica. Trent. Exhibition, Castello del Buonconsiglio.

**Třeštík, Dušan**
1997 *Počátky Přemyslovců.* Prague.

**Troescher, Georg**
1939 "Weltgerichtsbilder in Rathäusern und Gerichtsstätten." *Wallraf-Richartz-Jahrbuch* 11, pp. 139–214.

**Turin**
1996 *Il tesoro della città: Opere d'arte e oggetti preziosi da Palazzo Madama.* Exh. cat. edited by Silvana Pettenati and Giovanni Romano. Turin. Exhibition, Reale Palazzina di Caccia Di Stupinigi.
2004 *Scrinium cardinalis: Un tesoro medievale per il Museo Civico d'Arte Antica di Torino.* Exh. cat. by Simonetta Castronovo. Turin. Exhibition, Palazzo Reale.

**Urbánek, Rudolf**
1940 "Královny Johana a Žofie." In *Královny, kněžny a velké ženy české,* edited by Karel Stloukal. Prague.

**Urbánková, Emma**
n.d. *Illuminované Rukopisy státní Knihovny Ceské Socialistické Republiky v Praze.* Prague, n.d. [198-].
1957 *Rukopisy a vzácné tisky pražské universitní knihovny.* Prague.

**Urbánková, Emma, and Karel Stejskal**
1975 *Pasionál Přemyslovny Kunhuty / Passionale Abbatissae Cunegundis.* Prague. Includes a facsimile of Státní Knihovna ms. CSR (XIV A 17).

**Urešová, Libuše**
1980 "Stříbrný poklad vrcholného středověku." *Acta Uměleckoprůmyslového Muzea v Praze* 15, no. 2, Commentationes.
1985 "Karlštejnský poklad." In *Středověké umělecké řemeslo ve sbírkách Uměleckoprůmyslového Muzea katalog výstavy.* Prague.
1987 "Karlštejnský poklad." *Umění* 35.

**Valois, Noël**
1893 *Le projet de mariage entre Louis de France et Cathérine de Hongrie et le voyage de l'empereur Charles IV (Paris, janvier 1378).* Paris. Extracted from *Annuaire Bulletin de la Société de l'Histoire de France.*

**Vaníček, Vratislav**
2002 *Velké dějiny zemí Koruny české.* Vol. 3, 1250–1310. Prague and Litomyšl.

**Vareschi, Severino**
1997 "Profili biografici die Princioi Vescovi di Trento dal 1338 al 1444." *Studi Trentini di Scienze Storiche, Sez. I,* 76, pp. 257–326.

**Vavřinec of Březová**
1893 "Kronika Václava Vavřince z Březové." *Fontes Rerum Bohemicarum,* vol. 5, edited by Jaroslav Goll. Prague.

**Vavřínek, Vladimír**
**2000** "Mission in Mähren: Zwischen dem lateinichen Westen und Byzanz." In *Europas Mitte um 1000,* edited by Alfried Wieczorek and Hans-Martin Hinz, pp. 304–10. Stuttgart.

**Végh, András**
**1999** "Adatok a budai kisebb Szűz Mária, más néven Szent Zsigmond templom alapításának történetéhez." In Feld 1999, pp. 25–34.

**Végh, János**
**1987** "Zsigmond király képzőművészeti ábrázolásairól." In Budapest 1987, vol. 1.
**1992** "Die Bildnisse Kaiser Sigismunds von Luxemburg: Typus und Individuum in den Herrscherdarstellungen am Ende des Mittelalters." In *Künstlerischer Austausch / Artistic Exchange: Akten des XXVIII. Internationalen Kongresses für Kunstgeschichte, Berlin, 15.–20. Juli 1992,* edited by Thomas W. Gaehtgens, vol. 2, pp. 127–37. Berlin.

**Veldtrup, Dieter**
**1988** *Zwischen Eherecht und Familienpolitik: Studien zu den dynastischen Heiratsprojekten Karls IV.* Studien zu den Luxemburgern und ihrer Zeit, 2. Warendorf.
**1989** "Johann Propst von Vyšehrad. Illegitimer Sohn eines 'impotenten' Luxemburgers." In *Studia Luxemburgensia: Festschrift Heinz Stoob zum 70. Geburtstag,* edited by Friedrich B. Fahlbusch et al., pp. 50–78. Studien zu den Luxemburgern und ihrer Zeit, vol. 3. Warendorf.

**Veleslavín, Daniel Adam of**
**1590** *Kalendář hystorický.* Prague.

**Venice**
**1994** *Omaggio a San Marco. Tesori dall'Europa.* Exh. cat. edited by Hermann Fillitz and Giovanni Morello. Milan. Exhibition, Palazzo Ducale.

**Verdier, Philippe**
**1973** "Le reliquaire de la Sainte Epine de Jean de Středa." In *Intuition und Kunstwissenschaft: Festschrift für Hanns Swarzenski zum 70. Geburtstag am 30. August 1973,* edited by Peter Bloch et al., pp. 319–44. Berlin.

**Verlet, Pierre**
**1957** "Une Vierge d'Annonciation en orfèvrerie de la fin du XIVe siècle." *Bulletin des musées de France,* 1957, pp. 6–7.

**Vermeiren, Marie-Louise**
**1953** "La Bible de Wenceslas du Musée Plantin-Moretus a Anvers." *De Gulden Passer* 31, pp. 191–229.

**Vetter, Ferdinand, ed.**
**1892** *Das Schachzabelbuch Kunrats von Ammenhausen.* Frauenfeld.

**Viard, Jules, ed.**
**1917** *Journaux du trésor de Charles IV le Bel.* Paris.

**Vidmanová, Anežka**
**1979** "Die mittelalterliche Gesellschaft im Lichte des Schachspiels." *Miscellanea Mediaevalia* 12, pp. 232–35.
**2000** "Karel IV. jako spisovatel." In *Karel IV: Literární dílo,* pp. 9–22. Prague.

**Vienna**
**1952** *Abendländische Buchmalerei. Ausstellung im Prunksaal der Österreichischen Nationalbibliothek.* Exh. cat. foreword by Josef Stummvoll. Vienna. Exhibition, Österreichische Nationalbibliothek.
**1962** *Europäische Kunst um 1400. Achte Ausstellung unter den Auspizien der Europarates.* Exh. cat. Vienna. Exhibition, Kunsthistorisches Museum.
**1979** *Die Zeit der frühen Habsburger: Dome und Klöster, 1279–1379.* Exh. cat. edited by Floridus Röhrig and Gottfried Stangler. Kataloge des Niederösterreichischen Landesmuseums, n.s., no. 85. Vienna. Exhibition, Wiener Neustadt.

**1990** *Gotik: Prag um 1400: Der schöne Stil, Böhmische Malerei und Plastik in der Gotik.* Exh. cat. Vienna. Exhibition Historisches Museum der Stadt Wien.
**1994** *Der Meister von Grosslobming.* Exh. cat. edited by Arthur Saliger. Vienna. Exhibition, Österreichische Galerie.
**1996** *Thesaurus Austriacus: Europas Glanz im Spiegel der Buchkunst. Handschriften und Inkunabeln von 800 bis 1600.* Exh. cat. by Martin Roland et al.; edited by Eva Irblich. Vienna. Exhibition, Österreichische Nationalbibliothek.
**2002–3** *Die Kunst des Steinschnitts: Prunkgefässe, Kameen und Commessi aus der Kunstkammer.* Exh. cat. by Rudolf Distelberger. Vienna, 2002. Exhibition, Kunsthistorisches Museum Wien, Kunstkammer.

**Vilíkovský, Jan**
**1938** *Próza z doby Karla IV.* Prague.

**Vilímková, Milada**
**2000** *The Prague Ghetto.* Translated by Iris Urwin. Prague.

**Viollet-le-Duc, Eugène-Emmanuel**
**1871– ** *Dictionnaire raisonné du mobilier français de l'époque*
**75** *carolingienne à la Renaissance.* 6 vols. Paris.

**Vítovský, Jakub**
**1976** "Nástěnné malby ze XIV. století v Pražské katedrále." *Umění* 24, pp. 473–502.
**1991** "Lampa z pozostalosti kráľovnej Žofie Bavorskej v Mestkom múzeu v Bratislave." *Ars,* no. 1, pp. 45–58.
**1994** "K datování, ikonografii a autorství Staroměstské mostecké věže." *Průzkumy památek* 2, pp. 15–44.
**2003** "Fresco of the Theban legion from the Royal Chapel, the Alram Estate and the Royal House in Brno." In Fajt 2003, pp. 194–200.

**Vlček, Emanuel**
**1984** "Tělesné vlastnosti Karla IV." In *Karolus Quartus,* edited by Václav Vaněček, pp. 471–93. Prague.

**Vlček, Pavel, ed.**
**1996** *Umělecké památky Prahy (Staré Město, Josefov).* Prague.
**1999** *Umělecké památky Prahy (Malá Strana).* Prague.
**2000** *Umělecké památky Prahy (Pražský hrad, Hradčany).* Prague.

**Vlk, Miloslav**
**1963** "K otázce předlohy Jenského kodexu." *Sborník Národního Muzea v Praze,* ser. A, 17, pp. 1–19.

**Vorbrodt, Günter, Ingeburg Vorbrodt, and Walter Paatz**
**1971** *Die akademischen Szepter und Stäbe in Europa.* Corpus Sceptrorum, vols. 1–2. Heidelberg.

**Vrtel, Ladislav**
**2003** *Osem Storočí Slovenskej Heraldiky / Eight Centuries of Slovak Heraldry.* Mudroňova.

**Všetečková, Zuzana**
**1979** "Nástěnné malby v kostele sv. Václava na Zderaze v Praze." *Umění* 27, pp. 215–28.
**1991** "Zpráva o fotodokumentaci Josefa Krásy." *Umění* 39, pp. 259–72.
**1994** "Monumentální středověká malba." In Merhautová 1994, pp. 96–132.
**1996** "Gotické nástěnné malby v křížové chodbě kláštera Na Slovanech." *Umění* 44, pp. 131–48.
**1999** "Středověká nástěnná malba ve středních Čechách." *Průzkumy památek* 6, suppl.
**2001** "Gotické nástěnné malby v kostele sv. Petra a Pavla na Vyšehradě." In *Královský Vyšehrad* 2001, vol. 2, pp. 133–53.
**2002a** See Všetečková 2002b.
**2002b** "The Man of Sorrows and Christ Blessing the Chalice as Iconography of Utraquist Towns in Bohemia." In *The Bohemian Reformation and Religious Practice IV,* edited by Z. David and D. Holeton, pp. 193–214. Prague.

**Wagner, Franz**
**2000** "Kunsthandwerk." In *Geschichte der bildenden Kunst in Österreich,* vol. 2 Gotik, edited by Günter Brucher, pp. 568–92. Munich.

**Wallis, Carl**
**1912** *Görlitzer Inschriften.* Görlitz.

**Ward, Anne, John Cherry, Charlotte Gere, and Barbara Cartlidge**
**1981** *The Ring: From Antiquity to the Twentieth Century.* London.

**Warnke, Martin**
**1985** *Hofkünstler. Zur Vorgeschichte des modernen Künstlers.* Cologne.

**Washington**
**1975** *Medieval and Renaissance Miniatures from the National Gallery of Art.* Exh. cat. compiled by Carra Ferguson, David S. Stevens Schaff, and Gary Vikan, under the direction of Carl Nordenfalk; edited by Gary Vikan. Washington, D.C. Exhibition, National Gallery of Art.

**Węcławowicz, Tomasz**
**1990** "Dekoracja figuralna prezbiterium kościoła Mariackiego w Krakowie a zagadnienie mecenatu Mikołaja Wierzynka Starszego." *Rocznik Krakowski* 56.
**2002** "Transitus Sancti Stanislai." In *Magistro et amico amici discipulique: Lechowi Kalinowskiemu w osiemdziesięciolecie urodzin,* pp. 73–86. Kraków.

**Węcławowicz, Tomasz, and A. Korczynska**
**1998** "Prezbiterium wierzynkowe. Historia badań i nowe pytania badawcze." In *O konserwacji prezbiterium kościoła Mariackiego w Krakowie,* edited by J. Daranowska-Łukaszewska, pp. 39–56. Kraków.

**Weibel, Adele**
**1946** "A Late Medieval Chasuble Cross." *Art Quarterly* 9 (Spring), pp. 144–52.

**Wellstein, Gilbert**
**1953** *Abtei Marienstatt.* 3rd ed. Limburg an der Lahn.

**Weltsch, Ruben Ernest**
**1968** *Archbishop John of Jenstein (1348–1400): Papalism, Humanism, and Reform in pre-Hussite Prague.* Studies in European History, vol. 8. The Hague.

**Wenceslas Bible**
**1981– ** *Die Wenzelsbibel: Vollständige Faksimile-Ausgabe der*
**98** *Codices Vindobonenses 2759–2764 der Österreichischen Nationalbibliothek Wien.* 11 vols. Codices selecti phototypice impressi, vol. 70, nos. 1–9. Graz.

**Wentzel, Hans**
**1957– ** "Wentzel: Ein unbekanntes deutsches
**59** Marienbild des 13. Jahrhunderts in Italien." *Mitteilungen des Kunsthistorischen Instituts in Florenz* 8, pp. 185–98.
**1962** "Ein Elfenbeinbüchlein zur Passionsandacht." *Wallraf-Richartz-Jahrbuch* 24, pp. 193–212.

**Wenzel, Gusztáv**
**1874** *Stibor Wajda: Eletrajzi tanulmany. Ertekezesek a történelmi tudomanyok.* Vol. 4. Budapest.

**Wernicke, Ewald**
**1876** "Maler und Bildschnitzer des Mittelalters in Görlitz." *Neues Lausitzisches Magazin* 52, pp. 62–65.
**1878** "Ein böhmischer Altar im Dom zu Brandenburg a.d. Havel." *Der Bär. Blätter für Vaterländischer Geschichte,* 1878, pp. 4, 24.

**Westermann-Angerhausen, H.**
**1996** "Werkstattkunst und künstlerische Individualität im späten Mittelalter." In *Miscellanea Mediaevalia, Veröffentlichungen des Thomas-Instituts der Universität zu Köln,* vol. 24, *Individuum und Individualität im Mittelalter,* edited by J. A. Aertsen and A. Speer, pp. 819–28. Berlin.

**Westermann-Angerhausen, H., and D. Taübe, eds.**
**2003** *Das Mittelalter in 111 Meisterwerke aus dem Museum Schnütgen.* Cologne.

**Wetter, Evelin**
**1996–** "I ricami boemi dei paramenti per la consacrazi-
**98** one a vescovo di Giorgio di Liechtenstein." *Studi
Trentini di Szient Storiche,* ser. 2, 75–77, pp. 7–92.
**1999** *See* Wetter 2001.
**2001** *Böhmische Bildstickerei um 1400: Die Stiftungen in
Trient, Brandenburg, und Danzig.* Berlin.
**2003** "Sakrálne poklady v 14. a ranom 15. storočí:
Náčrt fragmentárnej tradície na Slovensku." In
Bratislava 2003.
**2005** "Herrschaftswechsel in der Mark Brandenburg
und kunstlandschaftliche Entwicklungen." In
*Heilige Gewänder—Textile Kunstwerke,* edited by
Helmut Reihlen, pp. 42–66. Regensburg.

**Whiteley, M.**
**1989** "Deux escaliers royaux du XIVe siècle: Les
'grand degres' du palais de la Citè et la 'grande
viz' du Louvre." *Bulletin Monumental* 147,
pp. 133–54.

**Wichner, Jacob**
**1888** *Kloster Admont in Steiermark und seine Beziehungen
zur Kunst.* Vienna.

**Widder, Ellen**
**1993** *Itinerar und Politik: Studien zur Reiseherrschaft Karls
IV. südlich der Alpen.* Cologne.

**Wiegand, Eberhard**
**1934–** "Drei südostdeutsche Federzeichnungen des 14.
**35** Jahrhunderts." *Anzeiger des Germanischen
Nationalmuseums* 1934–35, pp. 49–53.

**Wiegel, Karl Adolf**
**1973** *Die Darstellung der Kreuzauffindung bis zu Piero
della Francesca.* Cologne.

**Wiese, Erich**
**1923** *Schlesische Plastik vom Beginn des XIV. bis zur Mitte
des XV. Jahrhunderts.* Leipzig.

**Wilckens, Leonie von**
**1965** "Ein Kaselkreuz in Rokycany. Hinweise zur
böhmischen Marienverehrung unter Karl IV. und
den ersten Prager Erzbischöfen." *Anzeiger des
Germanischen Nationalmuseums* 1965, pp. 33–51.
**1966** "Böhmische Stickerei um 1400: Stil, Thematik,
Auswirkungen." *Kunstchronik* 10, pp. 311–12.
**1991** *Die textilen Künste von Spätantike bis um 1500.*
Munich.

**William of Conches**
**1997** *A Dialogue on Natural Philosophy (Dragmaticon
Philosophiae).* Translation of the new Latin criti-
cal text and notes by Italo Ronca and Matthew
Curr. Notre-Dame, Ind.

**Wilson, Christopher**
**1990** *The Gothic Cathedral: The Architecture of the Great
Church, 1130–1530.* London.

**Windecke, Eberhard**
**1893** *Denkwürdigkeiten zur Geschichte des Zeitalters Kaiser
Sigmunds.* Edited by Wilhelm Altmann. Berlin.

**Winston-Salem, N.C.**
**1996–** *A Thousand Years of Czech Culture: Riches from the
**97** National Museum in Prague.* Exh. cat. Winston-
Salem. Exhibition, Old Salem, Inc.

**Winter, Eduard**
**1964** *Frühhumanismus: Seine Entwicklung in Böhmen und
deren europäische Bedeutung für die
Kirchenreformbestrebungen im 14. Jahrhundert.*
Berlin.

**Winter, Zikmund**
**1906** *Dějiny Řemesel a obchodu v Čechách v XIV. a v XV.
století.* Prague.

**Wirth, Zdeněk**
**1913–** *La richesse d'art de Bohême: Recueil d'oeuvres d'art
**15** en Bohême depuis les origines jusqu'à la fin du XIXe
siècle.* 2 vols. Prague.

**Wixom, William D.**
**1977** "Leaves from a Prague Antiphonary." *Bulletin of
the Cleveland Museum of Art* 64, pp. 310–25.

**Wödke, K., ed.**
**1897** Homily on Saint Ludmilla, by Charles IV.
*Zeitschrift des Deutschen Vereins für die Geschichte
Mährens und Schlesiens* 1, no. 4, pp. 41–76.

**Woisetschläger, Kurt, and Peter Krenn**
**1968** *Alte steirische Herrlichkeiten: 800 Jahre Kunst in der
Steiermark.* Graz, Vienna, and Cologne.

**Wolf, Norbert**
**2002** *Deutsche Schnitzretabel des 14. Jahrhunderts.* Berlin.

**Wolfskron, Adolf, Ritter von**
**1846** *Die Bilder der Hedwigslegende nach einer Hand-
schrift vom Jahre MCCCLIII in der Bibliothek der
P. P. Piaristen zu Schlackenwerth.* Vienna.

**Wolný, Gregor**
**1855** *Kirchliche Topographie von Mähren meist nach
Urkunden und Handschriften.* Part 1, *Olmützer
Erzdiöcese.* Vol. 1. Brno.

**Wonisch, P. Othmar**
**1951** *Die Kunstdenkmäler des Benediktinerstiftes
St. Lambrecht.* Österreichische Kunsttopographie
31. Vienna.

**Workman, Herbert B.**
**1926** *John Wyclif: A Study of the English Medieval Church.*
2 vols. Oxford.

**Worstbrock, Franz-Josef**
**1985** "Konrad of Haimburg." In *Die deutsche Literatur
des Mittelalters, Verfasserlexikon,* edited by Wolfgang
Stammler; continued by Karl Langosch, vol. 5,
cols. 182–90. 2nd ed. Berlin and New York.

**Wortmann, P.**
**1970** "Die Parlerkonsolen im Ulmer Münster." *Bonner
Jahrbucher,* no. 170, pp. 289–311.

**Wyss, Arthur, ed.**
**1883** *Die Limburger Chronik des Tilemann Elhen von
Wolfhagen.* Edited by Arthur Wyss. Monumenta
Germaniae historica, vol. 4, part 1. Hannover.

**1973** *Die Limburger Chronik des Tilemann Elhen von
Wolfhagen.* 2nd ed. of 1883. Monumenta
Germaniae Historica, vol. 4, part 1. Zürich. First
published

**Zachová, Jana**
**1978** "Un privilège de Přemysl Otakar II." *Judaica
Bohemiae* 14, no. 2, pp. 71–74.

**Zahlten, Johannes**
**1979** *Creatio mundi: Darstellungen der sechs Schöpfungs-
stage und naturwissenschaftliches Weltbild im
Mittelalter.* Stuttgarter Beiträge zur Geschichte
und Politik, vol. 13. Stuttgart.

**Žáry, Juraj**
**1990** "Kaplnka českej kráľovnej Žofie Bavorskej v
bratislavskom dóme." *Umění* 38, pp. 1–14.

**Žáry, Juraj, Anton Bagin, Ivan Rusina, and Eva
Toranová**
**1990** *Dóm sv. Martina v Bratislave.* Bratislava.

**Zbraslav Chronicle**
**1884** *Chronicon Aulae regiae.* In *Fontes Rerum
Bohemicarum,* vol. 4, pp. 1–337. Prague.
**1976** Otto, Abbot of Zbraslav, and Petrus Zittaviensis.
*Zbraslavská Kronika: Chronicon Aulae Regiae.*
Translated by Frantšek Heřmanský and Rudolf
Mertlík; edited by Zdeněk Fiala. Prague.

**Zelenka, Aleš**
**1979** *Die Wappen der böhmischen und mährischen
Bischöfe: Wappen von Antonín Javora, Dana Koutná,
Jaroslav Pechácek.* Veröffentlichungen des
Institutum Bohemicum, vol. 2. Regensburg.

**Zeschick, Johann**
**1969** *Das Augustinerchorherrenstift Rohr und die Reform
in bayerischen Stiften vom 15. bis 17. Jahrhundert.*
Passau.

**Zibermayr, Ignaz**
**1929** "Zur Geschichte der Raudnitzer Reform."
*Mitteilungen des Österreichischen Instituts für
Geschichtsforschung, Ergänzungsband* 11,
pp. 323–53.

**Ziesmer, Walther**
**1911** *Ausgabenbuch des Marienburger Hauskomturs für die
Jahre 1410–1420.* Königsberg.

**Zimmermann, Gerd**
**1964** "Der Kult der böhmischen Heiligen in der
Diözese Bamberg." *Berichte des Historischen Vereins
für Oberfranken* 100, pp. 243–53.

**Zingerle, Oswald von, ed.**
**1909** *Mittelalterliche Inventare aus Tirol und Vorarlberg.*
Innsbruck.

**Zolnay, László**
**1976** "Der gotische Skulpturenfund von 1974 in
der Burg von Buda." *Acta Historiae Artium* 22,
pp. 173–331.

**Zolnay, László, and Ernő Marosi**
**1989** *A budavári szoborlelet.* Budapest.

Beautiful Style, *continued*
  origin of term, 111n5
  painting and (fig. 114.1), *266, 267*
  Pietàs (Schönen Pietàs; fig. 110.1), 49, 105, 111n12;
    cats. 110–12
  sculpture and (figs. 9.3, 9.4), *107,* 108–10, 239, 315, 317;
    cats. 106–12, 115, 121, 122, 127
  stained glass and, cat. 114
Beccari, Niccolò, 59
Bedford Master: Missal for the Church of Saint-Magloire
  (fig. 9.2), *106,* 106–7
beer drinking, 204
Beheim, Heinrich, the Elder, 248
*Belles heures* of Jean, duke of Berry, 27–28
*Bellifortis* of Konrad Kyeser of Eichstätt (cat. 89; fig. 8.9),
  99, 100, *100,* **233–35,** *234, 235,* 236
Benedict, Saint, 162, 191
Benedict IX, Pope, 141
Benedict XII, Pope, 40
Beneš Krabice of Weitmile (d. 1375), 13, 23, 25, 31, 31n3,
  35, 39, 43, 47, 70, 75, 156, 162, 205
Beneš of Waldstein, breviary of, 213
Benigna, Maria, cat. 7
Benigna, Saint, tomb altar of (Zaječov), 6, 18n36
Berger, Štěpán Emanuel (1844–1897), cat. 63c
Berlin:
  Hochschule für die Wissenschaft des Judentums, cat. 79
  Humboldt-Universität zu Berlin: university scepter,
    cat. 72
  Staatliche Museen zu Berlin, Gemäldegalerie: The
    Crucifixion, cat. 1; The Mocking of Christ and
    The Crucifixion, cat. 92; The Pregnant Virgin at
    the Spindle, cat. 95
  Staatliche Museen zu Berlin, Skulpturensammlung und
    Museum für Byzantinische Kunst: head of a
    prophet from Beautiful Fountain, Nuremberg,
    cat. 100; two fragments of a Pietà, cat. 110
Bernard of Clairvaux, Saint, 7, 42, 114, 115
Bern Cathedral, Pietà excavated at, 262n4
Bernhard, Duke, 305n3
Berthold von Hohenzollern of Eichstätt, bishop, 41, 44n54
Bertram of Minden, Master (ca. 1345–1415), 55
Bertrand de la Barre, 126
Bertrandon de la Brocquière, 127
Beseny, Pál Ezdegei, 129
Bible, 64, 210
  Czech (cat. 136), *297,* **297;** Boskovice Bible (cat. 133),
    228, 233n11, 284, *292,* **292–94,** *293,* 294, 295,
    295n5; Zamojski Bible (cat. 134), *294,* **294–95,** *295*
  Hebrew, 85; copied in Prague in 1489 (cat. 79), 86–87,
    **212–15,** *213, 214;* subjects from, in Gothic
    manuscripts from Prague, 87
  illuminated manuscripts of, cats. 80, 85, 133–36; from
    era of Hussite Revolution, 116, cats. 133–36; in
    Jagiellonian Library, Kraków (cod. 284/1-2),
    174–75; Martinice Bible (cat. 135), 117, 294,
    295n5, *296,* **296;** Metten Bible, 276–77;
    Olomouc Bible, 218; of Provost Franciscus, 226;
    of Sixtus of Ottersdorf, 228, 294, 294n11, 295n7;
    Vatican Bible (Pal. lat. 1), 219; Velislav Bible
    (fig. 3.3), 37, *38;* of Vicar Kuneš, 249; in
    Washington, D.C. (Library of Congress, Ms 7),
    295n5. *See also* Wenceslas Bible
  translation of, into vernacular, 99, 220
Blanche of Valois, 4, 6, 9, 20n106, 23, 60, 63
  stone sculpture of (from Saint Stephen's, Vienna;
    fig. 4.9), 53
Bloomington, Lilly Library, Indiana University: The
  Adoration of the Magi (from Seitenstetten
  Antiphonary), cat. 116d
Bobovac Castle, 306
Boemel, Arnold, 125
Bohemian Bible of Andreas of Austria (cat. 80; fig. 7.7), 86,
  *87, 215,* **215–16**
Böhler, Julius, Munich, cat. 112
Böhler, Julius Harry, Munich, cat. 112
Böhler, Julius Wilhelm, Munich, cat. 112
"Bohunko pictor," 93–94
Boleslav I (r. 929–67), 141, 160n2
bolt heads, ceremonial (cat. 156), **323–25,** *324*
Boniface IX, Pope, 115
Bonn, Rheinisches Landesmuseum: Virgin and Child, cat. 107

Bonne of Luxembourg, 17n7, 55
  Psalter and Hours of (fig. 2.2), 23, *24*
bookbindings, leather, 204–5
book box (leather; fig. 69.2), 204, *205*
*Book of Jewish Laws, The,* by Isaac Alfasi, Abraham and
  Samuel, scribes (fig. 7.5), 85, 86, *86*
Boreschow, Bartholomew, tondo of (cat. 138), **299–300,**
  *300,* 302
Boreš of Riesenburg, 17n16
Bořìjov I, duke, 60, 61
Borovský, František, cat. 65
Boskovice Bible (cat. 133), 228, 233n11, 284, *292,* **292–94,**
  *293,* 294, 295, 295n5
Boston, Museum of Fine Arts:
  The Dormition of the Virgin, cat. 26
  Golden Bull of Charles IV, cat. 22
  Virgin and Child, cat. 18
Bottenwieser, Paul, Berlin, cat. 18
Bourges, prophets from Sainte-Chapelle in, 306
bowls:
  amethyst (cat. 36b), **166–70,** *167*
  jasper (cat. 36b-e, i, k), **166–70,** *167–69*
box, imperial (cat. 71), 204, *206,* **206**
Brandenburg, 40–41, 42, 44n26, 50, 51, 55, 95, 302
  Altar (fig. 43.1), **176–78,** *177*
  Domstift: Saint Paul and Scenes from the Life of Saint
    Peter, cat. 43
  hereditary union of Bohemia and, 177–78
  Sigismund's seals as elector of (fig. 11.2), 121, *121*
Bratislava:
  Brotherhood of Corpus Dei, cat. 143
  Castle, 128
  City of, cat. 143
  Collegiate Church of Saint Martin, 98, 128, 304; cat. 143
  Mestské Múzeum: chandelier of Queen Sophia of
    Bavaria, cat. 143
Braunschweig, Herzog Anton Ulrich-Museum: sketch-
  book (fig. 99.1), 140nn3, 5; 227n10, *246,* 247, 291
Břetislav I, Bohemian duke, 141, 142, 161n3
  tomb of, 146, 194, 195
Breuner, J., cat. 7
Breviary of Beneš of Waldstein, 213
Breviary of Saint George's Convent, 227n11
Břevnov, Benedictine Abbey of, 77–78, 142, 290
  chasuble with embroidered orphrey, cat. 128
Březnice:
  Castle Chapel, cat. 81
  Parish Church of Saint Ignatius, cat. 81
Bridget, Saint, 254, 293
Bringing of Gifts to the Temple, The (from Wenceslas
  Bible; fig. 7.8), 88, *88*
British Museum, cat. 88
Brno, 326, cats. 4, 132
  Church of Saint James, Virgin and Child from
    (fig. 4.1a), *134,* 134–35
  Church of Saints Peter and Paul, cat. 119
  Monastery of, cat. 133
  Moravská Galerie: chasuble with an embroidered
    orphrey, cat. 119; four heraldic roundels, cat. 158;
    Gradual (Sedlec), cat. 124; The Martyrdom of
    Saint James the Great (Master of Rajhrad), cat.
    153; Portable Altar, cat. 54; The Way to Calvary
    (from Rajhrad Altarpiece), cat. 154a
  town hall, cat. 158
bronze sculpture, cat. 32
brooches:
  from Karlštejn Hoard (cat. 66), *202,* **202–3**
  Reliquary with the Eagle of Saint Wenceslas (cat. 16),
    *145,* **145–46,** 203
Brotherhood of Saint Luke, 76, 77, 78–79, 93, 162
Broumov, Benedictine Abbey of, cat. 128
Brzeg, Convent of Saint Hedwig, cat. 7
Buchel, Gertrude, 298
buckles:
  from Curtea de Arte, Romania, 123
  from Karlštejn Hoard (cat. 65), **200–202,** *201*
Buda:
  Church of Our Lady, 128
  luxury goods production in, 129
  Royal Castle of, 56, 124, 126–28, 129, 306; Apostle series
    at, 128; court artists at, 127–28, 308, 310; three
    heads from (cat. 145), 128, **306–8,** *307*

Saint Sigismund's Collegiate Church, 124, 128
Budapest:
  Budapesti Történeti Múzeum: three heads from Buda
    Castle, cat. 145
  Magyar Nemzeti Múzeum: Reliquary Bust, cat. 141
  Szépművészeti Múzeum: leaves from Sedlec Choir
    Books, cat. 124
Bürhle, Emil G., Zurich, cat. 113
Bušek, 223
Bust of a Young Woman with Parler Family Emblem
  (cat. 58), **191–92,** *192*
busts of female saints (wood sculptures; Hluboká and
  Düsseldorf; cat. 108), *258,* **258–59,** *259,* 266
busts of Saints Peter and Paul (gilded copper and enamel;
  cat. 125), 98, *286,* **286–87**
buttons, from Karlštejn Hoard (cat. 65), **200–202,** *201*
Butzbach, Johann, prior of Maria Laach (1476–1526), 298
Byzantium and Byzantine art, 4, 6, 7, 13, 30, 39–40, 68, 97,
  135, 154, 160, 184, 312
  Kykkotissa and, 156, 171, 216–17

C
Camaldolese Order, 141
Cambridge, Mass., Harvard University Art Museums:
  Angel of the Annunciation (drawing; fig. 9.8), 109,
  *109,* 275–76, *276*
Capuchin Cycle, three panels from (cat. 147), 310, **310–12,**
  *311*
Carolingian period, 85, 160, 184
Carona y Fernández de Córdoba, Pedro Antonio de
  Aragón Folc de, cat. 86
case with coat of arms of Říčany family (leather; fig. 69.1),
  204, *205*
Casimir III, king of Poland (r. 1333–70), 38, 47–48, 123
Cassian, Saint, reliquary bust of (Vienna), 123, 303
Castra Regina (Regensburg), 160
Catherine (daughter of Charles IV), 27, 52
Catherine of Alexandria, Saint, 13, 26–28, 33n75, 72n35, 304
  depictions of, 98, 200, 279, 280; stone sculpture in
    Jihlava, 110, 279
  reliquary of (cat. 56), 28, 182, **190,** *190,* 281
Čeněk of Vartenberk, burgrave of Prague Castle (1414–20),
  292–93, cat. 133
ceramics:
  beaker in leather case (cat. 69), 204, **204–5**
  floor and stove tiles (cat. 67), *203,* **203**
  Sezimovo Ústí, ceramic workshops in, 203
Černohorský, Václav, of Boskovice, cat. 133
České Budějovice:
  Biskupství Českobudějovické: The Madonna of
    Březnice, cat. 81
  Municipal Museum, cat. 108a
  Národní Památkový Ústav, Územní Odborné Pracoviště
    (National Institute of Historical Monument
    Care): The Nativity, cat. 97
chalices, 116, 129
  agate, or sardonyx (cat. 50), 30, 169, **183–85,** *184,* 198
chandelier of Queen Sophia of Bavaria (cat. 143), 98, 200,
  **304–5,** *305*
Chapi family, 306
Charlemagne, 7, 13, 30, 40, 44n45, 64, 129, 153, 162, 197
  painting of, attributed to Master Theodoric (cat. 33), 14,
    30, **162,** *164*
  reliquary bust of (fig. 2.7), 7, 29, *29,* 153
Charles I of Anjou, 303
Charles II the Bald, Holy Roman Emperor, 185n3
Charles IV of Luxembourg (1316–1378), 3–73, 93, 99, 101,
  116, 139, 140–41, 150, 153, 156, 162, 178, 184, 196,
  225, 298, 299, 302
  accession of, to Bohemian and imperial thrones, 6, 7–8,
    9, 60n19, 62, 63, 66, 71, 140, 171
  autobiography of, 9, 23, 24, 59
  bishops and other ecclesiastics appointed by, 37–38,
    40–41, 50
  boyhood of, at French court, 4, 23, 41, 60, 101n2
  Charlemagne revered by, 30, 64, 153, 162
  Christian beliefs and practice of, 23–33
  coats of arms associated with (cat. 49), **182–83,** *183*
  courtiers and advisers of, 35–45
  crown of (fig. 1.4), *8,* 9, 19n68, 28, 33n68, 62, 68, 153,
    184, 206
  deacon status of, 25, 26, 95, 150

# photograph credits

AiP Beroun S.R.O.: cats. 39, 41, 73, 133–36, 148; fig. 3.6
Archive of Czech Tourism: fig. 77.1
Dean Beasom: cats. 105, 116a, 116g, 124d, 126
© Biblioteca Apostolica Vaticana: cat. 96
© Bildarchiv Foto Marburg / Art Resource, NY: figs. 100.1, 107.1, 110.1
© Bildarchiv Preussischer Kulturbesitz / Art Resource, NY / Jörg P. Anders: cats. 1, 92, 95
Radovan Boček: cats. 5, 11, 14, 48, 49, 105, 106, 125, 128, 152; figs. 1.1, 1.6, 1.7, 2.1, 2.4, 2.5, 3.1, frontispiece
Ladislav Bulva: cat. 97; fig. 97.1
Dana Cabanová: cat. 77
© Cistercian Abbey Sankt Marienstern, Panschwitz-Kuckau, Germany / Jürgen Matschie, Bautzen: cat. 15
Joseph Coscia Jr., The Photograph Studio, The Metropolitan Museum of Art, New York: cats. 25, 36g, 75, 80, 86, 90, 94, 99, 116e, 131, 156a–c, 157; figs. 5.3, 7.7, 9.10, 137.2, endpapers, half titles
Paul Crossley: figs. 5.2 (after Kutal 1971, p. 34), 5.9 (after Benešovská and Hlobil 1999, p. 24)
© Bernhard Dietrich: cat. 111

Jan Diviš: cats. 29, 33, jacket front
© Jean-Christophe Doërr, Bibliothèque Historique de la Ville de Paris: fig. 6.6
© Dombauarchiv Köln / Matz und Schenk: cat. 59
Christopher Foster: cat. 7
Fotoarchiv Tiroler Landesmuseum Ferdinandeum, Innsbruck: cat. 120
Foto Studio Lambda, Trent: fig. 66.1
© Owen Franken / CORBIS: fig. 8.1
Jan Gloc: cats. 8, 31, 32, 45, 50, 51, 53, 55–57, 67, 150, jacket back
Jaroslav Jeřábek: cat. 37
Jiří Kopřiva: cats. 28, 149; figs. 1.2, 8.6, 59.1
© Kunstreferat der Diözese, Würzburg / Thomas Obermeier: cat. 151
Erich Lessing / Art Resource, NY: fig. 147.1
Piotr Ligier: fig. 137.1
H. Lilienthal © Reinisches Landesmuseum Bonn: cat. 107
Peter Maes: cats. 68, 85
Metropolitní Kapitula u Sv. Víta, Prague: figs. 1.2, 1.4, 3.1, 5.7, 5.8, 6.1, 6.2, 8.5, 8.6, 16.1, 59.1
© Museum of Fine Arts, Boston: cats. 18, 22, 26
Národní Památkový Ústav, Územní Odborné Pracoviště Středních Čech, Prague: figs. 1.1, 1.6, 1.7, 2.1, 2.4, 2.5, 6.3
© Niedersächsische Staats- und Universitätsbibliothek Göttingen: cat. 89; fig. 8.9
Sven Nilsson © The Royal Collections, Stockholm: cat. 36d

Österreichische Nationalbibliothek Bildarchiv, Vienna: figs. 4.1, 4.10, 7.1, 7.8, 9.1, 84.1–84.7, 90.1
Oto Palán: cats. 19, 40, 115
Prokop Paul: fig. 16.1
Milan Posselt: cats. 9, 27, 30, 81, 123
Milan Posselt, Jan Gloc: cat. 6
Milan Posselt, Jiří Kopřiva: cat. 52
Quattrone–Firenze: cats. 36c, 36k, 122
Jan Rendek: cats. 12, 60, 62, 63, 69; figs. 5.1, 124.2
© Réunion des Musées Nationaux / Art Resource, NY: cat. 36f; fig. 117.1
© Réunion des Musées Nationaux / Art Resource, NY / Daniel Arnaudet: cat. 121
© Réunion des Musées Nationaux / Art Resource, NY / Gérard Blot: cat. 16
© Réunion des Musées Nationaux / Art Resource, NY / Konstantinos Ignatiadis: cat. 93
Anandaroop Roy, New York: pp. xiv (after Kavka 1989, p. 172 [Matthias Weis]), xv (after Spěváček 1986, insert)
© Salzburg University Library, Department of Special Collections: cat. 2
Miroslava Sošková: cats. 54, 91, 147
Libor Teplý: cats. 119, 153, 154
Tihanyi-Bakos Fotóstúdio, Budapest: cat. 145
Gabriel Urbánek: cats. 21, 65, 66, 114, 129, 130
Thomas C. Vinton: fig. 69.2
© Antonia Weisse, Berlin: cat. 72
Joseph Zehavi: fig. 9.9

PRAGA

MVLTAV